The Drawings Of

MICHELANGELO

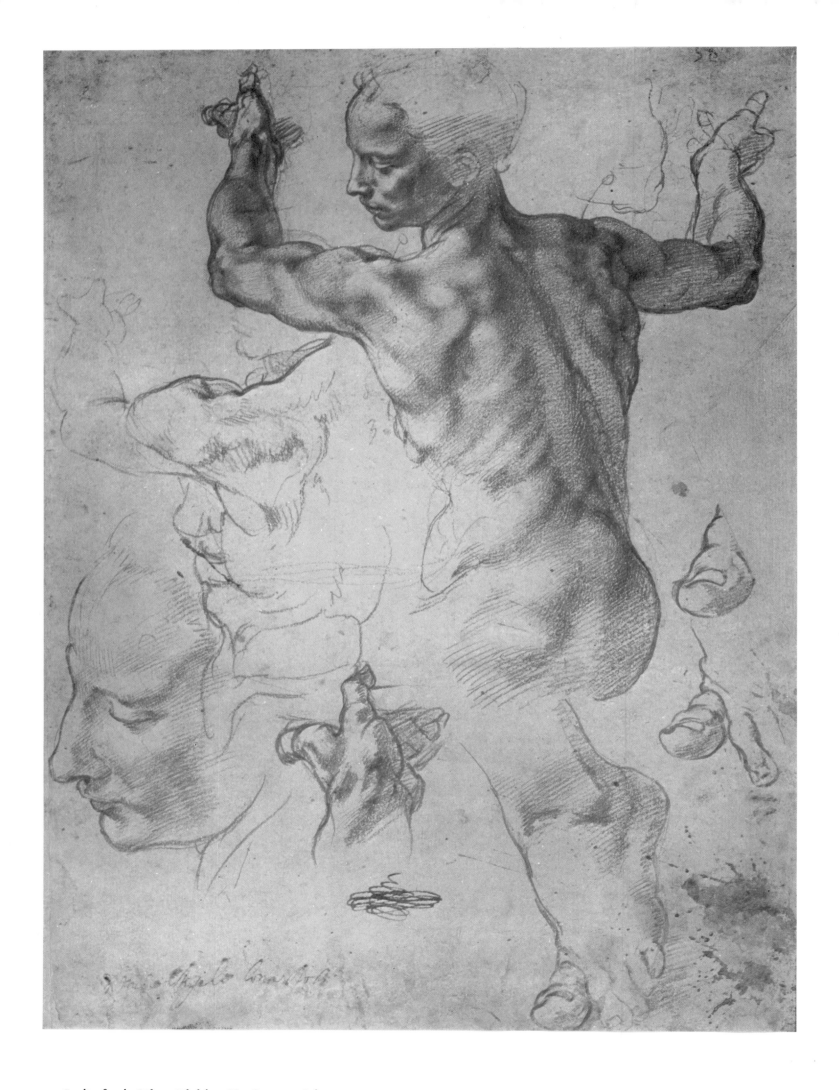

Studies for the Libyan Sibyl (see No. 87, page 83)

THE DRAWINGS OF
MICHELANGELO

FREDERICK HARTT

Chairman, Department of Art, University of Virginia

THAMES AND HUDSON·LONDON

MILTON S. FOX, *Editor-in-Chief* PATRICIA EGAN, *Editor*
Book designed by Robin Fox

First published in Great Britain in 1971 by
THAMES AND HUDSON LTD, LONDON
All Rights Reserved. No part of this publication
may be reproduced or transmitted in any form or
by any means, electronic or mechanical, including
photocopy, recording or any information storage
and retrieval system, without permission in writing
from the publisher

For sale only in the United Kingdom,
the British Commonwealth (excluding Canada)
and the Republic of South Africa

Printed in Japan

0 500 09078 5

Contents

To the incomparable

BERNARD BERENSON

in happy and grateful memory

Foreword

While this book is intended primarily for the general public, the scholar will not lose his soul on opening it. For, despite the mountainous literature on Michelangelo and his art, three surprising claims can be made for the present volume. First, it is the only time that all (or nearly all) of Michelangelo's surviving drawings have been published in a chronological arrangement, so that the development of his drawing style and the relation of his drawings to works of sculpture, painting, and architecture can be followed in detail. Second, it contains by far the largest group of reproductions of Michelangelo's drawings ever illustrated in a single study. Third, a number of important drawings are reproduced, as far as I know, for the first time.

To keep the book from becoming inordinately large, certain drawings have had to be excluded. As a class, the numerous diagrams of blocks of marble intended for the use of stonecutters in Carrara or Pietrasanta are not treated here, beyond an occasional illustration. These drawings, of great interest to scholars, are less attractive to the general reader. They are all reproduced elsewhere, in Charles de Tolnay's volumes on Michelangelo and in Paola Barocchi's catalogue of the drawings in the Archivio Buonarroti in Florence (see Bibliography). Ground plans of houses, sketches of building sites, slight sketches of architectural moldings, and figure sketches too faint for reproduction have been omitted for the same reasons. Also, no drawings which I am convinced, for one reason or another, are not by Michelangelo himself are treated here. All the omitted drawings are listed in the Concordance by Richard J. Betts at the back of this book, and all of them, save for certain obscure and unpublished attributions, can readily be found by the serious student through the use of this Concordance.

In a book like this it is impossible to give credit to individual scholars in the text—or to identify there those authors with whose opinions I differ. Therefore the only such identifications are made in the case of opinions unpublished at the date of writing. Again this is where the Concordance will prove invaluable to the scholar, who can rapidly locate the source of any opinion or discovery whether supported or contested in the text. The bibliography concerning each drawing, the provenance of the drawing before it came into its present collection, and a precise transcription of the passages of handwriting on the drawing (I give only English translations) are to be found in Luitpold Dussler's indispensable study, and in the great collection catalogues of Johannes Wilde, K. T. Parker, and Paola Barocchi. The dimensions given here are translations into inches of the metric measurements appearing in the last-named catalogues, where possible; otherwise of those listed by Dussler.

The book has been organized in terms of groups of drawings made for or connected with the paintings, sculptures, and buildings arranged in the nearest approach to chronological order possible in the art of a master who kept so many projects going at the same time. In accordance with this plan, the rectos and versos of Michelangelo's drawings have required separate catalogue entries. Sometimes the same drawing remained in his studio for twenty, thirty, or even as much as sixty years. He did not, as far as I have been able to find, tamper with the drawings on one side of a sheet at a later date, and he usually but not always drew on the recto first. But the verso could be used for drawings of an entirely different nature and purpose, or for drafts of letters, poems, or even for financial accounts. Throughout the catalogue, therefore, the rectos and versos receive individual numbers, and are often separated by many pages. They are, however, cross-referenced.

Details, in a work of this sort, are maddening. Every collection has its own system of numbering, and scholars often list a drawing not by its collection number but by the number in Frey, Berenson, or some other catalogue, which necessitates a long search from one catalogue to the next before an unillustrated drawing can finally be run to earth. This is another beauty of Mr. Betts's Concordance. At a glance all the numbers of the major catalogues can be seen, and the drawing located in this one. Every scholar who ever treated Michelangelo's drawings has made mistakes in numbers, references, dimensions, or rectos and versos. It ill becomes me to point out any of these errors, because I am likely to have made many of them myself, even though Richard Betts and David van Fossen carefully checked all my numbers. What we all claim, however, is that the Concordance offers a reasonably new approach to an ancient confusion.

In the following pages, a number of fresh solutions are proposed for some baffling problems. Sometimes I am sure of being right, and have produced a good deal of evidence to support my conclusions. Sometimes these are nothing but hypotheses which, to borrow a phrase from a myopic reviewer of one of my earlier books, I can be discovered brandishing. *Va bene!* I shall continue to brandish them in the belief that this is one way that knowledge can be advanced, as long as attractive hypotheses are *clearly labeled as such*. Eventually they will be either accepted or discarded. The whole mass of drawings I have connected with the façade of San Lorenzo is a case in point; all of them belong roughly to the period during which Michelangelo was working on this commission, some can be identified with actual saints named in the documents or with their legends, all fit together and into the scheme of the façade. One even looks like a

figure in a sketch of the façade by another artist. It is agreeable to be able to find a solution for drawings otherwise completely unidentifiable. But until some stronger evidence than this is put forward, the whole structure must be considered another hypothesis.

In general, I have tried to avoid cant and jargon in the language I have used. This is not easy. Every nation has its special repertory of this sort of thing. "Ductus," for example, may be a useful term to paleographers, but to art historians it is dangerous. Wherever possible I have adopted phrases that can be readily approached by layman, scholar, and artist, and attached them to actual draftsmanly procedures. Every now and then I have found it necessary to express emotion in the presence of a great masterpiece of draftsmanship. Michelangelo himself admits to a great deal of *passione* at times. It is a poor and desiccated attitude toward art that finds emotion unbearable.

The attribution of drawings to Michelangelo has been the subject of strong disagreement among scholars for two generations. Views expressed in the major catalogues are listed in the Concordance by means of symbols emulated from Dussler's careful bibliographic summaries. I am willing to do battle for the authenticity of all the drawings illustrated here, but I may have unjustly excluded a number of genuine ones, even in my indications in the Concordance. I await the judgment of other scholars.

In the general interest I ought to explain how this volume came to be written. My original proposal to the publishers was a selection of approximately two hundred of Michelangelo's most important and generally accepted drawings. It was they, not I, who insisted on a complete catalogue of *all* the drawings. We compromised on just those drawings which had artistic rather than purely informative interest, which accounts for the deliberate omissions listed above. Even so, I approached the task with awe, considering the identity and the number of those who had already tried their hand at it. Many years ago I had been trained in the tradition which, here and there throughout this book, I have dubbed as "revisionist," for want of a better word—that is the tendency, beginning at the turn of the century, which tried to arrive at a pure text of Michelangelo's drawings, so to speak, by discarding all the false accretions which had overgrown his work in the past. By the time I became acquainted with this doctrine in 1935, it had reached its most extreme phase, although I did not know this at the time. With the present commission I began a preliminary survey of the material, under the impression that these great attribution problems had largely been solved. I was at the time quite unprepared to accept the arguments advanced just after World War II by Johannes Wilde and followed by the majority of British scholars, justifying the reattribution to Michelangelo of a great many drawings rejected definitively, or so I thought, in the 1920s by the revisionist group, including Erwin Panofsky (my teacher), Fritz Baumgart, and Anny Popp. At the start of my work on this book I followed almost without question the attributions of the two present defenders of the revisionist position, Luitpold Dussler and Charles de Tolnay.

The moment of truth came on a cold July day in Haarlem. Studying in the company of the courteous, devoted, and determined curator, Dr. J. van Borssum-Buytmann, the Michelangelo collection in the museum of the Teylerstifting, which I had been taught to believe was almost entirely composed of spurious drawings, I was presented with visual evidence of authenticity beyond my power to dispute. This will be presented in the text and in the various entries. For the first time I began to take seriously Wilde's gentle admonition to scholars to "take a fresh look" at the whole question of the attribution of Michelangelo drawings. This I have now done, drawing by drawing, all the 537 listed and illustrated here, not to speak of hundreds more appearing only in the Concordance. The intervening years of study have not brought me to agree with Wilde and with Parker in all cases, notably in the still-vexed question of Sebastiano del Piombo, but my position is now far closer to theirs than to either of the widely separated fortresses still defended by the sole survivors of the revisionist school, Dussler and De Tolnay. Perhaps in the matter of attributions I am most in sympathy with the work of Paola Barocchi, from whose studious and sensitive catalogues I have found only occasional grounds for disagreement. I admire especially Professoressa Barocchi's plausible separation of hands among Michelangelo's imitators. And, looking back at the whole jungle of conflicting opinions and interweaving problems, it is remarkable how close, generally speaking, Wilde, Parker, Barocchi, and the present effort have come in the matter of attribution, not only to each other, but to Bernard Berenson's opinions first formulated at the turn of the century and elaborated nearly a generation ago.

At this moment I should think that the exposed nature of their present position would recommend caution to both Dussler and De Tolnay. Dussler is an exact bibliographer and a meticulous surveyor of scholarly problems. But the precision of his examination of the actual drawings may sometimes be questioned. Not untypical are his characterization of the drawing of a middle-aged man (No. 384) as a *Jünglingsakt*, or of the study of a torso seen from the front (No. 413) as a *Rückenakt*. It is true that we owe many discoveries of hitherto unrecognized sketches by Michelangelo to De Tolnay's energy and perception. I wish it were not equally true that he is responsible for the omission or rejection of a formidable number of important finished drawings. Whenever in the following pages I can be overheard grumbling at "the same two objectors," the reader will have little difficulty identifying them. (Just as, when I triumphantly declare that a certain contested drawing has been "recently revindicated," I mean by Wilde.)

No matter; Dussler's monumental catalogue is the only book in my library of which it can be said that it has remained propped open on my desk constantly for three years. And De Tolnay's positive achievements are immense, beyond all praise. As in my other volumes on Michelangelo's paintings and sculpture, I am indebted to his insights and discoveries at innumerable points in this book. We all await his new treatment of the entire material in his forthcoming Corpus of Michelangelo's drawings.

Nor are these the only recent writers to whom all students of Michelangelo's drawings must be grateful. Innumerable questions of authorship, purpose, and date among the architectural drawings have been quietly and irrefutably settled by the research of Rudolf Wittkower. These days the beginning of wisdom, in the study of Michelangelo's architecture and architectural drawings, is the thorough monograph by James S. Ackerman. Among Ackerman's many new contributions I was especially impressed by his proposal that the fortification drawings in the Casa Buonarroti were done by Michelangelo not for the hasty defenses of the city thrown up in the crisis of 1529, but in a calmer moment in 1528, when the government of the Third Republic was contemplating a permanent system of fortifications. In support of Ackerman's theory, I have attempted to show that the

fortification drawings were intended for a complete system and account for every gate.

One of the most remarkable Michelangelo discoveries in recent years has been the memorandum of Giovan Battista Figiovanni, canon and eventually prior of San Lorenzo, which we owe to Gino Corti. This astonishing document, in addition to the revelations that Michelangelo fled Florence in 1529 to save his fortune from requisition by the Republic and that he was slated for assassination (and the prospective murderer identified) by the Medici governor of Florence in 1530, has also put to rest forever the old dispute about the date and authorship of the architecture of the lower story of the Medici Chapel. It was started on November 4, 1519, by Michelangelo. My opinions on the delicate problem of authenticity have been presented in lecture form at the Art Historical Institutes of the universities of Amsterdam, Utrecht, and Leyden, at the Harvard University Center of Renaissance Studies at Villa I Tatti, and at the Institute of Fine Arts at New York University.

The staffs of a number of museums have been kind and helpful. I am especially grateful to Dottoresse Giulia Sinibaldi, Anna Forlani Tempesti, and Maria Fossi Todarow di San Giorgio of the Uffizi, Mme. Jacqueline Bouchot-Saupic and Mlle. Rosaline Bacou of the Louvre, Dr. J. van Borssum-Buytmann of the Teylersmuseum, Messrs. Philip Pouncey and John Gere of the British Museum, Miss A. Scott-Elliott of the Royal Library at Windsor, and Mr. G. L. Taylor of the Ashmolean Museum, all of whom put at my disposal the resources of the magnificent collections in their charge, and helped me in innumerable ways. I extend my warmest thanks to the private collectors who have generously permitted me to reproduce drawings in their collections, especially Her Majesty the Queen, Mr. Brinsley Ford, His Grace the Duke of Portland, Dr. A. Scharf, and Count

Antoine Seilern. Although the present book is not involved, I should like to take this moment to express my gratitude to Dr. Dioclecio Redig de Campos for particular kindnesses during a difficult moment in Rome.

Richard J. Betts was once an invaluable collaborator. He not only prepared the vast Concordance in ten months of continuous research, but save me important suggestions throughout the book. Some reattributions originally due, of course, to Wilde, Mr. Betts insisted on, despite my initial incredulity. I was eventually constrained to admit he was right. The visual evidence was too strong for argument. Although by his own words and actions Mr. Betts has since made further collaboration impossible, in the interests of scholarship all accounts of his contributions to this book must stand substantially as written. The proofreading of the Concordance—a frightening task—was cheerfully and efficiently undertaken by David van Fossen.

The Concordance and its proofreading were supported by a grant from the Committee on Faculty Research of the University of Pennsylvania, to which I am duly appreciative.

What can I possibly say about my publishers and their whole staff? I am deeply grateful for their encouragement and support at every moment in these years of research and writing. The work could not have existed without their enthusiasm and vision.

In closing I can say no more than that I have tried, to the best of my ability, to take the "fresh look" that Dr. Wilde asked for. From now on the problems belong to the reader.

F. H.
Old Ordinary
Charlottesville, Virginia
July, 1970

MICHELANGELO DRAWINGS

Drawing was the foundation of Renaissance art. For drawing is the method of predetermining form, and form for the Renaissance, especially in Florence, was the alpha and omega of artistic creation. A sketch could record a pose or a compositional idea before it fled. A precise study could help the artist investigate the structure of the body and its musculature, the light playing upon features, or the behavior of a piece of heavy cloth when hung in massive folds, before he actually had to paint or carve these things. The architect could sketch out on a piece of paper the relation of the masses of his building, in plan or in elevation, and develop all the elements of the structure, down to the capitals and the moldings, in such detail that masons could build the walls and stonecutters could do the actual carving from his drawings.

During the meteoric rise of the first great Italian figurative art in the thirteenth and fourteenth centuries, culminating in Cimabue and Giotto, remarkably little use seems to have been made of preparatory drawings on paper. The artist drew directly on the surface of the panel or the wall, and his drawing was covered up in the piecemeal process of painting. During the last twenty years, in the course of detaching threatened frescoes from their original wall surfaces for preservation, many of these original underdrawings by great masters have turned up. But it can scarcely be an accident that among the limited numbers of drawings on paper or on parchment preserved from these far-off times, very few were meant for use in the creation of a work of art. We have little but notes on reality or on *other* works of art,

especially ancient sculpture, essential for an artist in the days before photography, and detailed small-scale presentation drawings, or *modelli*, intended to give a patron a preview of the work he was ordering.

With the advent of visual realism and the consequent all-over unity of picture space and surface in the fifteenth century, it became essential to execute both fleeting sketches and careful life studies, sometimes in very great numbers, so that the artist could use them in the creation of the finished painting. These paintings were not, as in the fourteenth century, intended for the narration in human terms of a sacred story across a wall surface, but rather for the presentation of a credible and coherent image of the visual world. The most cursory reflection on the nature of the visual image in the later Middle Ages in Italy as compared with that in the Renaissance will suggest how much preparatory drawing must have been necessary for the encyclopedic world of nature presented in fifteenth-century art and how little for the beautiful but highly schematized art of the fourteenth. Most Italian paintings before the Renaissance give every evidence of having been drawn and then painted directly on the final surface without recourse to much preparatory study of compositional relationships or of visual phenomena. Drawing, the foundation of this art of form, was hidden by the supervening layers of plaster and pigment.

The immense importance of drawing to Michelangelo is attested by many passages in his letters and his poems, similar to that quoted at the beginning of this essay. Yet according to Giorgio Vasari, Michelangelo's pupil and friend,

and one of the earliest of art historians, the great artist burnt a large number of his preparatory drawings and cartoons shortly before his death, so that no one could see what pains he had been to in working out his compositions and figures, and thus his works would appear to have been perfect from the start. Undoubtedly the aged artist was thinking of the judgment of history. But his jealous concern for the welfare of his drawings during his youth and maturity and his destruction of them with his own hand during his last days are obverse and reverse of the same coin. Both attest to the great significance of the process of drawing for this supreme master of form.

The study of Michelangelo's drawings, then, admits us to the private world of his creative experience. We watch, in these often tattered and discolored leaves, the great ideas take on shape and substance as they spring from the master's mind. We see them encounter obstacles, give way to new ideas, undergo refinement until they really "work." We observe the infinitely laborious procedures of observation, analysis, and digestion of visual reality, study of line, shape, light, and surface, as well as the fitting of ideal constructions to real necessities, and even the battle with refractory materials and engineering problems. After examining these drawings with care our understanding of Michelangelo's surviving creations will never again be quite the same. We will know what at the end he did not want us to know—some of the pains he underwent in struggling with those great works whose solutions seem to us today final and absolute (to use, without blasphemy, the line from Dante that Michelangelo quoted on the Cross of the *Pietà* he drew for Vittoria Colonna, No. 455, "Non vi si pensa quanto sangue costa"—No one thinks how much blood it costs). If such a realization makes the artist seem somewhat less the "divine Michelangelo" he had already become in the eyes of his contemporaries, it will at least reveal fascinating aspects of the rich, warmly human character his letters and all his personal relationships show him to have possessed.

In such sad cases as the great cartoon for the *Battle of Cascina*, and the bronze *David*, the drawings will help us to a great extent in re-creating in our mind's eye the appearance of vanished masterpieces by Michelangelo or, in the scarcely less tragic instances of the façade for San Lorenzo and the church of San Giovanni dei Fiorentini, of splendid ideas that for one reason or another were never carried out. Finally, to twentieth-century eyes, the preliminary drawings with all their tentative, exploratory, unfinished quality, or the minutely polished drawings made for presentation to dear friends, are magnificent works of art in their own right, containing inexhaustible beauties of fantasy and form.

THE PURPOSES OF DRAWING

The purpose for which a drawing was made has so great a bearing on its character and appearance that we might best begin with a consideration of the various kinds of demands which Michelangelo's artistic activity made on the practice of drawing. First, there are the "drawings after." Like every great revolutionary, Michelangelo was deeply rooted in the past. The earliest drawings we possess by his own hand are those in which he studied great works of painting from his own proud heritage as a Florentine (Nos. 1, 2, and 6–8), and those works of ancient sculpture (Nos. 3, 4, and 6, of works not necessarily great, but at least available) in which he could observe the way in which the artists in classical antiquity treated the problem which interested Michelangelo the most, his whole life long—the depiction of

those activities of the human body in which the passions of the human spirit could find their expression. Giotto and Masaccio remain embedded in Michelangelo's bloodstream; he never forgets the simple grandeur of their utterance and gesture, or the clear power of their form. But to classical antiquity he has to turn again and again, and in middle age we find him still drawing from ancient art (Nos. 241–44).

The second class which springs naturally to mind is that of the composition sketch. Very revealingly, this group is distinguished by its extreme rarity among Michelangelo's surviving graphic works, for reasons which will be considered a bit later. Most of these few composition sketches are rude and formless (Nos. 25, 66, 69, and 370–72, for instance), a general melee in which few elements can be distinguished clearly. Those figures that do succeed in establishing themselves at this stage seem to have been remembered from ancient art or from life, or both, rather than to have been invented for the composition. What is particularly strange about all these composition sketches is that Michelangelo never starts with the limits of the picture or sculptural composition, as one might think necessity would require him to do. The tangles of figures float in nowhere, contemptuous of all limits. When Michelangelo actually started working, however, he planned the enframing elements with watchmaker precision, and with astonishing mechanical ingenuity, then forced his unruly compositions into the borders. Often a kind of warfare is kept up between frames and compositions, and painted figures and even statues overstep their limits, issuing from thrones or niches with some violence. Sometimes (Nos. 217 and 503) this sort of conflict seems to have been planned from the start.

Then come the figure sketches (for example, Nos. 64, 65, 73, and 93–100). These seem to have arisen spontaneously in Michelangelo's mind on the basis, of course, of long experience and intensive observation of the behavior and potentiality of the human figure, but related more to the eternally mysterious sources of Michelangelo's creative imagination than to any external reality. Poses are explored, altered, changed, rejected, crossed out. In the process an individual figure may acquire three heads, six arms, or five legs, in varying degrees of mistiness. Then even when the final position of a limb is established, its exact contour still changes constantly as the drawing instrument moves across the paper. These changes are known as *pentimenti* (literally, repentances—or changes of mind).

Once the pose of a figure has been established, then it has to be checked against the physical resources and limitations of the human body (Nos. 46–49, 77, 87, 89–92, 101–5, 227–40, 379–81, and 389–91). Vasari does indeed say, when referring to Michelangelo's portrait of his friend Tommaso Cavalieri, "that neither before nor after did he ever make a portrait of anyone, because he abhorred making the resemblance of life, if it was not of infinite beauty." This passage has been taken to mean that Michelangelo never drew from the living model. Nothing could be further from the truth. There is a very large group of drawings which show all the circumstances of the studio and the posed model, down even to such prosaic details as brief Renaissance underwear. In the absence of any exact information there is little point in speculating who Michelangelo's models may have been, but one thing is certain—they were not always "of infinite beauty." In fact, quite a number of them are badly proportioned, probably through the heavy work to which they were accustomed. Bodies subjected daily to great weights can develop powerful arm, leg, and back muscles, for instance, but not splendid pectorals. Michelangelo's nude studies

display little of the harmony of the ideal athlete of ancient times, save for his drawings of adolescents, whose native animal grace was not yet distorted by heavy labor. It is amazing to watch what, after utilizing these models to find out just how a muscle would act under a given set of conditions, Michelangelo was able to make of his sometimes physically unpromising raw materials. The final figures on the Sistine Ceiling—Adam for one—are "of an infinite beauty" one could never have predicted from the life study, No. 77. Sometimes, too, the separate heads, not only for Prophets and Sibyls who would require a certain degree of character and realism, but also for the nudes of the Sistine Ceiling, are so obviously drawn from living, breathing models that there would seem to be little room for doubt. Numbers 85 and 86, for example, are so vivid and so salty that Michelangelo could scarcely have dreamed them up, and the smile of the lad in No. 106 is too impish for any invention.

Of course Michelangelo knew his anatomy, and was one of the pioneers in turning anatomical dissection to an artistic purpose. If his account some sixty years later is to be believed, he persuaded the prior of Santo Spirito to allow him to dissect corpses in the hospital, in return for making the recently rediscovered *Crucifix* for the high altar of the church. Unless No. 51 is one of the drawings he made then (and there is no firm basis for such a tentative attribution), Michelangelo's anatomical studies are not preserved. Aside from his dissection in 1550 of the body of a Negro of perfect proportions, there is no indication that Michelangelo went any further in the scientific analysis of the human machine. Certainly he had no interest in the precise muscle-by-muscle, tendon-by-tendon studies undertaken in such exhaustive detail by Leonardo da Vinci about 1510 in Florence. (One can hardly help noting that after those investigations Leonardo very nearly lost interest in painting the human figure.) And very often in Michelangelo's painted or sculptured figures one gets the impression that he allowed his imagination to supplant his anatomical knowledge.

A very important class of drawings was the cartoon (from the Italian word *cartone*; heavy paper or, today, cardboard). The cartoon was a full-scale drawing of an entire pictorial composition, made in order to establish the exact shape and position of every element before painting began. The cartoon came into common use only about the middle of the fifteenth century, replacing the underdrawing on the rough plaster which had been customary up to that time. The cartoon provided many advantages, chief among which was the fact that it was not covered up, as the underdrawing was when the artist added smooth plaster for his day's work, but remained a constant guide during the course of the entire painting. It was made up of many separate folio sheets of paper pasted together. During the fifteenth century the outlines were transferred to the soft plaster by means of "pouncing," that is, pricking the contours in many places to make little holes, through which powdered charcoal could be quickly dusted onto the plaster. Michelangelo was probably the first to utilize a new and more rapid means of transference, holding the cartoon against the wall or ceiling and tracing the contours heavily with a pointed metal instrument, or stylus, into the soft plaster. The stylus marks can be easily seen in many detail photographs of the Sistine Ceiling taken in raking light. It has often been remarked that, once the outlines were transferred mechanically to the surface of the plaster, Michelangelo paid only the most general attention to them, proceeding to expand his forms far beyond their original limits. Possibly in the general holocaust of his last days, most of Michelangelo's cartoons have perished, but luckily three remain, Nos. 407, 438, and 440, to give us some idea of this essential intermediary between imagination and execution.

From the surviving evidence, Michelangelo does not seem to have been in the habit of making *modelli* for his own use. He must have worked directly at the great cartoons, on the basis of composition sketches and model studies. But occasionally circumstances demanded a *modello*. The patron perhaps required one, especially for a monumental work of architecture or combined architecture and sculpture (Nos. 45, 320, 524, 527, and 529), and the finished and labeled plans of the fortifications of Florence (Nos. 327, 328, 334–46) certainly fit into this category. He did, however, make a number of very beautiful drawings as gifts for persons particularly close to him, such as Tommaso Cavalieri and Vittoria Colonna (Nos. 353–62, 408, 437, and 455), in which various aspects of personal affection, religious feeling, or both received an elaborate formal statement which must be considered the visual equivalent of the complex allegories, similes, and metaphors of Renaissance poetry, including Michelangelo's own. Characteristically, many of Michelangelo's most intensely moving and exquisitely constructed poems were written for the recipients of these same presentation drawings. After the freedom and ease of the composition and figure sketches, and the exploratory keenness of the life studies, the presentation drawings come as a shock. They are finished with delicate smoothness of surface and contour, down very nearly to the final detail. One says "very nearly" advisedly, because Michelangelo, with his lifelong distaste for Flemish art, never approached visual reality with the microscopic reverence of the great Northern masters. But Vittoria Colonna looked at her Michelangelo drawings with a magnifying glass, and it has been recently and wisely suggested that we ought to do the same. The artist who painted on an undreamed-of scale in the Sistine Chapel could still pore over nuances of tone and surface in these miraculous presentation drawings, several of which must have taken weeks of quiet work.

There were other personal drawings, too, apparently made on the spur of the moment for the amusement as well as instruction of his pupils, such as Nos. 19 and 310–14. Along with patterns of eyes, ears, locks of hair, and the like, and an occasional affectionate or monitory written phrase, these sheets contain quick *ghiribizzi* (caprices)—bits of fantasy or even caricature, sometimes (to borrow an expression from the late Aldous Huxley) mildly obscene. And during those strange last years when the old man lived in so much physical pain and spiritual uncertainty, hardly able to leave his house in the Macello dei Corvi to superintend the vast architectural projects which sprang from his imagination, or for that matter even to climb the stairs from one floor to another, he drew to give vent to his own musings on death, salvation, the sacrifice of Christ, the incarnation—the ultimate mysteries of the Christian religion and of man's existence. Some of these drawings (Nos. 410–36) may have been intended for embodiment in monumental art, but many seem to have had no purpose beyond themselves, and to be again a visual equivalent of Michelangelo's poetry, in this case the religious sonnets in which man's need for God is set forth with such devastating intensity.

A final class, the working drawings, may exert less romantic attraction on the rapid page-turner, but are nonetheless of vast importance for Michelangelo's creations of sculpture and architecture, and are often beautiful in themselves. Sketch plans of extant houses and of sites for future building offer little aesthetic interest, even when produced by

Michelangelo's hand. But the ground plans of libraries, churches, chapels, and fortifications (Nos. 281, 282, 325–46, 502, and 514–17) make magnificent designs. Even the numerous diagrams of marble blocks furnished to the stonecutter to give him the precise dimensions of a mass of stone from which a column, an entablature, or a statue was later to be carved, merit a stylistic study they have not yet received and, alas, will not here. It is understandable enough that such quasi-sculptural elements as classical capitals should be analyzed by a great artist in exact detail. But it is surprising to find him so concerned with the profiles of moldings—those vanishing elements in the architecture of our own time. Such things meant just as much to Michelangelo as the locks of hair or the drapery of his human figures. In designing them, nothing was left to chance. The exact formal and rhythmic—even coloristic—effect of every turn of line and shape was investigated with fanatical zeal. Every now and then a face is formed by one of these profiles, indicating how human the artist felt them to be. A mere glance at such designs as Nos. 208, 209, 271–73, and 277–79 will show what attention one should pay to these so often neglected details of Michelangelo's architecture.

Michelangelo's humanity is a fit subject for our contemplation, because humanity, and divinity concealed within humanity, and the divine origin and divine destiny of humanity, was his only subject, in whichever of the four arts he was working at any given moment. The human figure and its activities and inner life is therefore the sole determinant of his compositions. In the fifteenth century Alberti had announced principles for the proper division of the pictorial surface, and on these principles the great early Renaissance doctrines of composition and perspective, inseparable in theory and in practice, had proceeded to their triumphal culmination in the serene art of Piero della Francesca. Neither composition nor perspective, in the early Renaissance sense of division and proportion, based on the relation between the object and the eye, held much interest for Michelangelo. His compositions were a product of the interactivities of his figures, and he could not therefore tell what the final composition would be until he knew what the figures were going to do. His method was antipictorial, but so were his beliefs. Sculpture was to him the lantern for painting. The pictorial composition proceeded, then, not from what the eye saw in a given space but from what the figures did anywhere. Only as their relationships became precise could the composition itself be formulated and localized. The surviving composition sketches are always composed of thumbnail-size figures. Their motions expanded as their scale increased, when the individual figures and groups of figures came to be studied. Even in the vast wall painting of the *Last Judgment*, composition was a process of trial and error. Individual figures and groups were moved about freely in the drawings, or substituted for others. The over-all scheme, and the relationship of the masses to the actual space of the room in which they were to go, were the ultimate, not the initial, phase in Michelangelo's creative procedure. In the Sistine Ceiling, for instance, these essential (or so one would think) aspects of the work changed drastically as he painted, so that the first section of the composition exerts an entirely different effect from that produced by the last section.

Painting could grow, but not sculpture. The blocks for the great statues could, of course, not be ordered while the poses were changing in Michelangelo's mind. But once the marble arrived, the statues could only shrink, and sometimes they shrank alarmingly as Michelangelo worked. Still, the procedure of composing them in relation to each other and to the enframing architectural and ornamental elements was identical to that followed in pictorial composition. In both, drawings provide the key. Sometimes it seems as if the individual figures must have been composed on much the same principle as the vast paintings and sculptural groups, for the drawings often concern only *disjecta membra* (disjointed fragments)—torsos, legs, arms, shoulders, hands. And even these are subjected to an analysis so profound that they have been mistaken repeatedly for studies from flayed cadavers, which the very tautness of the tendons and tonus of the muscles immediately denies. Often the figures studied from life are headless, perhaps because the models did not possess heads that satisfied Michelangelo. These he supplied from other sources. It is striking how often Michelangelo reuses the same hand or leg, or even the same pose, between one great work and another and even in various portions of a work as populous as the Sistine Ceiling. He seems to have had a kind of body bank in which these spare parts could be stored against the next necessity.

But then, he kept his drawings around his studio an incredible length of time. Who knows how wide a chronological range may have been included in that sack he asked his father to pack up and send to him on January 31, 1506? Quite possibly it contained some of those old dissection studies done at Santo Spirito in 1495. The one possibility for such an identification is indeed accompanied on the same sheet, No. 51, by life studies for the *Dying Slave*. Time and again one finds an early drawing on the recto of a sheet and a late one on the verso. Sometimes the time lag is as much as thirty years (Nos. 43 and 384), or even sixty (Nos. 51 and 413)—that is, if the anatomical studies on No. 51 were really made in 1495.

FORM AND TECHNIQUE

Michelangelo was at heart always a sculptor, and sculpture, in the classical tradition, is an art of line. This may be difficult for modern viewers to appreciate, but it is true. Perception of form is approximate if it must rely solely on light and shade, but exact if it can be reduced to contour. Line is the prime and absolute determinant of form. The classical sculptor always studied his shapes earnestly as they appeared and overlapped along the ever-changing profile—rotating the figure, observing the elements from every side, from above, and from below. And how often in the twentieth century has sculpture almost dissolved into linear structures that suggest masses rather than carve them, or that organize the empty air in terms of lines (Gabo, Lipchitz, Calder, Lippold)! Characteristically a sculptor's drawings are founded on contour, even in the case of so fluid a style as that of Rodin.

Michelangelo, therefore, in all of the visual arts he practiced, began with line. His basic sculptural procedure consisted of drawing the contours on the faces of the block and pursuing them inward, around the indwelling figure, with a pointed chisel or *subbia*. In draftsmanship he set down his contours tentatively and delicately at first. *Pentimenti* were the inevitable forerunners of the authoritative contour. Sometimes these were not sufficient, and Michelangelo made what is known as a counterproof, that is, rubbed the drawing off on another sheet, naturally reversing it in the process. He was thus enabled, however, to get a fresh start. Once the final contour was established, whether slowly or rapidly, it was generally reinforced so as to flow with an apparent ease and power that was really the result of prolonged analysis and

thought. Then Michelangelo was free to study the inner forms, first by means of rapid contours of bony and muscular masses, many examples of which survive in Michelangelo's drawings, especially in marginal areas or unfinished sections of the principal studies. The next step, corresponding to the blocking-in of sculptural masses with the two-toothed chisel or *calcagnuolo*, was the low, diagonal hatching—almost horizontal—covering wide areas with great speed, power, and surprising uniformity. Thereupon, subtler relations of shape and surface were studied by means of crosshatching in detail, bringing out all the most delicate pulsations of shape in the manner of the third stage of stone carving, the analysis of surface by means of the three-toothed chisel or *gradina*; this is the semifinal stage in which so many of Michelangelo's most beautiful surfaces are left, such as the head of the *Medici Madonna* or most of the *Victory*. Then came the finishing of the drawing surface, analogous to the filing of the marble and its polishing by pumice or straw. In the chalk drawings the finish appears to have been achieved with the fingers, but sometimes with a cloth. In the great presentation drawings of the 1530s, and perhaps even earlier, the shading, thus modeled, was then delicately stippled with a sharpened point of chalk to produce a surface of gossamer delicacy and pearly shimmer. This fourfold draftsmanly procedure, like the sculptural technique to which it so nearly corresponds, seems to have been Michelangelo's own invention.

At the start, Michelangelo drew by preference with the pen. It was sharp, like a chisel, and, like the mark of steel on stone, the pen line lasted as long as the substance on which it was drawn. Pen was, of course, the favorite drawing instrument of the Ghirlandaio workshop in which the young artist received his first training, but he did not use pen in the loose, generalized manner of Ghirlandaio and his pupils. In his old age Michelangelo told his biographer Ascanio Condivi about how when a boy he copied an engraving of the *Temptation of St. Anthony* by the great German master Martin Schongauer. It has often been noted how strongly the early pen technique of Michelangelo, with its meticulous surfaces hatched, crosshatched, and recrosshatched, resembles the engravings of Schongauer, produced by the action of a steel burin on a copper plate. However, Michelangelo did not necessarily use the pen from the beginning. Probably he started with a few tentative charcoal lines which could be easily erased after the first ineradicable pen lines went down. Later on, when he used chalk so much, one finds delicate tracings of pen over initial chalk lines. Boldness with the pen, or with any other instrument, came only with time. Some of the pen drawings for the Medici Chapel are amazing in the violence of their attack on the paper.

The importation of red and black chalks into Florence, probably by Leonardo da Vinci on his return from Milan in the early sixteenth century, offered enormous new possibilities for Michelangelo's drawing style. He seems to have adopted chalk only about 1506 for some of his most delicate model studies for the Tomb of Julius II, and then continued using it when he resumed work on the now-lost cartoon for the *Battle of Cascina* after his return to Florence. Chalk—hatched, modeled, and stippled as described above—surpassed pen in its luminosity and richness, and was particularly suited for studies for painting. Most of the drawings for the Sistine Ceiling, the *Last Judgment*, and the Pauline Chapel are accordingly in red or black chalk.

Only occasionally does Michelangelo seem to have resorted to silverpoint, the delight of the fifteenth-century painter-draftsman. Probably it was just too dainty for him, but once in a while, as in Nos. 101 and 102, he found that nothing else would produce just the right softness of warm, young skin. Wash—probably a thinned-out ink (and this is no place to go into the fantastic question of the composition of Renaissance inks)—was very useful to Michelangelo at times. Vasari tells us he employed it in the battle cartoon, and he certainly utilized this convenient means in drapery studies, only two of which survive, Nos. 82 and 84. In architectural plans made for presentation to laymen, wash came in very handy as a means of distinguishing the walls from the neighboring ground and the banks from the moats. Also large areas could be covered with it at great speed, so architectural and ornamental masses could be modeled in wash, also for the benefit of a patron, with a minimum of effort. Only once in a while do we find Michelangelo resorting to white highlights, so popular in the fifteenth century (Nos. 41, 44, and 105). Usually he resists the temptation.

The appearance of a sheet of studies or sketches by Michelangelo, some right side up, some upside down, some on their sides, can be perplexing. This was due to his method of utilizing the paper as fully as possible in a period when paper was still very expensive, and of turning the sheet as he worked, possibly so as not to be too influenced by what he had already done. In consequence the reader will find himself constantly rotating this book in order to catch up with the changing directions of Michelangelo's drawings. However, the way these images went on a page is not without its significance for Michelangelo's monumental works, particularly those in painting. It is not possible to see all the figures and scenes in the Sistine Ceiling properly from a single point of view (as one can in Baroque church and palace interiors, for instance) any more than it is with these drawings. In fact, to the four basic directions the images can assume on a sheet of paper, Michelangelo adds four diagonal directions in the Sistine Ceiling!

Often, after studying a figure in minute detail and with the greatest power of form and delicacy of surface, Michelangelo still found it necessary to go after some portion of the figure a second (or third or fourth) time in the margins. Perhaps a hand or foot did not fit on the sheet, and needed to be studied separately (No. 105). Or perhaps he felt it necessary to penetrate a little more deeply into the plastic structure of some crucial bit of anatomy (Nos. 87 and 90–92), or to feminize for a Sibyl a face drawn from a tough male model. Often the same sheet was used for drawings, letters, poems, and accounts, or merely cryptic remarks. Sometimes in the drawings, particularly the early ones, Michelangelo adds to the fun by establishing a proto-Surrealist double-image relationship between quite separate sketches. But no matter for what purpose the studies or sketches were drawn, or in what order, manner, and direction they hit the paper, they *compose*, and compose rightly. This is the miracle of Michelangelo's draftsmanship, which can be followed with delight by the simple expedient of turning the pages of this book. Every sheet, whether or not Michelangelo deliberately intended it to be so, is a masterpiece of composition, with all the weights balanced against each other in a vital and meaningful way, all the relationships displaying the tensions, suspensions, resolutions, harmonies, and dissonances of his monumental art. To this the drawings make a perfect introduction.

Always in these sheets the sublime drama of form is played out as an eternal interaction between the divine mirrored in the human, the human reaching out to the divine. In the last awesome spectacles of the Crucifixion on Golgotha (the divine suffering death for the human), or the Annuncia-

tion at Nazareth (the divine incarnate in the human), one is put in mind of the religious music of Michelangelo's contemporary, Palestrina. The linear contours, the *pentimenti*, the hatching, float and blend on the paper like the voices of choral polyphony in the air. But even here, and perhaps here most of all, while earthly substance dissolves around the artist, in these tremulous last drawings his vision of form increases in power and majesty.

THE PROBLEM OF AUTHENTICITY

And now we come to some embarrassing questions. If Michelangelo is indeed one of the greatest draftsmen who ever lived, the public is justified in asking why scholars are unable to agree on whether a given drawing was really done by him, or by Sebastiano del Piombo (a gifted but very different sort of artist), Antonio Mini (an unfortunate hack), Daniele da Volterra (a competent pupil, whose style is known), or some elusive but astoundingly proficient imitator. And why in so many and such striking instances have gifted scholars changed their minds over the same drawing or the same group of drawings? Attributions of necessity involve estimates of quality. By definition an imitation must lack the quality of the real thing. Is it impossible to determine the difference objectively?

The reasons for the rejection of vast numbers of drawings formerly attributed to Michelangelo himself would be obvious if we could be transported back to the European drawing cabinets of seventy years ago. But the necessary revision of the optimistic eighteenth- and nineteenth-century lists, in order to sort out imitations, irrelevant attributions, or just plain copies, got out of hand during the last thirty years. More recently the revisionist tendency has been reversed, and many of the rejected drawings reinstated. In line with the present policy of careful re-examination, it might be wise at this point to consider just what are the criteria for authenticity.

The customary formula for the rejection of a given drawing runs somewhat like this: The drawing shows characteristics *a*, *b*, and *c*. (These are carefully enumerated, but often in a tone which betrays that the issue has been prejudged.) Such characteristics are "nowhere found among Michelangelo's authentic drawings," or are "completely foreign to Michelangelo's drawing style." The case is then considered proved and the drawing resolutely rejected. This rejection is then, of course, used as a fulcrum to pry loose from the structure of Michelangelo's work other drawings, which show the same array of stylistic traits. The separation of "authentic" from "apocryphal" drawings, thus carefully arrived at, will appear to rest on a scientific foundation, since every stage of the process has been verbally justified.

But the method has a fatal flaw. Nothing prevents the critic from consigning initially a complete category of original drawings by Michelangelo to the limbo of apocryphal works because he does not recognize their style, or because someone else does not. Once this has happened, every other drawing in that same style is at once rejected, because there are no accepted drawings left to compare it with. Of course the questioned drawing is "foreign to Michelangelo's style"! One is reminded of the tearful complaints of the Walrus and the Carpenter who looked around for more of those trusting oysters who were walking with them on the sand, and found none:

And this was scarcely odd because
They'd eaten every one.

The *reductio ad absurdam* of the entire procedure may be found in the fact that as lately as 1949 an eminent scholar rejected the great Metropolitan Museum study for the *Libyan Sibyl*, No. 87, a masterpiece whose authenticity seems to most of us unassailable. But the arguments used were perfectly logical. Number 87 was demonstrably by the same hand as all the Haarlem drawings for the Sistine Ceiling, Nos. 74–76, 92, and 103, which the revisionists had long ago rejected. Here one can only agree. The style *is* identical, down to the last touch of the chalk, throughout the group including the *Libyan Sibyl*. Would it not have been more sensible, then, to take another look at the Haarlem drawings?

What has happened is simply this: In their laudable zeal to purge the list of Michelangelo's drawings of all impostors, the revisionists have started with a preconception of the master's style, and thrown out every drawing which did not fit. How much better it would have been to start with those drawings which must have been done *for* rather than *after* Michelangelo's paintings or sculptures, and arrive at a notion of the possibilities of his drawing style from those! Such a procedure might have resulted in many a discovery regarding Michelangelo's technique, particularly in the investigation of the art of a man renowned during his own lifetime for his unpredictable and revolutionary methods.

Is it possible to determine whether a drawing was made for or after another work of art? Let us examine the requirements of the problem. The drawings at issue (and there are a surprising number of them) have been proposed by some writers as copies after Michelangelo's works of art, the Sistine Ceiling for example. A copy, again by definition, is something made to resemble the original as closely as possible. But the poses of all the figures in this group differ slightly if significantly from those of the corresponding figures in the frescoes or statues. Sometimes the figures in the drawings are even seen from a different point of view. Sometimes limbs concealed by drapery or by other figures in a fresco are beautifully delineated in the drawing. Sometimes the drawing shows two or three solutions for the same form or pose, none of them corresponding exactly to that adopted in the painting or work of sculpture. Sometimes the drawing shows all the idiosyncrasies of a not-too-harmoniously proportioned model, instead of the nobility of the idealized final figure. If any of these discrepancies can be demonstrated, the hypothesis of a copy after the finished work is no longer tenable, although some of the revisionists have not yet recognized that fact.

Others have, however, and can present us with a second explanation. To them the contested drawings are still copies, not after finished works of art but after Michelangelo's lost preparatory drawings. Now in order to prove such an assumption it would be necessary to find some examples— copies of universally accepted Michelangelo drawings—and compare them with the real thing. Luckily many such copies are available for the purpose, in every major drawing collection. Not one shows the quality of the challenged drawings. All can be easily recognized as copies, due to their overcareful, halting line and soggy treatment of form.

Drawing is the most intimate of all modes of artistic expression, the immediate concretion of the artist's imagination and vision. The spontaneous movements of his hand cannot be accurately imitated in *shape* without destroying their spontaneity, nor can their *spontaneity* be emulated and the same shape retained. It can be stated with little fear of contradiction that no copyist can ever produce lines as crisp, free, and sure as those set down by an artist in the freshness of creation or observation. The artist works from imagina-

tion, memory, experience, emotion, impulse, or any combination of these. The copyist can only try to set down exactly what he sees. In the copyist's version the artist's rapid line will inevitably slow down and wander a bit. The artist's shorthand, made only for himself, will be misunderstood by the copyist.

How about the *pentimenti*? The artist changes his mind half a dozen times before the pose is just right or, even with the model sitting in front of him, before the contour of a limb flows the way he wants it to. Can the copyist not make *pentimenti* too? Indeed he can, but his attempts to copy the artist's *pentimenti* will run the same risks as his efforts to reproduce any other lines he did not invent. An artist's *pentimenti* are fresh, free, and rapid, with clean, clear marks of the equal drawing tool held by a hand moving swiftly, without external controls. The copyist, who has to look and draw, look and draw, cannot imitate this speed and freedom. His *pentimenti* will be about as convincing as a stage fall. More often, the *pentimenti* in a copy are the result of the copyist's own mistaken and corrected transcription of the artist's lines. Any reader who has studied academic drawing seriously, particularly from the nude, or who has ever tried to copy a master drawing, will be able to verify and enrich these remarks from his own experience.

So the contested drawings are not copies after the frescoes and not copies after the preparatory drawings. But they are not yet safe—the determined revisionist retreats the better to advance. A third possibility is proposed. The drawings are imitations. Again we must examine what circumstances are necessary to prove such an assumption, and we find the difficulties immeasurably increased. Most of the drawings are life studies. We would have to believe that someone managed to get hold of Michelangelo's models, whoever they may have been, posed them in the exact successive positions Michelangelo himself went through as he was evolving in his mind the final poses of the figures in the frescoes and the statues, and then drew them in a style so precisely imitated from Michelangelo's own that only three or four critics in the entire history of Michelangelo scholarship have been sufficiently acute to detect the fraud.

Now if there were such a miraculously gifted imitator, why do we not know his name? Did he never do any paintings or any sculpture on the basis of such a phenomenal technical endowment? Can no one point to a single work he has left? And if there be indeed such an imitator, could not the revisionists agree on his identity, or at least on the consistency of the group of drawings he is supposed to have produced? Alas, each doubter has compiled his own list of suspect drawings, and his own name or group of names for their authorship. Under close examination, all these candidates have now evaporated. We are left with nothing but the "anonymous *destailleur*," to quote the expression used by one of the two revisionists still writing.

By now the whole question has taken on the proportions— and the absurdity—of the attempts to give Shakespeare's plays to Bacon, or the Earl of Oxford, or Marlowe, or whomever, and it will rapidly, let us hope, suffer the same fate. As the catalogue will show, the questioned drawings are works of very high quality. One can only wonder why the lightning struck just those and not others. As a bit of future insurance it ought to be accepted that when a drawing is (*a*) of sufficient quality to have impressed a great many sensitive persons as genuine, (*b*) too different from the finished work of art to be considered a copy after it, (*c*) too fresh and too full of *pentimenti* to be a copy from a vanished original drawing, then the burden of proof is on the accuser. In future, revisionist attacks will require serious demonstration with comparative photographs and detailed analysis. We have long passed the moment in the history of criticism when generally accepted masterpieces could be rejected by formula, dismissed with a word, or ignored altogether.

The matter would remain no more than a quarrel among specialists were it not that the omission or rejection of a large and important group of Michelangelo's drawings from certain standard works on his art has now deprived about a generation of students and the general public of magnificent creations, including some of the most beautiful life studies for the Sistine Ceiling. Moreover the decimation of Michelangelo's graphic production has been so widespread and so capricious as to prevent the formation of any coherent idea of the relation of his drawings to his paintings and sculptures, and of the evolution of his style as a draftsman. If the comments throughout this catalogue are occasionally tinged with bitterness, a glance at the accompanying illustrations of majestic but rejected works will explain why.

1

Studies after Florentine painting, classical sculpture, and the human figure.. Florence, c. 1490–1500

None of Michelangelo's drawings for his earliest sculpture in Florence, Bologna, and Rome has survived. Surely the *Battle of Lapiths and Centaurs*, the *Madonna of the Stairs*, the newly rediscovered *Crucifix* for Santo Spirito, the three statuettes for San Domenico in Bologna, and the lost *Hercules* and *St. John* needed at least some preparatory sketches. The elaborate anatomical constructions of the *Bacchus*, and of the *Pietà* in St. Peter's, must have required careful analytical drawings from life. The disappearance of every one of these suggests that Michelangelo himself destroyed them, possibly, as Vasari says (see page 20), so that no one would know how much labor the finished works of art had demanded. In view of the total absence of early studies for the artist's own works, the preservation of several drawings by Michelangelo after the works of others acquires a special significance. Apparently these were works which had made a certain impression on the young man, or from which he had learned valuable lessons. Giotto and Masaccio, the great masters of the classic tradition of Florentine painting, were to provide the foundation of Michelangelo's drapery style. The heroic action figures of the Hellenistic and Roman tradition inspired his nudes. He must have returned to these early studies again and again. In 1528, when he was probably at work on the *Victory* and the Academy *Slaves* for the Tomb of Julius II, and was in Florence awaiting the siege of the papal and imperial troops, he had No. 3 in his hands.

All the early drawings are in pen, but the technique has little to do with the manner of pen drawing in the school of Ghirlandaio in which Michelangelo had been brought up. Ghirlandaio sketched freely and openly, with uncorrected contours, few *pentimenti*, and loose, broadly spaced hatching. The technique of Michelangelo's early pen drawings is remarkably linear, engraver-like in its careful hatching and crosshatching, building up a rich and dense surface modeling. This manner has often been compared with the artist's sculptural technique, especially the way in which he developed the surface of his marble forms with the *gradina*, or three-toothed chisel, the penultimate stage just before the finishing with file, pumice, and straw. It is also very close to the way in which the great German engraver Martin Schongauer, whose prints the young artist admired, worked the surfaces of his copper plates with the burin.

Numbers 3 and 4 are generally dated several years later than suggested here. Yet they are from works of art in Rome, not Florence, and can hardly be memory images. The exact position from which the artist drew these two figures—in both cases, from an angle—is clearly visible. The sheets must date during the period of the *Bacchus* and

the *Pietà*, in the Rome of Alexander VI. The elaborate pen technique projects an intense activity of rippling muscles based on an analysis of actual moving figures, completely absent from the blank and smooth surfaces of the relatively inferior ancient originals the artist actually saw.

1. *Two figures, after Giotto*
About 1490
Pen, 12½×8″, cut down
PARIS, LOUVRE, 706 recto (for verso see No. 14)

The young artist has selected only the two foreground figures from a group of five at the left side of Giotto's fresco, *The Ascension of St. John*, in the Peruzzi Chapel at Santa Croce in Florence. Santa Croce, parish church of the Buonarroti family, was only a short distance from their home in the Via dei Bentaccordi. While retaining the poses and the main contours of Giotto's figures, Michelangelo made a number of small changes. The drapery is more naturalistic than that in the fresco, betraying Michelangelo's training under Ghirlandaio. Several new folds have been introduced and some of the original ones suppressed, so as to indicate the actual behavior of masses of cloth. The hands have become more taut and nervous, and Giotto's calm faces are replaced by anxious ones. The timidity of the technique has caused scholars to consider this the earliest of Michelangelo's known drawings.

2. *St. Peter, after Masaccio*
About 1490
Pen with additions in red chalk, 12½×7¾″, cut down
MUNICH, GRAPHISCHE SAMMLUNG, 2191

St. Peter, giving the tribute money to the Roman tax collector, has been studied carefully as an exercise in form and shading, but again the drapery has been made somewhat more complex. Both in the folds of cloth and in the handling of the profile Michelangelo has worked out linear relationships which indicate the interaction of masses in a manner completely foreign to the style of Masaccio. The drawing is probably to be dated during the period when Michelangelo was living in the Medici Palace and working in the Medici gardens. During these years a fellow student, the sculptor Pietro Torrigiani, enraged at Michelangelo's sharp comments on his work while both were drawing after Masaccio's frescoes in the Brancacci Chapel, inflicted the blow which broke Michelangelo's nose, disfiguring him for life. Ac-

cording to Torrigiani's own account both were *fanciulletti* (little boys). This would seem to date the drawing well before the death of Lorenzo de' Medici in 1492, when Michelangelo was seventeen. The two arms and hands in red chalk are later additions, probably by Michelangelo. One points upward at the head of St. Peter; the other is extended to St. Peter's nose as if delivering a blow. Considering the frequency of autobiographical references in Michelangelo's work, it is not impossible that these additional sketches were meant to recall the violent incident in the Brancacci Chapel.

3. *Nude male figure seen from the back*
1496–1500
Pen, $16\frac{1}{2} \times 11\frac{1}{4}''$, cut down, folded, patched out at left; damaged by dampness
FLORENCE, CASA BUONARROTI, 73 F recto

It has been shown that Michelangelo studied this figure from a Roman sarcophagus depicting the legend of Hercules. Two examples of this type of sarcophagus are still in Rome, but none was ever known to exist in Florence. In order to get just this back view, the young artist looked *along* the sarcophagus from one end, since the original figure, in high relief, is placed in profile. In all known examples the Roman Hercules figure is stockier than Michelangelo's very supple version. The rich but inaccurate play of muscles and bones seems to have been derived from the artist's imagination rather than from observation of the original, in which no such modeling appears, or from any human figure. The contour was reinforced several times by the artist, who added some gratuitous flourishes along the left hip and a clumsy attempt to supply the right foot which, in the original sarcophagus, is covered by the foot of an adjoining figure. In its brilliant surface effects but its lack of interest in the turning of the figure in space, the drawing seems contemporary with the marble *Bacchus*. The hatching and cross-hatching are much more elaborate than in Nos. 1 and 2, the early drawings after Giotto and Masaccio. The inscription on the back of the drawing, in Michelangelo's handwriting, records how on September 24, 1528, his nephew Lionardo came to live in his house in Florence, and this is followed by an account of the money spent for Lionardo between October 10 and 30. Michelangelo probably intended to utilize the figure in his first idea for the *Battle of Cascina*, commenced about eight years later. But Nos. 34–40, actually done for that lost cartoon, are surer and more advanced in style.

4. *Nude male figure running*
1496–1500
Pen and brown ink, with addition in black chalk, $14\frac{3}{4} \times 9\frac{1}{8}''$, trimmed at top edge, two horizontal folds, patched; black chalk badly rubbed, head damaged by dampness
LONDON, BRITISH MUSEUM, W. 4 recto
(for verso see No. 11)

As is generally recognized, this drawing is based on the famous Hellenistic statue known as the *Apollo Belvedere* which, at the time of Michelangelo's first visit to Rome, was in the palace of Cardinal Giuliano della Rovere, later Pope Julius II, the artist's first papal patron. Cardinal della Rovere was then absent in France, a refugee from Borgia tyranny, but his cousin, Cardinal Riario, was a patron of Michelangelo, and could have admitted him to the Rovere palace. The statue has been seen from below and, as in the case of the Hercules, No. 3, been somewhat attenuated, and supplied with an enriched anatomy. Michelangelo's imagination has also allowed the curls to swing freely in the air, and removed the mantle whose folds conceal the chest. The beautiful and very convincing extended left arm may have been studied from a living model. An inscription in an unknown hand seems to be the beginning of a letter. Another, in Michelangelo's own writing, reads "I was nude, now I am badly clothed."

5. *A hand, a leg, a male figure seen from the back*
About 1498–1500
Pen, $10\frac{7}{8} \times 8\frac{1}{2}''$, spotted and faded
FLORENCE, ARCHIVIO BUONARROTI, II-III, 3 verso
(recto not reproduced)

A brief, undated letter from Michelangelo's brother Buonarroto is written on both sides of the sheet, whose recto was also used by the artist for a draft of his agreement with Cardinal Piccolomini for the Piccolomini altarpiece in the Cathedral of Siena, dated May, 1501. The sketches seem already to have been on the sheet by this time. The verso contains two passages in Michelangelo's hand, a quotation from Petrarch "Death is the end of a dark prison," and another "desire in desire, and then leave grief," which has not been traced. Opinions vary considerably as to the exact date of these little sketches, but all scholars think they are very early. The suppleness and delicacy of the lines connect them with the style of the *Pietà* and the fullness of the forms with the *Bacchus*. They may well be the earliest life drawings by Michelangelo preserved to us. They represent a notable step toward the rendering of movement which was to make the lost *Battle of Cascina* such a triumph.

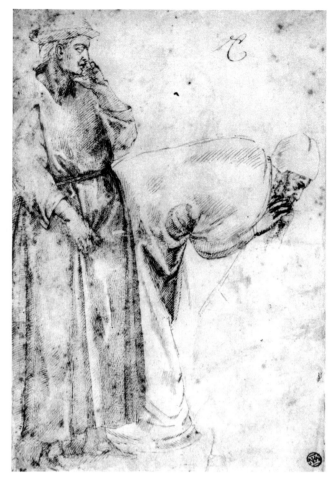

1

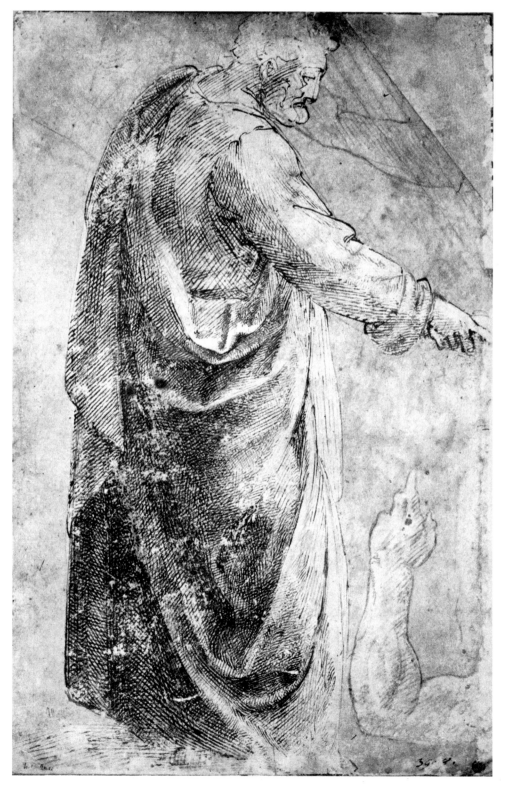

2

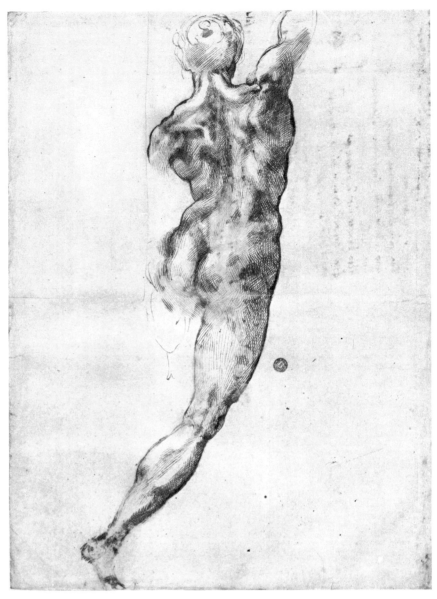

3

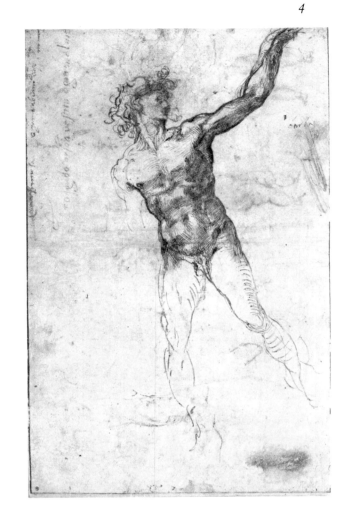

4

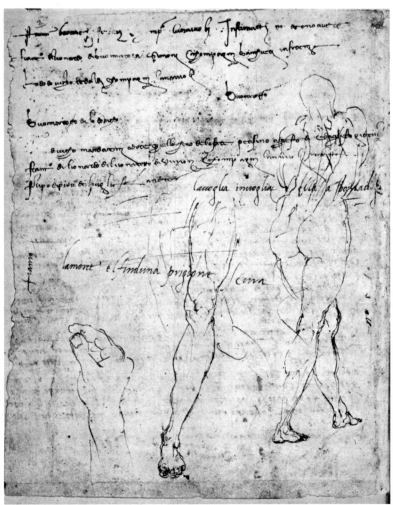

5

2

Drawings in the second Florentine period. Florence, 1500–1505

Studies after Florentine paintings and classical sculpture, 1501–3

Three drawings of much the same character as Nos. 1–4 are here dated after Michelangelo's return to Florence from Rome early in 1501. They display a far greater maturity in every respect: the increased flexibility of the figure, the unification of the inner forms with the contour, the easier motion of muscular masses and drapery folds in depth, the sense of a surrounding envelope of space and light. The crosshatching in pen is more expertly handled, not only in the meticulous polish it creates, but in the way this close-textured surface is used to build facets at angles to each other in depth. This is now the drawing style of a master sculptor, recording visual observations in a less fantastic and more controlled manner. Again the sources appear to be in ancient sculpture and Florentine painting, but only two of these (in Nos. 6 and 7) can be identified with any degree of conviction.

6. *Studies of nude and draped figures*
About 1501–3
Pen, 10⅜×15¼", cut down, folded, and patched; head of second figure from right patched in
CHANTILLY, MUSÉE CONDÉ, 29 recto
(for verso see No. 56)

The two nude women have been considered back and side views of the central figure in a late Roman group of the *Three Graces* in the Piccolomini Library of the Cathedral of Siena, which Michelangelo must have seen when he was in Siena in 1501, in connection with the statues for the Piccolomini Altar. If this feeble group is really the source of the two very lively studies, Michelangelo has done even more for it than he did for the originals of Nos. 3 and 4, building up a subtle succession of muscular contractions and releases, especially in the beautiful back. No one has found a possible source for the bearded male figure at the left, which looks as if it had been drawn after an ancient satyr statue or relief. The piece of drapery at the extreme right has been connected with Roman herms like those Michelangelo emulated in the designs for the Tomb of Julius II.
 Most scholars have agreed that the draped female figure is a study after a section of the lost *Sagra* of Masaccio (see No. 7), and at first sight the powerful projection of the

drapery masses does indeed suggest the monumental fresco style of Masaccio. But there is an insuperable objection. Not only does the delicate head look unlike Masaccio, but the hair is brought back from a high, plucked forehead, and wrapped around the head in intertwined braids in a manner that cannot be found in the art of Masaccio (died 1428) or any of his contemporaries. This style of headdress was popular in Florence in the 1440s, but may have arisen as early as 1438 or 1439. The figure suggests the art of Domenico Veneziano, especially the standing St. Lucy in the *Madonna and Saints* (the so-called St. Lucy altarpiece) now in the Uffizi, painted about 1445 for the little church of Santa Lucia dei Magnoli. But the resemblance is not exact. More likely the drawing was done after a figure in the now destroyed series of frescoes depicting the life of the Virgin, painted by Domenico with the assistance of Piero della Francesca for the hospital church of Sant'Egidio, from 1439–45. The beautiful passages of reflected light in the drapery folds recall the luminous style of Domenico Veneziano.

7. *Standing draped figures*
About 1501–3
Pen, 11⅝×8", patched in several places around edges
VIENNA, ALBERTINA, S. R. 150 recto (for verso see No. 8)

Universally recognized as a probable copy after one section of Masaccio's fresco representing the *Sagra* (consecration) of the church of the Carmine in Florence, a solemn event which took place in 1422 in the presence of the leading personalities of the Republic. The fresco was destroyed when the cloister in which it was painted was replaced by a new one at the end of the sixteenth century, and there is no evidence as to the exact appearance of Masaccio's composition. It is generally accepted that the figure lightly drawn at the right, with the keys hanging at his belt, is the gatekeeper of the monastery, described in Vasari's account. The power of Masaccio's fold structure is much more coherently realized than in No. 2, doubtless drawn at least ten years earlier.

8. *Kneeling draped figure*
About 1501–3
For medium, dimensions, and condition, see No. 7
VIENNA, ALBERTINA, S. R. 150 verso
(for recto see No. 7)

Generally believed, like No. 7, to be a study after one of
the figures of Masaccio's lost *Sagra*. In this case the hypothesis
is less likely. It is hard to see what a kneeling man would be
doing with his back to the spectator in a fresco representing
a ceremonial procession, and there are no indications of other
surrounding figures as in No. 7. Furthermore, the man is
wearing the traditional doctor's garb in which Sts. Cosmas
and Damian, patron saints of the Medici family, are custom-
arily represented. It has been noted that one of these
saints is shown kneeling in this position, in reverse, in a
panel by the minor fifteenth-century painter Pesellino.
Possibly both Pesellino's pose and Michelangelo's drawing
derive from the same original, now lost. Most likely this was
an altarpiece representing the Madonna and Child enthroned,
with Sts. Cosmas and Damian on either side. Even from
Michelangelo's beautiful study it is hardly possible to surmise
the identity of the original artist.

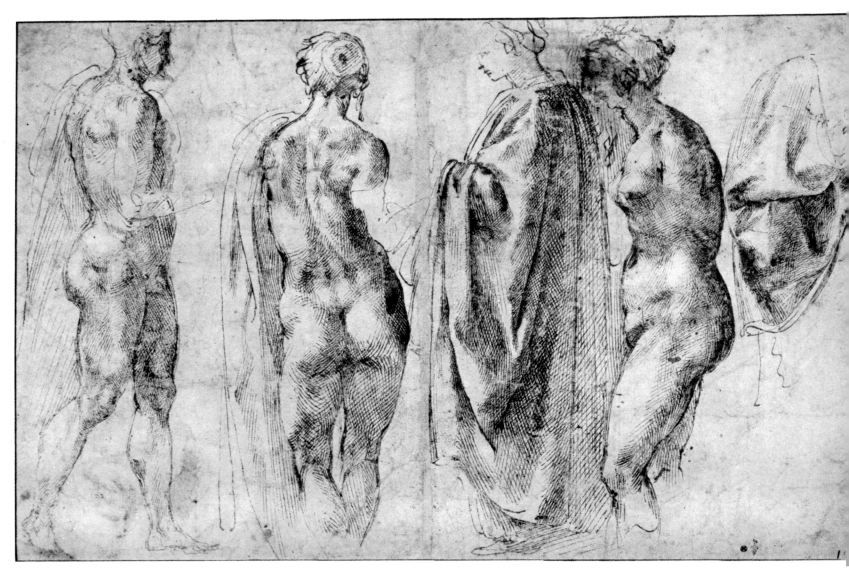

6

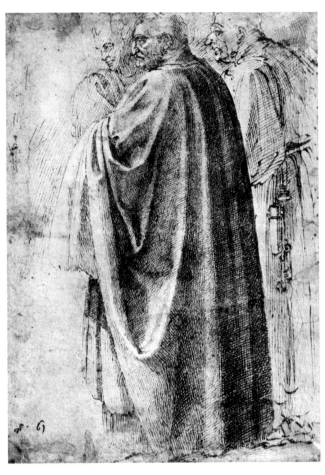

7

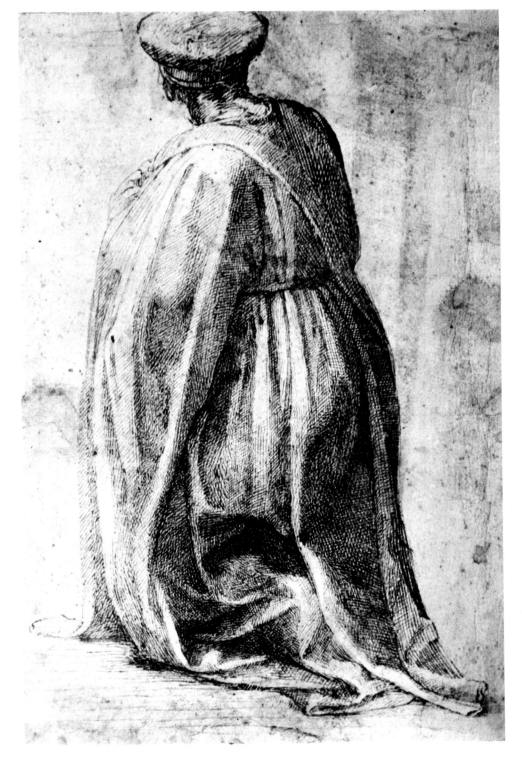

8

Drawings for Madonnas, 1501–4

In a number of fine drawings for the *Taddei Madonna, Doni Madonna,* and *Bruges Madonna,* Nos. 10–14, 24, and 27, we can follow the evolution of the artist's interest in playing children, to be used as the Christ Child and the infant Baptist, and in the pensive face of Mary. Although in two of these works, the *Madonna* for Taddeo Taddei and that for Agnolo Doni, Michelangelo was required to conform to the fashionable circular shape, he seems to have proceeded without regard for the frame—which in the later *Pitti Madonna* he was to violate. The series is all done in pen, save for two carefully executed drawings Nos. 12 and 14, for the *Doni Madonna.* Studies for the *Bruges Madonna,* including a group with the Virgin still nude, and independent sketches possibly for the Child walking, appear on recto and verso of black chalk drawings intended for the *Battle of Cascina,* Nos. 27 and 28, indicating that the marble group must have been carried out at about the same time as the great lost cartoon.

9. *The Virgin and Child with St. Anne*
1501–2
Pen and brown ink, 10⅛×7″, heavily corroded;
verso shows through
OXFORD, ASHMOLEAN MUSEUM, P. 291 recto (for verso see No. 16)

All recent writers have agreed that Michelangelo's group was derived from the lost second cartoon by Leonardo da Vinci for the *Madonna and St. Anne* now in the Louvre. This cartoon was exhibited at the Santissima Annunziata at the time of Michelangelo's probable return to Florence in the spring of 1501. Several of Leonardo's drawings for the cartoon are known. Although the dense, pyramidal grouping of the figures is surely Leonardo's invention, the younger artist made a number of significant changes, such as the highly characteristic rubbing together of the Virgin's knees (like the knees of the recently rediscovered early *Crucifix* in Santo Spirito, or the *Dying Slave* in the Louvre). The mantle strap over the left shoulder, which plays so strong a role in the Rome *Pietà,* reappears as a powerful diagonal, counter to the diagonal movements of the left arms of both women. The vigor and freshness of this sketch indicate that it was no more than a recapitulation of Leonardo's idea, sharply altered according to Michelangelo's own conceptions. The composition, never utilized directly by Michelangelo as it was to be by a host of other artists in Florence in the early sixteenth century, nonetheless gave a special direction to his Madonna compositions at that time (see Nos. 56 and 57) and to some of his Sibyls in the Sistine Ceiling later.

10. *Sketches and life studies for the Taddei Madonna; Self-Portrait of Michelangelo*
1501–2
Pen, 11¼×8¼″, cut down
BERLIN-DAHLEM, STAATLICHE MUSEEN, KUPFERSTICHKABINETT, 1363

The genuineness of this glorious drawing, one of the most brilliant studies from Michelangelo's second Florentine period, has been inexplicably doubted by a few scholars.

The sheet was omitted entirely from the major modern study of Michelangelo. The style is identical with that of Nos. 16 and 18, both universally accepted. The drawing should be welcomed as the earliest known complete study of a head from life by Michelangelo. The model, probably a young man, reappears in the nude study, No. 16. Here the head is treated in the utmost detail of which Michelangelo's early pen style was capable, bringing out every facet of the rich modeling of nose, eyes, mouth, cheeks, and forehead. The hair has been partly tucked inside the headcloth, partly allowed to fall over the right shoulder upon the breast. A mantlestrap crosses the breast as in the Rome *Pietà,* and is held by a brooch above the bosom. As is common in Michelangelo's head studies from life, the nose and eye have been drawn again, this time at the left, with the eye looking outward. The high polish and bright illumination of the life studies suggest the *Doni Madonna.* The rest of the sheet is filled with a separate study of the Christ Child, probably not from life, a sketch of the Christ Child at the top, and two quick sketches of children's heads in full face and in profile. The bent leg of the Christ Child reappears in reverse in the Child of the *Doni Madonna.* The masses of hatching and crosshatching recall the handling of the unfinished surface of the equally crowded *Taddei Madonna.* None of the child studies was utilized in this work, but the head was feminized for the purpose, as in the case of the *Libyan Sibyl* (No. 87).

The easily recognizable self-portrait of Michelangelo in his late twenties, almost at the center of the sheet, has thus far escaped notice. The broad, low forehead, the strong cheekbones, the furrowed brow, the broken nose, the short beard, the look of corrosive inner anxiety, even the tilt of the head, are to be encountered throughout all the portraits of the artist at all stages of his life. The placing of the head, between the Christ Child and His mother, is especially instructive with regard to the inner feelings of the artist who declared that he drank in the love of stonecutter's tools with the milk of his wet nurse, and placed his only sculptured signature on the mantle strap over the bosom of the Virgin in the *Pietà.* The same head reappears, under even more revealing circumstances, in two other early drawings, Nos. 16 and 17.

11. *Twelve sketches of children for the Taddei Madonna*
1501–3
Pen, faint sketches in black chalk, 9⅛×14¾″
LONDON, BRITISH MUSEUM, W. 4 verso
(for recto see No. 4)

Three of the children, to the right, on their sides, were intended for the infant Baptist in the *Taddei Madonna.* The child in the upper right-hand corner, upside down, is related to the Christ Child in No. 10. All the children are indistinguishable in style from those in Nos. 10, 58, and 59. Such is the sense of immediacy in these vivid sketches as to suggest that Michelangelo made them as he watched naked infants at play. The words "things of Bruges" in an unknown sixteenth-century hand, twice repeated, are hard to explain, as these figures have little to do with the Christ Child in the *Bruges Madonna.* "Alessandro Manecti" was written by Michelangelo himself.

12. *Study for the head of the Doni Madonna*
1503–4
Red chalk, 7⅞×6¾″, cut down and rubbed
FLORENCE, CASA BUONARROTI, 1 F recto

This superb study has never been doubted. It may have
been done from the same model as No. 10, in which the same
concern for the appearance of the eye when directed upward
is responsible for the glance of the Christ Child. There is
no difference in quality between the two drawings. There
have been unsuccessful attempts to connect this study with
the head of *Jonah* in the Sistine Ceiling, turned in the opposite
direction and quite different in style. Most critics now agree
that the drawing is much earlier, and is a preliminary model
study for the head of the *Doni Madonna*, turned a little dif-
ferently in the finished painting, so as to show both rolling
eyes instead of just one. The broad, low, diagonal hatching
does not change in Michelangelo's other head studies before
about 1510.

13. *Study for the Child in the Doni Madonna*
1503–4
Pen, 6⅜×3⅝″, cut down, spotted, mounted
FLORENCE, CASA BUONARROTI, 23 F

Although it was initially doubted, and was seldom even
noticed, all recent writers have accepted this powerful
drawing as genuine. In the cramped position of the leg, made
even more compact in the finished picture, and in the ferocity
of the heavy, loaded pen strokes, the immense latent power
of Michelangelo's art is evident as in few of his other early
drawings.

14. *Study for the left arm of the Doni Madonna (portion of sheet)*
1503–4
Red chalk over stylus preparations; for dimensions of whole,
see No. 1; badly rubbed and in places indecipherable
PARIS, LOUVRE, 706 verso (for recto see No. 1)

This interesting sketch was brought to light in 1945. It
has been variously dated. No one has yet noticed that it
corresponds fairly well to the left arm of the *Doni Madonna*,
and is in a style identical with that of No. 12. On turning the
sheet upside down, the badly damaged left side of a child
will emerge, thus far unnoticed, probably a preliminary study
for the Christ Child in the same painting.

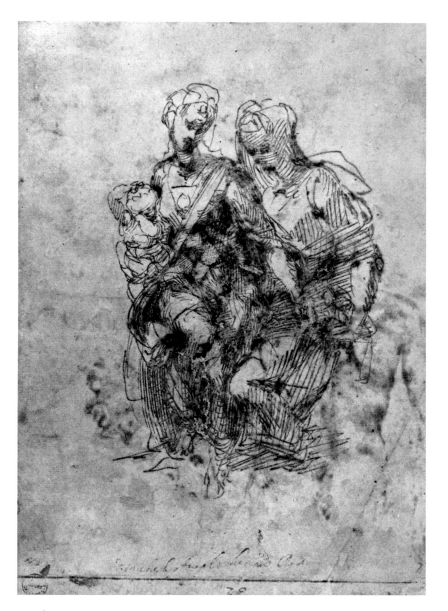

9

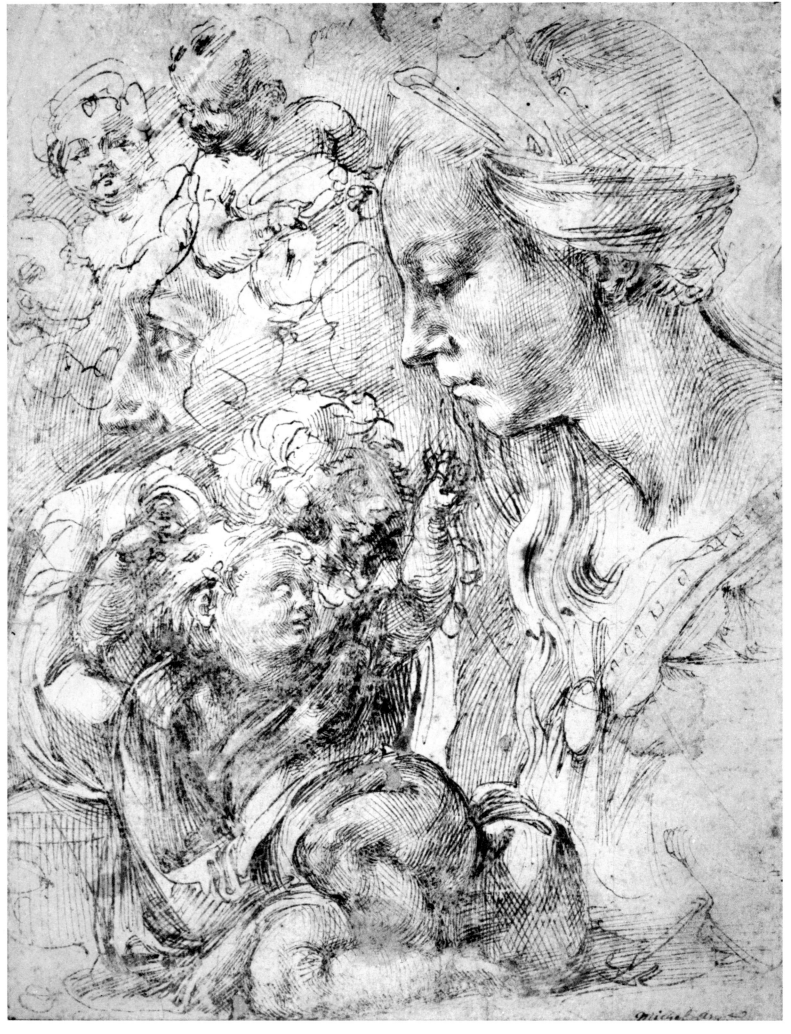

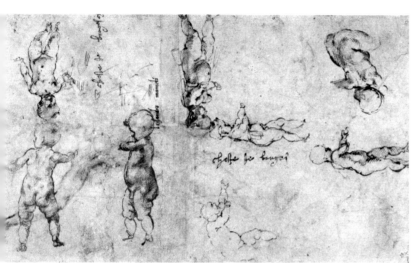

11

12

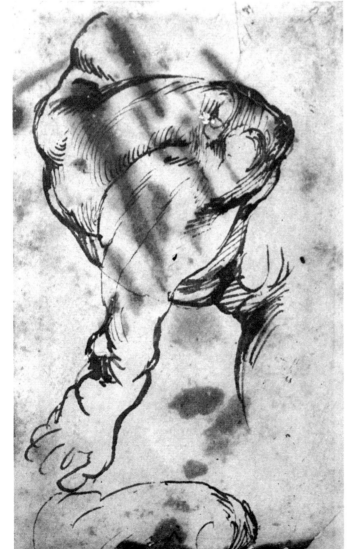

13

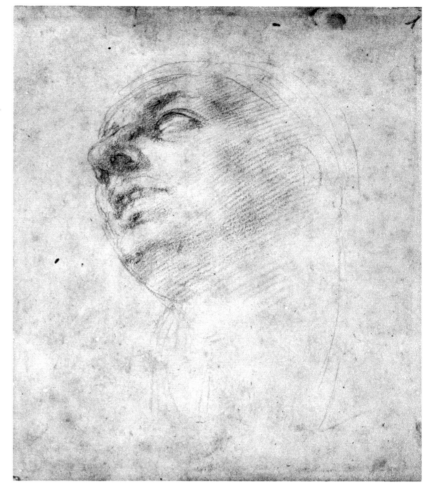

14

Studies for other early works, 1501–2

Parallel with the foregoing Madonna studies, Michelangelo developed his ideas of the nude male figure, sometimes heroic, often in action, occasionally with distinct autobiographic and erotic overtones. To our infinite regret, out of all the drawings he must have made for the marble *David*, only No. 20 remains; this same sheet gives us our only evidence regarding the original appearance of the lost bronze *David*, started in 1502 and delivered only in 1508, not finished by the artist himself. A number of sketches and studies (Nos. 15–18) exploit the mobility of various limbs of the male body, always in the careful pen technique of the drawings from ancient sculpture and Florentine painting. In these studies Michelangelo approaches his first grand-scale realization of struggling figures, the lost cartoon for the *Battle of Cascina*, designed in 1504.

15. *Studies of a man digging, a head and shoulders seen from the back, and sketches of shoulders*
Probably 1501–2
Pen, 10½×7⅜″, cut down
PARIS, LOUVRE, 714 verso (for recto see No. 20)

The digging man repeats in reverse, as is generally known, the *Adam Digging* by Jacopo della Quercia on the portal of San Petronio in Bologna, which Michelangelo had had opportunity to study in 1494–95. The pose is enriched here and there by study from a living model, who was then studied from the back in the carefully hatched and crosshatched study at the lower left. Between the head of one figure and the arm of the other, the artist has drawn the head a second time, converting the previous head into a shoulder for the new one, so that it functions as a double image, with almost Surrealistic effect. Above, the right shoulder of the digging figure has been analyzed in line, and at the right the back view of the right shoulder restudied twice to determine the behavior of the bones and muscles. The lines at the top of the sheet, "To the sweet murmur of a little river, which descends slowly from the green shadow of a clear spring," are not otherwise known, nor is the purpose of the drawing.

16. *Studies of a male back, four heads, and a self-portrait*
Probably 1501–2
Pen and brown ink, 10⅛×7″, heavily corroded; recto shows through
OXFORD, ASHMOLEAN MUSEUM, P. 291 verso
(for recto see No. 9)

The same model who posed for No. 15 was studied again from the back, with indications of the buttocks and legs, in the identical hatched and crosshatched style. The sheet was then turned on its right side and two female heads, possibly from a male model, lightly sketched in, along with a harsh and bony male profile. At the right corner, a nude boy is delicately studied to the waist, his head in profile surrounded by long curls, apparently the same model utilized for the magnificent Madonna in No. 10. In the center appears the recognizable head of the artist in his late twenties, as in Nos. 10 and 17, his eyelids barely open, his head thrown back, with an expression of curious languor. The word "Leardo" in Michelangelo's writing may stand for Leonardo.

17. *A nude youth, and two self-portraits*
Probably 1501–2
Pen and brown ink, 9¼×7½″, spotted
OXFORD, ASHMOLEAN MUSEUM, P. 292 recto
(for verso see No. 18)

Apparently the same adolescent model who posed for the sketch in No. 16, but this time the torso is drawn to include indications of the thighs. A wild fantasy has then converted the extremities into suggestions of a triton's serpentine fins, and crowned the soft, youthful torso with the scraggy middle-aged profile seen in No. 16, supplied with a winged helmet. Again the head of the artist, once with and once without the scarf visible in No. 16, is shown twice, first approaching, then overlapping the youthful groin. An unidentifiable beardless head, with an expression similar to that of the later *Dying Slave*, appears under the uplifted right arm.

18. *Studies of a male back and uplifted arm*
Probably 1501–2
For medium, dimensions, and condition, see No. 17
OXFORD, ASHMOLEAN MUSEUM, P. 292 verso
(for recto see No. 17)

The same strong, male back drawn in No. 16 is studied to indicate the play of muscles around the waist, and the effect of lifting is seen in the forms of the left shoulder and upper arm from the back. This same arm is studied again from the front, suggesting the later *Dying Slave*. The self-portraits in No. 17 show through from the recto.

19. *Sketches of heads and features*
1504(?)
Pen, 8×10″, cut down, patched at bottom
HAMBURG, KUNSTHALLE, 21094

Mentioned only four times and once rejected, this little-known drawing shows all the traits of Michelangelo's style during the period immediately after his return from Rome to Florence. The brilliant pen technique is identical with that of No. 10. The eyes in profile are handled in a manner strikingly similar to their treatment in No. 16. The eye and brow at the bottom of the sheet are very close to those of the marble *David*, and the locks to the treatment of the hair of the Child in the *Bruges Madonna*. The sensitivity of the details, above all the astonishingly beautiful mouth, is worthy only of a great master. All these elements are characteristic of the delicate, exploratory phase of Michelangelo's early maturity, during which he constantly sought to push further the understanding of surface play and of skin and muscle developed by the marble sculptors of the later fifteenth century. Such whimsies as the child made up of a few flourishes of the pen are thoroughly characteristic of Michelangelo's fantasy at most periods of his life. The fantastic warrior head, with its eagle-and-dragon helmet, was repeated by the artist in a later drawing known only through copies. The handwriting is that of Michelangelo himself. The following words can be read:

> Upper left-hand corner: "Love"
> Upper right-hand corner: "Antonio"
> Below this: "My sweet dear . . . I pray that nature me . . . Friend" "Lord Alessandro"

20. *Studies for the bronze David and the marble David*
Probably 1501–2
Pen, 10½×7⅜″, cut down
PARIS, LOUVRE, 714 recto (for verso see No. 15)

A rapid and brilliant study, possibly from a living model, of the lost bronze *David*, 2½ *braccia* high, ordered by Pierre de Rohan, Maréchal de Gié, for which Michelangelo signed a contract on August 12, 1502; and upside down, a somewhat more detailed drawing, certainly from life, for the right arm of the marble *David*, commissioned a year earlier. These supple and vibrant studies, still marked by the grandeur of classical art observed in Rome and by the tension of Donatello, define a new stage in the evolution of Michelangelo's figure style toward the expression of the capabilities and power of the human body in action fully realized in the great series of studies for the *Battle of Cascina* (Nos. 25–44A). Probably the arm of the marble *David* was drawn first, in 1501, in the careful, engraver-like style of Nos. 3–8, and then Michelangelo utilized the remainder of the sheet at the left in 1502 for the much freer study for the bronze *David*, whose left foot toys with the severed head of Goliath in the manner of the *Davids* by Donatello, Verrocchio, Castagno, and Pollaiuolo. He is a pensive rather than a triumphant victor. At the right Michelangelo has written, "David with the slingshot and I with the bow," a recently clarified allusion to the bow used to rotate a stonecutter's drill, and "Broken is the high column, the green . . .", the first line of a sonnet by Petrarch.

15

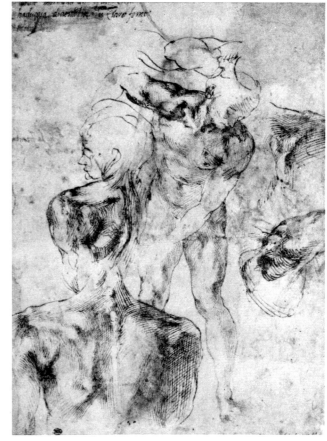

16

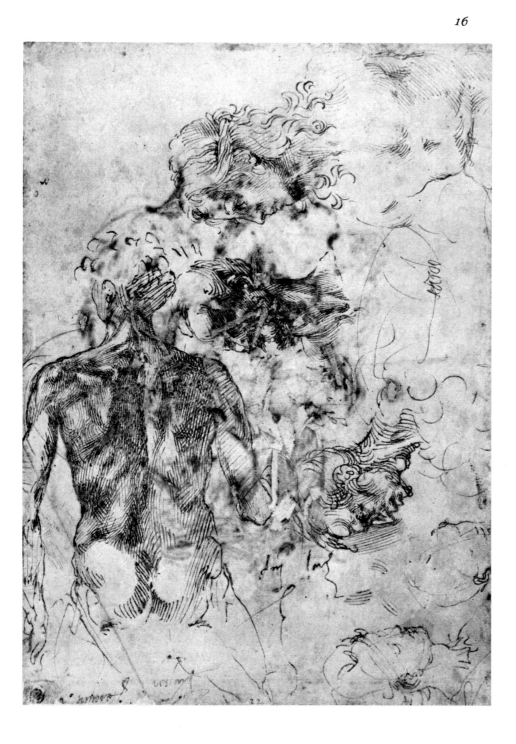

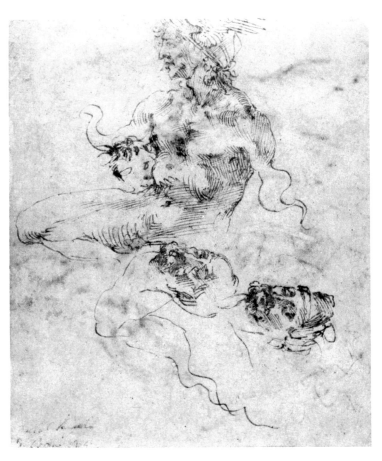

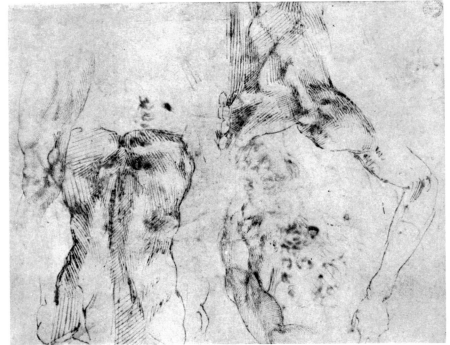

18

17

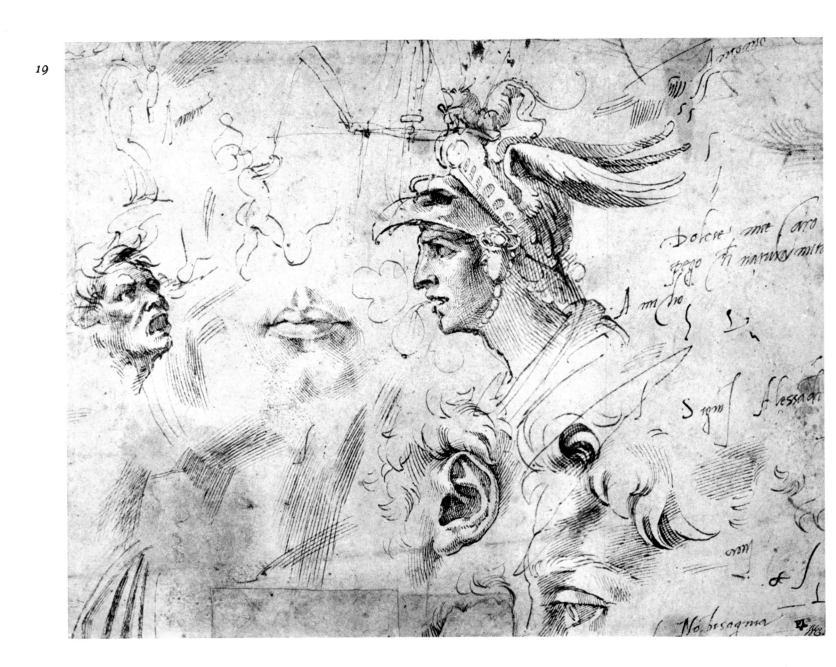

19

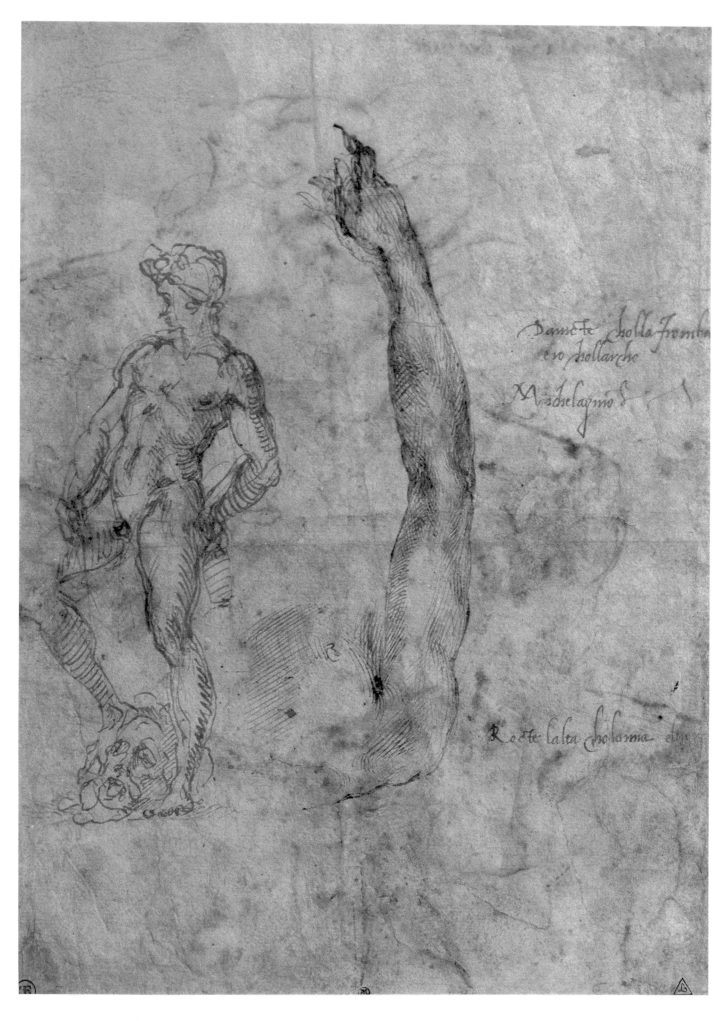

Studies for the Twelve Apostles, 1503–4

On April 24, 1503, Michelangelo signed the contract for the twelve statues of the Apostles which were to be placed in the Cathedral of Florence. One was to be carved each year for the next twelve years. The quarrying of the marble for the statues began at Carrara in 1504. Only one statue was ever executed, the *St. Matthew* now in the Accademia in Florence, probably somewhat later, in 1506 and 1507, and even that remains unfinished. The contract was annulled in 1508. Several sketches for the statues are preserved, Nos. 22 and 24, and one finished study, apparently a presentation drawing, No. 21, is here connected for the first time with the series of statues. Between the preparatory sketches with their powerful diagonal arrangement of masses in space, and the finished drawing with its gleaming marmoreal surfaces, the effect of the great series of statues can be imagined, in the vast spaces of Santa Maria del Fiore. Studies for the *Battle of Cascina*, the paper for whose cartoon was ordered in 1504, and for a Madonna and Child group, probably the *Bruges Madonna*, show how many separate ideas were going on in Michelangelo's mind at the same time during this very creative period in his imaginative development, while the marble *David* was nearing completion. The arm of the *St. Matthew* was studied in No. 50, probably after Michelangelo's inglorious return to Florence in 1506.

21. *St. James the Greater* (?)
Probably 1503
Pen, yellow-brown and gray-brown ink, 13 × 8½",
carefully patched hole below right elbow
LONDON, BRITISH MUSEUM, W. 1 recto
(for verso see No. 245)

At once the most carefully finished and the most majestic of Michelangelo's early drawings, this bearded figure has been the subject of much speculation. The object he holds forth has been variously interpreted as a sphere and a skull. Although not provided with readily recognizable features, such as eye sockets, teeth, and nostrils, the ovoid but irregular shape and the flattened base of the object, the only unfinished passage in the drawing, certainly suggest a skull. The curious shape of the hat, typical of those worn by Greek visitors to Florence, reappears in Renaissance representations of ancient philosophers. This hat is, however, worn by the Empress Helena in the frescoes of the Legend of the True Cross by Agnolo Gaddi in the choir of Santa Croce in Florence, which must have been familiar to Michelangelo from childhood. The cockleshell on the crown of the hat is the symbol worn by pilgrims to the shrine of Santiago (St. James) de Compostela in Spain, and is incompatible with the hypothesis of a philosopher (or even alchemist, according to some scholars). Representations of St. James during the Middle Ages and the Renaissance often show him as a pilgrim with a broad-brimmed hat, and always with a cockleshell (the *coquille St. Jacques*).

St. James, according to tradition, was beheaded. It is natural, therefore, that he should be carrying a skull. The Epistle of St. James culminates in a tribute to the efficacy of the prayer of Christians for one another, and ends:

> ... He which converteth the sinner from the error of his way shall save a soul from death, and shall hide a multitude of sins.

For these reasons it seems probable that the drawing really represents St. James interceding for the dying through the example of his own martyrdom. As has often been remarked, the high finish of the study is characteristic of Michelangelo's later presentation drawings, and seems to emulate the glowing and reflecting surface of polished marble. The compact profile of the figure, with its limited and controlled projections, suggests sculpture in the round. The only Apostle actually finished, the *St. Matthew*, holds a previously unnoticed moneybag, and therefore the other Apostles were probably also to be provided with symbolic attributes. This splendid drawing, with its careful polyphony of hanging and clinging folds, may very well have been the drawing Michelangelo submitted in order to show the officials of the Opera del Duomo how the marble statues of the twelve Apostles would look. It remained in his possession, however, as is indicated by the study for the head of the *Dawn* on the verso.

22. *Studies for a statue of St. Peter and for the Battle of Cascina*
Probably 1503–4
Pen and yellow-brown ink, 7⅜ × 7¼",
cut down at left and top
LONDON, BRITISH MUSEUM, W. 3 recto
(for verso see No. 23)

Much of the left side of the sheet is filled with a rapid sketch for a portion of the *Battle of Cascina*, probably drawn later than the two studies of a standing figure (see page 45 for a discussion of the battle sketch). It has been shown that the Latin quotation at the upper right, in Michelangelo's handwriting, is from Psalm 54:1 (Psalm 53 in the Vulgate): "Deus, in nomine tuo salvum me fac" (Save me, O God, by thy name). The verse appears in a number of places in the Breviary and in the Roman Missal during Lent. It has not been noticed, however, that St. Peter addressed Christ in almost these words when about to sink in the water (Matthew 14:30): "Domine, salvum me fac" (Lord, save me), probably quoting the Psalms as he so often did. The words written vertically in Italian at the right edge: "ore stanza nellinferno" (hours remaining in Hell) may be a similar instance. At the time of the Pentecost St. Peter quoted Psalm 16 (Vulgate 15): 10: "Thou wilt not leave my soul in hell." Most likely these two passages were furnished to the artist by a member of the Cathedral clergy, as the theme for his statue of St. Peter.

At the extreme left Michelangelo sketched in the figure without drapery, then worked out the drapery masses with some clarity at the right. The Apostle, his right foot elevated on a block to provide a dramatic contrast of angles, holds an object which cannot be securely identified, but may be St. Peter's keys. All the figures save this are set down with great speed and freedom; only in the Apostle at the right has the artist worked out carefully the zigzag relationships of masses which were to provide the theme for some of his most powerful compositions during this second Florentine period.

23. *Studies for the Battle of Cascina and for capitals*
Probably 1503–4
For medium, dimensions, and condition, see No. 22
LONDON, BRITISH MUSEUM, W. 3 verso
(for recto see No. 22)

The tiny figure sketches will be discussed on page oo. Two capitals are lightly indicated, Michelangelo's earliest

known architectural studies. One has volutes formed of griffins whose necks interlace. As you turn the sheet once counterclockwise, a scowling bearded mask appears in profile. A second turn brings up one half of another capital made up of griffins back to back, their tails entwined around a lamp, with a mask below filling the lower portion of the capital. Throughout Michelangelo's career his architectural fantasies were based, like this first one, on living beings. Some scholars have suggested a connection between these studies and the Tomb of Julius II, but this is not demonstrable. An enticing, if unproved, hypothesis identifies them as capitals in the house provided by the Opera del Duomo for Michelangelo's studio, in which he was to work on the *twelve Apostles*. The house, built by Michelangelo together with the professional architect and mason Simone del Pollaiuolo, called Il Cronaca, is no longer standing. The six lines of verse, the beginning of an unfinished sonnet, constitute our first evidence of Michelangelo's activity as a poet.

24. *Studies for a St. Peter and another Apostle, the Bruges Madonna (?), the Battle of Cascina, and a capital*
Probably 1503–4
Black chalk and pen, 10⅝ × 10¼", cut down, spotted, patched at lower right and in center
FLORENCE, UFFIZI, 233 F recto

Incredible as it may seem, this excellent drawing, indistinguishable in style from Nos. 11, 22, and 23, has been considered an assemblage by a pupil of motives lifted from drawings by Michelangelo, or even an outright forgery. It is still rejected by certain scholars. The nude study is discussed on page 46, as well as the Madonna sketches. The standing saint is clearly a variant, probably later, of the St. Peter in No. 22. The forms are more simple and monumental, and the relationships between them clarified. But the freshness of touch and the numerous small changes make perfectly clear that this is an original drawing by Michelangelo himself, as is the little capital study below it, developed from the sketches in No. 23. The identity of the Apostle in the preliminary nude sketch in the lower left-hand corner cannot be determined in the absence of any certain attribute or an inscription. The object on which the figure is leaning might be a saw, in which case he is St. Simon, who was martyred by this instrument.

21

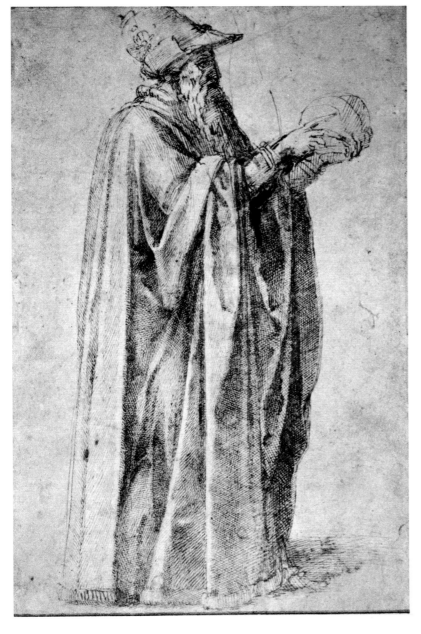

22

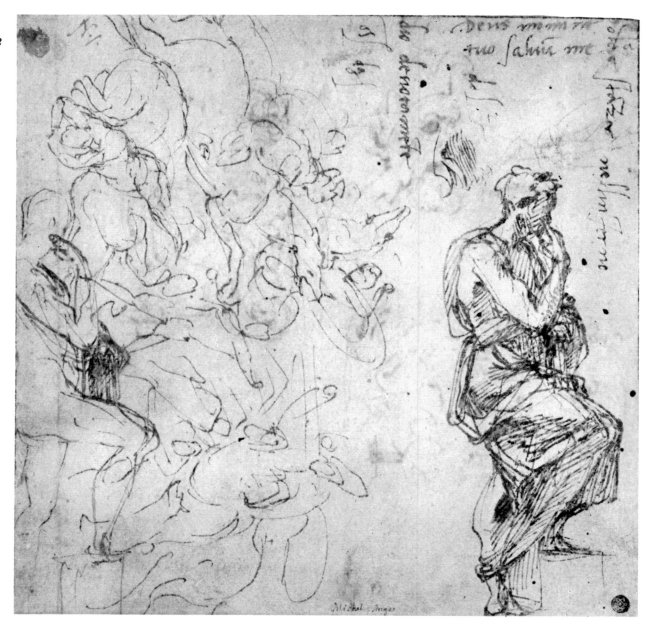

23

24

One of the principal concerns of the re-established Republic of Florence in the early sixteenth century was the recapture of Pisa, to provide an outlet to the sea. The huge fresco of the *Battle of Cascina* was commissioned from Michelangelo by the Republic as one of the major ornaments of the recently completed Hall of the Great Council, in the Palazzo Vecchio, to celebrate a Florentine victory over the Pisans. It was intended to flank the *Battle of Anghiari* by Leonardo da Vinci, on the other side of the entrance to the Hall, both facing the altar. (After the Medici were installed as Dukes the room was remodeled, and the original spaces are no longer recognizable.) The paper for the huge cartoon was ordered in October, 1504, so the preparatory drawings must have been done that summer, the only propitious time for nude studies in the Florentine climate. Some of the painting must actually have been done by 1506, when Michelangelo returned to Florence after the fiasco of the first project for the Tomb of Julius II, to judge by letters from Piero Soderini, Gonfaloniere of the Republic. Whatever painting may have been commenced has completely vanished. The cartoon itself seems to have been cut up at some time after the re-entry of the Medici into Florence in 1512. All fragments have since disappeared.

The subject was a battle, in July, 1364, of the Florentines against the Pisans, who had no cavalry. Because of the great heat the Florentine soldiers were bathing in the Arno and resting on its banks, when a trumpet call gave the alarm for the arrival of the Pisan forces. The Florentine soldiers leapt from the river, struggled into their clothes and armor, and, according to Vasari's account, were represented by Michelangelo not only in these positions but running toward the battle and commencing to fight. From copies of sections of the lost cartoon, especially two engravings, and from a painted copy now in the collection of Lord Leicester at Holkham Hall, the central section of the composition is fairly well known. A drawing after the cartoon shows a distant scene of soldiers preparing for battle on the left. It is assumed that the battle itself was depicted on the right. Both these lateral scenes must have been fairly far back from the foreground.

A considerable number of Michelangelo's preparatory drawings survive, ranging from a major composition sketch No. 25, and brief jottings for other sections of the composition (No. 23), to detailed figure studies from life. Numbers 26 and 27 give a possibility of following preliminary stages in the evolution of the grand central composition of moving, struggling nude figures aroused by the emergency. Numbers 22 and 29–31 allow us to guess at what the actual battle scene must have been like. In Nos. 32 and 33 we can deduce some of the arrangements of the preparation of the Florentine soldiers for the encounter. The same sheets that contain these preparatory sketches are full of other ideas as well, for the *Twelve Apostles* for the Florentine Cathedral, for the *Bruges Madonna*, for architectural ornament, and for an unknown composition of Leda and the Swan. Fragments of poetry and religious writings also appear on many of the drawings.

Ten of the surviving drawings (Nos. 35–44) are detailed studies from nude models, sometimes attended by marginal analyses of features that needed special attention. All are either entirely headless or show only the backs of heads. The faces must have been drawn separately, as was the case in the drawings for the Sistine Ceiling and the *Last Judgment*. All of these heads have perished.

Vasari's account of the cartoon, based on the fragments still visible in his day, indicates that it was done in black chalk, pen, wash, and white. All these media appear in the drawings, which include loose, free sketches in pen, showing nothing but the principal contours or lines of motion of the figures in a composition; soft, rapid, black chalk studies; elaborately finished pen drawings from the model; and—typical of so much of Michelangelo's later graphic work—hatched, crosshatched, and modeled drawings in black chalk. These chalk drawings look more developed than the rest of the series, and therefore a little later. It is impossible, so far, to decide whether this impression is simply due to the greater flexibility offered by the medium, or whether they were really drawn when the artist returned to his work on the battle scene after the fiasco of the first project for the Tomb of Julius II in 1506. The entire series shows forth to such a degree the new power and grandeur with which Michelangelo had endowed the human figure as to give us a tragic insight into what we have lost in the destruction of the great cartoon, and to make comprehensible the intention of Julius II to entrust the painting of the Sistine Ceiling to this sculptor.

25. *Composition sketch for the Battle of Cascina*
1504
Black chalk and silverpoint, 9¼ × 14″, cut down, spotted, rubbed
FLORENCE, UFFIZI, 613 E recto (for verso see No. 26)

Apart from the studies for the *Last Judgment* (Nos. 370–72 and 374–76) which it in many ways resembles, this great drawing is the only preserved sketch for a major section of one of Michelangelo's paintings. There must have been many like it for the central scenes of the Sistine Ceiling, and for the wall paintings of the Pauline Chapel. It is perhaps the destruction of drawings with which this could be compared that has rendered this study difficult for some scholars to accept. There are, however, no reasonable grounds for rejecting it. The poses and relationships of many of the principal figures correspond with those in the most reliable surviving copies of the lost cartoon, and those that differ can only be explained as first ideas of the artist, later rejected when he came to build up the final composition. This drawing is a work of great power and intensity, full of the excitement of the impending battle. The nudes struggle like those in the early relief of the *Battle of Lapiths and Centaurs*. The free, loose drawing style is identical with the black chalk figures in Nos. 29 and 32–35. The ancient figure studied in Rome (No. 3) is used in the upper register, just left of center. There have been a number of explanations for the two groups of figures at the top of the sheet, upside down. The most likely seems that they were further experiments for groups in the battle scene.

26. *Figure sketches for the Battle of Cascina*
1504
For medium, dimensions, and condition, see No. 25
FLORENCE, UFFIZI, 613 E verso (for recto see No. 25)

A rapid sketch for the central figure of the group in No. 25 fills the left half of the sheet, over a still more fleeting indication for a figure seated on the riverbank. A third figure, much smaller, is a variant of the pointing nude left of center in No. 25.

27. *Figure sketches for the Battle of Cascina and the Bruges Madonna*
1504
Black chalk, and pen over leadpoint, 12½×11″, rubbed
LONDON, BRITISH MUSEUM, W. 5 recto
(for verso see No. 28)

Perplexity over the nature and purpose of the group of three male figures has recently been resolved by the simple explanation that the first nude at the left is drying his lifted left foot, the second is standing on the bank and pointing outward, and the third, a sword dangling in his left hand, is walking and pointing inward. The pointing motive recurs in Nos. 26 and 28. The second figure is based on the pose of the *Apollo Belvedere* (see No. 4), and the third on one of the *Horse Tamers* on the Quirinal in Rome, thought in the Renaissance to be works by Praxiteles and Phidias. While the Apollo figure was not utilized in the final composition, the horse tamer was, but turned one-quarter counterclockwise and carefully restudied from life in No. 43. The figure reappears viewed from slightly different angles in Nos. 28 and 43. Apparently Michelangelo brought back studies of the *Horse Tamers* from Rome. The free use of black chalk relates this drawing to Nos. 28 and 32–34.

The tiny sketch for the *Bruges Madonna* shows her figure still nude, as will be customary in most of Michelangelo's preparatory sketches for Madonnas. Most of the elements of the statue are in their final positions in this little drawing, but the underlying leadpoint shows that Michelangelo originally intended the Christ Child's left arm to be lying along her knee. The clear, quick, hooklike touches of the pen, generally building up a firm and consistent contour, are typical of the artist's pen style in most of his figure sketches.

28. *Figure sketches for the Battle of Cascina, a leg, and two putti*
1504
For medium, dimensions, and condition, see No. 27
LONDON, BRITISH MUSEUM, W. 5 verso
(for recto see No. 27)

A restudy of the third figure in No. 27, seen from slightly further left, in the same soft, freely hatched chalk style. The leg drawn in pen, upside down, is a restudy of the earlier leg in No. 5, apparently to indicate the relations of bones, joints, and muscles. The *putti* could be for the children in any of the Florentine *Madonnas*. Fragmentary verses in leadpoint can be made out, not connected with any known poem. The four lines in pen are complete, apparently the beginning of a sonnet, one of Michelangelo's earliest known poetic efforts.

29. *Composition sketches for the Battle of Cascina, and Leda and the Swan*
1504
Black chalk and silverpoint, 9½×8¼″, rubbed and spotted
FLORENCE, UFFIZI, 18737 F

Only Vasari's description (see page 45) indicates the probable purpose of this sketch, the fray taking place at the upper right-hand side of the fresco, in the middle distance. The chalk lines flow very freely, as the figure emerges from Michelangelo's fantasy. One soldier attacks another, while a horseman can just be made out, flailing a foot soldier. The exquisite erotic abandon of the probable Leda, clockwise left, is a surprise for the early Michelangelo. No such com-

mission is known until the *Leda* done for Alfonso d'Este (see page 218), which bears no resemblance to this.

30. *Three studies of a horse; composition sketch for the Battle of Cascina*
1504
Pen, 16⅞×11¼″
OXFORD, ASHMOLEAN MUSEUM, P. 293 recto

Horses seldom appear in Michelangelo's work. When the subject demanded them, however, he could and did render them superbly. Here the quiet body of a horse is studied as if it were a human nude, in the familiar contoured, hatched, and crosshatched style, brilliantly clear and strongly projected. The head, like so many human heads in Michelangelo's figure studies, was left for separate treatment. At the bottom the rump of the same horse, still parallel to the picture plane, is more rapidly studied in contraction, then at the lower left still more swiftly from the rear. Below is a tiny sketch of foot soldiers reeling and falling on the ground before the onslaught of the cavalry, with horses rearing and riders plying their lances. A more detailed but still lightly drawn version, with foot soldiers and cavalry in combat, fills the left half of No. 22.

31. *Combat of horsemen and foot soldiers*
1504
Pen, 7×9⅞″, corroded in several places
OXFORD, ASHMOLEAN MUSEUM, P. 294

One of the most powerful battle scenes in Western art, this great drawing has been connected with a number of possible subjects and moments at widely varying stages of Michelangelo's career. The most probable explanation is that it was a further development from Nos. 22 and 30, for the fray in the right background of the *Battle of Cascina*. Similar figures and relationships are found throughout the group, but this drawing is apparently the most advanced of the series. The figures are beginning to assume definite volume and mass while the rearing horse, already clear in the artist's mind from previous sketches, is left blank save for his legs. The figures were all apparently sketched in in the same cursive, linear style as Nos. 22 and 30, then attacked so fiercely with hatching in a heavily loaded pen that it blotted, and the iron rust in the ink corroded the paper. For the first time in the series the full weight and fury of the conflict is felt.

32. *Composition sketch for the Battle of Cascina*
1504
Black chalk over stylus preparations, 10¼×6⅞″, corners torn off and patched
OXFORD, ASHMOLEAN MUSEUM, P. 296 verso
(for recto see No. 35)

A nude soldier is climbing on a horse, while another apparently holds the saddle and stirrups, although these are not represented. In the finished work the soldiers were doubtless intended to be clothed. In all probability the drawing was a study for the upper left side of the scene in which, according to the copy in a sixteenth-century drawing, the Florentine cavalry were preparing to do battle. It cannot be clearly determined from the damaged sketch whether or not this group was ever used. The standing figure is studied from life in No. 35. The soft chalk treatment is similar to

that in Nos. 27, 28, 33, and 34. The background is filled with free hatching and crosshatching, as in the pen treatment of the *Madonna and Child* in No. 10.

33. *Figure sketches for the Battle of Cascina*
1504
Black chalk, 8½×6¼″, cut down, badly rubbed
ROTTERDAM, BOYMANS-VAN BEUNINGEN
MUSEUM, I. 513 recto (for verso see No. 68)

The nude soldiers have climbed on the same horse, seen from the back. This group, with some variations, occurs at the extreme left in the background of the British Museum copy of the lost cartoon. The soft black chalk style is identical with that of Nos. 27 and 32. The group is lightly indicated at the right in a second version, experimenting with different poses of the arms. Upside down, a fine life study emerges, for the figure at the left in the Holkham Hall copy (also visible in the British Museum copy), turning in profile toward the left, his right arm raised, his mouth open in alarm. Scarcely mentioned, and only once before illustrated, this drawing has nonetheless been disputed. To reject it would involve the dismissal of all the black chalk studies for the background groups.

34. *Sketches of figures and horses for the Battle of Cascina*
1504
Black chalk and pen, 7½×10¼″
OXFORD, ASHMOLEAN MUSEUM, P. 295

The charging horseman in pen seems to have been intended for the scene at the upper left of the final composition. The horse in black chalk might have gone on the other side. The brilliant [little pen] sketch of a male back is for the figure climbing out of the water at the left in the Holkham Hall for cartoon copy.

35. *Figure study for the Battle of Cascina*
1504
Pen over black chalk, 10¼×6⅞″, damaged by dampness
OXFORD, ASHMOLEAN MUSEUM, P. 296 recto
(for verso see No. 32)

A careful study, apparently from a nude model but possibly after a piece of ancient sculpture, for the figure holding a horse on the verso (No. 32). At first sight the drawing seems to be in the same style as No. 3, but a closer examination shows differences. Number 3, done from a sarcophagus figure, is drawn entirely in ink, whereas this drawing was first sketched out in black chalk, as in the verso. Furthermore, its contours are lighter and freer, and its hatching conforms more closely to the curves of muscles than does the arbitrary, engraver-like hatching of No. 3. The tentative nature of the treatment suggests that this may be the earliest of the preserved nude studies for the cartoon.

36. *Figure study for the Battle of Cascina*
1504
Pen, black chalk, 11¼×8¼″, cut down and spotted
FLORENCE, CASA BUONARROTI, 9 F

The relation between this and No. 35, clearly intended for the same figure, has been the subject of some controversy, first one and then the other being rejected as a copy. It has recently been claimed that both are genuine, but that No. 36 is a preliminary sketch. It seems more probable that it

belongs to the rather numerous class of restudies often found in the margins of Michelangelo's elaborate life drawings. In these sketches Michelangelo could analyze rapidly an underlying anatomical structure of whose nature he was not entirely sure when he made his original drawing from the model (see especially No. 87, for the *Libyan Sibyl*). The shoulder structure is studied again twice in black chalk.

37. *Two figure studies for the Battle of Cascina*
1504
Pen, extended in black chalk, 10½×7⅝″,
damaged by dampness
VIENNA, ALBERTINA, S.R. 157 recto
(for verso see No. 44)

The left figure is recognized as a life study for the bearded man rushing forward, near the center of the Holkham Hall copy. The right figure appears, third from the right, in the center row of the same copy. Apparently Michelangelo was not satisfied with this preliminary study, and turned the figure further around in the cartoon so that the play of · the back muscles could be more clearly observed. Number 42 is a study for the final version. The present drawing is very lightly sketched; the artist is abandoning his attachment to engraver's methods. He is also aware of the excitement to be derived from the shadows of the figures on the ground of the riverbanks. U-shaped marks indicate the insertion of the trapezius muscle in the shoulder bone; crosses, the insertion of the deltoid. The construction of the shoulder seems to have concerned the artist especially at this period.

37A. *Figure studies and sketches for the Battle of Cascina*
1504
Pen and black chalk, 13⅜×7⅛″, cut down
PARIS, LOUVRE, 718 verso

Accepted by the majority of scholars, although rejected by the revisionists as copies, most of the drawings on this sheet were intended for the *Battle of Cascina*. The figure seen from the back, in the center of the page, seems to be an early idea for the figure at the extreme left in the Holkham Hall copy, climbing out of the water. The figure appears here in a stage developed immediately from No. 25 and before the introduction of the beautiful spiral *contrapposto* which the same figure enjoys in the Holkham Hall copy. The next figure to the right is a first sketch for the soldier at the upper right in the Holkham Hall copy, holding forward a baton in his right hand, while his left grasps a shield extending into the composition. This is the only known sketch for this figure. The indeterminate sketch at the lower left cannot be identified with any known element in the composition. The tormented figure rapidly set down in pen—an invention of extreme poignancy and beauty—must have been a rejected idea for a soldier crouching on the bank and reaching for his armor. The pose is further developed in the famous nude, doubtless for the Tomb of Julius II, in No. 50, drawn in all probability during the year following the execution of these sketches. The languor of the figure reappears in the *Dying Slave* in the Louvre, and the motive of the outstretched arm, half hiding the agonized face seen from below, in the *Haman* of the Sistine Ceiling. As for the two superb life studies of the left half of a male back, hatched and crosshatched in pen in the typical manner, these could have been made to enable Michelangelo to understand more clearly the play of muscles, preparatory to designing both of the splendid figures near the center of the Holkham Hall copy.

38. *Figure study for the Battle of Cascina*
1504
Pen, 15⅜×7¾″, folded, patched, badly spotted
VIENNA, ALBERTINA, S. R. 152 recto
(for verso see No. 59)

Universally accepted by older scholars, this sensitive study has been unjustly rejected of late. No such figure appears in any of the surviving copies of the lost cartoon, so it cannot be decided what the study was meant for. The legs of the soldier adjusting his breeches, toward the left in the Holkham Hall copy, somewhat resemble those of this figure. The legs are still very tentatively traced, probably over black chalk outlines since erased, but the back is a miracle of pulsating muscle, as fine as any of the other early nudes in pen, especially No. 35, apparently done from the same model.

39. *Figure study for the Battle of Cascina*
1504
Pen, heightened with white, 9⅞×3½″
PARIS, LOUVRE, 712 recto

Another study accepted by all older writers and doubted only in the last twenty years. This is surely for the soldier at the upper right in the Holkham Hall cartoon, completely and delicately studied even though in the final version all that appears of him is his head and shoulders and his raised right arm. The rest is hidden by intervening figures, carefully studied in Nos. 42 and 43, and even the portions which still show are covered by the armor. It could very well be that the beautiful pose was intended to be seen entire, and that the two powerful figures were afterthoughts. In any case, Michelangelo did not forget the legs, but used the pose, in reverse, for the legs of the *Dying Slave* in the Louvre which, if the hypothesis of Richard J. Betts is correct, was originally blocked out for the 1505 version of the Tomb.

40. *Six studies of a raised right arm, for the Battle of Cascina*
1504
Black chalk and pen, 8⅞×12⅜″
VIENNA, ALBERTINA, S. R. 167

Another searching and delicate study, accepted by all earlier authors and only recently rejected. Apparently Michelangelo was trying out several variations of the pose of the raised right arm of the soldier at the extreme right in the Holkham Hall copy, whose figure is studied in No. 39. Though very lightly touched in, much like the handling of No. 39, the arm in the middle is closest to that finally adopted. The little hieroglyphs attached to lines seem to be Michelangelo's private symbols for certain muscles—the biceps, the triceps, the insertion of the trapezius, etc.—much as in No. 37. The four pen sketches have all the shimmer of Michelangelo's early pen style, but the powerful chalk drawings at the lower right are certainly later, and seem to have been done for the Sistine Ceiling. They are very close to Nos. 70, 71, 73, and 80 in the authority and power of the rapid line and parsimonious hatching. The raised arm may be an experiment in transforming one of the pen studies into the raised right arm of the nude to the right above *Isaiah*, restudied in No. 99.

40A. *Study of a left knee and architectural sketches*
1504
Pen, 8×12″, cut down, folded in two,
patched in many places, badly spotted
FLORENCE, CASA BUONARROTI, 6 A verso

In the vast literature on Michelangelo this drawing (on the verso of a sheet whose recto has been convincingly attributed to Raffaello da Montelupo) appears to have been mentioned only three times—and twice rejected. After the words "Fantuzzi . . . my dear friend" can be read a quatrain from Sonnet 236 by Petrarch, with the word "Amor" changed to "Signore." All are in Michelangelo's handwriting. The architectural sketches are difficult to interpret. A window-frame is visible enough, also a sketch for a cornice profile. At the bottom of the sheet the plot thickens; turned upside down, the diagrams may represent sections of a vault designed to uphold a floor in the house given to Michelangelo by the Opera del Duomo for the execution of the statues of the twelve Apostles. It is surprising that, up until now, no one has noticed the knee. It is clearly legible, though, and beautifully drawn, in the hatched and crosshatched manner of the other pen studies for the *Battle of Cascina*. The bony, slender forms also place the study early.

41. *Figure study for the Battle of Cascina*
1504
Pen, brush, brown and gray ink, heightened with white, 16⅝×11¼″, paper corroded by ink and damaged by dampness
LONDON, BRITISH MUSEUM, W. 6 recto

A lithe, long-torsoed model was seated by the artist on a ledge or bench in the position intended for one of the most conspicuous foreground figures in the cartoon, on the bank with one foot hanging above the water of the river. The unusual proportions were made normal in the cartoon. Some of the hatching and crosshatching was done in pen, but much of it in brush, also used for the white. The brilliance of the drawing is so compelling that it is difficult to understand the murmurs of disapproval from some scholars and downright rejection from others. The red chalk studies on the verso are probably by Michelangelo's pupil Antonio Mini.

42. *Figure study for the Battle of Cascina*
1504 (or 1506)
Black chalk, 16×10¼″, cut down,
folded across and patched, spotted
HAARLEM, TEYLERSMUSEUM, A 18 recto
(for verso see No. 66)

This and No. 43, intended for overlapping figures in the cartoon, are among the most striking examples of Michelangelo drawings maligned by hypercriticism. They have been considered copies, imitations by pupils, or even attributed to specific artists (with whose works their style has nothing to do). Recently they have been rehabilitated as superb works by the hand of the youthful Michelangelo. Both drawings are strikingly similar in handling to No. 89, which no one has ever doubted. They represent our first evidence of nude studies by Michelangelo in the black chalk medium (see page 23). While chalk enabled Michelangelo to set down his melodious contours with great speed and freedom as compared with the labored and often-repeated

contours in pen, and to hatch and crosshatch much more rapidly, both drawings show traces of the older pen technique, which will be completely renounced in the mature model studies for the Sistine Ceiling. In both it seems to have occurred to Michelangelo for the first time that he could model the shadows, possibly with his thumb or finger, possibly with a bit of cloth, and produce an effect similar to the polished surface of marble. As a result, these drawings look deceptively advanced, here and there, but careful comparison with the pen and brush drawings will show that the same feeling for shape and lighting prevails through the entire series. The freedom of the contours alone, not to speak of the sketchiness of certain portions and the numerous *pentimenti*, should have silenced any contention that these two drawings could possibly be copies. And copies from what? Both the arms and the lower legs of this figure were completely hidden in the cartoon.

43. *Figure study for the Battle of Cascina*
1504 (or 1506)
Black chalk, 15⅝ × 10", cut down, wrinkled, spotted
HAARLEM, TEYLERSMUSEUM, A 19 recto (for verso see No. 384)

For the technique of this superb drawing, see No. 42. The study was intended for the man at the extreme right of the group of bathing soldiers. The linear torrent of the right leg contours must have seemed too summary to the artist as he took a second look at the model, so, as we often find, he studied the structure of the inside of the right knee a little more carefully in the right margin. Then he decided to extend the merely sketched right arm a little farther, as in the cartoon, holding a baton. This redrawn arm at the upper right is strikingly similar in style to the arm studies for the Sistine Ceiling (Nos. 62 and 89). At the lower left, Michelangelo has drawn the right heel of the model, for which in the principal study he had left no room. The heel plays an important role in the cartoon itself.

44. *Figure study for the Battle of Cascina*
1504 (or 1506)
Black chalk over stylus preparations, heightened with white, 7⅝ × 10½"
VIENNA, ALBERTINA, S. R. 157 verso (for recto see No. 37)

Another splendid drawing, reluctantly accepted by scholars who, nonetheless, detect much reworking by a later hand. No evidence of this is visible. The drawing is in exactly the same style as No. 105, for one of the nudes of the Sistine—also rejected by a number of critics, but certainly genuine. At this point Michelangelo was able to handle the white with the same freedom as the black chalk, instead of with the graphic neatness of No. 41. The figure appears, holding a spear, at the upper center of the Holkham Hall copy, and was clearly intended from the first to be cut off by other figures. The breadth and openness of style, together with the greater simplicity and monumentality of the masses, would seem to place this at the end of the series of surviving drawings for the cartoon.

44A. *Studies for a left leg*
1504
Red chalk, 8⅜ × 11⅛"
OXFORD, CHRIST CHURCH, B 21 verso

The recto of this splendid study is generally accepted as a composition by Sebastiano del Piombo. Opinion about the verso is divided, but the quality is so overwhelming that most recent scholars have accepted it. Sebastiano used to plead with Michelangelo to send him drawings of bodies, legs, arms, and the like; possibly the verso was one of these, and Sebastiano later drew his own study on the vacant recto. The little symbols indicating the position of joints connect the verso with the series for the *Battle of Cascina*. The leg was sketched out in No. 28 and here studied carefully from a living model, who was obliged to hold his leg out straight to exhibit the muscles under the utmost tension. One of the earliest known red chalk drawings by Michelangelo (see also No. 12), the study shows the artist still utilizing this medium as if he were holding a pen. The outlines of inner forms and the profiles of the leg have been set down lightly, probably as in the unfinished sketch of the same leg from the left, in the center of the page. Then the contours were reinforced, sometimes repeatedly. Finally, the hatching and crosshatching were worked out in detail, here and there in three layers, but without any of the modeling Michelangelo was to display very shortly in his finished red chalk studies.

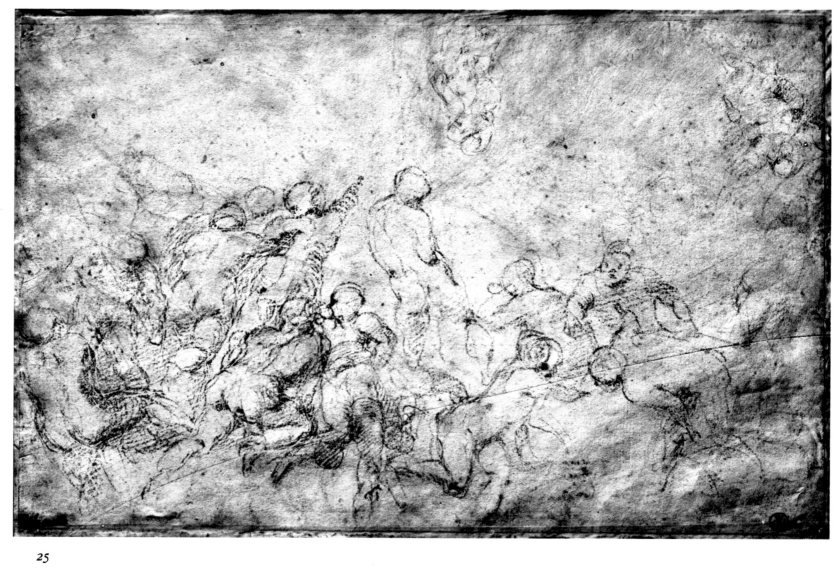

25

26

50

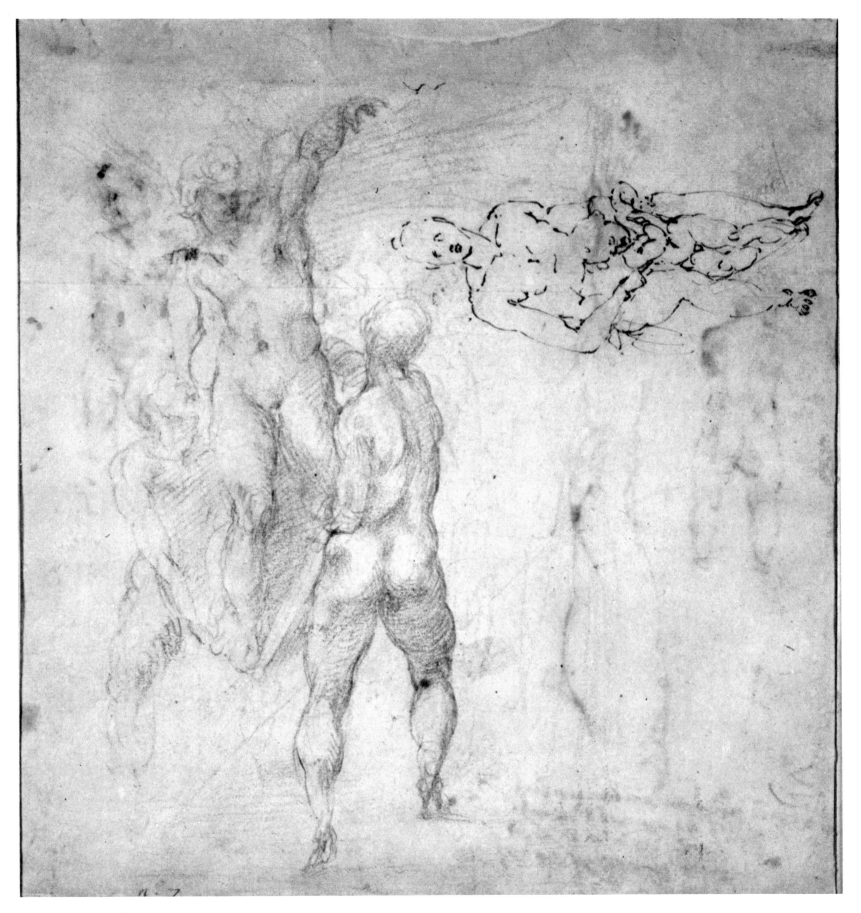

27

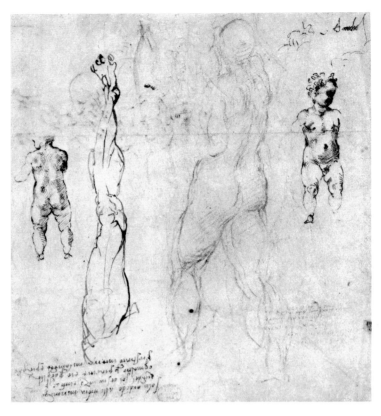

28

29

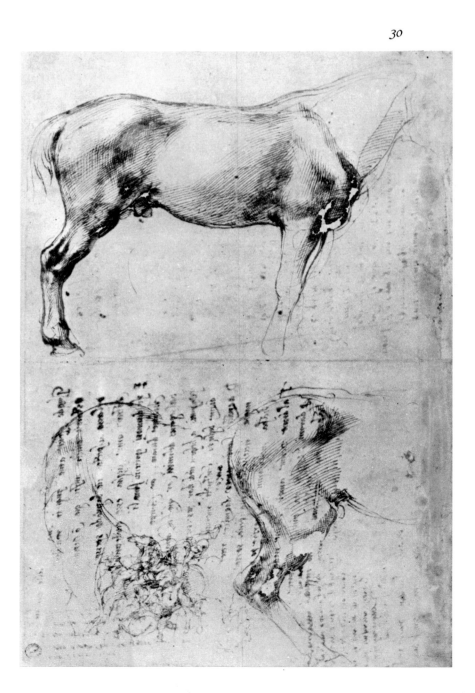

30

52

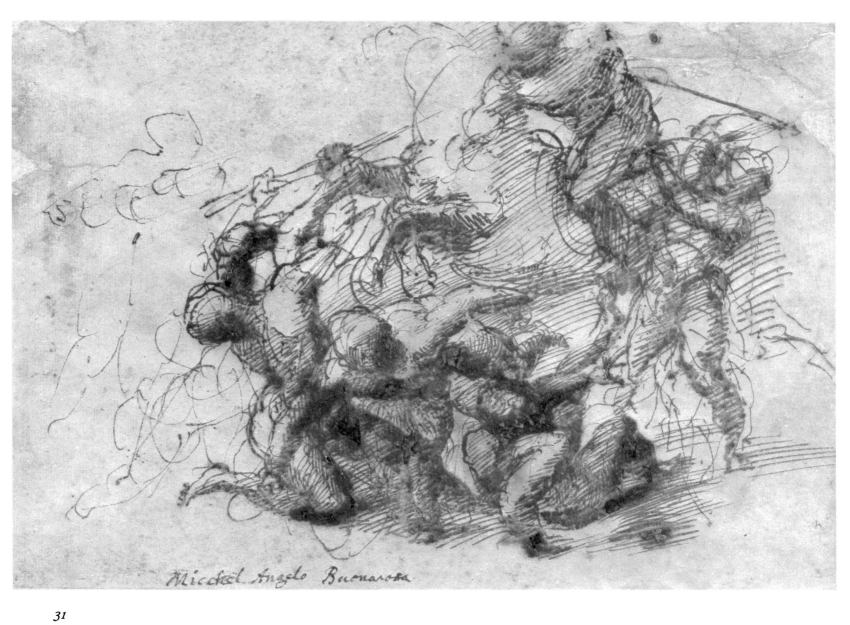

31

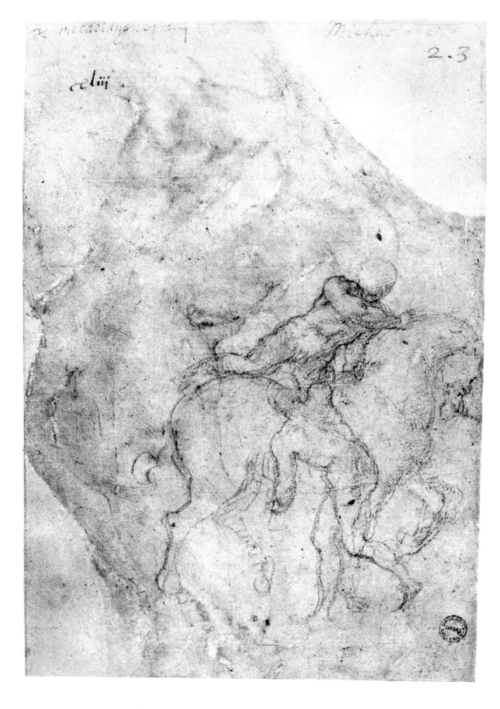

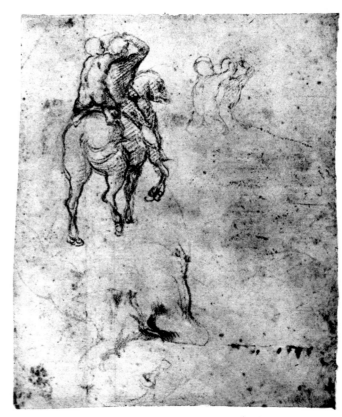

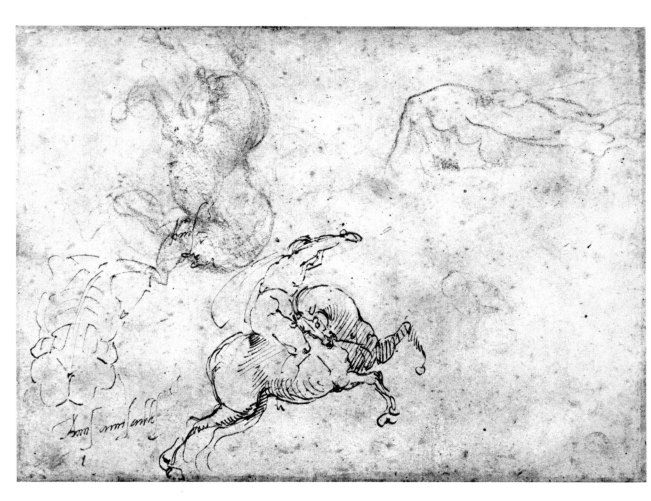

34

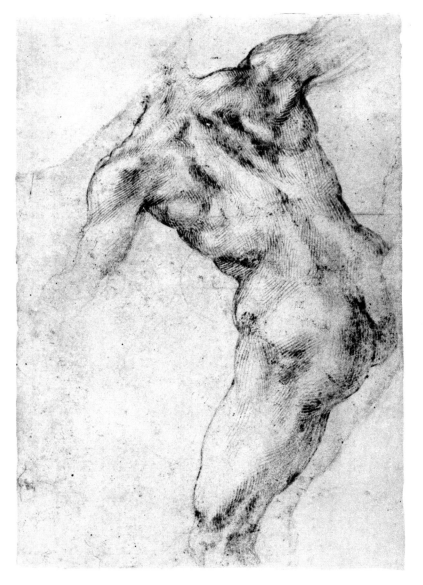

35

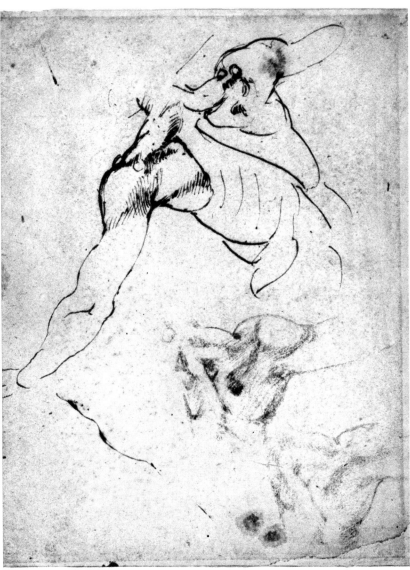

36

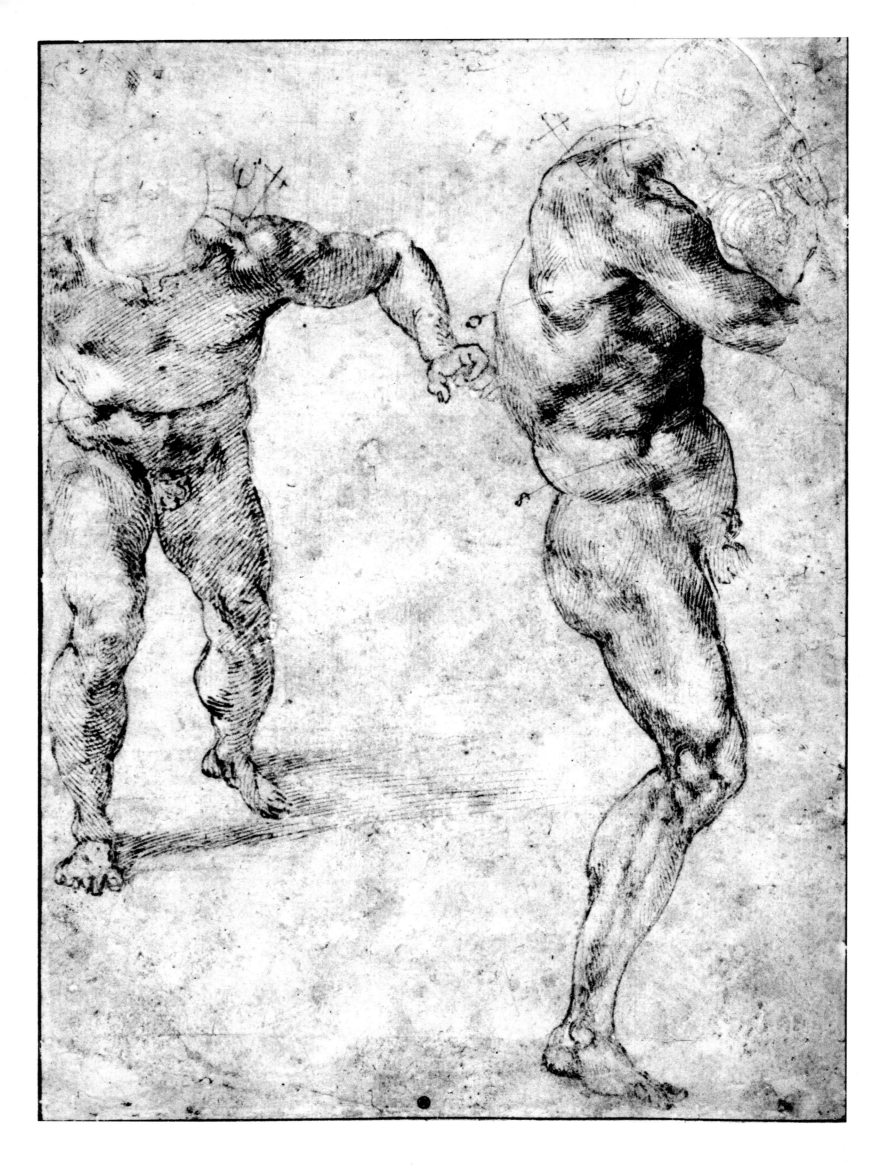

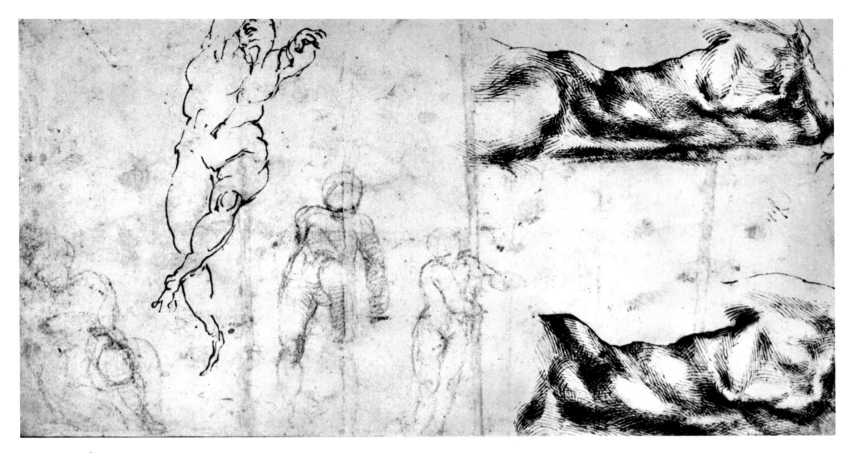

37A

◄37

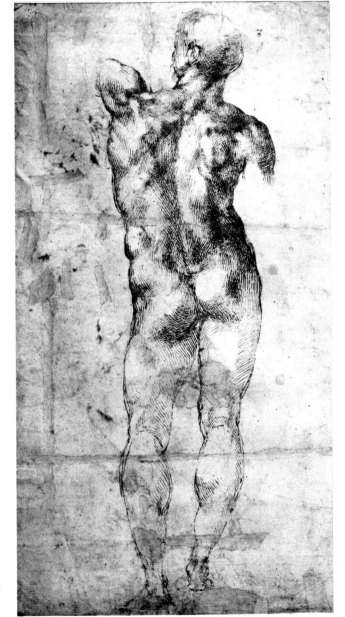

39

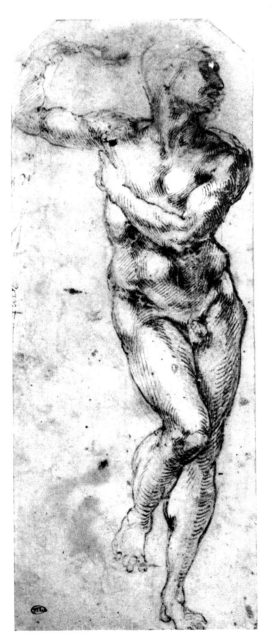

38

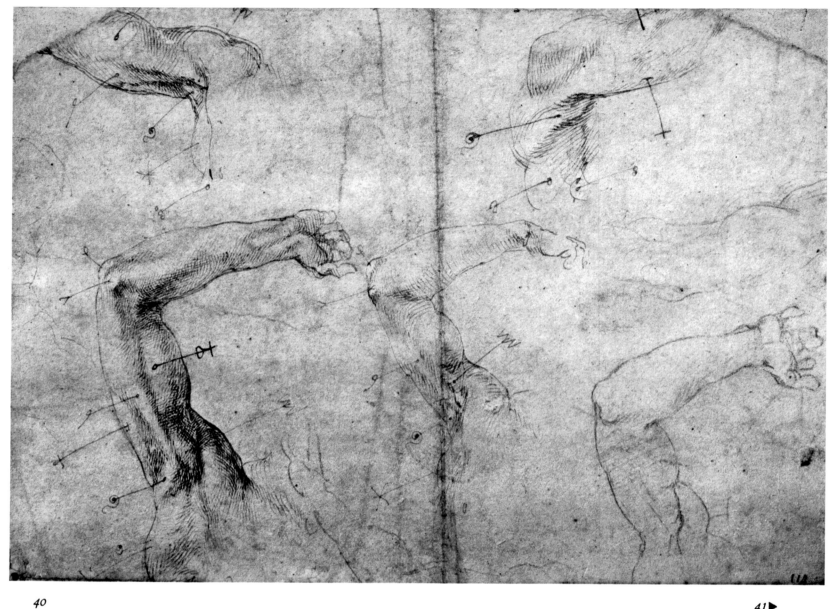

40

41▶

40A

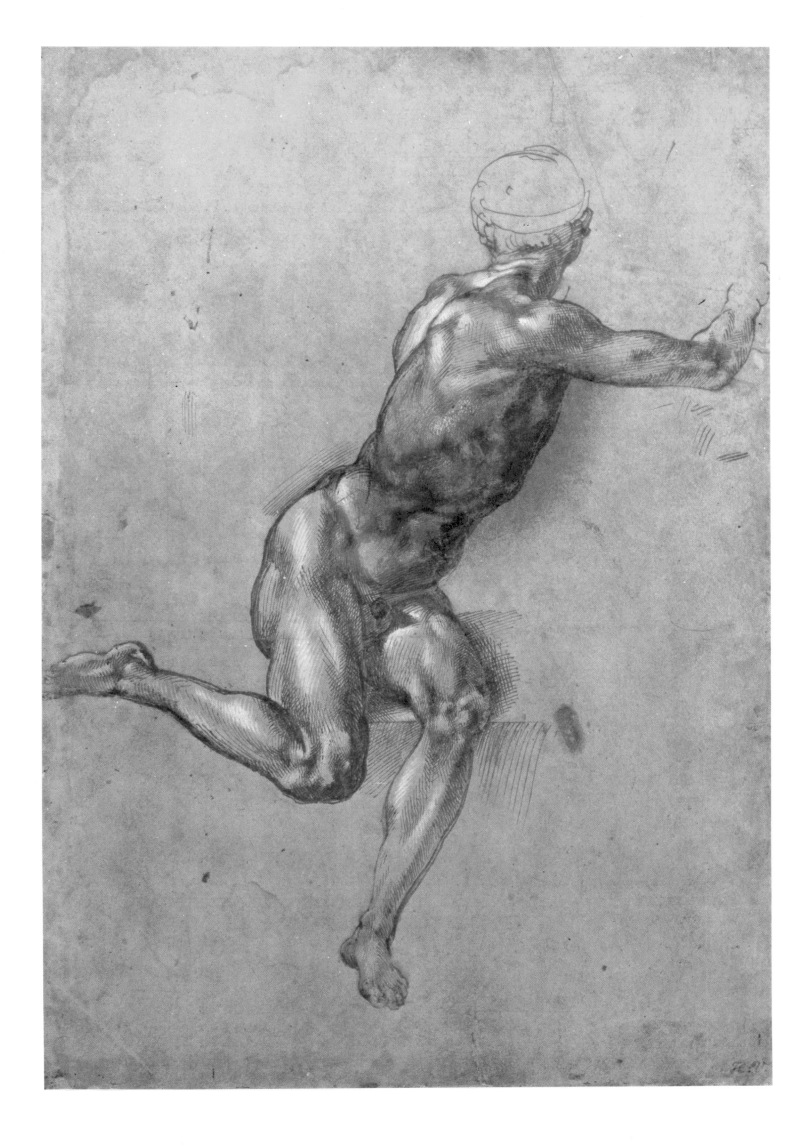

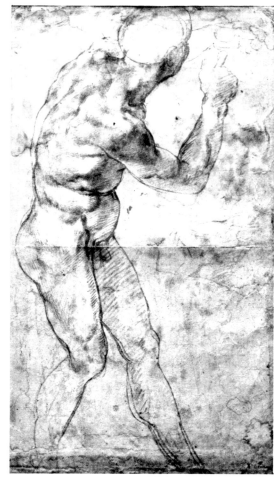

42

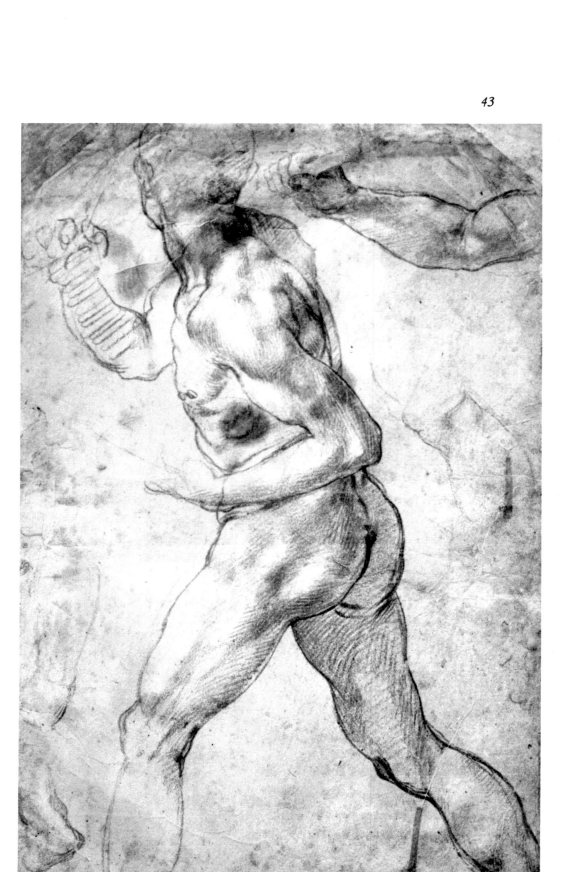

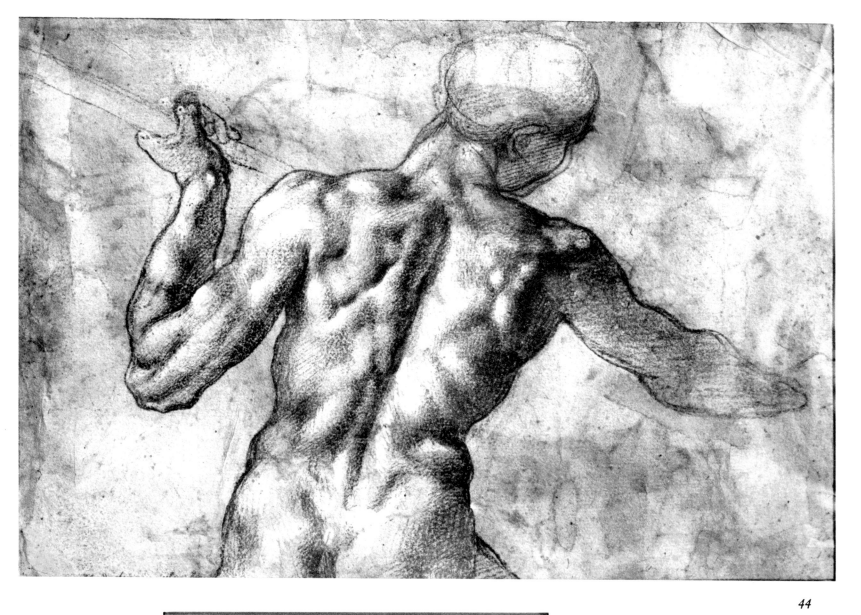

44

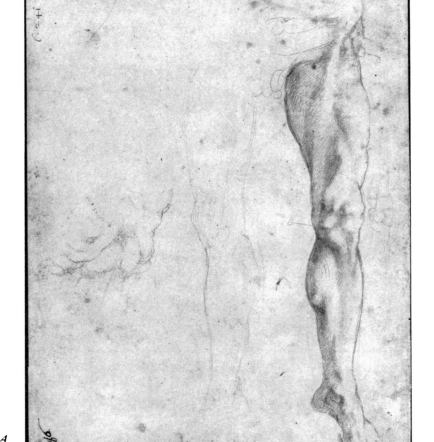

44A

61

3

Drawings for, or contemporary with, the first project of the Tomb of Julius II. Rome and Florence, 1505–8

The first project for a freestanding tomb, commissioned by Julius II in the second year of his pontificate, would have been a wonderful thing, with its more than forty over-lifesize statues. The project was tragically interrupted, leaving the marble blocks lying all over St. Peter's Square. We do not even possess any complete and reliable evidence regarding its appearance, only descriptions written nearly half a century later by Condivi and by Vasari, in which it is not even certain whether these friends of Michelangelo saw a model and drawings, or whether they relied upon Michelangelo's memory. The surviving drawings which may be connected in one way or another with the 1505 design lack just the elements we most need. There is no sketch of the whole Tomb, no indication of the nature of its architectural elements, no design for the sarcophagus with the effigy of the Pope (probably intended for the interior). A drawing in Berlin, No. 45, too badly ruined to permit a decision regarding its authorship, was copied by Michelangelo's pupil Girolamo Rocchetti, in a design now in the Uffizi in Florence (see No. 45A). The slight nature of the figures indicates that this must have been one of the alternate proposals for the 1505 project. The drawings of hands on the verso of this copy (No. 52) and in another drawing in Haarlem (No. 51), showing the evolution of the ideas for the *Dying Slave*, are here attributed to Michelangelo himself. This project, for a structure culminating in a niche containing a statue of the Madonna and Child, was adopted as the definitive design after the Pope's death in 1513. The lower story in the Berlin-Uffizi project corresponds to the Condivi-Vasari descriptions, in showing niches containing Victories and flanked by Bound Captives. Numbers 46–50 are studies of male nude figures, possibly connected with the idea of the Bound Captives. Some of the sketches are very close to the *Dying Slave*. Others were undoubtedly done from live models, although they may reflect poses of ancient statues. They seem to show Michelangelo's preoccupation with the problem of expressing the inner dramatic life of a figure that cannot move from its position, a much subtler and more complex problem than the free and violent action of the *Battle of Cascina*. These life studies are closely related to the marble *David*, finished in 1504; as in that masterpiece, the movement of torsos and limbs is restricted to a single plane. In the *Rebellious Slave* and the sketches made for the Bound Captives in 1513 and later (Nos. 128–30), the artist was to experiment with strong depth tensions. In the present series he did not always know exactly what to do with projecting hands and arms, a severe problem for a marble sculptor. In the *Pietà* and the *Bacchus*, hands are allowed to wander freely outside the main mass of the statue, and quite possibly

Michelangelo originally intended to treat the Bound Captives in just this manner.

The *putti* flanking the thrones of the four seated figures of the second story of the Tomb are sketched in Nos. 46 and 55; an early idea for the head of the *Moses* appears in No. 50; and it is here suggested that Nos. 55 and 56 were intended for two of the four enthroned statues. A number of drawings for other works, some well known and others mysterious, are included here because they are strongly related to the drawings for the 1505 project.

45. *Modello for the Tomb of Julius II*
1505
Pen, wash, 20⅝ × 13⅜", cut down irregularly, corroded, traced with stylus, patched, remounted
BERLIN-DAHLEM, STAATLICHE MUSEEN, KUPFER-STICHKABINETT, 15305 recto (for verso see No. 53)

This unfortunate drawing is so devastated that many critics have thrown up their hands, considering a judgment impossible (see the Uffizi copy, No. 45A). Certainly this is no case for a dogmatic pronouncement, but it is by no means out of the question that the drawing is by Michelangelo himself. A few portions of the original surface have been spared by the stylus tracings, notably the heads of several of the herms and the bodies of the *putti* flanking the thrones of the seated figure in the second story. These lines show the quality of Michelangelo's early pen style. One factor of the utmost importance in dating the project has thus far escaped attention. It can be made out with the aid of a magnifying glass, beyond any question whatever, that the head of the papal effigy being lowered into the sarcophagus (or lifted from it?) is beardless. Julius II grew his famous beard only in the winter of 1510–11. The present drawing is, therefore, as has been recently claimed, an *alternative design for the project of 1505*, and not drawn for the second contract of 1513. This fact explains the numerous discrepancies between the drawing and the 1513 contract. After the death of the Pope, therefore, when it was no longer possible to build the freestanding tomb in St. Peter's itself, the alternative project was revived, and altered according to changed circumstances. The appearance of the 1513 project is clearly spelled out in the contract. The author's re-examination of the present drawing was undertaken at the urging of Richard J. Betts, who is responsible also for the reattribution of its verso, No. 53. A variant (No. 45A) may be a copy of an even earlier idea for the lower portions of the Tomb.

45A. *Sixteenth-century copy of lower portion of one of Michelangelo's projects for the 1505 version of the Tomb of Julius II*
Pen and wash, red chalk, 11¾×14⅝″,
cut across at center and patched together
FLORENCE, UFFIZI, 608 E recto (for verso see No. 52)

46. *Mercury; putto carrying amphora*
1505
Pen, 15¾×8¼″, cut down, folded horizontally, and patched
PARIS, LOUVRE, 688 recto (for verso see No. 47)

Although the winged cap and the graceful, thoroughly classical stance of the figure suggest an ancient model, none has ever been identified. Michelangelo may have done the drawing from some Mercury statue subsequently lost, and perhaps enriched the modeling by direct observation from life; there is no telling. The hands, forearms, and drapery, so lightly sketched in, must be additions from the artist's fantasy, as is certainly the incongruous, anachronous, and delightful viol the god is twirling with his left hand. The sensuous fullness of the forms recalls the *Bacchus* of 1496–98, but the penetration of anatomical structure seems more developed. The pose of the *putto*, derived from a type very common in Roman ornamental sculpture (and still to be had in mass-produced fountains), turns up again and again in the paintings of the Sistine Ceiling, especially the *Deluge* and some of the seated nudes. It is here proposed that Michelangelo drew the Mercury in his search for the poses and modeling of the Bound Captives of the Tomb of Julius II, and the child for one of the caryatid *putti* flanking the thrones of the second story of that structure, about which our knowledge is still too fragmentary and too contradictory to permit reconstructions in detail.

47. *Tracing of Mercury; putto, head of youth, winged cherub head, head of bearded man with plumed hat, sketch for a Bound Captive, study of left leg*
1505
For medium, dimensions, and condition, see No. 46
PARIS, LOUVRE, 688 verso (for recto see No. 46)

A great deal of foolishness has been written of late about the central figure. The undeniable fact that the lines are dull and mechanical indicates not necessarily that it was done by a pupil, but simply that someone reversed the sheet, held it to a pane of glass, and traced the contours. Not even Michelangelo's hand could produce a lively drawing following such a procedure. The circumstances of personal observation and study so evident in the drawings on both sides of the paper render a pupil's intervention both unlikely and superfluous. The hatching across the knees and the touches of modeling here and there differ in no way from the characteristic pen style of the early Michelangelo. The drawing of the leg crosses the tracing, and is certainly studied from life, so brilliant and so beautiful as to render absurd its attribution to any other hand than that of Michelangelo. It is done from the same model as No. 48 and in the same style. Turning the sheet around the other way, the exquisite Praxitelean torso fragment with its suggestion of legs emerges with all the delicacy of Michelangelo's most refined touch. The *putto* has been justly compared to the sketch for the *Bruges Madonna*, No. 24, but is more probably connected with the Tomb, like the *putto* in No. 55, flanking the throne of the *Contemplative Life*. The boy's head, placed across the groin of the tracing just like the self-portrait in No. 17, is strikingly similar to the profile in No. 16. Is it too farfetched to detect that the same model is now two or three years older?

The wonderfully supple sketch at the lower left is surely an early idea for one of the Bound Captives of the Tomb, possibly a never-executed figure visible in the much-discussed Berlin drawing, No. 45, of a project for the entire Tomb (copy in the Uffizi, No. 45A, recto of No. 52), or again it may be a first sketch for the *Dying Slave* in the Louvre. Then how about the man with the plumed hat? Some find it impossible to imagine Michelangelo other than grandiose, heroic, and perfect, in spite of the strong comic and satiric vein running through so much of his writing, and indeed through the painting and sculpture, in inconspicuous places. There seems no reason why we should not accept this ruffian as a rare and precious example of Michelangelo's observation of contemporary life, like the heads in Nos. 302 and 313.

48. *Standing male nude*
1505
Pen, 13⅜×6⅝″, cut down, folded across, patched
PARIS, LOUVRE, R.F. 70-1068 recto (for verso see No. 50)

This magnificent figure is at once lithe and bony, languorous in expression and feral in its immense latent power. Luckily its authenticity has never been doubted. Like No. 46, the pose may have been suggested by a classical statue, but the variations from the canon of classical proportions are so great as to require the supposition of a living model. This rangy youth did not even stand still while Michelangelo was drawing him; the left and right shoulders, the left and right sides of the torso, were done when the body was in different positions. This discrepancy gives the figure a look of disjointedness, belied by the study of the closely articulated details. Although none of the Bound Captives was placed in just this pose, life studies such as this must have been essential for Michelangelo in his effort to translate the free action he had exploited in the *Battle of Cascina* into the language of inner torment expressed in muscular tension, which was to embody the tragic poetry of the Bound Captives.

49. *Standing male nude*
1505
Pen, 14¾×7¾″, cut down
PARIS, LOUVRE, 689 verso (for recto see No. 58)

Although the authorship of No. 48 has been doubted by no one, a considerable group of the scholars who accept it have rejected No. 49, identical in style in every respect. Shifting the eye constantly from the accepted to the rejected drawing, it is impossible to find any objective grounds to justify such a decision; it might just as well have gone the other way, rejecting No. 48 instead. The left shoulder, leg, and arm of No. 49 are unfinished and somewhat weak; so are those of No. 48. The finished portions, however, are sure and exact in both, and are lighted, contoured, hatched, and crosshatched in precisely the same way. A different model was used, fuller and fleshier than the rangy young man who posed for No. 48. But the physical differences serve only to underscore the consistency of technique in the two studies. If anything No. 49, so generally maligned, is somewhat the better drawing, in the breadth and fullness of the forms, and in the inner anguish communicated partly in the expression of the unfinished face, but largely through the vibration of the musculature. The lifted arm, repeated in variant forms in the *Dying Slave*, in *Isaiah* and in some of the nudes in the Sistine Ceiling, and in the *Dawn* in the Medici

Chapel, is a characteristic Michelangelo device for conveying emotional tension. The artist decided to move the unfinished lower extremities, finding a more vertical stance for the right leg and twisting the left upward and back in a manner to be fully exploited only in the pose of the *Rebellious Slave*. This is a superb drawing, and it insists on its rightful place in Michelangelo's surviving graphic production.

50. *Standing male nude; right arm; sketch for head of Moses*
1505
Pen, 13⅜×6⅝″, cut down, folded across, patched
PARIS, LOUVRE, R. F. 70-1068 verso (for recto see No. 48)

Never doubted as a work by Michelangelo, this graceful and poignant sketch, apparently derived largely from imagination, has nonetheless been dated at widely different periods. It has been suggested that the drawing was really intended for the crucified *Haman* in the Sistine Ceiling spandrel. There is no direct connection—the positions of head, arms, and legs vary too widely for that. Numbers 90–92, actual studies for the *Haman*, make the difference in conception of the figure abundantly clear. Much more probably the sketch was made in the process of defining the poses of the Bound Captives. The style corresponds closely to that of the smaller sketches in Nos. 46 and 47. In none of the series is the artist's concern for the flexibility of the struggling human figure, as a vehicle for tragic emotional expression, more impressive. Such a sketch would, presumably, have preceded more exact study from the posed model. It has been pointed out that the immense, two-tailed beard of the aged head sketched lightly at upper right relates him to the *Moses*. Probably this was an early idea, direct and literal, compared to the universal and ideal grandeur of the finished figure, whose carving was undertaken only for the 1513 project. Certainly it corresponds to the appearance of the figure in the Berlin-Uffizi drawings for the project (see page 62). This sheet must have been brought back to Florence when Michelangelo left Rome in 1506, because at the right, upside down, he drew a right arm for the *St. Matthew*, contracted for in 1503 (see page 42), resumed in 1506, and never completed. The words in Michelangelo's handwriting include: "Gather them together at the foot of the wretched mound," from Dante's *Inferno*, apparently associated with the arm of *St. Matthew*; and the unidentified fragmentary phrases "In man God thou art . . . in thought (or worry) . . . this . . .", which may suggest an aspect of the meaning of the Bound Captives, attempting to escape to God from their fetters.

51. *Studies of arms and hands for the Dying Slave; dissection of arms*
1505–6
Red chalk, pen, 11¼×8¼″, cut down
HAARLEM, TEYLERSMUSEUM, A 28 recto
(for verso see No. 413)

Although only twice mentioned in print, this drawing has already been rejected on the same grounds as No. 52, classed as student work by almost all critics. Both deserve careful restudy. The absence of studies surely by Michelangelo's own hand after flayed cadavers gives little comparative material against which the anatomical drawings (of extended right and left arms, seen from above and below) can be evaluated. But we know Michelangelo occasionally made such studies. These four were clearly already on the sheet when Michelangelo fitted the chalk drawings around them. Their style is close to that of the earliest pen drawings and

differs sharply from that of the later anatomical drawings here attributed to Michelangelo (Nos. 132A–E). It is by no means impossible that these are the only surviving examples of the dissection drawings the young artist made at Santo Spirito in 1492. (A less convincing anatomical study in Haarlem and three more at Windsor have been proposed as examples done for Michelangelo's use.) About the red chalk studies there should be much less doubt. Just left of center the bent right arm of the nude in No. 52 is beautifully restudied, the hand slightly lowered and all the implications of the underlying muscles brought out in light. The remaining three arm studies and one slight contour of a hand show what would happen if the same arm were to be lowered across the chest, in the position of the *Dying Slave*. The detailed study at the right is as beautiful as that of the lifted arm, delicate in its understanding of fluid contour and of the nuances of light playing across bones, tendons, and muscles. Turning the drawing upside down, we find the arm and hand of the *Dying Slave* emerging first: at the left, somewhat as later executed; then, in the center, in almost exactly the executed position. Farther up the left side of the sheet, the hand is analyzed in elaborate detail, with the tendons thrown into strong relief and the fingers gently pressed into the flesh. The difficulties in the way of the acceptance of the drawing vanish if it is considered not as a study for a statue and done from scratch in 1513–16, but as a study blocked out, perhaps almost finished, in 1505–6. The chalk drawings fit perfectly into Michelangelo's style just after the *Battle of Cascina*. Anyone attempting to explain them as the work of a pupil will henceforward have to suppose that such a supernaturally endowed individual (still anonymous) recapitulated all the stages through which the pose of the hands of the *Dying Slave* evolved in Michelangelo's mind, utilizing a complacent living model for the purpose. This drawing was still in Michelangelo's studio fifty years later, as is proved by the drawing on the verso.

52. *Studies of the right hand and arm of the Dying Slave, and of a left arm*
1505–6
Red chalk, 14⅝×11¾″, cut across at center and patched together
FLORENCE, UFFIZI, 608 E verso (for recto see No. 45A)

This luminous drawing, on the verso of an old copy (No. 45A) of one of the early designs for the Tomb on which Michelangelo later based his 1513 project (see No. 45), has generally been dismissed as a copy by a pupil after the hands of the *Dying Slave*. Richard J. Betts has convinced the author that this is impossible—the differences are too great. All the slender bones and tendons shown in the exquisite drawing (so reminiscent of the hands of Christ in the Rome *Pietà*) are smoothed over in the broad, generalized shapes of the finished statue. This is a series of careful studies after a model, and a rather peculiar one at that, with exceptionally faceted, supple joints and prominent tendons, all of which have been drawn with fascination and authority, and veiled in shimmering skin. The drawing, of the greatest transparency and beauty, seems to have been made just after No. 51, in Michelangelo's intensive process of investigation of the hands on which so much seemed to depend. In the lower section of the drawing, the left arm added lightly to the tracing on No. 51 has been drawn more accurately, from a relatively fleshy and stocky model. Mr. Betts's reattribution of this drawing to Michelangelo, of course, automatically brought with it the attributions of Nos. 51 and 53.

53. *Studies for the legs of the Rebellious Slave*
1505
Pen, wash, 20⅝×13⅜″, cut down irregularly, corroded, traced with stylus, patched, remounted
BERLIN-DAHLEM, STAATLICHE MUSEEN, KUPFER-STICHKABINETT, 15305 verso (for recto see No. 45)

The verso of the project for the Tomb was, luckily, not subjected to the brutal mishandling that has almost demolished the drawing on the recto. The drawing shows careful study of both right and left legs of the so-called *Rebellious Slave*. In view of their stylistic identity in every detail of contour and hatching with the pen studies of male nudes, Nos. 46–50 and 54, their attribution to Michelangelo is not open to serious question. These studies settle once and for all the fact that by 1505 Michelangelo had established the pose of the *Rebellious Slave* in all its essentials, if from a model considerably slenderer than the massive figure now in the Louvre. Possibly this figure was already blocked in during the first campaign. It is noteworthy that, at the lower left, Michelangelo tried out two alternative poses for the right leg, one bent and one straight. Upside down, the lower right corner shows the bent leg from the outside, and the sharply bent knee of a seated figure, possibly the *Moses*.

54. *Studies for the left leg of the Rebellious Slave*
1505
Pen, 11¼×7⅝″
OXFORD, ASHMOLEAN MUSEUM, P. 297 verso
(for recto see No. 89)

Not the *Dying Slave*, as has often been supposed, but the *Rebellious Slave* was the purpose of these vivid pen sketches. The leg is first shown in a somewhat straighter position than that of the statue, but identical in form and style to that in No. 53, which again makes one marvel that some of the scholars who accept No. 54 reject No. 53. The leg was studied a second time in a slightly bent position at the bottom of the sheet.

55. *Study of a seated female figure, probably the Active Life*
1505–6
Pen and brown ink, 16×11″, torn and mended at the top, cut down, corroded, damaged by dampness
LONDON, BRITISH MUSEUM, W. 29 recto

Although occasionally doubted, and even attributed to the so-called "Andrea di Michelangelo," this powerful drawing has been accepted by most scholars. No unanimity prevails regarding its date, however, and its sex is the subject of an absurd misapprehension. The figure is not only not a study for the *Prophet Isaiah*, it is not a prophet at all. The décolletage, the sloping line of the mantle strap (its final appearance in Michelangelo's costumes), the fullness of the bosom and shoulders, and what can be made out of the knotted veil over the head make it perfectly clear, even in Michelangelo's world of sexual ambiguity, that this figure is female, and the ancestress of the Sibyls of the Sistine Ceiling. A superficial similarity of pen technique to the female figure in No. 160, surely datable around 1516–20, has caused critics to date this drawing far too late. The scratchy surface and elongated proportions are common to all the figure drawings connected here with the Tomb of Julius II, and the violent *putto* is very close in treatment to his brother holding the amphora in No. 47. The position of the *putto*

flanking the throne is elucidated by the Berlin drawing, No. 45, and its copies, which show all the seated figures of the upper story of the Tomb thus attended. The majestic lady, in her cascading cloak, twists, turns, and looks out so as to utilize her corner position. Her torso is attenuated and her knees slope so as to counteract perspective distortion inevitable when seen from below. After the lapse of nearly forty years, Michelangelo kept intact the position of her raised right arm and hand, down to the detail of the extended forefinger, when he came to carve the *Active Life-Leah* now on the Tomb. Presumably the drawing, before it was damaged, resembled in style No. 56. The architecture, of course, should be thought away; it belongs to the later drawing on the verso and has come through the paper.

56. *Study for St. Paul; sketches for the Pitti Madonna*
1505–6
Pen, traces of black chalk, 15¼×10⅜″, cut down, folded, spotted, and patched
CHANTILLY, MUSÉE CONDÉ, 29 verso (for recto see No. 6)

Generally given to a pupil, the seated figure is admittedly weak in the accordion anatomy of the torso; it is patched across the rib cage with new paper, and restored perhaps elsewhere. But the position is very grand, and the legs were utilized in the *Isaiah* of the Sistine Ceiling. The extended right arm shows all the magnificence of Michelangelo's early maturity, very similar to the delicately contoured unfinished arm of No. 40. Again, the figure was elongated to compensate for perspective distortion from a low point of view. The extended hand foretells the *Creation of Adam*, and this is not accidental. The hand must have pointed in the direction of the papal catafalque held by angelic figures, suggesting the resurrection of the dead prophesied by St. Paul. The corner studies, added later, are probably both connected with the *Pitti Madonna*, which must date after 1506.

57. *Virgin and Child with St. Anne; standing male nude; caricatured profile*
Probably 1505
Pen and gray and brown ink, over black chalk, 12¾×10¼″, cut down, folded, patched
PARIS, LOUVRE, 685 recto (for verso see No. 60)

No certain identification has yet been proposed for this, one of the most powerful of early Michelangelo drawings. It is unanimously conceded that some relationship exists between this composition and the *Madonna and St. Anne* by Leonardo, but Michelangelo has here gone even further from the original theme than in No. 9. Possibly a patron simply commissioned him to design a relief on this subject, in which case some correspondence with Leonardo's composition was inescapable. The pose of the Virgin is more deeply influenced, it has been shown, by one of the sibyls by Giovanni Pisano on the pulpit of Sant'Andrea in Pistoia. The St. Anne, aged and sunk in darkness and meditation, is a direct ancestress of the *Persian Sibyl* on the Sistine Ceiling. What seems to have escaped comment is that, if one removes St. Anne, the pose of the Virgin is so close to that of the *Pitti Madonna*, sketched in No. 56, as to be conceivable only as a preparation for that unfinished relief. It is here suggested that an original commission on the part of Bartolommeo Pitti for the *Madonna and St. Anne* was converted at Michelangelo's own request into a *Madonna and Child* composition.

The figure below, on its side, is closely related to the foregoing series of male nudes, although it remains in outline. Shaggy and wild, it suggests a satyr or barbarian from Roman sculpture.

The Child reaches upward for His mother's breast, which she presses with her right hand. This motive, that of the *Virgo lactans*, sets the drawing in the group of nursing Virgins by Michelangelo, continuing from the early *Madonna of the Stairs* through the next two drawings, Nos. 58 and 59, to the colossal embodiment in the *Medici Madonna*, whose life-giving pose is the central energizing principle of the Medici Chapel. Below the group, an irreverent grotesque head looks upward apprehensively as if some drop might fall on him. An eminent authority has characterized my hypothesis of a similar situation in the Medici Chapel as mirth-provoking. The expression of Michelangelo's little caricature indicates that he also found it so.

The breadth of the masses and the power of the great diagonals enable us to imagine how the seated statues of the upper story of the Tomb of Julius II might have looked. The disjointed phrases in Michelangelo's hand include a line from Petrarch, and the words, "Who would ever say that she (was?) from my hands." The further words, "Praise our lord, you poor, praise him forever," may be a paraphrase of Psalm 74 (Vulgate 73): 21, "Let the poor and needy praise thy name."

58. *Two sketches for a Virgo lactans*
Probably 1505–6
Pen, 14¾×7¾", cut down
PARIS, LOUVRE, 689 recto (for verso see No. 49)

These two strange sketches seem related to the motive of the nursing Madonna in No. 57. The Virgin is first sketched nude save for a mantle, then entirely nude and without the Child. The extension of the hand of one sketched figure onto the shoulder of the next is typical of the kind of free connection between separate motives that constantly recurs in the early studies. The anxiety in the upward glance of the mother is surprising, as if she were supplicating the mercy of God the Father by indicating the breast with which she nourishes the Son. The purpose of this and No. 57 has so far defied identification. The motive was taken up in the *Medici Madonna*, done in the 1520s. Was this version intended for a group on some unknown early version of the Tomb of Julius II? The drawing is loosely sketched in the simple, carved hatching of the Captive in No. 50.

59. *Study for a Virgo lactans*
Probably 1505–6
Pen, 15⅜×7¾", corroded, patched,
a large gap pieced in at bottom
VIENNA, ALBERTINA, S. R. 152 verso
(for recto see No. 38)

This very beautiful drawing, accepted by all but a handful of scholars, is even closer to the pose finally adopted for the *Medici Madonna*. The Child is a further development of the motive invented in No. 58, but the pose of the Virgin has apparently been studied with the intervention of a lay figure supplied with actual drapery. The free, open hatching and crosshatching is typical of Michelangelo's pen technique throughout the series.

60. *Study for Salome with the head of John the Baptist; head of an eagle; lantern*
Pen and gray and brown ink, over black chalk, 12¾×10¼", cut down, folded, patched
PARIS, LOUVRE, 685 verso (for recto see No. 57)

This great drawing is sometimes identified as Judith with the head of Holofernes, sometimes as Salome with the head of John the Baptist. Judith cut off the head of Holofernes, but bade her maid to put it in a wallet. Salome demanded the head of John the Baptist, and brought it to her mother in a dish. The fact that the head is carried in a dish would rule out Judith, if Michelangelo had not painted the head of Holofernes in a dish on the Sistine Ceiling. But Judith, who knelt to nobody, is effectively eliminated by the kneeling position. Salome kneels in the fresco by Giotto in Santa Croce, in the relief by Andrea Pisano on the south doors of the Baptistery of Florence, and in the fresco by Filippo Lippi in Prato, to mention a few of the many depictions of this scene known to Michelangelo. As in Filippo's fresco, Michelangelo has drawn Salome looking away from her ghastly burden, turning her head inward.

No such subject is mentioned in any of the documents or sources, so we can only speculate. Was there some notion of putting a group by Michelangelo over Andrea Pisano's doors, in the position eventually filled by Vincenzo Danti's three figures (one of whom is Salome) representing the *Beheading of St. John the Baptist*? This hypothesis is reinforced by the two smaller sketches: the eagle's head and the lantern. The eagle was the symbol of the ancient guild of Calimala (the refiners of imported woolen cloth), which bore the responsibility for the maintenance and decoration of the Baptistery. And Christ Himself referred to St. John the Baptist as "a lantern to our footsteps." Our confusion, alas, is increased by the fact that the lantern also appears in the passage (describing the ideal housewife) from Proverbs that was read as the Epistle on the feast of St. Anne, and she is represented on the recto.

The drawing was made on a sheet of business paper from the firm of Donato di Berto and Buonarroto Buonarroti, Michelangelo's brother, but the document bears no date.

The elaborate modeling and strong projections suggest a work of sculpture.

61. *Sketch for Hercules and Cacus*
1508
Pen, 5¾×3½", badly torn at upper and right edges, patched
FLORENCE, CASA BUONARROTI, 63 F

This rapid sketch, indicating the principal masses of two struggling figures and repeating the crouching figure at the lower left, has been successfully identified with the colossal group of *Hercules and Cacus* which Michelangelo was commissioned to carve as a companion to the *David*, before the entrance of Palazzo Vecchio. The marble was ready in 1508. After many vicissitudes, the commission was eventually carried out by Baccio Bandinelli. The line, free and yet incisive, scratchy, and often repeated, is instructive for the identification of Michelangelo's pen sketches.

66

45

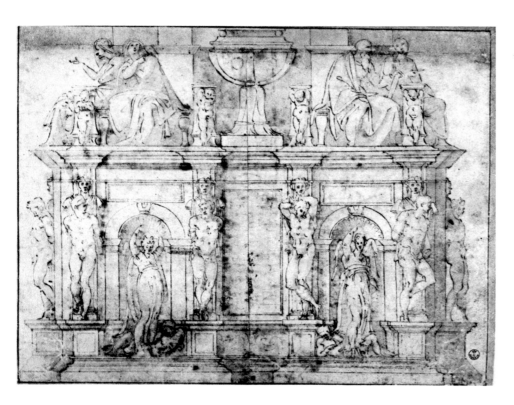

45A

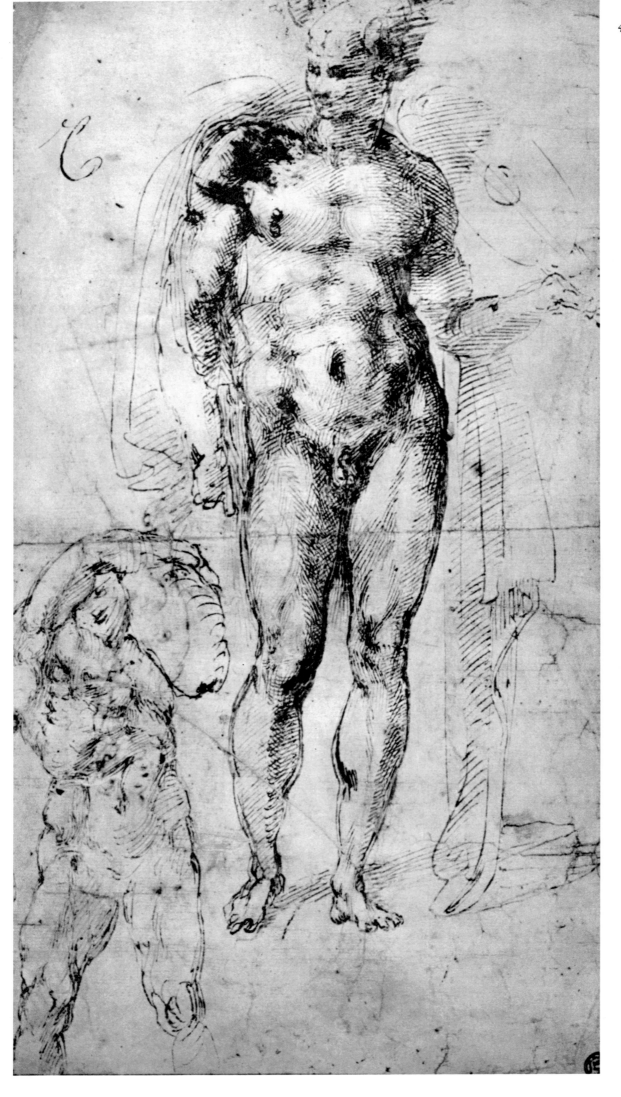

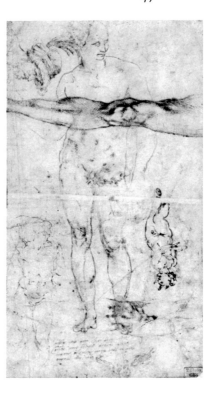

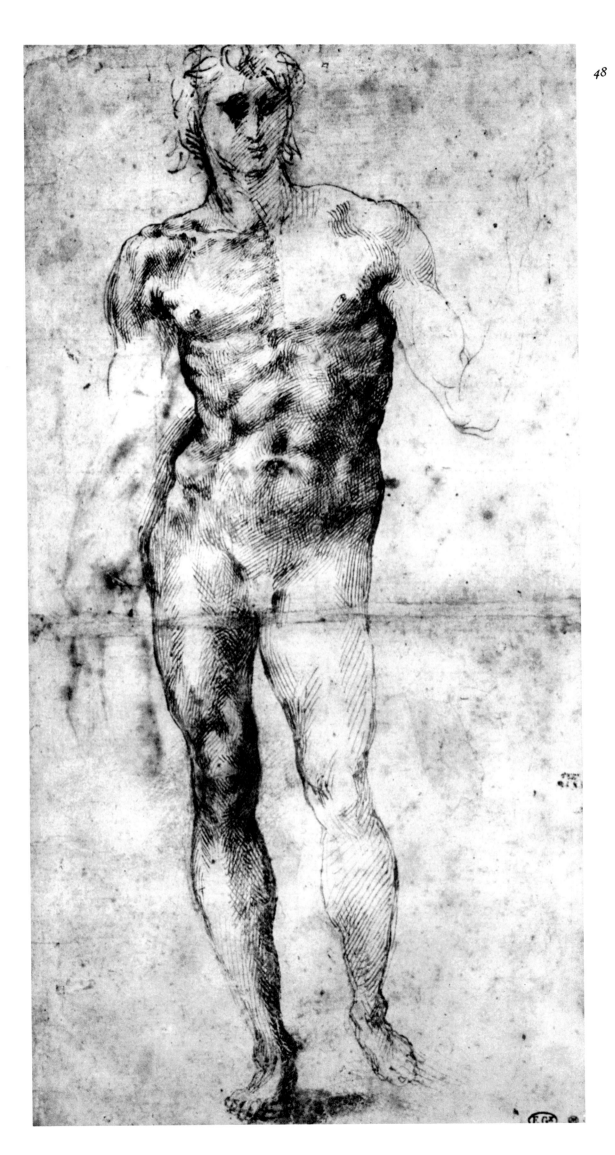

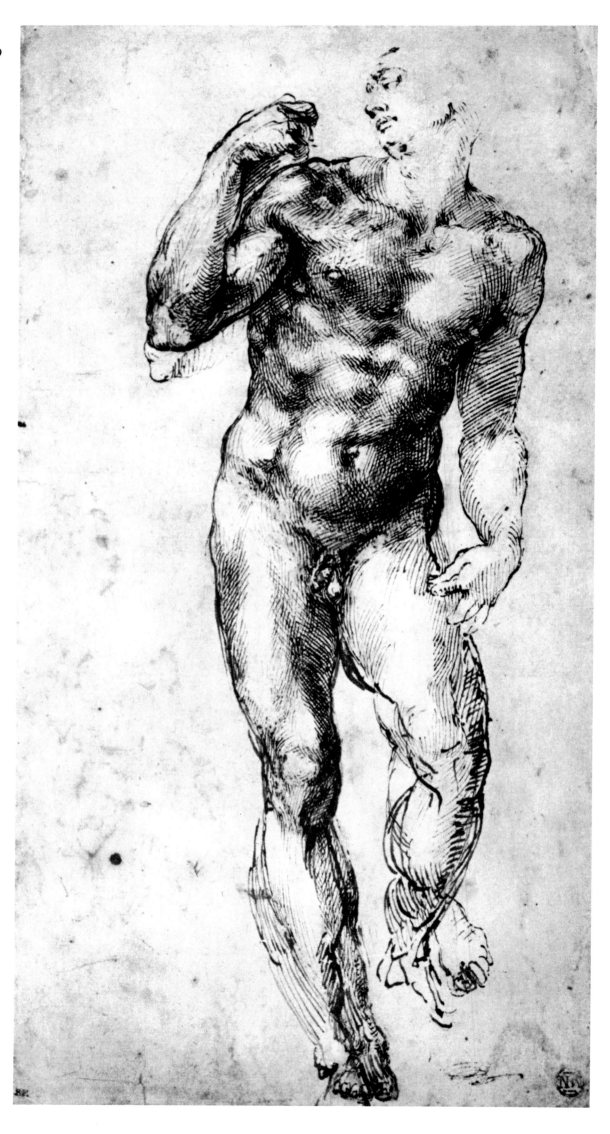

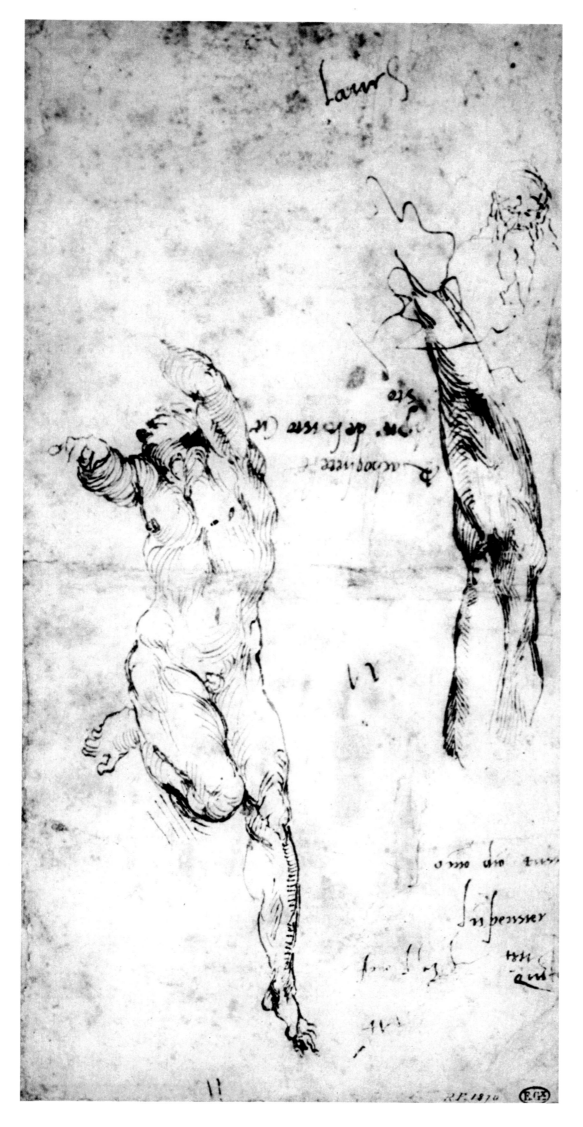

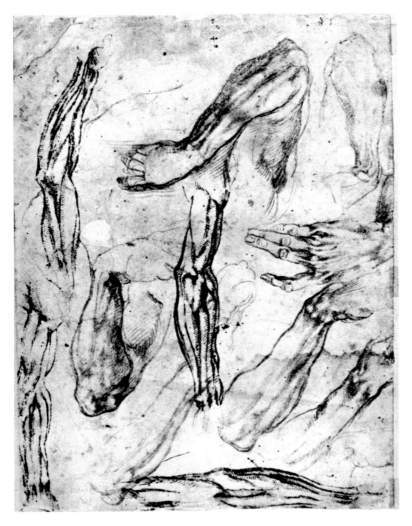

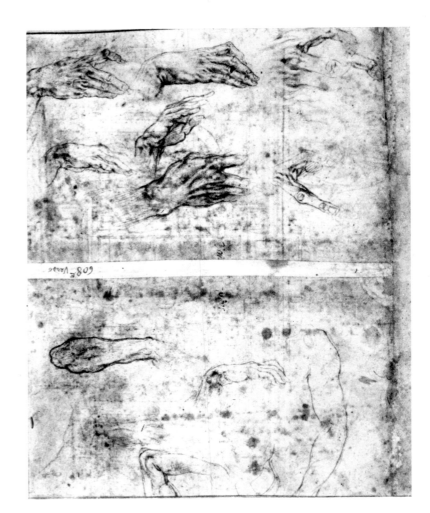

51

52

detail of 52

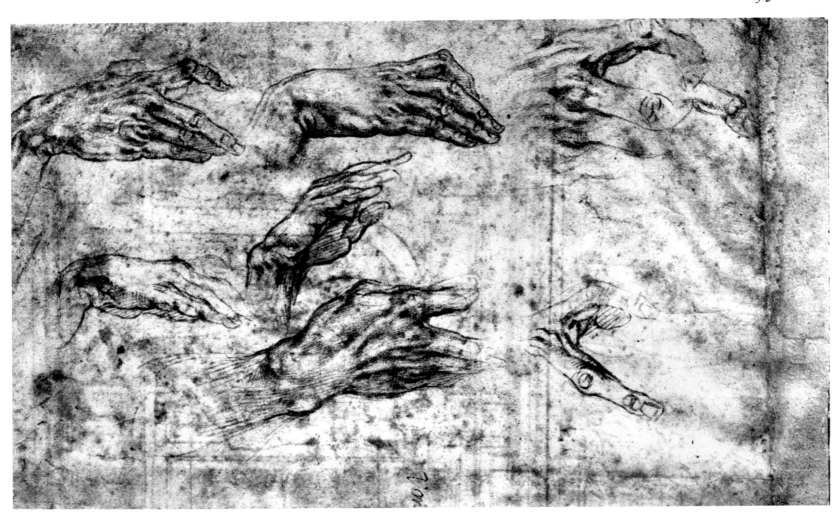

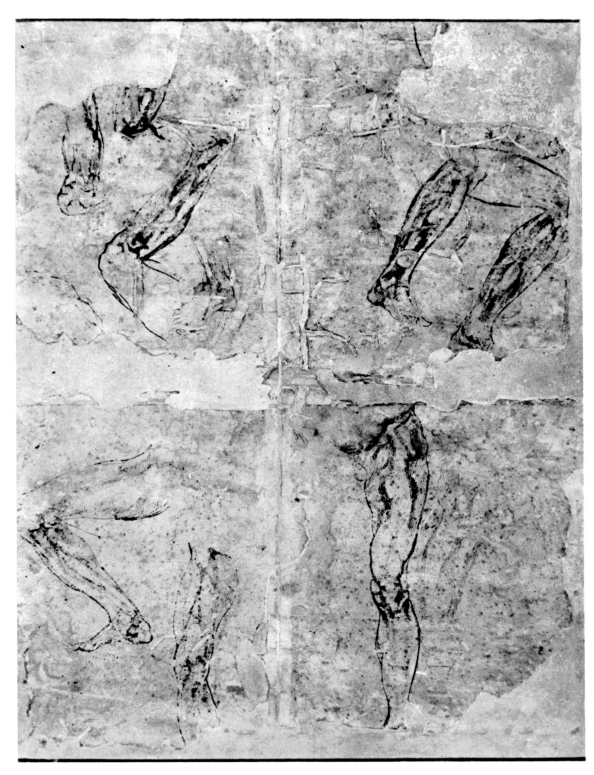

55

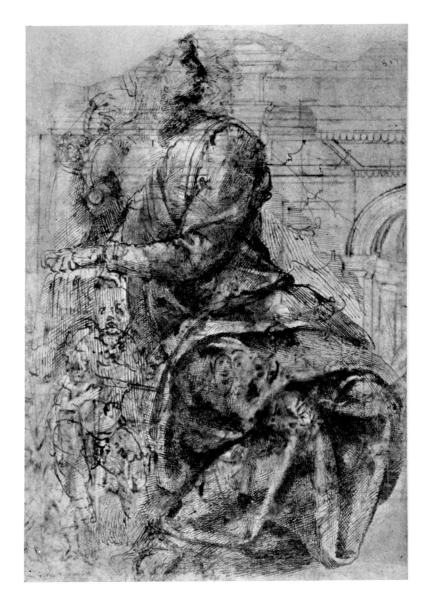

56

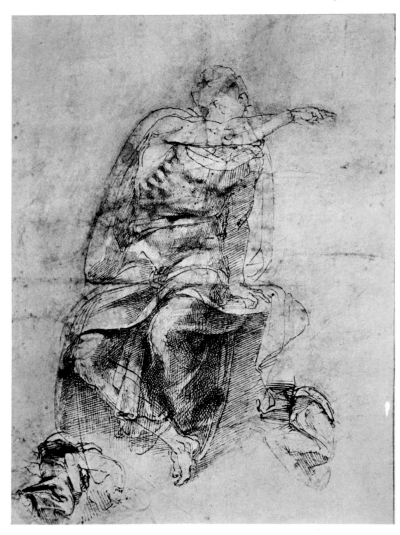

74

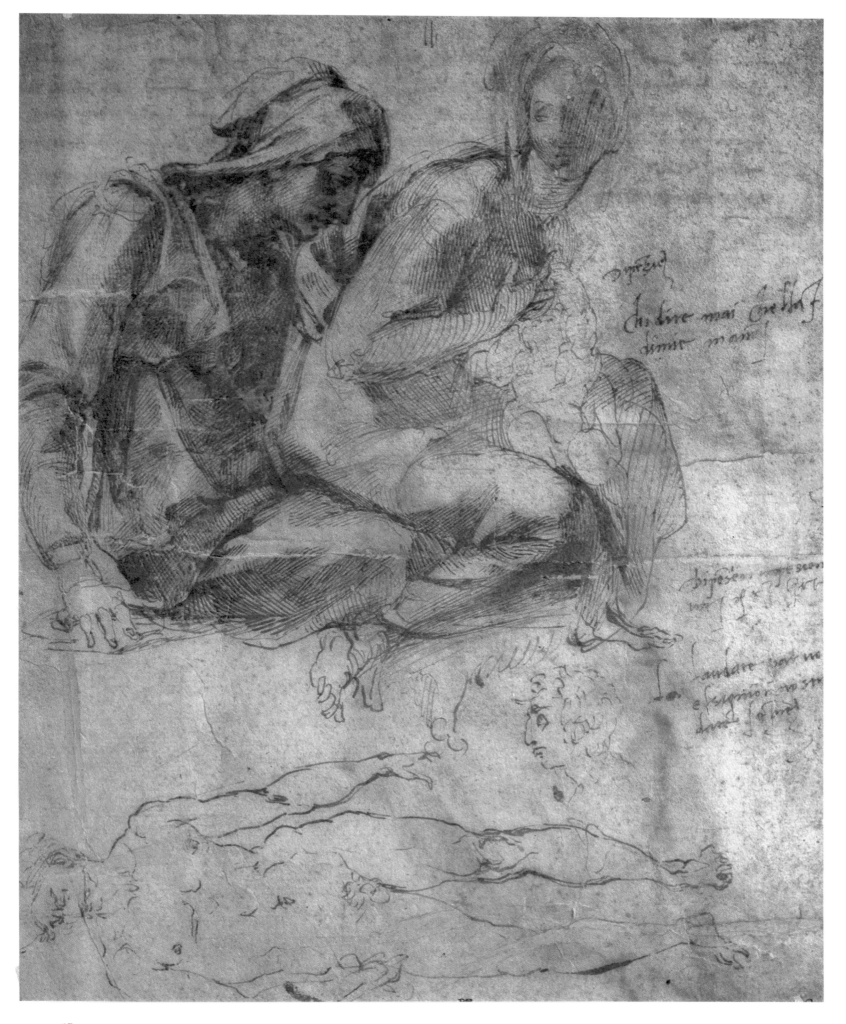

57

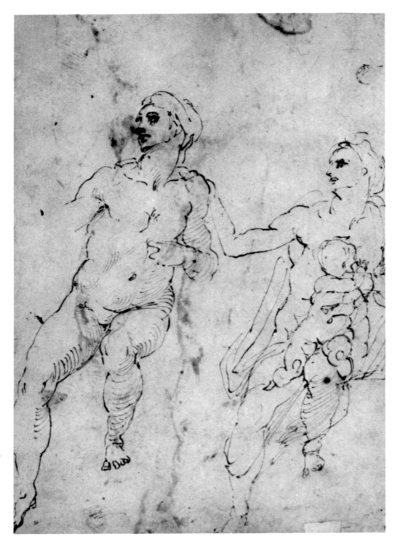

58

59

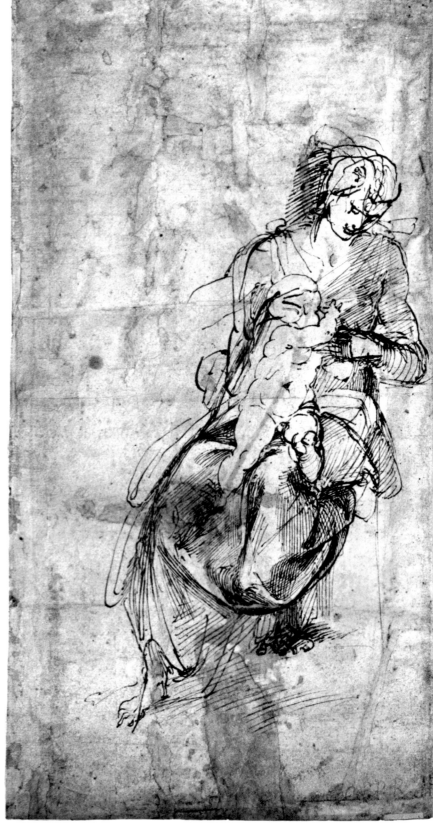

76

4

Drawings connected with the ceiling of the Sistine Chapel. Rome, 1508–12

The Sistine Ceiling was the most ambitious pictorial commission of the entire Renaissance; possibly it is the most elaborate arrangement of human figures in the entire history of painting. Michelangelo's technical procedure involved a theoretically unlimited number of sketches from imagination for compositions and for individual figures, until groups and poses had crystallized in his mind. Each figure then had to be studied, insofar as possible, from the nude model. Heads were generally the subject of separate drawings, and not necessarily from the same models who posed for the figures. Drapery was arranged on lay figures, and the behavior of its folds carefully analyzed. Given the necessity of at least one study for every foreground figure, no matter how completely it was later to be overlapped by others, and given the fact that we sometimes have more than one study preserved for the same figure, the detailed drawings from the model must have numbered between three and four hundred. Out of what must have been an even larger total of sketches and finished life studies, only sixty-five surviving drawings are here presented as genuine. Oddly enough, none of these is a detailed scale model for any of the nine scenes from Genesis or the four corner spandrels. Could all the scale models without exception have perished? Or did Michelangelo not make any? Perhaps he considered his composition sketches and life studies sufficient preparation for the full-scale cartoons, of whose one-time existence we possess abundant evidence.

Michelangelo did not follow the classic procedure of the fifteenth century for the transfer of the cartoon to the surface of the wet plaster (*intonaco*) by means of pricking the surface —pouncing, as the method is called—so that the outlines could be reproduced through the holes with tapped-in charcoal dust (*spolvero*). He preferred to trace the contours directly through the cartoon into the plaster by means of a stylus, a substantial short cut in the lengthy operation. The stylus marks can be distinctly seen in certain photographs of the ceiling frescoes, taken in a raking light. The cartoons themselves, alas, have all perished, but their stylus marks survive even in some of the smallest figures, like the pairs of caryatid *putti* in simulated marble on the thrones on either side of the Prophets and Sibyls.

No sketches or studies of any sort survive for these *putti*, or for any of the single *putti* below the thrones, or for the bronze-colored nudes in the spandrels flanking the thrones, or stranger yet, for the ten bronze medallions with scenes from Samuel and from Kings, or for the eight vaulting compartments with their crouching figures of the Ancestors of Christ. Perhaps Michelangelo, under constant pressure from the Pope for rapid completion, skipped still another stage, and composed these smaller groups directly, with a minimum of preparatory sketching, on the large sheets of paper to be used as cartoons. This, again, is pure speculation but is encouraged by the evidence.

Of one thing we can be fairly certain. There are many repetitions of substantially the same hand, or back, or leg, or sometimes an entire figure, in widely separated portions of the Ceiling; and there are (conversely) many studies of hands, arms, legs, and other portions of the body difficult if not impossible to connect beyond question with any specific figure to the exclusion of all others; thus we can only conclude that the artist must have had a repertory of life studies into which he could dip for the factual basis of a figure he happened to be working on—a kind of body bank in which any number of spare parts were deposited, drawing interest, ready for instant use.

For the first sketches at the start of the long job, Michelangelo still relied on his youthful experience with the pen. This medium he seems rapidly to have given up. Most of the sketches and almost all of the studies are in chalk. At first this was black, and hastily ground onto the surface even in the rather finished nude studies, as a kind of shorthand for the elaborate hatching in the latest studies for the *Battle of Cascina*. Eventually, as the project moved along into 1510 and 1511, he renounced black chalk in favor of red, and took greater and greater pains with the production of a smooth, consistent draftsmanly surface, to reproduce the shimmer and even the feel of the luminous skin of his adolescent models and all the suppleness of their underlying musculature. These nude studies are of the greatest beauty. Inexplicably almost all of them have been rejected by one scholar or another, although every bit of visual evidence shows that they are all by the same hand, all original studies and not copies, and all done *for* rather than *after* the frescoes. The surviving nude studies remain among the most glorious expressions of man's belief in the nobility of man.

The dispirited sketches for the Ancestors in the lunettes, as remote from the accepted idea of Michelangelo's style as the strange, sometimes comic, sometimes bitter paintings for which they were done, come as an anticlimax. They seem to be symptomatic of the artist's disillusionment, following the sublime achievement of the paintings of the Ceiling itself. Their quality should not be underrated.

62. *Composition sketch for the Sistine Ceiling;
studies of arms and hands*
1508–9
Pen, over leadpoint, black chalk, 10 ¾ × 15¼″
LONDON, BRITISH MUSEUM, W. 7 recto
(for verso see No. 82)

According to a letter from Michelangelo in 1523 (which survives in two versions), the original idea for the decoration of the Ceiling was to include seated figures of the twelve Apostles in the twelve spandrels between the windows; the rest was to be filled with "a certain division full of ornament according to custom." It has recently been shown that the ornaments indicated lightly in pen in this drawing were indeed "according to custom" in Rome, and that that custom was derived by Pinturicchio from a study of ancient Roman ceiling decorations. Michelangelo has here sketched out one bay of the Ceiling according to such a plan, extending it sufficiently at top and sides to enable the Pope to see how it would look if continued throughout the entire surface of the vault. The painted cornice which in the Chapel itself forms a frame around the entire ceiling is already present, interrupted at the spandrel by a niche containing a seated Apostle whose knees are wedged between the two arches. The sides of the niche are formed by pilasters whose cornices abut the main cornice and support a shell which forms the semidome of the niche. On the projecting cornices stand winged herms, whose heads support two more cornices. The herms are flanked by diagonal volutes, and their wings embrace a roundel which grows out of one of the four points of a lozenge. The lozenge, then, would occupy the center of this bay of the ceiling, so that the opposite roundel would fit into the top of the corresponding throne on the other side; this the reader may supply for himself, upside down, as it would appear if he were standing in the Chapel, looking at the ceiling from below. The remaining two points of the lozenge culminate in identical roundels. Between the roundels of one lozenge and those of the next are placed oblong panels running down the spine of the vault. Between each oblong and the cornice the space is filled with ovoid fields in square frames. One of these gets a bit of hatching, and it is by no means clear whether or not the artist intended to fill them with representations. In any case, the entire structure, which it is easy enough to extend following Michelangelo's indications, would have been a complex network of large and small, curved and rectangular fields, and longitudinal, transverse, and diagonal directions. Most of these elements and principles recur in the final structure of the Sistine Ceiling, but they are made more compact, broad, and simple, with the purpose of the abstract shapes largely taken over by figures. This sketch is the first monumental architectural design we know from Michelangelo's hand. The use of cubes to build up the beautiful little Apostle figure, sitting so serenely under the overwhelming structure of geometrical shapes, is instructive for the attribution to Michelangelo of other figure sketches in this manner.

The pen sketch must have been made early in 1508, shortly after the commission for the Sistine Ceiling. Probably during the following year, while actually painting, Michelangelo utilized the empty paper at the right for the splendid drawings of arms and one hand for the *Delphic Sibyl*. These same studies were used again for the right arm of the nude seated at left above the *Persian Sibyl*. The larger hand at the top of the sheet may be a preliminary study for the famous left hand of Adam in the *Creation of Adam*.

63. *Composition sketch for the Sistine Ceiling;
study of left hand and torso*
1508, 1509, 1510
Pen, black chalk, 9 ⅞ × 14¼″, cut down, badly rubbed
DETROIT INSTITUTE OF ARTS, 27.2 recto
(for verso see No. 81)

Although doubted by one critic, this great drawing has been accepted by all others. Michelangelo has strengthened and simplified the preliminary organization of the structure in No. 62, binding the niches, ovoid fields, and oblongs into a single bank running across the ceiling from throne to throne in the manner of the ribs, bronze medallions, and octagonal fields in the composition as it was carried out. The idea of sacrifice now appears in the form of rams' skulls hanging over sacrificial garlands, above the niches for the Apostles. These, too, persist in the final version, the rams' skulls poised between the vault compartments and the cornice, the garlands flowing out of cornucopias held by the nude youths. The ovoid fields or medallions are not only hatched but filled with curved pen strokes to indicate an eventual figural composition. They are, moreover, drawn to give the illusion of being recessed at the top. They are flanked by winged cherubs, descendants of the herms of No. 45 and ancestors of the paired *putti* in the thrones that were finally painted. No indication of the nude youths as yet appears. The transverse ribs separate large octagonal fields filling the whole center of the Ceiling. The almost vanished torso, on its side, seems to be a study for one of the sons of Noah in the *Sacrifice of Noah*. The left arm and hand have been connected with those of Adam in the *Creation of Adam*, but they seem too full and soft; more likely they were done for the gentle, fleshy nude at left above the *Cumaean Sibyl*. The powerful grid design of the ceiling as carried out can be seen lightly sketched in No. 83.

64. *Sketch for an Apostle*
1508
Pen, 4¼ × 2 ⅜″, cut down
FLORENCE, UFFIZI, 17379 F

This and the following drawing have been accepted by all but two scholars, but there has been little agreement about their purpose. The best explanation seems to be that they were intended for the first project for the Ceiling, represented by Nos. 62 and 63. Both figures, brandishing books, are set down in the vigorous pen style of the *Hercules and Cacus* drawing, No. 61, and the sketch for the *Deluge*, No. 69. Contours are frequently doubled, as the artist's pen moves with great speed. The poses of these rejected figures nonetheless served Michelangelo for some of the nudes in the first portion of the Ceiling.

65. *Sketch for an Apostle*
1508
Pen, 4¼ × 2 ⅜″, cut down
FLORENCE, UFFIZI, 17380 F

Similar in every respect to the style of No. 64.

66. *Composition sketch for Judith and Holofernes*
1508–9
Black chalk, 10¼×16″, cut down, folded across,
and patched, spotted
HAARLEM, TEYLERSMUSEUM, A 18 verso
(for recto see No. 42)

This drawing is generally neglected, usually misunderstood,
and almost never reproduced. It has even been attributed
to Giovanni da Udine! It shows a view into Holofernes'
chamber in the center with a staircase rising in the back-
ground. On the right Judith and her maidservant are ap-
proaching on tiptoe. In the center, sharply foreshortened,
sprawls the headless corpse. On the left the two ladies
gracefully remove their ghastly prize. In the fresco the story
has been telescoped into a single incident, but the body of
Holofernes appears in substantially the same pose, merely
seen from the left rather than foreshortened. Judith at the
left is also in the same pose indicated here, although turned a
few degrees clockwise. The maid was painted almost exactly
according to this sketch. The graceful little drawing is of the
highest quality, full of suspense and tragedy. The propor-
tions, linear rhythms, and cubic shapes are the chalk equiva-
lent of the pen lines of the Apostle figures in Nos. 64 and
65. The cubes remain dominant in the composition as
painted.

67. *Right arm, possibly a study for the Drunkenness of Noah*
1508–9
Black chalk, 3⅞×5¼″, cut down almost to the contour of
the arm at top
FLORENCE, CASA BUONARROTI, 8 F

Although seldom mentioned, this powerful drawing has been
rejected by only two scholars. It cannot be, as has been
suggested, a copy—the lines are much too free and fluid.
The broad lines and summary hatching show all the authority
of the new style which had to be rapidly developed for the
immense project of the Sistine Ceiling. If the study was
really made for the extended right arm of Shem (and this is
by no means certain), it was altered somewhat in execution.
Similar hands turn up again and again in the Ceiling; for
example—in reverse—the left hand of the Lord in the
Creation of Adam (No. 74).

68. *Two studies of right arms for the Drunkenness of Noah*
1508
Black chalk, 8½×6¼″, cut down
ROTTERDAM, BOYMANS–VAN BEUNINGEN
MUSEUM, I. 513 verso (for recto see No. 33)

About the purpose of this drawing there can be little ques-
tion. It was intended for the pointing right hand of Shem,
exactly as painted, and the extended arm and hand of his
brother. It is a handsome and remarkably free life study, and
does not deserve its recent rejection.

69. *Composition sketch for the Deluge*
1508
Pen, 4×9¾″, spotted
FLORENCE, UFFIZI, 17381 F

Only the usual two doubters have experienced any dif-
ficulty with this vibrant sketch, in which the artist studied
separately the fighting groups in the round boat (originally
intended, as we see, to be much larger than the final version)

and on the ledge of the Ark. The style is identical with that
of No. 61, for the *Hercules and Cacus* group. In a manner to be
seen throughout Michelangelo's mature pen sketches, a few
rapid hooks serve to establish the main masses and their
directions. Some of the poses were altered in the painting,
always in the interest of greater compactness of masses.

70. *Sketch for Adam in the Expulsion*
1510
Black chalk, 10½×7½″
FLORENCE, CASA BUONARROTI, 45 F

The freedom of this rapid preparatory sketch, radiating
that new power which seemed to flow from the artist's own
realization of the implications of the tremendous scale on
which he was now required to compose, renders absurd the
rejection by two recent cholars. As conceived by Michel-
angelo, the figure was much slenderer than the massive
Adam in the fresco. The torso, right arm, and right thigh
are set down with swift, strong strokes, the left arm and
thigh barely suggested, and the head and lower legs not
drawn at all.

71. *Studies possibly for the right arm of Adam in the Expulsion*
1510(?)
Black chalk, 9½×5¾″
OXFORD, ASHMOLEAN MUSEUM, P. 329 verso
(for recto see No. 382)

Generally dated much too late, and rejected by three
scholars, these drawings are certainly genuine, and seem to
come from the period of the Sistine Ceiling. It is often
difficult to pin down anatomical replacement parts to specific
figures, but the pose is very close to the right arm of Adam,
extended in a futile attempt to ward off the sword of the
expelling angel. Both repeat in reverse the pose of the left
arm of No. 4, derived from the *Apollo Belvedere*.

72. *Studies possibly for Eve in the Expulsion*
1510(?)
Red chalk, touches of pen, 10⅝×7½″
VIENNA, ALBERTINA, S. R. 155 verso
(for recto see No. 105)

This often rejected but perfectly genuine study of the
shoulders and torso of a nude youth nervously clutching his
hands probably represents an early idea for the tragic figure
of Eve expelled from Paradise, much more compact in the
fresco. Slight variations of the pose of the hands are worked
out at the top. The drawing was certainly used by Sebastiano
del Piombo for the grieving Mary in his *Pietà* in Viterbo, for
which Vasari tells us Michelangelo provided the "cartoon";
this may have been no more than the present drawing. The
hands at the bottom, soft and pudgy, are probably additions
by Sebastiano.

73. *Figure sketch for the Lord in the Creation of Adam; knees;
sketch for a lunette*
1511
Red chalk, black chalk, pen, silverpoint, 10×13¾″
FLORENCE, UFFIZI, 18722 F recto (for verso see No. 99)

All but the same two doubters have accepted this splendid
drawing and its verso. The red chalk drawing, one of the
earliest by Michelangelo in this medium, seems to be his first
idea for the floating figure of the Creator. Only the torso

and legs are sketched in, with the multiple contours which will be characteristic for the artist's maturity and old age. As in No. 80, the figure is slighter in the initial conception than in the overwhelming realization on the Ceiling. It is possible that the precise position of the arms had not as yet occurred to Michelangelo. The two knees in silverpoint may be for the nude to the right over *Daniel*. The purpose of the pen sketch, upside down, with its curious arched stairway suggesting a millwheel, has provoked considerable discussion. The most reasonable suggestion seems to be that of a preliminary idea for the filling of the lunettes, to contain the forty generations of the ancestry of Christ. It was certainly not a bad notion, if restricted to a single lunette, but the repetition of steps around the Chapel would have been intolerable. Michelangelo may well have thought so too.

74. *Arm studies for the Lord, and studies for angels in the Creation of Adam*
1511
Red chalk over black chalk preparations, 8⅜×11″, cut down
HAARLEM, TEYLERSMUSEUM, A 27 verso (for recto see No. 103)

This glorious drawing has been rejected by one group of scholars as a copy, and incomprehensibly attributed to Daniele da Volterra by another. Luckily, with its companions Nos. 75–77, it has been recently and triumphantly revindicated. It is original, and one of the great nude drawings of the Renaissance, thoroughly characteristic of the formal imagination and anatomical observation of Michelangelo at what is generally considered to be the climax of his artistic career. The sheet overflows with energy like the great fresco itself. Michelangelo studied in red chalk the pointing right arm of the Creator from a powerful nude model, following light strokes of black chalk, presumably the original imagination sketch for the pose. The torrential contours are stronger than anything we have seen up to this moment. Between them the masses of the bony and muscular structure are built up with hatching and crosshatching, and then modeled with the finger or thumb. The hand has been restudied with slight variations at the lower right. Upside down, the drawing shows the Lord's left arm modeled with astonishing completeness in the shoulder, and with just the underlying hatching in some of the portions to be concealed in the fresco by the angel, under the mighty arm. This engaging youth has been separately studied, in the nude, at the right, in the same style. His head, waist, and hips are barely indicated, but the portions appearing in the fresco have been observed with great care, and modeled as if in marble. Below, the *angioletto*, who in the finished fresco appears only dimly over the Creator's left arm, has been drawn in exactly the same manner from an earnest and still chubby child model. The method of hatching is most instructive, particularly in the unfinished portions. It is the same followed throughout the series of figure studies for the Sistine Ceiling.

75. *Studies for the legs of the Lord in the Creation of Adam; head of the Nude at right above the Persian Sibyl*
1511
Red chalk over black chalk preparations, 11⅝×7¾″, cut down
HAARLEM, TEYLERSMUSEUM, A 20 recto (for verso see No. 76)

Another magnificent drawing, in the same style as No. 74 and with the same unfortunate history. The left lower leg

and foot of the Creator, hardly visible in the fresco, have been carefully drawn from a strong, mature model. The contours are complete, the hatching almost so. Instead of crosshatching the artist has apparently ground the end of the chalk down into the shadows. Sideways and clockwise, the right leg, with the beginning of the same shadow that floats across it in the fresco, is somewhat more lightly drawn. The foot is repeated in more detail above, and below, the right ankle is lightly redrawn. In the center, right side up, Michelangelo has caught in a brilliant, quick study an expression of intense excitement on the face of a youthful model. The head was used, with an idealized profile, for one of the most famous nudes.

76. *Studies for Adam's right knee and for three angels in the Creation of Adam*
1511
For medium, dimensions, and condition, see No. 75
HAARLEM, TEYLERSMUSEUM, A 20 verso (for recto see No. 75)

Still another superb drawing, generally maligned but recently reinstated. At the lower left, the right knee of Adam is carefully observed from a rather bony model, probably the same one that posed for the whole figure in No. 77, in which the rapid and sometimes scratchy hatching is close to the treatment of this drawing. At the right are beautiful nude studies for the angels dimly and partially visible in the fresco, one just to the left of the Creator's head and under His right arm, the other in the shadow below the whole group of angels, with the right leg lifted and the left trailing off against the sky. The central study of a sturdy nude youth from the back is for the nude angel upholding the Lord's right leg as the group moves through the Heavens. The left side of the torso, so important in the fresco, is indicated here only in profile, and the right arm and the legs omitted, but the back and buttocks are nobly rendered by means of thick, fluid contours, rough hatching, and the grinding method of modeling we will find in drawings for the seated nudes (see No. 100). The effect of these lovely figures is lost in the familiar, heavily exaggerated black-and-white reproductions of the scene, but is fully visible in the Ceiling, translated into lyrical color, even though some portions of the figures are hidden and most of them submerged in translucent shadow.

77. *Study for Adam in the Creation of Adam*
1511
Red chalk, 7⅝×14⅛″, cut down, varnished
LONDON, BRITISH MUSEUM, W. 11 recto (for verso see No. 107)

While contemplating the fierce power of this unprecedented nude study, the doubts that have plagued some scholars seem especially hard to understand. It cannot possibly be a copy, either after a drawing or after the fresco. The drawing shows all the peculiarities of a not-too-harmoniously proportioned model, whose raised left leg was moved at least three times during the pose. Despite the ugliness of the raw-boned torso as compared with the beauty of the Adam in the fresco, the drawing is sustained in every stroke by the steady inspiration of its lofty destination. The technique is, of course, identical with the other life studies for the fresco— low, diagonal hatching (sometimes rough and scratchy),

thumb or finger modeling, and point grinding. The right hand has been drawn and shaded separately at the lower left corner, and the left hand sketched out again at the upper right. Near the right edge the right hand has been lightly contoured a third time, to show the relation of its forms with those of the torso.

78. *Sketch for the face of Adam in the Creation of Adam*
1511
Black chalk, 8⅝×8¼″, badly rubbed
LONDON, BRITISH MUSEUM, W. 25 verso
(for recto see No. 212)

There has been an inordinate amount of discussion about this little sketch. It is very difficult to account for by means of any supposition other than the simplest and most obvious —that it is just what it looks like, a delicate first sketch for the famous face of Adam looking upward at his Creator. The drawing, incidentally, must be from imagination. Doubtless the frescoed head was also. The spontaneity of the drawing and its many *pentimenti* preclude the hypothesis of a copy. Tender and gentle, surprisingly so, the drawing represents an early phase of Michelangelo's ideas for the noblest of all his painted heads.

79. *Studies for an angel in the Creation of Sun and Moon, the Nude at right above Daniel, and the figure attending Jonah*
1511
Red chalk, 9⅜×13¼″, cut down, folded, broken, patched
CLEVELAND MUSEUM OF ART, 40.465 verso
(for recto see No. 104)

This transparent and luminous study has been as badly treated by critics as the nude study on the recto—but not by the restorer, who has left it untouched. The left foot is that of the nude at the right above *Daniel*, studied in detail, and brilliantly. The slightly lifted great toe, whose exact angle is crucial for the rhythm of the whole figure, is redrawn three times in slightly varying positions; the central study is the one finally adopted. The same scholar who noted that the head was connected with that of the angel under the raised right arm of the Creator in the *Creation of Sun and Moon*, inexplicably rejected the drawing. Ironically enough, the drawing is of higher quality than the hastily constructed head in the fresco. The model, in a more solemn mood, is the same who posed for the impish head in No. 106. The same boy also tugged on something so as to serve for the largely concealed figure (pulling on a net, apparently) above *Jonah*; only the pose of the head has been changed.

80. *Sketches for the Separation of Light from Darkness, and for a Nude*
1511
Red chalk, 10×7½″, cut down
HAARLEM, TEYLERSMUSEUM, A 16 verso
(for recto see No. 92)

Since the harsh lines at the left side of the sheet have generally been looked at upside down, they have not till now been identified anatomically. As here reproduced, they show the left side of a torso with arm raised. The nipple, the pectoral muscle, the intercostal muscles, and the edge of the latissimus dorsi are clearly recognizable. The fullness of the masses and the power of the broad curves complete the re-

semblance to the corresponding portion of the body of the Lord separating the light from the darkness in the first scene on the Ceiling. In the fresco, of course, the corporeal details are veiled partly by clothing and partly by Michelangelo's soft method of painting, dictated by the subject itself. Upside down, the sheet shows a small sketch of the upraised right arm of the Creator and the underside of His head and neck, derived (apparently) from a tracing on the recto of the arm and neck of Haman (see No. 92), an interesting commentary on the interchangeability of parts in Michelangelo's anatomical repertory. The little figure sketch may be a preliminary idea for one of the nudes or for one of the Ancestors; no closer identification seems possible. The drawing, of course, has been rejected by most recent critics.

81. *Sketches and studies for Sibyls and a throne*
1508–9
Black chalk and pen, 9⅞×14¼″, cut down, badly rubbed
DETROIT INSTITUTE OF ARTS, 27.2 verso
(for recto see No. 63)

This important drawing has suffered an inexplicable fate. Although the little pen sketch for a sibyl is indistinguishable in style from the sketch for the *Bruges Madonna*, No. 27, and the drapery study identical with those for the *Pitti Madonna*, No. 56, many of the same scholars who accept the last two drawings reject this one. The arched niche was developed from the forms shown on the recto, No. 63. The graceful nude woman, holding a book propped against her knee while she looks into another book held by a *putto*, may be an early idea for the *Delphic Sibyl*, for whom the drapery study (counterclockwise) was certainly done, probably from cloth laid over the knees of a lay figure. In the fresco the position of the folds was somewhat altered. The arm study in black chalk (upside down) from a male model, and in a style very close to that of the black chalk drawings for the *Battle of Cascina*, corresponds to the pose of the hanging right arm of the *Erythraean Sibyl* down to the wrist. The separately drawn hand, however, may have been added later when the drawing was reused for the seated *Boaz* in one of the lunettes.

82. *Sketches and drapery study for the Delphic Sibyl*
1508–9
Leadpoint and brush on gray prepared paper, 15¼×10¾″
LONDON, BRITISH MUSEUM, W. 7 verso
(for recto see No. 62)

The drapery study is one of Michelangelo's rare early brush drawings. It is a variant, possibly through further study, of the pen study in No. 81 for the cloak over the knees of the *Delphic Sibyl*. Some rearrangement was made before the fresco was painted. (There is supposedly a small nude in leadpoint on its side above this study, invisible to the author.) Clockwise, a sketch of a Sibyl, later blotted out by broad masses of wash. This looks too soft for Michelangelo, and may be the work of a pupil, possibly Silvio Falconi.

83. *Sketch for the Erythraean Sibyl; plan of the ceiling; study of a hand*
1508–9
Gray-brown and black chalk, 15¼×10¼″, rubbed, torn, patched
LONDON, BRITISH MUSEUM, W. 10 verso
(for recto see No. 84)

A powerful, quick sketch, universally accepted, full of the new sense of mass dictated by the grandeur of the conception. The head, torso, and legs are in substantially their final position, but in making the cartoon Michelangelo renounced the poses of the arms so that he could show the Sibyl turning the pages of a book; he also omitted the veil. The hand, as has been recently shown, is a study for the left hand of one of Noah's daughters, placing the brand in the burning. At the bottom, very faint, can be made out the final rectilinear plan for the composition of the Ceiling.

84. *Drapery study for the Erythraean Sibyl*
1508–9
Black chalk, pen, and brown ink wash; for dimensions and condition, see No. 83
LONDON, BRITISH MUSEUM, W. 10 recto
(for verso see No. 83)

This brilliant study represents a combination of media not as unusual as has been generally supposed. It is just the sort of procedure Vasari describes Michelangelo following in the cartoon for the *Battle of Cascina*, an example of which still survives in a study of a nude for that work, No. 41. In old age he was to take up combined chalk and brush in the *Crucifixion* drawings (especially Nos. 416, 421, and 423). Here very probably he laid in the brush tones first, and then picked out the hatching and crosshatching exactly in pen, in the manner of his highly finished early pen studies. Certainly the drawing reproduces folds prearranged on the knees of a lay figure, whose jointed wooden shapes can be clearly made out in the lightly sketched brush drawing of the torso and head.

The elaborate arrangement of the folds of the Sibyl's cloak corresponds almost exactly with their appearance in the fresco; a few small folds have been softened or eliminated in order to bring out a clear **S**–curve. Apparently the great pocket of folds at the left was established to provide a receptacle for the arm studied in No. 81.

85. *Study for the head of Zechariah; studies of knees*
1508–9
Black chalk and leadpoint, 17⅛×9½″, rubbed
FLORENCE, UFFIZI, 18718 F recto (for verso see No. 108)

One of the most justly famous of all Michelangelo's drawings, this massive study of the head of an aged model has, luckily, been doubted by just one scholar. What is more remarkable is the difference of opinion about the purpose of the drawing. It was once widely considered a preparatory study for the head of Julius II in the lost portrait statue of 1506–7, in spite of the fact that the Pope did not grow his celebrated beard until December, 1510. But some scholars still find it hard to believe the drawing was really intended for *Zechariah*. The entire formation of the eyebrows, eyes, nose, and mustache corresponds with the head in the fresco, line for line and facet for facet. The forehead has been changed in the fresco, slanting back to a close-cropped white pate. There is, of course, no resemblance to the well-known features of Julius II even after he grew the beard, and still less to the *Moses*. Before the virility and immediacy of this study, the venerable fallacy that Michelangelo was not interested in portraiture can scarcely survive. The firm, long diagonals of the hatching are found in other studies for the Ceiling, especially No. 86. The beautiful leadpoint studies of knees seem to have been done for the two nude youths above *Joel*.

86. *Study for the head of the Cumaean Sibyl*
1510
Black chalk, 12½×9″
TURIN, BIBLIOTECA EX-REALE, 15627 recto

This corrosive portrait of some hag from a Roman slum is inseparable in style from the foregoing drawing, No. 85, and has been condemned by most of the same scholars who accepted No. 85, but has again been recently revindicated, with great success. The differences between the Zechariah head and this one are due only to the fact that in the former case Michelangelo did not go beyond drawing the mask, whereas here the entire neck is studied and the shoulders are indicated. The "monotonous hatching" of which one scholar complains is identical in both drawings. The Zechariah head has simply suffered a bit more rubbing in the course of time. Only the rigorous control of a master hand could maintain so even a tone and spacing as this throughout a hatching set down with such speed. As in the Zechariah study, the top of the head is barely indicated. Covered by a skullcap here, it culminates in a richly articulated mass of folds in the fresco. Originally, it should be noted, the mouth and chin were in a somewhat different position, as if Michelangelo had changed his mind after first posing the model. Even if the astonishing quality of the drawing were not sufficient to rule out the hypothesis of a copy, this circumstance certainly would. When Michelangelo came to the painting of the head in the fresco, he built on the basis of the life study a powerful architecture of organic shapes, and transformed the particular—the old market woman—into the universal, the mighty symbol of the Roman Church.

87. *Studies for the Libyan Sibyl*
1511
Red chalk, 11¼×8⅜″, cut down
NEW YORK, METROPOLITAN MUSEUM, 24.197.2 recto (for verso see No. 88)

The authenticity of this noble drawing (see Frontispiece), which seems to Americans the keystone of Michelangelo's figure style, was doubted as recently as 1949 by a scholar who was, nonetheless, perceptive enough to recognize that it is by the same hand as the pariahs in Haarlem (Nos. 74–76 and 103). This can be proved stroke for stroke by an examination of the reproductions. The hand that drew them all is, of course, Michelangelo's own; the series must be accepted or rejected *en bloc*. Less comprehensible is the attempt on the part of several writers to attribute the marginal studies to pupils, while accepting the principal figure and the great left hand below it. All are by the same master. Michelangelo posed a rugged youth (apparently the same model used for Adam in No. 77) in the desired position, drew the contours, hatched the surface, crosshatched, and then rubbed, in most sections of the left arm and shoulder and the back, producing a surface polish thus far unprecedented in his drawing, but soon to be followed by several more. Even those few portions of the back which have not received their final modeling have been rubbed. The original hatching (identical with the style so widely condemned in No. 77) survives in the brief indications of hair and in the face at the lower left. This is a mask of the utmost beauty, the artist's preliminary attempt to transform the commonplace features of his model into the Hellenic loveliness of the *Libyan Sibyl*. The structure of the torso and shoulder, turned slightly farther clockwise, has been summarily analyzed in the

drawing at the left, which shows the figure in a position closer to that of the frescoed figure. At the upper right the contour of the right forearm has been studied again. (See No. 89 for the right hand.) The remainder of the sheet is taken up by detailed analyses of the fulcra of the figure, on which colossal weights are brought to bear—the left hand holding the book, the foot, two toes, and again the great toe by itself.

88. *Studies for the Libyan Sibyl; figure sketch*
1511
Black chalk; for dimensions and condition, see No. 87
NEW YORK, METROPOLITAN MUSEUM, 24.197.2
verso (for recto see No. 87)

It is difficult to make out whether this is a life study or a figure sketch—most probably the latter, on the basis of the magnificent drawing on the recto, No. 87, which the artist seems to be attempting to feminize, as he had already done with the face in the margin of No. 87. The knee seems to have been drawn from life. The little figure sketched at the upper right-hand corner defies identification.

89. *Study for a putto and for the right hand of the Libyan Sibyl; sketches for the Tomb of Julius II*
1511 and 1513
Red chalk, pen, 11¼×7⅝"
OXFORD, ASHMOLEAN MUSEUM, P. 297 recto
(for verso see No. 54)

This splendid sheet enjoys the distinction of being the only finished figure study for the Sistine Ceiling whose authenticity has never been doubted. It fits into No. 87 like a plug in a socket. The chalk drawings must have been done during the same days as No. 87. The right hand of the *Libyan Sibyl* is studied at the lower left, with all the tension of muscles and tendons resulting from the enormous load of the book. The *putto* is also a study from life, and, as usual, the back of his head is indicated only by a broken line and a patch of hatching. Never were Michelangelo's melodious contours more eloquent than in this drawing, but it is not above the level of the whole cycle of great drawings which have been so often rejected. Figure studies of just this finish and beauty must have been made for most of the *putti* accompanying the prophets and sibyls. The six Bound Captives attached to vertical elements (they look more like columns than herms) were sketched in later by Michelangelo, presumably when the second contract, of 1513, for the Tomb of Julius II was under consideration. The figure at the lower left recalls the *Dying Slave*, the next the *Rebellious Slave*. The pose of the figure second from the right was also carried out, with some modifications, in one of the *slaves* now in the Academy in Florence, for the 1532 version of the Tomb. The clearly visible helmet and body armor accompanying the second figure from the left suggest that at one time there really was a scheme to make the Captives signify the military triumphs of the Pope, like those designed by Leonardo da Vinci for the monument to the Milanese Gian Giacomo Trivulzio. The rich and fantastic cornice, with its acorn ornament below the upper molding, has been identified as the cornice of the lower story of the Tomb.

90. *Studies for the crucified Haman*
1511
Red chalk, 16×8¼", folded, corner torn, patched
LONDON, BRITISH MUSEUM, W. 13 recto
(for verso see No. 91)

This highly finished drawing—the figure as powerful as the *Rebellious Slave*—has been rejected as being a copy after the fresco, or even a copy after Michelangelo's supposedly lost drawing. The numerous small changes between drawing and fresco rule out the first suggestion, the startling freshness and immediacy and the many *pentimenti* the second; and the superb quality cancels both of these untenable notions. No copyist, however gifted, could draw with such freedom. And the very circumstances of the posed model are vividly enough shown, down to the suggestion of the breech clout and the representation of pubic hair. The figure was to be in one of the most spectacular spots in the Chapel, visible immediately from the door, and turning toward the center as a despairing counterpart to the triumphant *Jonah*. The model, forced to hold an unenviable pose, may well have writhed under the strain; possibly this accounts for some of the widely spaced *pentimenti*. The left thigh, left lower leg, and right foot all required extra study in the marginal drawings. The style, in its contours, hatching, crosshatching, and modeling, is in every respect identical to that of Nos. 91 (perhaps done from the same model) and 92. No more passionate embodiment of Michelangelo's tragic world- and self-view in human form can be seen in any of his drawings.

91. *Studies for the crucified Haman and for Ahasuerus*
1511
Red chalk, black chalk;
for dimensions and condition, see No. 90
LONDON, BRITISH MUSEUM, W. 13 verso
(for recto see No. 90)

A careful attempt to work out the problems of foreshortening posed by No. 90 in regard to the left arm, extended toward the spectator, this excellent study has suffered a similar critical fate. Michelangelo outlined the principal shapes, reinforced certain contours, but hatched only here and there. The problem is attacked again in No. 92. The roughly indicated left side of a male breast and shoulder in black chalk may be for the recumbent Ahasuerus.

92. *Studies for the crucified Haman*
1511
Red chalk, 10×7½", cut down
HAARLEM, TEYLERSMUSEUM, A 16 recto
(for verso see No. 80)

Now the artist studies the tragic expression of Haman's face, slighting the left arm which, in the fresco, hides the left side of the face entirely. This is another superb preliminary study (generally rejected, of course) for an exceptionally difficult and revolutionary figure. The left hand is carefully worked out at the upper left, in one of Michelangelo's most brilliant hand studies—almost hallucinatory in its sense of projection. The foreshortened right arm is developed in every throbbing muscle with equal intensity, but still not so sharply foreshortened as in the fresco. At the extreme lower left the fingers of the right hand are quickly contoured, and the center of the sheet, surprisingly, is occupied by a beautiful analysis of the ear.

93. *Sketch for the Nudes*
1508(?)
Black chalk, 11×8½″, badly rubbed
LONDON, BRITISH MUSEUM, W. 9

Never doubted, this drawing, with those which follow, admits us into the private world of Michelanglo's creative imagination. A primitive, potentially human substance— anthroplasm, if you will—pulsates through these astonishing sheets. One watches in amazement as the same figure sprouts numerous pairs of arms and legs in several directions at once. It rests, leaps, props itself on a cube, supports its head dreamily on one fist, points into space in great excitement, drops an idle hand over one knee, all at the same time. The multiple possibilities of these figures, the envy of any Shiva statue, show Michelangelo's method of experimenting with all sorts of attitudes for the seated nudes. These beautiful youths, whose poses represent for us today paradigms of finality, and have often been shown to be derived in many respects from classical works known to Michelangelo, did not spring into being complete. The soft chalk moved around on the paper, probably at lightning speed, and the same emerging figure with its many arms and legs must have served as the source for several of the final poses. Probably all the poses were sketched out quite early as the Ceiling took form in Michelangelo's mind, but those executed later did not crystallize until shortly before they were painted.

94. *Sketch for the Nude at left above Daniel*
1508(?)
Black chalk, 11¾×8⅜″, cut down and spotted
FLORENCE, CASA BUONARROTI, 33 F

Very similar in style to No. 93, and almost unanimously accepted as authentic, this vivid sketch must have been drawn at about the same time. The legs of the nude as painted are here already in final position. The left arm was tried out moving forward, then returned over the head as at present. It had apparently not yet occurred to the artist to twist the right arm behind the back, as in the finished figure, itself a prototype (in reverse) for the pose of the *Rebellious Slave*. The soft, broad lines and hastily scribbled hatching are typical of the series. Another nude (or Sibyl?) is lightly sketched below.

95. *Sketch for the Nude at right above the Libyan Sibyl*
1508(?)
Black chalk, 7½×4⅜″, rubbed, cut down, spotted
FLORENCE, UFFIZI, 18736 F

Accepted by all but one scholar, this sketch has been connected recently with the figure of *Tityus* in No. 353, to which the pose certainly corresponds in some degree. But this is one of Michelangelo's commonest poses, related to the *Adam*, one of the Resurrection drawings, and a number of other figures. The style seems closer to the tempestuous series for the Sistine nudes, and the legs are almost identical, in reverse, to those of the yearning figure at right above the *Libyan Sibyl*. At the right the lifted arm is lightly redrawn, in the same position as in the finished nude. Michelangelo was to study this pose more exactly in No. 99. Even the retracted arm, bent into the side, seems to be an early idea for the nude as painted. Probably this drawing went back into the body bank, to be resurrected when Michelangelo was working on the *Tityus*.

96. *Sketches for the Nudes*
1508(?)
Leadpoint and pen, 7⅜×9⅝″
LONDON, BRITISH MUSEUM, W. 8 verso
(for recto see No. 100)

This group of sketches has been almost universally accepted as a more definitive phase in the evolution of some of the poses in Michelangelo's mind. The published suggestion that the three pen drawings were copied from the paintings, presumably by a pupil, is untenable, for the elementary reason that none of them corresponds exactly to any of the frescoed nudes, and the figure at the upper right does not appear on the Ceiling at all. All four were drawn lightly in leadpoint, in a less excited moment in Michelangelo's creativity, then reinforced in pen. The ink used for the figure at the left was much lighter and yellower than the dark brown ink in which the other three were drawn, which may indicate a difference in the time of execution. The pose of this figure has been derived from a kneeling *Aphrodite Bathing*, now in the Terme Museum in Rome. But the pose of the arm should be compared also to that of one of the figures at the left of the *Battle of Cascina*, carefully studied in No. 40. Eventually it seems to have occurred to Michelangelo to fuse the upper part of the figure in the present drawing, including the wonderful pose and expression of the head, with the body developed in No. 95, to produce, in reverse, the pose of the youth at right above the *Libyan Sibyl*. The two lower figures on the sheet are variants for the symmetrical pair of youths at left and right above *Joel*. It is noteworthy that, even in this phase, Michelangelo was concerned with the depiction of the bands the nude youths support. The rapid, powerful pen line is characteristic of the master's quasi-definitive pen sketches.

97. *Sketch for the Nude at right above Isaiah*
1508
Black chalk, 4⅜×2½″
FLORENCE, CASA BUONARROTI, 49 F

A rapid sketch with soft, blunt chalk; the upper half of the body is identical with the pose of the figure as actually painted, but Michelangelo was still experimenting with the legs.

98. *Sketches for the Nudes; a cornice*
1508
Black chalk and pen, 16¼×10⅝″, lightly spotted
FLORENCE, CASA BUONARROTI, 75 F

Eight little sketches for the seated nudes and a profile of a cornice fill this sheet, accepted by all but two scholars. At the left appear the amorphous masses of chalk with Shiva limbs that we have seen in Nos. 93 and 95, in this case sufficiently concrete to make possible their identification as the nude at left above *Ezekiel*. The other four principal sketches on the lower half of the sheet are for the nude at right above *Isaiah*, which had already appeared in No. 97. Of these, the version in the center, an experiment in mirror image, has been gone over in ink, apparently by a later hand. At the bottom the figure appears almost exactly as in the fresco, and with even more verve. Between the inked-in central youth and the group at the left can be made out an early try for the larger figure at the top of the sheet, the soft, plump youth at left above the *Cumaean Sibyl*. He, too, has

been partly inked in, very possibly by Michelangelo's own hand; the style is not unlike that of several other authentic drawings. At the extreme left and right are faint traces of sketches for the heavily laden tragic figure at right above *Jeremiah*.

99. *Sketches for two Nudes*
1508
Silverpoint and red chalk, 13¾×10″
FLORENCE, UFFIZI, 18722 F verso (for recto see No. 73)

Recto and verso are accepted by all but two critics. The leg in red chalk was done for the symmetrical pair of youths above *Joel* whose poses were developed in No. 95, the lifted arm with its beautiful flow of line for the youth at right above *Isaiah*, sketched in Nos. 96 and 97. Both the present studies are sufficiently precise anatomically to have required models.

100. *Study for the Nude at right above the Delphic Sibyl*
1508
Black chalk, 9⅝×7⅜″
LONDON, BRITISH MUSEUM, W. 8 recto
(for verso see No. 96)

A powerful, unanimously accepted study from life, this drawing has been dated at all sorts of times up to and including the period of the *Last Judgment*. The identification with the nude at right above the *Delphic Sibyl*, probably the earliest of the seated nudes, is no longer open to question. In the cartoon, Michelangelo moved the torso a bit to the left and raised the head, but made no other changes. As he proceeded with the nude studies, he became fascinated with the pictorial problems presented by luminous adolescent flesh, and renounced the rough style of this drawing, with its harsh passages of ground-in chalk almost obscuring the preliminary hatching.

101. *Study for the Nudes above Isaiah*
1508
Silverpoint, 16½×10½″
FLORENCE, UFFIZI, 18720 F recto (for verso see No. 102)

The lower halves of the bodies of the two lively nudes above *Isaiah* were done from the same cartoon reversed, as Michelangelo did with the entire bodies of both pairs of nudes in the first bay. Thereafter he gave up this (by now) antiquated practice. The pose, whose evolution we have been able to follow in unusually rich detail in Nos. 97 and 98, is now enriched by actual observation. Silverpoint alone, apparently, seemed able to convey the silkiness of the youthful skin and the yielding of soft muscles, and these are represented with exquisite delicacy. While the pose of the terrified youth to the right had already been worked out, Michelangelo is experimenting here with the arms and head of his lighthearted companion (whose face is studied from a model in No. 106). To our immense relief, no one has been able to attack the authenticity of this drawing, although one eminent scholar has managed to ignore both this and No. 102 entirely.

102. *Studies for the Nude at left above Isaiah*
1508
For medium and dimensions, see No. 101
FLORENCE, UFFIZI, 18720 F verso (for recto see No. 101)

The legs of the happy youth are barely touched in, in a drawing unusually transparent for Michelangelo. But he did delight in luminous effects, and exploited them in his marble surfaces and many of his drawings. Here he seems interested in little else. Upside down, the left foot of the frightened companion appears, and some faint lines at upper left tracing the position of his legs.

103. *Study for the Nude at right above the Persian Sibyl*
1511
Red chalk over black chalk preparations, 11×8⅜″, cut down
HAARLEM, TEYLERSMUSEUM, A 27 recto
(for verso see No. 74)

This superb drawing, one of the greatest of Michelangelo's nudes and one of the few to be ranked with the Metropolitan study for the *Libyan Sibyl* (No. 87), has suffered the critical fate of most of the Haarlem drawings, but luckily, has been recently revindicated. It has not, however, escaped retouching, if only with some form of eraser. The *pentimenti* so visible on the upper surface of the calf have been removed elsewhere on the leg, with the result that the front contour seems inert as compared with the vibrant outlines elsewhere throughout the figure. In general, however, the modeled surface is intact. In the drawings for the nudes in the penultimate bay of the Ceiling (three finished figure studies, two heads, and a foot are preserved—Nos. 79 and 103-7), Michelangelo had perfected his chalk manner, combining the vehemence of the initial sketches (Nos. 93-95 and 97) with the finesse of the silverpoint studies (Nos. 101 and 102). These must all have been carried out in the same intensive draftsmanly campaign that produced the great nude drawings for the *Creation of Adam* and the *Libyan Sibyl*. All are in red chalk, highly finished by rubbing almost, but not quite, throughout, with the plastic magnificence and shimmering surface polish of Michelangelo's sculpture at its finest. In this one, there was no longer room on the paper for the bent right arm, so Michelangelo studied it separately over at the right. Even this strange amputation cannot impede the heroic drive and power of the glorious figure, throbbing with a strange fury. The back will, of course, be exploited in the *Day* of the Medici Chapel, of which this figure is the direct ancestor in Michelangelo's development. It is interesting that the roughly sketched head (only shaded here and there, with the same low diagonal hatching of the left arm) did not please the artist. Possibly the model's features were too coarse. At any rate, he found a better subject in No. 106. The shape of the drapery mass must have seemed too skimpy, for in the fresco it was replaced by a huge bundle.

104. *Study for the Nude at right above Daniel*
1511
Red chalk over black chalk preparations, 13¼×9⅜″, folded, patched, cut down
CLEVELAND MUSEUM OF ART, 40.465 recto
(for verso see No. 79)

This superb drawing seems to have been published in only four places, and twice rejected. It is certainly genuine, although extensively retouched in chalk of a somewhat

bluer red than the original. The retouchings, a meticulous stippling, here and there run throughout the figure. The head and right arm show little or no reworking. The contour of the back has been touched by an eraser, and spoiled. In spite of this reworking, which seems much later than the sixteenth century, the drawing has not lost its freshness or its power. It is for the exultant, bronzed boy above *Daniel*, fairly dancing on his pedestal. The old woman's head at the top, upside down, has not been identified.

105. *Study for the Nude at left above the Persian Sibyl*
1511
Red chalk, heightened with white, 10⅝×7½″
VIENNA, ALBERTINA, S. R. 155 recto
(for verso see No. 72)

Another glorious drawing, widely rejected—one of the most perfect and carefully finished of all Michelangelo's nude drawings, a foretaste of the presentation drawings of the early 1530s. The head and feet remain unfinished and the hands are separately studied at the lower left.

106. *Study for the head of the Nude at left above Isaiah*
1508
Black chalk, heightened with white, 12×8¼″, spotted
PARIS, LOUVRE, 860 recto

This entrancing study of a laughing boy has been accepted by almost all recent critics, although ignored completely by one. There is no fresher witness to Michelangelo's delight in the youth and energy of his models than this impish portrait, simplified and idealized in the fresco, as a jubilant foil to the terrified youth on the right, but here apparently ready to play some particularly irresponsible prank. The broad, free, sometimes scratchy hatching and crosshatching recall the technique of the latest chalk drawings for the *Battle of Cascina*.

107. *Study for the head of the Nude at left above the Persian Sibyl*
1511
Red chalk, 14⅛×7⅝″, cut down, varnished
LONDON, BRITISH MUSEUM, W. 11 verso
(for recto see No. 77)

This very fresh and gentle study of a boy's head was utilized for the solemn youth with a veil blowing from his head, whose figure was so beautifully studied in No. 105. Both are strongly simplified, but the drawing is somewhat richer in handling than the finished painting. Many scholars have rejected this study; it would make just as much sense to reject the painting.

108. *Studies of legs*
1508
Black chalk and leadpoint, 17⅛×9½″, rubbed
FLORENCE, UFFIZI, 18718 F verso (for recto see No. 85)

These studies, all apparently from life, have been connected with specific nudes. This reasoning is not easy to follow considering the close resemblance between so many of the leg poses.

109. *Michelangelo painting the Sistine Ceiling*
1511 (?)
Pen, 11⅛×7⅛″
FLORENCE, ARCHIVIO BUONARROTI, XIII, fol. 111

This brilliant little caricature is intended as a vivid demonstration of the sonnet in whose margin it appears, describing in sarcastic phrases the painful procedure of painting the Sistine Ceiling standing up on the scaffold (not lying down, as is so often believed). According to both Condivi and Vasari the consequent bodily distortion was so great that for several months Michelangelo was unable to read or to look at drawings unless he held them over his head. The forceful hooks of pen that described the artist's figure and the delightful monster he is painting (a prophet?) are characteristic of his tiny thumbnail sketches for some time thereafter. The weariness expressed in the sonnet seems to indicate that Michelangelo had been painting the Ceiling for some time. It would seem reasonable to date the sketch toward the end of the final campaign of the Ceiling proper, in 1511.

110–23. *Sketches for the lunettes of the Sistine Chapel*
1511
Pen, some in black chalk, 5½×5⅝″
OXFORD, ASHMOLEAN MUSEUM, P. 299–306

Eight small sheets, probably deriving from a single large piece of paper folded three times to make an octavo signature, once formed a sketchbook, apparently in Michelangelo's possession since his writing is to be found on some of the pages. The sheets are drawn on both sides. All but one of the resultant sixteen pages relate to the Sistine Chapel, but not all the sketches are by Michelangelo's hand. P. 301 recto is almost entirely filled with repeated sketches of the *Separation of Light from Darkness* and of the figure of Bathsheba from the *David-Solomon* lunette, all substantially as these figures appear in the frescoes, and all quite weak and flabby. (Although this sheet contains two sketches by Michelangelo, these are too faint for reproduction.) Some sketches by the same pupil appear on other sheets of the series. The pupil is apparently Silvio Falconi, from Magliano, who wrote his name twice on P. 301 recto. Although the group has been rejected in its entirety by some scholars, and almost so by others, the majority of the drawings make sense only as Michelangelo's original sketches. Many are inseparable in style from the little caricature of the artist painting the Sistine Ceiling, No. 109. They are fresh, sometimes lively, sometimes intensely despondent, and differ essentially from the figures as finally painted.

The greatest concentration of sketches relates to the destroyed lunettes that were formerly above the altar, and to those in the immediately adjacent bays. There is only one sketch apiece for the *Manasses-Amon*, *Abiud-Eliakim*, and *Azor-Sadoc* lunettes, and none at all for *Joatham-Achaz*, *Jechonias-Salathiel*, *Achim-Eliud*, *Matthan-Eleazar*, and *Jacob-Joseph*, the last two of which are over the entrance. This distribution suggests that Michelangelo's greatest interest lay in the provocative and well-known figures of the first generations of the Ancestors of Christ, and that it ran thin as he got on with the series. This is just what one would suppose from the style of the lunettes, the last of which are lower in quality than any other preserved paintings by Michelangelo. Unless otherwise indicated, the sketches are in pen. The sequence adopted is, roughly, that of the lunettes proceeding left and right from the altar wall. The original sequence of the leaves cannot be reconstructed.

110. P. 302 verso

Upper left: probable early sketch for Bathsheba. Center: probably an early sketch for the destroyed Jacob. Lower center: a sketch for Boaz.

111. P. 306 verso

Left: black chalk sketch, probably for the torso and legs of Jacob. Right: chalk sketch, probably for Aram.

112. P. 306 recto

A powerful and supple black chalk sketch, probably from life, for Jacob in the now-destroyed *Abraham-Isaac-Jacob-Judah* lunette; the figure is nude, although it was eventually to be clothed, and he is writing, although Jacob was painted reading.

113. P. 303 verso

Upper left: unidentifiable, but related both to Aminadab and to Aram in the destroyed *Phares-Esron-Aram* lunette. Upper right: a gamboling nude related to the figure at left above *Jeremiah*, which must at that time have been completed. Lower center: the sleeping Phares, from the *Phares-Esron-Aram* lunette, in reverse. Lower right and lower left: early ideas for the wife of Naason, looking into her mirror.

114. P. 301 verso

Black chalk sketch for Phares. Nudes in ink, probably by Falconi.

115. P. 305 recto

Powerful black chalk sketch, probably from an aging nude model, for Phares. Three pen sketches after the *Separation of Light from Darkness*, probably by Falconi.

116. P. 305 verso

Softly suggested, heavily hatched black chalk sketch for Naason's wife looking into her mirror, draped, substantially as painted, but provided with attendant figures later that were eliminated.

117. P. 299 verso

Three sketches of a man reading a book may be early ideas for Naason himself, shown reading from the side in the fresco. The other figures are not identifiable, but the two coarse chalk sketches seem to be by Falconi.

118. P. 304 verso

Upper left: a lightly sketched woman with a child for the *Manasses-Amon* lunette. Lower left: the same reading figure as in No. 117, possibly for Naason. The other sketches are unidentifiable.

119. P. 300 recto

Lower left: sketch for Aminadab, with attendant figure, later eliminated. Lower right: sketch for Boaz, substantially as painted. The remainder of the leaf is filled with quick studies for the hands of Boaz, possibly from a model.

120. P. 303 recto

Eight sketches, of which only three are even tentatively identifiable. Center: a woman nursing her child, possibly an early idea for Ruth in the *Boaz-Obed* lunette. Michelangelo's comment "dagli bere" (give him to drink) recalls his ambivalent concern with the activity of nursing. Center right: an old man with a hat slung on his shoulders, possibly an early idea, in reverse, for Boaz. Lower center: an early idea for the spinning Bathsheba, in reverse.

121. P. 299 recto

In Michelangelo's writing, "the fifteenth day of September," possibly the date when he began composing the lunettes. Upper left: the sleeping Abiah from the *Roboam-Abiah* lunette. Left center: a possible early idea for Josaphat in the *Josaphat-Joram* lunette. Lower right: a male figure with his chin and hands on one knee, possibly for Sadoc in the *Azor-Sadoc* lunette. Lower left: a faint sketch possibly for Azor and his mother in the same fresco.

122. P. 300 verso

Two powerful and thoroughly characteristic pen sketches for the sleeping Abiah. Upper right: probably an early idea for Abiud in the *Abiud-Eliakim* lunette. Lower right: early idea for Joram and his mother in the *Josaphat-Joram* lunette.

123. P. 302 recto

Quick, large sketches for the torso and arm of Abiah and the legs of Boaz. Upside down: tiny sketch for Josaphat.

124. *Three studies for the right arm and shoulder of Boaz (portion of sheet)*
1511
Black chalk, 9½×13⅝" (whole), cut down
WINDSOR, ROYAL LIBRARY, 12767 verso
(for recto see No. 256)

Hitherto unrecognized, these strong studies can be connected only with the aged Boaz, Michelangelo's fierce caricature of Julius II.

125. *The Resurrection*
1512(?)
Black chalk, 14¾×8¾", cut down
WINDSOR, ROYAL LIBRARY, 12768

So great is the beauty of this incomparable drawing, which has represented to most scholars the sum of Michelangelo's achievements in the understanding of the anatomical possibilities—and spiritual significance—of the human body, that it is hard to understand how it was ever rejected. One of the two critics who once did so has recently welcomed the

drawing back, but with reservations about the hatching of the cloak and sarcophagus. The drawing has been slightly retouched, it is true, but not in the lovely, airy mantle. The left contour of the torso, from armpit to flank, has had its *pentimenti* erased, as in the leg in No. 103, with a similar effect of dryness. No other faults are evident.

Several *pentimenti*, major and minor, are still visible. The right leg was originally more sharply bent, so that the foot went considerably higher. The artist seems to have toyed with and rejected an outline for the thigh which would have made it considerably heavier and less graceful. At least two discarded positions for the right hand and arm can still be seen. By straightening the arm, Michelangelo strengthened the vertical movement of the entire figure. The left hand was also moved around, but not so extensively. The drawing was originally hatched, crosshatched, contoured, and modeled in the familiar manner. Then the artist resorted to a new technical device, for the first time among his preserved drawings, if the date suggested here is realistic. He stippled the surface with tiny strokes of a needle-sharp piece of hard black chalk, producing an effect of unheard-of transparency and delicacy—a soft shimmer as of crystal shining through gauze. Under this exquisite surface, the heroic body pulsates with alternate muscular tensions and releases, in an immense, symphonic sequence not surpassed in majesty and power in Michelangelo's entire career.

The spectacular novelty of the pose and the extreme refinement of the finish suggest a destination and patron of the highest importance. Neither has as yet been identified, largely through misconception regarding the date of the drawing, generally placed in the 1520s or even 1530s (the latter on account of a superficial technical resemblance to the drawings made for Tommaso Cavalieri, Nos. 353 and 358). The freshness and resiliency of the youthful flesh in this drawing, never again repeated in Michelangelo's art—increasingly concerned, as he himself grew older, with the mature body—connect the style with the Sistine Ceiling. The floating mantle is that of the Creator in the four latest scenes. The head, seen from below, suggests that of the Lord in the *Separation of Light from Darkness* and of *Jonah*, twisting on his throne above the altar. The figure, in con-

sequence, could be read easily together with these two, and, since Jonah is the prophet of the Resurrection, would complete their meaning.

A new hypothesis is here advanced. After his unexpected triumph over the French in June, 1512, Julius II seems to have contemplated an altarpiece, celebrating the miraculous deliverance of the Church (the mystical body of Christ) in the appropriate form of a painting of the Resurrection. Several drawings for such an altarpiece by Raphael are known. The idea of an altarpiece was then abandoned, and many of the motives invented by Raphael for the Resurrection were utilized in his fresco of the *Delivery of Peter from Prison*, in the Stanza d'Eliodoro, which allegorizes the papal victory in great detail in the wall and ceiling frescoes. Could the original altarpiece have been intended for the Sistine Chapel? Was Michelangelo's drawing submitted in competition with Raphael? However splendid the idea of a completely nude risen Christ might have seemed to Michelangelo for such a position, it must have shocked the papal court as much as it startles us today, with substantially the same results as in the case of the nudes in the *Last Judgment*, later painted for that very wall. It may have seemed necessary to the Pope to give up the idea of an altarpiece entirely, in favor of the wall paintings of another Stanza, in order to placate his two favorite painters. In any case, Michelangelo's disappointment at a monumental papal slight is expressed in a famous sonnet, and his rage at Raphael continued for a generation after the latter's death. Furthermore, a *Resurrection* by Michelangelo for the end wall of the Sistine Chapel was well on its way to becoming an accomplished fact in 1532, and the wall was actually prepared for it. Possibly Michelangelo had talked Clement VII into commissioning the very subject renounced by Julius II.

Whether or not the hypothesis here presented is eventually accepted, the stylistic and spiritual connections with the Sistine Ceiling are undeniable. And what a High Renaissance altarpiece it would have made—the Incarnate Word rising from the altar-tomb, triumphant over death, His divinity once more united with that glorious body of which St. Paul speaks, and ascending toward the Father, who broods over the primal deep!

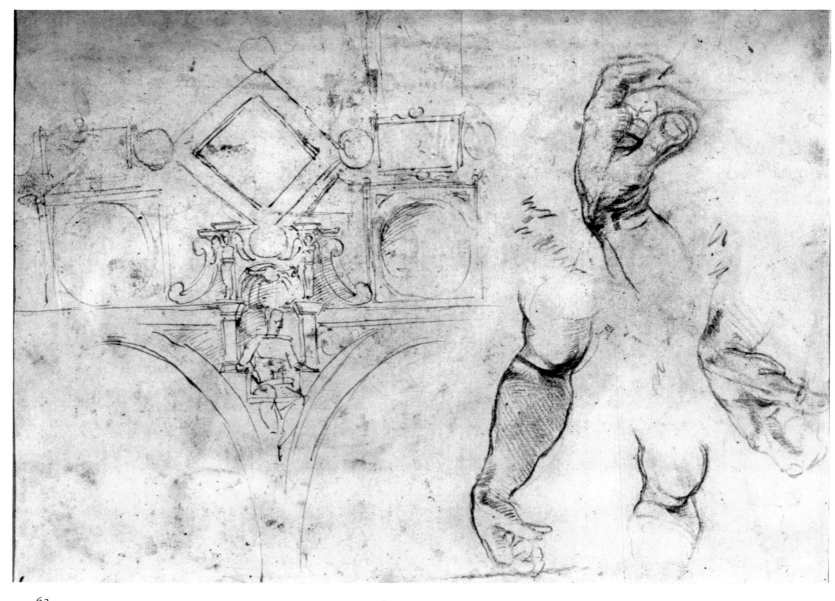

62

63

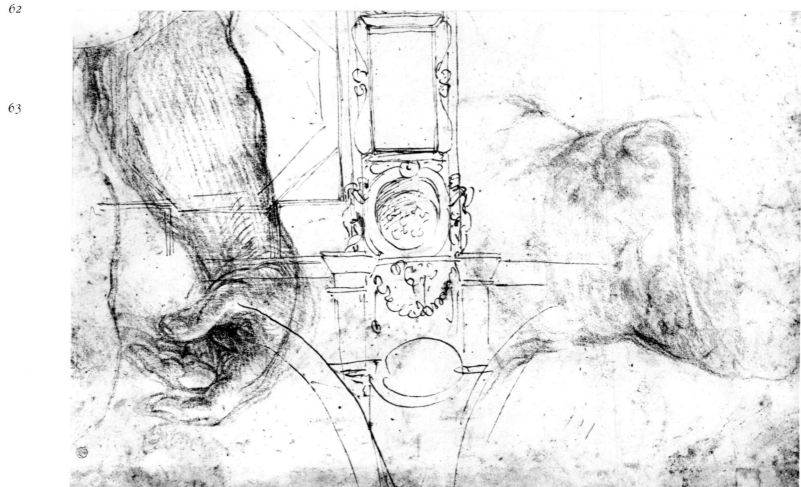

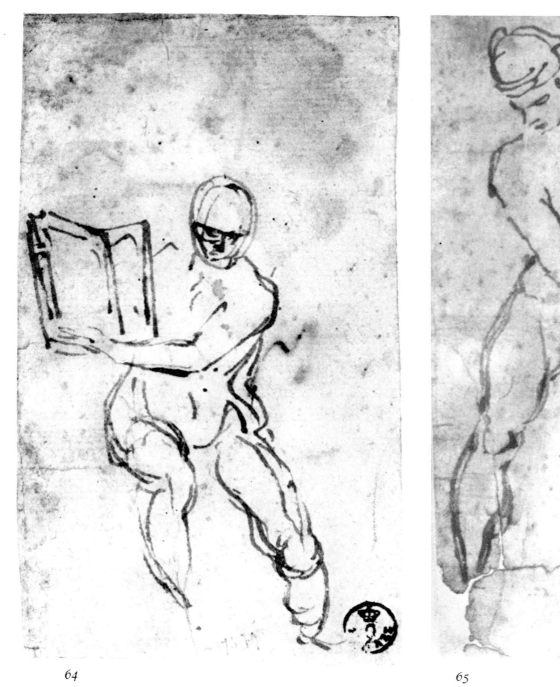

64

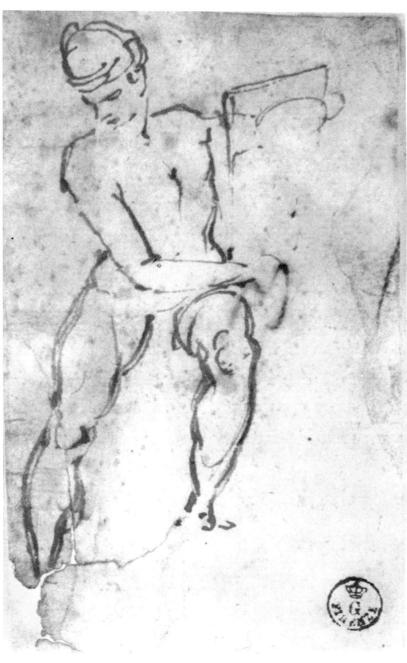

65

66

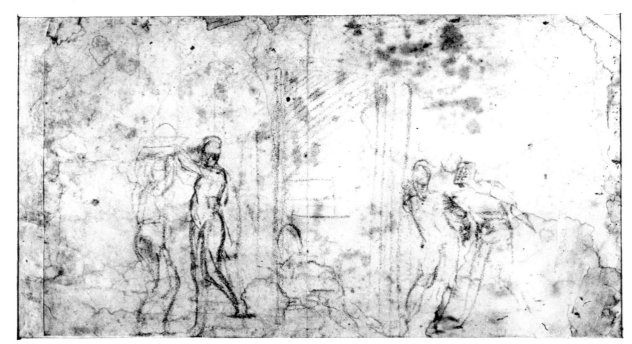

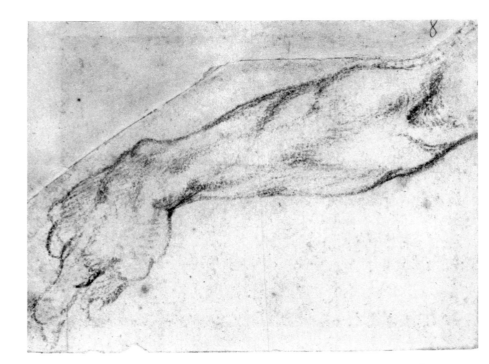

67

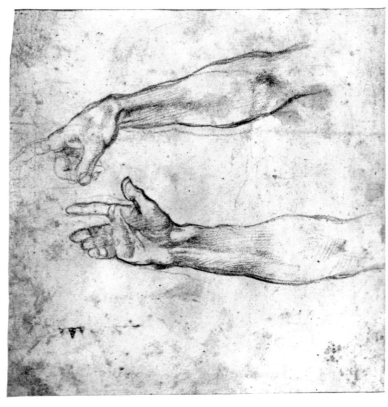

68

69

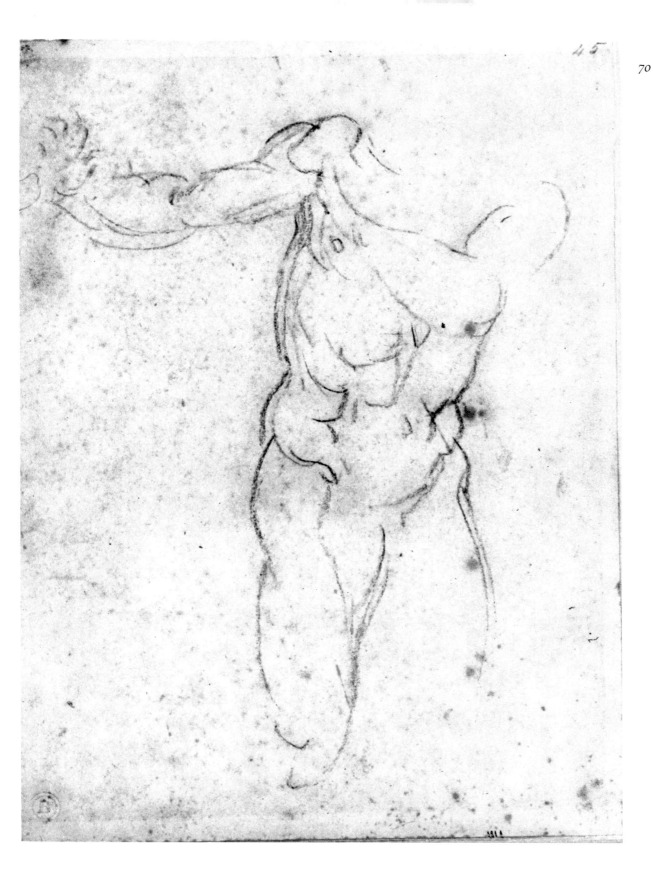

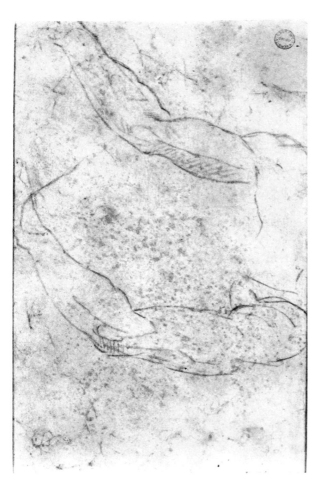

71

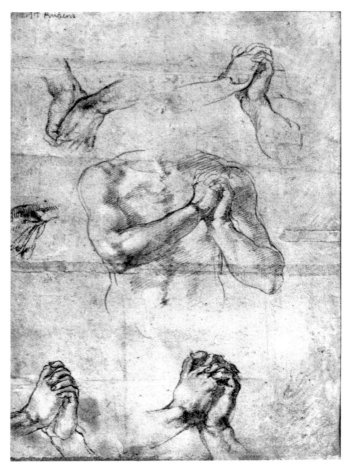

72

73

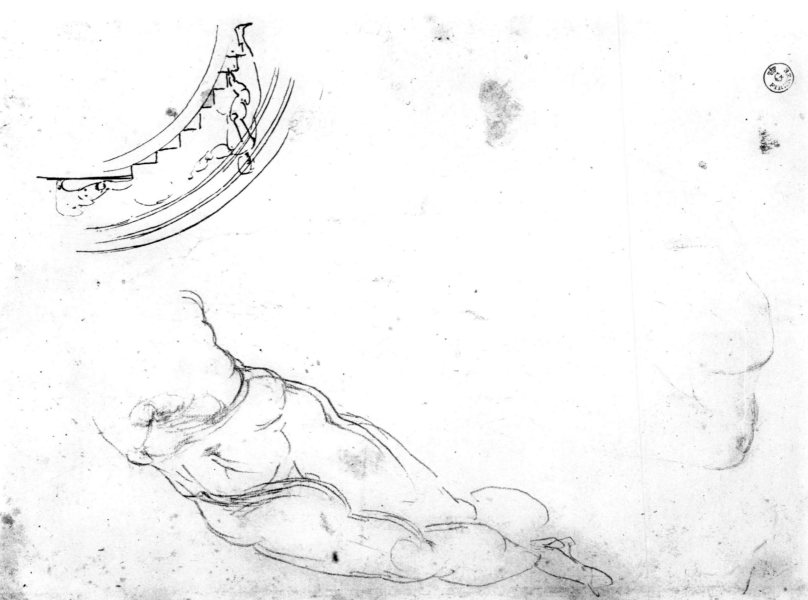

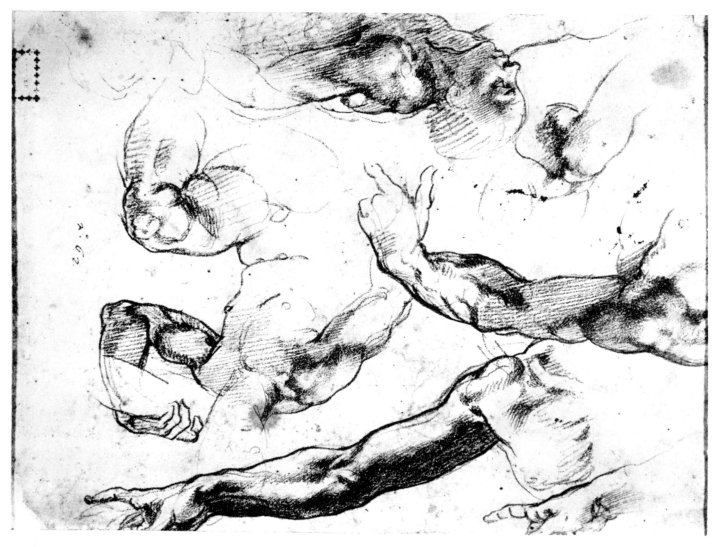

74

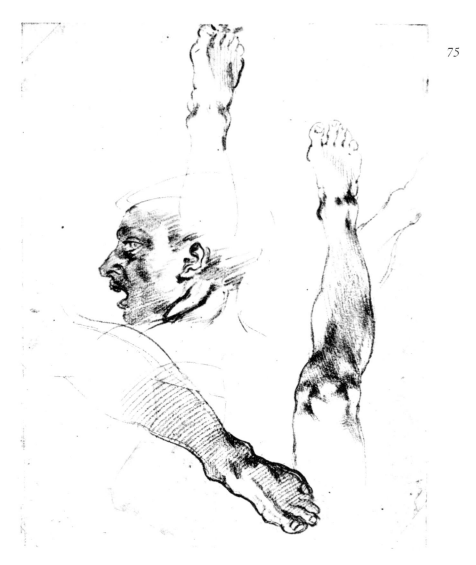

75

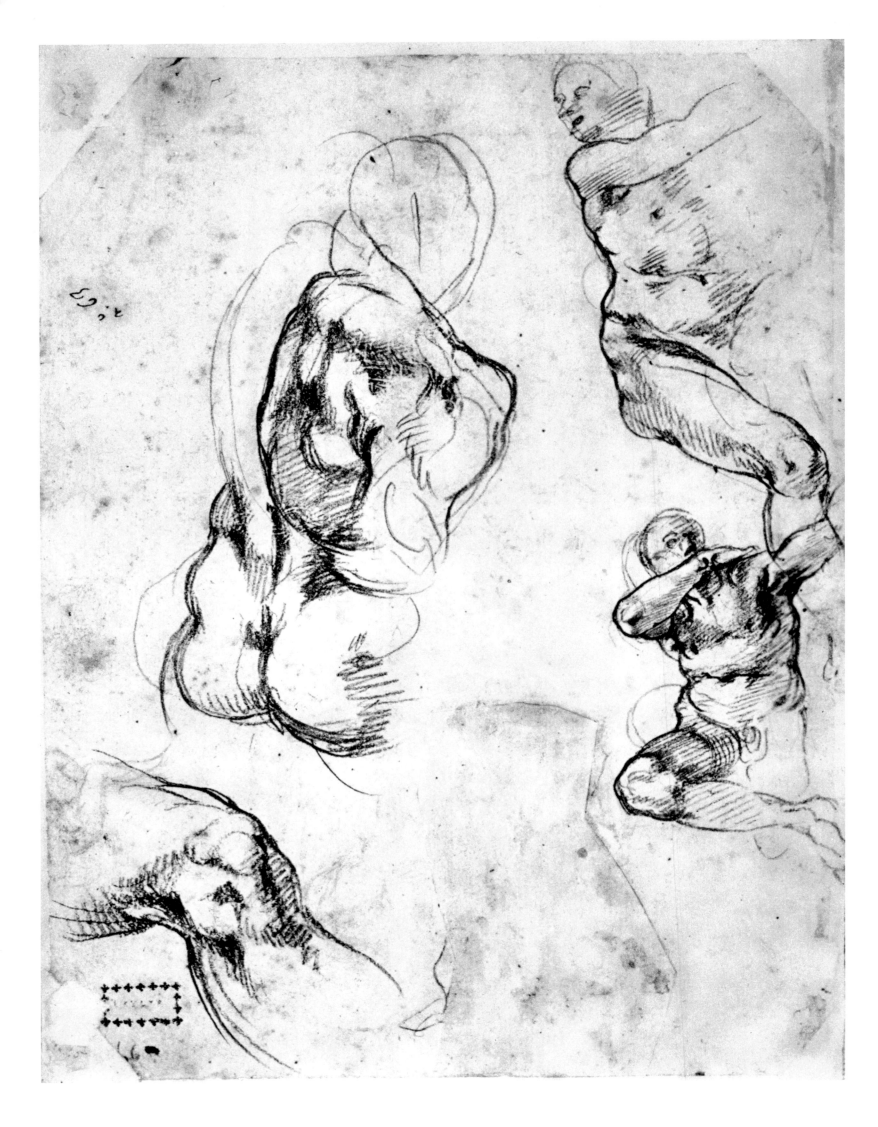

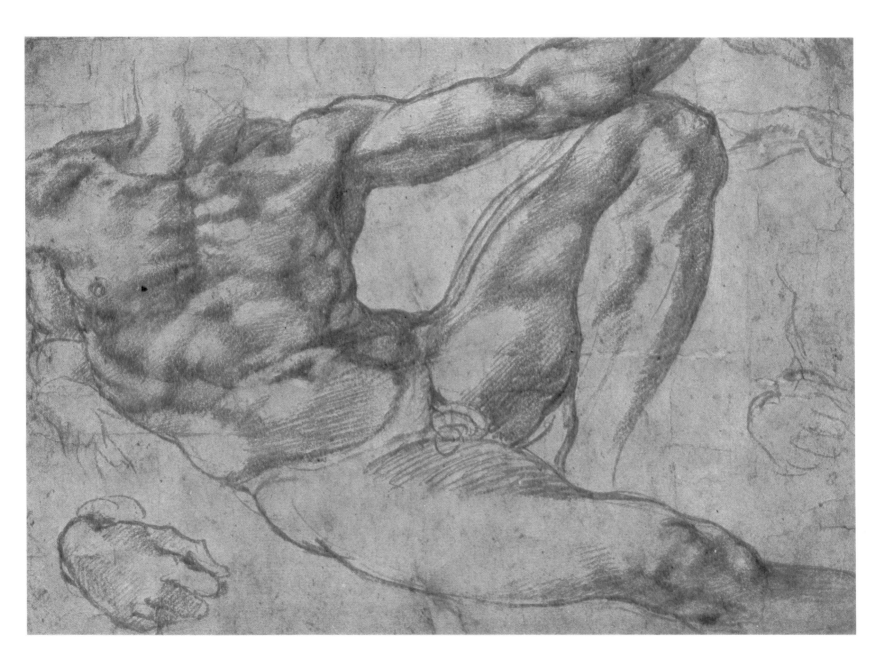

77

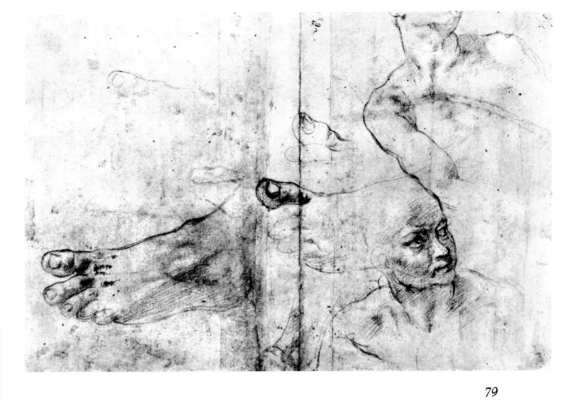

79

78

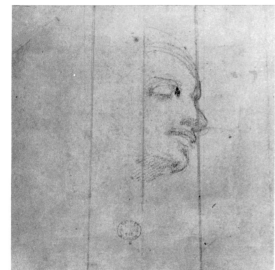

80

81

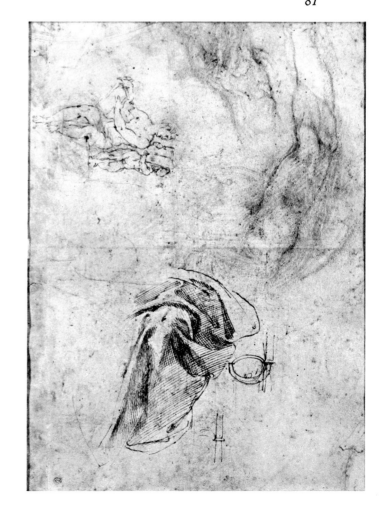

82

83

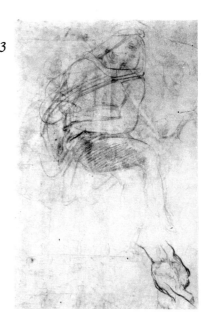

84

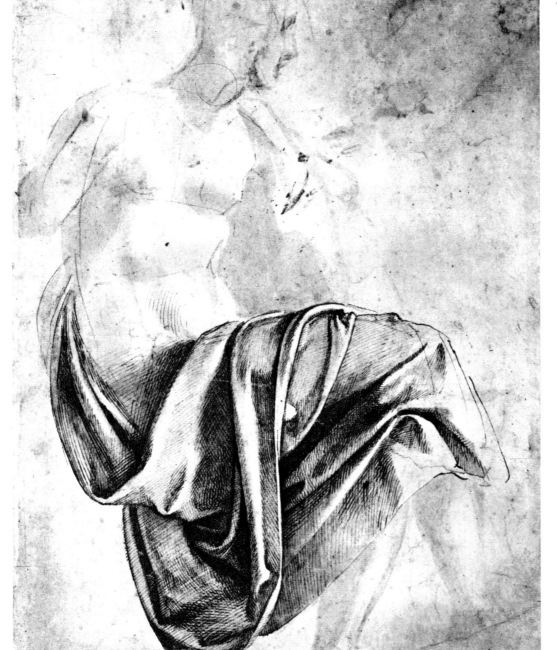

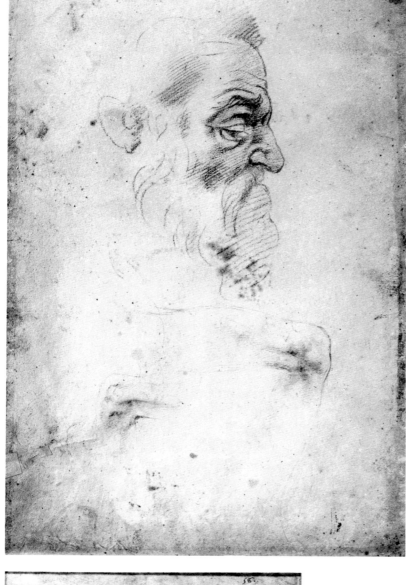

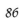

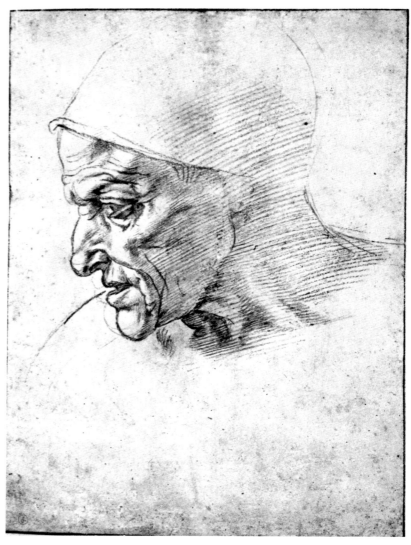

88

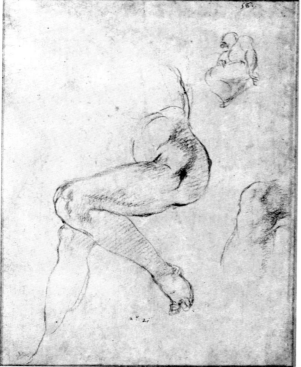

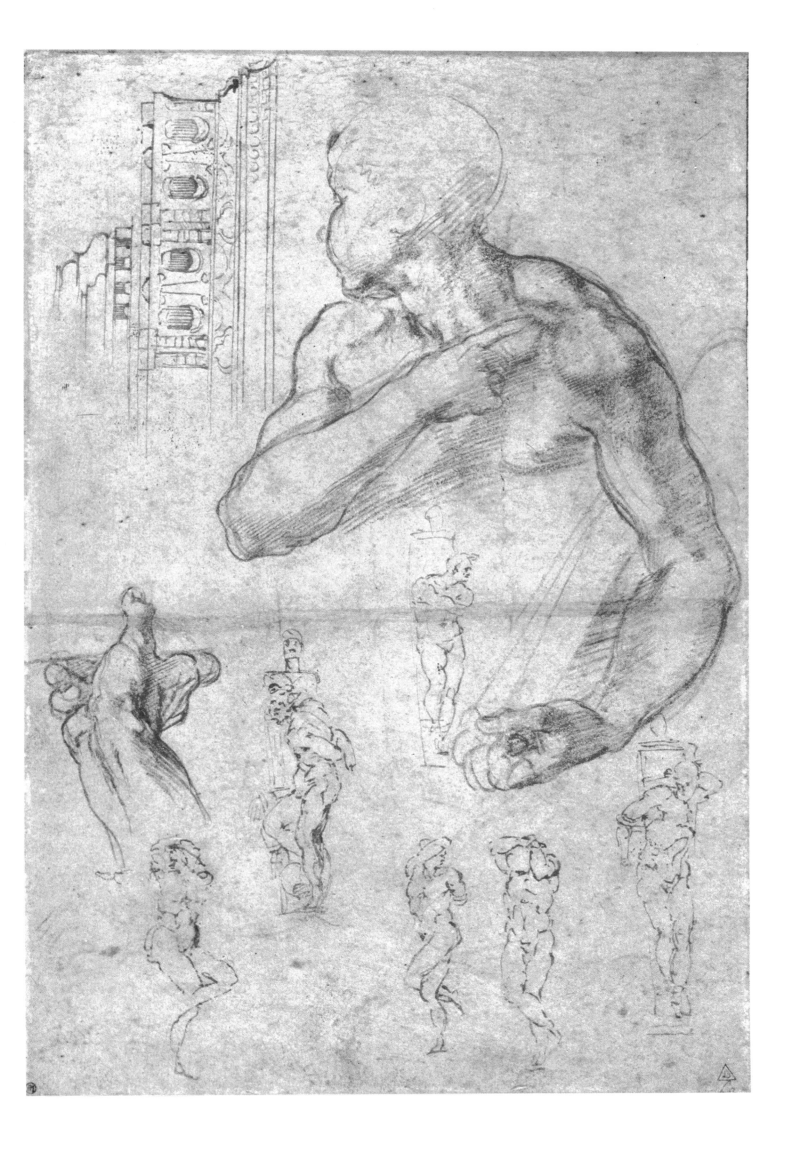

101

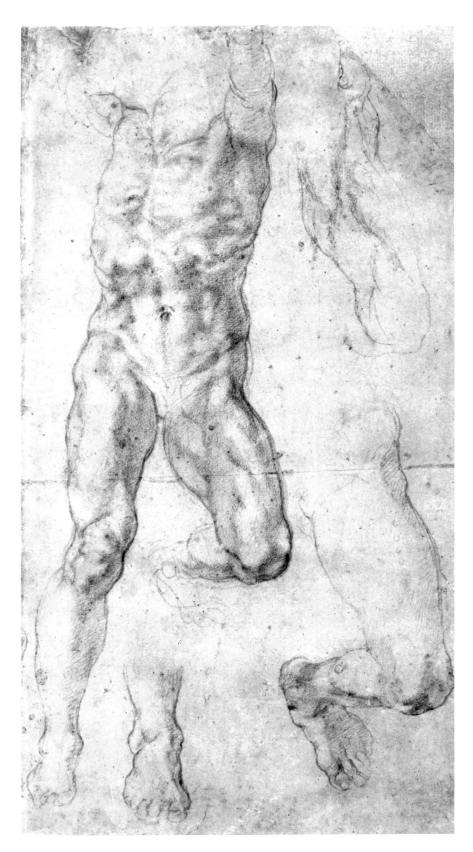

90

91

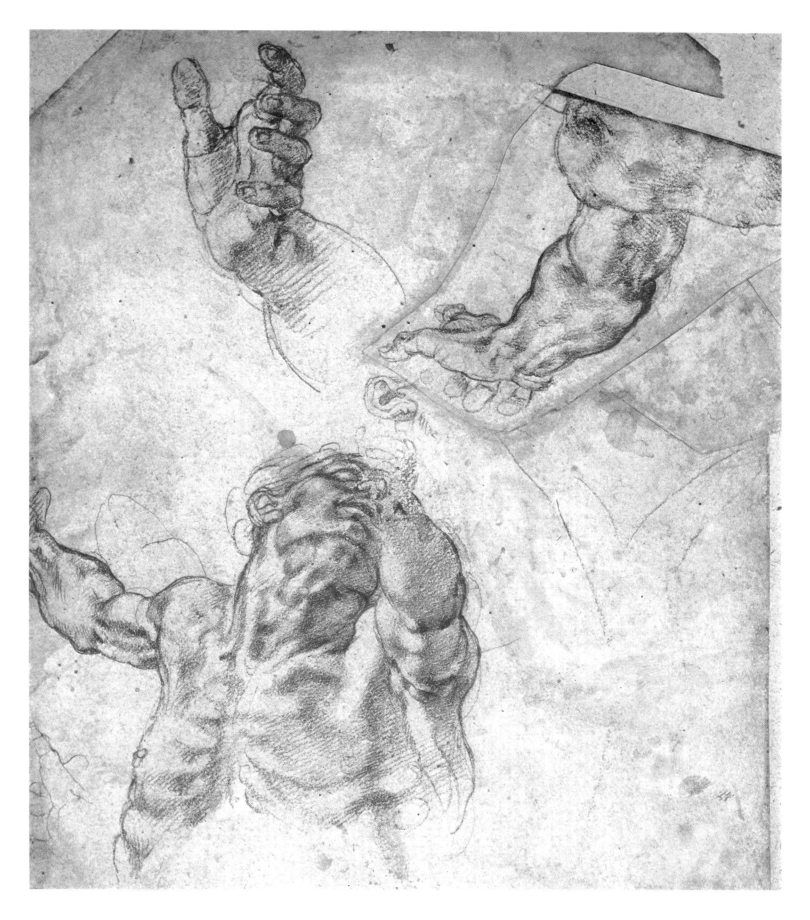

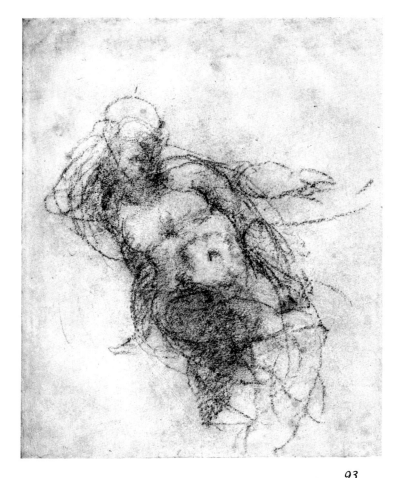

93

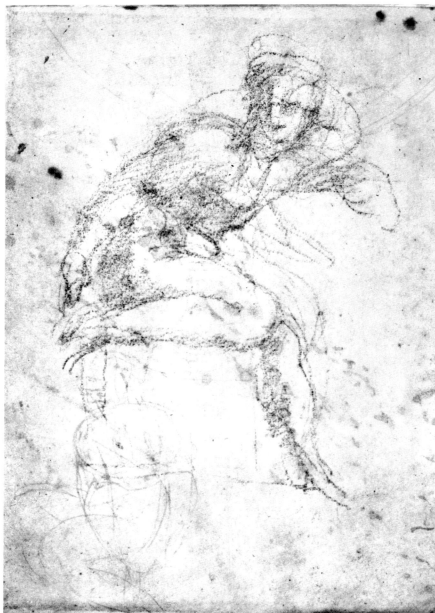

94

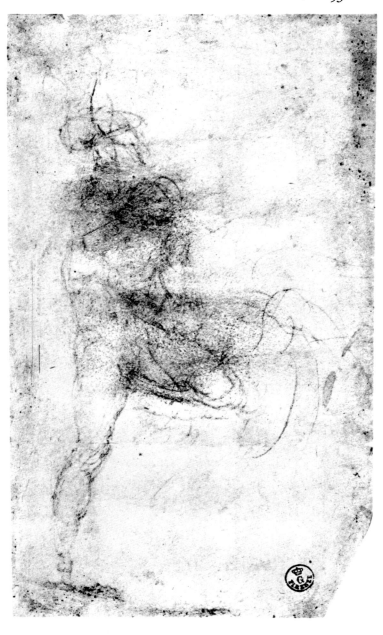

95

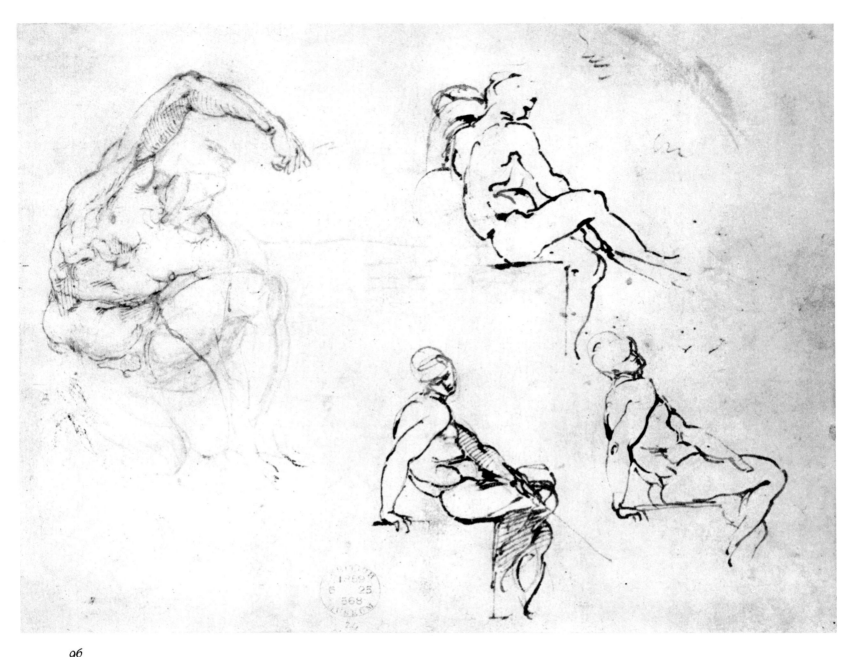

96

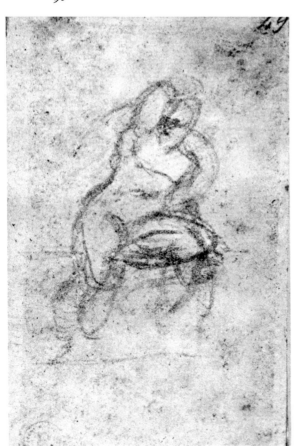

97

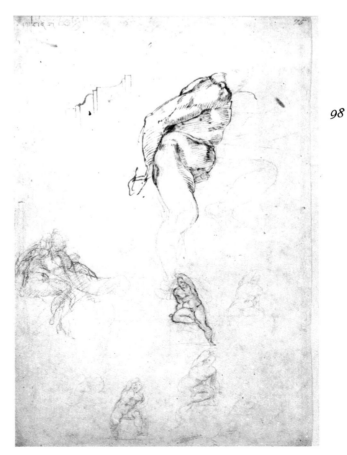

98

99

101

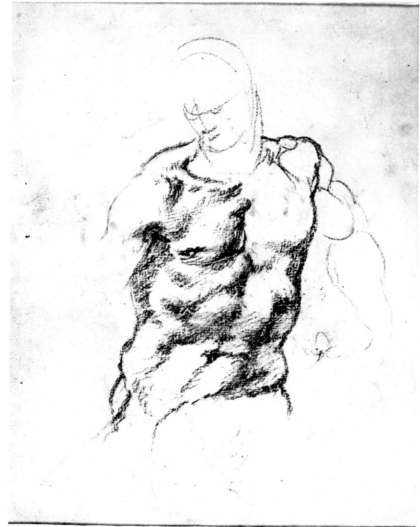

100

102

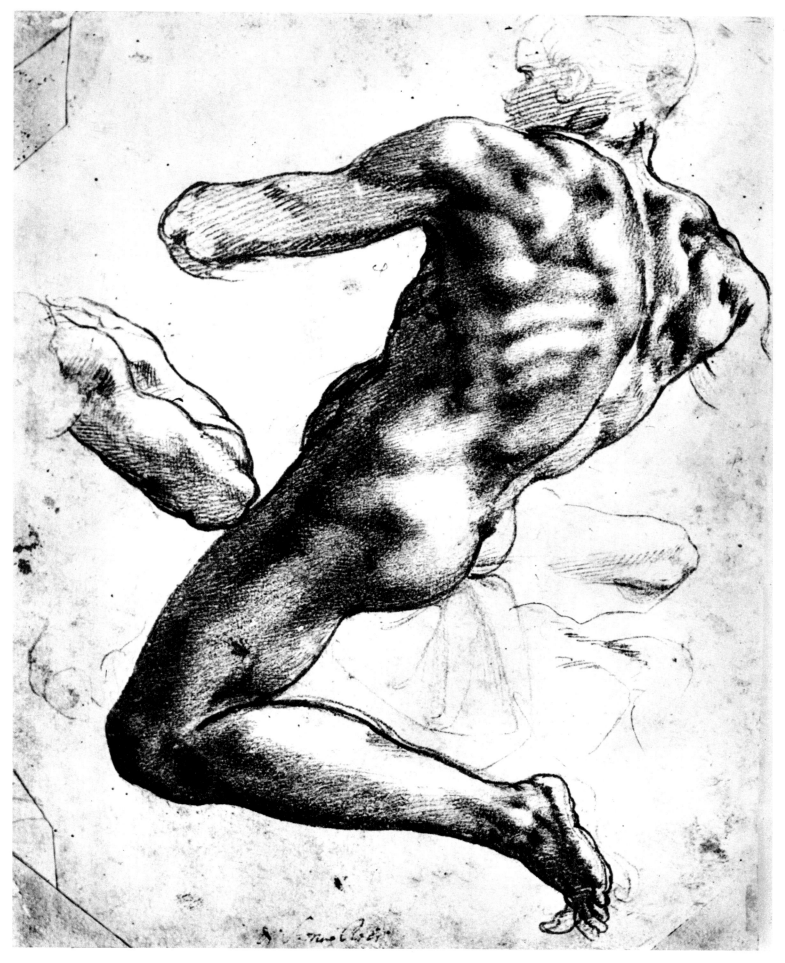

103

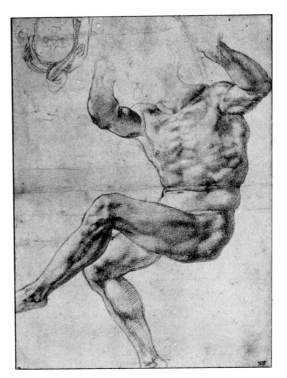

104

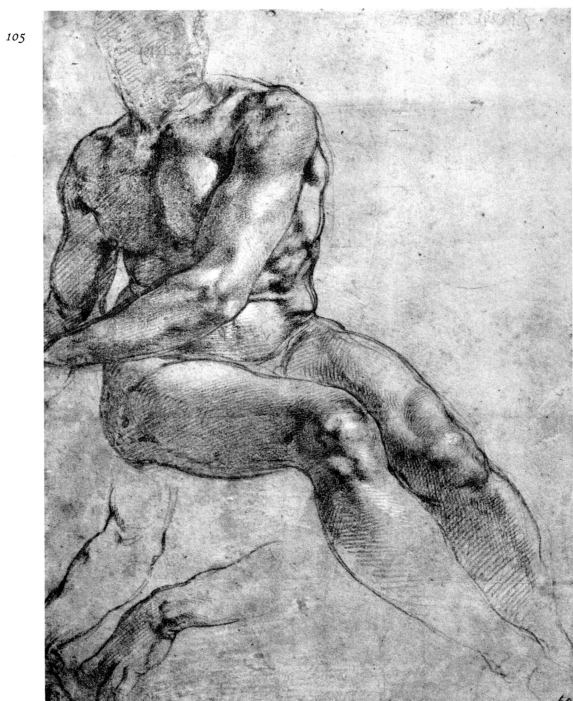

105

108

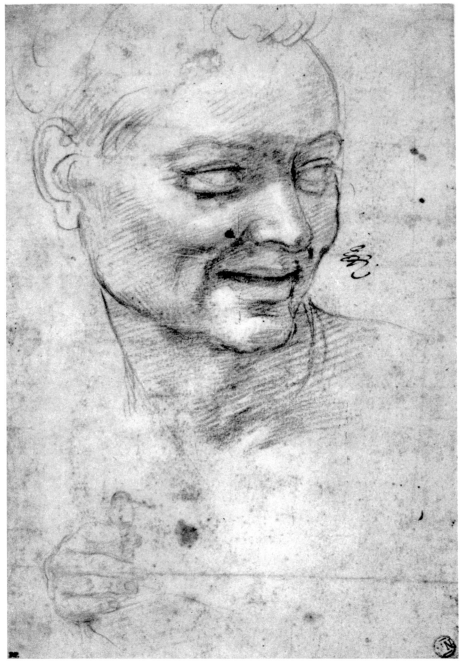

106

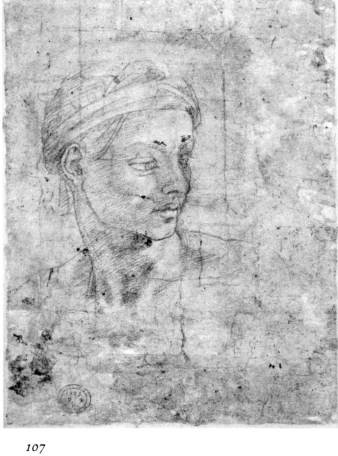

107

108

I o gia facto ūgozo iquesto stēto
chome fa lacqua agacti i lonbardia
ouer daltro paese ēt essi chesisia
cha forza luētre apicha soctolmēto

L abarba alcielo ellamēmoria sēto
īsullo scrignio e pecto fo darpia
e lpenel sopraluiso tuctania
mel fa gocciando ū richo pauimēto

E lobi entrati miso nella peccia
e fo delcul p chotrapeso groppa
e passi seza ghochi muouo ī uano

D ināzi misallūga lachorteccia
e p pregarsi adietro sragroppa
e tēdomi Comarcho soriano

Po fallace e strano
surgie iludicio ħ lamēte porta
ħ mal sipra p Cerbodana torta

lamia pictura morta

di fedi orma giouanni elmio onore
no sēdo ī loso bō ne io pictore

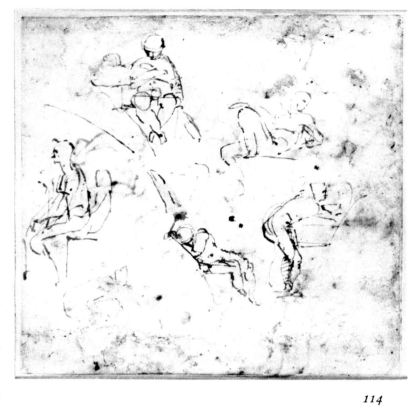

114

112

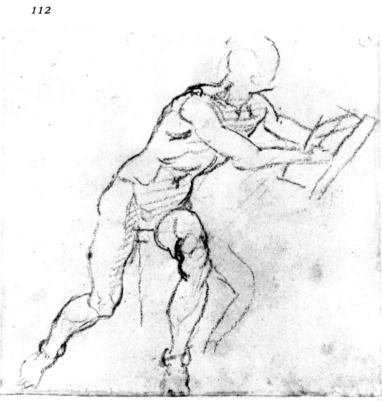

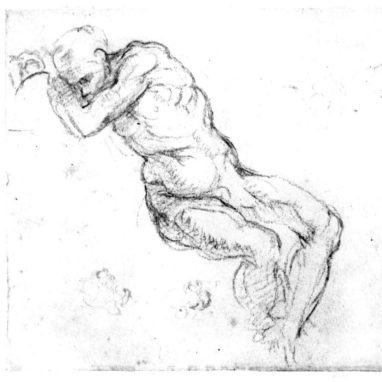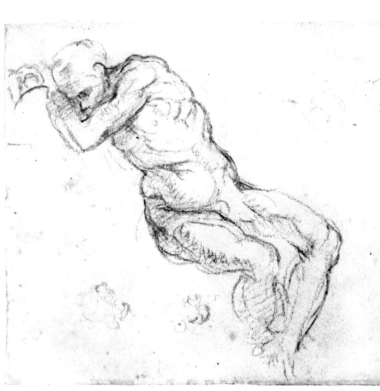

113

115

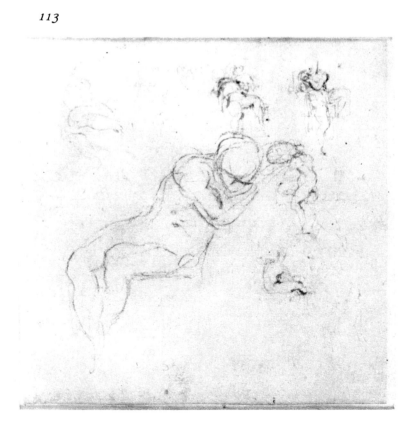

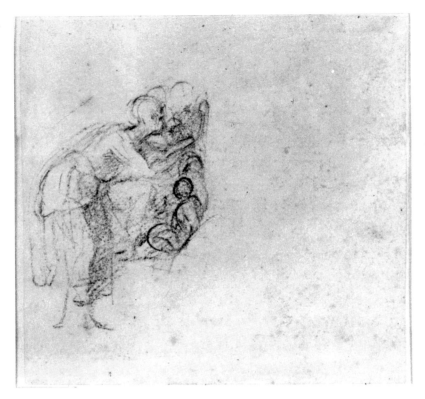

116

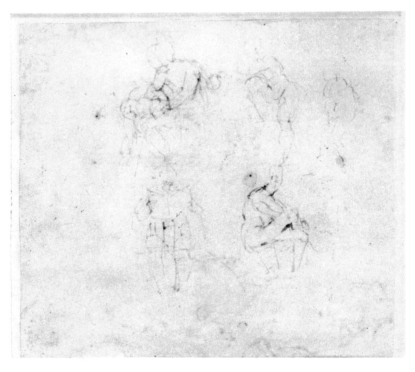

117

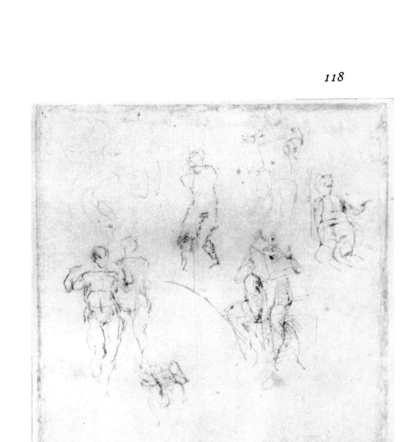

118

119

120

121

122

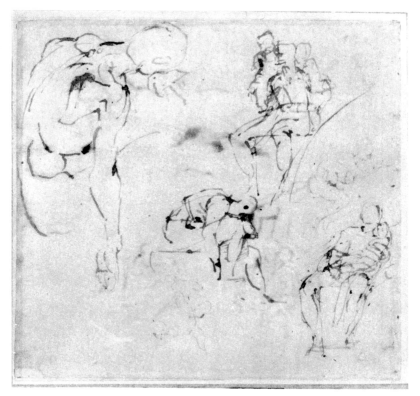

123

113

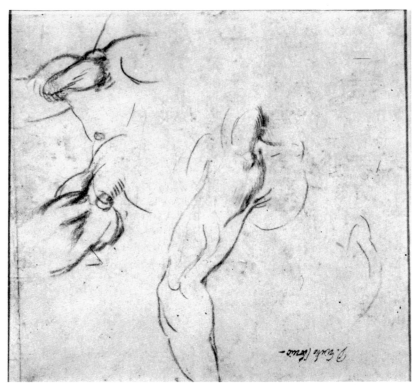

124

125

114

5

Drawings for the second project of the Tomb of Julius II. Rome, 1513–16

Judging from the character of the few preserved drawings that can be connected with the second project for the Tomb of Julius II in 1513 and the reduced third project in 1516 (substantially the same in the elevation of the ground story), Michelangelo must have made careful model studies in order to analyze the behavior of muscles and tendons under the strain imposed by the cramped positions he had invented for the Bound Captives. What happened to all the missing sketches? Presumably the whole mass of drawings was in the house in the Macello dei Corvi, just off the Forum of Trajan, which was lent to Michelangelo for his workshop, and in which the carved and uncarved blocks for the Tomb were also stored. The house, by all accounts, was not well kept, and the drawings may have been pilfered. Or, since this house eventually became Michelangelo's property and he spent his later years there, he may have destroyed the drawings himself. We can be grateful for what little is left. The sketches, Nos. 130 and 131, show a new authority and decision in the rapid command of contour—of which, paradoxically, the life studies, Nos. 128 and 129, display a surprising independence. Perhaps the apparent opposites are obverse and reverse of the same intellectual coin. It could be that Michelangelo now understood contour so well that he no longer needed to explore it, and could concentrate on the intricate drama of the relations between masses and planes.

126. *Sketch of the lower story of the Tomb of Julius II*
1518
Pen, 10¼×9″
LONDON, BRITISH MUSEUM, W. 23 recto
(for verso see No. 127)

A sketch intended for a practical purpose, to assist Michelangelo's caretaker in Rome, Leonardo the saddler, with a kind of inventory of the blocks for the Tomb which had been assembled, whether carved or not, for the visit of the Duchess of Urbino in April, 1516. The correspondences with the actual Tomb are not exact, because apparently Michelangelo made the sketch from memory in Florence, Pisa, or Carrara, while he was engaged in quarrying the marble for the façade of San Lorenzo. The herms and the niches for the Victories are shown substantially as they now appear, although the herms had not yet been executed. The pedestals for the Captives are left blank. The inscription in Michelangelo's hand reads: "This sketch is a part of the façade in front of the sepulchre which is all finished blocking and cutting, which part is six cubits high from the ground to the first cornice and from one corner to the other eleven cubits, and is of seventy-seven pieces with those pieces indicated which are

in the number. And it is put together in a room in the house off the courtyard in which room are two wheels of a wagon which I had made and left the rest in another room on the ground floor in the house in Rome." The other inscriptions give dimensions. In the flood of the Tiber in 1530 the floor under the assembled blocks was weakened, and when it collapsed they fell into the basement with considerable damage.

127. *Diagrams of blocks for the Tomb of Julius II*
1518
For medium and dimensions, see No. 126
LONDON, BRITISH MUSEUM, W. 23 verso
(for recto see No. 126)

Blocks forming the assembled portion of the Tomb, with Michelangelo's notations and dimensions.

128. *Torso of one of the Bound Captives*
1513–16
Black chalk over stylus marks, 9⅞×11″, corners cut off
LONDON, BRITISH MUSEUM, W. 45 verso
(for recto see No. 248)

This handsome drawing, never doubted though often ignored, has generally been misdated. It is a life study for the second Captive from the right, clearly visible in the Berlin and Uffizi drawings (see Nos. 45 and 45A) which preserve, if only in the form of copies, Michelangelo's ideas for an alternative project in 1505, actually adopted in the 1513 contract. The figure in our present drawing was intended to follow exactly the pose as indicated in the project copies, down at least to the waist. That the arms were to be raised above the head may be inferred from the position of the lightly touched-in back and shoulder muscles. The figure was repeated by Giulio Romano, apparently on the basis of this drawing, as a herm in the frescoes of the Stanza dell'Incendio, finished in 1518 at a time when Michelangelo was not in Rome. The original drawing must, therefore, have been made before July, 1516, when Michelangelo left Rome for Florence to work on the façade of San Lorenzo.

The drawing shows a decreasing reliance on the firm and continuous contour; in fact, such contours as appear seem to have been added last. Linear boundaries were first established by means of stylus marks on the paper, then the inner forms of muscles and bones were built up by a Cézanne-like procedure of separate planes or patches of tone, similar to the construction of the background nudes in the early *Doni Madonna*.

129. *Study for the Rebellious Slave*
Black chalk over stylus, 10⅞ × 5⅝″
LONDON, BRITISH MUSEUM, W. 15 A

Long recognized as connected with Sebastiano del Piombo's *Flagellation* in San Pietro in Montorio in Rome, this drawing has had a stormy critical career involving rejection and acceptance by the same scholar. It has recently been shown past argument that the head and the tremulous contours are the work of Sebastiano. Yet the torso was originally drawn and modeled in exactly the same style as No. 128, and is far more intense than any anatomical study of which we know Sebastiano to have been capable. Apparently this is one of the fragmentary drawings Sebastiano constantly begged from Michelangelo for use in his own paintings. Sebastiano modeled it a bit more, supplied his own contours, and extended the extremities, usually missing in Michelangelo's drawings of this period and character, so as to turn the *Rebellious Slave* into a flagellated Christ.

130. *Sketch for a Bound Captive (portion of sheet)*
1513–16
Pen, over red chalk sketches by a pupil, 11⅛ × 8¼″ (whole)
LONDON, COUNT ANTOINE SEILERN, verso
(for recto see No. 131)

In spite of determined attempts, it has not been possible to specify which of the Captives this fine sketch was intended for; not enough is known about those which do not appear on the front of the Berlin-Uffizi project copies (Nos. 45 and 45A). The drawing, with its variant poses for the right arm, is an instructive example of Michelangelo's brilliant and sure line. The red chalk sketches are the work of a pupil, and some of the drawing on the recto shows through.

The difficult verse fragments in Michelangelo's hand read:

Thus in or out of his rays
I am in the fire, which burns my weak body,
And I know . . .
. .
Thus overflowing with grace and full of bitterness
An occult thought shows itself to me, and says:
To see her I wait for you a second time:
That which will be, see her in a sad aspect.

131. *Sketch of a left leg; pupil's sketch of Christ before Pilate*
1513–16
For medium and dimensions, see No. 130
LONDON, COUNT ANTOINE SEILERN, recto
(for verso see No. 130)

About the fine sketch of a left leg, inseparable in style from the Bound Captive on the verso, there has been no argument. Few, however, are willing to accept the curious, rough, and scraggly composition sketch as the work of Michelangelo. The open, curved hatching has little to do with his style, nor do the weak poses and frenzied movements. But here and there occur linear passages of extraordinary power, such as the contours of the profile of the figure kneeling before Pilate, and his shoulder and back, and an occasional face and drapery passage elsewhere. Hazardous as it may be to see Michelangelo's intervention in the drawings of pupils, this may be one of many such instances.

132. *The Resurrection*
1513–16
Black chalk, 16 × 10⅝″
LONDON, BRITISH MUSEUM, W. 53

Once a victim of the rejectionist school, this magnificent drawing has crept back into even the strictest lists. There can no longer be any serious reason to doubt any portion of it. But the drawing is still misdated. The pose of the Christ was used exactly, in reverse, all but the lifted arm, by Sebastiano del Piombo for his *Raising of Lazarus* in the National Gallery in London, started for Cardinal Giulio de' Medici (later Pope Clement VII) in 1516, for his cathedral in Narbonne. The drawing, therefore, must have been one of those given to Sebastiano to help him in his endeavors. It must originally have been intended for a relief. The space is strictly limited, the projections slight, the modeling of unprecedented delicacy and refinement. The figure, framed by the mouth of the cave as a kind of dark *mandorla*, would have fitted perfectly into the proportions of the space in the 1513 version of the Tomb of Julius II that was originally to have been a doorway into the burial chamber, in the 1505 version. Through this doorway the observer was to have seen Julius lifted from his tomb. In the present hypothesis the resurrected Christ would be substituted. The modeling, moreover, is soft and fluid, as would befit execution in clay for a relief in bronze, with many subtle gradations of projection and of tone. While for the present this identification must remain conjectural, it is hardly possible to deny the date, and very difficult to conceive of another purpose for so highly finished a drawing during the years when Michelangelo was concentrating all his efforts on the progress of the Tomb. If this suggestion is correct, he would have given the departed Pope a new, tender version of the heroic *Resurrection* that was refused as the altar piece for the Sistine Chapel (No. 125).

"Écorchés," 1513–16 (?)

Red chalk unless otherwise noted

132A. *Three studies of a bent left leg, and two of a bent left arm for the Moses*
10¾ × 16¼″, patched at corners
HAARLEM, TEYLERSMUSEUM, A 37 recto

132B. *Study of the left half of a man from the back with leg bent*
For condition and dimensions, see No. 132A
HAARLEM, TEYLERSMUSEUM, A 37 verso

132C. *Studies of a left arm extended, the bones of a left hand and forearm, and of a left shoulder from front and side, for the Moses*
Partially overdrawn, and muscles lettered, in pen,
10⅜ × 7⅞″
HAARLEM, TEYLERSMUSEUM, A 39 recto

132D. *Four studies of a bent left leg, from outside, inside, front and back, for the Rebellious Slave*
Overdrawn, and muscles lettered, in pen; for dimensions, see No. 132C
HAARLEM, TEYLERSMUSEUM, A 39 verso

Inscription in Michelangelo's hand:

"Under two beautiful eyebrows
With peace and wonder
Love has put a bridle on my thoughts"

132E. *Two studies of a straight right leg, from the inside and from the back*
11 × 8", cut down at top and bottom
WINDSOR, ROYAL LIBRARY, 0803

At various times in his life Michelangelo is known to have made *écorchés* (anatomical studies from flayed corpses). Yet it has been widely doubted that any such drawings survive. The five drawings listed above are certainly by the same hand, and three others (see below) have been grouped with the same series. All are in red chalk, and the dimensions are so close that the differences are probably to be explained by later trimming. Nos. 132A and 132C are undeniably connected with the *Moses*, and 132D with the *Rebellious Slave*. All five show the characteristics, as analyzed consistently throughout this book, of original drawings rather than copies. To date only one critic has changed his mind in print and accepted Nos. 132C, 132D, and 132E as by Michelangelo. No one has previously noticed the connection of 132D with the *Rebellious Slave*. The very existence of Nos. 132A and 132B has until now been overlooked by scholars, and are therefore here published for the first time.

Were these drawings done by Michelangelo himself, by an imitator who manipulated corpses into poses based on statues by Michelangelo, or by a pupil commissioned by the master to study anatomical details for him? The absence of comparative material by Michelangelo hampers our judgment. We must therefore rely on our estimate of probability and our assessment of quality. No. 132A shows what is recognizably the celebrated left arm of the *Moses*, somewhat slighter than in the statue but with the same idiosyncrasies of structure. The arm is drawn once in a pose which can be neatly superimposed on a photograph of the arm of the *Moses*. Then the arm is drawn again, considerably more

extended. In No. 132C the arm is extended fully, its structure analyzed to differentiate the bones, muscles, tendons, and even the veins, which play so important a role in No. 132A and in the statue. The muscles are lettered from "a" to "k", then skipping to "o". In the next study they are removed to show the bare bones. Finally the muscles of Moses' square, powerful shoulders are studied twice. In No. 132D the left leg of the *Rebellious Slave* is analyzed from that of a cadaver, placed in the same unmistakable position, the knee slightly bent, in order to see just what muscles this pose would bring into play. The leg is seen from the four principal sides, the muscles lettered "a" through "f" and "n" through "q".

Of our three initial hypotheses, the second is ruled out by the presence of poses not derived from the statues. The third is scarcely more probable. Michelangelo, faced with the necessity of creating figures subjected to a kind of organic stress which no Renaissance artist had ever attempted to study before, would not have turned over to an assistant the analysis of the very limbs whose shapes were to be determined by the activity of such unprecedented forces. This would have been uncharacteristic of everything we know about his character and his methods and would, in fact, have defeated the very purpose for which the studies were made, depriving the artist of the intimate knowledge which can be gained only from first-hand experience.

Probability, therefore, argues for Michelangelo's authorship. So does quality. The lines are authoritative and sure, the shapes can be found in many other drawings by Michelangelo (compare, for example, No. 132B with No. 87), and despite its grim subject and basically informative character, No. 132E is a plastic creation of glorious strength and beauty.

Two more drawings in the Royal Library at Windsor, No. 0624 and No. 0802, have had the same critical history as the others in this series, to which their technique, medium, and dimensions clearly unite them. But both have been so extensively reworked by a later artist who knew nothing of anatomy that only a few passages show Michelangelo's hand. The remainder is ludicrous. There is also a drawing from the same series in the Gathorne-Hardy Collection, but it has been impossible to obtain a photograph of it so no judgment can be made.

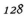
128

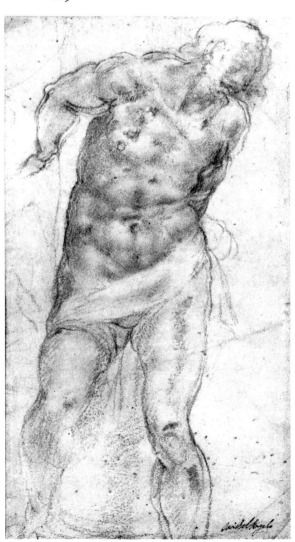
129

119

130

132▶

131

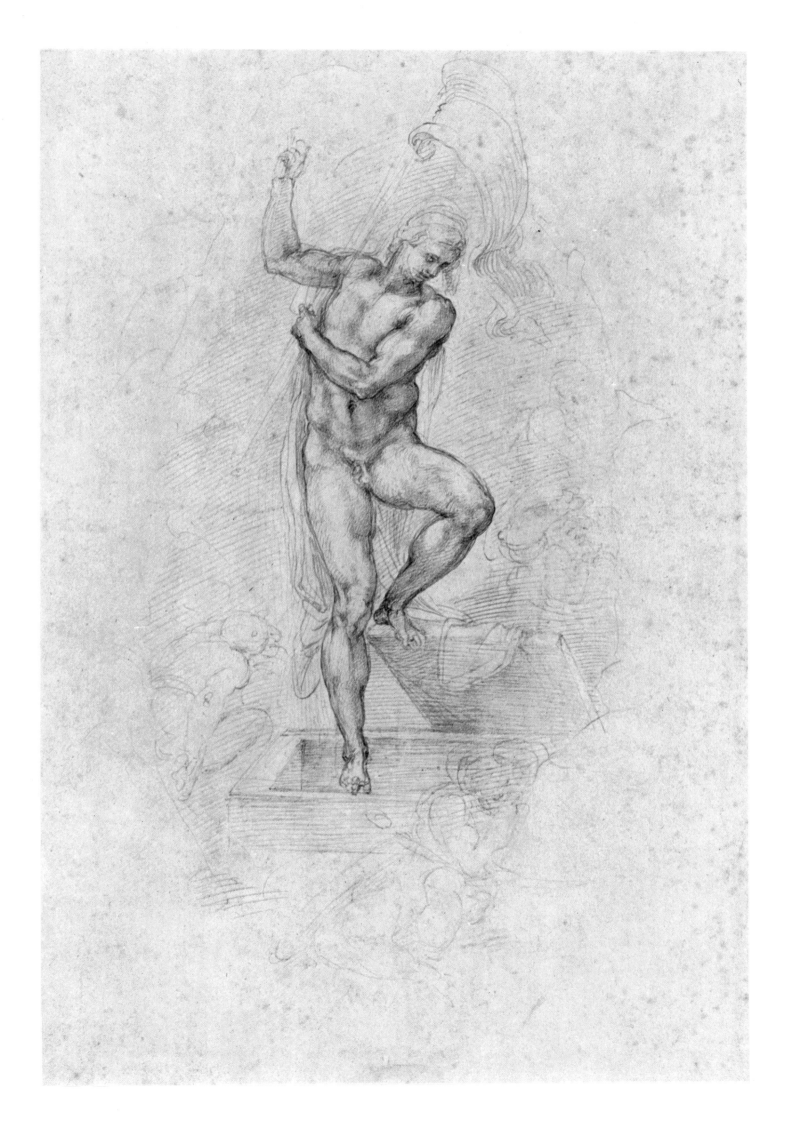

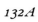

132A

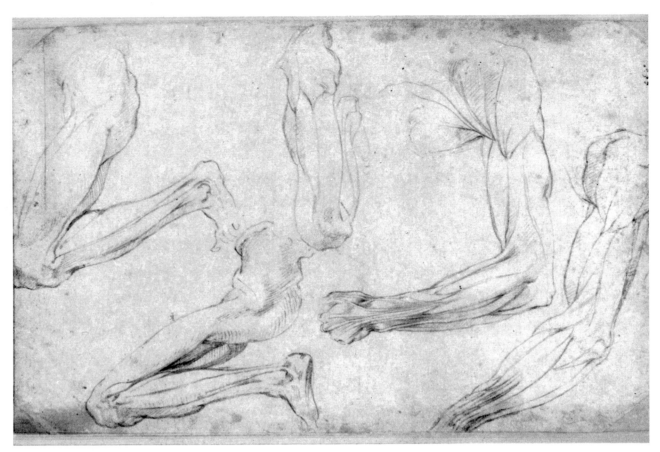

132B

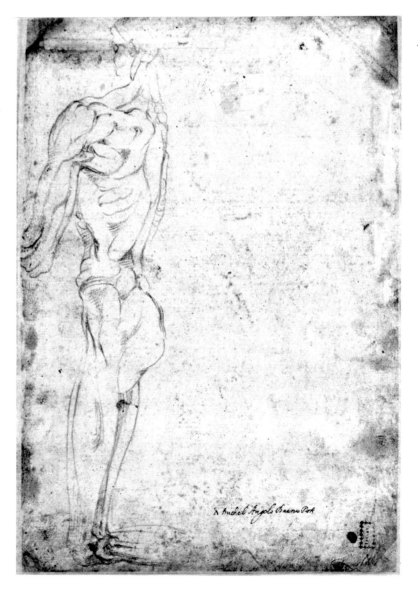

132C

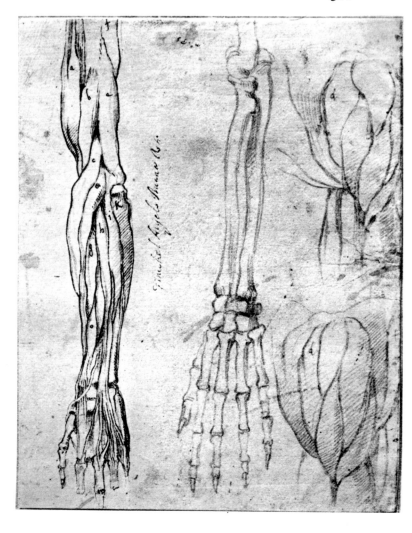

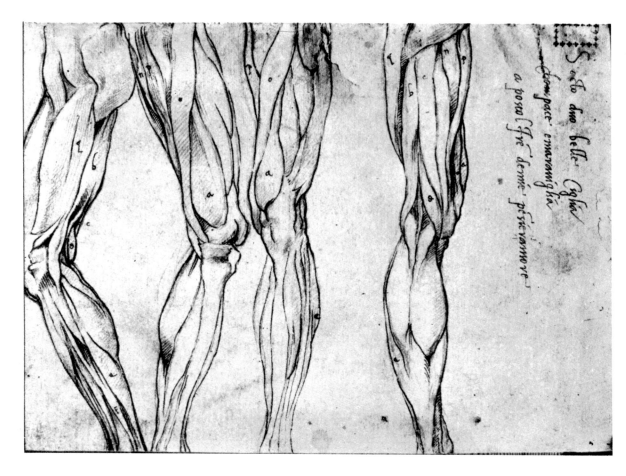

132D

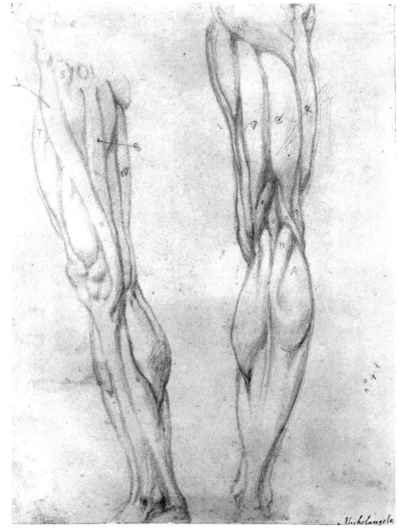

132E

6

Drawings of Roman architecture. Rome, 1515–16

The following red chalk drawings in the British Museum and the Casa Buonarroti, all on the same paper and of almost identical dimensions now variously recombined, once formed a continuous folio sketchbook of six sheets folded once, to form twenty-four pages. Twenty-two of these pages were filled with drawings of architectural details (in No. 141 an entire building, or almost) selected in general from ancient monuments in or near Rome, but in some instances from buildings constructed during the Renaissance, some of which Michelangelo had watched rising. It has been proven that these drawings were all made, not from the original buildings, but from another and more detailed sketchbook, the so-called Coner Codex now in Sir John Soane's Museum, London. This Codex was done by a Florentine living in Rome about the year 1515. He has been identified with the learned Giovanni Battista Cordini da Sangallo, called the Hunchback, who was the translator of the ancient Roman architectural theorist Vitruvius.

The connection with Michelangelo cannot be denied. One of the drawings bears inscriptions in his handwriting, in the same chalk as the drawing itself, harmoniously spaced. Time and again the profiles correspond, in their energy and incisive brilliance, to those of the architectural drawings universally recognized as his. Yet there is still no general critical agreement about the detailed drawings of capitals, bases, entablatures, etc., copied from the Coner Codex. They are here presented as a unified group, because it has proved impossible to find any definable variation between those portions generally accepted and those still at issue. Why should a great, revolutionary, and influential master humble himself to copy motives from an archaeological pattern book? One can only suggest that Michelangelo, whose previous connection with architectural design had been limited to the visionary structure of the Sistine Ceiling and the free architectural play of the Tomb of Julius II, had suddenly discovered by experience with an actual building (the façade of the Chapel of Leo X in Castel Sant' Angelo) how exciting real architecture could be, and how much technical knowledge of antiquity was demanded of an architect before he could build structures in the Renaissance style. The Coner Codex offered a free ride through the best ancient and new monuments, without the necessity of consuming a vast amount of time in studies made on the spot.

Recent writers have pointed out that Michelangelo ignored all the measurements and similar notations in the Coner Codex, altered the proportions subtly—and possibly unconsciously—to suit his own taste, and omitted what did not interest him; also that his drawings are artistically su-perior to those he copied from. The sketchbook can scarcely be called a pattern book, since few of the elements in it were ever used in Michelangelo's architecture, and none exactly. His fascination with Doric entablatures containing triglyphs is especially striking, since he never executed a single triglyph. He drew, as always, with great vitality. He still thought as a sculptor, and treated the contours and inner forms of the architectural members like the contours and inner forms of living flesh. The secondhand copies tremble with life as we watch. It has been shown that this was the moment when Michelangelo was dreaming and scheming for his great commission, the façade of San Lorenzo in Florence. To fit himself for this massive work, the sculptor set out to learn the language of architecture—Berlitz fashion. Small wonder that in the finished buildings he was later to speak with such sublime disregard for convention.

133–41. *Twenty pages, cut along folds and remounted as five pairs; here listed as nine drawings, counting each recto and verso, since two pages were left blank*
FLORENCE, CASA BUONARROTI

133. 1 A recto
$11\frac{1}{8} \times 16\frac{3}{4}''$

Capitals, bases, and a console: from the Arch of Titus, the Theater of Marcellus, and the Arch of Septimius Severus; from ancient capitals in Roman churches and collections; and unidentified pieces. It is particularly noticeable, and very important, that Michelangelo tends to abstract the contour as a separate melodic form, expanding and contracting of itself.

134. 1 A verso
For dimensions, see No. 133

Profiles of cornices, columns, and capitals: from the Arch of Vespasian, Roman churches, the papal Chancellery, the Belvedere of the Vatican; and after Antonio da Sangallo the Elder.

135. 2 A recto
$11\frac{3}{8} \times 16\frac{7}{8}''$

Cornices from the Theater of Marcellus and San Lorenzo in Miranda; entablature and capital from the Basilica Emilia.

The masses emerge from these block diagrams in a manner strikingly similar to those of such anatomical drawings as No. 128, for the Tomb of Julius II.

136. 2 A verso
For dimensions, see No. 135

Cornices from the Milvian Bridge and the Colosseum; façade and niche molding from the Mausoleum of the Plautii; profile of unidentified column base and plinth.

137. 3 A recto
11¼ × 16⅞″

Block diagrams of cornices from the Temple of Castor and Pollux, the Temple of Minerva, Old St. Peter's, and other sources.

138. 3 A verso
For dimensions, see No. 137

Moldings and entablatures from various Roman buildings, including the church of the Santi Quattro Coronati, the Pantheon, and several now lost or not identifiable.

139. 4 A recto
11 × 17″

Pilaster base from the temple in the Colonna gardens; cornice of the papal Chancellery; cornice of Santa Prassede; Doric entablature and pilaster capital after Antonio da Sangallo the Elder; Doric entablature and capital from a tomb on Via Nomentana.

140. 4 A verso
For dimensions, see No. 139

Capital from the Theater of Marcellus; entablature and capital from the lower court of the Belvedere; entablature and pediment from the temple in the Colonna gardens; cornice profile from the Baths of Nero; cornice from the Capitoline.

141. 8 A
11⅜ × 16⅞″

Doorway of a temple and left half of a window frame from Tivoli; central and left sections of the Arch of Constantine; two bases in profile; left side of a Corinthian capital.

142–45. *Four pages, originally one sheet, cut in two, here listed as four drawings, counting each recto and verso.*
LONDON, BRITISH MUSEUM

142. W. 18 recto
11⅜ × 8⅝″

Doric entablature and capital from the Theater of Marcellus; separate study of a sunk mutule. One of the handsomest of all the Doric studies, to remain forever unused.

143. W. 18 verso
For dimensions, see No. 142

Eight Doric capitals from various Roman sources; two Doric profiles. The third capital from the top at the left is from the papal Chancellery.

144. W. 19 recto
11⅜ × 8½″

Main cornice of the Arch of Constantine; entablature and Corinthian capital from the Temple of Vesta at Tivoli; details from other Roman monuments; profile of entablature from the Theater of Marcellus.

145. W. 19 verso
For dimensions, see No. 144

Column from the Temple of Castor and Pollux, with diagram of entablature; diagram of capital; section of the architrave and attic of the Arch of Septimius Severus.

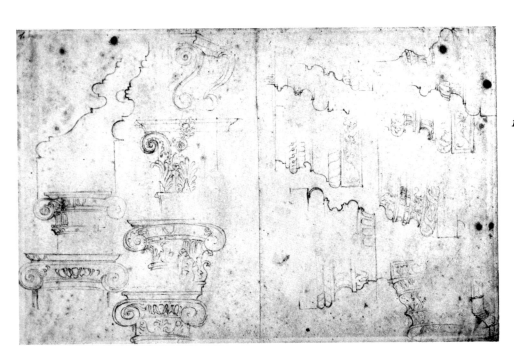

133

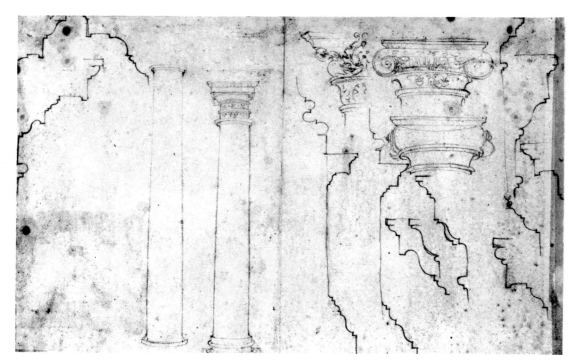

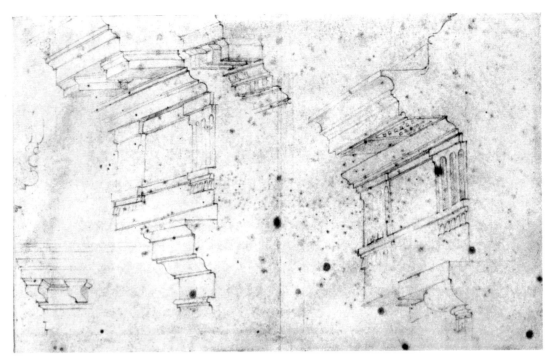

139

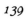

140

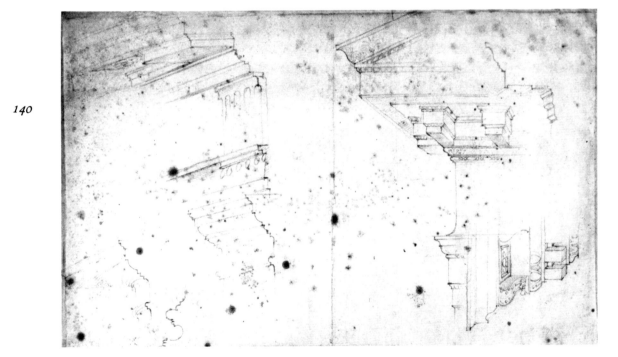

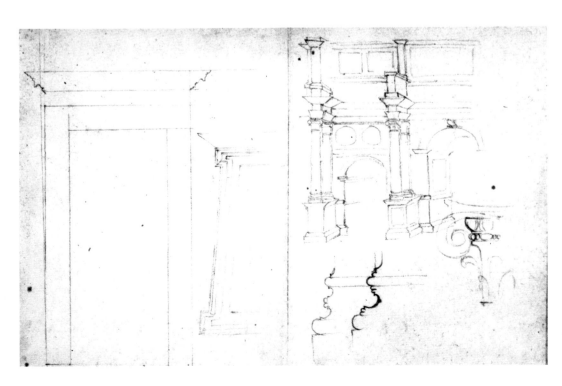

141

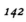142

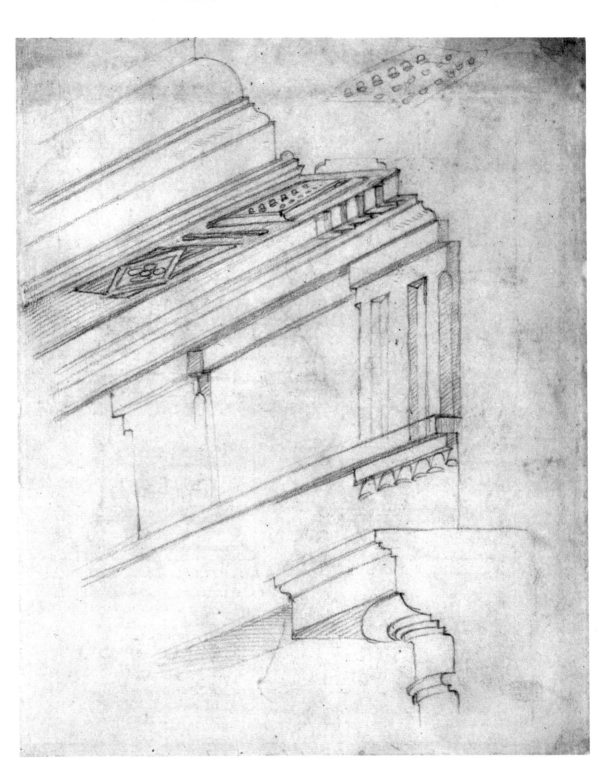

143

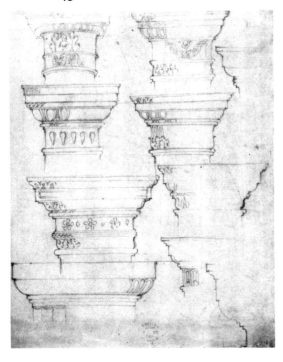

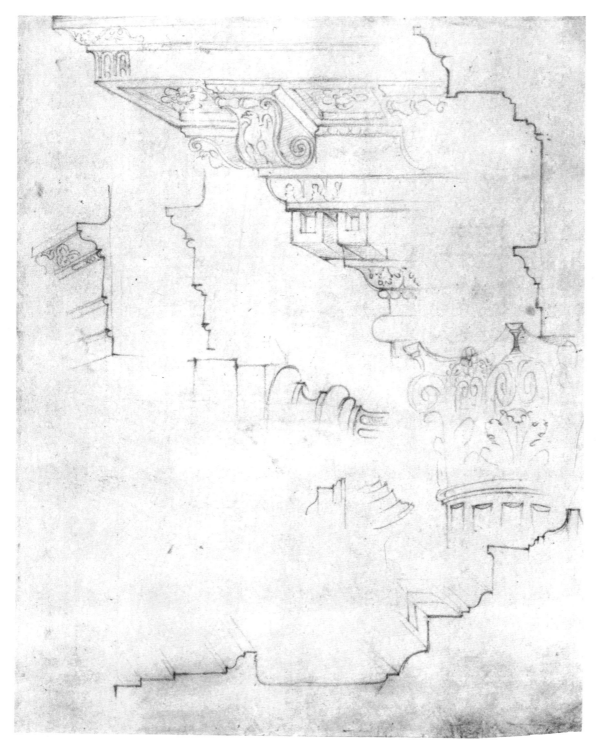

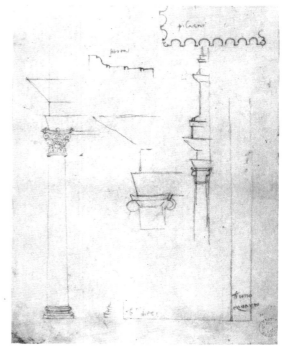

145

7

Drawings connected with the façade of San Lorenzo, Florence, 1517–18

Much has been done to reconstruct the various stages of Michelangelo's disastrous project for the façade of San Lorenzo in Florence, from the first competition for the design, apparently as early as 1515, to its final unexplained abandonment, to the artist's acute sorrow, in 1520. There has even been a highly successful attempt to identify the various blocks of marble quarried for the façade according to the numerous diagrams, still in the Casa Buonarroti, which Michelangelo furnished for the stonecutters at Carrara and Pietrasanta. But there has been surprisingly little interest in the possible appearance of his statues and reliefs for the façade, which he intended as a "mirror of architecture and sculpture for all Italy." Second, there exists a wealth of striking and sometimes boldly original drawings, apparently for sculpture, dated by most critics in or near the second decade of the sixteenth century, and these have never been successfully connected with any of Michelangelo's known projects. Finally, no one knows why the contract was suddenly canceled. Under the optimistic conviction that equations with three variables may on occasion be permitted to solve themselves, the problem has been attacked in the following pages as if everything belonged together. Quite possibly it does not. There may be many extraneous elements in the present reconstruction. If so, Michelangelo scholars may be trusted to throw them out.

Domenico Buoninsegni, charged by Pope Leo X and his cousin, Cardinal Giulio de' Medici, with the administration of the new building, wrote to Michelangelo from Rome on February 2, 1517 (see page 134), giving the artist directions for the identity and the positions of the ten statues which were to appear in the niches of the façade. The meek way in which Michelangelo received these instructions, and later wrote back for approval even of the costumes the figures were to wear, should provide a healthy antidote to the romantic belief that he proceeded to select his subjects entirely on his own, in order to figure forth some mystical Neoplatonic cosmogony, without regard for the wishes of his patrons or the religious character of the projects. The letter lists, on the lower story, St. Lawrence, patron of the basilica, St. John the Baptist, patron of Florence, and St. Peter and St. Paul, princes of the Apostles. Seated, on the second story, appear to have been the four Evangelists, although only three statues are mentioned. Saint Luke, patron of doctors (*Medici* means doctors), was to come first, above St. Lawrence; St. Matthew above St. John the Baptist; and St. Mark above St. Paul. The only place for the missing St. John would thus be above St. Peter. Saints Cosmas and Damian, patron saints of the Medici family, were to go on top (*in cima*) above St. Law-

rence and St. Paul, apparently standing on the tabernacles against the sky, because no niches in the design remain unoccupied. No reliefs are mentioned.

The contract of January 18, 1518, is much more elaborate. The façade, now consisting of two full stories with intervening mezzanine and no tabernacles, is expanded to a freestanding structure, or narthex, projecting out into the Piazza di San Lorenzo, provided with returns of one bay each at the sides (see No. 149). In consequence, the contract stipulated six standing marble statues, each five cubits high, on the first story (rather than the original four, since the niches in the returns would have to be filled); six seated statues in bronze, each four and a half cubits high, for the mezzanine; and six standing statues in marble, each five and a half cubits high, in the niches of the second story. In addition, probably above the heads of the statues of the first story, there were to be reliefs; the number is not specified, but in the model there are six spaces. A seventh relief might have gone over the door. In the upper story were to be placed four more reliefs, each eight cubits long, and another relief nine cubits long, and two circular reliefs whose diameter was set at between six and seven cubits. The attic story was to be provided with six seated figures in marble, lifesize, in high relief. The Medici arms were to be placed in the pediment. For a hypothetical distribution of these sculptures, see page 396.

Doubtless the second iconographic scheme was an expansion of the first, and we should imagine that the same four saints were kept on the first story and the four Evangelists, standing, on the second. Saints Cosmas and Damian would be dethroned from their now-vanished tabernacles: where would they then go? The right and left returns, first story, would seem the only logical answer, in keeping with the importance of these saints for the Medici. Traditionally accompanying the four Evangelists are the four Fathers of the Church, and these should almost certainly be imagined in the mezzanine. We have now fairly well established the scheme, except for the returns and the reliefs. For the returns of the mezzanine, above Sts. Cosmas and Damian, two Florentine saints are suggested, Zenobius and Reparata. As new evangelists, to continue the mission of the original four, Sts. Dominic and Francis are proposed for the niches of the returns on the second story. Saints Giovanni Gualberto, Leo, Julian, Mary Magdalen, and Minias are likely candidates for the seated attic saints, but we are still shy one saint. Logical subjects for the reliefs on the side of St. Lawrence are scenes from his life and martyrdom (this was shown in Giuliano da Sangallo's drawing for the competition) and, for the corresponding reliefs on the other side, incidents

from the protracted martyrdom of Sts. Cosmas and Damian. Over the doorway, a Resurrection would be logical (the resurrected Christ is, symbolically, the keystone), and in the central niche a Madonna and Child.

As will be seen below, quite a number of mysterious and hitherto unidentified drawings fit more or less neatly into this scheme. Their vivid, angular shapes and rich plasticity must be imagined inside the beautiful grid of the last design, which nobody seems to have connected with the gridiron on which St. Lawrence was martyred, although this is just the kind of visual pun that delighted the Renaissance.

There remain the drawings for smaller reliefs: the fires of St. Lawrence, suggested for the six panels above the statues of the first story, and the salamanders, which might well have decorated the bases of these same statues. The fiery theme which unites them has a political explanation. After the death without legitimate issue of Giuliano de' Medici in 1516 (Pope Leo X's younger brother, relegated since 1513 to positions far from Florence), the family future rested in the person of Lorenzo, son of the Pope's deceased older brother, Piero. In a discreditable and expensive war, the Pope obtained for his nephew the Duchy of Urbino in 1516; and the great project to complete San Lorenzo, which was not only the parish church of the Medici family but the sanctuary of Lorenzo's patron saint, may well have been transformed by the desire to honor the new Duke. It is noteworthy that the images of Pope Leo himself, attended by Justice and other Virtues, which decorate Giuliano da Sangallo's façade designs, do not reappear in the instructions given to Michelangelo. In the final drawing (No. 149) their places are taken by the six candles of the Mass, probably the Mass of St. Lawrence. In the spring of 1518 the Pope succeeded in marrying Lorenzo to the French princess Madeleine de la Tour d'Auvergne, a relative of Francis I. Doubtless he hoped that the Medici family, now raised to the rank of independent princes, would be made more secure by blood relationship with the most powerful monarchy in Europe. This is the reason why Sts. Francis and Mary Magdalen have been suggested for the iconographical structure of the façade, and also why the salamander drawings have been included, since the salamander was the heraldic beast of Francis I. The salamander in flames and St. Lawrence on his roasting fire would have fitted together nicely in Leo's mind.

His machinations came to a tragic close with the death of Madeleine de la Tour d'Auvergne on April 29, 1519, two weeks after the birth of her daughter, Catherine, and the equally unexpected demise of Lorenzo on May 4 of the same year. Leo is said to have exclaimed, "Now we are no longer the House of Medici but the House of God!" So ended together the direct male line of the Medici family and the proud French alliance, celebrated in the fresco by the Raphael school in the Vatican in which Leo is shown crowning a Charlemagne recognizable as Francis I.

In June, 1519, Charles V came to the imperial throne, and Leo began to seek an alliance. In July Cardinal Giulio de' Medici, now governing Florence, already communicated to Giovan Battista Figiovanni, canon of San Lorenzo, the Pope's idea for a noble tomb chapel in which Giuliano and Lorenzo, as well as the incomparably greater Giuliano and Lorenzo the Magnificent, would all receive fitting monuments. The façade must have been doomed from this moment. Michelangelo was still allowed to proceed, but it has been recently shown that he must have received the bad news by the middle of September. The contract was not finally annulled until March 10, 1520, and the marble was turned over to the Cathedral of Florence for use in the new pavement. Considering the questions of high policy involved in the decision to substitute the Medici Chapel for the façade of San Lorenzo, it is small wonder Michelangelo could not be informed.

146. *Sketch for the façade of San Lorenzo*
1516–17
Red chalk, $3\frac{1}{2} \times 3\frac{1}{2}''$, cut down and spotted
FLORENCE, CASA BUONARROTI, 91 A recto

Rough sketch for a two-story façade, with intervening mezzanine; there are spaces for ten statues, four on the ground floor between the paired columns, four in positions directly above them in the mezzanine, and two freestanding on the cornice. A powerful but still not completely integrated design, this is the first sketch for an entire building we have from Michelangelo's hand. It probably represents an early stage of the second design for the façade. (No sketches for the supposed first design are preserved.)

147. *Sketches for the façade of San Lorenzo and for other projects*
1517
Pen, $7\frac{7}{8} \times 10\frac{5}{8}''$
FLORENCE, CASA BUONARROTI, 44 A

This drawing is dated in January, 1517, by the notations in Michelangelo's hand, and was made in Pietrasanta, where the artist was superintending the opening of new quarries for the marble. The façade is in a state of flux; in an attempt to reinstate the arched pediments the extremes of the mezzanine are made into tabernacles, doubtless for the statues of Sts. Cosmas and Damian. A pediment is inserted in the first story of the façade. Michelangelo seems to have had his doubts about the whole thing. He could not decide how the mezzanine should now be divided, or how high the pediment of the upper story was to be. The sketches for columns and other forms cannot be exactly identified. The herm (upside down) has been associated with the Tomb of Julius II.

148. *Sketch for the façade of San Lorenzo*
1517
Red and black chalks, $5\frac{1}{2} \times 7\frac{1}{8}''$, cut down and spotted
FLORENCE, CASA BUONARROTI, 47 A

A magnificent drawing, and a perfect solution for the problems of the probable second design. The mezzanine has been simplified to include the tabernacles easily, and to run behind the columns of the second story, which the elimination of the inconvenient first-story pediment now permits to rest directly on the entablature. There is room for four statues in each story, according to Cardinal Giulio de' Medici's directions, but the statues of Sts. Cosmas and Damian would still have had to stand on top of the tabernacles. The small arches of the upper story remain to be explained. Possibly, since this was still a veneer façade and no reliquary chapel had as yet been decided on, these were to be windows, continuing Brunelleschi's motive of clerestory windows around the façade.

149. *Sketch for the façade of San Lorenzo (portion of sheet)*
1517
Pen, with additions in red and black chalks by a pupil
(not illustrated), 8⅜ × 5⅝″ (whole), cut down
FLORENCE, CASA BUONARROTI, 43 A recto
(for verso see No. 290)

One of the great classic designs in architectural history.
Under the guise of a mere grid of horizontal and vertical
lines, interacting masses and forces are constantly implied.
In most respects, except for the divided mezzanine, this
drawing, an almost final stage of the third design, corresponds
with the wooden model in the Casa Buonarroti. All the
preceding steps are united and enriched. The façade is now
a freestanding building, which must have enclosed a narthex,
and on the flanks was to have returns of the side bays. Thus
there was room for all the sculpture stipulated in the contract
of 1518—four standing marble statues on pedestals between
the columns of the lower story, and another in each return,
each statue with a square relief above it; four seated bronze
statues in the mezzanine above the marble statues, and again
two more in the returns, with three rectangular reliefs in
bronze between the paired column bases (one rectangle
above the main door is indicated), four standing marble
statues in niches, with two more in the returns; two circular
reliefs; four seated figures in high relief over the niches, and
two more in the returns; two rectangular reliefs over the
circles—verily the "mirror of architecture and sculpture for
all Italy." Instead of the statues of Sts. Cosmas and Damian,
six great candlesticks holding candles with marble flames—
the six candles of the Mass—would have stood against the
sky. It may seem strange that Michelangelo should go to
so much trouble to work out the architectural framework
without giving the faintest indication of the sculpture to go
in it—not even the comparative heights of the figures, and
in some cases not the edges of the fields for the reliefs—but
this seems to have been his custom. First he made an elaborate
structure, precise down to the most minute detail, then, as
often as not, violated it with the overwhelming figures placed
inside. The serene and balanced building we see in the design
might well have looked very different when the zigzags of
the poses and the drapery masses protruded from it, to con-
flict with the flawless grid (see page).

150. *Column, with scale of measurement and directions*
1517
Pen, 12¾ × 8″
FLORENCE, CASA BUONARROTI, 64 A

Although it cannot be proven that the diagrams were drawn
by Michelangelo's hand, they are supplied with directions
written by him, and accompanied by an explanation by
Matteo di Cuccarello, stonecutter from Carrara, under sub-
contract to Michelangelo. The spacing and the character of
the diagrams indicate the great artist's taste. The line at
the right gives, in actual size, one third of a Florentine cubit
(*braccio*) for the use of the Carrara stonecutters, who had a
different measure. The scale at the left indicates the size of
a cubit divided in three, to give the dimensions of the
column, destined for the lower story of San Lorenzo.

151. *Plan of a capital; architectural diagrams*
1517(?)
Pen, 11⅞ × 7¾″, cut down and spotted
FLORENCE, CASA BUONARROTI, 77 A recto

There is no general agreement as to the purpose of this sketch,
but the most likely proposal seems to be that both this and
the sketches on the verso (not illustrated) were made for the
façade of San Lorenzo. The wavery, tentative lines are prob-
ably experiments in the intricate formal relationships in-
volved in the intersection of so many architectural elements.

152. *Capitals and profiles of bases*
1517–18(?)
Pen over ruled stylus preparations, 10⅞ × 8½″
LONDON, BRITISH MUSEUM, W. 20

Very similar in general character to the "pattern book"
drawings, Nos. 133–45, these studies are generally thought
to be somewhat later. Only the Ionic capital can be identified,
appearing with slight variations in No. 133. The upper
capital on the left is pure Corinthian, the lower one Com-
posite, while the central capital looks more like those in-
vented by Alberti and his followers in Florence in the fifteenth
century. None of the façade sketches gives any indication as
to what order Michelangelo intended. The model in the Casa
Buonarroti is resolutely Corinthian in both stories. It is here
suggested that this sheet represents a set of what must have
been very numerous experiments before Michelangelo
arrived at his choice.

153. *Studies for the cornice of the façade of San Lorenzo(?)*
1517–18(?)
Pen over metalpoint, 11¼ × 17″, cut down
FLORENCE, CASA BUONARROTI, 5 A recto

Like the preceding drawing, No. 152, this shows greater
authority and freedom in handling motives drawn from
Roman architecture. No precise models can be identified.
It can be assumed with some probability that this page of
studies, also, was made in preparation for San Lorenzo, even
though none of the cornices corresponds exactly to those of
the necessarily schematic model.

154. *Study for the central niche of the façade of San Lorenzo(?)*
1518(?)
Red chalk, 11¼ × 8¼″
FLORENCE, CASA BUONARROTI, 112 A

The letter to Piero Gondi, dated January 26, 1524 (1523,
Florentine style), which shows through from the verso,
provides the date before which this beautiful drawing, one
of the most harmonious of all Michelangelo's architectural
studies, must have been done. In connection with his despair
over the abandonment of the San Lorenzo project, it may be
important that he thought so little of this study that he was
willing to send it off with a letter on the back. Nothing but
a blank tabernacle is indicated in the wooden model, if it can
be believed. From the drawing, No. 149, it is impossible to
tell whether a tabernacle or a niche was intended. Certainly
not a window, since it was no longer possible to light the
interior through a narthex façade, and this must have been
the reason for abandoning the four probable windows that
appear in No. 148. Possibly the tabernacle in the model

dissatisfied everybody, including Michelangelo. The magnificent niche for the apparently essential statue of the Madonna and Child, overlooked in the letter of 1517 (see page 131) and in the contract, would then have a home. The inventive shape, probably the first of Michelangelo's broken pediments, gives to the niche the arched form of the pediment in the drawing and model, now embraced by a new pediment that has the same angle as the raking cornice of the pediment crowning the façade. The space between the entablature above and the pediment is filled with a delicately suggested little attic, with recumbent figures. The orientation of the niche as foreseen by Michelangelo is that of the façade of San Lorenzo; this is made clear by the strong sunlight from the left (south) which brings out the form of the niche.

155. *St. Cosmas with one of his brothers*
1517–18(?)
Pen over black chalk preparations, 13 × 7½″
OXFORD, ASHMOLEAN MUSEUM, P. 324

This superb drawing, full of the macabre fantasy which appears again and again in the writings and imagery of Michelangelo, has nevertheless been rejected by several scholars. None of the attempts to attribute it to other artists has met with success. The drawing was well known in the sixteenth century and often copied. The subject is generally considered female, and characterized either as a beggar or a witch. Difficult as it may often be to pin down the sex of a Michelangelo figure, this one is not a case in point. Nothing about the costume, gait, or appearance indicates a woman. The heavy hooded cloak, the slouched beret, and the short tunic are surely items of male apparel, and probably represent Michelangelo's idea of what a doctor should wear. In the second design for the San Lorenzo façade, Sts. Cosmas and Damian were to be placed above the tabernacles, and therefore would probably appear in profile. In the third design, represented by No. 149 and by the wooden model, the only position left for them would have been in the niches of the returns on the ground floor, again making a profile position almost mandatory, with each saint looking toward the center of the huge composition around the corner. In Domenico Buoninsegni's letter of February 2, 1517, giving Michelangelo the directions for the iconography, he says, "As for the kind of figures, and how they should be dressed, the Cardinal told me that you should choose the dress in your own way, because he does not understand the mysteries of the tailor." But later, speaking of Sts. Cosmas and Damian, "you must show them as doctors because they were doctors." Apparently this was not enough, because on March 8 Buoninsegni wrote, "As for the dress of those saints, I referred it to the Cardinal, and he wanted to see the letter, and so he showed it to the Pope; and they converted the matter into laughter. And finally he said that you should dress them as you wished." Which is just what Michelangelo seems to have done. It is not difficult to see what provoked the Medicean laughter, but for all its ingredient of caricature, the drawing is very grand. Michelangelo has revived his early pen technique and his early admiration for Masaccio's massive drapery, both on a new plane of ease and freedom.

156. *Study for the head of St. Damian(?)*
1517–18(?)
Red chalk, 6⅛ × 4⅞″
OXFORD, ASHMOLEAN MUSEUM, P. 322

The wild conception—the physical type with bulbous nose, and the combination of heavy cloak with hood and great, soft beret pulled forward—unites this drawing to No. 155, in spite of the difference in medium. The drawing of the locks of hair and beard is so characteristic for Michelangelo and the modeling so rich and beautiful that it is hard to understand the disagreement over the authorship of this sheet, with proposals as contradictory as Antonio Mini and Battista Franco. The head seems to be a careful study, perhaps from a model, of the head of the saint on the other return, which would have been St. Damian. The luminosity of the rolling eye is especially beautiful. The head of an animal can faintly be discerned in the front of the cap.

157. *Study for the head and shoulders of St. John the Baptist(?)*
1517–18(?)
Pen, 5⅛ × 5⅛″, cut down heavily, and corroded
LONDON, BRITISH MUSEUM, W. 2

This violent fragment has been ignored by many scholars but seems now impregnable. Superficially it appears to resemble the early pen sketches, but on reflection it will be observed that the manner is too loose and free to permit an early dating. The wildly rolling eye is typical of the series here isolated as belonging to the San Lorenzo façade. There are no contours in the earlier sense, the hatching and cross-hatching are very rapid, and the masses of hair show many memories of the Sistine Ceiling, not to speak of the similar locks in No. 156. Variously identified as Satan and as a satyr, although it possesses the visible attributes of neither, the drawing would be most suitable for a St. John the Baptist, and is proposed here as a study for the head and shoulders of the figure to the left of the central doorway.

158. *Sketch for a standing saint (St. Lawrence?)*
1517–18(?)
Red chalk, 8⅜ × 5″
OXFORD, ASHMOLEAN MUSEUM, P. 307 verso
(for recto see No. 219)

This thoroughly characteristic figure sketch has suffered from the usual doubters, with the same lack of agreement among them. It can be compared successfully with any number of authentic figure sketches. The pose, with its sharp, protruding zigzags, suggests a position on a pedestal in the lower story, rather than in a niche above, in which all the special quality of the rhythm would be lost, and where in fact, there would scarcely be room for the bent left elbow. Candidates such as Sts. John the Baptist, Cosmas and Damian, Peter and Paul are eliminated by their beards. This leaves only St. Lawrence, who should be dressed as a deacon. It could be that Michelangelo preferred to ignore this fact, as he was later to do in the *Last Judgment*, in the interests of his all-consuming desire to show the complete human body. And after all, St. Lawrence did not go to his martyrdom dressed in a dalmatic. Or possibly Michelangelo, as always in his draped figures, sketched the principal masses in the nude. At any rate, the pose would make sense if the bent leg were intended as a prop for the gridiron.

159. *Sketch for St. Augustine or St. Ambrose*
1517–18(?)
Pen, 6¼×4½", cut down, especially at top, spotted
FLORENCE, CASA BUONARROTI, 21 F

Although initially doubted by two scholars, this brilliant sketch is now universally accepted as genuine. The lightning flash of the linear movement is characteristic of the best of Michelangelo's figure sketches, and the pose comes from the same dramatic and dynamic repertory as the Prophets and Sibyls of the Sistine Ceiling. Doubtless the mitered figure was to be clothed, and it has been suggested that the study was originally intended for one of the tombs of Popes Leo X and Clement VII; these were first to have been erected in the Medici Chapel, then in the choir of San Lorenzo, and after many misfortunes they came to rest in Santa Maria sopra Minerva in Rome, in dull versions by Antonio da Sangallo the Younger and Baccio Bandinelli. But even for an artist as unconventional as Michelangelo it is hard to conceive of a ceremonial portrait of a Pope on a funeral monument in such a pose. The twist of the torso and the movement of the legs to one side make sense only for a figure designed to be seen from below. The copy in the Uffizi by Antonio da Sangallo of a lost design by Michelangelo shows a figure in the mezzanine in just this flattened zigzag pose, the only one possible for statues seated in such a shallow space and so far above eye level. The mitre would seem to identify the bishop as one of the two episcopal Fathers of the Church (Gregory was a Pope and Jerome a Cardinal), and since the Sangallo drawing for the left side of the façade shows a figure seated in the opposite direction, this one must have been designed for the other side. The original basilica of San Lorenzo had been dedicated by St. Ambrose in person, so he must be the saint to the right (the observer's left) in the Sangallo drawing. We are left with St. Augustine, and as this figure is clearly holding and reading a large book in the manner of the *Libyan Sibyl* (this has not been previously noticed), what could be more natural for so prolific an author?

160. *Study for a seated female saint (St. Reparata?)*
1517–18(?)
Pen, 10½×7⅞", heavily creased and patched, corroded
OXFORD, ASHMOLEAN MUSEUM, P. 325

Inseparable in style from No. 155, this tempestuous pen drawing has suffered an even worse fate at the hands of critics, given back and forth from Passarotti to the non-existent "Andrea di Michelangelo," but it has been revindicated of late. It is thoroughly characteristic of the vein of wild fantasy which flowed freely in Michelangelo's imagination after the lunettes of the Sistine Chapel, and its broken crosshatching and heavy, fragmentary contours are of the greatest intensity. The placing of the figure, so as to be seen from the side and from below, and the propping of one foot on a block to render the knee visible, are devices used in No. 162. The terrified woman has been called a sibyl, but for this there is no evidence. If she was designed to flank the four Fathers of the Church (see page 131), then she must be a saint. A natural candidate would be St. Reparata of Florence, dethroned only in the fifteenth century from her traditional patronage of the Cathedral of Florence. This young lady, represented with a veil in her statue by Arnolfo di Cambio, was sprinkled with melted lead, paraded nude through the city of Caesarea, and thrown into an oven, after which her breasts were cut off, her entrails divided, and she was de-

capitated. From her severed neck a dove ascended to heaven. If one is searching for a motive for the agitation of our figure, the fate of St. Reparata might provide it. A probable position for her on the façade would be the right return of the mezzanine, so that her glance would be directed toward her former cathedral, through whose portal a silver dove flies from a great cart every Easter Saturday.

161. *Study for the head of an Evangelist (?)*
1517–18(?)
Red chalk, 11⅛×7¾"
OXFORD, ASHMOLEAN MUSEUM, P. 316 recto
(for verso see No. 303)

Another wild drawing, identical in soft hatching and delicate modeling to No. 156; it has the pointed nose and protruding lower lip of No. 155, and the dilated, staring eye common to the entire series. The tufted masses of the hair, and the beret worn at a rakish angle, together with the broad opening of the mantle, heighten the impression of strangeness in the features and expression. Ignored by some but doubted only once, this study seems to have won a secure place in Michelangelo's work. Again, the concentration on proportional abnormality, even ugliness, raised to the plane of beauty, develops directly out of the Sistine lunettes. Who can this weird individual be? All the saints of the lower register are either accounted for or ruled out. The position of the head and the swelling chest suggest a standing figure. The Evangelists in the niches of the second story remain, and St. Luke offers the most likely possibility. The slouching hat recalls Nos. 155 and 156, proposed as Sts. Cosmas and Damian; St. Luke, too, was a doctor, which may account for the garb.

162. *Seated monastic saint*
1517–18(?)
Pen, red chalk, 6½×10½" (half of drawing lost)
WINDSOR, ROYAL LIBRARY, 12763 recto
(for verso see No. 168)

The impressive pen sketch has had the usual critical history. It clearly belongs with the others of the series. Most likely it was done for a seated figure in the highest row, the attic story of the San Lorenzo façade, but cannot yet be further identified, although San Giovanni Gualberto, founder of the Vallombrosan order, is a distinct possibility. It has been proven that the chalk studies of a young man asleep, with his left arm hanging, were done after a famous work of ancient sculpture, a Cupid and Psyche known in the Renaissance as the "Bed of Polycletus." This marble relief, now lost, was in the possession of Lorenzo Ghiberti and was inherited by his grandson Vittorio, who was a friend of Michelangelo's. This fact, however, does not establish the authorship of the drawings, which show a dull contour and crude, sometimes sloppy hatching difficult to accept as the work of the master. Michelangelo's sovereign disregard for these studies, placing his seated figure right over one of them, may be a further indication that they are pupil's work.

163. *Study for right half of a scene from the lives of Sts. Cosmas and Damian*
1517–18(?)
Pen, 10⅝×7¾″
HAARLEM, TEYLERSMUSEUM, A 22 recto
(for verso see No. 164)

Another frequently rejected drawing, this belongs with the other pen studies of the series. The left half of the drawing has been lost, so it is not possible to reconstruct the incident accurately. It might have been the martyrdom; but as the kneeling brother is still wearing his cap (this time a more conventional doctor's cap), that supposition seems unlikely. Both saints are praying, perhaps for the miraculous delivery from demons of the proconsul Lycias. The proportions of the whole drawing must have been roughly equal to those of one of the horizontal reliefs, either for the mezzanine or the upper story of the façade. The standing saint is beautifully studied, with a rich construction of folds which allows full expression to the underlying masses of the thighs. The tufted hair reminds one of other drawings in the series, and the tunic, reaching just below the calf, is the same as that worn by the saint in No. 155. The triple hatching is rare in Michelangelo's pen drawings.

164. *Left half of a scene from the lives of Sts. Cosmas and Damian*
1517–18(?)
For medium and dimensions, see No. 163
HAARLEM, TEYLERSMUSEUM, A 22 verso (for recto see No. 163)

Again, the loss of half the drawing prevents the identification of the scene, but not of the right-hand figure, who wears the best doctor's gown of the series. The drawing might have represented the brothers before Lycias. Certainly something rather astonishing is going on, perhaps it is another miracle of Sts. Cosmas and Damian, that of the grafted leg. Even the passages of contour and underdrawing are very beautiful.

165. *Sketch for the Crucifixion of Sts. Cosmas and Damian*
1517–18(?)
Pen over metalpoint, 9⅞×6⅜″, cut down
LONDON, BRITISH MUSEUM, W. 12

In spite of two doubters, this astonishing drawing is now generally accepted. From this electrifying sheet radiates all Michelangelo's authority in the construction and movement of the human figure, and all the passion of his most intense conceptions. It has been connected with the *Haman* of the Sistine Ceiling, but without success; the artist has clearly intended two different figures, for one is bearded and the other is not. The crucifixion of the two saints, one among numerous unsuccessful attempts to do away with them, would have made a fitting subject for one of the circular reliefs. Michelangelo's device of crucifying them on trees, one higher than the other, breaks up the regularity of Fra Angelico's predella on this same subject, now in Munich but then still on the high altar of San Marco.

166. *Figure sketch for the Crucifixion of Sts. Cosmas and Damian*
1517–18(?)
Pen, 3¾×3⅝″
OXFORD, ASHMOLEAN MUSEUM, P. 313

While the executioners were shooting arrows and throwing rocks at the crucified Cosmas and Damian, the saints' three younger brothers were tied to a pole connecting the two crosses. This upward-looking figure, with at least two pairs of arms in various poses and an extra leg, seems to be an experiment in establishing one of these figures. Oddly enough, no one seems to have questioned its authenticity.

167. *Figure sketch for the Crucifixion of Sts. Cosmas and Damian*
1517–18(?)
Metalpoint, 3½×1⅝″, cut down
LONDON, BRITISH MUSEUM, W. 51

Clearly intended to be reinforced later with ink lines, this diaphanous yet perfectly constructed little figure was probably for another of the younger brothers of Sts. Cosmas and Damian.

168. *Figure sketch for the Crucifixion of Sts. Cosmas and Damian (detail of sheet)*
1517–18(?)
Pen, red chalk, 10½×6½″ (half of drawing lost)
WINDSOR, ROYAL LIBRARY, 12763 verso
(for recto see No. 162)

Another tiny sketch in the same style as Nos. 171–76, probably for one of the bound brothers, sharply foreshortened and brilliantly defined in a few powerful strokes. The weak drapery masses on the rest of the sheet (not illustrated) are clearly by a pupil.

168A. *Two figure sketches for the martyrdom of Sts. Cosmas and Damian(?)*
1517–18(?)
Pen and black chalk over stylus preparations, 8¼×9″, cut down
HAARLEM, TEYLERSMUSEUM, A 17 recto

Seldom mentioned and generally either doubted or rejected, this drawing has nonetheless been recently compared by one of its negators to the style of Nos. 163 and 164. The connection is inescapable, in the contours of the figures, the construction of the profiles, the hatching and crosshatching, and above all in the characteristic handling of the feet and ankles. Moreover the study clearly belongs with the other pen drawings in the series, with which it invites detailed comparison. The bending woman is holding an axe (not a hoe, as one author put it). She seems to be either picking it up from the ground or, more probably, handing it to a person below her, not shown. The same author called the male figure a "satyr," of which there is no indication. He wears a hat on which a plume can be made out, and half sits, half leans on a block of some sort, with a piece of drapery between his right knee and elbow. Doubtless he is a soldier. Both figures may have been intended for the final act in the protracted drama of the attempted martyrdom of Sts. Cosmas and Damian—their decapitation.

The bending woman resembles in style and pose a figure in the boat in No. 69, for the *Deluge* on the Sistine Ceiling.

The fantastic construction of the soldier's face points directly to the giant head, No. 304, and even to the monstrous soldiers who inhabit the Pauline Chapel. The pose of his right leg was sharply lifted after the stylus preparations, to increase both tension and compression. In all details, both sketches show the idiosyncrasies of Michelangelo's pen style. Certain passages of light and shade on the masses of the soldier's torso and legs are very grand.

The words in Michelangelo's handwriting at the lower left, apparently written over preceding marks in pen, seem to read "cari cari."

169. *Fires of St. Lawrence*(?)
1517–18(?)
Red chalk, 4⅜×7½″
HAARLEM, TEYLERSMUSEUM, A 31 recto
(for verso see No. 316)

Although for a while attributed by three scholars to Daniele da Volterra, this remarkable drawing has now been re-vindicated by one of them; it should be accepted as a sketch by Michelangelo, completely in keeping with those done a few years later for the Medici tombs, Nos. 212 and 216–18. The hatching, broad and loose, and the relative softness of the strokes indicate this period. An endless number of subjects have been proposed for this and the following clearly related drawings, Nos. 170–76, all the way from the Fall of Phaëthon to Moses on Mt. Sinai, and they have recently been connected with Michelangelo's work on a picture of the Martyrdom of St. Catherine which, for twelve years, his friend Bugiardini had been unable to complete, an intervention described "in great detail" by Vasari. But Vasari's account mentions no drawings on paper. Michelangelo simply "went up to the *panel* [italics mine] with a piece of charcoal, outlined with the first touches, solemnly sketched a row of marvelous nudes, which, foreshortened in various gestures, fell variously, now forward, now backward, with certain dead and wounded made with that judgment and excellence which were proper to Michelangelo." This description has little to do with the present group, which is largely not foreshortened, is partly clothed, and includes one woman; and even less with the others in the series, all showing groups of three.

St. Lawrence is the patron saint of all who are in danger from fire—firemen, cooks, bakers, glassblowers, pressers—and the collect for his Mass is a prayer to God to "extinguish the flames of our vices, as Thou hast given to blessed Lawrence to overcome the fires of his torments." While No. 169 does not correspond to any space now visible on the model of the façade or in the latest drawing, No. 149, the pen sketches do. The spaces over the statues of the first story, including the returns, number six. There are six pen sketches. The spaces are square, squares (*quadri*) are stipulated in the contract, and the little figure compositions are all square. Could No. 169 have been a preliminary idea, before the notion of the six little metopes had been decided on? August 10, the feast of St. Lawrence, finds our planet in the midst of its annual meteor shower. In Italy these falling stars are known as "fires of St. Lawrence." It may be that such fires are attacking these anguished figures, the same fires which St. Lawrence and Sts. Cosmas and Damian are undergoing, and from which, by virtue of their martyrdom, they can deliver us. The flaming salamanders of Francis I, suggested below (page 139) as subjects for the decorated bases of the columns, would have made a perfect accompaniment to the series.

There is one hitch. Number 176, clearly in the same style

and belonging to the same series, shows three figures: one is youthful with arms raised, the others are old and bearded, and gaze at him in wonder, but all are rejoicing rather than frightened. This has often been called a Transfiguration, and that still seems the most accurate title. The contract of 1518 does not tell us *how many* square reliefs there were to be. Possibly this *Transfiguration* was to have gone over the central door as a symbol of the divine origin of all fire.

The entire series, but especially the pen sketches, witness the amazing sureness of Michelangelo's hand in summarizing with a few powerful strokes the movements of bodies twisting and turning in pain and terror within their narrow fields. Together the independent pen strokes create a steely fabric of great resiliency and beauty.

170.
Pen over leadpoint, 4×4⅛″
OXFORD, ASHMOLEAN MUSEUM, P. 321

171.
Pen and leadpoint, 6⅝×8¼″, spotted and relined
FLORENCE, CASA BUONARROTI, 38 F

In addition, at least six faintly sketched leadpoint figures, impossible to photograph and thus not illustrated here, are scattered over the portions of the sheet not covered by pen drawings. These, too, were doubtless sketched first in leadpoint.

172.
Pen, 3¾×3⅝″, cut down and spotted
FLORENCE, CASA BUONARROTI, 17 F

173.
Pen, 3½×4¼″, cut down and relined
FLORENCE, CASA BUONARROTI, 18 F

174.
Pen, 4⅜×4⅝″, cut down and relined
FLORENCE, CASA BUONARROTI, 67 F

175.
Pen, 4×4⅜″, cut down and relined
FLORENCE, CASA BUONARROTI, 68 F

176. *Transfiguration*
Pen, 2¾×2⅞″, cut down and relined
FLORENCE, CASA BUONARROTI, 58 F

177. *Two sketches for a Madonna and Child*
1517–18(?)
Pen, 16¼×10⅝″
LONDON, BRITISH MUSEUM, W. 31 recto

The notations in Michelangelo's hand on the verso concern payments made in October, 1524, for materials to be used in making the tomb sculptures for the Medici Chapel. As in the

case of No. 154, the writing provides a date after which the universally accepted drawing cannot have been made. The drawing may also have been intended for the same purpose as No. 154. The dates on which both sheets were reused are remarkably close. One of the drawings on this sheet, possibly the earlier of the two, shows the Virgin seated upon a block in the manner of the early relief *Madonna of the Stairs* and holding the Child, who embraces her—a tender, surprisingly Raphaelesque motive. The other, seen from below, with the Child lifted up, presupposes a lofty position. Both merely sketch or indicate the positions of the Virgin's legs, but they must have been intended for full-size groups or high reliefs, appropriate for a central niche in the façade or, even more, at the apex of the pediment, in the spot reserved for Pope Leo X in the Sangallo designs. Both are drawn in a translucent style with broadly spaced hatching. At the bottom is Michelangelo's remark to his pupil Antonio Mini, "Draw, Antonio, draw, Antonio, draw and don't waste time." From the chalk sketches Antonio drew in a pathetic attempt to copy the breezy style of the master, we can only wish that he had not taken this advice.

178. *Two studies for a Madonna and Child, one with the young St. John the Baptist, the other with St. Joseph*
1517–18(?)
Pen, 12¼ × 8⅝", cut down, damaged, and spotted by water
PARIS, LOUVRE, R. F. 4112 recto (for verso see No. 179)

Although this drawing and its verso have been generally accepted, there is a wide difference of opinion about the possible participation of pupils and about the date. There can be little reason to doubt the authenticity of either study. Both, with all their peculiarities, are natural outgrowths of the latest lunettes of the Sistine Chapel, whose often homely and peasant-like quality is far too little understood as an essential component in Michelangelo's imagination. The features of the St. John, severely criticized of late, can be found again and again among the unruly children who populate the lunettes. The pen style is identical with that of the rest of the series. This and the presence of St. John, the Florentine patron saint, should rule out the suggested connection with the early projects for the Tomb of Julius II. The grouping recalls, perhaps deliberately, the artist's early Florentine Madonnas. The other image, upside down, shows St. Joseph sleeping in a foreshortened pose strikingly similar to that of St. Jerome in the background of Parmigianino's famous *Vision of St. Jerome* in the National Gallery in London, commenced in 1526. Especially noteworthy is the Virgin's halo, very rare in Michelangelo's art. The sudden intensity of her embrace is to be found in some of the later Madonna and Child studies by Michelangelo. Neither the squares nor the notations are in Michelangelo's hand.

179. *Madonna with seated Child*
1517–18(?)
For medium and dimensions, see No. 178; cut down, badly damaged by water, head of Virgin illegible
PARIS, LOUVRE, R. F. 4112 verso (for recto see No. 178)

Somewhat less earthy in feeling, this drawing was doubtless intended for the same purpose as the two on its recto (No. 178). Possibly all three represented alternative solutions to the same problem, a Madonna image enclosed in a niche rather than silhouetted against the sky. In this case the niche is indicated by shading. The enchanting Child reads in a little book. His mother, whose obliterated face is a sad loss, gazes down at Him as she protects Him with her mantle, almost in the manner of a Madonna of Mercy. The second Child, at the bottom of the sheet, has suffered some damage, but is clearly authentic, added in the manner of the separate studies of important passages so often found in Michelangelo's drawings. Much more serene than the sketches on the recto, the drawing abounds in delicately harmonized passages of surface. The three stanzas in Michelangelo's hand were written later, over the lateral passages of shading.

180. *Sketch for a Resurrection*
1517–18(?)
Black chalk, 13 × 7¾"
FLORENCE, CASA BUONARROTI, 66 F

The number of Resurrection compositions by Michelangelo is too large, and the poses they contain are too various, to justify the customary connection of all of them with either a supposed (never executed) fresco for the central lunette of the Medici Chapel or for the well-documented fresco intended for the end wall of the Sistine Chapel in 1534. One, No. 125, has here been proposed as an altarpiece for the Sistine Chapel in 1512. A second, No. 132, appears here as a study for the central relief in the first story of the 1513 project for the Tomb of Julius II. A third composition, represented by a substantial group of drawings, may be connected with a relief over the central door of the San Lorenzo façade. It should be borne in mind that this suggestion has no documentary support, and that its value lies, so far, in its iconographic plausibility and its coherence with the rest of the series here proposed for the same great work. We do not know the subjects of the seven major reliefs for the façade of San Lorenzo, but given the appearance of Sts. Cosmas, Damian, and Lawrence as full-size statues, it has seemed reasonable to divide the reliefs between the patron saint of the basilica (and of the Duke: Lorenzo de' Medici) and the patron saints of the family. An equal division leaves one relief unaccounted for. Saint Paul's quotation from Psalm 118, characterizing Christ as the "stone that the builders rejected [which] has become the head of the corner," was responsible for a mass of medieval imagery placing the Resurrection in the keystones of arches. For these reasons the Resurrection would have been appropriate for the commanding position over the central doorway, uniting the martyrdoms of the patrons saints. It may be significant that a drawing of the salamander of Francis I (see page 132) is on the verso of No. 183, the most nearly finished of the series.

This loosely sketched drawing appears to be the first of the group. As in the sketches for the nudes of the Sistine Ceiling, there are several sets of legs. One has been fairly accurately drawn (traced?) after the contours of the legs of No. 125. But the pose of the arms of this heroic figure was too intimately bound up with the symbolism and the style of the Sistine Chapel for use in a horizontal relief with many figures, so a different attitude was devised, with the right hand extended downward to the watchers at the tomb, the left pointing heavenward. The legs, moreover, were resketched at least four times. Although the drawing was rejected by several critics, it has been convincingly vindicated in the most recent publications.

181. *Sketch for a Resurrection*
1517–18(?)
Black chalk, 15×10″, a large piece missing at left, and patched in
FLORENCE, CASA BUONARROTI, 61 F recto
(for verso see No. 182)

Another swift and fluid sketch, with many variants of the leg poses. Antonio Mini may have attempted to continue the arms, whose hard, dull lines are scarcely characteristic of Michelangelo's drawing style.

182. *Sketch for a Resurrection*
1517–18(?)
For dimensions and condition, see No. 181
FLORENCE, CASA BUONARROTI, 61 F verso
(for recto see No. 181)

Developed from No. 181 in reverse, but not on the basis of a tracing. The raised leg has suddenly become very clear and beautiful in Michelangelo's mind, and the straight one is taking shape. But the arms elude him, and the head is total confusion.

183. *Study for a Resurrection*
1517–18(?)
Black chalk, 16¼×10¾″
LONDON, BRITISH MUSEUM, W. 54 recto
(for verso see No. 190)

Now the artist has begun to arrive at a more convincing pose, but the fact that he abandoned the drawing in its unfinished condition, after the meticulous stippling of the legs, torso, and beautiful left arm, indicates that he was still not satisfied. The legs were perhaps too close now, the raised left arm a little hesitant for the amount of finish it received. Number 125 seems to have lain before Michelangelo as he worked, but the modeling of the knee is here much softer than in that noble study. The drawing has been accepted by the very scholars who reject the preparations for it, including one who has recently changed his mind.

184. *Sketch for a Resurrection*
1517–18(?)
Black chalk, 13×7½″, corroded at edges and slightly cut down
WINDSOR, ROYAL LIBRARY, 12771 verso
(for recto see No. 353)

If the present reconstruction of the series is correct, Michelangelo was arriving in this sketch at a clear definition of the difficult figure and of its relation to the surrounding watchers. Now Christ at once floats and springs. All the knowledge gained by the doodles in the preceding sketches and the careful anatomical study in No. 183 is summarized in brief, authoritative contours. It is possible at last to imagine, through the pose of the figure at the right, the lateral extension of the composition.

185. *Sketch of a watcher for a Resurrection*
1517–18(?)
Red chalk and black chalk, 10½×7⅝″
FLORENCE, ARCHIVIO BUONARROTI,
XIII, fol. 148 verso

A light sketch for one of the guards, probably for the same composition for which No. 184 was made, on the left of Christ looking up.

186. *Sketches for the Medici escutcheon, for two executioners for a Martyrdom of St. Lawrence, and for a shouting head*
1517–18
Black chalk (escutcheon and head), red chalk (figures), 13¾×10″
LONDON, BRITISH MUSEUM, W. 33 verso
(for recto see No. 496)

Only two critics have ever doubted this drawing. There should be even less doubt about its purpose. The balls on the Medici arms can still be made out on the escutcheon, with its fantastic curved pediment broken into two wings, the progenitor of a long line of such pediments in Mannerist ornament. Above the arms the apex of a larger, complete pediment is visible. Since the contract required Michelangelo to put the Medici arms in the pediment, there must have been a Martyrdom of St. Lawrence among the seven major reliefs for the façade. Executioners with staves, in poses quite similar to these, appear in Bronzino's huge, oppressively Michelangelesque fresco in San Lorenzo itself, pushing the saint down on his grill for even roasting. Some of Bronzino's figures look upward like these. As for the screaming face, on its side, there is no telling.

187. *Two figures of executioners for a Martyrdom of St. Lawrence*
1517–18
Pen, traces of red chalk, 3⅝×2½″, cut down
FLORENCE, UFFIZI, 618 E

Doubted by a single critic, this lightning sketch cannot be separated from the other powerful pen sketches of the series, especially those probably intended for the reliefs of the Fires of St. Lawrence, Nos. 170–76. Their most likely purpose was to define the poses of the executioners tending St. Lawrence's grill.

188. *Salamander*
1517–18
Black chalk, 5¼×8¼″
OXFORD, ASHMOLEAN MUSEUM, P. 320

Is this a salamander or isn't it? Most scholars have been convinced that it is, even if Michelangelo was not entirely sure what the fabulous salamander of Francis I should look like. The flames gathering around the poor beast leave little doubt. The wind god with puffing cheeks blowing the flames from the left is typical of Michelangelo's humor, and could hardly have been intended as an addition to the design. Neither could the person advancing from the right, apparently preparing to beat down the flames. Probably this and the following drawings were preparations for ornamental figures to go on the bases of the six great columns of the lower story of the San Lorenzo façade, counterparts to the Fires of St. Lawrence reliefs above the statues.

189. *Salamander*
1517–18
Black chalk, 5 × 3⅝″
LONDON, BRITISH MUSEUM, W. 50

This amusing little sketch, clearly a variant of No. 188, has always been reproduced on its side, as if the animal were recumbent. In this position, the hatching could only have been done with the left hand. The sketch should be turned the other way round, as reproduced here, and it will then be seen that the hatching is identical to that of No. 188. Sitting up the creature looks much better; in fact this is the only way to explain the position of tail, hind legs, and neck. This way he fights back.

190. *A female salamander; sketch of a male nude (portion of sheet)*
1517–18
Black chalk, 16¼ × 10¾″ (whole)
LONDON, BRITISH MUSEUM, W. 54 verso
(for recto see No. 183)

This is the same mythological species as Nos. 188 and 189. Only the gender has changed, as the creature is provided with breasts. The little figure below, similar to that on No. 167, and the salamand(ra?) are both squared off, like the Madonnas in No. 178, also probably for the San Lorenzo façade. The *Resurrection*, suggested for the San Lorenzo façade, is on the verso.

191. *Salamander(?)*
1517–18(?)
Pen over black chalk outlines, 10 × 13¼″
OXFORD, ASHMOLEAN MUSEUM, P. 323 recto (for verso see No. 311)

This magnificent and by now universally accepted example of Michelangelo's demonic fantasy seems to belong to the same series, though provided with hind legs only, a pair of drooping wings, and a wonderful neck daintily knotted with the tail. From the beautiful pen treatment, identical with that in the pen figure drawings of the series, we get a hint as to the probable appearance of the final sculptured ornament. Like so many of the group, this was given to the wretched Antonio Mini to practice on, and he perpetrated the profiles.

146

147

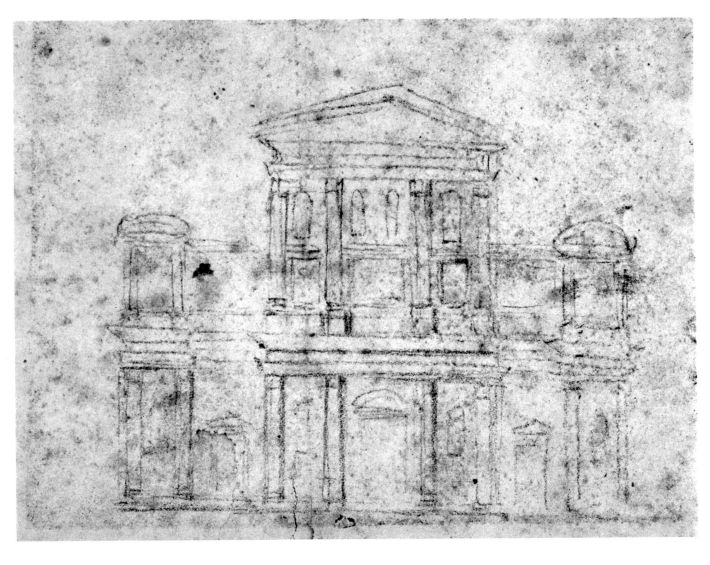

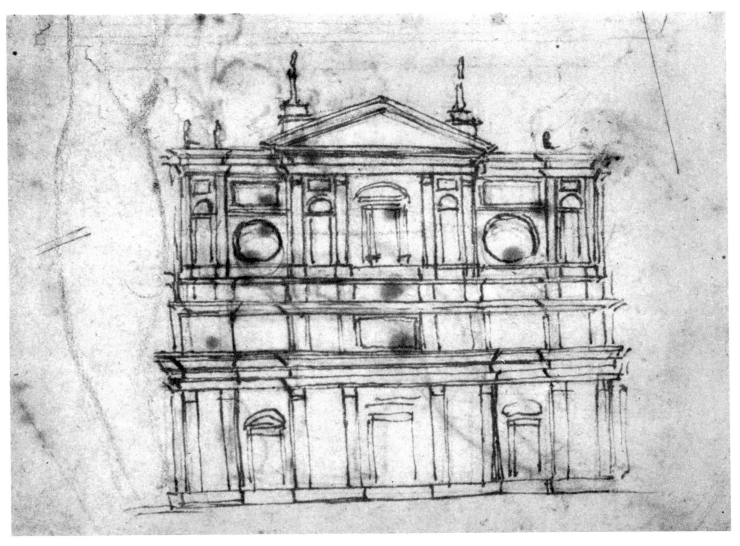

150

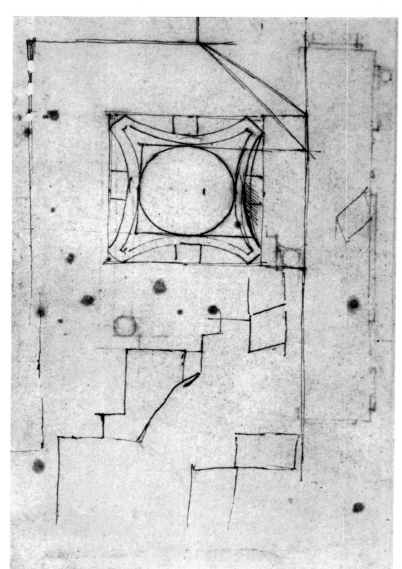

151

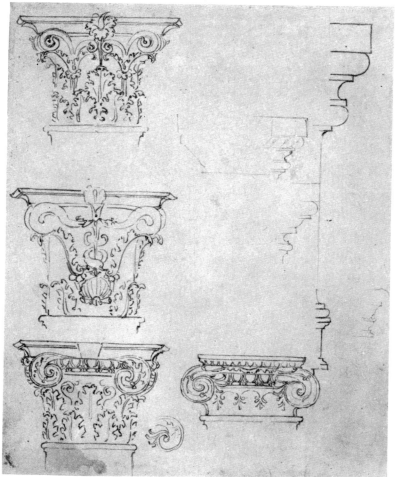

152

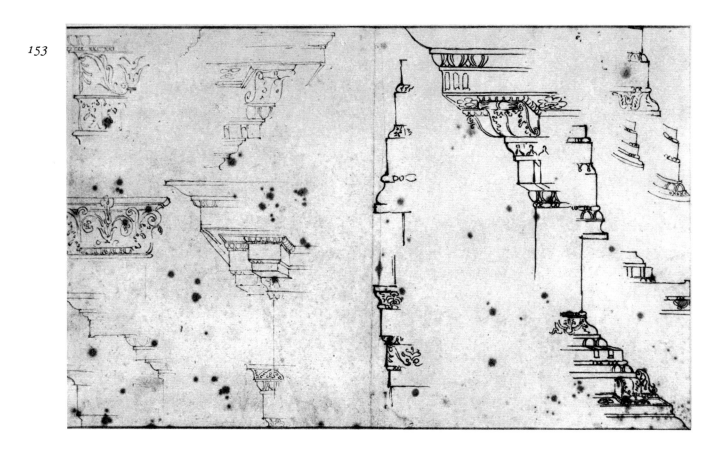

153

154

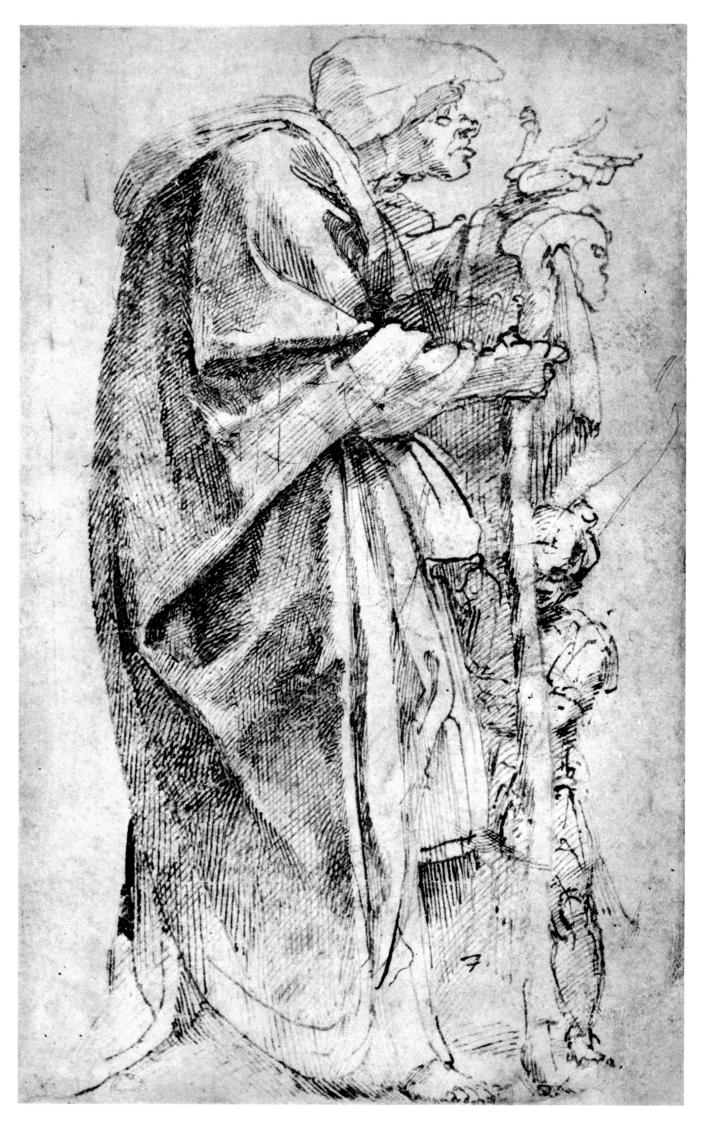

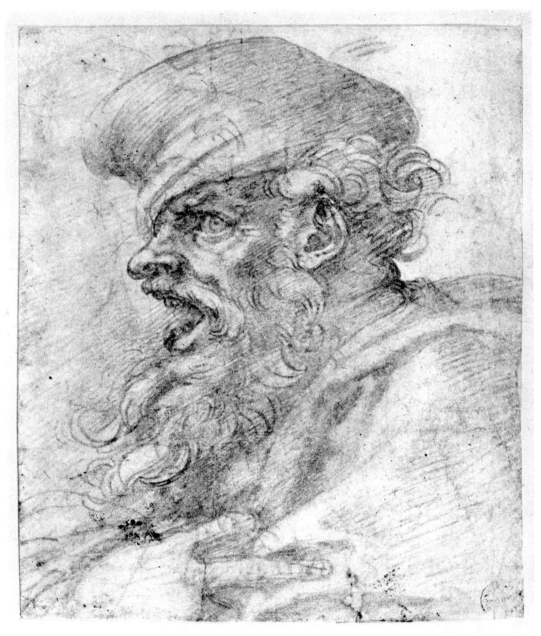

156

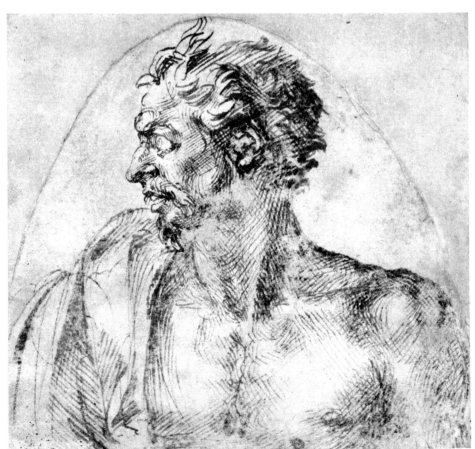

157

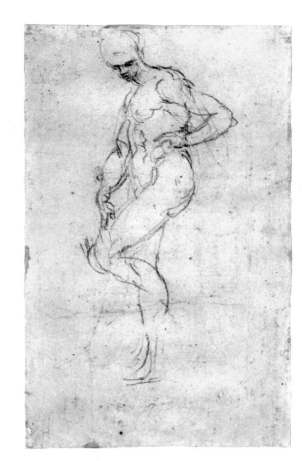

158

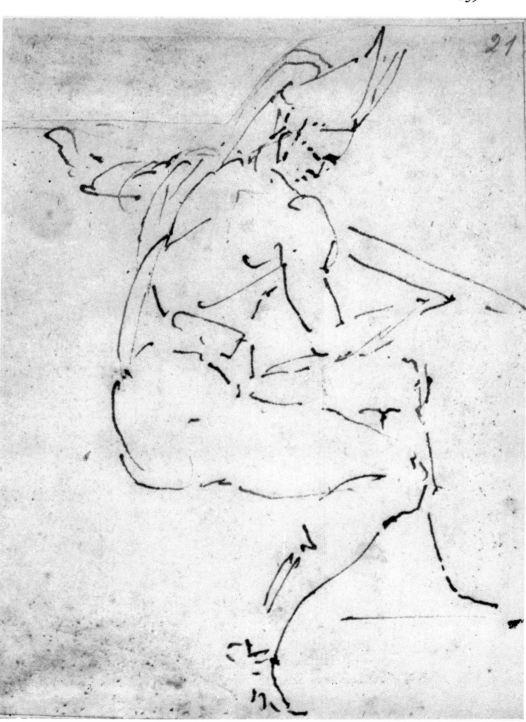

159

21

146

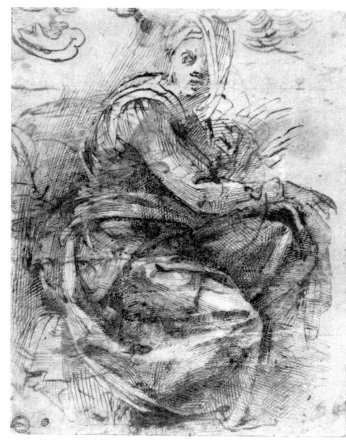

160

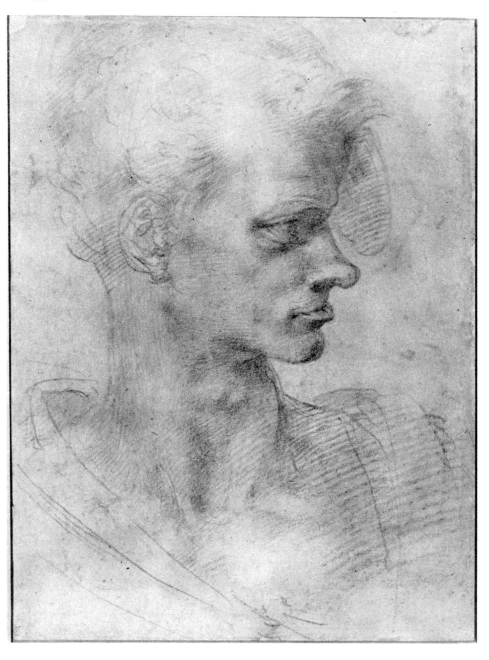

161

147

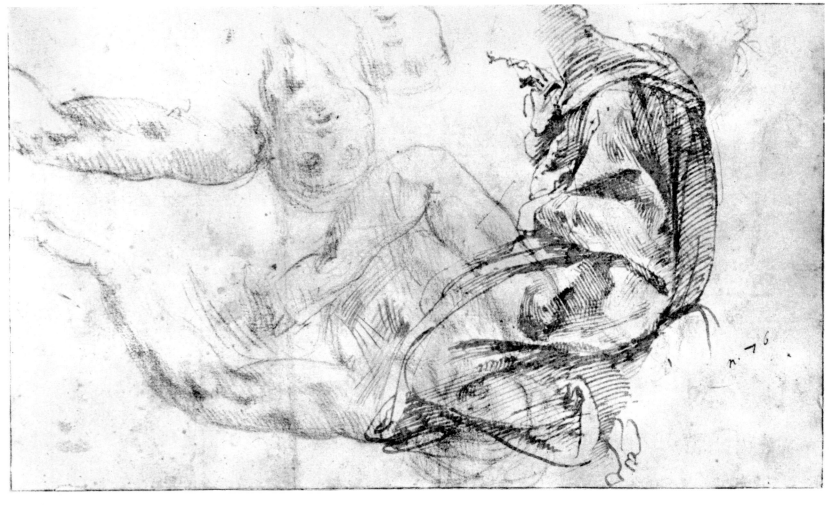

162

163

164

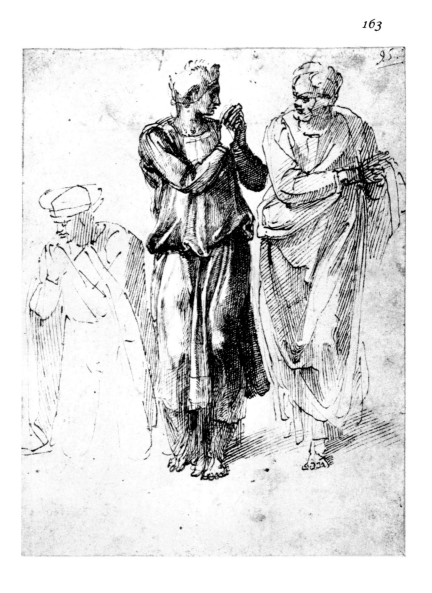

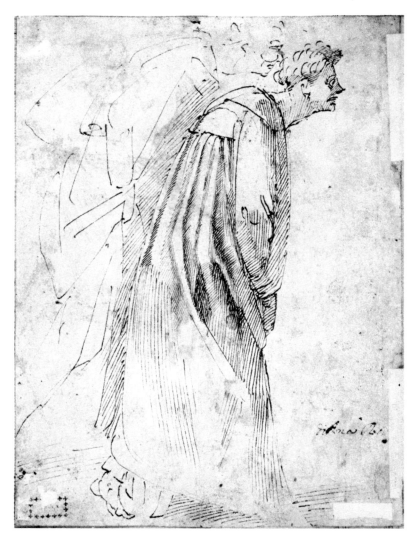

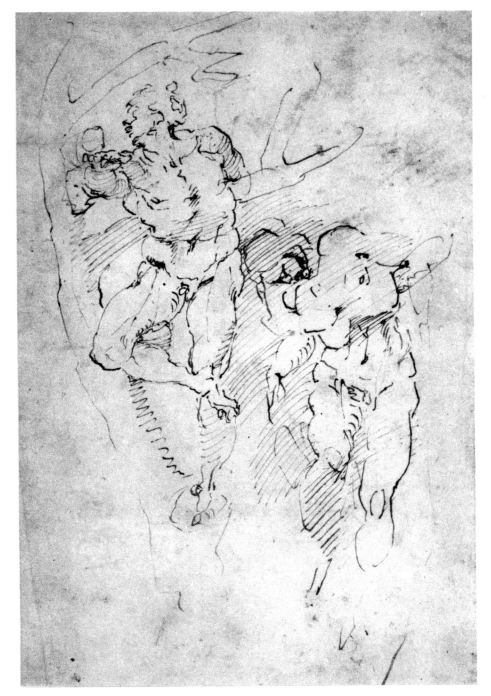

165

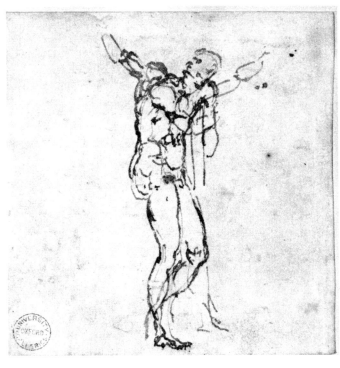

166

167

168

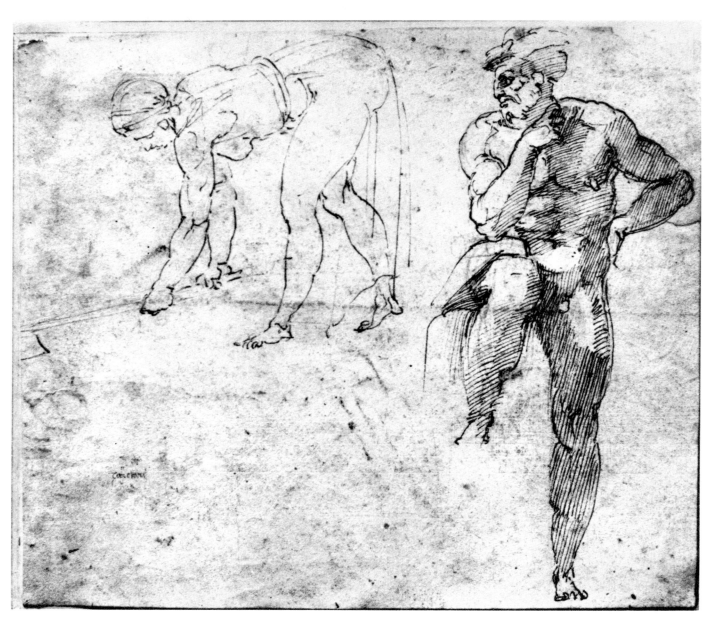

168A

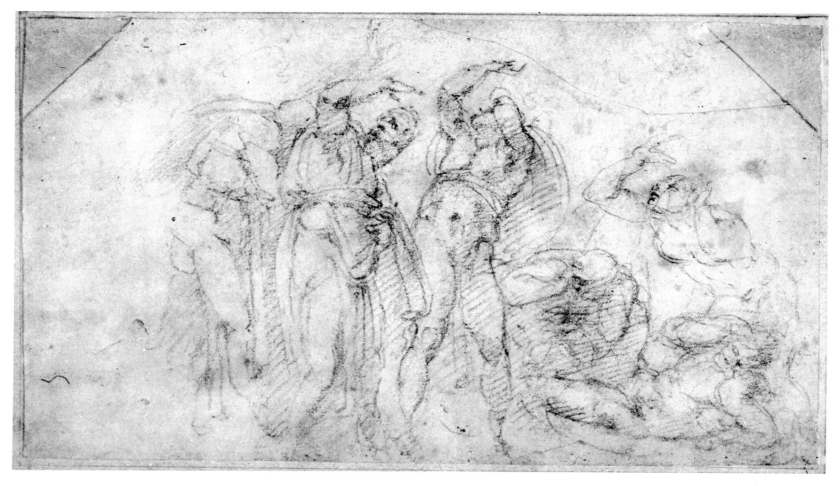

169

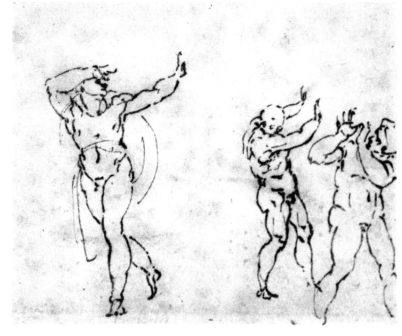

170

171

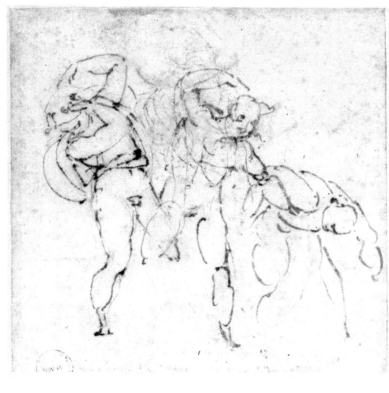

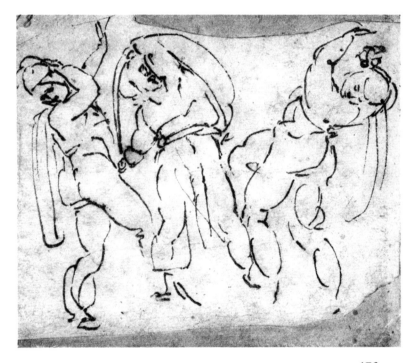

173

172

151

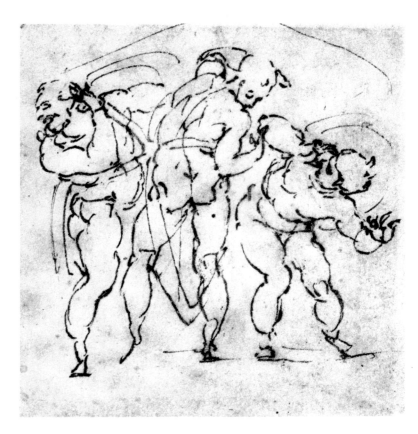

174

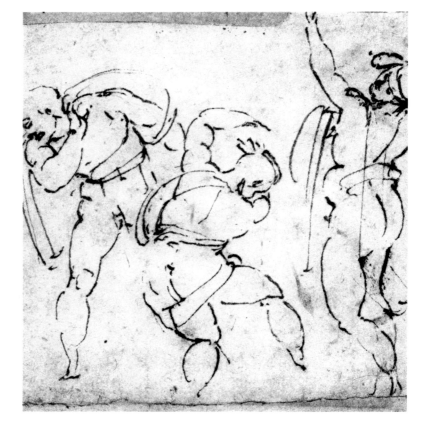

175

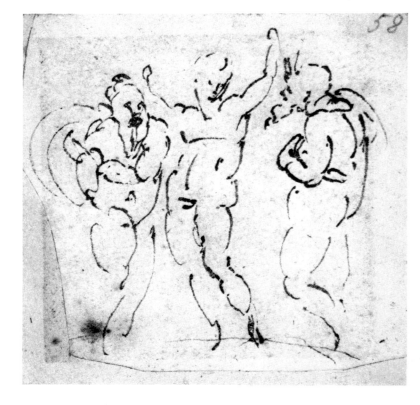

176

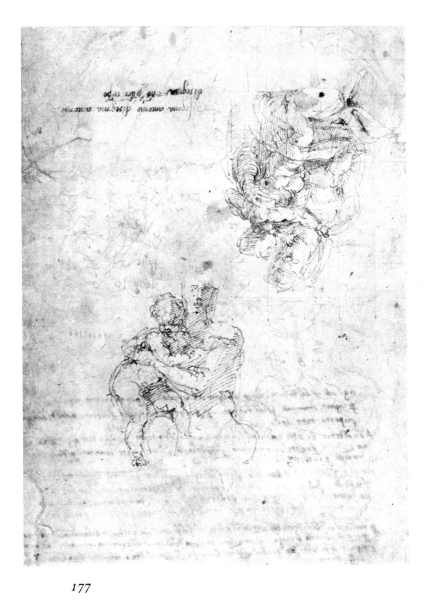

177

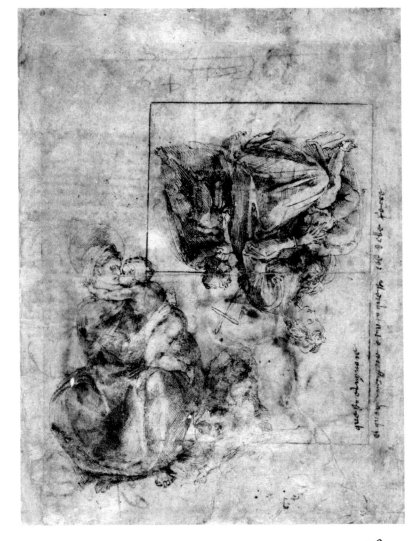

178

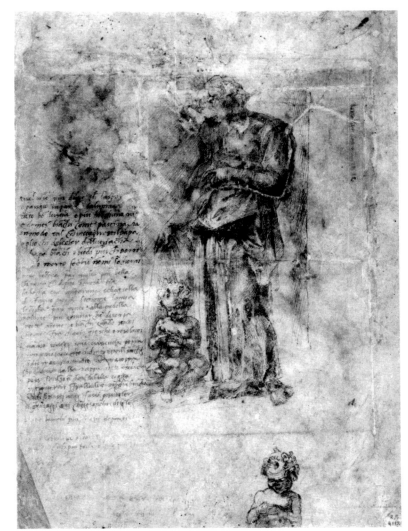

179

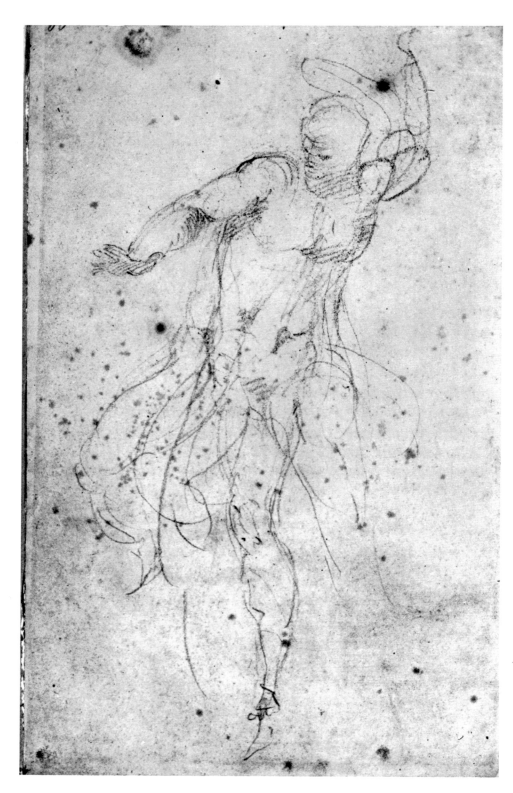

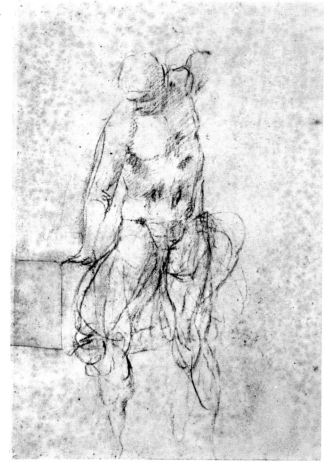

182

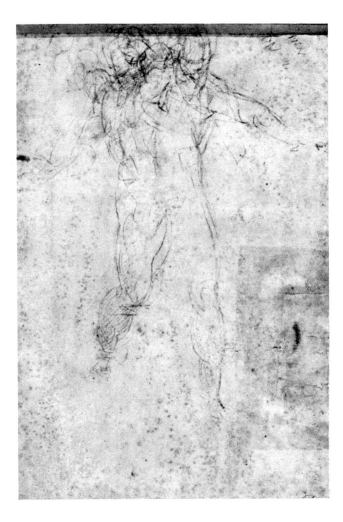

183

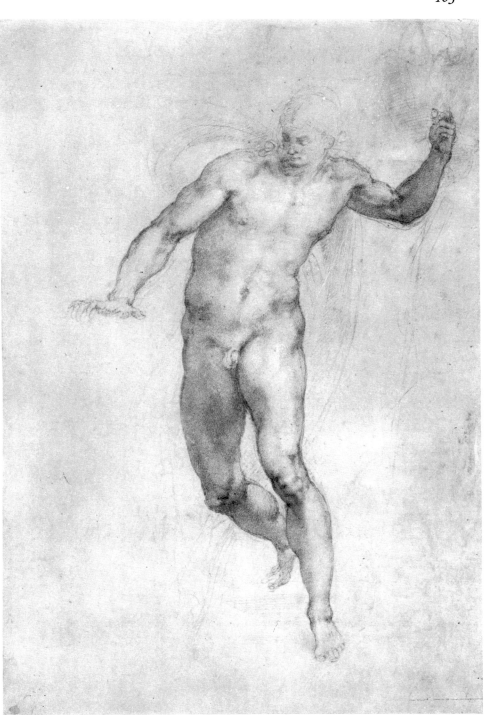

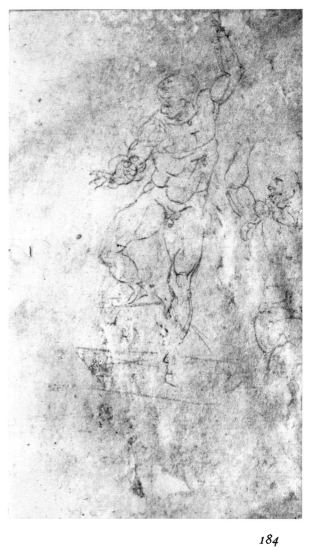

184

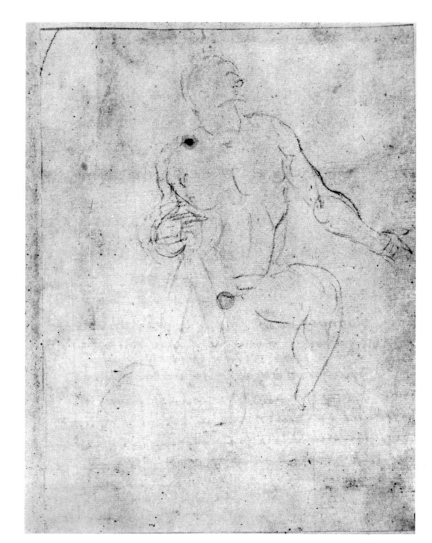

185

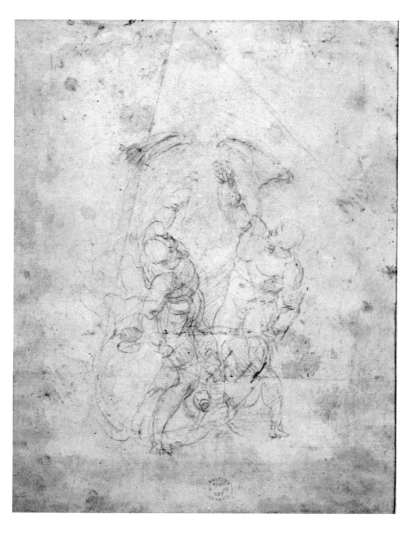

186

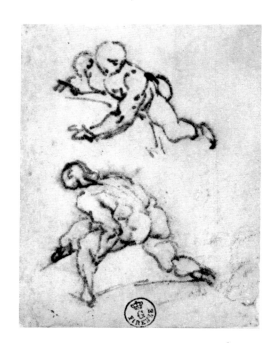

187

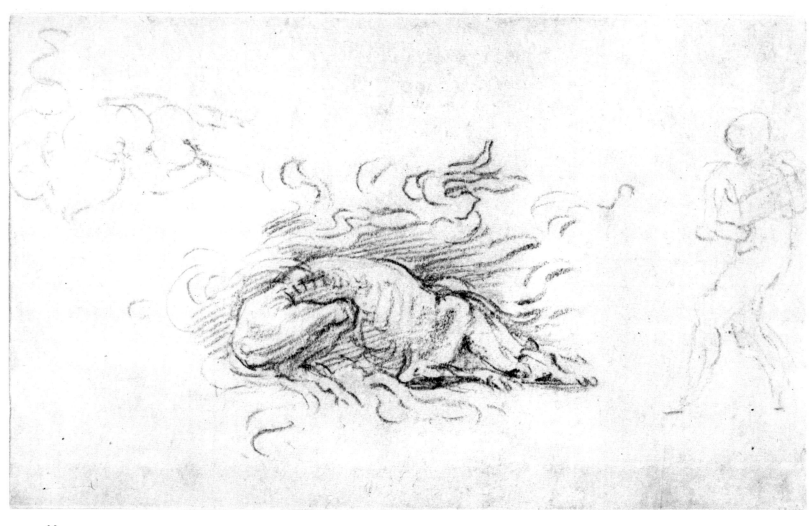

188

189

190

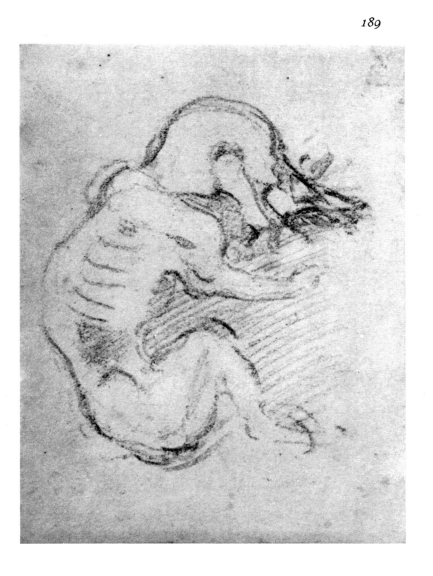

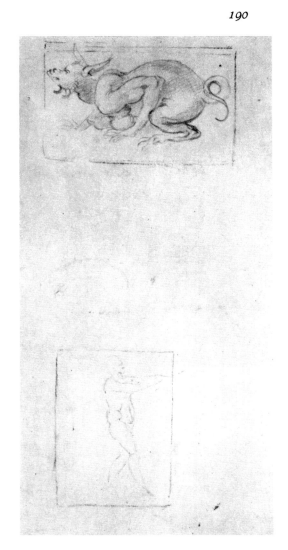

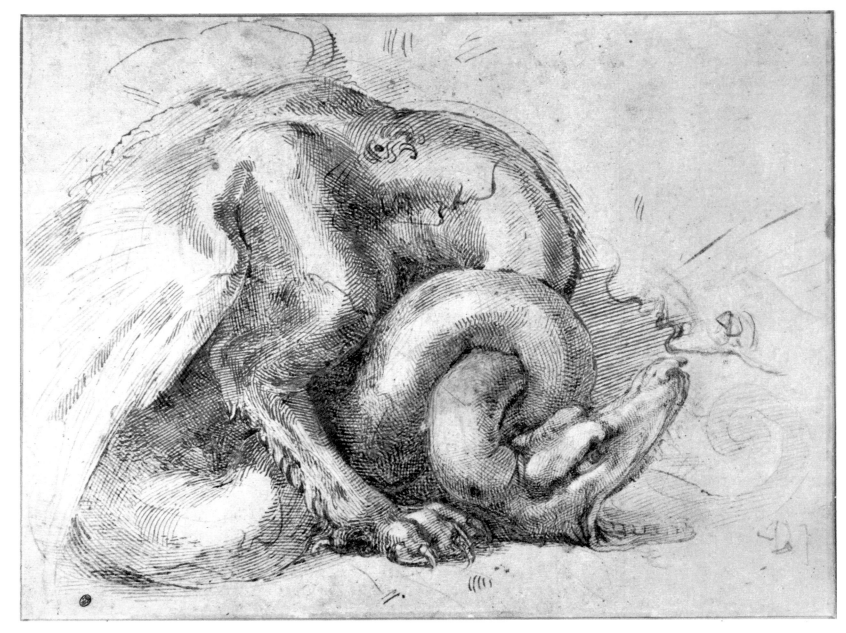

191

8

Architectural drawings. Florence, 1516–20

192. *Sketch of a portion of the dome of the Cathedral of Florence*
1516–20
Pen, 9⅞×8″, cut down
FLORENCE, CASA BUONARROTI, 50 A recto (for verso see No. 193)

When Michelangelo arrived in Florence in 1516 he protested strongly against the section of gallery erected by Baccio d'Agnolo (his collaborator on the first design of the San Lorenzo façade) on the dome of the Cathedral of Florence, which had been left incomplete by Brunelleschi. Calling the new gallery a "cage for crickets," he insisted that the monument needed a completion worthy of its majesty, and undertook to provide a model. This and the following sketches were made for it. The result, alas, was that nothing whatsoever was done from here on out, and the dome remains as Baccio left it. This sketch shows Michelangelo's idea for a corner pilaster, with more "design, art and grace" (Michelangelo's words) than Baccio's clumsy creation. Brunelleschi's projecting spurs are shown at the left, as supports for a new gallery.

193. *Sketch for one of the oculus windows in the dome of the Cathedral of Florence*
1516–20
Red chalk, notations in pen; for dimensions and condition, see No. 192
FLORENCE, CASA BUONARROTI, 50 A verso (for recto see No. 192)

Below his notations on the length and thickness of the walls of Brunelleschi's great drum, and a tally with two sums of money, Michelangelo has roughly sketched out a grand design for remodeling one face of the drum, apparently desiring to substitute giant rectangles on either side of the oculus for the more elaborate grid of Brunelleschi's marble incrustations.

194. *Study for the dome of the Cathedral of Florence*
1516–20
Red chalk, 10¾×8⅛″, cut down and spotted
FLORENCE, CASA BUONARROTI, 66 A recto (for verso see No. 195)

A noble drawing elaborating the conception for the drum of the dome, as set forth in No. 193. In view of this connection, and of the summary indication of the ribs rising above the drum, it is difficult to understand the recent contention that

the drawing was intended for the altar of the Medici Chapel. The draft of a letter on the verso shows that both sides must have been drawn before June, 1520, and it is unlikely that by that time Michelangelo had any notion of how the altar in the Medici Chapel was to look. On the right he shows a panel rising to fill the space between the stylobate and the band connecting the capitals. He seems to have been dissatisfied, for the left panel, brought as far toward completion as the medium would permit, is restricted to a height governed by the diameter of the oculus.

195. *Sketch for the dome of the Cathedral of Florence*
1516–20
For medium, condition, and dimensions, see No. 194
FLORENCE, CASA BUONARROTI, 66 A verso (for recto see No. 194)

The letter drafted above another sketch for the drum of the dome was intended for Cardinal Bibbiena, as a recommendation for Sebastiano del Piombo for frescoes in the Vatican, after the death of Raphael; it reads in part, "I pray your most Reverend Lordship not as a friend or servant, because I do not deserve to be either one or the other, but as a man vile [i.e., humble], poor and mad . . . and if it should appear to your Lordship to throw away his service in one like me, I think that still in serving [i.e., being served by] madmen that one can now and then find some sweetness, as he does in onions who is fed up with capons."

196. *Sketches for an octagonal structure*
Before 1518
Pen, 6⅝×5¾″, folded and patched
OXFORD, ASHMOLEAN MUSEUM, P. 312 recto

Variously identified as the Barbazza tomb in Bologna, a ciborium for Naples, the choir of St. Peter's, and an ambo for somewhere, this drawing and No. 197, clearly for the same structure, remain riddles. This is a pity, because they are beautiful sketches, clear, orderly, and strong. It would have been a handsome structure, whatever it was meant to be, with its pilasters, jutting cornices, niches, and candelabra. The notations on the verso concern an unusual length of rope Michelangelo needed in 1518, and this is just what the seated figure seems to be hauling on.

197. *Sketches for an octagonal structure*
Before 1518
Pen, 5¾×7″
LONDON, BRITISH MUSEUM, W. 24

More developed than the tentative sketches of No. 196, and now set forth in plan and elevation. The attic is much higher, apparently as a protective parapet. Perhaps the structure was intended for the exposition of relics to the faithful.

198. *Elevation and cross section of a window for the Medici Palace*
1517
Pen, 10⅝×7⅜″, cut down
FLORENCE, CASA BUONARROTI, 101 A

Although one critic has doubted it, all others now accept this vivid sketch for one of the "kneeling windows" Michelangelo invented in 1517, at the order of Pope Leo X, to convert the entrances to the long-defunct Medici bank into proper windows for the ground floor of a princely palace. The style is close to that of the sketches for the façade of San Lorenzo, and the hatching, rapid and secure, yet loose and free, resembles that of the figure drawings associated here with the project.

199. *Studies for a ciborium and a sarcophagus*
1518(?)
Black chalk, 10¾×8⅛″, cut down and spotted, rubbed
FLORENCE, CASA BUONARROTI, 110 A

Once doubted, this lovely group of projects is now accepted by all. But its purpose is still not known. Perhaps the best of the many suggestions is its identification with the ciborium requested by Piero Soderini for the church of San Silvestro in Capite, in Rome. The architecture is still rather traditional, recalling the dome of the Cathedral of Florence and Benedetto da Maiano's great bronze lantern for Palazzo Strozzi, but it is beautifully presented, and full of the dynamism of Michelangelo's architectural designs. The smaller sketch is somewhat richer and more intricate in its relationships. The sarcophagus profile recalls Verrocchio's work.

200. *Sketches for tombs in San Silvestro in Capite*
1518
Pen, 11⅜×17⅜″, cut down, folded, and patched
FLORENCE, CASA BUONARROTI, 114 A verso

The recto of this sheet contains a plan of San Silvestro in Capite, in Rome. These still rather traditional sketches for wall tombs correspond to the commission given Michelangelo by Piero Soderini in 1518. The notes concern a trip by Michelangelo to Pietrasanta.

201. *Sketches probably for the altar of San Silvestro in Capite*
1518(?)
Black chalk, in some parts gone over in pen, 11½×8⅝″
LONDON, BRITISH MUSEUM, W. 22 recto

Never doubted as Michelangelo's work, this set of drawings has been difficult to place, topographically and chronologically—all the way from the Tomb of Julius II to the free-standing tombs originally planned for the center of the Medici Chapel. The most likely suggestion is the identification with the commission for the altar of San Silvestro in Capite (see Nos. 199 and 200), intended to enclose the head of St. John the Baptist. Conceived in the still somewhat conservative, strongly classical manner of Michelangelo's earliest architectural projects, the altar is based on Roman triumphal arches—at first, in the upper left-hand corner, quite literally. As Michelangelo keeps moving the page around, he toys with other possibilities, at first enlarging the central arch and placing superimposed small niches at the sides (an idea repeated in No. 202), then returning to single niches, with medallions in the attic, and the central arch replaced by a panel. Turning the sheet, he gets the idea of an arched pediment, retaining the entablature which tied the whole together, then he experiments with another arch, then comes up with a beautiful and more finished version, with arched pediment, lateral niches, and a grand entablature.

202. *Sketch probably for the altar of San Silvestro in Capite (portion of sheet)*
1518(?)
Black chalk, 6⅛×6⅝″ (whole)
FLORENCE, ARCHIVIO BUONARROTI, IX, fol. 539 verso

Almost exact repetition of the second sketch in No. 201. The figure sketches (not illustrated) on the rest of the sheet are the work of a pupil.

203. *Sketches probably for the altar of San Silvestro in Capite*
1518(?)
Black chalk and pen, 10¼×13½″
OXFORD, CHRIST CHURCH, DD 24 verso (recto not illustrated)

The identity of style between this and No. 202 has not prevented some of the very scholars who accepted one from rejecting the other. Michelangelo is here considerably more imaginative, experimenting at first with alternating round and gabled pediments supported by columns on consoles, then with a broken pediment. The most complete solution, partially inked in, is the handsomest so far, eliminating arches and providing a giant order of columns, doubled in the center, that embrace superimposed vertical and horizontal rectangular fields in all three bays; the central one is crowned by a splendid separate cornice, which interrupts the entablature of the giant order and threatens to break the pediment. This is one of the earliest symptoms of the struggle among architectural elements which is the hallmark of Michelangelo's revolutionary architectural style, and reaches its full fruition in the Medici Chapel and the Laurentian Library.

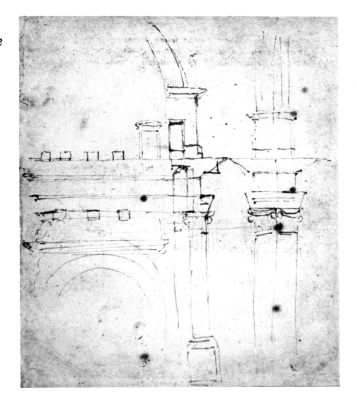

192

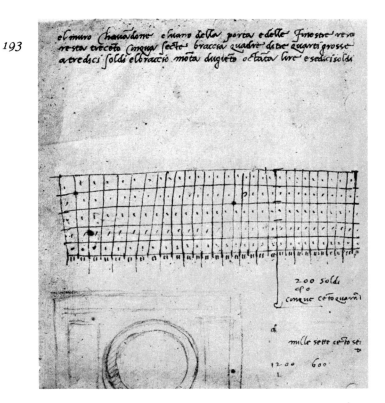

193

el muro chauadone esuaro della porta edelle finestre vera
resta erecoto cinqua secte braccia quadri di tre quarti grosse
a tredici soldi elbraccio mota duqueto octata lire e sedici soldi

200 soldi
q o
cimane cetto quarti

mille sette cetto sei

1200 600

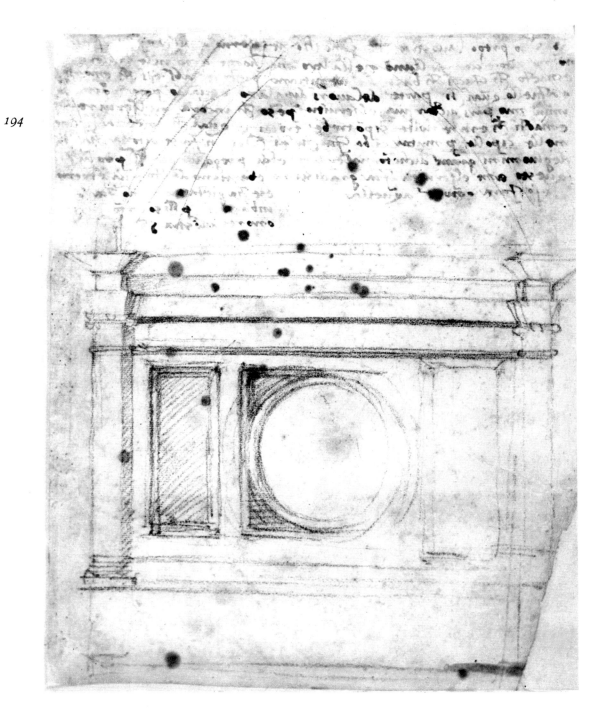

194

195

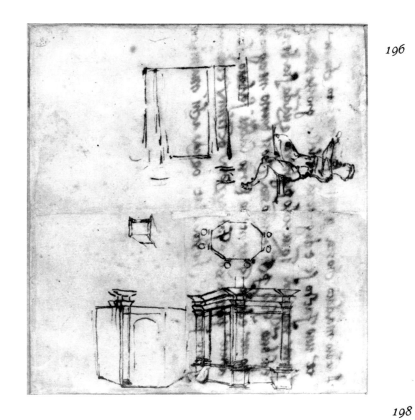

196

197

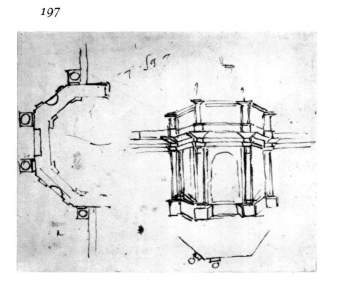

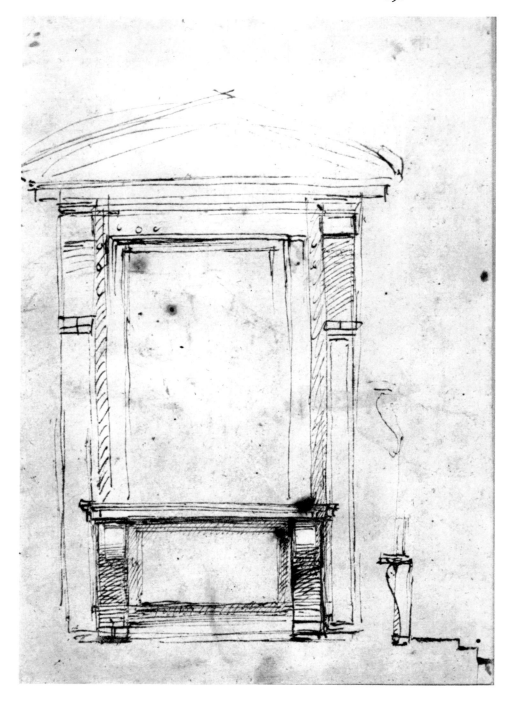

198

162

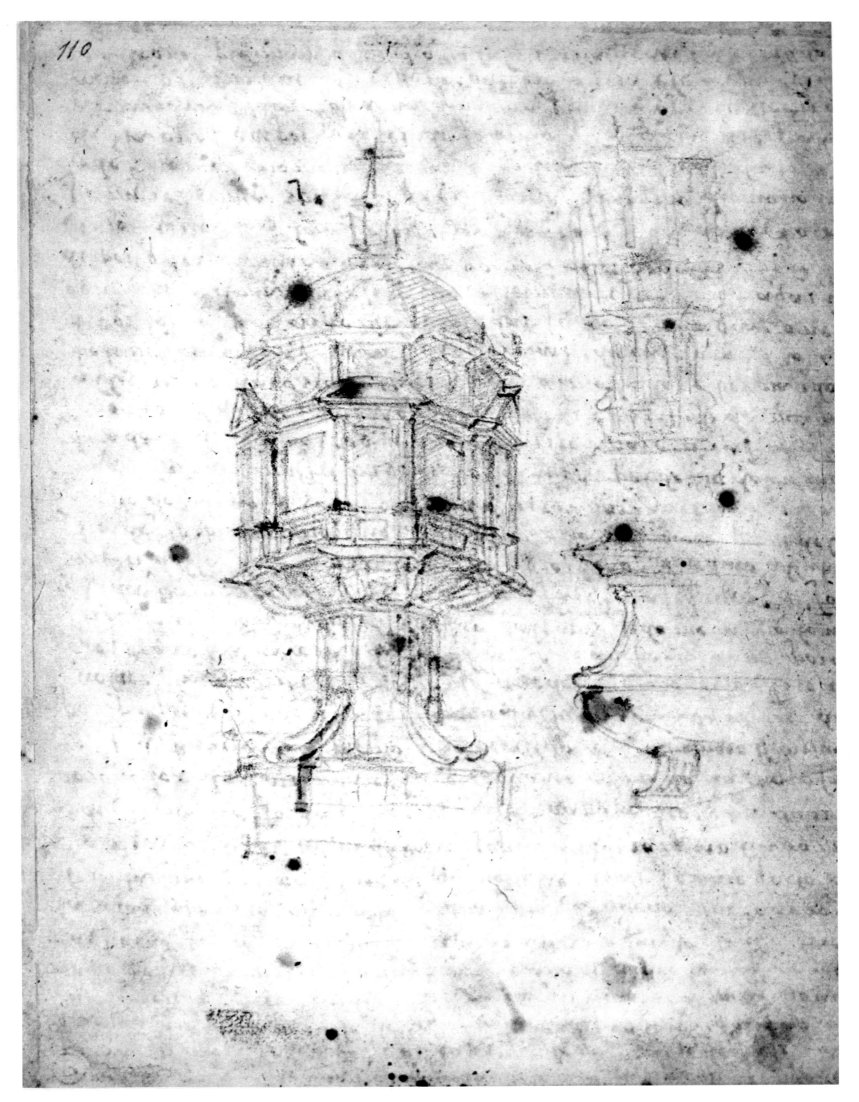

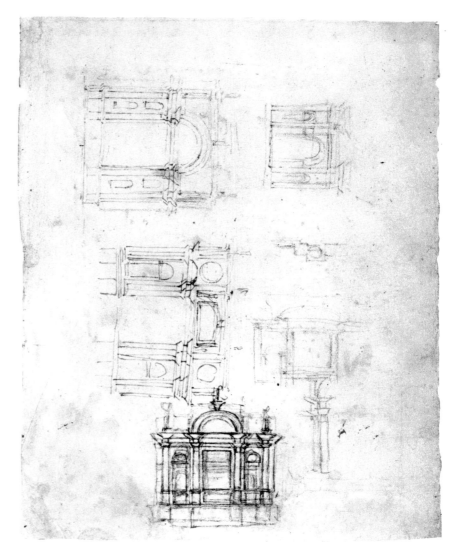

200

201

202

203

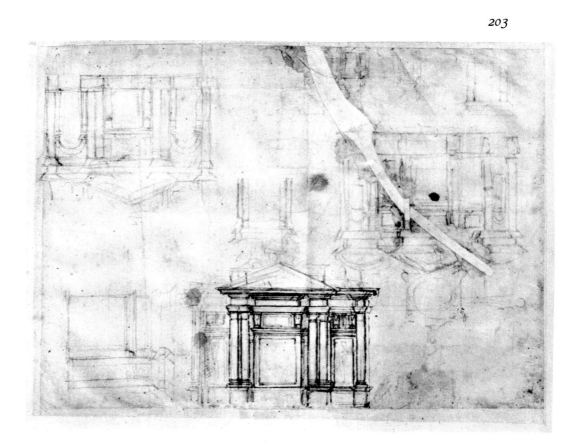

9

Drawings connected with the Medici Chapel. Florence, 1519–24

Architecture and tombs

There has been a lengthy controversy about whether Michelangelo designed the basic structure of the Medici Chapel, or whether he took over in 1520 a building that had already been commenced by others and carried out as far as the first cornice in the interior. The evidence on both sides has seemed irrefutable. There the problem would have remained, had it not been for the recent discovery of a memorandum (*ricordo*) by Giovan Battista Figiovanni, canon and later prior of San Lorenzo, concerning his part in the work. It appears that in June, 1519, when Cardinal Giulio de' Medici assumed the government of Florence after the death of Duke Lorenzo, Figiovanni found the Cardinal at lunch in the loggia of the Medici Palace; to his astonishment, he was taken aside into a nearby room and, behind locked doors, was offered the supervision and administration of a great new project for San Lorenzo, to cost about 50,000 ducats: "the library and the sacristy as a counterpart for the one already built, and it will have the name of a chapel, where there will be many sepulchres to entomb our ancestors departed this life, who are in temporary resting places: Lorenzo and Giuliano our fathers and Giuliano and Lorenzo brothers and nephews." The work got under way on November 4, 1519, with the demolition of two houses belonging to the Nelli family and a wall of the church itself. Figiovanni describes the immensity of the operation, lists the principal masons, and even notes the sidewalk superintendents "who delight in architecture" that stood around to watch. "The principal master of the architecture was the unique Michelangelo Simoni, the which Job having had patience would not have had it with him one day."

The question is now settled. Michelangelo was the architect of the Chapel from the very start, and it was built from scratch without a single stone or design by anyone else. The only restriction imposed by the patron was its correspondence with the plan and general articulation of the Old Sacristy, built in the early fifteenth century by Brunelleschi. Only a handful of drawings for the architecture of the Chapel are preserved. These must have been made before November, 1519; even if the demolition could have proceeded without plans, that was surely completed in a few days, and detailed working drawings were necessary for the foundations. The model described as finished in December, 1520,

must have been made to give Pope Leo X and Cardinal Giulio de' Medici a clear idea of how the interior of the Chapel was to look. It was not necessary for construction, because the same letters tell how the *pietra serena* pilasters and arches were being set in place before the model was done. From Figiovanni's precious memorandum we know that work on the Chapel progressed rapidly and without interruption until political troubles began in 1526. The lantern over the dome was finished in 1524 and its beautiful gold polyhedron set in place. The sketches, plans, and studies must therefore have proceeded with great speed, and should all be dated early.

From the very start Michelangelo gives signs of a new architectural style. The clover-leaf chapels sketched in the ground plan, No. 204, are unusual, but the window study, No. 207, is strikingly so, in spite of its classical derivations. Michelangelo was beginning to champ at the bit, and before long would kick over the traces of High Renaissance architecture entirely. Very important is the fact that a drawing, No. 209, for profiles of the bases of the great pilasters of the first story, and thus dated before November, 1519, contains in Michelangelo's own hand the germ of the symbolism of the sculptural decoration.

Michelangelo went to Carrara on April 10, 1521, to make all the models and measured drawings for the marble architecture and the colossal statues of the tombs. The designs must, therefore, have been completed and approved by the patrons before that time. A great many are preserved that show, significantly enough, all but the final stages of the projects for the tombs. This is understandable, as Michelangelo must have taken the working drawings with him to Carrara, while all the preliminary sketches stayed in his studio. Many have never left Florence. We are able to follow in extraordinary detail the evolutions of the various ideas in the artist's mind. Plans for small wall tombs in the spaces now occupied by the useless but beautiful tabernacles; for a freestanding block tomb in the center of the Chapel; for the Cardinal's inconvenient proposal for a tomb made of four arches meeting in the middle, with the sarcophagi of the Dukes and the Magnifici above and his own in the center; for double wall tombs, the Dukes on one side and the Magnifici on the other; and finally for the single tombs for the Dukes, on either side wall, and the double tomb for the

Magnifici (this last never executed) on the entrance wall—these succeed each other in bewildering complexity in the sketches and partly finished studies. Sometimes ideas for several different kinds of solutions appear on the same sheet. It is difficult, perhaps impossible, to work out a reasonable chronological succession, and the one given here may be far from the truth. Michelangelo may even have worked on several sheets at once, picking up and redrawing an abandoned idea after a lapse of several days. All must have been designed at fever pitch, in a relatively few months—marble architecture, statues, and all—during 1520, or in all certainty, before April, 1521.

Architecture and figures are both revolutionary. No more do we behold an architect at the beginning of his career, learning patiently from classical antiquity and his great forebears in the early Renaissance. (One of the most recent writers, under the illusion that the lower two stories of the Medici Chapel were done by someone else, says that the windows of the second story "could have been designed only by a reactionary architect in 1520." That reactionary architect was Michelangelo.) Now he is able to treat the heritage of classical architectural forms—columns, entablatures, arches, pediments, niches, and the like—with the same freedom he had long exercised in his figural style. The architectural elements overlap, conflict, expand, contract, in the same manner as the figures in the most advanced scenes in the Sistine Ceiling, for instance the pell-mell rush of forms in the *Brazen Serpent*. Michelangelo's contemporaries recognized that he had created a new architecture, emancipated from the classical rules and full of individual passion and caprice.

The figures, likewise, are freed from ordinary notions of verticality and horizontality, standing, sitting, reclining. They are able to move in new ways, derived, of course, from classical antiquity but from such unrestful sources as the figures wedged into spandrels of Roman triumphal arches. As one can observe the figures of the Times of Day turning up throughout the series, resembling the statues as executed in all but their colossal scale, there is no comfort whatever in the strange notion that these statues might have been intended for positions other than those they now occupy. They show a renewed concern with the anatomical structure of the body, after several years in which Michelangelo had done little sculpture. But not only the beauty and harmony of the musculature; in these steely drawings the figure has now been pushed almost to its limits of muscular tension and involvement of limbs. The statues grew in Michelangelo's mind as he worked. In what seem to be the earliest designs, they could have been no more than half lifesize. Halfway through the series, colossi make their appearance. Eventually, in the Chapel itself, they dominate the architecture and the space. Only seven were ever done by Michelangelo himself, and two by pupils. The four river gods were never carried out.

We possess a number of splendid life studies for the statues, in pen, chalk, and silverpoint. Eight drawings for *Day* remain, allowing us to follow almost from hour to hour the progress of Michelangelo's transformation of the abnormally muscular back and flanks of a brutish workman into an overwhelming image of Promethean frustration and despair. As the poses changed constantly, even in the life drawings, involving heaven knows what strain on the models, these magnificent works cannot be shrugged off as copies, as some have done. Neither can they be dated after April, 1521, or Michelangelo would not have been in a position to make the measured drawings for the stonecutters at Carrara. The

changing poses would have made calculations impossible. Imagine, for example, the effect that the constriction of a formerly projecting arm or leg would have on the dimensions and proportions of a block. The studies were not done in 1524 in preparation for the final carving of the blocks, because the poses themselves were evolved by means of these drawings. All such experiments must have been at an end before the artist could have drawn such a diagram as No. 252, for example, the one remaining example of one of these measured drawings.

There were to have been paintings in the Chapel, and not just the decorative designs and figures for the dome painted and gilded by Giovanni da Udine. There is no documentary evidence to connect Nos. 254–57 with the Medici Chapel, but the hypothesis put forward many years ago is too alluring to abandon, and the compositions do fit in, stylistically and iconographically, with the structure and statuary of the monument. There is no other explanation for these drawings and there are no other drawings that fit the spaces, so, for now at least, it is best to retain them.

204. *Ground plan of the Medici Chapel*
1519
Red chalk, $11\frac{1}{2} \times 7\frac{1}{2}''$
FLORENCE, ARCHIVIO BUONARROTI,
I, 77, fol. 210 verso

This rapid sketch is at once the earliest ground plan for the Medici Chapel that has survived, and the earliest known plan of any sort by Michelangelo for a building he actually built. He was clearly still trying to conform to the Old Sacristy of San Lorenzo, because he preserved the columns with which, in that masterpiece of the early Renaissance, Brunelleschi flanked the doorways. The four doorways had a practical use only in connection with the two passages which were to provide access to the adjacent choir of San Lorenzo itself. The four tombs were to be placed on the side walls, on either side of chapels, summarily indicated, that were provided with three niches like the altar chapel. It is not clear whether these could or could not have been built. One would have projected into the prior's garden, the other would have required the demolition of still another house belonging to the Nelli family. A fifth tomb (for Cardinal Giulio?) is evident between the two entrances at the left.

205. *Cross section of one wall of the Medici Chapel*
1519
Red chalk, $6\frac{1}{8} \times 4\frac{3}{8}''$, cut down and rubbed
FLORENCE, CASA BUONARROTI, 57 A recto

The two superimposed orders of Corinthian pilasters of the Chapel are visible here substantially as executed.

206. *Probable plan for the lantern of the Medici Chapel*
1519–20
Black chalk, $6\frac{3}{4} \times 5\frac{3}{8}''$, cut down and relined
FLORENCE, CASA BUONARROTI, 70 A

If this is indeed a sketch for the lantern, Michelangelo's original idea was to provide a colonnette in the center of each window.

207. *Study for a window in the Medici Chapel*
1519–20
Red chalk, 7½×5⅛″, cut down
FLORENCE, CASA BUONARROTI, 105 A

One of the rare studies for a detail of the architecture of the Medici Chapel. The window was carried out according to this sketch, with slight but important adjustments. The idea of breaking the arched pediment was given up, but in recompense a more complex relation of dovetailing shapes was adopted for the frame. The tabs at the corners, so striking in the actual window, are here merely hinted at. The idea of canting the sides was derived from the Roman window in Tivoli studied in No. 141.

208. *Profiles of bases for the Medici Chapel*
1519–20
Red chalk, 11⅛×8⅜″, cut down
FLORENCE, CASA BUONARROTI, 9 A recto

It is a delight to study the play of Michelangelo's "melodious contour" as he experiments with possible moldings for the bases of the great pilasters of the Corinthian order.

209. *Profiles of bases for the Medici Chapel*
1519–20
Red chalk, 11⅛×8½″
FLORENCE, CASA BUONARROTI, 10 A recto

The play of line has taken a savage turn. As Michelangelo works with contracting profiles, it occurs to him that they have personalities, and the last drawing, lower right, really bites, and glares with a little eye the artist has provided. The words written in red chalk, "one hundred eighty-seven," mean nothing to us today. But above the profiles, after "the heavens and the earth" (which is in another, perhaps later hand), comes one of the grandest passages ever written by Michelangelo, giving us the nucleus of his conception of the meaning of the tombs:

> Day and night are speaking and saying, we have with our swift course led the Duke Giuliano to his death, and it is quite just that he should take revenge on us as he does, and the revenge is this, that we having slain him, thus dead he has taken the light from us and with his closed eyes has fastened ours so that they may no more shine forth above the earth. What would he have done with us, then, had he lived!

210. *Sketches for the Medici tombs*
1520
Pen over black chalk, 7⅜×9¼″, cut down and spotted
FLORENCE, CASA BUONARROTI, 88 A

Three different solutions are tried out: at upper left is a freestanding tomb divided into base, main story, attic, and cornice; it is articulated by doubled columns supported on consoles that traverse a sarcophagus, and crowned by a broken-arched pediment. No sculpture is indicated, and the fields for sculpture would not be very satisfactory. Below comes what has been correctly identified, through its lofty and narrow proportions, as a wall tomb intended for one of the narrow spaces now occupied by doors and tabernacles.

A higher central niche between columns, containing a standing statue, is flanked by two narrow and lower niches. Below emerges, for the first time perhaps, the form finally adopted for the tombs of the two Dukes—the sarcophagus surmounted by a broken arch on whose segments figures recline in the celebrated "slipping off" poses, their feet projecting beyond the mass. A roundel appears between them. The lower portion of the composition is in a fluid state, with several mutually incompatible and rapidly rejected members. According to this scheme, the statues would have been hardly more than half lifesize. The last two sketches, one on its side, are halfhearted attempts to comply with the Cardinal's absurd proposal (contained in Buoninsegni's letter of December, 1520) for a cubic arch with four faces, like the Arco degli Argentari in Rome. The Cardinal's tomb would go in the center and one of the others above each arch.

211. *Sketches for the Medici tombs*
1520–21
Black chalk and red chalk, 4⅛×6⅛″, cut down and spotted
FLORENCE, CASA BUONARROTI, 49 A recto

First Michelangelo tries again for the Cardinal's arch, but quickly gives it up. Then he studies with more care the principal motive of the block tomb in No. 210, supporting each column on its own building console. That motive, too, is rapidly abandoned, and we shall not meet it again. Finally, and in greater detail, he resumes the shapes of the wall tomb in No. 210, adapted to the principle of the block tomb. However, he is forced by the new proportions to expand the width somewhat, particularly in the lower story, and he attempts to bind the lateral arches more closely to the central mass by means of a cornice running through the entire story. There are no indications of sculpture in the large, rectangular field. The roundel is expanded into a powerful motive, tying a mezzanine to the handsome, more angular shapes of the sarcophagus, on which two reclining figures have been faintly indicated.

212. *Studies for the Medici tombs*
1520–21
Black chalk, 8⅝×8¼″
LONDON, BRITISH MUSEUM, W. 25 recto
(for verso see No. 78)

A new idea, faintly drawn, makes its appearance at the upper left—an octagon with alternating long and short faces, the long faces framed by doubled columns. The whole proceeds to a bulky attic, all of whose faces are filled with large roundels, and culminates in a pyramidal roof. Candlesticks appear above the corners of the attic. Below, carefully studied, is another new idea for the block tomb, with the familiar paired columns again, now very long and slender, much as they will appear in the pilasters of the final version. An odd form emerges in the lower story, recently described as a "symbolic" sarcophagus with claw feet, seen from the end, with the rest resorbed into the block. Over each sarcophagus end, a console ties the shape to the main mass, and is in turn linked to the edges of the field by festoons. Against the sarcophagus, in the corners, languish delicately drawn figures with their legs hanging off, their poses recalling the nudes of the Sistine Ceiling. The diminutive proportions are indicated by a tiny line below, a Florentine cubit (*braccio*), corresponding to about 60 millimeters, although this varies

continually. The greatest width of the tomb comes to 4.6 cubits. Since the whole chapel was only 19.5 cubits square, this would not leave much room to walk around in. A horizontal section, lower center, taken just above the sarcophagus lids, shows the relationships with some clarity. The lateral niches and medallion of No. 211 turn up again at upper right in what has been described as a block tomb, but that is far from clear. The rough lines at the sides may indicate it as a wall tomb. The inverted consoles of the sarcophagus lid are delightful forms, but would have provided an uncomfortable position for sculpture. The faint sketch at center right tries the paired columns again, with less success, over an arch embracing another symbolic sarcophagus. At the lower right, Michelangelo is already concerned with cornices, especially one with a sharp overlapping projection.

213. *Sketches for the Medici tombs*
1520–21
Black chalk and red chalk, 5½×4¾″, cut down, spotted, rubbed
FLORENCE, CASA BUONARROTI, 71 A recto

At upper left is the plan of an octagon, apparently a simplified version of the structure faintly indicated in No. 212. Below, the symbolic sarcophagus is worked out in some detail, the claw feet continuing into monstrous heads above. There seems to be no room for sculpture. An arched solution is faintly sketched at the right, and, upside down, a further variant of a wall tomb with single columns enclosing an arched tabernacle. This may have been a sheet of tryouts for No. 212, which is more elaborate.

214. *Sketch for the Medici tombs*
1520–21
Pen and red chalk, 11½×11⅝″, cut down
FLORENCE, CASA BUONARROTI, 93 A recto
(for verso see No. 215)

A very handsome and imaginative attempt to dignify the block tombs with attic tabernacles taken from early versions of the San Lorenzo façade. A sarcophagus projects along the left profile. Was a sarcophagus intended for the central niche on this face, or were these alternate proposals? Square fields at left and right contain standing statues. The sketch has been connected with the Barbazza tomb in Bologna, but this seems unlikely; the relation to the other sketches for the Medici tombs is too clear.

215. *Sketches of tabernacle and moldings for the Medici tombs*
1519–20
Red chalk; for dimensions and condition, see No. 214
FLORENCE, CASA BUONARROTI, 93 A verso
(for recto see No. 214)

A tabernacle from No. 214 studied separately, and six profiles of cornices.

216. *Sketch for the Medici tombs*
1520–21
Black chalk, 5⅞×6″, cut down, yellowed, spotted, rubbed
FLORENCE, CASA BUONARROTI, 107 A

A first idea for double wall tombs, called a copy by one critic, but too fresh and immediate for that and full of the undeniable personal touch of Michelangelo. The artist started to work out one lateral pier in detail, with a statue in an oblong niche; he suggested the spaces for two sarcophagi, sketched out an arched niche on the other side, drew in briefly a recumbent figure, possibly the first appearance of the river gods, and then he gave up. It is not clear whether he had even worked out the proportions exactly, for the visible drawing does not correspond to the space available.

217. *Study for the Medici tombs*
1520–21
Black chalk, 10⅜×7½″
LONDON, BRITISH MUSEUM, W. 26 recto
(for verso see No. 218)

This fascinating and universally accepted drawing is a palimpsest of stages in the evolution of a double wall tomb in Michelangelo's mind, and extremely difficult to decipher. The tombs are now proportioned to fit the wide wall spaces which, in Michelangelo's sketch plan (No. 204), were to be chapels. A double tomb was not an easy problem, requiring an unpleasant equality of emphasis on both sides. Michelangelo seems to have been more satisfied with the solution on the right, because he worked it out in great detail, adopting the panel niches of No. 216 but moving their statues down below, where they could be freer. A central niche with an arched pediment contains a standing statue. The solutions at the left involve several redrawn, and constantly expanding, pedimented niches. Eventually the artist sketched the right-hand solution over all of them, and placed a standing colossus in the center to pull the whole thing into focus. A small statue is touched in at the left, but at the right another colossus emerges. The sarcophagi below are composed of curious doubled consoles, with reclining figures, and a different articulation on each side. In the space below, one recumbent figure is drawn, but not in the other: again, doubtless, the river gods. The roundel from earlier sketches reappears above the central colossus, and above that a vertical form, possibly a herm, with festoons on either side. At upper right, upside down, a figure already suggests in reverse the pose of *Dawn*.

218. *Sketch for the Medici tombs*
1520–21
For medium and dimensions, see No. 217
LONDON, BRITISH MUSEUM, W. 26 verso
(for recto see No. 217)

This sheet was first ruled for a larger version of much the same scheme as No. 217, apparently to study it in still greater detail. Then suddenly the artist gave it up, turned the sheet on end, and worked out a brilliant new version which, although less carefully studied and not hatched, is a much more unified solution, successfully centralizing the scheme, reducing the plethora of statues big and little, and avoiding the cramped feeling of No. 217. All this is accomplished by the simple expedient of adopting the grand motive at the right of No. 217 as the single theme, now filling the whole area. The side panels are eliminated, the niche towers to the top of the field, and the festoons hang above two relaxed colossi in the poses of the smaller statues of No. 217. The two sarcophagi are united in a single form.

219. *Study for the Medici tombs*
1520–21
Black chalk, 5 × 8⅜″
OXFORD, ASHMOLEAN MUSEUM, P. 307 recto
(for verso see No. 158)

Michelangelo wrote in the upper left-hand corner, "On the 16th day of June Mona Angela brought twenty-one *soldi* to the baker and I began to carve for the new [sacristy?— missing words] in 1524." Despite these words the drawing has been given by two critics to Vincenzo Danti and by another to Stefano di Tommaso. Most writers are impressed by the power of the hatching and the grandeur of the figure, in spite of many strangenesses about the architecture. But just these weird qualities are unthinkable for anyone save Michelangelo himself. Who else could invent niches that explode at the top, enclosed by frames forced to detour for the explosion? Or arched pediments that overlap and indeed *overhang* their cornices? (This device first appears above the central niche of No. 218.) And the central niche of the present drawing is fused with its flanking niches in the miraculously simplified and elegant tabernacles as actually executed above the doors, among the most original of Michelangelo's architectural inventions. They are still a bit clumsy, but the basic idea is there, and also, for the first time, a concerted attempt at a reasonable solution to the whole problem on the basis of a single wall tomb, with the enthroned Duke already gazing in the direction of the Madonna.

220. *Study for the Medici tombs*
1520–21
Black chalk, 11¾ × 8¼″
LONDON, BRITISH MUSEUM, W. 27 recto
(for verso see No. 291)

The tiny remark "last design" (not in Michelangelo's hand) in the middle of the big blot toward the lower right seems not to have been noticed, but it corresponds to the universal view. Nonetheless, there were a great many changes made between this drawing and the final version of the Ducal tombs. It has been suggested recently that Michelangelo intended to run this design from one Corinthian pilaster to the other; but that when he narrowed it, constricting the central field to an oblong niche and eliminating the seated figures in the lower panels at either side, he was forced to insert the present flat strips of *pietra serena* to fill in. The same author, however, points out that the masonry of the strips is of one piece with that of the pilasters, so such a change must have been made in the design. This suggestion is impossible, since we now know that construction had been going on since November 4, 1519. A definitive plan for such basic architectural elements must have been ready well before that, and the projects for the tombs were still under way more than a year later. The real explanation is surely that Michelangelo decided to expand the sculpture at the expense of the architecture and ornaments, contracting and simplifying both the latter. The proportion of the field occupied by the drawing, between the base line and the line irregularly sketched at the top, is roughly two to three, and that is the proportion of the space as built. Michelangelo enlarged the sarcophagus and almost doubled the size of the figures. This is responsible for their extreme projection, with their toes almost reaching the controversial strip and their heads lifting well above the marble cornice. They almost hide the panels which were originally intended for seated statues. In all other respects the reclining figures conform

to the ideas we have seen advanced thus far. The coupled pilasters are brought much closer together and greatly enlarged. They are made to flank a narrow niche rather than a broad central field. In the attic story, little room is left for the crouching figures, and the fantastic structures above the so-called thrones (they do not look at all like thrones in the drawing—they appear to be flanked by herms and are crowned with shells) are eliminated entirely. A great many changes went on as the work on the marble architecture progressed. The shell (the stonecutter called it a knob) between the volutes of the sarcophagus was eliminated only in 1524. Another drawing, No. 221, was made for the "thrones," indicating a new position for the crouching figures. Only one of these was carved, probably by Tribolo, and it was never put in place. The trophies in the center were blocked out, but not on the scale indicated in the drawing. They also were not installed. The final simplifications were merciful, as they removed elements sure to distract from the great statues, the dominating feature of the Chapel as carried out. And the quiet strips of *pietra serena* intervening between the marble architecture and the embracing Corinthian pilasters were, it may be remarked, a simple necessity if the observer was to avoid ocular indigestion from all those rich forms. The reader may test this for himself by imagining the mass of shapes in this drawing inserted between giant, fluted Corinthian pilasters.

221. *Studies for the "thrones" of the Medici Chapel*
1520–21
Red chalk, 6½ × 5¼″, cut down and relined
FLORENCE, CASA BUONARROTI, 72 A

Attempts to reduce and make more compact the diffuse forms of these enigmatic elements as they appear in the attic of No. 220. The shells and possible herms are gone in the careful study at upper left, replaced by small consoles (which would have been invisible from the floor) supporting a low oblong panel, crowned with finials. Below, a plan is made of the relation of the balusters to the projecting central piece. At the right the panel between the "thrones" is made more compact, with a new suggested alignment for the crouching figures. But Michelangelo still seems to have been dissatisfied with the rather stumpy balusters, and at the upper right he experimented with another, more delicate shape with vaselike concave contours. In the final marble version, he kept the proportions of the second sketch but returned to the convex contours of the first. The changes studied here must have been adopted almost immediately after No. 220, in order to fit the new idea for the tomb, with enlarged statues, into the existing space.

222. *Sketches for the Medici tombs*
1520–21
Pen, 15⅛ × 10⅜″
OXFORD, ASHMOLEAN MUSEUM, P. 308 recto
(for verso see No. 286)

Although omitted by one recent scholar, this interesting sheet is now accepted by all. But the latest suggestions regarding its purpose as a set of studies for the tombs of Popes Leo X and Clement VII in San Lorenzo raise many doubts.

We have no examples of double papal tombs, and since the Medici could dispose of the entire choir of San Lorenzo, with one tomb on either side, why resort to such crowding? Also, the drawing is generally placed wrong way round. Michel-

angelo never began at the upper right. The first drawing on the sheet is certainly the study of a shell-crowned wall niche flanked by two square niches, at the bottom. It is difficult to say what this can have been meant for. The coupled columns in recesses, deeply shadowed, mark an early appearance of the famous motive that dominates the vestibule of the Laurentian Library, and the windows with their projecting tabs suggest the shapes used for the tabernacles of the Medici Chapel in 1524. The central niche is connected with nothing. But, turning the drawing clockwise on its side, the two sketches for a double tomb clearly are intended for the double tomb of Lorenzo and Giuliano the Magnificent on the end wall of the Medici Chapel. The first study, at the right, is relatively finished, showing two sarcophagi not unlike those for the Dukes, but without the voluted lids, and spaces for three large seated statues (one is shown seated on the left) and two smaller standing ones above. The blank upper rectangle proved defeating, so in the next sketch, just to the left, Michelangelo redrew the motive, eliminating the standing statues and lifting the central niche to the upper limit of the space. The seated figure must be an initial idea for the *Medici Madonna*. The sketches below show the artist doodling with various arrangements of columns in depth.

223. *Sketch for the Medici tombs*
1520–21
Pen, 8¼×6⅜″, cut down, patched at corner
LONDON, BRITISH MUSEUM, W. 28 verso
(for recto see No. 224)

A fusion of the two corner sketches in No. 222, lifting the Madonna, standing now, to a higher position, her feet above the heads of the flanking Sts. Cosmas and Damian. The sarcophagi are now flatter, and traversed by their legs as in the tombs of the Dukes. The whole thing is very tentative, and the side areas were abandoned as insoluble.

224. *Sketch for the Medici tombs*
1520–21
For medium and dimensions, see No. 223
LONDON, BRITISH MUSEUM, W. 28 recto
(for verso see No. 223)

A new solution, probably close to the final one. Between columns on high bases, Sts. Cosmas and Damian stand under medallions that recall the circular reliefs of the façade of San Lorenzo. In the center the *Medici Madonna* sits in a niche crowned by an arched pediment, its broken horizontal cornice projecting sharply in the manner of the later tabernacles above the doors in the Chapel. Below, traced rapidly and decisively, are two strange, boatlike sarcophagi, less like the Ducal tombs than like the symbolic sarcophagi of the early versions. Above them in the center, the faint lines of a seated figure can be made out stretching out its arms toward tablets over festoons. Below, in a firm and powerful hand, Michelangelo has written lines important for the understanding of the entire Chapel: "Fame holds the epitaphs resting. It goes neither forward nor backward because they are dead and their working is finished."

225. *Template for the Medici tombs*
1524(?)
Black chalk and pen, 12¾×5¾″
FLORENCE, CASA BUONARROTI, 59 A

This and No. 226 were undoubtedly made for the guidance of the stonecutters finishing the roughhewn bases of the pilasters for the tomb of the Magnifici. Michelangelo's writing reads, "The pattern of the columns of the double sepulchre of the sacristy." The existence of such full-scale templates, extremely rare in the Renaissance, and the slight but significant differences between their profiles witness Michelangelo's attention to the ornamental surroundings of his statues, a matter of great importance to him since he defined the subtlest nuances of contour with the utmost precision. Perhaps this profile, with its active, mordant shapes, was intended for the columns flanking the central niche; and the other, with its gentle, ascending lines, for those of the side niches.

226. *Template for the Medici tombs*
1524(?)
Black chalk and pen, 12¾×5¾″
FLORENCE, CASA BUONARROTI, 61 A
See No. 225.

204

205

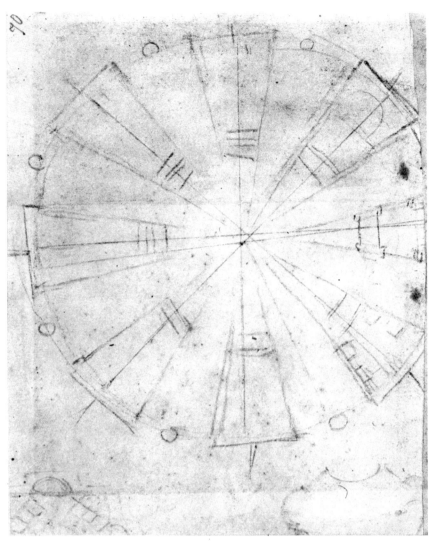

206

207

el cielo e la terra

e chi e lame[...] parlano edichono noi abiano cholnostro veloce chorso cho do
[...] allamorte olduchn gulano e bo guseo [...] e no facci vedecta chome fa
ela vedecta e quesra [...] mondo noi morto lui lui cho si mova actolta la
luce amoi e choglochi chiusi a servato enostri [...] no vi spledo piu so
pra la terra [...] avrebbe dinoi du [...] faeto medre in ue[...]

j costo octo tras[...]

210

213

211

212

214

215

216

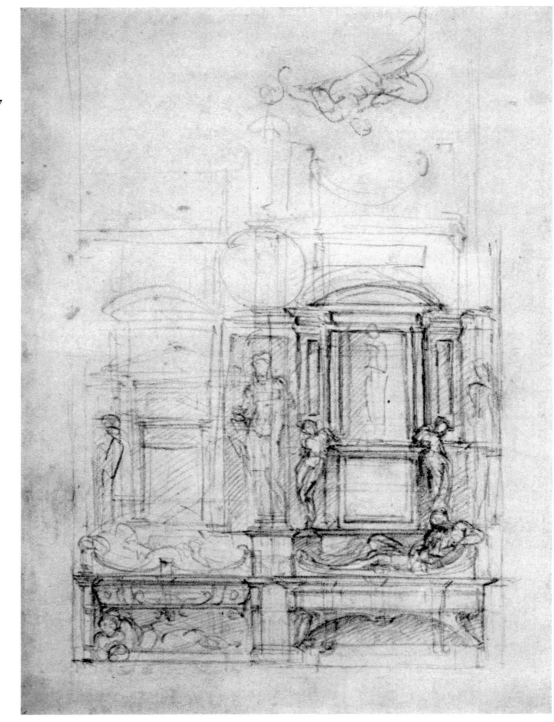

217

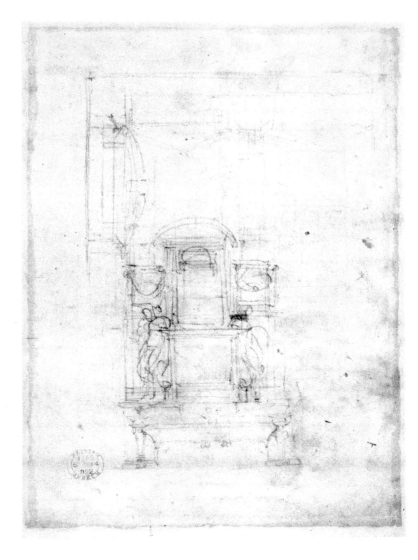

218

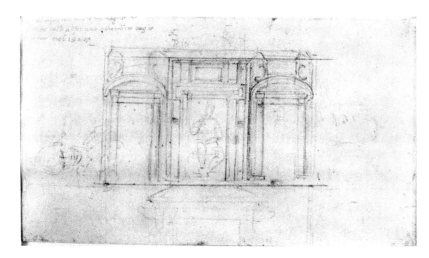

219

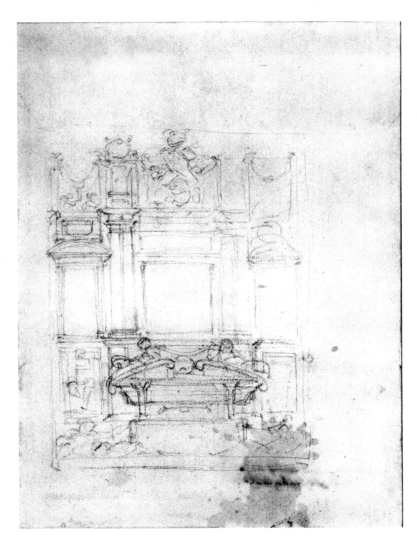

220

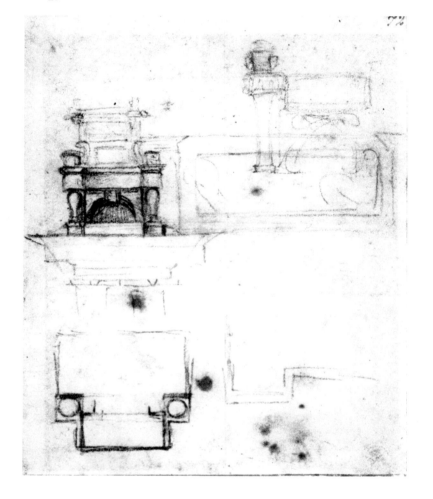

221

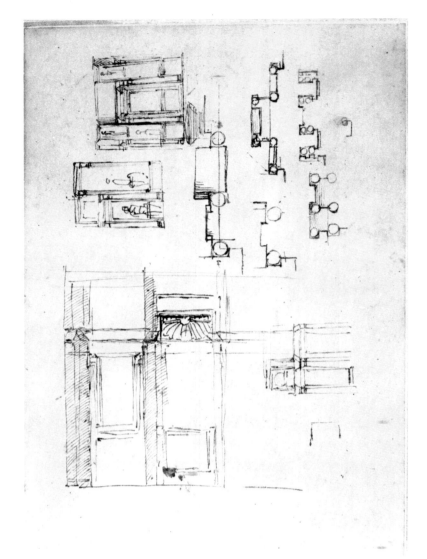

222

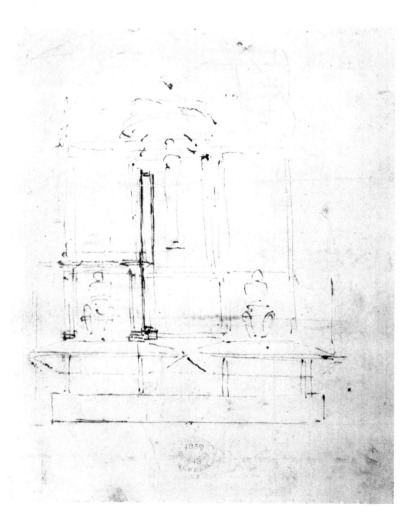

223

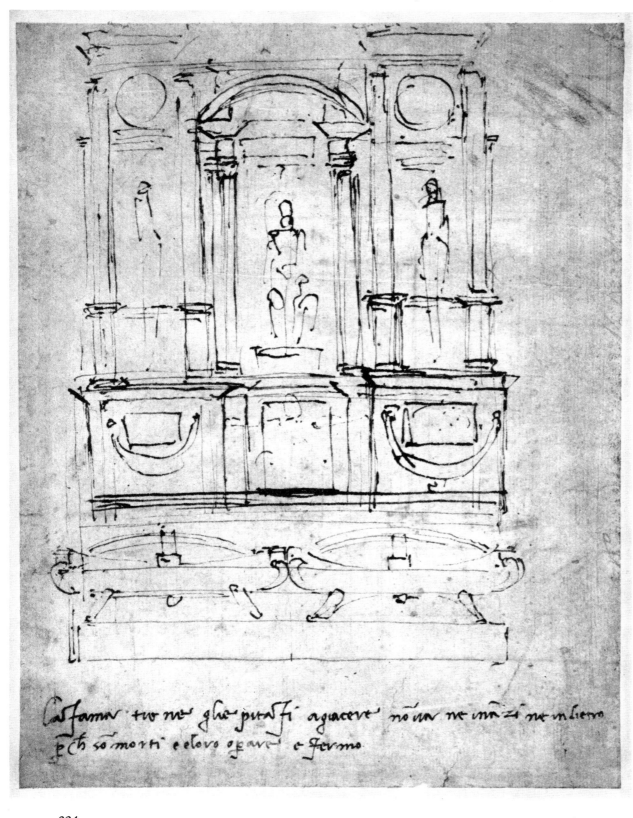

Caf famv tuo me glio puolfi agiacere nõ ua ne ina zi ne in sierra
p ch sõ morti e eloro ogauõ e fermo

224

225

226

Sculpture

227. *Study for Day*
1520–21
Black chalk, $7 \times 10\frac{5}{8}''$
OXFORD, ASHMOLEAN MUSEUM, P. 310

All but two writers have held this powerful drawing to be a life study for the *Day*. There is no reason to doubt it. The drawing, moreover, is an additional piece of evidence to indicate that the statue was planned for its present position and angle. The muscles are indicated in a new and unconventional technique. Broad patches of very rough hatching are often quickly wiped with the thumb or a finger to produce a system of flickering tones suggestive of the technique of the background figures in the *Doni Madonna*. These patches are set down within a tentative, lightly drawn, and sometimes broken contour, only seldom reinforced in the manner of the melodious contours of the Sistine drawings. Michelangelo's principal interest at this point is the interplay of the larger masses of the torso and right leg. The position of the arms below the shoulders and of the left leg has not even been suggested. The head is not indicated in any of the series, and in the statue itself Michelangelo abandoned it merely roughed in.

228. *Study for Day*
1520–21
Black chalk, $10\frac{1}{8} \times 13''$
OXFORD, ASHMOLEAN MUSEUM, P. 309 recto
(for verso see No. 293)

A further study on the basis of No. 227, rejected by the same two doubters. The incredible model (one of Michelangelo's workmen?) is seen from a slightly different viewpoint, but the torso is at the same angle—even if Michelangelo's decision to omit for the moment the entire left side of the back and shoulder does not make it seem so. The right leg has been lifted a bit, and positions adopted for the right arm, strongly contoured this time, and left leg. Both were changed in the final work, in the interest of increased tension—the arm made to cross the body and disappear behind it, the left foot brought over so the shin rests on the right knee. The transparency of these forms may indicate that the definitive pose was dawning on Michelangelo as he drew.

229. *Study for the right shoulder of Day*
1520–21
Red chalk, $7\frac{3}{4} \times 10\frac{1}{8}''$, cut down, spotted, rubbed
HAARLEM, TEYLERSMUSEUM, A 30 verso
(for recto see No. 232)

Another powerful drawing in exactly the same style as Nos. 227 and 228, rejected by three scholars and ignored by a fourth, but indubitably genuine and recently reinstated. In the same contourless patch technique, the artist now devotes himself to a single detail, as in the succeeding studies, analyzing the swell of the muscles across the astonishing back.

230. *Studies for the shoulders of Day and the left arm of Dawn*
1520–21
Black chalk, $10\frac{7}{8} \times 14\frac{1}{8}''$
LONDON, BRITISH MUSEUM, W. 46 verso

After the initial burst of energy in Nos. 227 and 228, Michelangelo now settles down to a more exact study of the behavior of the deltoid, trapezius, and latissimus dorsi muscles, and the motion of the scapulae underneath them, delicately cross-hatched and here and there rubbed with the end of the chalk in the manner of some of the early studies for the Sistine Chapel. The contours of left and right shoulders are studied separately below, and at the upper left corner the same model has been told to flex his arm in the position of the left arm of *Dawn*, seen from the side invisible to the spectator. The critical fate of this drawing is similar to that of No. 229.

231. *Studies for the left arm and shoulder of Day*
1520–21
Black chalk, $15\frac{3}{4} \times 9''$, cut down
HAARLEM, TEYLERSMUSEUM, A 36

The mixed reception this drawing has experienced at the hands of scholars has found one of the archdoubters switching to the opposite camp, and an eminent art historian of a past generation unable to understand the central study at all. It records exactly what goes on in such a massive shoulder when the arm is bent slightly behind the back, and is perfectly comprehensible. The hatching is done with a more carefully sharpened chalk as Michelangelo proceeds, and the rubbing begins to produce the sheen of the latest nudes for the Sistine Ceiling. In the upper and lower studies, delicately hatched but not rubbed, the artist experiments with poses for the left arm, which he seemed to want to leave trailing.

232. *Studies for the back and left arm of Day*
1520–21
Black chalk, $7\frac{3}{4} \times 10\frac{1}{8}''$
HAARLEM, TEYLERSMUSEUM, A 30 recto
(for verso see No. 229)

Apparently the latest of the series for the back and shoulders of the mighty figure, this drawing incorporates the position of the left arm twisted behind the back, substantially as executed, as if the artist had suddenly recalled the pose of the right arm of the Child in his adolescent work, the *Madonna of the Stairs*. A great deal of attention was lavished on this study, the hatching rubbed to an exquisite smoothness which increases the force of the underlying musculature. At upper right and lower left the arm was gently restudied. The critical history of the drawing is similar to that of No. 229. This is one of the grandest of Michelangelo's nudes.

233. *Study for the left leg of Day; head*
1520–21
Black chalk, $5\frac{7}{8} \times 7\frac{1}{4}''$
LONDON, BRITISH MUSEUM, DEPARTMENT OF MANUSCRIPTS, Add. Ms. 21907, fol. 1 verso
(for recto see No. 247)

This very fresh and beautiful drawing has been rejected by a single scholar, without the slightest comment. Luckily everyone else accepts it. There can be no doubt that this is a preliminary study, from a model, for *Day*; it fulfills all the requirements of such studies. The touch is sure and strong, it was done for the work and not after, and the quality is superb. The very beautiful head, strangely suggestive of Leonardo's style, is a mystery. It is certainly by the same hand that drew the leg, but what can it have been meant for?

234. *Studies for the left leg of Day*
1520–21
Black chalk, $16\frac{1}{8} \times 8\frac{1}{8}''$,
made of two cut-down sheets pasted together
HAARLEM, TEYLERSMUSEUM, A 33 recto
(for verso see No. 262)

This is a very instructive example of the confusion which has for too long attended the study of Michelangelo's drawings. It is indistinguishable in style from Nos. 231 and 232—contours, hatching, and all—save only that it has been rubbed less, yet almost all the scholars who rejected those drawings have accepted this one. The lower sheet, or what is left of it, is occupied by a beautifully finished study of the inner side of the left leg, done apparently just after No. 233. Judging by the extreme tension of the muscles, the model must have been obliged to drop his right leg and hold the left one this way while Michelangelo drew. On the upper sheet the same leg is studied from the outside, that is, the side destined to be permanently hidden from view, and the massive knee is repeated four times.

235. *Study for Night*
1520–21
Black chalk, on rough paper, 7 × 11⅝″,
partly indented by a copyist
LONDON, BRITISH MUSEUM, W. 48 verso

A free, rough drawing from a posed male model; rejected by several scholars, but recently and rightly reclaimed. Michelangelo has not yet made up his mind as to the exact pose of the figure. The right foot seems to be indicated, tucked under the left thigh, whose position is changed during the course of the drawing. The drawing can have been intended only to establish the main lines of the pose, because the torso was to represent that of the mother of many children, with a collapsed abdominal wall. It has been suggested that the drawing was done for the *Leda* in 1530. But why should Michelangelo have made more studies for a pose he already knew so intimately, through drawings and actual carving?

236. *Studies for the left leg of Night*
1524(?)
Pen, 6¾ × 7¾″, cut down and relined
FLORENCE, CASA BUONARROTI, 11 F

In this and the following brilliant studies Michelangelo allowed himself to be carried away by the possibilities of a powerful male leg, although all these steely forms would eventually be veiled in the leg of *Night*. Although he pursues the muscles with the relentless incisiveness of a study from a cadaver, the tension alone suggests a living model. The line is of extraordinary harshness in this and the following drawing. No one has ever doubted its authenticity.

237. *Study for the left leg of Night*
1520–21
Black chalk, 10¾ × 5¼″, cut down
FLORENCE, CASA BUONARROTI, 13 F

Despite the absolute stylistic identity (the only difference is the use of black chalk instead of pen) between this and Nos. 236 and 238, a single scholar has recently rejected the study as the work of a pupil. The line and form display a power which can only be Michelangelo's own, and the drawing is inseparable from the other studies for *Night*.

238. *Study for the left leg of Night*
1524(?)
Pen, 5¾ × 7⅝″, cut down and relined
FLORENCE, CASA BUONARROTI, 44 F

A single doubt, uttered long ago, has been forgotten in the general chorus of acceptance. The identification with *Night* is certain, in spite of the position of the right leg tucked under. This was Michelangelo's original idea for the pose (see No. 235), later relaxed in the beautiful line of the extended leg in the statue. The words "I remember" are in Michelangelo's increasingly blocky handwriting.

239. *Studies for Night*
1520–21
Silverpoint, 11 × 13½″, spotted, corroded, and patched
FLORENCE, UFFIZI, 18719 F recto
(for verso see No. 240)

Again a single doubt. All other scholars have accepted this majestic drawing as a study for the raised leg of *Night*, from a male model. The style is very close to that of the series for *Day*, but there has been some new hatching over the modeled portions. The lower leg is still schematic, based apparently on such studies as Nos. 236–38, but the powerful, knotty thigh is developed in great detail, as is the shoulder. The same thigh is studied slightly more from the rear and then turning the sheet clockwise on end, the contracted leg is viewed from below, foot foremost. Michelangelo retained the massive musculature in the actual statue. The original position of the dangling left forearm is clearly visible. While carving the statue, Michelangelo twisted the arm behind the back and carved the original forearm into a leering mask. The modeling of the abdomen, irrelevant to the final appearance of the statue, is omitted.

240. *Studies for the left leg of Night*
1520–21
For medium, dimensions, and condition, see No. 239
FLORENCE, UFFIZI, 18719 F verso
(for recto see No. 239)

Apparently an attempt to feminize the series of studies from a male model. A similar procedure was followed in the studies for the sibyls of the Sistine Ceiling. The lower leg as carried out in marble is soft and feminine.

241. *Study of classical female torso*
1520–21
Black chalk, 10⅛ × 7⅛″, torn off and patched at lower right
LONDON, BRITISH MUSEUM, W. 43

This and the following three drawings, all from the same roughly Praxitelean torso, are at first sight surprising because they can be compared to so few other Michelangelo drawings. Perhaps for this reason they have been seldom noticed and twice rejected. But a comparison with the broad, firm, carefully separated forms of the body of *Dawn* will justify the recent contention that Michelangelo made these studies from a torso, related to the ancient fragment in Siena studied in No. 6, for the purpose of reaching a clear definition of those female forms he had so seldom treated, and which were now required by the iconographic program. The breasts, underlying pectoral muscles, thoracic cage, and abdominal muscles are almost identical to those of the *Dawn*. The heavy, decisive, vibrant hatching is similar to that of the studies for *Day*, and the supple contours strongly resemble the preparatory series for *Night*. The authenticity of the group of drawings seems no longer in doubt.

242. *Study of a classical female torso*
1520–21
Black chalk, 10⅛×7½″
LONDON, BRITISH MUSEUM, W. 44

The same handsome torso, seen from the rear. The artist is at pains to study the effect of the pose on the rich curves of the flanks.

243. *Study of a classical female torso*
1520–21
Black chalk, 5⅛×3⅛″, cut out and remounted
FLORENCE, CASA BUONARROTI, 16 F

The same torso seen from the back, turned slightly left; the most violent of the series.

244. *Study of a classical female torso*
1520–21
Black chalk, 16×11⅜″, cut down, relined, spotted, rubbed
FLORENCE, CASA BUONARROTI, 41 F

The same torso is studied more lightly in both profiles.

245. *Study for the head of Dawn*
1520–21 (or later)
Red chalk, black chalk, and pen, over stylus preparations, 13×8½″
LONDON, BRITISH MUSEUM, W. 1 verso
(for recto see No. 21)

One eminent scholar has characterized this haunting drawing as a copy by Sebastiano del Piombo, corrected by Michelangelo in pen; for another, it is a chalk drawing by Michelangelo with Sebastiano's pen strokes. There is no reason to doubt any portion of the drawing. It is glorious throughout, passionate in feeling, majestic in form. The author suggested in 1950 that the head might be connected with the Medici Chapel figures, and noted a resemblance to the *Medici Madonna*. The identification with the Chapel has proved correct, but the drawing is really a study for *Dawn*, exact in almost every detail (although from a male model), as can be seen in views of the head taken somewhat below. The ear of the statue has been tucked inside the scarf, but the rhythm of the folds remains the same. So do the features, save for a certain ornamentalization in the marble version. Eye, brow, forehead, nose, lips, chin, even the Adam's apple, are very nearly identical. The only question which remains to be decided is whether Michelangelo drew this head at the same time that he was studying the figures, in 1520 and the first months of 1521, or whether he studied this and the other heads after 1524, when he was engaged in the actual carving. For this decision we do not have sufficient evidence; no other studies for the beautiful heads of the Medici Chapel are preserved. The weight of probability seems to lie on the side of a later date, since the artist's hands must have been overfull trying to produce all the life studies necessary for the definition of the measured drawings. For the heads there was no such necessity. What is surprising in this case is the mixture of media. The head was first contoured with a stylus, then with red chalk, lightly. Then the features were exactly drawn and hatched with black chalk, very forcefully. Finally the beautiful forms of the eye, nose, and lips were brilliantly picked out in pen, and the background partly hatched. Soft as the results seem at first sight, suddenly the polished marble emerges

as one looks. The hand, loosely indicated in black chalk, is a preliminary study for the right hand of *Giuliano de' Medici*.

246. *Sketch for the feet of Twilight*(?)
1520–21(?)
Red chalk, 9½×6⅜″
LONDON, BRITISH MUSEUM, W. 14

Seldom mentioned but never questioned, this powerful sketch has been connected with two specific figures in the Sistine Ceiling by two scholars, despite the dangers inherent in any attempt to establish the ownership of a pair of homeless feet. A third critic has linked the feet with *Day*, and it must be admitted that the style, with its open, scratchy hatching and free contours, is close to that of the numerous drawings for that figure, and very far from the manner of the Sistine drawings. But the proportions of these two left feet are slenderer and longer than those of *Day*. *Twilight* is perhaps a better suggestion; his left foot, still unfinished, is important in the entire composition, and has similar proportions.

247. *Fame (portion of sheet)*
1520–21
Black chalk, 5⅞×7¼″ (whole)
LONDON, BRITISH MUSEUM,
DEPARTMENT OF MANUSCRIPTS,
Add. Ms. 21907, fol. 1 recto (for verso see No. 233)

This universally accepted tiny sketch is in the margin of a sheet containing a sonnet by Michelangelo. It has been suggested that this figure was intended for one of the "thrones" in the attic story, because these "thrones have high backs." Actually No. 220 shows nothing that can surely be identified as thrones, and the "backs" are really shells. One is hard put to imagine four of these little figures blowing trumpets, two on each side of the Chapel! Number 224, however, for the tomb of the Magnifici, shows a figure blowing a trumpet, and is identified as Fame in Michelangelo's writing. Number 247 must be a sketch for this figure.

248. *Study for the right leg of Giuliano de' Medici*
1520–21
Pen over leadpoint, 11×9⅞″, corners cut off
LONDON, BRITISH MUSEUM, W. 45 recto
(for verso see No. 128)

This and the following drawing have never been doubted, and have long been connected with the Medici Chapel, but not with specific figures. Their positions correspond closely to those of the legs of Giuliano as seen from the sides in the photographs taken before the statues were replaced. Their loose handling is the pen counterpart of the chalk drawings for *Day*. The significance of the word *infuora* (outside) in Michelangelo's hand is not clear.

249. *Three studies for the legs and torso of Giuliano de' Medici*
1520–21
Pen, 10¼×10¼″, cut down and relined
FLORENCE, CASA BUONARROTI, 10 F

As in the preceding drawing, No. 248, the tensely muscled legs of a male model are studied for the seated figure of Giuliano with the same intensity as the pen drawings for *Night*. There can be little doubt about the identification; note the identical emphasis on the folds of the abdominal muscle, sharply pinched below the thoracic cage, and even the sloping angle of the pectorals.

250. *Study for the left hand of Giuliano de' Medici (portion of sheet)*
1520–21
Pen, $11\frac{1}{2} \times 10\frac{3}{4}''$ (whole)
FLORENCE, ARCHIVIO BUONARROTI,
XIII, fol. 169 verso

A brilliant and undoubted sketch for the hand which, in the statue, holds coins; an interesting indication that this function was not originally in Michelangelo's mind.

251. *Torso and legs*
1520–25
Pen, $7\frac{5}{8} \times 4\frac{3}{4}''$, cut down and relined
FLORENCE, CASA BUONARROTI, 48 F

This never doubted but seldom noted drawing has been successfully connected with the never executed river gods intended to rest along the plinths below the sarcophagi. The style is that of the series of pen studies for *Night*.

252. *Measured drawing for a river god*
1520–25
Pen, $5\frac{3}{8} \times 8\frac{1}{4}''$
LONDON, BRITISH MUSEUM, W. 35 recto

The line on the verso, referring to the approaching death of King Francis I in prison in Spain (which was believed imminent in 1525), may also date the drawing, but this is not conclusive. Blocks for the river gods arrived in Florence in October, 1525, but Michelangelo's letter objecting to them cannot be clearly interpreted. The recently suggested change of scale for the river gods in Michelangelo's mind at this time is a possibility that still lies beyond demonstration. The drawing may have been made in 1525 or it may have been one of the original group he took to Carrara in 1521.

253. *Christ on the Cross*
1525–34(?)
Red chalk, $3\frac{3}{4} \times 2\frac{3}{8}''$ (fragment)
LONDON, BRITISH MUSEUM, W. 68 recto

This tiny colossus has escaped all doubts. It is different from any other representation of the Crucifixion by Michelangelo in that the arms are stretched taut, parallel to the crossbar. This and the diminutive scale support the recent contention that the sketch was made for the crucifix on the altar of the Chapel. The hard, blocklike contours suggest a late date.

Paintings

254. *Sketch for a Resurrection*
1520–25(?)
Red chalk, $6\frac{1}{8} \times 6\frac{3}{4}''$, cut down
PARIS, LOUVRE, 691b

Never doubted, this explosive sketch has been connected, like the finished study No. 256, with the lunette on the entrance wall of the Medici Chapel. As has been stated, the evidence is entirely stylistic and iconographic. In date the drawings seem to belong to the period of the Medici Chapel, and Michelangelo was not one to take time from important commissions for imaginings without a purpose. The composition would fit the space admirably. The Chapel was dedicated to the Resurrection. Leo X's bull against Martin Luther, dated June 15, 1520, began, "Rise up O Lord." An explosive Resurrection is celebrated on Easter Saturday in the festival of the Explosion of the Car (*Scoppio del Carro*) in front of the Cathedral of Florence. This early scheme shows the Lord leaping from the tomb with His arms raised, as in No. 256, but with one foot firmly on the ground, and a less billowing mantle. An indication of the cave in the background suggests a painting and a lunette shape. The contours are loosely and freely drawn, and there is little hatching.

255. *Sketch for a watcher at the sepulchre*
1520–25
Red chalk, $5\frac{3}{8} \times 7\frac{5}{8}''$, cut down and relined
FLORENCE, CASA BUONARROTI, 32 F

A splendid sketch, accepted by almost all recent scholars, for the watcher pushed off the sarcophagus by the rising lid. This figure is summarily indicated in No. 254, but restudied here substantially as he will appear in No. 256. This is the kind of drawing which may well have influenced the draftsmanship of Tintoretto.

256. *The Resurrection*
1520–25(?)
Black chalk, $9\frac{1}{2} \times 13\frac{5}{8}''$, cut down
WINDSOR, ROYAL LIBRARY, 12767 recto
(for verso see No. 124)

Like No. 254, this wonderful drawing has never been placed in question. Contrary to some statements, it fits perfectly into a semicircle. The Christ has been developed from No. 254 with slight changes, mostly in the interest of greater verticality. The recumbent figure has been moved farther right and reversed, so that he looks at the miracle without turning his head. Another soldier carrying a shield and attempting to rise has been inserted between this recumbent figure and Christ. The soldier seen from the back has been carefully worked out, and another sleeping figure added, in the shadow at the extreme right. A great deal has now been made of the watcher slipping off the rising lid, and a richly intertwined group of four added at the left. There is a great deal of rubbing, and stippling over the modeled portions, close to the presentation drawings of the early 1530s.

257. *The Brazen Serpent*
1520–25(?)
Red chalk, $9\frac{5}{8} \times 13\frac{3}{4}''$
OXFORD, ASHMOLEAN MUSEUM, P. 318 recto
(for verso see No. 412)

A wild and terrible vision, prophetic of the most awe-inspiring passages in the *Last Judgment*, this drawing is one of the few unassailed composition drawings by Michelangelo. It has been suggested that the artist has really represented not one but two scenes, first the attack by the fiery serpents (above) and then the delivery of the Israelites from this menace. The absence of the Brazen Serpent itself can readily be explained, since Christ is the Brazen Serpent according to His own words ("as Moses lifted up the Brazen Serpent in the wilderness, so shall the Son of Man be lifted up"), and since the two lunettes would have flanked the Resurrection in which Christ is lifted up. The attack of the fiery serpents is clearly alluded to in the same Bull of 1520, as a symbol of the Lutherans attacking the faithful with poisonous doctrines. Many of the figures are barely indicated by a few rapid contours, but in each whirlwind scene the central group is modeled with some completeness. Certain figures in these unused compositions turn up later in the *Last Judgment*.

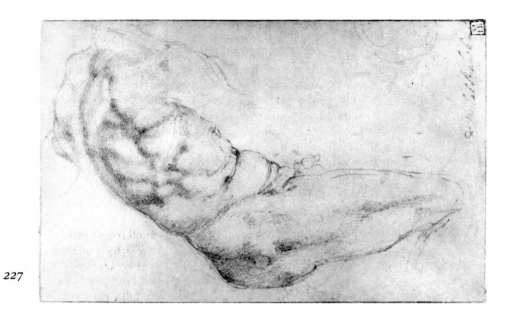

227

228

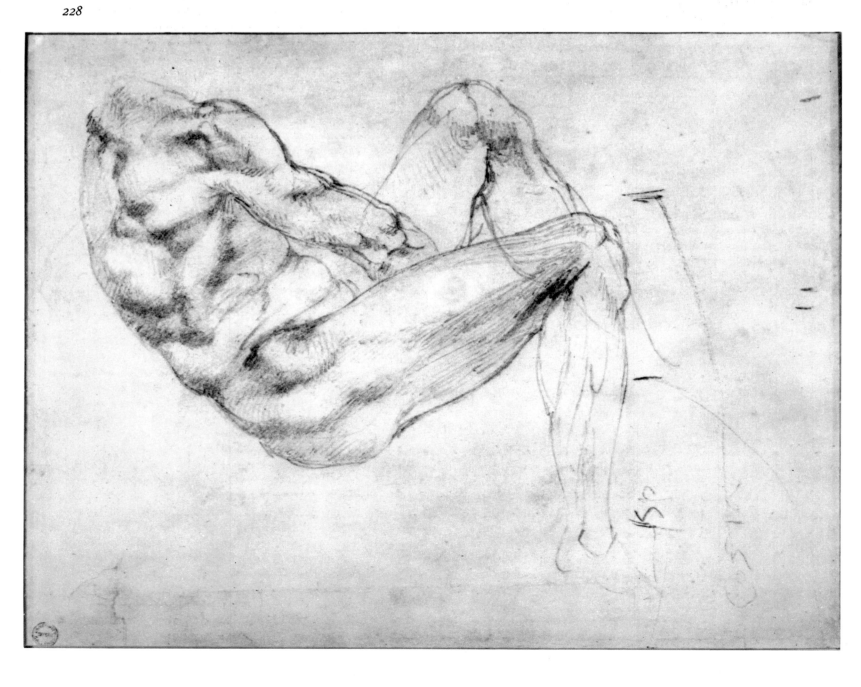

229

231

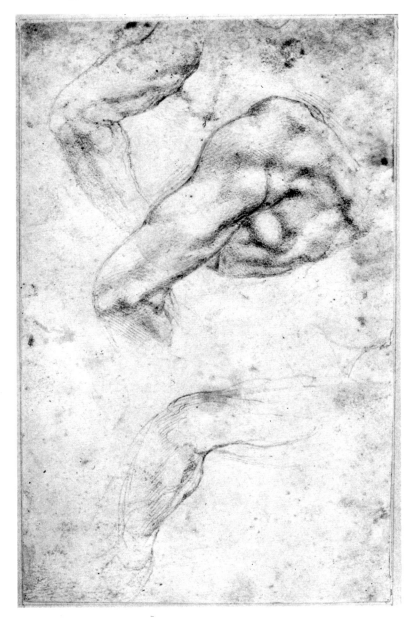

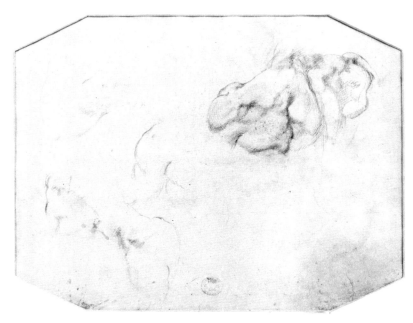

230

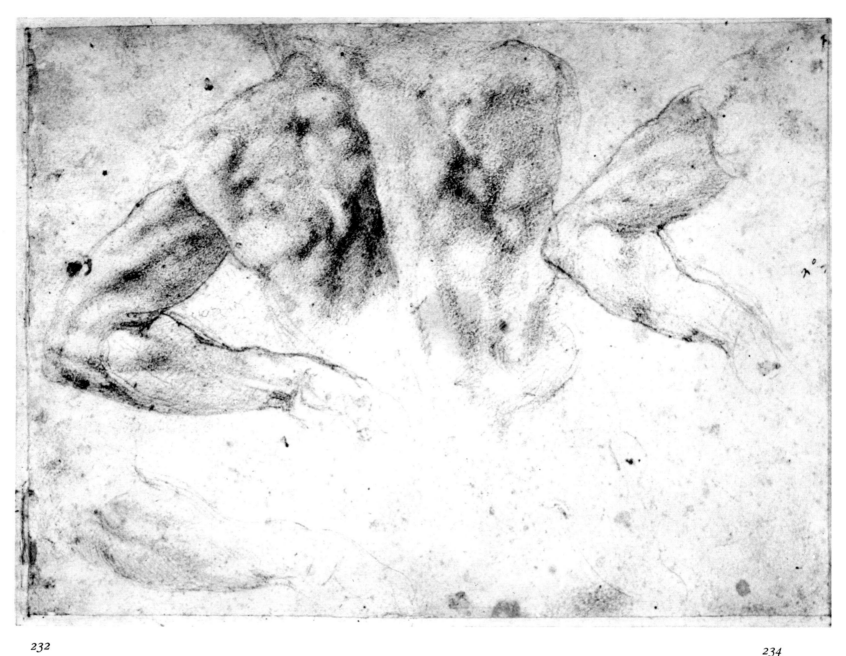

232

234

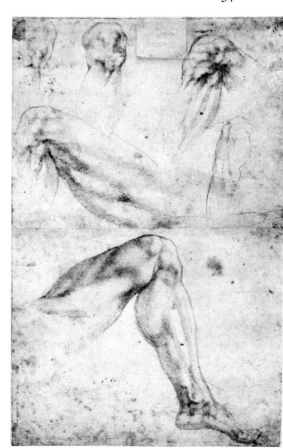

233

184

235

236

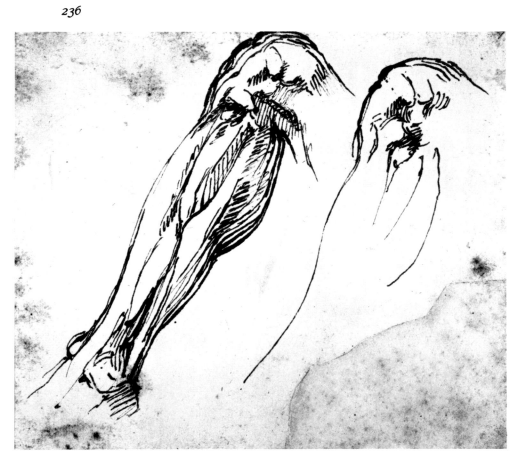

237

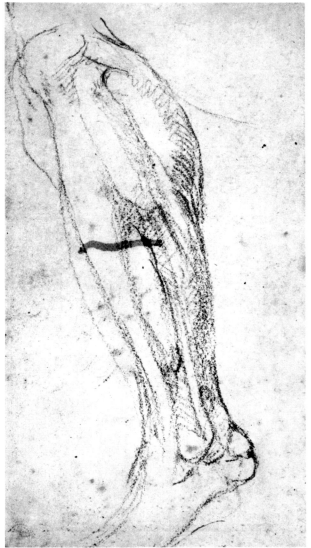

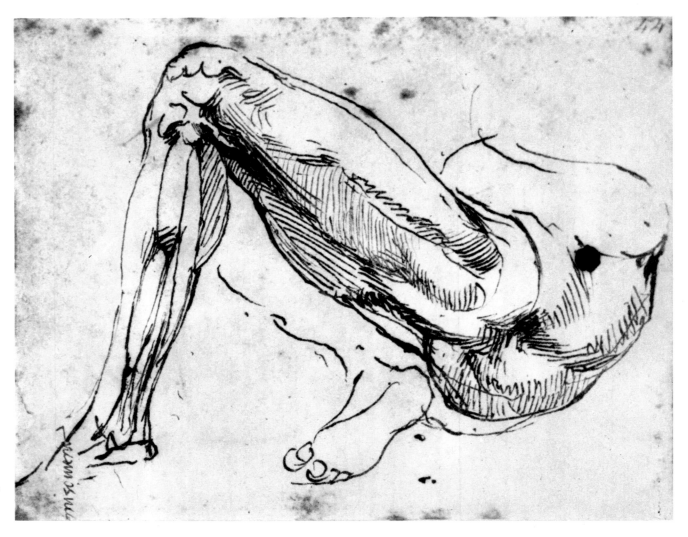

238

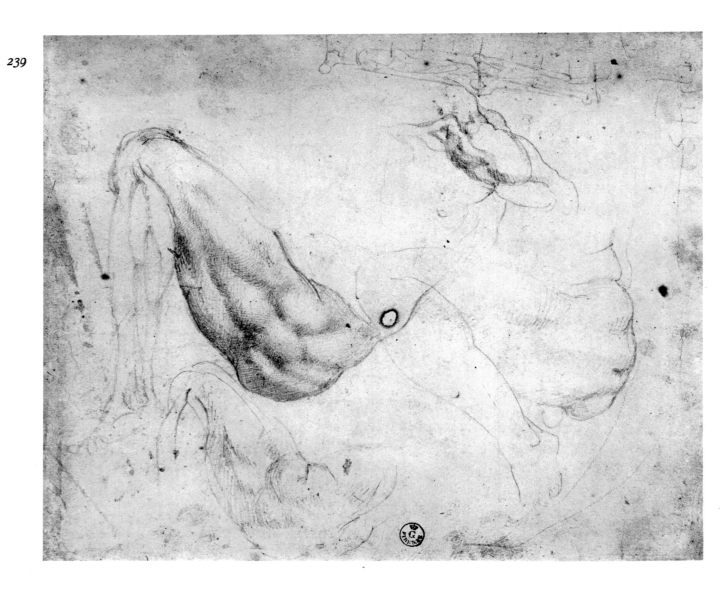

239

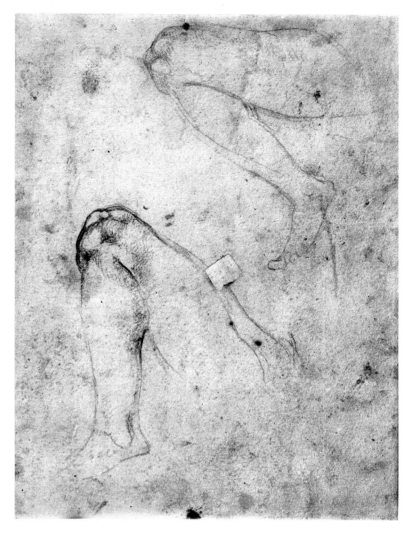

240

241

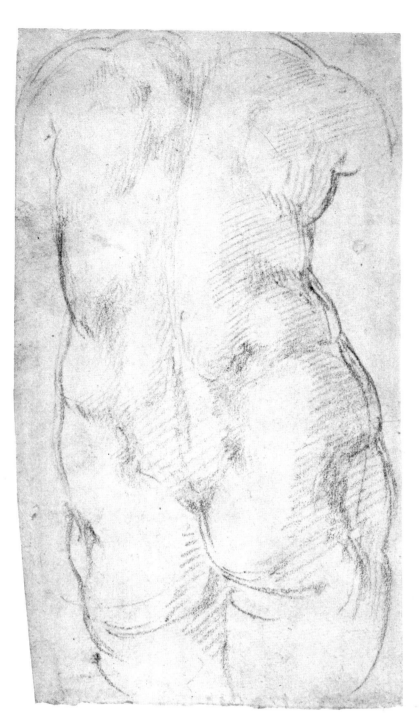

242

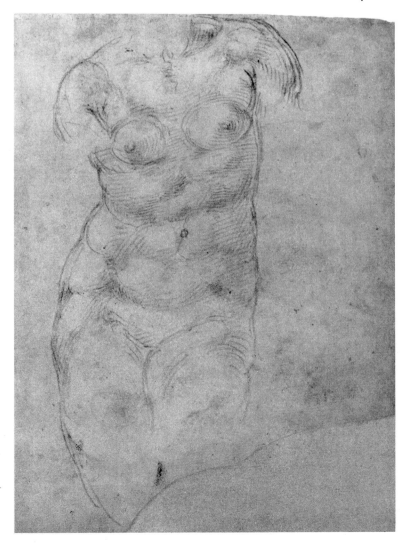

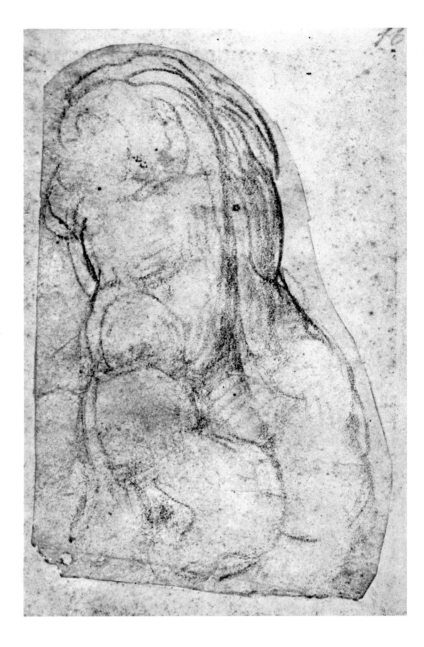

243

244

188

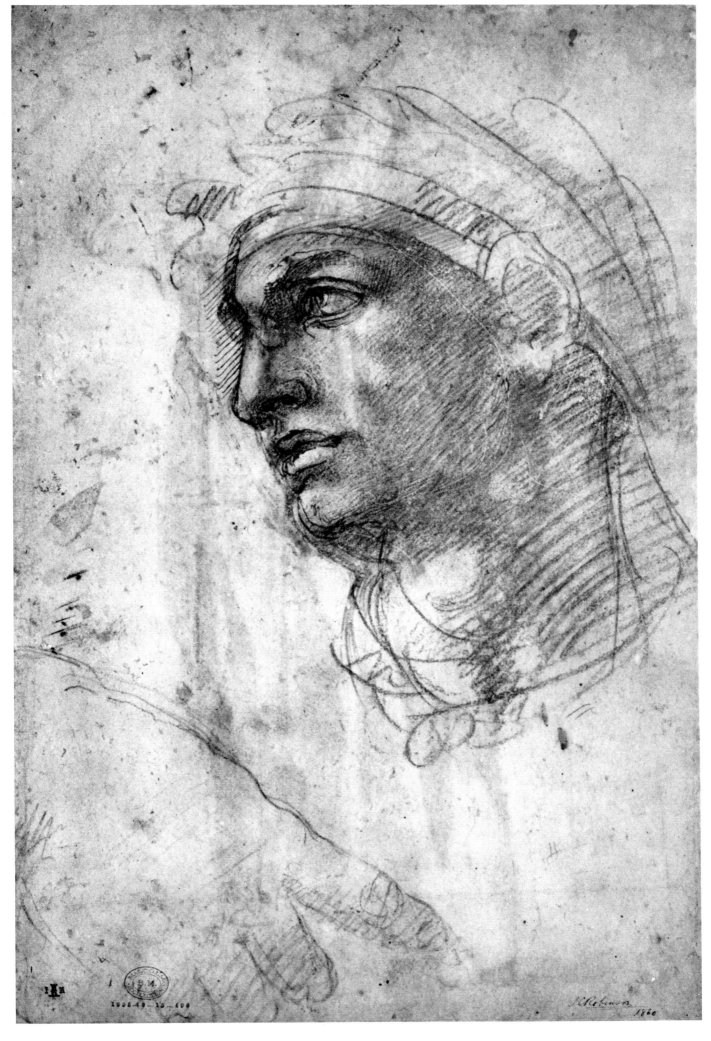

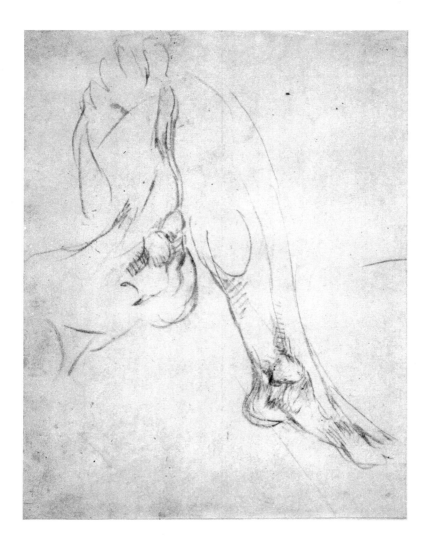

246

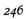

247

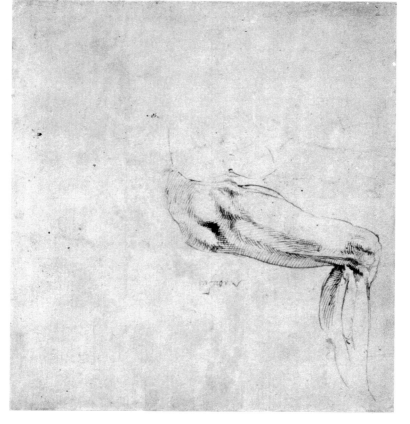

248

249

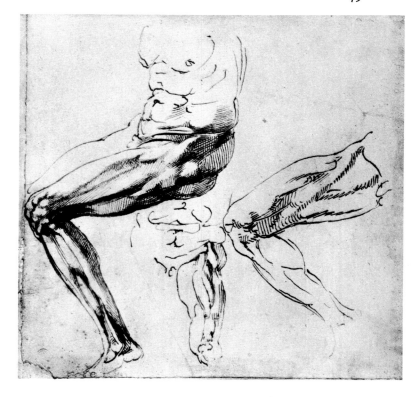

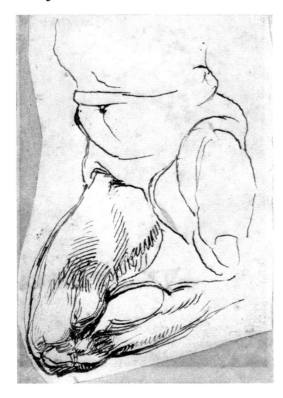

252

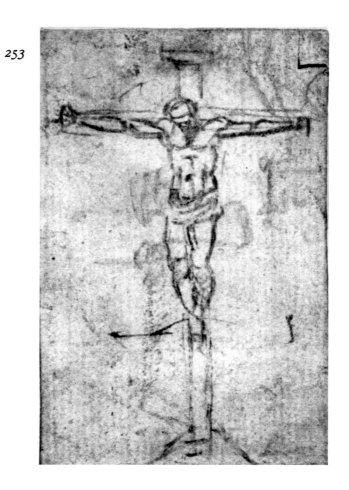

253

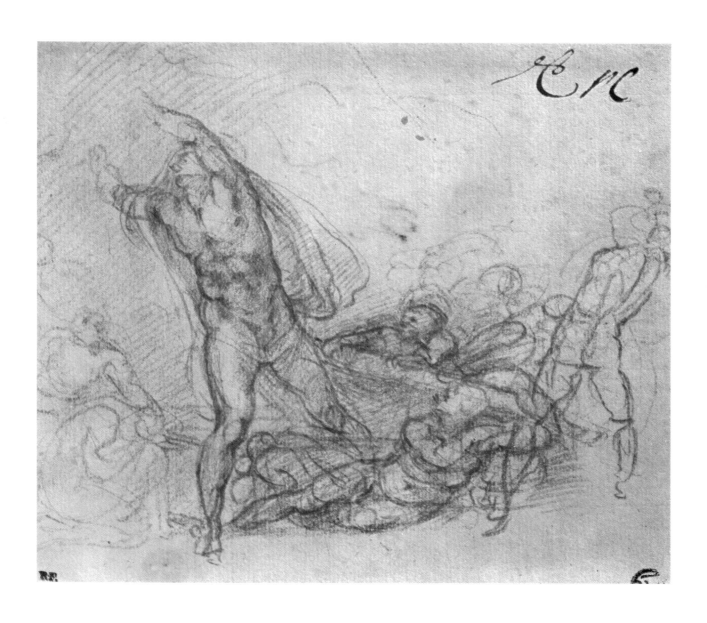

254

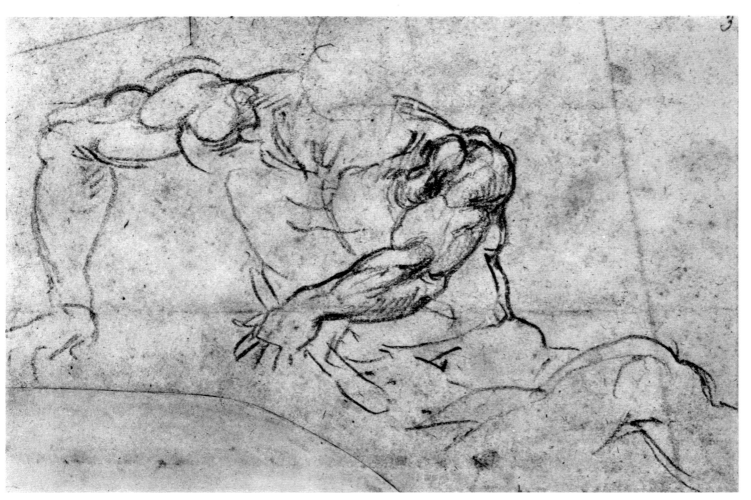

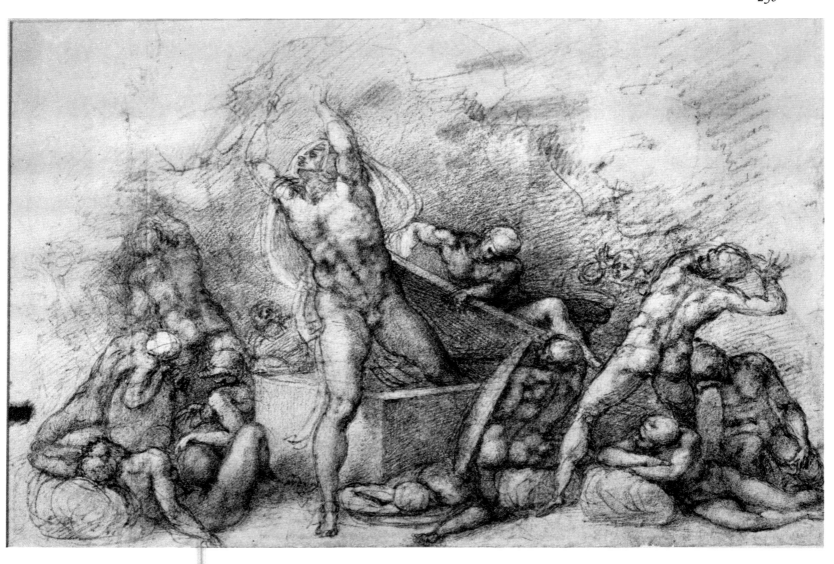

257

10

Drawings connected with the Laurentian Library. Florence, 1524–33

Although the recently discovered memorandum of Giovan Battista Figiovanni shows that as early as 1519 Cardinal Giulio de' Medici cherished the idea of a new library for San Lorenzo, to contain the great Medicean collection of books and precious manuscripts, he does not seem to have given Michelangelo the commission to build the structure until December, 1523, a few weeks after his election as Pope Clement VII. A remarkable number of original drawings for the project have been preserved, in the customary media of black chalk, red chalk, and pen. So generally have these been accepted by scholars that mention of the critical fate of individual drawings will be limited here to the rare cases of rejection.

After some initial site-plans and other diagrammatic sketches, not here reproduced, the series begins with an early three-aisled design for the reading room (No. 258), apparently made at a time when the exact site for the library had still not been decided. Unfortunately, no later drawings for the reading room have survived, so that we cannot follow its evolution in Michelangelo's mind. We do possess a considerable series of studies for portals, niches, windows, tabernacles, cornices, capitals, and bases for the reading room and for the dramatic entrance hall, one of Michelangelo's most characteristic architectural creations, as well as important preliminary studies for an early, single-story stage of the entrance hall (Nos. 262–65) and for a double staircase (Nos. 260 and 283). The original, very beautiful design for the ceiling (No. 286) and a sketch for the reading desks (No. 285) are likewise preserved. Especially important is the set of plans for a small rare book room (Nos. 281 and 282), whose unusual triangular shape, determined by the limitations of the site, was brilliantly exploited by Michelangelo.

258. *Study for the Laurentian Library*
1524
Pen over black chalk, 8¼×11½″, cut down and badly torn
FLORENCE, CASA BUONARROTI, 42 A recto

This drawing used to be considered a study for the entrance hall, but has more recently been identified with an early stage of the evolution of the reading room, between January and April, 1524, when plans were still fluid and even a definitive site had not been chosen. Michelangelo started with a towering three-story design in black chalk, then quickly reduced it to two, apparently with a basilical arrangement in mind, flanking the high central reading room with lower side-aisles, if one can judge from the heavy hatching of the areas between the columns of the first story. It has been estimated that lower windows built to this scale would

not have risen above the level of the cloister roof, and therefore would have remained blind. As yet the artist has not seemed to recognize the effect the reading desks would have on the lower portions of the architecture. In the finished building the bases of the pilasters are placed above the tops of the desks. The elaborate articulation with paired slender columns between the principal columns of the first story seems to have been renounced as Michelangelo experimented with a simpler solution at the right. However, these paired columns stuck in his mind. They are sketched in the plan at upper center, possibly as they would eventually appear in the entrance hall. The figure sketches are by a pupil.

259. *Studies of door, windows, and niche for the Laurentian Library*
1524
Red chalk, 11⅞×9″
FLORENCE, CASA BUONARROTI, 96 A verso

Beautiful studies, similar in style to No. 154 (here identified as for the San Lorenzo façade). Classical elements are combined in an unclassical way, hitherto seen only in the studies for the Medici tombs. The elements appear related to Nos. 267–69. A working drawing, probably by a pupil, shows through from the recto.

260. *Plans for the Laurentian Library*
1524–25
Pen, 9¾×8⅞″, cut down
FLORENCE, CASA BUONARROTI, 89 A recto
(for verso see No. 261)

The plan at upper left has generally been taken to refer to a chapel to be connected with the Library. This was disapproved in a letter dated April 12, 1525, in favor of a rare book room (see Nos. 281 and 282.) In the same letter was communicated the Pope's rejection of Michelangelo's idea of a double staircase for the entrance hall, with the two flights hugging the walls and joining before the door (see No. 283). This project is also represented here, and x'd out.

261. *Sketches for the Laurentian Library*
1524–25
For medium and dimensions, see No. 260
FLORENCE, CASA BUONARROTI, 89 A verso
(for recto see No. 260)

Of the various suggestions put forward for these handsome sketches, the most convincing seems that they were intended to define a double entrance, seen from the reading room side. But there is no complete agreement and insufficient evidence. The firm, quick pen style is characteristic of the series.

262. *Sketches for the Laurentian Library*
1524–25
Pen, 8⅛ × 16⅛″, two cut-down sheets pasted together
HAARLEM, TEYLERSMUSEUM, A 33 verso
(for recto see No. 234)

Done on the verso of studies for *Day*, these sketches have been rejected entirely by several critics, but they seem genuine nonetheless. The pen line varies in the series according to the kind of pen Michelangelo used. This was done with a long-cut, flexible point, which produced a relatively light and scratchy line. The sketch at upper left tries out two possibilities for the entrance hall at a time when it was still to be a single story building with a low vault. A broader grouping, reminiscent of some of the arrangements for the Medici tombs, is seen below, with a sketch for the double stairs as in the plan, No. 260. At the right is a sketch for the ceiling vault. Upside down, the other sheet shows one bay of the entrance hall with attic story and vault above.

263. *Study for the Laurentian Library*
1525
Pen and red chalk, 10½ × 7¾″, cut down and badly torn
FLORENCE, CASA BUONARROTI, 48 A recto
(for verso see No. 264)

Michelangelo was proceeding with the design of the entrance hall in April, 1525, but by November the Pope, although he liked the *occhi* (eyes, e.g., circular windows) very much, complained that he would have to pay two monks full time to clean the dust off the glass. The one-story vaulted scheme was abandoned in favor of a two-story arrangement. The wonderful idea of the doubled, recessed columns appears full-blown for the first time, but the conflict between these columns and the wall is softened by the introduction of pilasters flanking the recesses. In the hall as executed these were given up in favor of unbroken wall masses, and in consequence the design greatly strengthened.

264. *Sketch for the Laurentian Library*
1525
Red chalk; for dimensions, see No. 263
FLORENCE, CASA BUONARROTI, 48 A verso
(for recto see No. 263)

Renewed experimentation with motifs from No. 263; possibly the final solution is appearing.

265. *Studies for the Laurentian Library*
1525
Pen, 11¼ × 10⅛″, spotted
LONDON, BRITISH MUSEUM, W. 36 recto
(for verso see No. 266)

Very close to the final version in which, however, the panels between the columns are left free of ornament, and the beautiful consoles no longer reach down to the plinth. As

a result, the columns seem to be struggling upward, almost floating, in their attempt to restrain the inert walls. The tabernacle appearing in the upper left is a separate study in a different scale, not intended to be read together with the bases. The downward-tapered pilasters are already indicated. Turning the drawing on its side, a profile of the single story and attic combination for the first design of the entrance hall can be made out.

266. *Studies for the Laurentian Library*
1525
For medium and dimensions, see No. 265
LONDON, BRITISH MUSEUM, W. 36 verso
(for recto see No. 265)

The sheet is covered with careful studies of profiles of the bases of columns and pilasters for the entrance hall. The dull heads in chalk are by a pupil.

267. *Sketch for a window for the Laurentian Library*
1525(?)
Black chalk, 14¾ × 11⅛″, cut down and heavily spotted
FLORENCE, CASA BUONARROTI, 37 A recto
(for verso see No. 270)

A still rather clumsy attempt at the formulation of a window for the second story of the entrance hall, with characteristic corner tabs propped by consoles. Upside down, an early idea for the broken pediment of the main portal to the reading room can be made out.

268. *Sketch for a window and pilasters for the Laurentian Library*
1525(?)
Black chalk, 15¾ × 10⅝″, cut down and spotted
FLORENCE, CASA BUONARROTI, 39 A recto
(for verso see No. 269)

The same forms set forth in No. 267 are now compressed, by virtue of their position between the paired pilasters.

269. *Sketch for a window for the Laurentian Library*
1525(?)
For medium and dimensions, see No. 268
FLORENCE, CASA BUONARROTI, 39 A verso
(for recto see No. 268)

Very close to the final version, as actually built. The festoons below the windows are replaced by quiet oblong panels in *pietra serena*, and the obstreperous tabs moved from the upper to the lower corners of the windows. The panel shown at the top was later to be replaced by the revived circles, blind now, inscribed in squares.

270. *Sketch of a block and a hand*
1525(?)
Black chalk, 14¾ × 11⅛″, cut down and heavily spotted
FLORENCE, CASA BUONARROTI, 37 A verso
(for recto see No. 267)

The block appears to belong to the balustrade of the stairway. The magnificent hand has been identified by one scholar as the left hand of *Giuliano de' Medici*, which it does not much resemble, and by another as a hand from the cartoon of

Venus and Cupid which Michelangelo drew in 1532–33. Neither solution is decisive.

271. *Profiles of cornices for the Laurentian Library*
1525(?)
Red chalk, $10\frac{3}{4} \times 8\frac{3}{8}''$, cut down and heavily spotted
FLORENCE, CASA BUONARROTI, 62 A recto
(for verso see No. 272)

This and the following drawing study with great care and relatively slight variations several possibilities for the great cornice of the entrance hall. The hatched study at the upper right corresponds most closely to the cornice as actually carved. The formal repertory is full of unexpected projections and hanging shapes, of zigzags and flattened parabolic curves. The fluid calligraphy with which these shapes are set down should be compared with the labored quality of Michelangelo's earlier architectural profiles. This new freedom corresponds to his freedom from convention in throwing together architectural forms in the surface articulation of the building.

272. *Profiles of cornices for the Laurentian Library*
1525(?)
For medium and dimensions, see No. 271
FLORENCE, CASA BUONARROTI, 62 A verso
(for recto see No. 271)

More profiles ringing changes on the same basic forms. At the upper right Michelangelo again has seen a face in one of his cornices.

273. *Profiles of cornices, capitals, and bases for the Laurentian Library*
1525(?)
Red chalk, $7 \times 9\frac{1}{4}''$, cut down
FLORENCE, CASA BUONARROTI, 63 A

At the right, profiles of Tuscan capitals; at the left, upside down, bases.

274. *Block diagram and plan of capital for the Laurentian Library*
1525(?)
Pen, $12\frac{1}{4} \times 8\frac{1}{2}''$, cut down and relined
FLORENCE, CASA BUONARROTI, 78 A

The rough diagram below is Michelangelo's indication to the stonecutter, complete with measurements, of the outside shape of a block from which one of the Tuscan capitals of the entrance hall was to be carved. Above he has shown the stonecutter the inner forms for which provision would have to be made in cutting the block.

275. *Study for the portal of the Laurentian Library*
1526
Pen, $11\frac{1}{4} \times 8\frac{1}{4}''$
LONDON, BRITISH MUSEUM, W. 37 recto
(for verso see No. 276)

A superb drawing for the reading room side of the entrance portal, dated exactly in April, 1526, by Michelangelo's correspondence. The doorway was not executed until after

August, 1533, and perhaps still later, for Michelangelo omitted the papal arms (after the death of Pope Clement VII in 1534?) in favor of a gabled pediment projecting from the arched one, suppressed the consoles, and lowered the plinth.

276. *Study for the portal of the Laurentian Library*
1526
For medium and dimensions, see No. 275
LONDON, BRITISH MUSEUM, W. 37 verso
(for recto see No. 275)

The principal drawing defines the portal from the staircase side, again with papal arms, later omitted. In execution, Michelangelo broke the pediment more decisively and more widely. The smaller studies have not been identified, but may not be doors at all. They show some relation to the exterior windows.

277. *Profiles for the portal of the Laurentian Library*
1533
Pen, $14\frac{1}{2} \times 21\frac{3}{4}''$, cut down and spotted
FLORENCE, CASA BUONARROTI, 53 A recto
(for verso see No. 278)

The inscriptions in Michelangelo's hand identify these profiles with the second version of the portal, as they mention Ceccone, the stonecutter named in the contract of 1533.

278. *Profiles for the portal of the Laurentian Library*
1533
For medium and dimensions, see No. 277
FLORENCE, CASA BUONARROTI, 53 A verso
(for recto see No. 277)

Further profiles for the portal; it has been shown that this and No. 277 were followed exactly in executing the carving.

279. *Template for the Laurentian Library*
1530–33(?)
Red chalk and pen, $10\frac{7}{8} \times 8\frac{3}{4}''$, cut out
FLORENCE, CASA BUONARROTI, 60 A

Close to the preceding profiles, but so far not exactly identified. The notations concerning measures of grain, oats, and broad beans are not in Michelangelo's hand.

280. *Sketches for a chapel for the Laurentian Library*(?)
(*portion of sheet*)
1525(?)
Pen, $16\frac{3}{4} \times 10\frac{1}{8}''$ (whole), cut out at top, mended
LONDON, BRITISH MUSEUM, W. 38 recto

This little sketch has been connected with Michelangelo's proposal to put the tombs of Leo X and Clement VII in the "lavamano" outside the Medici Chapel, which space was considered too small and otherwise unworthy by Pope Clement. The drawing has also been identified as a project for the papal tombs when they were proposed for the choir of San Lorenzo. Both suggestions seem unsatisfactory in the absence of any indication of a sarcophagus or even a place for one. Michelangelo's tomb designs always incorporate the sarcophagus into the organization of the wall as a whole.

A more likely possibility is the recent suggestion that the plan, with its definitely indicated altar space, and the cross section with a flattened dome were intended for the chapel Michelangelo wanted to build at the end of the main reading room, replaced at papal request by the rare book room. The recessed columns are stylistically very close to those of the entrance hall of the Laurentian Library, and this little structure would have made a fitting culmination to the long, uniformly articulated reading room.

281. *Sketch plan for the rare book room, Laurentian Library*
1525–26
Pen, 11⅛×16¼", cut down, folded
FLORENCE, CASA BUONARROTI, 79 A recto

This and the following drawing show the evolution in Michelangelo's mind of one of his most extraordinary inventions, the *libreria secreta* demanded by the Pope instead of a chapel at the opposite end of the reading room. Both the fantastic shape and possibly the fate of this brilliant creation were apparently determined by the limitations of the site. The house of Ilarione Martelli faced on the Via Zanetti, which cuts across at an acute angle, so that the back of the house left only a triangular space at the end of the reading room. It is not clear from the correspondence whether the Pope was trying to buy a piece of Ilarione's house, or just the back wall, to be replaced by Michelangelo's adjoining wall of the rare book room, nor is it even clear whether or not the Pope's offer was ever accepted. But the strange shape looks as though Michelangelo were trying to avoid taking any of Ilarione's property, whose limits are ruled off at the right. Surely this is the first triangular room in architectural history. The present drawing, rapidly abandoned, shows the artist's initial uncertainty as to how to handle the reading desks. Putting them parallel to the two equal sides of the triangle they collide with the third, which was to be the entrance. He attempts to make them curve around the opposite point, but that will not work either. The elevation of one corner is indicated, with circular windows again in the attic. The verso contains a memorandum of payments to an assistant, running from August 3, 1525, to January 20, 1526. It is possible that the recto was used for a plan only after the negotiations with Ilarione fell through.

282. *Plan for the rare book room, Laurentian Library*
1525–26
Pen and wash, 8¾×11", cut down and relined
FLORENCE, CASA BUONARROTI, 80 A

The triangular shape is now fully expressed in the labyrinthine disposition of three continuous reading benches. The outer two break around to enclose the inverted V of the third, between whose legs, facing the door, is a round desk. The sense of menacing enclosure, so powerful in the entrance hall itself, is made even more intense here, after the long, deliberately monotonous extent of the reading room. Michelangelo's inscriptions read, at the left, "From here on one can do what one pleases because it belongs to the priests"; at the right, "the house of Ilarion Martelli," and "the wall of Ilarion Martelli." Below these one reads, "It reduces to a circle above and all the light is received from the vault because one cannot get it from elsewhere." In each of the corners, cut off by a niche flanked by two columns, Michelangelo has written, "light from above." The cut-off corners, clearly, have a simple, practical purpose—to provide air

shafts so that the round windows in the attic could have a source of light, as in the sketch in No. 281. The niches with their columns, surmounted by the attic with its round windows, provide the strongest possible accent on the corners. Each wall is then divided into one square flanked by two round niches. The nonexecution of this delightful room, ancestor of many secret spaces in Mannerist architecture, must be considered a tragedy almost on the level of the loss of the façade of San Lorenzo, of the *Battle of Cascina*, and of so much of Michelangelo's early sculpture.

283. *Sketches for the stairway of the Laurentian Library;*
profiles of bases
1525
Pen, red chalk, black chalk, and wash, 15⅜×11", cut out
FLORENCE, CASA BUONARROTI, 92 A verso
(for recto see No. 284)

This heavily used sheet contains several chalk studies for heads, legs, and drapery which have been convincingly attributed to Antonio Mini. With complete disregard for these, Michelangelo utilized the sheet for large profiles of bases, then, working around his profiles when the latter had already been inked in but otherwise ignoring them also, he studied the problems created by the Pope's refusal to let him build a double staircase as he had originally wished (April 4, 1525). Toward the top can be seen the rejected staircase (see also No. 260), with its balustrade. Then, below, Michelangelo tries to make one out of two by splaying the staircases. At the bottom, he works on the principle of nesting semicircles used in Bramante's staircase for the Belvedere in the Vatican.

284. *Sketches for the stairway of the Laurentian Library;*
profiles of bases
1525
For medium and dimensions, see No. 283
FLORENCE, CASA BUONARROTI, 92 A recto
(for verso see No. 283)

No identification has been made for the frame at the upper left. Below it comes another semicircular diagram, also hard to decipher. Then a brilliant, if terrifying, solution uniting the lateral flights with a central one by means of dovetailing recessions based on the old perspective cube ornament common in the early Renaissance. This was to be the nucleus of Michelangelo's final, wonderful stairway, built from his model only in 1559. He succeeded in placating the Pope and still retained the doubled motive he felt necessary.

285. *Sketch for a reading desk, Laurentian Library*
1524–33
Pen, red chalk, 6¼×7½", cut down
FLORENCE, CASA BUONARROTI, 94 A

The reading desks at which the visitor was obliged to consult the codices (each volume at its own desk) were designed by Michelangelo as an essential part of the structure of the reading room. The present sketch shows how the back of one desk serves as a bench for the next, and how a person can sit and contemplate a book. Aside from the brilliance of the practical and architectural solution, the drawing is not without a touch of Michelangelo's whimsy. The weak red chalk sketches have been recently and justifiably placed in doubt. They are impossible to accept as Michelangelo's work.

286. *Sketch for the ceiling of the Laurentian Library*
1524
Black chalk, 15⅛ × 10⅜″
OXFORD, ASHMOLEAN MUSEUM, P. 308 verso
(for recto see No. 222)

This recently discovered rough sketch, too authoritative and powerful to doubt, gives an early answer to the Pope's request (April 13, 1524) for a ceiling design with "a little fantasy." It was rejected because the equal division of the spaces did not bring the longitudinal beams over their supporting pilasters.

287. *Study for the ceiling of the Laurentian Library*
1526
Red and black chalk, 14¾ × 8¼″, cut down
FLORENCE, CASA BUONARROTI, 126 A

A beautiful and surprisingly delicate study, whose spacing now conforms to that of the pilasters below. The center oblong runs across the ceiling, whose longitudinal axis is firmly reinstated by the device of a long oval, with four recesses suggesting a cross. In each recess is placed a ram's skull, recalling those of the Sistine Ceiling, and from each ram's skull hang two festoons, each joined to another ram's skull to make a lozenge of flowering garlands. The corners are filled with oblong panels, and those on the right are framed with consoles, like those of the early designs for the Sistine Ceiling (No. 63). Winged *putti* flank the rams' skulls. The lateral fields were to be divided into three oblong panels whose moldings were diverted in the center of each long side to form a delightful triple interlace. Between the panels figures are sketched, and each panel has its own arched pediment and base. This exquisite design, with all its memories of the Sistine Ceiling, was only very roughly followed in the wooden ceiling erected after 1537, when Michelangelo was irrevocably settled in Rome.

258

259▶

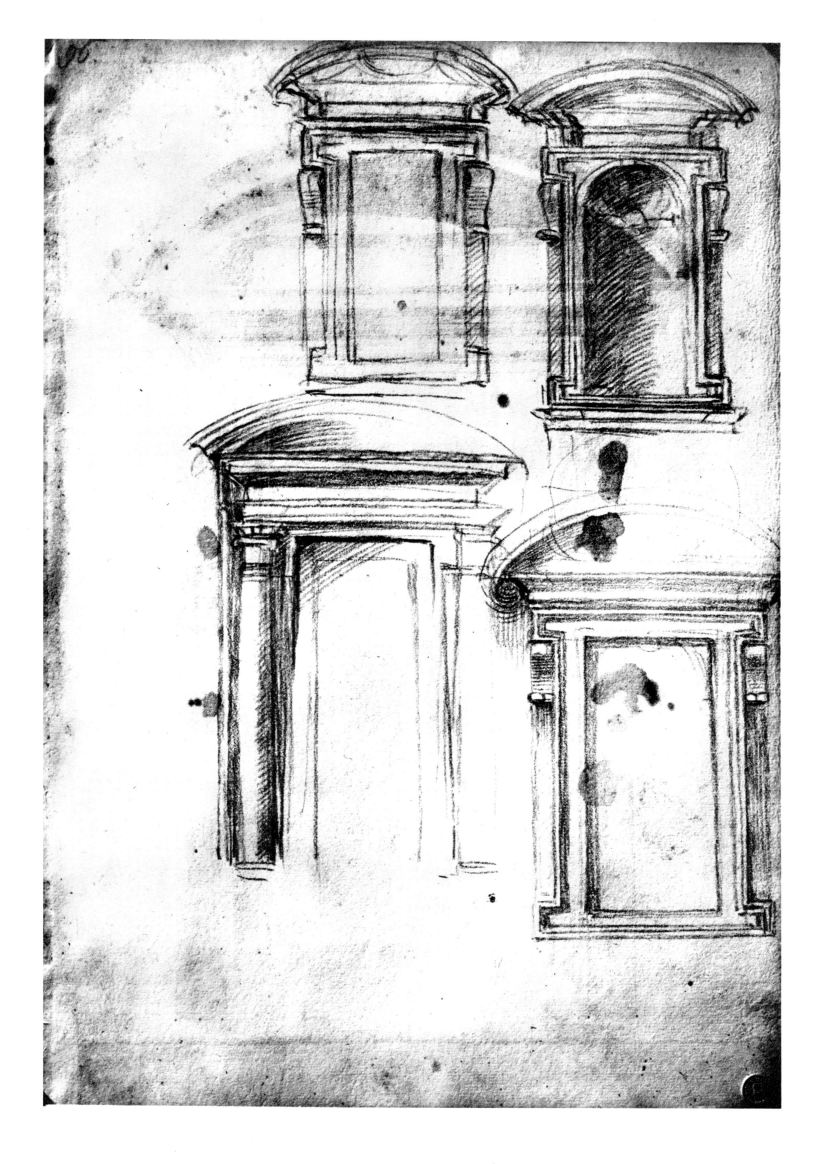

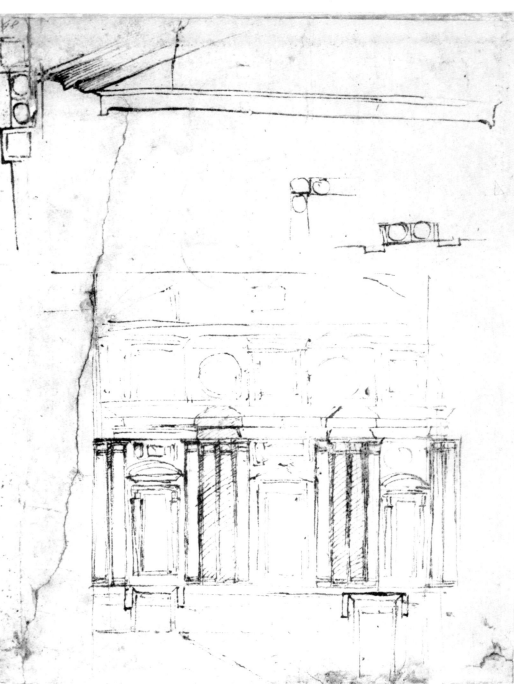

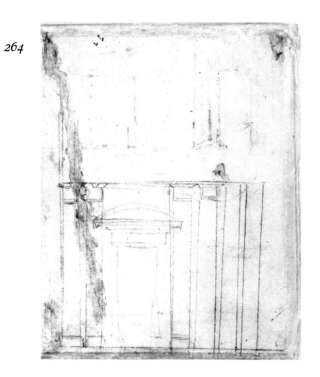

264

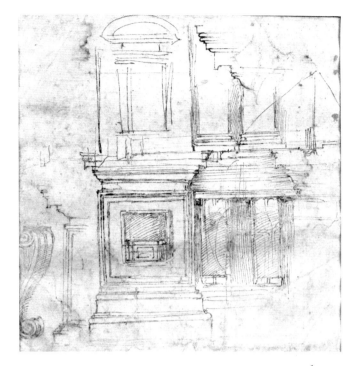

265

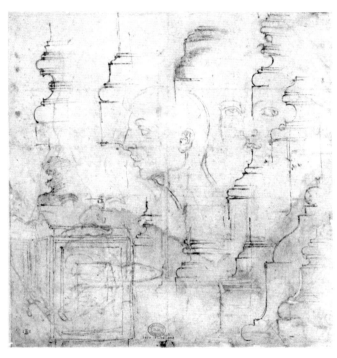

266

267

269

268

270

271

272

273

274

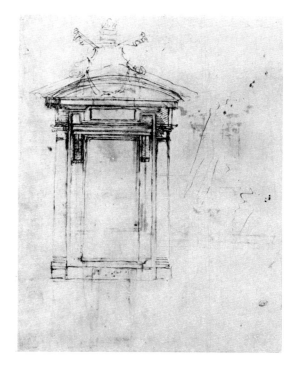

275

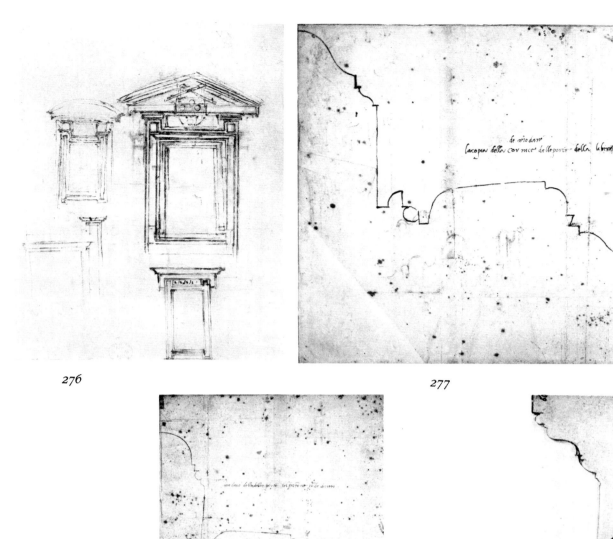

276

277

278

279

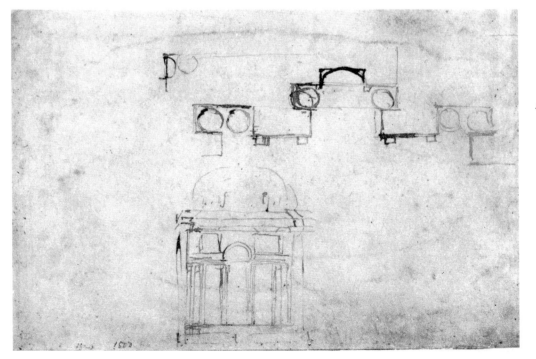

280

205

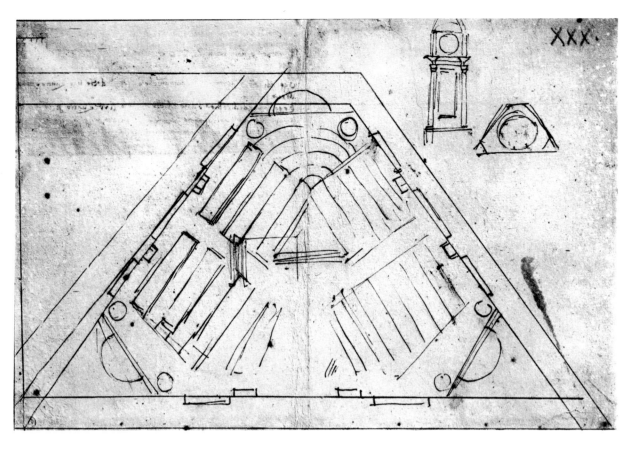

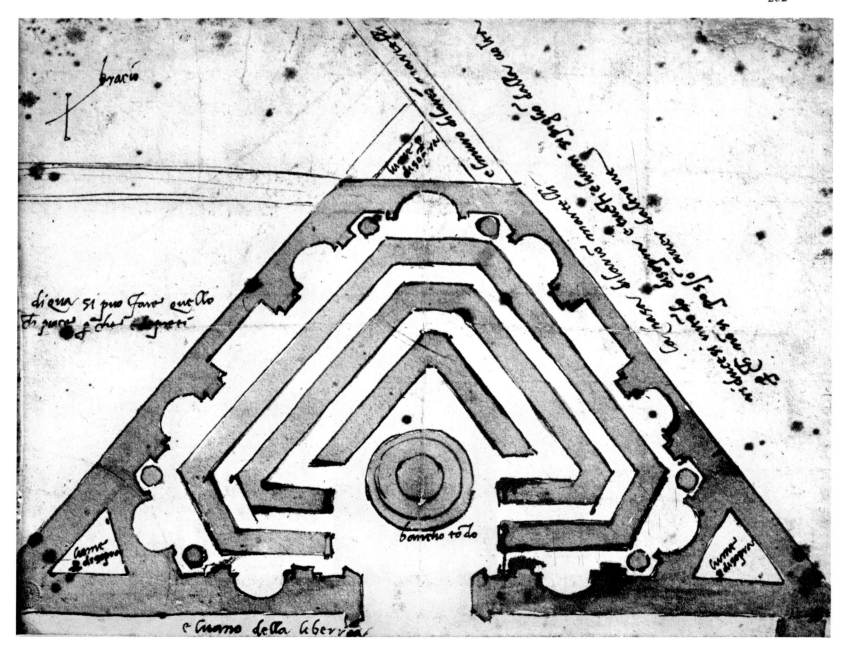

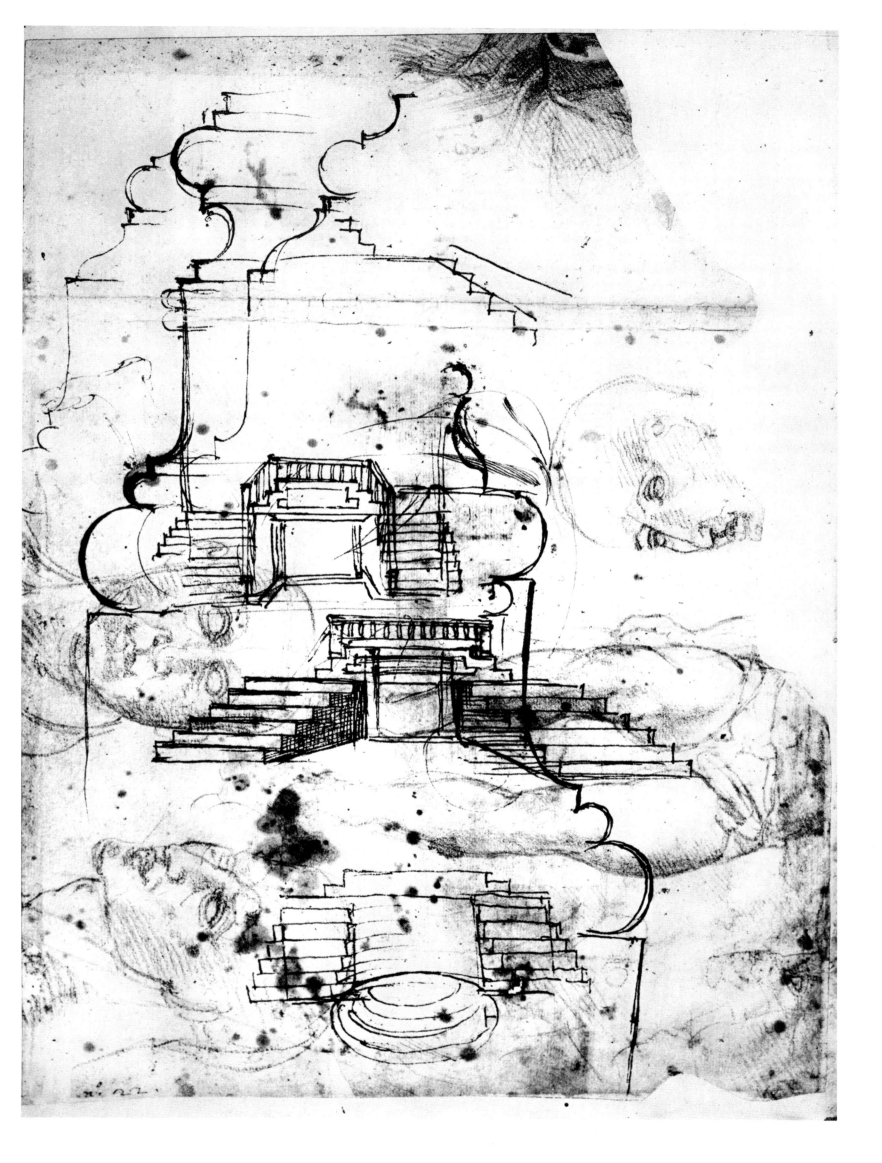

284

285

286

287

11

Drawings for the third and fourth projects of the Tomb of Julius II. Florence, 1516–32

The third contract for the Tomb of Pope Julius II, signed July 8, 1516, provided for a great reduction in the mass of the monument as compared to the 1505 freestanding and the 1513 projecting designs. It was now to be a wall tomb, but with returns each providing for a niche containing a Victory and flanked by Bound Captives before termini, as in the front. The reduction, however, eliminated the rear niches with their Victories, Captives, and termini. The space for the papal sarcophagus and recumbent effigy on the second story was also sharply constricted. Few new drawings were necessary, but Nos. 291–95 appear to be among these, and No. 290 certainly is, because it shows how the effigy, apparently the same one blocked out in 1508, could be raised to an inclined position, still upheld by angelic figures as in the 1513 contract and, in all probability, in the 1505 version as well, when it must have been intended for a position in the inner burial chamber of the first story.

Little or nothing can have been done to make the third project a reality, but in 1526 political difficulties forced a slowdown in the work on the Medici Chapel and the Laurentian Library, and in 1527, with the third expulsion of the Medici from Florence, these projects stopped altogether. Until his appointment in 1529 as governor of the fortifications of Florence, Michelangelo had time to return to the Tomb of Julius II, and this is probably when he rethought the whole formulation of the lower story, partly because the two *Bound Slaves* (now in the Louvre) were in Rome and inaccessible, but more important, because the experience of the Medici Chapel had transformed his ideas about the human figure and its possibilities. It must have been that he then carved the four unfinished *Captives* now in the Academy in Florence and the more nearly completed *Victory* now in the Palazzo Vecchio. The contract for the fourth project, a wall tomb without returns, was not drawn up and signed until 1532, but it was doubtless prepared long before in Michelangelo's mind, possibly on account of his success with the wall tombs in the Medici Chapel, and it may even have been approved verbally in May, 1527, or in April, 1528, during visits to Florence by the Duke of Urbino, heir and executor of Julius II and ally of the Republic of Florence. Numbers 292 and 293 are exceptionally beautiful drawings for the *Victory*, and Nos. 294 and 295 seem to have been made in preparation for two of the Academy *Captives*.

288. *Measured drawing for the upper story of the Tomb of Julius II* (*portion of sheet*)
1516–17(?)
Pen, 8¾ × 12½″ (whole), cut down and relined
FLORENCE, CASA BUONARROTI, 69 A

This undoubted Michelangelo sketch has been hard to place exactly, in spite of Michelangelo's own notations at the right (not illustrated) bearing the date of January 21, 1517. There is no telling which went on the sheet first, the drawing or the writing, or how much distance in time there may have been between them. The sketch was once connected with the façade of San Lorenzo, but that no longer appears likely. It seems to be for the upper story of the Tomb of Julius II. The flaw in this explanation lies in the discrepancy between the drawing and the contract. Not only do the dimensions differ (the structure designed here would have been four feet higher), but the upper cornice is unbroken, giving a strange, blocklike appearance to the attic. This is in direct contradiction to the contract, which provided for a broken cornice, corresponding to the projections of the columns below. Exactly this sort of cornice, although upheld by pilasters, crowns the final version of the Tomb in San Pietro in Vincoli. Was this an early calculation, preceding the contract? Or was it an idea which crossed Michelangelo's mind after the contract, only to be renounced later? The inscription could help us decide, if its subject were in any way relevant to the drawing. We must look for other evidence, and none is forthcoming. But it seems unlikely that Michelangelo would have *expanded* the Tomb project by so much at a moment when he was swamped with work for the façade of San Lorenzo, and was already in financial difficulties with the heirs of Julius II. The most acceptable hypothesis seems that of a rejected stage in Michelangelo's planning, just prior to the 1516 contract.

289. *Capital and profile for the Tomb of Julius II* (*portion of sheet*)
1516–17(?)
Black chalk, 9⅜ × 8″ (whole)
OXFORD, ASHMOLEAN MUSEUM, P. 337 verso
(for recto see No. 397)

The profile is almost identical with that of the upper cornice of the Tomb as finally executed. The relative timidity and conservatism of the shapes as compared to those developed for the Medici Chapel and the Laurentian Library place this drawing almost automatically in the period of Michelangelo's first architectural experimentations, for the façade of San Lorenzo, the altar of San Silvestro in Capite, and the dome of the Cathedral of Florence. A capital with a skull can be related only to a tomb. The smiling skull connected with a garland derives from Antonio Rossellino's tomb for the Cardinal of Portugal in San Miniato, which Michelangelo must have studied during this period when he seemed to be

delving into the achievements of his fifteenth-century predecessors. The close correspondence of the profile with that of the cornice as carried out is further evidence in favor of placing the pen drawing, No. 288, at some time prior to the formulation of the 1516 contract.

290. *Sketch for the effigy of Pope Julius II*
1516–17(?)
Pen, 8⅜×5⅝″, spotted and stained
FLORENCE, CASA BUONARROTI, 43 A verso
(for recto see No. 149)

This brilliant and characteristic pen sketch is in keeping with innumerable other line sketches by Michelangelo and inconceivable as a copy; it has nonetheless been rejected by three of the six critics who have noticed its existence. The headgear has also been incorrectly described as a mitre. Michelangelo frequently doubled his pen lines, as in the shoulder of the angel, the chin of the Pope, the wrinkles on the abdomen, the lid of the sarcophagus, etc. The shape alone would indicate a tiara rather than the towering, flattened form of a mitre (see No. 159). At this preliminary stage the artist has omitted the three crowns just as he omitted clothing. The effigy can be understood correctly if it is turned on the lower right-hand corner so as to be seen lying horizontally. It will then be clear that the lines depict the original statue as blocked out by Matteo di Cucarello, Michelangelo's stonecutter in Carrara, and sent to Rome with a quantity of especially beautiful marble in 1508. This must have been the statue stipulated in the 1513 contract and recorded in the Berlin drawing (No. 45), where it can be seen with its feet toward the observer, upheld by two angels in much the same position as the one drawn here. (The presence of a second angel on the other side is suggested by a few touches, and two are required in the contract.) The only substantial difference lies in the fact that in the Berlin drawing the Pope's arms are crossed on his breast, and here lowered to the sides, as they would have to be. This change would make no difference in the rough outlines of the block. But clearly the statue blocked out in 1508 was not going to be thrown away, and in all probability is still there today, recarved by Michelangelo's ungifted pupil Tommaso di Pietro Boscoli so that the Pope reclines on his right elbow. The limits of the original block could well have been the same both for the present drawing and for the dreary statue executed for the 1542 version of the Tomb.

291. *Sketches for the Victory and for two vases*
1527(?)
Black chalk, 11¾×8¼″
LONDON, BRITISH MUSEUM, W. 27 verso
(for recto see No. 220)

On the verso of the semifinal drawing for the wall tombs of the Medici Chapel, Michelangelo drew very delicately two vases, for an unknown purpose, and then a fine line sketch of the torso and head of the *Victory* now in the Palazzo Vecchio, intended for one of the niches of the lower story of the Tomb according (as it would seem from a recent hypothesis) to the 1532 project. The twist of the torso is complete, also the pose of the right arm and the turn of the head. Two lines indicate lightly the direction in which the legs are to go. Three disjointed verses and ten lines of a sonnet were added by Michelangelo apparently after the sketches were made. Only one scholar has doubted this beautiful drawing, and even he seems to be changing his mind.

292. *Study for the torso of the Victory*
1527(?)
Black chalk, 8⅞×6⅜″
LONDON, BRITISH MUSEUM, W. 47

Labeled a copy—without justification—by a single scholar, this magnificent life study has been accepted by all others. The style develops immediately from that of the great drawings for the Medici Chapel sculptures, as does the architectural style of the Laurentian Library from that of the Medici tombs. The tormented pose is beautifully studied in its implications for the relations and tensions of bony and muscular structure. Moreover, the drawing provides conclusive evidence for the original upright position of the statue, before it was provided with a prop to tilt it forward in its present position in the Palazzo Vecchio. The magically delicate lines of the contour drawing at the right are identical in style to the tiny sketch in No. 291.

293. *Studies for the right arm of the Victory*
1527(?)
Red chalk with touches of black, 13×10⅛″
OXFORD, ASHMOLEAN MUSEUM, P. 309 verso
(for recto see No. 228)

Although rejected by three critics and called a woman's arm (*sic*) by a fourth, these beautiful studies are certainly genuine. They have generally been considered studies for *Night* in the Medici Chapel, but it was pointed out by Richard J. Betts that they correspond more exactly to the right arm of the *Victory*, and were apparently done from the same slender, rangy model. It may not be possible to decide the question accurately. Quite likely the position of *Night's* arm had been determined on the basis of more powerful studies, of the nature of Nos. 235–40, at the time the *Victory* was planned, during the hiatus of work in the Medici Chapel from 1527 to 1530. When Michelangelo returned to work on the statues, after the entrance of the papal forces into Florence in 1530, he could well have utilized these studies originally made for the *Victory* as an aid in finishing the arm of *Night*.

294. *Studies for the Bearded Captive*
1527–30(?)
Red chalk, 8⅝×6¾″
OXFORD, ASHMOLEAN MUSEUM, P. 314 recto
(for verso see No. 295)

Never doubted, but omitted by one major scholar, these two life drawings appear to have been made for the *Bearded Captive*, now in the Academy in Florence. A right leg is sketched out in profile, and the upper leg carefully modeled. Then, upside down and with a heavier chalk line, the right side of a torso with right arm lifted is rapidly blocked in. The difference between the freedom and force of this drawing and the delicacy of No. 293 for the *Victory* is symptomatic of the wide range of expressive possibilities among Michelangelo's drawings for any given project.

295. *Study for the torso of the Youthful Captive*
1527–30(?)
For medium and dimensions, see No. 294
OXFORD, ASHMOLEAN MUSEUM, P. 314 verso
(for recto see No. 294)

A considerably rougher and quicker study than those on the
recto, this is also generally accepted. In all probability it is
connected with the unfinished torso of the *Youthful Captive*
in the Academy in Florence, also done for the fourth project
for the Tomb of Julius II, formalized in 1532.

288

289

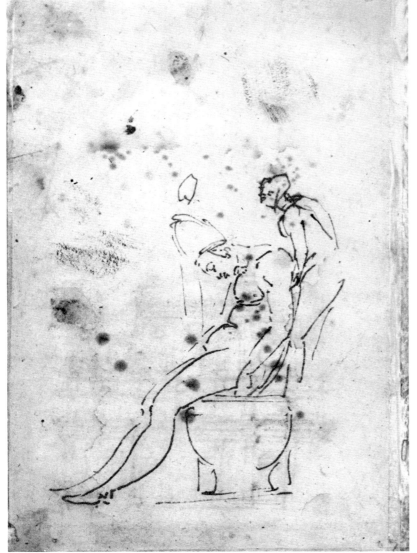

290

291

292

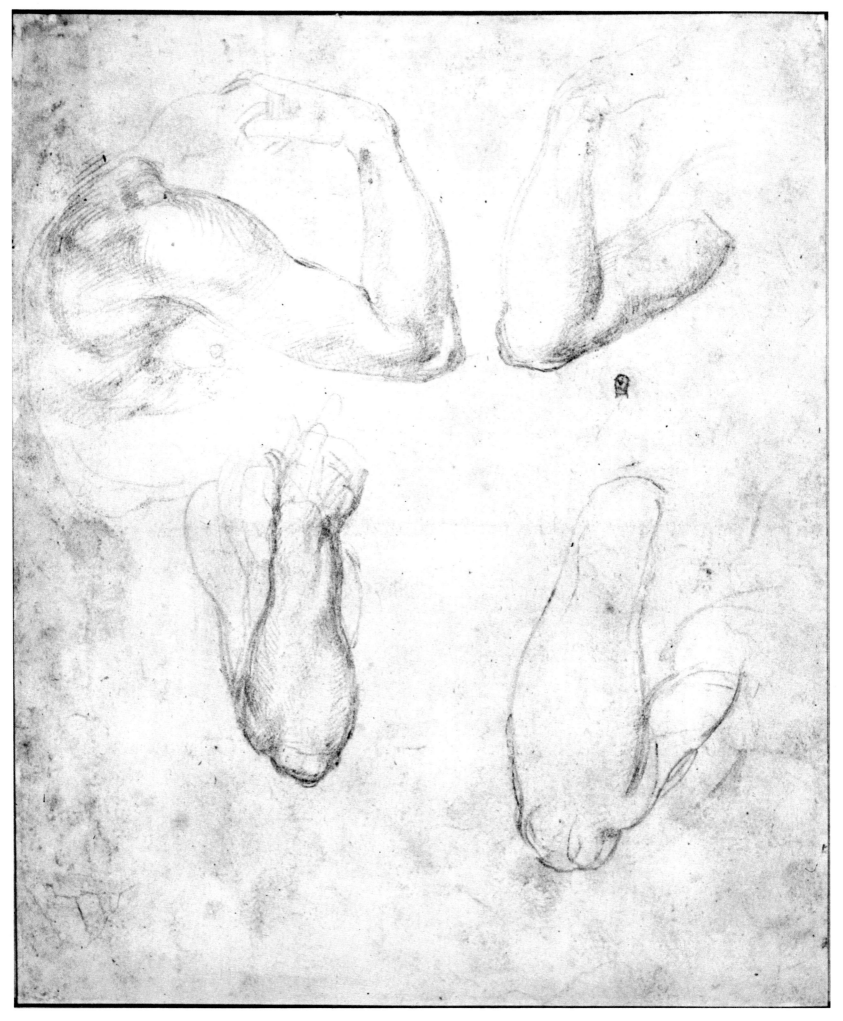

293

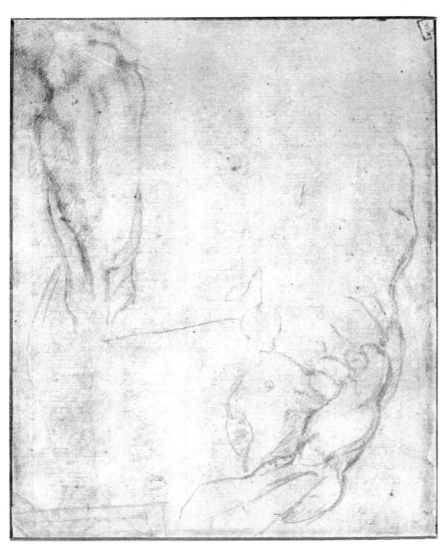

294

295

12

Drawings for various paintings and sculptures. Florence, 1516–34

296. *Study for the Christ of Santa Maria sopra Minerva*
1518(?)
Pen, red chalk, black chalk, 9½×8⅜″, cut down,
cracked, patched
LONDON, MR. BRINSLEY FORD, recto
(for verso see No. 297)

The magnificent pen study on the recto has never been
contested, and its purpose has always been clear enough, but
its date is open to discussion. Most scholars have considered
it a preparation for the first version of the statue, begun in
1514 and abandoned when Michelangelo struck a black vein
of marble which would have ruined the face. Such an hypo-
thesis cannot be justified. We have no idea what the appear-
ance of the lost first version of the statue was like. The
drawing is remarkably close to the final version, differing no
more than any Michelangelo study is likely to differ from the
finished statue. Moreover, all we know about the artist's
character and working methods precludes the assumption
that, four years after such a disaster, he would have sketched
out the statue a second time in precisely the same pose. De-
signed for a completely new block, the present statue rep-
resents more probably a considerable refinement of the
original pose. The brilliant pen style, with double cross-
hatching, is characteristic of the artist's revival of his earlier
engraverlike pen style after his return to Florence in 1516,
and is close to some of the drawings here suggested for the
façade of San Lorenzo. The arbitrary modeling of some of the
anatomical forms (the strangely doubled external oblique
muscle is a case in point) suggests the later violence of some
of the studies for the Medici tombs. Originally sketched out
in black chalk, the contours were first very delicately re-
traced in pen, then the torso was studied to produce the
utmost finish including several alterations of the course of
contours, greatly strengthened as the pen continued its
course. Doubtless the figure was originally complete.

297. *Studies for the Christ of Santa Maria sopra Minerva*
1518(?)
Red chalk and pen; for dimensions, see No. 296
LONDON, MR. BRINSLEY FORD, verso
(for recto see No. 296)

Few writers have accepted as the work of Michelangelo the
crude red chalk studies, originally doubtless representing
entire figures, but the superb pair of legs in pen is another
matter, and many consider them by Michelangelo's hand.
Although not brought to the same degree of finish as the

great drawing on the recto, they betray no detectable differ-
ence in conception or touch. Yet these pen strokes are drawn
over one of the pupil's studies in red chalk and one of these,
the pair of legs in profile, is obviously connected with the
figure as it stands in Santa Maria sopra Minerva. One ex-
planation might be that Michelangelo, pressed for time in
respect to both the San Lorenzo façade and the Tomb of
Julius II, and no longer in need of composition sketches for
this single figure he had already partially carved, simply
posed a model in the proper position and set a pupil to work
drawing him. Using these school drawings as a framework,
he then set about his own careful studies of the play of surface
and contour.

298. *The Three Crosses*
1520–21(?)
Red chalk, 15½×11″
LONDON, BRITISH MUSEUM, W. 32

The detailed composition study, of the highest degree of
formal originality and beauty, not to speak of tragic grandeur,
has been harshly dealt with by scholars, at least half of whom
have at one time or another attributed it to Sebastiano del
Piombo. One, however, the author of an important work on
Sebastiano, is now certain the drawing is Tuscan, although
he cannot agree that it is really by Michelangelo. A compari-
son with the drawings for the Medici tombs, especially No.
217, should make clear that there is no essential difference in
contour, hatching, rhythm, and spacing between this ques-
tioned study and those undoubted ones. The recumbent
figure of Mary, almost identical with the reclining tomb
figure in No. 217, alone should make this connection clear,
but there are a great many other similarities as well. The
lightly contoured central and lower figures are close to those
throughout the series of chalk drawings for the Medici
Chapel and, no matter how delicately they are traced, retain
the compact and blocky quality of Michelangelo's masses.
Some, in fact, display in striking form the "cubism" so often
noted in the great *Deposition* of 1521 by Rosso Fiorentino
in the Pinacoteca at Volterra, a relation which, together with
the framework of ladders and the figure leaning over the
crossbar, should be sufficient to provide a terminus for this
drawing if it is by Michelangelo, and no other Tuscan artist
of sufficient power has yet been suggested. The great inten-
sity of the figure of Christ, the masterly foreshortening of the
impenitent thief, the long, hanging lines of the penitent thief,
witness only Michelangelo's knowledge and control. The
horses, it is true, are summarily treated and faintly ridiculous.

This is what we would expect from the rare and often unsatisfactory appearances of this animal in Michelangelo's art (other than the exact life study, No. 30). Moreover, the connections with Michelangelo's later renderings of the Crucifixion are numerous and persuasive, especially the triangular Cross.

The meaning of this shape is not immediately apparent. It appears infrequently in paintings of the school of Lucca in the thirteenth century. Michelangelo may well have seen some of these pictures on one of his innumerable trips to Carrara and Pietrasanta, both near Lucca. The triangle, ruled in some of the late Crucifixion drawings (Nos. 424 and 425), may refer to the entire Trinity, as one of the three points concentrates on the head of Christ. It may also be intended to recall the special Y-shaped cross commonly seen on the backs of chasubles. For Michelangelo it was important aesthetically as well, since it enabled him to produce a form more compact than that provided by the customary widespread arms of the Cross.

The exact moment depicted here has been misunderstood, even by the scholar chiefly responsible for rehabilitating this great drawing. The writhing figure on the right—Christ's left—cannot be the penitent thief. The *impenitent* thief is always placed in this position. The soul faintly indicated at the upper right, carried away by an angel, does not come from his direction. Nor can it, for the thief is not dead, but still struggling. That is why his legs are about to be broken, the Roman method of terminating the agony of crucifixion by shock and suffocation. The quiet figure at the left is the penitent thief, and his legs are shown by horizontal lines as broken. He is already dead ("Today shalt thou be with me in Paradise"). The soul belongs to neither of the two thieves, but to Christ, and is shown proceeding from the direction of His turned, bowed head and apparently open mouth. A soldier is shown climbing the ladder of Christ's Cross and looking down toward another on the ground below, who lifts his arms. The drawing is a precise illustration of John 19: 30–33, the Gospel for the Mass of the Catechumens on Good Friday:

> . . . he said, It is finished : and he bowed his head, and gave up the ghost.

> The Jews therefore . . . besought Pilate that their legs might be broken, and that they might be taken away.

> Then came the soldiers, and brake the legs of the first, and of the other which was crucified with him.

> But when they came to Jesus, and saw that he was dead already, they brake not his legs.

The fact that the first part of John 19: 30, referring to the vinegar, is not shown would suggest that Michelangelo had instructions from an ecclesiastical patron to represent only the very moment of Christ's death, according to the Good Friday Gospel. No other such representation comes to mind in the entire history of Christian art—certainly none in which the soul of Christ is depicted, which might very well have involved patron and artist in a theological quicksand. Including traditional nonscriptural elements such as the swooning Mary (recalling the reclining Adam and Eve, Noah, and Puarphera in the borders of Ghiberti's *Gates of Paradise*) and the figure at the top of the Cross whose purpose is still unexplained, Michelangelo has worked out the scene with the greatest subtlety and intensity in order to concen-

trate on the instant of death. The penitent thief, inert, hangs from a cross slightly to the rear of the Cross of Christ and a little farther removed. The impenitent thief awaiting the liberating blows is thrust into the foreground. With the immediacy of a newsreel, these two moments just after death and just before it, frame that of Christ's expiration. The drama is very great, but the inner reality of Christ's sacrifice has not yet begun to speak to Michelangelo with the shattering power of the late Crucifixion drawings.

For what purpose can this extraordinary composition have been intended? We are referred to a small picture ordered by Cardinal Grimani (either in relief or in painting) for his study. The correspondence alone, in 1523, would rule out this drawing which must have been made before 1521. Nor does the composition with its many figures suggest a diminutive scale, unexampled in Michelangelo's work, but rather a monumental altarpiece. One is tempted to speculate on the possibility of such an altarpiece in San Lorenzo, and also on the propriety of the subject to the crucified patron saints of the Medici family. As the following drawings will show, the commission, whatever it was, received considerable earnest study on Michelangelo's part.

299. *Studies for the Three Crosses*
1520–21
Black chalk, red chalk, 13 × 9″, cut down
HAARLEM, TEYLERSMUSEUM, A 34 recto
(for verso see No. 300)

Once doubted, this powerful drawing is now universally accepted. It has escaped attention that the central figure is a life study for the crucified Christ in the *Three Crosses* (No. 298), the flexibility of the original motive now somewhat limited by the actual possibilities of the human body (one pities the model). The muscles are drawn taut over the bony structure in a manner not dissimilar to that of the Haman drawings (Nos. 90–92) but more sharply contoured. Michelangelo still has not quite made up his mind which lower leg is to cross over the other. The head is lightly shown, first apparently in profile as in the *Three Crosses*, then redrawn in a more seemly position, hanging forward. The right-hand study analyzes the torso of the penitent thief, exhibiting the full play of muscles over the thoracic cage. Even in the composition study, this figure is seen slightly from the left. At the extreme left, more lightly drawn, appears the right shoulder and clavicle of the soldier on the ladder of Christ's Cross.

300. *Tracing of Christ for the Three Crosses; ten cornice profiles*
1520–21
For medium and dimensions, see No. 299
HAARLEM, TEYLERSMUSEUM, A 34 verso
(for recto see No. 299)

As in No. 47, there is no reason to assume that this tracing was not made by Michelangelo himself as a necessary step in the evolution of the figure in his mind. In this reversed position the legs are somewhat closer to their original position in the preparatory composition study. The left leg is now clearly outlined, crossing over the right, and this is not a tracing. Upside down, a walking Roman soldier can be seen, shown from the rear, possibly an elaboration of one of the spidery figures barely touched in at the left of the *Three Crosses*. The cornice profiles cannot be exactly duplicated anywhere in Michelangelo's known work, but their relatively simple forms in merely additive combinations are character-

istic of the earliest period of his architectural activity. They may be trials for the Medici Chapel, and are certainly no later.

301. *Sketch for the impenitent thief in the Three Crosses; head of the soldier on the ladder; vase*
1520–21
Black chalk, partly reinforced in pen, 5×4⅞″
LONDON, BRITISH MUSEUM, W. 30 recto

Too rough for a life study, this uncontested sketch seems to have been a preliminary idea for the impenitent thief, much more powerful and compact in the foreshortened version in the *Three Crosses*. The head, with its beautiful turn and downward glance, and the strong tension of the neck muscles, is a study for the soldier on the ladder below the Cross of Christ, turned slightly more to the right than the shoulder and clavicle studied in No. 299. This personage, the first to discover that Christ was really dead, would have been crucial in the composition and the drama. The vase has the simplicity of the lustral pitchers pouring, in the marble reliefs above the Medici tombs, but shows the two handles of the jars under the tabernacles. It may be a preliminary idea for both, as yet undifferentiated, and provides still another indication of early dating for the series. The verse fragments in Michelangelo's writing read, at top: "Therefore . . . loving I strive that victory does not become an enemy"; at bottom: "To the eyes to virtue to your valor"; along the left edge, "That they have no other pleasure where one lives . . . where I am dead and perished and I know myself made nothing, nothing to you."

302. *Sketches for Hercules and Antaeus; two caricatures; two owls; optical diagrams; a left leg*
1524–25
Red chalk, 11⅜×16⅞″
OXFORD, ASHMOLEAN MUSEUM, P. 317 recto
(for verso see No. 312)

The two vivid sketches of struggling figures are generally accepted as Michelangelo's ideas for the group of Hercules and Antaeus, originally given him by the Florentine Republic in 1508. The 9½ cubit block was cut out in Carrara, but brought to Florence only in 1524 by Baccio Bandinelli, at the order of Pope Clement VII who did not want Michelangelo to take time off from the Medici Chapel, especially for a work with politically explosive overtones. The appeals of Michelangelo's friends in Florence proved unavailing, and in 1525 the Pope definitely assigned the block to Bandinelli, who committed the atrocity (*Hercules and Cacus*, this time) we must still endure in front of Palazzo Vecchio. The two sketches show Hercules' conquest over the son of Gaea, the earth goddess, invincible until he could be made to part with her. Hercules managed this by lifting Antaeus off the ground and crushing him. The powerful jutting masses would have been an amazing pendant to the marble *David*. The two half-humorous sketches of an owl may be related to the owl below *Night* in the Medici Chapel. The grotesque profile of an old woman, repeated by Michelangelo with a slightly different expression, exemplifies the vein of caricature extremely common in the artist's writings and sketches during the 1520s. The ineptly drawn leg and the diagrams made to show the optic rays appear to be the work of Michelangelo's pupil Antonio Mini.

303. *Sketch for Hercules with the boar(?)*
1517–20(?)
Red chalk, 11⅛×7¾″
OXFORD, ASHMOLEAN MUSEUM, P. 316 verso
(for recto see No. 161)

No one seems to know how to interpret this beautiful drawing, on the verso of a head that may be for the façade of San Lorenzo. If it is really Hercules, why no club and no lion's skin? Why the suggestion of clothing? And why does the boar come along without protest? No answer is provided in these pages either. All that can be said is that the free and open hatching and broad, loose contours are close to the other drawings here dated around 1517–18.

304. *Head of a Giant(?)*
1524–31(?)
Pen, partly over red chalk, 11×8¼″
PARIS, LOUVRE, 684 recto

This fierce and terrible drawing has been widely but quite unjustly rejected. Nearly forty years ago it was pointed out that the pen technique is inseparable from that of the so-called dragon (probably a salamander), No. 191, with triple hatching carried to the point where the surface suggests the chasing of bronze. The pen worked over a female head with long braids done in red chalk by Antonio Mini, who entered Michelangelo's service in 1521. The drawing is also closely related to the leering mask substituted for the left arm of *Night*, when that portion of the statue was recarved so that the unfinished left arm now goes around the mass of marble and disappears in the block. (This change was probably made when Michelangelo recommenced in 1530 the work on the statues that had been abandoned in the disorders of 1527.) The protruding brow and flaring eyebrows, flattened eyelids, nose hooked down till it almost meets the upper lip of the flaring mouth, all are strikingly similar to the menacing mask. Yet this drawing was surely not intended for such a purpose, nor can it have been meant for a faun as generally thought. It suggests, rather, the kind of fantasy Michelangelo expressed in a strange poem customarily dated in the early 1530s, describing a giant so huge that he could crush a city with one foot. The frightening features of our drawing are close indeed to the inhuman spirit of the "orribil figura" in this nightmare poem, describing the implacable monster for whom "the eternal abyss opened and closed." Yet even their monstrous ugliness contains beauties of form, line, and surface (for example, the curves of the nose, the delicate shaping of the ear) worthy of the vision of the greatest master and showing the control of the most practiced hand.

305. *Study for the head of Leda*
1529–30
Red chalk, 14×10⅝″
FLORENCE, CASA BUONARROTI, 7 F

Few would dispute the claim that this is one of the most beautiful heads in the entire history of Italian drawing. It has here been deliberately juxtaposed to No. 304 to show the immense range of Michelangelo's imagination, from the extreme of the terrible and monstrous to the greatest conceivable refinement of human tenderness and sensitivity. The artist's concern, as in the beautiful nudes of the Sistine Ceiling, is the raising of quite ordinary human comeliness

to the highest ideal plane, and the miracle is performed without "idealization." More is found in the model (certainly male) than nature put there. Even under the circumstances of a life drawing in the studio, the artist has been able to communicate his awe at the mystery of love between a mortal and a god. But was not the divine reflected in the mirror of humanity always Michelangelo's basic theme? This is why he is able to imagine again and again, and with utter purity of feeling, a totally nude Resurrected Christ. The drawing was once considered a study for the head of the crouching woman in the *Ozias* spandrel in the Sistine Ceiling, whose pose it does indeed suggest, and the author concurred in this view, superseded by the recent identification with the head of the vanished *Leda and the Swan*, painted in 1529–30 for Alfonso d'Este, and never delivered. It is unlikely that such careful studies were made for heads in obscure positions, destined to be almost invisible from the floor. Nor does the style correspond to the Sistine drawings. The pose does fit that of Leda's head in all the existing copies of the painting and cartoon, and the style is more comprehensible just before 1530 than at the time of the Sistine.

The artist has blocked the facial angles out very lightly, then hatched and crosshatched the surfaces within contours of spidery delicacy. That the present blurred state of the cheek and ear is not due to damage but to Michelangelo's own rubbing can be ascertained by comparison with the perfectly preserved crosshatching of the forehead and headcloth. The modeled surfaces were then minutely stippled in the manner Michelangelo was shortly to exploit in the great presentation drawings for Tommaso Cavalieri. After completing the head, it occurred to the artist that the eye should be seen closed, with the long lashes lying across the cheek, and this is the way it appears in all copies of the painting and the cartoon, as if the mystery were celebrated in Leda's sleep. The contouring and hatching of this last detail is, if anything, the greatest perceptual triumph in the entire drawing. Done with needle-sharp chalk and left unmodeled, the study records infinitesimal fluctuations of surface and their anatomical implications and luminary effects without ever losing the depth of feeling or the nobility of structure of the head as a whole. It is particularly revealing that, in a period of great danger and continuing emotional stress, when he was governor of the fortifications of Florence, Michelangelo could still pause to clothe such exalted concepts in a dress of such gossamer delicacy.

306. *Sketch for Leda's right arm*
1529–30
Pen, 2¾×4¾", cut down, heavily corroded, relined
FLORENCE, CASA BUONARROTI, 60 F

It has been ingeniously shown that this rapid pen sketch for Leda's right arm, with the hand dangling idly just across her left knee, originally formed a part of the same sheet in the Archivio Buonarroti (XIII, folio 150), too faint to reproduce here, on which the contours of the Leda were lightly sketched. The broken pen style is looser, if anything, than the potent drawings for *Night*, Leda's direct progenitrix.

307. *Sketch for Venus and Cupid*
1532–33
Pen, 3⅜×4¾"
LONDON, BRITISH MUSEUM, W. 56

A fleeting preliminary sketch, no longer doubted by anyone, and generally considered the first idea for another mythological picture, the *Venus and Cupid* whose cartoon, according to Vasari, Michelangelo made for his friend Bartolommeo Bettini, for a picture to be painted by Pontormo. The pose of the reclining figure makes this well-nigh certain, even though Michelangelo has started, as often in his female figures, with male anatomy. Cupid is shown about to shoot an arrow into Venus, instead of leaping upon her to kiss her as in the preserved copy of the lost cartoon, and as in Pontormo's damaged painting in the Uffizi.

308. *Sketch for the head of Venus(?)*
1532–33
Pen, 2½×2⅜" (fragment)
FLORENCE, CASA BUONARROTI, 57 F recto

This undoubted sketch contains echoes of the *Erythraean Sybil* from the Sistine Ceiling, but is certainly much later. It is hard to find female heads in profile in Michelangelo's work at any time. The *Venus* suggests itself, more especially in that the head is posed midway between the lowered position of the sketch, No. 307, and the lifted one of the cartoon. The verses on the verso, other fragments of which appear on the verso of No. 409, may have been written many years earlier.

309. *Sketches for Samson and a Philistine (portion of sheet)*
1527–30
Black chalk, 15⅜×22" (whole), recto shows through
FLORENCE, CASA BUONARROTI, 14 A verso
(for recto see No. 334)

On the verso of a presentation drawing for the fortification of the Porta al Prato, these sketches of lifted arms have been unanimously rejected by the few writers who have noticed them. They deserve a second hearing. The principal lifted arm is identical with the pose of the arm of Samson in Michelangelo's never-executed group of *Samson and a Philistine*, as known from contemporary copies, but in reverse. The carefully traced lines do not have the freedom of most of Michelangelo's sketches, and are deceptively similar to the wooden, threadlike lines of some of the pupils' work. But this may well be accounted for by the hypothesis of a counterproof of more spontaneous sketches, on the basis of which Michelangelo proceeded to analyze the anatomical forms with care, perhaps with the aid of a model. The lines are very close in feeling to a number of studies for the Sistine Ceiling and the Medici Chapel, and the concentration of forms in the armpit is far too powerful for a pupil. Moreover, the renewed plans to complete the ill-fated Hercules block in the form of Samson and a Philistine (or two Philistines) date from the period of the fortification plans.

310. *Fantastic heads; shells*
1525–30(?)
Pen, 11½×8⅜"
FLORENCE, ARCHIVIO BUONARROTI, XIII, fol. 145 verso

Only in the quadricentennial year of Michelangelo's death was this whole sheet rejected. Earlier the authenticity of the heads and hand had been doubted by two scholars. Yet it is impossible to separate the female profile from that of No.

308. Touch after touch of the pen are identical in both and so is the type, even to the shape of the tremulous upper lip with its peculiar downward turn at the corners, and the exact form of the eyelid. Both must be accepted as the work of the same hand. The sheet has been the subject of the most improbable conjectures. The male profile was once considered a self-portrait of Michelangelo, whom it does not resemble, then derived from an Etruscan tomb painting Michelangelo could never have seen. Most likely it is a memory image of many representations of Roman soldiers clad in wolfskins. As for the female profile, its presence on the verso of a sheet whose recto was used many years later for a sonnet mourning the death of Vittoria Colonna has caused older writers to connect this image, with its naked, pendulous breasts, with the saintly Marchesa di Pescara! One is reminded rather of the monstrous female companion who nurses and suckles the giant in the fantastic sonnet mentioned in connection with No. 304. The beautifully drawn shells may have been preparations for ornamental shells in the Medici Chapel.

311. *Sketches of eyes, locks of hair, profiles*
1525–31(?)
Red chalk with some touches of black, 10×13¼″
OXFORD, ASHMOLEAN MUSEUM, P. 323 verso
(for recto see No. 191)

On the verso of the famous "Dragon" (probably a salamander), this sheet has always been understood as a set of exercises in drawing, probably for Michelangelo's luckless pupil, Antonio Mini. As a similar practice in seeing, the reader might pick for himself those elements that seem to have been drawn by the master, before reading the next sentence. The most probably genuine ones are: the first profile eye in the upper left-hand corner; the second from the left in the upper row of three eyes shown in full-face; the first rich group of locks from the left; the upper of the two shaded profiles. These appear not to have been drawn from life. The pupil's copies are generally tedious, sometimes execrable, but here and there may have been corrected by Michelangelo. The passage at lower right is the beginning of the draft of a letter to Michelangelo's young friend Andrea Quaratesi, "Andrea, have patience. Love me, great consolation."

312. *Humorous sketches*
1525–31(?)
Red chalk, 11⅜×16⅞″
OXFORD, ASHMOLEAN MUSEUM, P. 317 verso
(for recto see No. 302)

Another page of exercises by Mini (the classical heads, etc.), utilized by Michelangelo for a *canzone* and for a delightful set of comic drawings. Over a beautiful pitcher, a horseman charges, without looking, in the direction of a contortionist who offers a most disrespectful view of himself. In the center is a skull; on the side, in Miróesque profusion, a ladder, a long-necked monster, and a nicely drawn hand holding a globe. Upside down, one is confronted with a giraffe who has come to so sudden a halt as to throw his inexpert rider.

313. *Heads; a figure*
1525–31(?)
Red chalk, 9¼×11¼″
LONDON, BRITISH MUSEUM, W. 42 verso
(for recto see No. 365)

Despite the skepticism of many writers, there is no reason to doubt the three principal sketches on the sheet–the boy in the plumed hat, the shouting satyr, and the squatting youth so cheerfully committing what the Italians would call a *dispetto*. The others seem to have been done by Mini, later if we can judge from the inept copy of the boy's head. The satyr derives from the same vein of rebellious fantasy which erupts so often in the 1520s. The boy's head, as touching and sensitive as a Titus by Rembrandt, is one of the rare personal witnesses in his drawings. Possibly this is what Andrea Quaratesi looked like at fourteen. (A careful chalk portrait of this boy, here considered a copy, is in the British Museum, attributed to Michelangelo.)

314. *Putto urinating into a cup*
1522(?)
Pen, black chalk, 9⅜×8½″
FLORENCE, UFFIZI, 621 E recto

Although this sheet of *ghiribizzi* (caprices) similar to the preceding ones has been accepted by most scholars, there is no agreement regarding its date. The principal motive, derived perhaps from Donatello, perhaps from antiquity, was used again in the famous and enigmatic sheet in Windsor, No. 361. But that is much later. A squatting *putto* and a number of trial hatchings in pen and a little St. Christopher in chalk complete the imagery. The name of Michelangelo's father, not in the artist's hand, appears at the extreme right. Michelangelo himself copied the opening line of a famous sonnet by Petrarch, and below it, "I pray you that you do not make me draw this evening because Perino is not here." This appears to refer to Michelangelo's young friend Gherardo Perini, who wrote him from Pesaro in 1522. The writing is generally thought to be characteristic of the early 1520s.

315. *Figure sketches*
1520–30(?)
Red chalk, 11½×7¾″
FLORENCE, ARCHIVIO BUONARROTI, I, 77, fol. 211 recto

Most critics have seen the magnificent leg picked out in heavier strokes of the chalk as the work of Michelangelo himself, correcting the sketches of a pupil, but it has recently been shown that even these sketches correspond to Michelangelo's method of evolving a figure from at first aimlessly wandering strokes, as in the nudes of the Sistine Ceiling. There may be some relation to the figures of the Medici Chapel, or perhaps to the *Victory* for the Tomb of Julius II, but no secure connection can be proved.

316. *Sketch for a figure walking to the right*
1520–30(?)
Red chalk, 7½×4⅜″
HAARLEM, TEYLERSMUSEUM, A 31 verso
(for recto see No. 169)

Astonishingly close to the free-flowing line of No. 315. Generally either rejected or ignored, but in the characteristic style of Michelangelo's first tentative figure sketches.

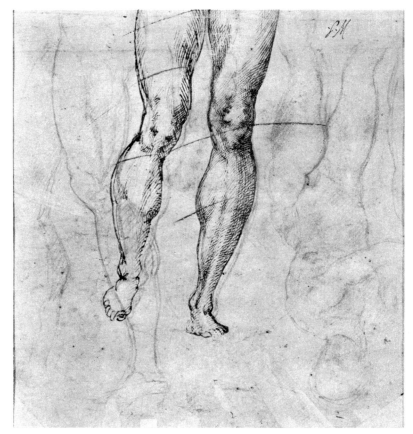

317. *Michelangelo's menus*
1518
Pen, 8⅜×5¾″, cut down
FLORENCE, ARCHIVIO BUONARROTI, X, fol. 578 verso

Probably dated by a letter to Michelangelo on the recto, this sheet gives the menus for three simple meals, accompanied by portraits of the food:
a. "Two rolls, a pitcher of wine, a herring, *tortelli* [a larger version of the more familiar *tortellini*]"
b. "A salad, four rolls, a round pitcher, a little quarter of sharp wine, a plate of spinach, four anchovies, *tortelli*"
c. "Six rolls, two fennel soups, a herring, a round pitcher"
The clear, strong forms have the same sort of peasant nobility so evident in the belongings carried by the unfortunates in the *Deluge* on the Sistine Ceiling.

297

296

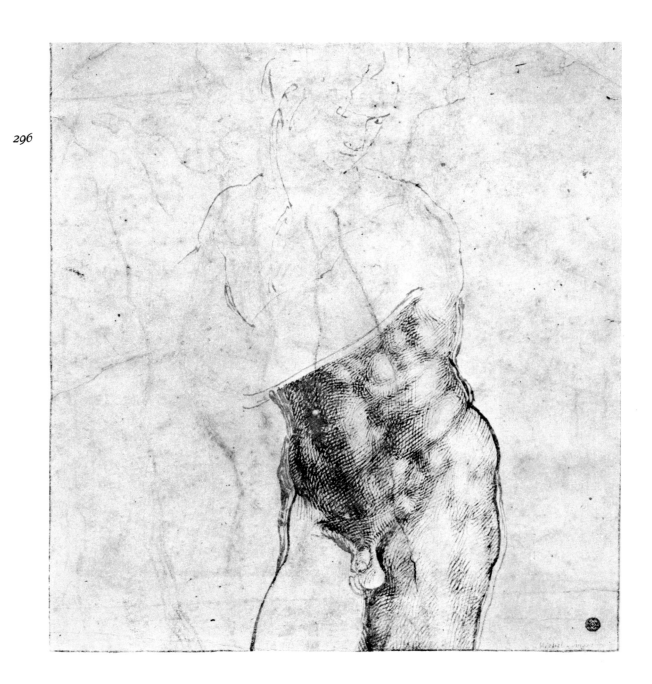

220

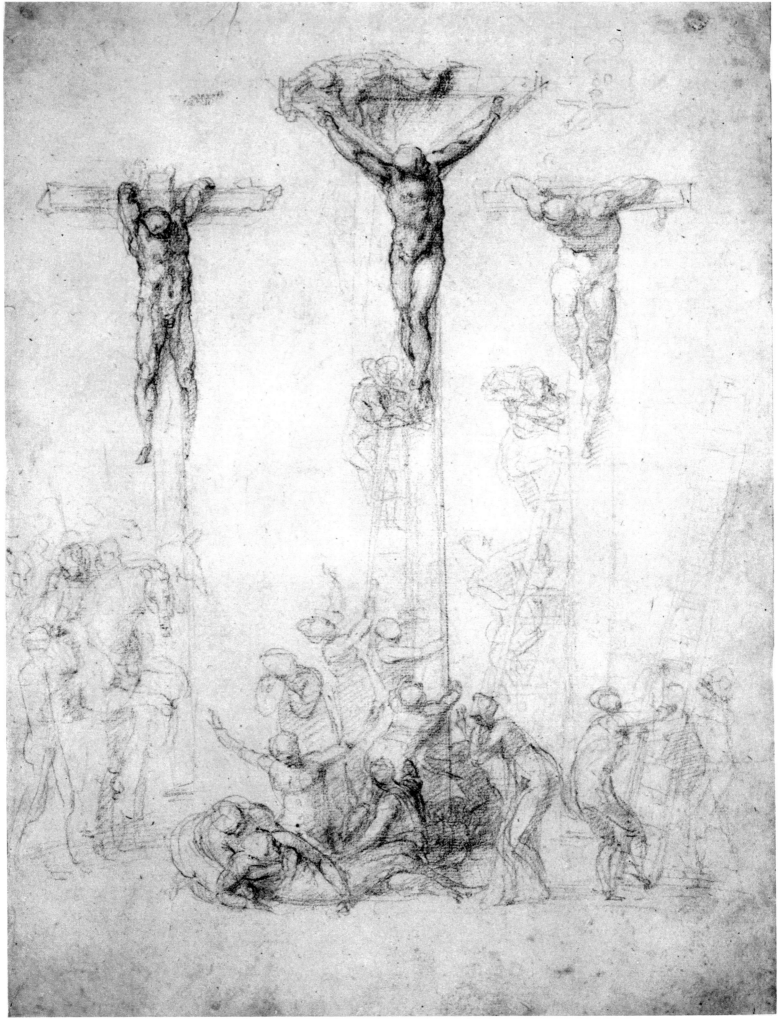

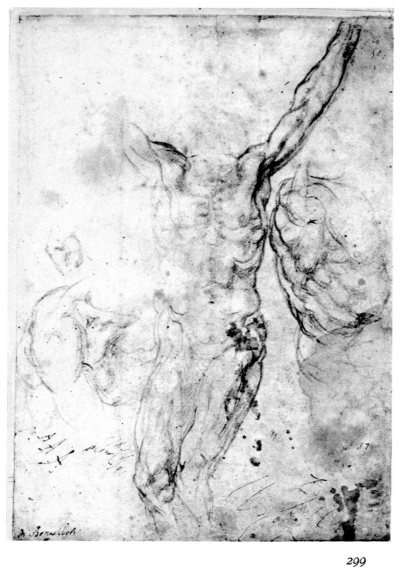

299

300

301

222

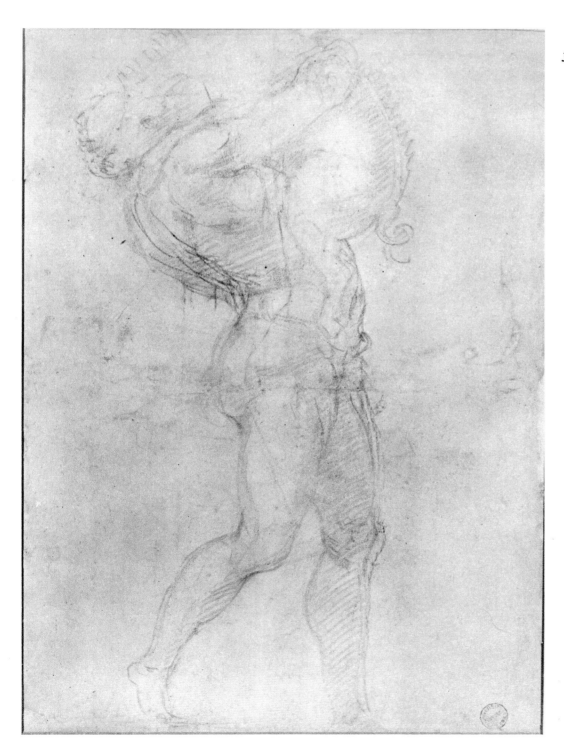

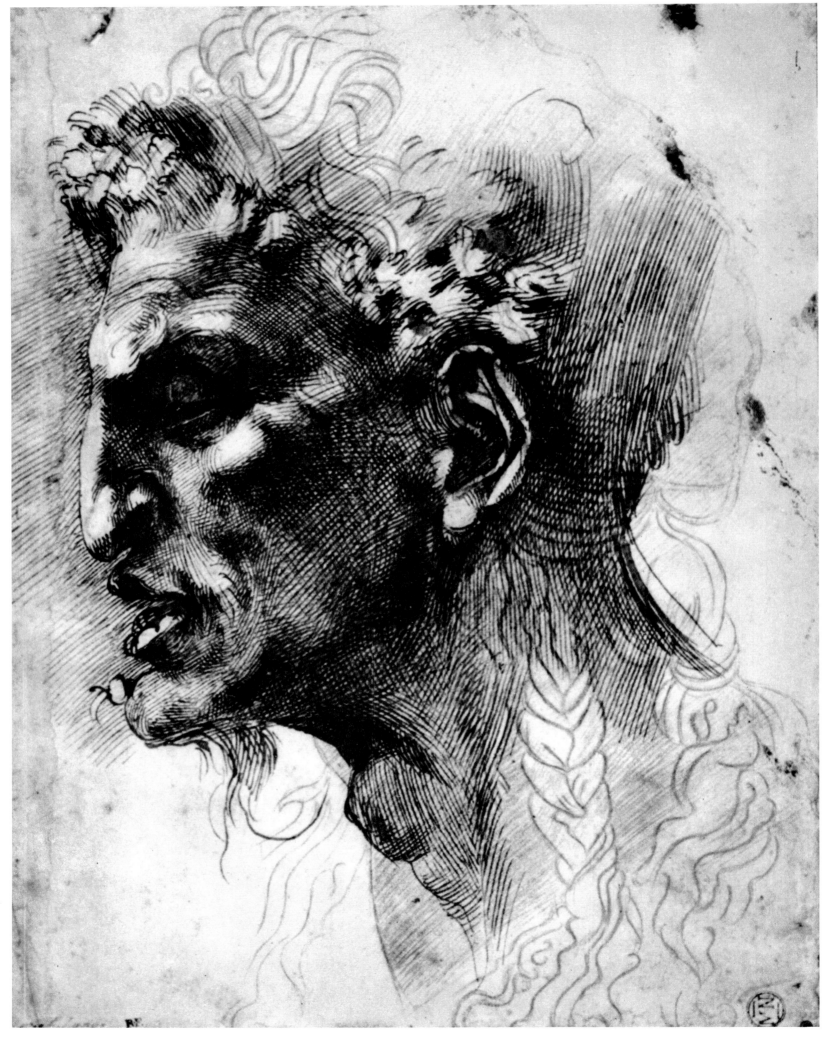

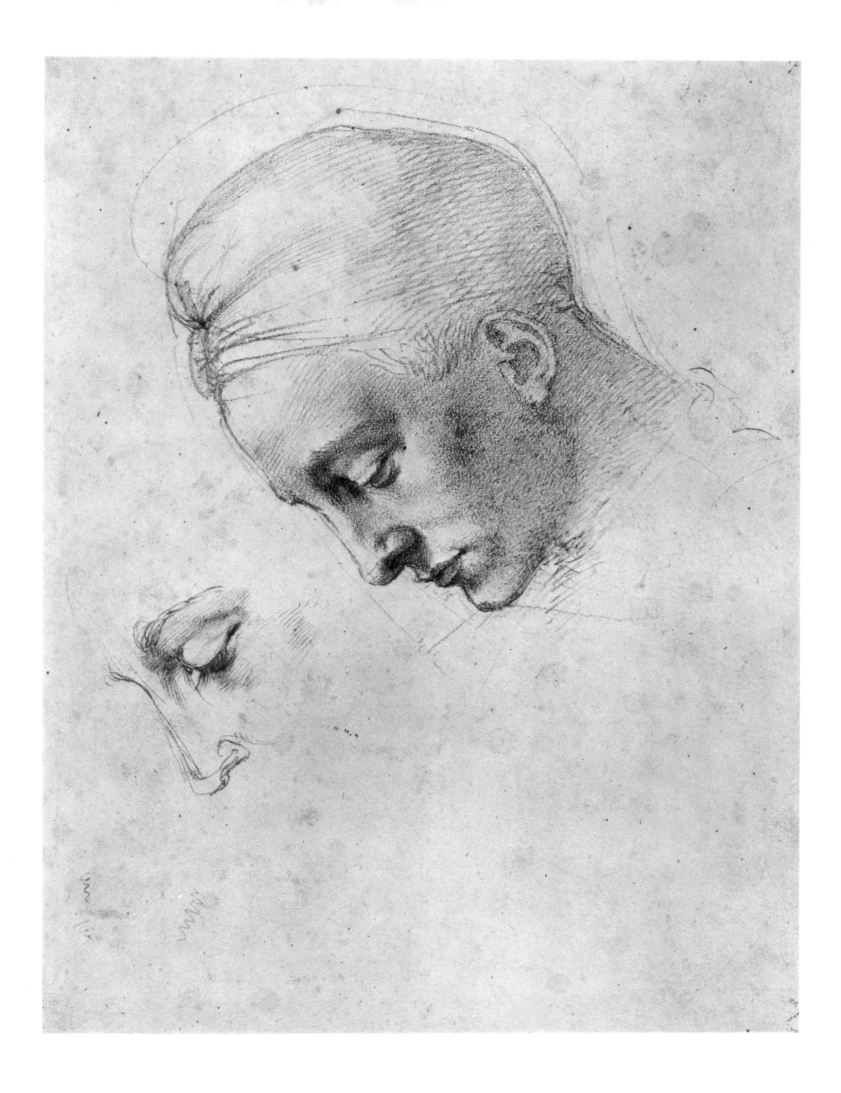

306

307

309

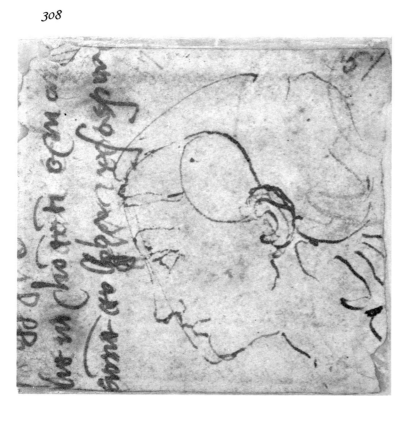

308

310 ▶

226

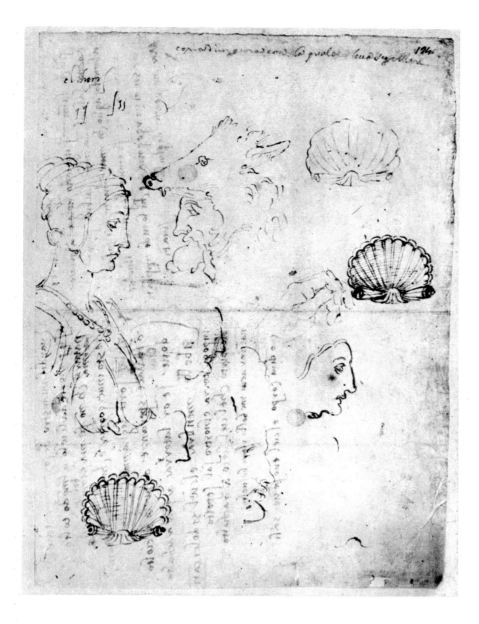

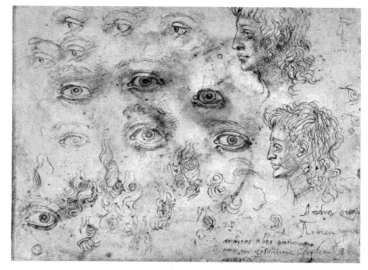

311

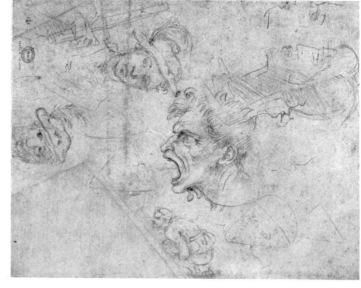

313

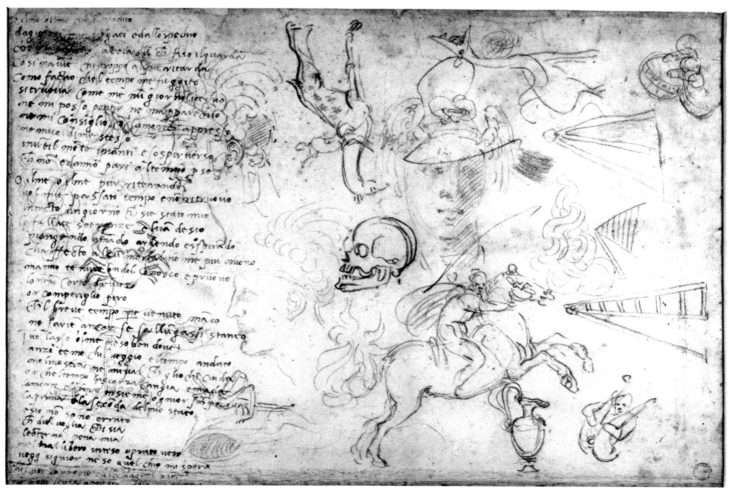

312

227

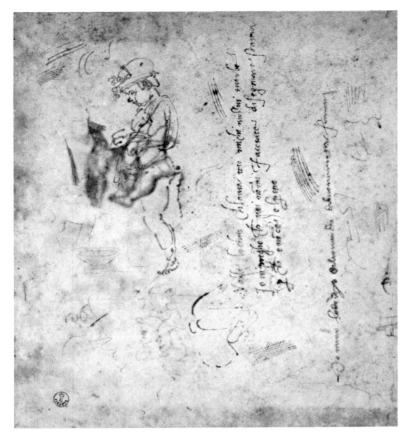

314

316

315

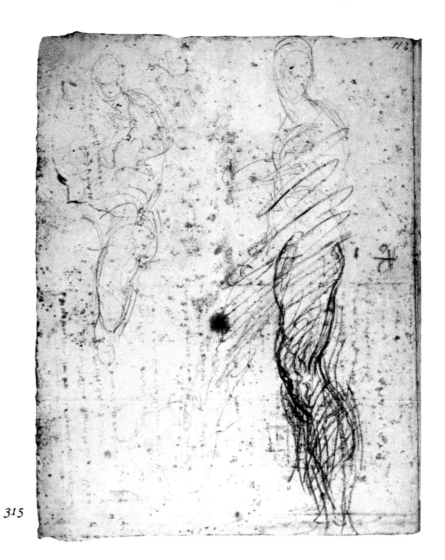

317

13

Architectural drawings. Florence, 1520–34

318. *Sketches for papal tombs in San Lorenzo*
1524–25
Pen, 6⅞×7¼″
LONDON, BRITISH MUSEUM, W. 39 recto

Pope Clement VII was concerned with the eventual location of his own tomb and that of Leo X, from 1524 to 1526. At first he tried to get them into the Medici Chapel, but matters were so far advanced that no essential change was possible. Michelangelo's counterproposal, to place the papal tombs in the adjacent anteroom with its *lavamano* was considered a bit cramped for two Popes. Clement then toyed with a site in the choir or elsewhere in the church of San Lorenzo. This and the following two uncontested drawings are generally believed to be projects for these never-executed tombs. The present sketch seems at first sight free enough in its arrangements to go almost anywhere, but a closer look discloses a return on the left side, apparently taking care of the junction of the tomb architecture with the crossing between choir and transept. The forms—coupled columns, tabernacles, niches, even the indicated sarcophagus—are drawn from the same repertory developed for the Medici Chapel, especially for the entrance wall, to have contained the tombs of the *Magnifici*. The paired columns, from the adjoining sketch plan, would have projected considerably to provide a deep wall recess. Below, another arrangement of columns is studied in elevation and in plan.

319. *Sketch for papal tombs in San Lorenzo*
1524–25
Pen, 5⅝×5¾″, cut down
FLORENCE, CASA BUONARROTI, 46 A

The general arrangement of No. 318 has been kept, but the central recess transformed into an enormous niche filling two stories, with the central motive ascending into a crowning pediment. The sarcophagus is lifted into the niche, as would be essential in a choir lined with high-backed choir-stools for the canons. The right side is studied in greater detail, with the roundels rejected in the San Lorenzo façade and in the Laurentian Library making still another appearance.

320. *Study for papal tombs in San Lorenzo*
1524–25
Pen, black chalk, and wash, 15¾×10¾″
FLORENCE, CASA BUONARROTI, 128 A

This very large and handsome study brings matters almost to the stage of working drawings. The problem has been attacked in an entirely new manner, independent of the Medici Chapel arrangements and well on the way to the kind of "Baroque" solutions which were to inspire Michelangelo's Roman architecture for the next generation. The elements carefully studied in elevation and in plan provide a spatial experience by way of climax. The observer would have confronted a richly articulated architectural working-inward starting at the left, from pilastered returns supporting an attic story, to a two-story mass, with superimposed tabernacles, then finally back in depth to the quite simple tomb, whose sarcophagus (still indicated in black chalk) would have led up to an abruptly elevated pedimented tabernacle and framed panel embraced by pilasters, crowned by a festooned attic. As a result, the entire choir of San Lorenzo would have been converted into a kind of papal tomb chapel, not walled off, but still largely secreted from the public gaze by what would have amounted to projecting wings of masonry and columns on either side. The tombs could not be seen from the crossing, only from the front, and the spectator would have approached them by way of advancing and retreating architectural masses, constantly ascending and descending in level, with the great tabernacles (presumably for portrait statues) on the highest level of all. It was a magnificent idea, even though it was eventually given up by the patron. The free and dynamic relationships embodied in this drawing, the giant order and embraced half-story panels, and above all the plastic carving of masses and spaces in order to produce a spatial climax as the observer proceeds from the framing elements to the more exalted mood of the sanctuary, lead the way to the Capitoline palaces, St. Peter's, and the architecture of the Counter Reformation.

321. *Sketch for a ciborium for San Lorenzo*
1525–26
Black chalk, 6⅞×3⅞″, torn and cut down
FLORENCE, ARCHIVIO BUONARROTI,
V, 29, fol. 2 04verso

This little sketch and its corresponding plan on the recto of No. 322 (not illustrated) were intended for a ciborium desired by Pope Clement VII for the choir of San Lorenzo, to contain the reliquary vases collected by the Medici over the years, in such a way that the relics could be periodically exhibited for public veneration. The Pope wanted four columns upholding arches, and a splendid entablature of bronze. This was to be very light and hollow, supported on an invisible

internal armature of iron, so that no one would be tempted to melt it down into cannon as was the case with Michelangelo's statue of Julius II. The ciborium would have been the focal point of the whole sanctuary Michelangelo was developing in No. 320. Here he has lightly sketched out the proportions as seen from the right, in perspective, together with the pavement of the choir. The Pope abandoned the project since it would cut off the view of the choir of San Lorenzo, and turned his attention to wall frescoes.

322. *Sketches for a reliquary gallery for San Lorenzo*
1526
Pen and black chalk, 11⅜×16½"
FLORENCE, CASA BUONARROTI, 76 A verso

On the verso of a plan (not illustrated) for the ciborium sketched in perspective in No. 321, Michelangelo drew another proposal, for a reliquary gallery over the central doorway of the nave, apparently when the Pope turned down the ciborium. According to the new notion, the gallery would have been supported by two consoles, and embraced by an entablature set on freestanding columns, with projecting impost blocks. At the right Michelangelo experiments with variations of an Ionic capital and with a Tuscan capital. As finally built in 1531–33, the structure was given Corinthian columns patterned on those in the nave designed by Brunelleschi and his followers.

323. *Sketches for a fountain*
1525–30(?)
Pen, 4⅝×6⅜", cut down and relined
FLORENCE, CASA BUONARROTI, 73 A

Attempts have been made to connect these sketches with a marble "vase" and "plate," whatever these may have been, mentioned in correspondence with Michelangelo during 1521. The freedom of the moldings looks later. The recent suggestion of a holy water stoup for San Lorenzo is clearly ruled out by what the little *putti* in the central sketch appear to be doing. The prow of a ship at the left is a forerunner of Bernini, and all the ideas show the kind of freedom that seems more typical of the Baroque than the Renaissance. No one has doubted this sheet.

324. *Sketch for a monumental portal*
1525–30(?)
Black chalk, 15¾×9½", cut down
FLORENCE, CASA BUONARROTI, 40 A recto

Accepted by all but one scholar, this handsome set of variations on a given theme has never been exactly identified or dated. The most plausible time seems to be that of the plans for the Laurentian Library and the choir of San Lorenzo, many of whose forms are related to those we find here. At first the project seemed too low, apparently, so Michelangelo raised the coupled columns on lofty socles. No concrete elements in the drawing can be connected either with an altar or a tomb. A church rather than a palace portal is suggested by these shapes.

318

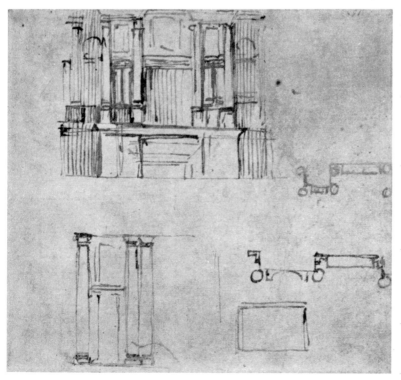

319

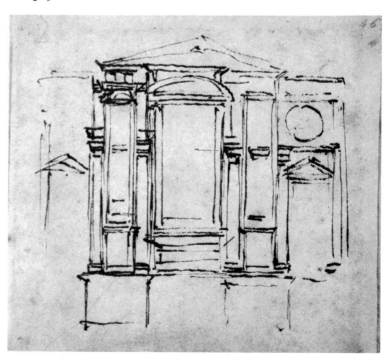

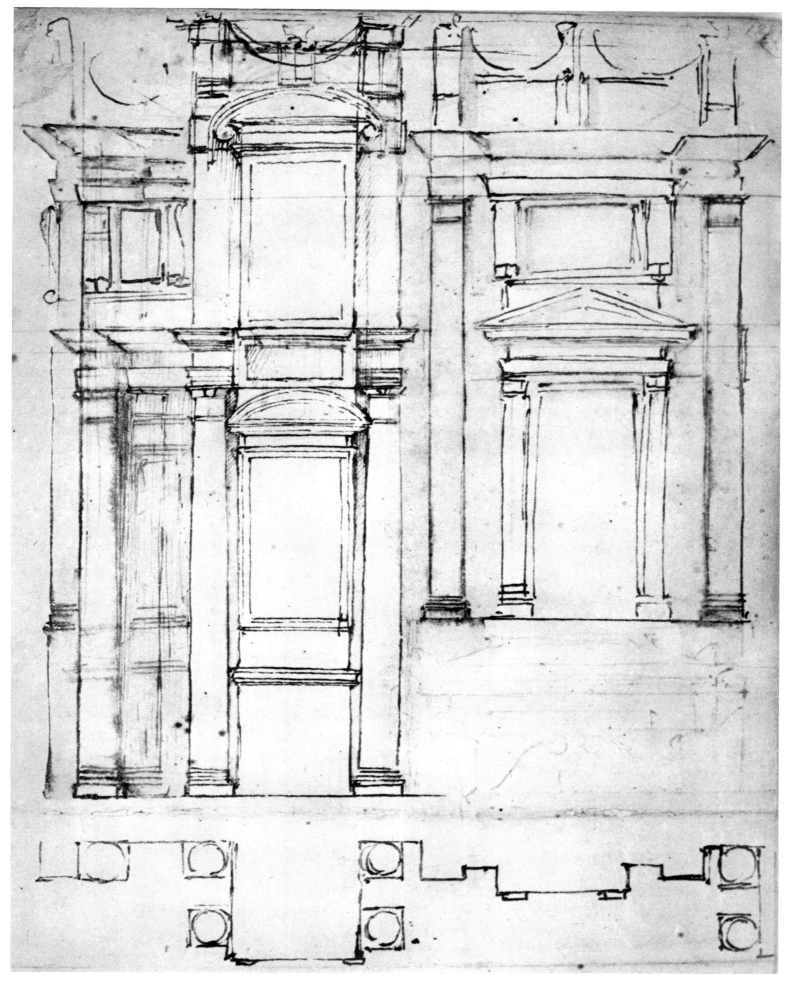

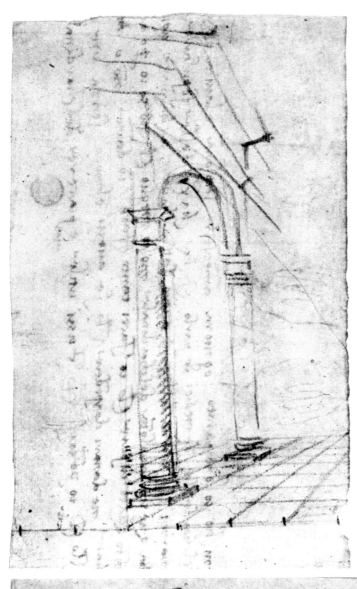

321

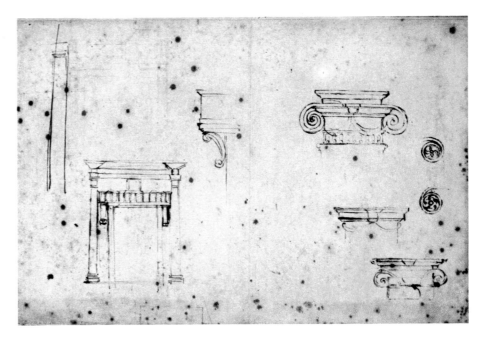

322

324

323

232

14

Drawings for the fortifications of Florence. Florence, 1528

A number of the greatest Renaissance artists (Brunelleschi, Francesco di Giorgio, Leonardo da Vinci), and Michelangelo's contemporaries, such as the Sangallo family, were as deeply concerned with problems of military engineering as with any purely "artistic" matters. The fortification drawings by Michelangelo still in the Casa Buonarroti, only one of which has ever been contested, form an unrivaled series of studies of the art of war as conceived in the later Renaissance. To critical eyes, unpracticed in the principles of fortification, they are also abstract designs of the greatest power, ferocity, and beauty. Before 1928 the fortification drawings, available to all in the Casa Buonarroti, were ignored by most military historians and Michelangelo scholars. The first serious publication took place only in 1940. The present interest in the artistic as well as military character of the designs is a direct result of the development of a new architecture in the twentieth century in America and in Italy.

The spread of artillery in the fifteenth century rapidly rendered useless the most massive fortresses of the Middle Ages. Curtain walls, anchored by square towers, crumbled beneath cannon balls, and narrow battlements offered no opportunity for the deployment of defensive cannon. The earliest solutions to the new problems of defense produced sloping, massive walls guarded by round towers of equal height, in the hope that cross fire from the broad ramparts and towers would deter invaders. But the most salient arc of any tower could not be covered from the ramparts. Therefore bastions, with points, were essential to provide cross fire. Michelangelo's designs experiment sometimes with starlike points, resembling those used in the classic fortifications of the later sixteenth and seventeenth centuries, but more often with a novel and never-followed system of clawlike embracing arms, resembling the broken pediments and arches we have followed in his drawings for the Medici tombs and the Laurentian Library and which can be found also in the costumes of his female figures. These have been criticized as impractical because the curves always produced blind stretches of wall, not covered by fire from anywhere. This seems unjust, as an attacker could reach the brief curved walls only after penetrating solid cross fire across a moat, sometimes from several well-protected points at once, and if he made it, would find himself treading water in a tiny triangle, unable to accomplish much. This is clearly indicated in Michelangelo's diagrams tracing the lines of fire. Secondly, it has been objected that the projections would have been too slender and consequently too fragile to withstand fire themselves. One might reply that presumably the great thickness and the slope of the walls would have been sufficient to cause the stone cannon balls of those days to glance off harmlessly.

The series has been dated in 1529, and connected with Michelangelo's appointment on April 6 of that year as governor general of the fortifications of Florence against the combined papal and imperial forces seeking re-establishment of Medici rule. Fortifications were actually erected according to his designs; these are described in some detail in the literary sources, and praised by an anonymous professional soldier who commented that they were "marvelously" placed according to the terrain. But the only fortifications mentioned in the sources are those of San Miniato, for which we have not a single drawing! Also, none of the fortifications described or depicted, which were reinforced earthworks rapidly thrown up, correspond in any way to the drawings clearly intended for stone, and in one case so labeled (No. 330). An ingenious and convincing recent solution to this dilemma suggests that the drawings and the actual fortifications have nothing to do with each other. The drawings must have been made when Michelangelo was called in as an advisor on fortifications in September, 1528. Memoranda of July and September, 1528, appear on two of the drawings. At this moment Clement VII, expelled from Rome to Orvieto by the terrible events of the Sack the preceding year, was only a potential enemy, and permanent masonry fortifications could be contemplated with calm. It is, alas, characteristic of Florentine history that this was all that ever happened. By 1529 when Michelangelo received his appointment as governor general, there was no longer time for anything more than earthworks. As a supporting argument it might also be noted that the terms of Michelangelo's appointment on April 6, 1529, refer to the "labor undergone by him and the diligence used in the above-mentioned work up to this day gratis and lovingly," indicating that the reason this artist was chosen for such a crucial undertaking was that he already knew so much about the problem.

Sufficient account has not been taken of the difference between the rough experimental sketches, sometimes abandoned midway, and the finished projects made for presentation to the authorities of the Republic. The latter always show masonry and the banks of moats carefully shaded in wash. Bridges, gates, moats, etc., are fully labeled for immediate comprehension. Only two of the gates and one crucial bastion are identified, but the others are all different. They add up to the precise number of gates in the walls of Florence. Moreover, the smaller bastions are types which could be repeated anywhere along continuous stretches of

wall. The conclusion is clear enough. In all probability Michelangelo was commissioned to design a complete set of fortifications for the existing walls of Florence. The series in the Casa Buonarroti, except for the possibility of some missing sketches, *is* the complete set. The bastions with special problems, like that for the Prato d'Ognissanti and those for the Porta al Prato and the Porta della Giustizia required carefully studied solutions. All the other gates in the long circuit could be divided into large and small, but within each class they were interchangeable and no precise identification was needed as long as Michelangelo provided as many separate solutions as there were gates. Would twenty years have sufficed to build them? We will never know.

One is tempted to speculate what later military planners would have made of Michelangelo's brilliant notions. The great French master of military design Vauban, for example, although he studied and admired the fortifications built by the Medici in 1534 on the site of Michelangelo's earthworks, knew nothing about the fortification drawings. Now, alas, we are reduced to pinning our own hopes of survival on defenses of a very different sort, but we can still enjoy the vast drama of interacting forces taking place as the giant claws open and close, the huge starpoints bristle with danger, and the phantom artillery fires at the enemies of the Republic in Michelangelo's pages. In retrospect, there could be no more vivid illustration of the *psychomachia* (warfare in the soul) in Renaissance guise than this silent battleground, setting forth in abstract terms the conflict that rages within Michelangelo's giant figures, and within himself. We should, however, picture these great designs in three dimensions, mentally erecting masses on Michelangelo's plans with the help of the single elevation sketch, No. 343 (showing rounded corners to repel artillery) and attempting, as has recently been advised, to imagine the effect of light on these astonishingly aggressive forms and broken, constantly moving spaces. It is true that Michelangelo's later architecture experienced a tremendous liberation of form and space from the catharsis of the fortification drawings. And without subscribing to the specious resemblance recently detected between them and the designs of Frank Lloyd Wright, we must admit that these are the freest, most "modern" expressions of architectural form and space of the entire Renaissance. The early Renaissance shibboleths of proportion, division, surface, ornament, even the harmonious radial relationships of the Leonardo-Bramante-Raphael tradition in the High Renaissance, are dismissed in favor of a new dynamic individuality of form and content. It is typical of Michelangelo himself, and of the forces that brought the Florentine Renaissance into being, that this bold stroke of architectural expressionism was primarily a practical manifestation of the defense of liberty.

Bastion for the Prato d'Ognissanti

North of the Arno, the so-called third circle of walls, built in the fourteenth century, followed the western flank of the then-expanding city along the natural defense line of the Mugnone River, but before its confluence with the Arno (which then took place at the spot where the Ponte della Vittoria now stands), the wall made a sharp angle and returned to rejoin the river at about the spot then and now

occupied by the dam (in front of the Grand Hotel). The still extant corner tower, easy enough to defend in the Middle Ages, was a sitting duck for Renaissance artillery. The following drawings represent the evolution of Michelangelo's ideas for the strengthening of this crucial point in the defense of the city.

325.
Pen, traces of red chalk, $14\frac{3}{4} \times 16\frac{1}{2}''$
FLORENCE, CASA BUONARROTI, 17 A recto
(for verso see No. 326)

Volute-like arms embracing a wedge-shaped salient are used to defend the tower in several sketches. Initially these arms themselves remain undefended, and in the later sketches, at the right, "orillons" (ear-shaped projections) are used to cover them.

326.
For medium and dimensions, see No. 325
FLORENCE, CASA BUONARROTI, 17 A verso
(for recto see No. 325)

Variants of No. 325, experimenting with blocky and with pointed terminations.

327.
Pen, wash, traces of red chalk, $15\frac{1}{4} \times 21\frac{7}{8}''$, folded, spotted, relined
FLORENCE, CASA BUONARROTI, 15 A

A finished presentation drawing, carefully labeled. At the top is the Arno, perpendicular to which runs a ditch ("this ditch is made"), and at an acute angle another, apparently proposed. Outside the wall one reads "street." The new ditch circumnavigates the bastion and joins forces with the Mugnone. The volutes are now protected by a double system of orillons, with minimal blind areas, all in the water. The immense scale of the bastion may be imagined from the fact that the present distance from the corner tower to the Arno is about eight hundred yards. If this distance has not changed since the sixteenth century, then the entire construction would have measured about five hundred yards across, or considerably greater than the height of the Empire State Building.

328.
Pen and wash, black chalk and red chalk, $15\frac{5}{8} \times 22''$, folded, cracked, spotted
FLORENCE, CASA BUONARROTI, 16 A recto

This has been identified as the second story of No. 327, to which it certainly corresponds. But more orillons are added to the curtain walls, and the other (subsequent?) studies indicate further enrichments of the arm-plus-orillon shape into a single cluster. The fourteenth-century wall is drawn as far as the Porticciola (postern gate), presumably to be protected by another set of fortifications (a bastion already existed, apparently based on the mill at the dam).

329.
Pen, wash, traces of red chalk, $8\frac{1}{2} \times 11''$, cut down and relined
FLORENCE, CASA BUONARROTI, 30 A

Star-shaped points replace the volutes, around a circular core. Then they are rounded at the right to resemble volutes again. Even the orillons become jagged. The power of the strokes witnesses the intensity of feeling with which the artist approached his task.

330.
Pen, wash, traces of red chalk, 16¼×22⅜″,
recto shows through
FLORENCE, CASA BUONARROTI, 13 A verso
(for recto see No. 331)

Further permutations and combinations of star-shaped points, now clamping the core, now radiating (at the extreme right) from a central wedge labeled "stone," guarded by orillons. These beautiful shapes have many military shortcomings, and seem to have been speedily discarded.

331.
For medium and dimensions, see No. 330
FLORENCE, CASA BUONARROTI, 13 A recto
(for verso see No. 330)

This elaborate presentation drawing solves all the defense problems of the difficult corner, but at the expense of demolishing the medieval tower and moving the Mugnone River. The combination of stars and volutes is planned to avoid having further constructions up the Arno, for the curtain wall is now well covered. Further cross fire is provided by semicircular cores in the curtain wall, halfway between the bastion and the Porticciola on one side and the Porta al Prato on the other, thus eliminating the orillons. Between the jaws of death is a real hell of cross fire. The bastion is surrounded by a star-shaped "ditch which moves within the bastion," continuing along the wall into a "ditch where today is the Mugnone." At the upper right can be seen the "Mugnone out of its bed," analyzed possibly because in floodtime high water would have endangered the cannon emplacements and drought would have left the moat dry. A military triumph, this final solution would also have been a structure of the utmost grandeur of form, space, and light.

Bastion for the Porta al Prato

The Porta al Prato still stands, and through it the road from the Prato (meadow) of Ognissanti leads to the city of Prato. The distance from the corner tower whose fortification was the problem of Nos. 325–31 is only about five hundred yards, as can be seen in No. 331. Michelangelo's task was now to control traffic passing through this, the principal western gateway of the city, and across the moat and also to command the Prato road, for the limited trajectory of Renaissance artillery.

332.
Pen, wash, traces of red chalk, 11¼×15⅝″, verso shows through
FLORENCE, CASA BUONARROTI, 20 A recto
(for verso see No. 333)

Starpoints guard a central salient, with orillons to provide cross fire. This is restudied, with clustered points, below. The labyrinthine access to the gate is worked out in some detail. Traffic is routed right and left around a central core (further sketched at the right), through antechambers, out side gates, and over plank bridges across the moat (labeled *fosso*) to the bank (*terra* means land here, not earthworks, as has been recently stated). No continuing route is provided.

333.
For medium and dimensions, see No. 332
FLORENCE, CASA BUONARROTI, 20 A verso
(for recto see No. 332)

Starpoints with volute tips now provide cross fire within a star-shaped moat, and are protected by orillons. Traffic now moves straight out the main gate, separates left and right along narrow passages, then back on plank bridges as in No. 332. How the rest of the moat would be crossed to the Prato road Michelangelo has not yet decided.

334.
Pen, wash, black chalk, red chalk, 15⅜×22″
FLORENCE, CASA BUONARROTI, 14 A recto
(for verso see No. 309)

Another superb presentation drawing like No. 327, of which it is the exact complement. The Mugnone, out of its bed again, flows across the upper left corner. The moat surrounds substantially the same star-volute bastion on all sides, so that it becomes an island. Traffic moves through the central gate as in No. 333, across the same plank bridges to land, and at every point is covered from gun emplacements carved out of the curtain wall. It then proceeds to lateral plank bridges across the entire moat, covered from the gate and from one of the starpoints, to a pier in the center, after which it comes under further fire from the angles of the projecting points. How it gets across the Mugnone is its own affair.

335. *Bastion for the Porta della Giustizia*
Pen, wash, 11¼×15½″, cut down and relined
FLORENCE, CASA BUONARROTI, 19 A

The Porta della Giustizia was another sore point in the walls of Florence, a corner gate again, and the last one to the east. Michelangelo has created a great claw with several protuberances, to cover the dam (*peschaia d'Arno*) as a crossing point, fire across the Arno itself, and provide the usual controlled double plank bridge across a moat, as well as traffic along the bank (*essodo della terra*).

336. *Bastion for wall near Porta Romana*
Red chalk, 14¾×10⅞″, cut down
FLORENCE, CASA BUONARROTI, 11 A

Identified by Michelangelo's inscription "from the Torre del Miracolo to the bastion of San Piero Gattolini two thousand nine hundred fifty." The Porta San Piero Gattolini is today called Porta Romana. A wall bastion required only starpoints for protecting fire. Perhaps this was to be duplicated in reversed pairs along this straight stretch.

Bastions for other gates

In addition to those analyzed above, there were nine other gates, the Porte Faenza, San Gallo, Pinti, alla Croce, San Niccolò, San Miniato, San Giorgio, San Piero Gattolini, and San Frediano. Exactly nine presentation drawings by Michelangelo remain, on eight sheets, and all are different. The presumption is, then, that he made a separate design for every one of the eleven Florentine city gates, and that the differences were intended to present to a prospective attacker problems which would have to be solved separately in every case. For the defender, the problem is always the same: how to divide entering from leaving traffic and route it through the gate and over the moat as slowly as possible, under constant and close supervision and under the threat of murderous fire from small arms at close range. Michelangelo's solutions are ingenious and delightful, often reminding us of the menacing cavern he had designed for the rare book room of the Laurentian Library. Widely differing solutions are sketched on a single preparatory sheet, No. 337.

337. *Sketches for gateways*
Pen, $11\frac{1}{2} \times 16\frac{1}{4}''$, patched at edges, spotted
FLORENCE, CASA BUONARROTI, 22 A verso
(for recto see No. 338)

It is impossible to determine the order in which the sketches went on the sheet. Toward the upper left a six-legged scheme is studied, apparently too fantastic, as it was not followed in any of the presentation drawings. A further and even stranger insectoid arrangement is barely contoured at the right. At the top and at the upper right and both lower corners Michelangelo experiments with radial overlaps, on the principle of a spiral staircase or a millwheel. This was adopted in No. 341. Below, he shortens the insect legs for a more sensible arrangement, worked out in detail in No. 339.

338.
Pen, wash; for dimensions, see No. 337
FLORENCE, CASA BUONARROTI, 22 A recto
(for verso see No. 337)

No distinguishing inscriptions, aside from the usual words for gate, moat, and bridge. Overlapping volutes compose a central salient protecting the gate and the bridge, and these in turn are covered by reversed pairs of volutes at either side. Traffic is divided by a central heart-shaped pier, and sent across one double bridge, covered by cross fire at both abutments.

339.
Pen, wash, $11 \times 16\frac{3}{8}''$, spotted, relined
FLORENCE, CASA BUONARROTI, 24 A

Volutes alternating with lozenges, as in the principal sketch in No. 337, cover two bridges. Divided traffic is routed to either side of the entire bastion, and covered as it moves from niche-shaped emplacements. A second, presumably smaller gate is given only two volutes flanking an arrowhead center. Traffic must proceed along lateral plank bridges converging on a single bridge over the moat.

340.
Pen, wash, $11 \times 14\frac{1}{4}''$
FLORENCE, CASA BUONARROTI, 21 A

Another smaller gate (compare the scale relation between gate, bridge, and bastion here with the important Porta al Prato). This needed only one pair of volutes embracing one bridge, doubled as usual, and covered by fire from flanking volutes. The traffic divider is itself a kind of doubled volute, allowing pedestrians to pass through a tiny central passage.

341.
Pen, wash, $10 \times 15\frac{1}{4}''$, cut down
FLORENCE, CASA BUONARROTI, 23 A

This is perhaps the most terrifying of the lot. On crossing the usual double bridge, the traveler found himself on still another bridge at right angles, subject to fire from eight radially arranged emplacements, coming from wedge-shaped recesses, like the folds of a fan, and presumably going down to the water. At either end of the second bridge he entered a passageway which Michelangelo provided with a "vault below as above."

342.
Pen, wash, traces of red chalk, $9\frac{1}{2} \times 16''$, cut down and relined
FLORENCE, CASA BUONARROTI, 25 A

A magnificent scheme for one of the principal gates, judging from the proportion of entrance to fortifications. The bastion is made up of six very heavy volutes, guarded by projecting wings rather than orillons, which cover not only approaching traffic but the curtain walls as well. Traffic crosses the moat on one triple bridge, and enters on either side of a lozenge-shaped divider.

343.
Pen, wash, $10\frac{1}{8} \times 15\frac{7}{8}''$, cut down and relined
FLORENCE, CASA BUONARROTI, 26 A

Another smaller gate, with a triangular divider, embracing volutes and covering orillons. The position of the bridge is given but the bridge itself not shown. The slight sketch at the upper left seems to be an elevation, with drawbridge raised, the only such indication we have for the actual appearance of these strange forms, which would have been rounded off to shed cannon balls as in Leonardo's fortification designs.

344.
Pen, wash, $10 \times 15\frac{3}{4}''$
FLORENCE, CASA BUONARROTI, 18 A

Again a small gate needing elementary protection. Two double bridges are amply covered from lateral recesses, while a simple bastion takes care of traffic from without.

345.
Pen, wash, red chalk, 8×10¾″, verso shows through
FLORENCE, CASA BUONARROTI, 28 A recto
(for verso see No. 346)

Scale alone rules out the general belief that this can be identi-
fied with the elaborately defined Porta al Prato. It was for
a smaller gate, but a strategically placed one, requiring com-
mand of a wide area by splayed points. Traffic was forced
out at the sides by two separate bridges, and made to pass
under the points.

346.
For medium and dimensions, see No. 345
FLORENCE, CASA BUONARROTI, 28 A verso
(for recto see No. 345)

A relatively standard bastion apparently flanking a gate,
but none is shown.

326

327

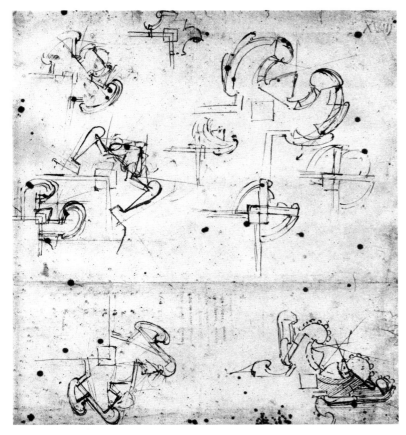

325

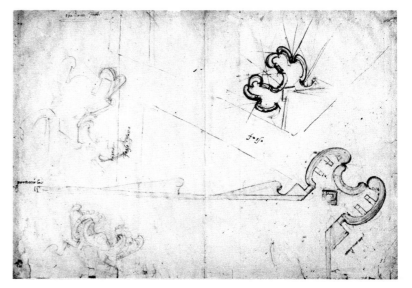

328

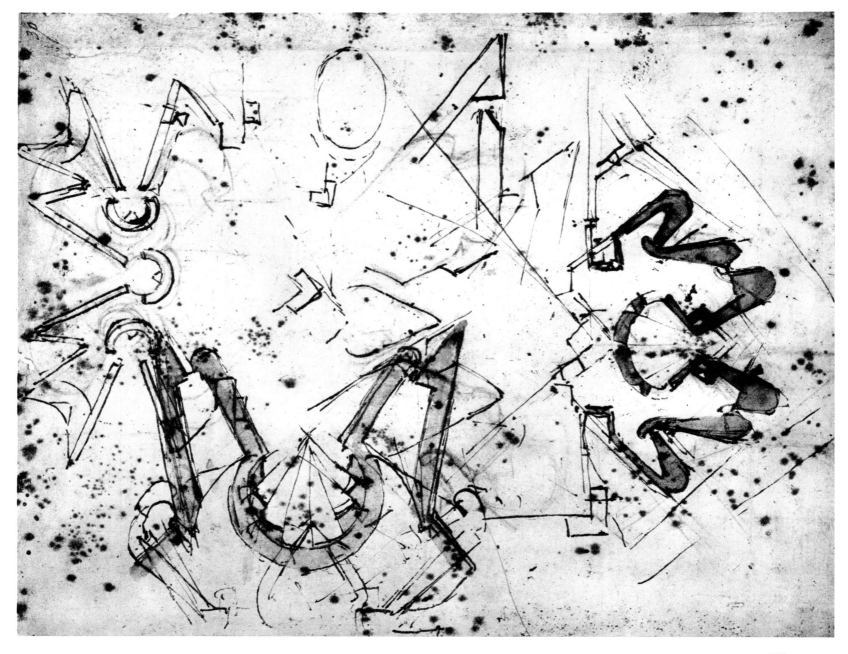

329

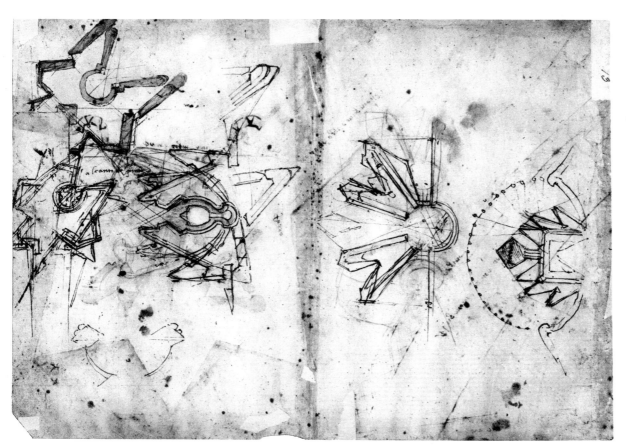

330

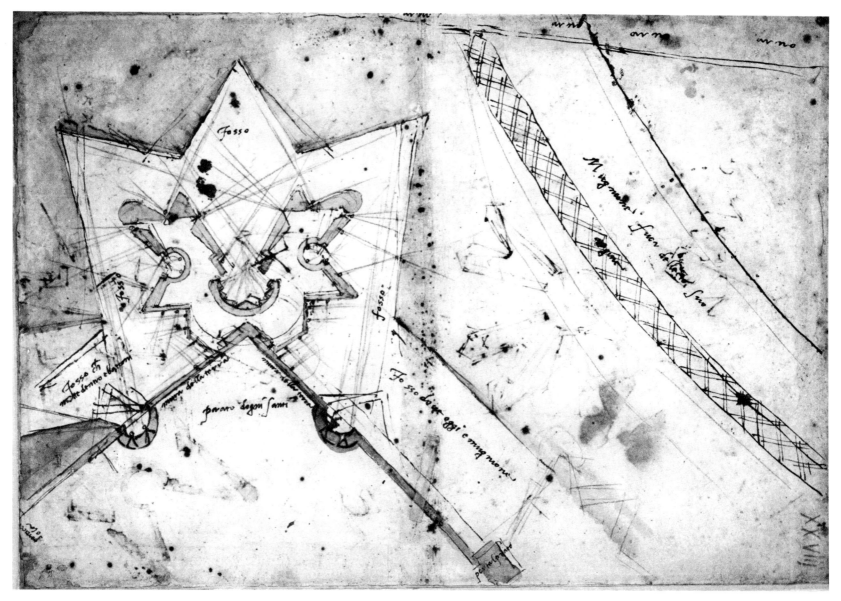

Fosso

Fosso

Fosso

Fosso et modesimo ellano

paravo dagon'santi

Fosso doue oggi e mig nuore

arno *arno* *arno*

331

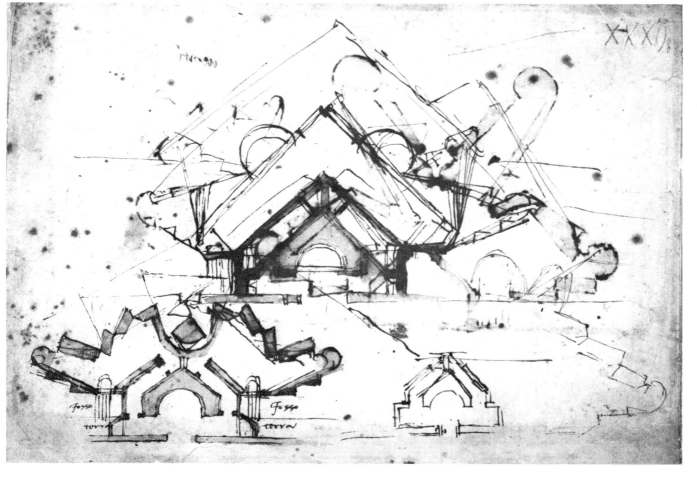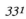

Fosso

terra

Fosso

terra

332

239

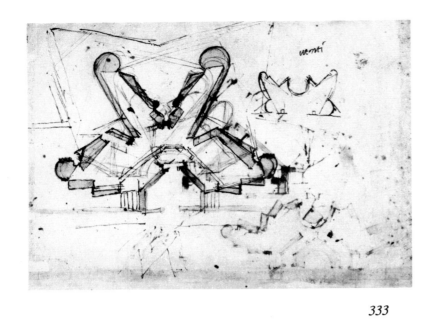

333

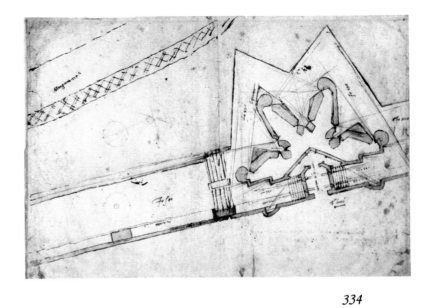

334

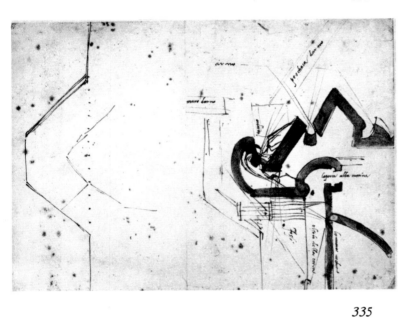

335

336

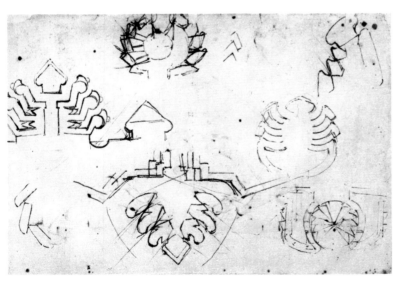

337

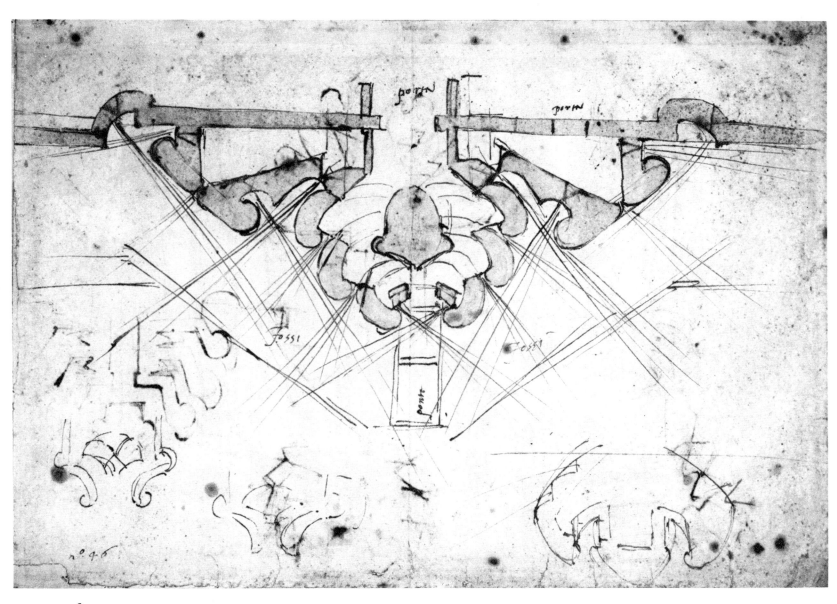

338

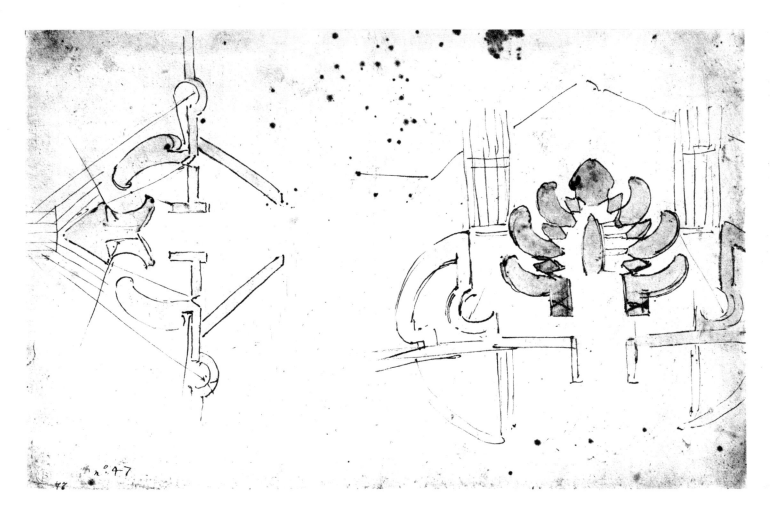

339

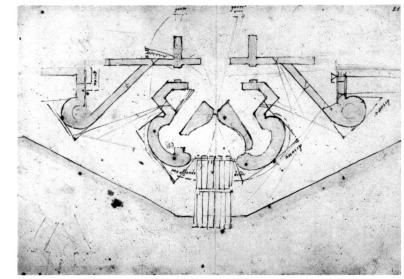

340

341

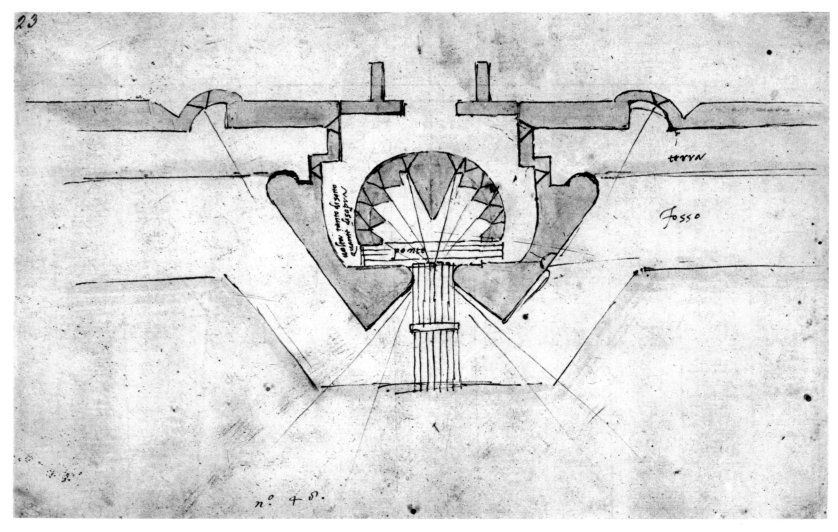

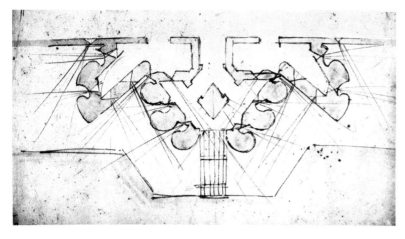

342

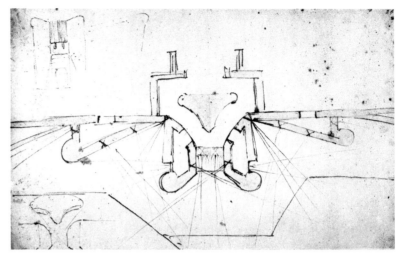

343

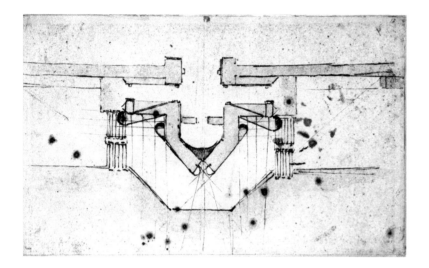

344

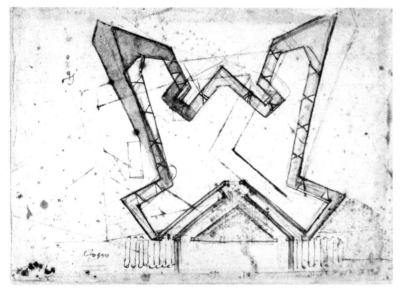

345

346

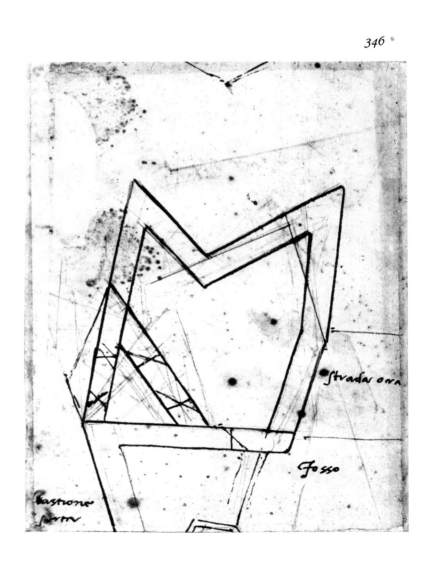

15

Drawings for a Resurrection for the Sistine Chapel. Rome, 1532–34

Among the innumerable projects contemplated but never carried out by Clement VII was a *Resurrection* for the altar wall of the Sistine Chapel, in the position for which it is here presumed that Michelangelo originally intended his first glorious Resurrection study, No. 125, in the far-off days of Julius II. By March 2, 1534, the scaffolding for this fresco was already erected. On September 23 the Pope died, and the project for a *Resurrection* was apparently not well received by his successor, Paul III, who commissioned Michelangelo to paint the *Last Judgment* in this position, covering the entire end wall. Four drawings, all now universally accepted, appear to be connected with this, presumably the fifth and last *Resurrection* to be abandoned in Michelangelo's career and the only one of which we possess certain documentary knowledge. One of these drawings, No. 348, is dated with some accuracy by material on its recto, two more are closely connected with them visually, and the fourth, a partially finished presentation drawing, seems to have evolved from them. In all four Michelangelo has deserted the motive of the physical stepping or leaping from the sarcophagus, apparent in all the earlier versions, in favor of a new and more transcendental conception, in keeping with the mysticism of the gathering Counter Reformation, now fully in power in Rome in these penitential years after the Sack of Rome. Now Christ floats upward, soaring above the barely indicated or even absent marble. Finally he glides upward, in an effortless conquest of death, No. 350.

347. *Sketch for a Resurrection*
1532
Black chalk, 10¾ × 6¼″, patched
OXFORD, ASHMOLEAN MUSEUM, P. 311 verso

On the verso of a plan for the reliquary tribune erected in San Lorenzo in 1531–33 (not illustrated), this drawing develops and enriches the motive of No. 184. The position of the legs was changed by lowering the right leg almost imperceptibly, but the right arm was brought inward to hold the banner against the torso, which was then turned delicately away from the observer. Although still raised to point upward, the left arm was now sharply bent, but this was apparently insufficient to produce the kind of compact figure Michelangelo now wanted, and he worked out a second pose, gathering the hand to the breast. The chalk is very blunt, and the doubled contours, blending with the free hatching, already suggest the multiple contours which will be so impressive in Michelangelo's late drawing style.

348. *Sketch for a Resurrection*
1532
Black chalk, 8¼ × 5½″, corroded and cut down,
recto shows through
FLORENCE, ARCHIVIO BUONARROTI, VI, fol. 24 verso

Sketched with great enthusiasm and violence on the back of a letter from Bartolommeo Angiolini, dated September 18, 1532 (at a time when Michelangelo was in Rome), this beautiful drawing twists the basic pose of No. 347 about 45 degrees counterclockwise, using the second or compressed pose of the left arm and lifting the right arm sharply upward. As a result, the *contrapposto* of the figure is greatly reduced and its verticality increased. The head now looks upward so that the glance follows the motion of the soaring figure. The position of the sarcophagus is only vaguely suggested by two lines. The contours are as bold and free as those of the sketches for the Sistine nudes, but all the masses are precisely indicated.

349. *Sketch for a Resurrection*
1532–33(?)
Black chalk, 16½ × 11⅜″
FLORENCE, CASA BUONARROTI, 65 F verso
(for recto see No. 371)

This superb drawing is a variant of No. 348. Leaving the torso in the same position, the legs are rotated clockwise a few degrees, and the arm lifted even straighter, in a position already prepared for by a *pentimento* in No. 348. The head is turned to look upward in the direction of the arm. The soft, amorphous masses of the body throb within fluctuating contours with many *pentimenti* prefiguring the pulsating figure style of the *Last Judgment*. The recto was later used for one of the major composition studies for the *Last Judgment*.

350. *Sketch for a Resurrection*
1532–33
Black chalk, 12¾ × 11¼″
LONDON, BRITISH MUSEUM, W. 52

This sublime drawing, one of the most beautiful of Michelangelo's entire career, now places the miracle in its setting. Dimly one sees the cave and the rocks in the background. The lid of the sarcophagus has been lifted by some mighty force, yet set down so quietly that the watcher reclining on it has not been disturbed. His companions are, for the most

part, not thrown back but recoil or flee in terror. Only one, the soldier with the shield, looks upward in wonder and, apparently, with the beginnings of understanding. All are lightly drawn, some merely sketched in outline, but the two watchers at the right and the wonderful Christ, gliding from the tomb in silence and without the slightest muscular tension, are carefully finished, at least as far as such a drawing can be finished. The dimness of a misty dawn is suggested in the soft blurring of the forms, hatched, crosshatched, and rubbed, then picked out in sure fluid strokes of contour line. Christ soars and gazes upward as if in a dream, fulfilling a Law which flows through Him and beyond Him.

351. *Sketch for a Noli Me Tangere*
1531
Red chalk, 9¼×5⅞″, cut down
FLORENCE, ARCHIVIO BUONARROTI, I, 74, fol. 203 verso

This light and airy sketch and its sequel, No. 352, have been connected with the *Resurrection* studies. This does not appear

likely. The figure is walking, not rising, and there is no indication of a sarcophagus or even a position for one. The figure has both feet on the ground, but is starting back from some stimulus. The best suggestion is certainly that the two drawings were done for a cartoon of the *Noli Me Tangere* ("Do not touch me, for I am not yet ascended to my Father," the words Christ said to Mary Magdalen in the Garden), which Michelangelo was preparing in 1531.

352. *Sketch for a Noli Me Tangere*
1531
Red chalk, 9¼×2¾″, cut down
FLORENCE, CASA BUONARROTI, 62 F

This further sketch for the same composition as No. 351 has of late been branded a copy: this would be *very* strange. The head rejected in No. 351 is reinstated in 352; the left hand, absent in 351, is beautifully supplied in 352. Stylistically the only difference between the two drawings is the greater resolution of pose and firmness of contour in 352. There is no difference whatever in quality or character.

347

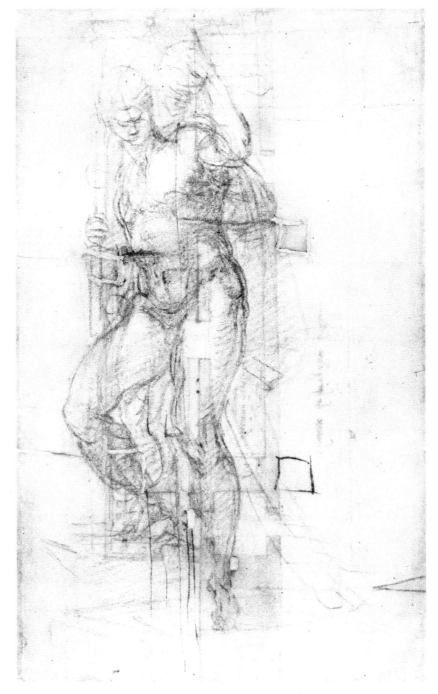

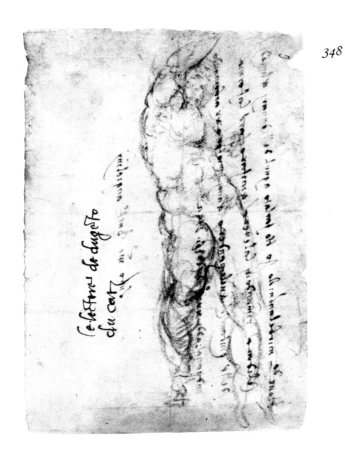

348

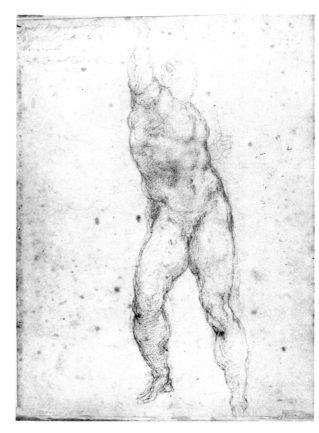

349

detail of 350▶

350

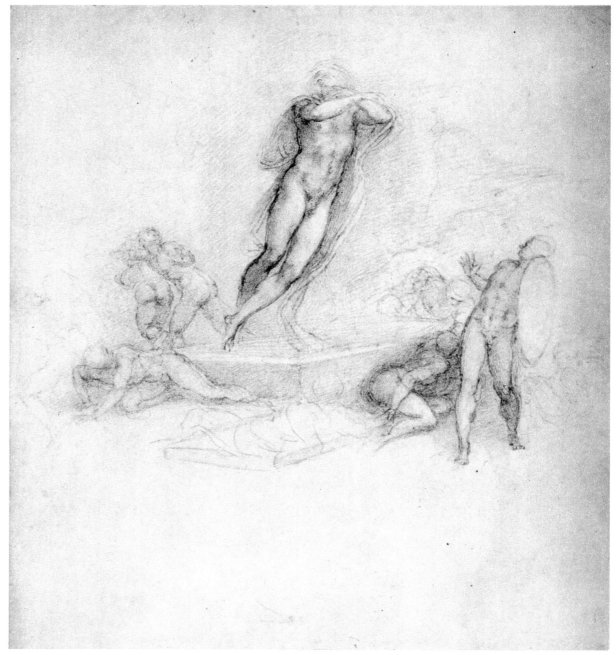

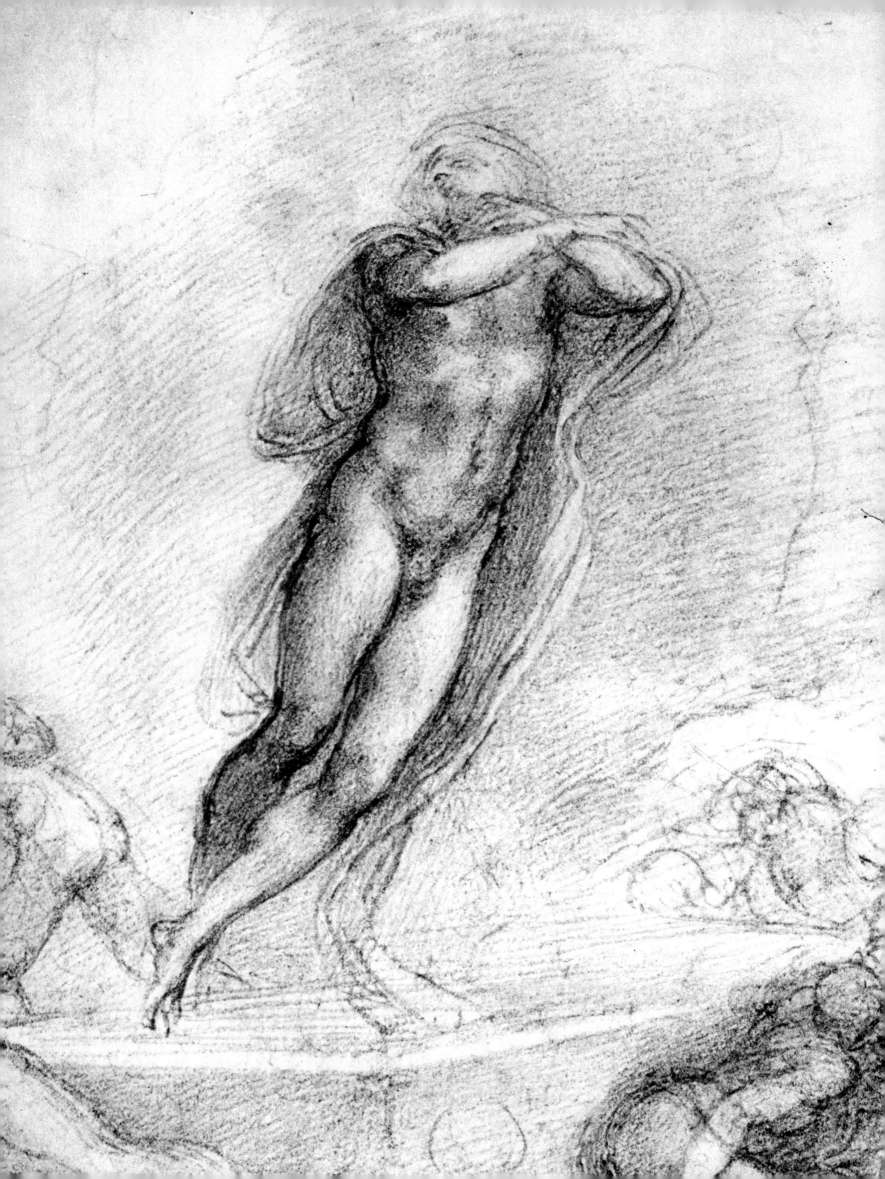

351

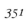

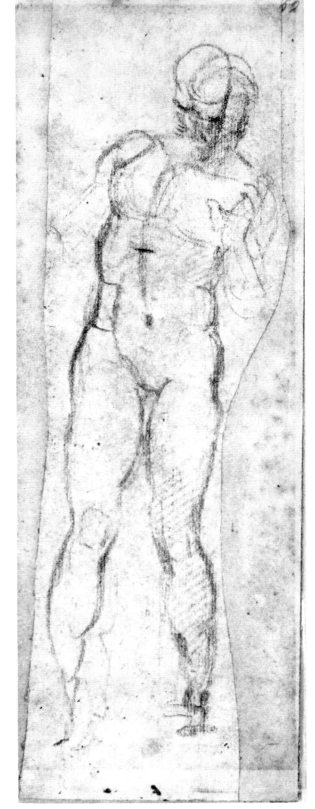

352

248

16

Presentation drawings. Florence and Rome, 1528–33

A considerable group of drawings by Michelangelo, generally of the highest finish, were done without the customary Renaissance purpose of preparation for works of painting or sculpture, but as complete works of art in themselves. Most of these were known to have been intended for presentation to certain individuals, and it is therefore presumed that all of them were. These drawings partake of the nature of poems, to be read in the hand rather than seen from a distance, and it has been justly suggested that their delicate surface quality, akin to that of gems or of illuminated manuscripts, was designed to be appreciated more fully with the use of a magnifying glass. Often these precious and intimate drawings reflect in miniature, or even prefigure, some of the grandest motives of Michelangelo's monumental compositions, but they have in common an unreal, sometimes a dreamlike, quality entirely their own. Perhaps for this reason some of the most beautiful have disturbed critics. The series presented here is self-consistent and cannot be separated. All were done within a very few years, and most of them for presentation to one of the most influential figures in Michelangelo's life, the young Roman nobleman Tommaso Cavalieri, a youth (according to Vasari) of divine beauty, to whom Michelangelo directed many poems and letters of the highest literary quality and of extraordinary emotional intensity. Much of that same feeling flows through the drawings, in which the artist celebrates his own unworthiness as compared to the exalted qualities he attributes to Cavalieri. It has not been generally noted that these drawings mark the last appearance in Michelangelo's art of the ideal male figure of youthful beauty and grace. Thereafter his imagination is possessed by qualities of a profoundly different nature.

353. *The Punishment of Tityus*
1532
Black chalk, 7½ × 13″, corroded at edges and slightly cut into at left and top
WINDSOR, ROYAL LIBRARY, 12771 recto
(for verso see No. 184)

This never-doubted and very beautiful drawing has been identified by all as one of the two works Michelangelo sent to Tommaso Cavalieri in the last days of 1532. The other was probably a *Ganymede*, now lost but recorded in several copies. The *Tityus* became immediately famous; it was copied many times, the first being the version in crystal done in 1533 at the order of Cardinal Ippolito de' Medici. On January 1, 1533, Cavalieri, then ill, wrote to Michelangelo thanking

him for the drawings, saying that he had spent two hours gazing at them, and that the more he saw them the more delight they gave him. Tityus, whose legend is recounted by both Virgil and Ovid, was a young Titan who conceived a great desire for Leto, the mother of Apollo and Diana. For this impiety he was doomed to be chained forever to a rock in Hades, where every day his liver (seat of the passions, for the ancients) was gnawed away by a vulture, only to grow afresh during the night. This dreadful punishment was Michelangelo's metaphor for the torments of his own presumptuous love for Cavalieri.

The pose of Tityus, turned on end, was traced by Michelangelo from a Resurrected Christ on the verso, which had already been derived from an earlier rendering of the same subject (No. 125). This is, however, far from being the entire story of the pose, instantly recognizable as related to Adam in the *Creation of Man* on the Sistine Ceiling, and also to the drunken Noah in that same cycle. Among the drawings done by Michelangelo close to the time of the *Tityus*, he utilized the same pose twice again, but in reverse and provided with the crossing arm of the Christ in No. 132, for the *Dream of Human Life*, No. 359, and *Samson and Delilah*, No. 466. Moreover Sebastiano del Piombo, doubtless with Michelangelo's approval, had used the Resurrected Christ, No. 132, for his *Raising of Lazarus* now in the National Gallery in London. That the same basic pose with slight variations should be used eight times by Michelangelo and an immediate follower for figures of the greatest importance seems hardly compatible with what we know of the master's extraordinary ingenuity in devising fresh and unheard-of arrangements of bodies and limbs, all the more when we consider that he did not invent the pose in the first place, but borrowed it from Jacopo della Quercia (*Creation of Adam*, Bologna, San Petronio), who had in turn derived it from a beautiful little Byzantine ivory carving representing *Adam Naming the Animals*, now in the Bargello in Florence. The apparent paradox can be resolved only on the plane of meaning. The figure became in Michelangelo's mind a classic and inexhaustible metaphor for divine love, either in its triumphant vehicle (the Resurrected Christ), its recipients (Adam, Lazarus, the awakened soul), or those most deeply in need (the drunken Noah, the agonized Tityus, the despoiled Samson). This identification of opposites by means of a common theme may be found again in the *Pietà* in the Cathedral of Florence, in which the pose of the dead Christ sinking into the tomb is derived from that of a damned soul in Hell, in the *Last Judgment* reliefs by Lorenzo Maitani on the façade of the Cathedral of Orvieto. Such an identification

is typical of Michelangelo's view of humanity, chiefly his own, continually at the mercy of inner warfare.

The tree trunk at the right, which breaks out into a yowling, bird-beaked demon, has been identified with the genius of the location in Hades; it establishes a setting of terror for the sufferings of Tityus. These, however–and this is of the utmost importance for the understanding of Michelangelo's art–are purely spiritual. The Titan is fettered only by one hand and one foot by means of straps which he could easily untie, and although the lower mandible of the vulture's beak vanishes into his body, it seems to merge rather than to penetrate. No wound is visible, nor does the torment produce a single drop of blood.

The beautiful shapes of the powerful body, richer than the adolescent forms more often celebrated on the Sistine Ceiling, are played off against the broader curves of the vulture's wings above and the fluctuating planes in the rocks below. These are partly modeled, partly left in crosshatched condition. But the body of Tityus is one of the most exquisitely modeled and stippled of all Michelangelo's figure studies, carried out with a precision which, far from diminishing, only enhances and enriches the immense strength of the work with its repertory of large and small pulsations of muscle, tendon, nerve, and skin.

354. *Sketch of an eagle(?)*
1532
Red chalk, $8^5/_8 \times 13^3/_4''$, cut down, later extended at top, bottom, and left
FLORENCE, CASA BUONARROTI, 119 A verso

This spirited sketch, on the verso of a plan by Michelangelo for a thus far unidentified house (not illustrated), has been mentioned only three times, but never rejected. It has, however, not been noticed that the sketch is closely related to the wings so beautifully treated in the *Tityus* (No. 353) and the *Dream of Human Life* (No. 359). Michelangelo obtained an eagle (or a hawk), apparently dead, from some huntsman, and drew out the basic relationships of feather structure. He must have made several such sketches, but this is the only one preserved.

355. *The Fall of Phaëthon*
1533
Black chalk, $12^1/_4 \times 8^1/_2''$, slightly cut down at left
LONDON, BRITISH MUSEUM, W. 55

This was apparently the next drawing Michelangelo made for Tommaso Cavalieri, immediately after the *Tityus* (No. 353) and the lost *Ganymede*. One reads in the artist's own hand, "Messer Tommaso, if this sketch does not please you tell Urbino so that I may have time to have another done by tomorrow evening as I promised you, and if you like it and want me to finish it send it back to me." We do not know whether Cavalieri liked the drawing or not, but there are two other versions (Nos. 357 and 358), so clearly this was not the final one. It has long been known that Michelangelo utilized works of ancient art in this composition, especially a Phaëthon sarcophagus then in the church of Santa Maria d'Aracoeli in Rome (now in the Uffizi). He took over no elements directly, however, but made many changes. The personification of the River Eridanus (the Po) below is related to an infinity of river gods in Roman art. It should be added that Michelangelo has made reference to the Sistine Ceiling, for one of Phaëthon's sisters at the lower right repeats in

reverse the pose of the guilty Eve expelled from Paradise. Scholars have often noted that the composition, with its three superimposed registers, contains in germ that of the *Last Judgment* of only a few years later. This resemblance is easy enough to account for, since the Phaëthon legend, as has been shown, was chosen by Michelangelo as a metaphor for his presumptuous attachment for Cavalieri, sure to be punished, as was the ambition of the overweening Phaëthon who dared to drive the chariot of the Sun. It was natural, therefore, for him to recall this formulation; Jupiter wielding his thunderbolt becomes the damning Christ, the falling Phaëthon the wicked driven down to Hell, the miserable sisters turned into trees as a punishment for their lamentations (the mythical origin of Lombardy poplars), and the brother Cygnus into a swan. Such wild hyperbole makes a striking contrast with the ease and intimacy of the accompanying note to Cavalieri, but this is the way things were in the Renaissance. And the inner struggle of Michelangelo himself, crystallized in this striking series, is real enough. The sisters, whose legs are turning to trunks and roots and whose hands become branches as we watch, prefigure Bernini's *Apollo and Daphne*. The poses of the horses are particularly imaginative. The drawing is not much more than what Michelangelo called it, however—a sketch. Although the horses have been hatched, crosshatched, and occasionally modeled, certain portions of the figures have been no more than outlined.

356. *Sketch for Jupiter in the Phaëthon drawings*
1533
Red chalk, $4^1/_2 \times 2^3/_4''$, cut down
FLORENCE, CASA BUONARROTI, 4 F

Seldom mentioned but never questioned, this tempestuous sketch has been connected with the Resurrection series, which is most unlikely. It shows Jove seated on his eagle (barely suggested), but in a more interesting pose, with his left arm crossing his body.

357. *The Fall of Phaëthon*
1533
Black chalk, $15^1/_2 \times 10''$, badly damaged, apparently by crumpling
VENICE, ACCADEMIA, 177

This uncontested drawing has generally been considered the second of the three complete Phaëthon compositions. It is difficult to find any basis for the recent contention that it was done much later. The passage in Michelangelo's hand has been deciphered, "I drew this as well as I know how, therefore I am sending yours back because I am [?] your servant that I will redraw it another time." In the present condition of the drawing, not even this dubious reading can be guaranteed, but what we can be sure of suggests that Michelangelo intended to make still another drawing. He may have crumpled the sheet himself. He has given no indication of the eagle, and has changed Jove's legs from their position in Nos. 355 and 356. Most striking of all, he has attempted a harsh, vertical axis for the entire composition, turning the chariot upside down before us, splitting the horses into embracing pairs, and spilling Phaëthon down toward Eridanus who reaches upward to receive him. The agonized sisters below could scarcely have been completed in their present exaggerated poses. All the lower figures

recall the chalk sketch presumed to have been done for the San Lorenzo façade (No. 169).

358. *The Fall of Phaëthon*
Black chalk, 16¼×9¼″, slightly cut down
WINDSOR, ROYAL LIBRARY, 12766 recto
(for verso see No. 369)

The largest and most carefully finished of the Phaëthon series, this unassailed masterpiece must have required a great deal of time and thought. It is doubtless to be identified with the drawing acknowledged by Cavalieri in a letter of September 6, 1533, written to Michelangelo in Florence: "Perhaps three days ago I got my Phaëthon, very well made; and the Pope has seen it, and the Cardinal de' Medici, and everyone, I do not yet know for what reason, seems desirous of seeing it." Apparently Michelangelo took the preparatory material with him when he left for Florence on July 10, and did the work there. Among this material must have been some of his own earlier drawings, for the Eve is not the only echo of the Sistine Ceiling we can find here. The shoulders and left arm of the new Jove follow almost exactly those of the nude youth seated at right above *Joel*. His legs are derived from the nude at right above the *Cumaean Sibyl*. But most striking is the figure of Phaëthon, which is the nude at right above the *Libyan Sibyl*, upside down, so that the left arm now hangs straight. This, too, may have a symbolic justification, for the nude in question gazes directly at the Deity in the *Separation of Light from Darkness*, comparable, therefore, to Phaëthon who dared to assume the luminary powers of divinity. The little water carrier Michelangelo studied in No. 46 is repeated exactly. Probably the wonderful river god reflects the pose of one of the river gods of the Medici Chapel, on which Michelangelo was at work at this moment, a further indication that these were intended to be geographical rivers, not, as has been absurdly maintained, the rivers of Hades. Finally, the horse just below Phaëthon repeats the pose of one of the Israelites writhing in pain from the bites of the fiery serpents in the *Brazen Serpent* study, No. 257.

The beautiful drawing is the most carefully composed of the series as well as the most delicately finished. Michelangelo has renounced the excessive verticality of No. 357 and its wild lower figural arrangements, but at the same time has given up the faintly ludicrous transformation of the sisters into poplars in No. 355. All forms are compactly arranged and exquisitely counterbalanced, leaving broad areas of paper to suggest the cosmic implications of the scene and utilizing blurred clouds, vegetation, water, etc. to effect a soft transition between the figures and the background. In its jewel-like precision, this drawing, repeated *ad infinitum* throughout the sixteenth century, had an enormous influence on both the composition and the figure style of later Mannerist painting.

359. *The Dream of Human Life*
1533–34(?)
Black chalk, 15⅝×11″
LONDON, COUNT ANTOINE SEILERN

This fantastic and wonderful drawing, well known and often copied in the Renaissance, has suffered a sad critical fate, rejected as a copy by at least half the scholars who have mentioned it. It should never have been questioned. No master other than Michelangelo could have been responsible for anatomical forms of such subtlety and delicacy. Techni-

cally the drawing is indistinguishable from the *Tityus* (No. 353) and the Windsor *Phaëthon* (No. 358), although it may have been done a year or two later, at a time when Michelangelo's figure types were changing. Perhaps the judgment of scholars has been affected by the very strangeness of the subject. This has been convincingly deciphered in an interpretation marred only by a description of the *six* vices represented by groups of figures in the background as "unquestionably the Seven Capital Sins," and the central figure as "reclining on a globe" when he is visibly seated on a box. The globe, also resting on the box, is utilized only as a prop. Supplied with an equator in this drawing, and with continents in all the copies, it clearly represents our planet, associated with the masks contained in the box, always a symbol of mendacious dreams. The sins can be identified as Gluttony (a man waiting impatiently at table for the food being cooked on a fire, a man drinking from a wine flask), Lechery (a man leaping upon and embracing a woman, a hand holding a phallus, a woman kissing a youth), Avarice (two hands holding a moneybag), Wrath (a man beating two boys with a stick), Envy (a youth attempting to tear off an old man's cloak), and Sloth (several figures sunk in sleep). Pride is missing. This may be merely because Pride is the root of all the other sins and encompasses them all, and therefore need not be separately represented. The winged figure, it has been shown, corresponds to the description of Fame in the *Iconologia* of the late sixteenth-century scholar Cesare Ripa, who says that "the trumpet of fame awakes the mind of the virtuous, rouses them from the slumber of laziness." The drawing, then, depicts the importance of the desire for fame in rousing mankind from the sinful dreams that haunt life on this planet, to contemplation of a higher sphere of existence. Michelangelo's intention may have been general, but it seems more likely that the drawing was destined for the guidance and inspiration of Cavalieri. It is especially interesting that, at this moment in the Counter Reformation, Michelangelo should have recourse to the symbolic method of marginal narration utilized at the beginning of the fifteenth century by the still medieval monastic painter Lorenzo Monaco, in his *Pietà with Passion Symbols* now in the Academy in Florence. And it is typical of Michelangelo throughout his life that, against a background of deadly sin, the principal figure should still be triumphantly and heroically nude.

360. *Three Labors of Hercules*
1528(?)
Red chalk, 10¾×16⅝″, slightly cut down, rubbed at center and right
WINDSOR, ROYAL LIBRARY, 12770

The critical onslaughts on this masterpiece constitute one of the less edifying chapters in the connoisseurship of Michelangelo's drawings. Although all older writers had accepted it with enthusiasm as one of the most splendid examples of a new phase in the master's work, the drawing was attacked as a late sixteenth-century forgery forty years ago. Then the very scholar who exhaustively refuted this aspersion classified the work as a copy by Antonio Mini. Recent studies show that, from all existing evidence of his style, Mini cannot be credited "even with the capacity to understand a masterpiece of this rank." The drawing, accepted in all the latest studies of Michelangelo's graphic work, may be considered thoroughly revindicated. In the left-hand section, perfectly preserved, is one of the most

hauntingly beautiful examples of the great artist's understanding of the play of light and shadow on the human body. The melody of line, the flow of surface, and the harmony of form are as fine as any passages of painting on the Sistine Ceiling, and are not surpassed by the best of the Cavalieri drawings. The central group, placed slightly farther back in depth, is somewhat less carefully finished, showing extensive *pentimenti* which should have ruled out at once any notion of a copy. The group on the right, with large unfinished areas in the monster and even in the left arm of Hercules, is a brilliant conception in the interrelation of highly complex forms in depth.

What can be the meaning of this study, and for what purpose was it intended? It has been carefully noted that only two of the groups—the Nemean lion and the Lernean Hydra—belong to the canonical series of the Twelve Labors of Hercules, also that Michelangelo's little inscription "this is the second lion that Hercules killed" accounts for his wearing the skin of the Cythaeronian lion he had slain earlier, and finally that he rends the lion's jaws as Samson did, instead of first beating the poor thing with his club and then strangling it, as he should. These observations prompt one to wonder whether there might not be some meaning in the connection between the theme of Hercules, that old hero of the Florentine Republic, and Samson, interchangeable with Hercules in Michelangelo's ill-fated commission for a statue to flank the early *David*. In these three specially selected scenes, the hero fights three powerful enemies, and he ages visibly in the process. Could these refer to the three expulsions of the Medici, in 1433, 1494, and 1527? The Nemean lion might well fit Cosimo, Antaeus turned upside down would do for Piero the Unlucky, and the Hydra, with one head throttled but all the others attacking, makes a vivid symbol of the enemies of Florence just before the siege, threatened by Pope and Emperor alike. The highly finished character of the drawing has suggested that it was intended to be complete in itself, like the Cavalieri drawings, for presentation to an individual. This fortunate person should in probability be identified as Niccolò Capponi, reinstated as Gonfaloniere of the threatened Republic in February, 1528. The date would correspond nicely with the style of the drawing, generally considered a precursor of the group done for Cavalieri in 1532–33. In the dreamlike character of the struggle and in the utter purity of the conception of the nude, the drawing comes close to the *Victory* for the Tomb of Julius II, carved in all probability at the same time and reflecting the same ideas and feelings.

361. *Children's Bacchanal*
1533(?)
Red chalk, 10¾ × 15¼"
WINDSOR, ROYAL LIBRARY, 12777

Certainly the most meticulously finished of all Michelangelo's presentation drawings, resembling nothing so much as a carving in crystal, this sheet, already famous in Vasari's time, has not escaped the imputation of being a copy, at the hands of two scholars, neither of whom has been able to point to a master of such prowess as its author. There has never been the slightest reason to doubt the authenticity of this work, again a complete painting in itself. Surface after surface, line after line, form after form, combine the most delicate precision with all the grandeur of Michelangelo's monumental compositions.

No text has yet been produced to solve the enigma of the subject, but this has not deterred those who, willy-nilly, manage to fit it into the lowest stratum in the structure of Michelangelo's supposed Neoplatonic cosmos. Thirty children about two years of age and mostly male are engaged in vaguely Bacchic activities. In poses, treatment, and expressions many of them resemble the infant caryatids above the thrones of the prophets and sibyls on the Sistine Ceiling. At the lower left, one is nourished by the pendulous breast of an ancient female satyr, on whose lap sits another child, his head resting on her knee. At the lower right four children, one of whom holds a cup, are occupied with a sleeping, presumably drunken young man about whose shoulders a child pulls a cloak, recalling the action of the sons of Noah on the Sistine Ceiling. In the center, on a goatskin whose head is upright, rests a wine cup, flanked by a smaller object, possibly the goat's tail. The rocky shelf above accommodates seven children struggling with the upside-down carcass of a deer, whether buck or doe we are not permitted to determine. At the upper left nine more children gather round a cauldron. Two carry wood for the fire beneath it, two poke and one blows the flames, two stir the pot in which some substance, apparently an animal, is already cooking, one brings a pig to add to the brew, and another, at the extreme left, puts his hands on his knees and laughs. At the upper right a wine vat has attracted eight more children. One drinks, one bathes, one gives a cup to another who drinks from it while pouring more out of a wineskin, one attempts to fill a cup from the spigot while another urinates into it, one looks on, and a last little creature apparently has gone to sleep. The background is formed by a huge cloth, hung from tree trunks at either side, and over the cloth is draped a boar's skin. Many writers have been reminded of the three reliefs on the base of Donatello's *Judith and Holofernes*, visible to Michelangelo in front of the Palazzo Vecchio near his *David* and known to him from childhood, when it stood in the Medici Palace; these scenes in all probability are related to the doctrine of the baptism by blood as taught by St. Antonine of Florence. No such meaning can be present here. Nor are there vine leaves or any other elements which could identify the scene securely as a Bacchic rite. The numbers seem to make no sense. Until a specific text is found, there would seem to be little point in speculation, beyond noting that the drawing radiates the irresponsible wildness of certain of Michelangelo's poems. It is perfectly possible that he did not mean us to penetrate its riddles any further.

362. *Archers shooting at a herm*
1533(?)
Red chalk, 8½ × 12⅝", slightly cut down all around
WINDSOR, ROYAL LIBRARY, 12778

Another magnificent drawing, listed as a copy by three scholars, but inseparable in line, modeling, and light from the *Tityus* (No. 353). This is also an enigma, which has so far successfully eluded all attempts at interpretation. Seven nude youths and two nude maidens are engaged in shooting arrows at a herm. Some run, some float through the air, some crouch, some lie on the ground. They are egged on by two *putti* in the background. Two more *putti* blow and feed a fire of logs, apparently to temper the heads of arrows before immersion in a cup. Below the herm a Cupid sleeps, his head resting on a helmet. Before him can be seen his quiver filled with arrows. At the upper left a bearded nude, possibly a satyr, runs away shouting, and bending a bow backwards. The nudes engaged in this magic dance shoot their arrows

without bows. Certainly the best explanation is that which tentatively identifies the scene with a passage in the writings of Pico della Mirandola, in which a distinction is drawn between "natural desire" and "desire with cognition." Those governed by the former are compared with arrows shot at a target; a goal is known to the archer but not to themselves. The disconcerting absence of bows remains unexplained, particularly when the single figure who has one bends it the wrong way and seems to be leaving the scene. More important yet, the herm itself, struck by nine arrows, was known to Michelangelo as a symbol of death and so utilized in the designs for the Tomb of Julius II. Is love here identified in some mysterious way with death, whose helmet Cupid guards? Is the whole contest an allegory of human life striving toward the attainment of love and reaching only death? Again, we must await the exact text, if any.

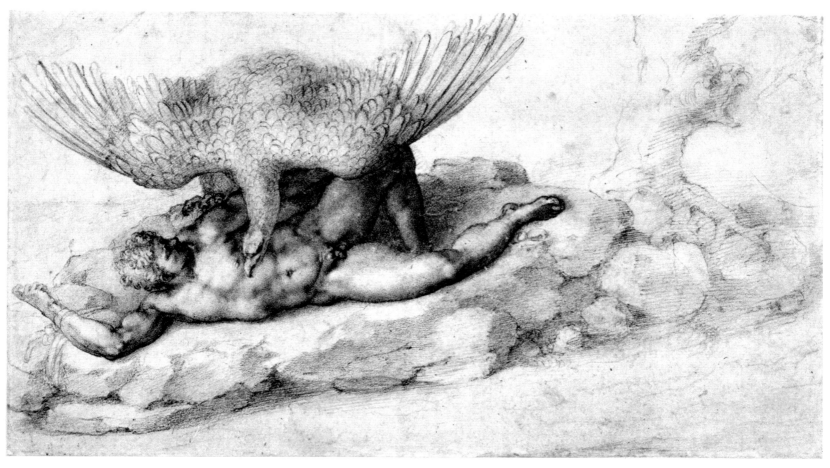

353

354

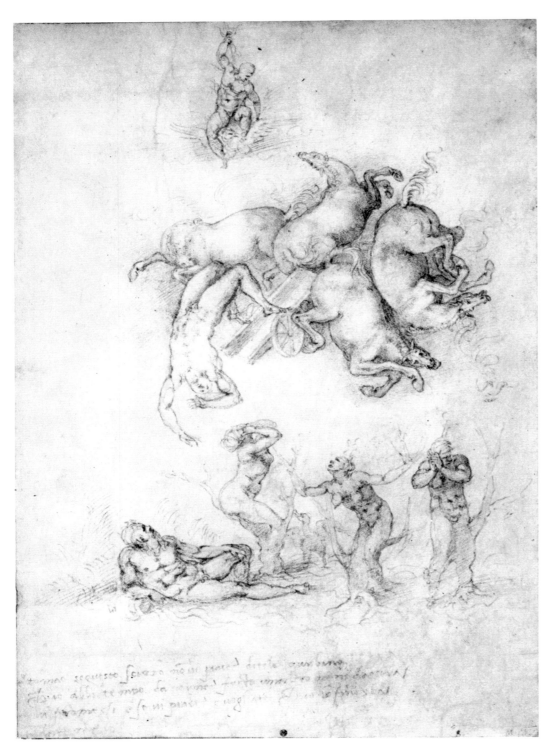

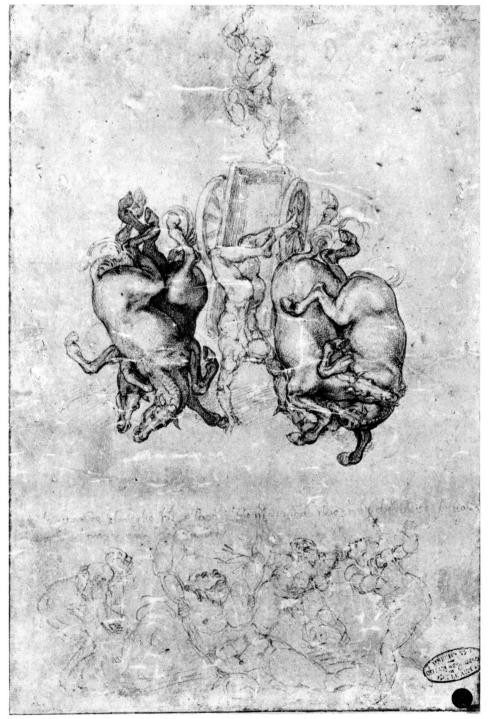

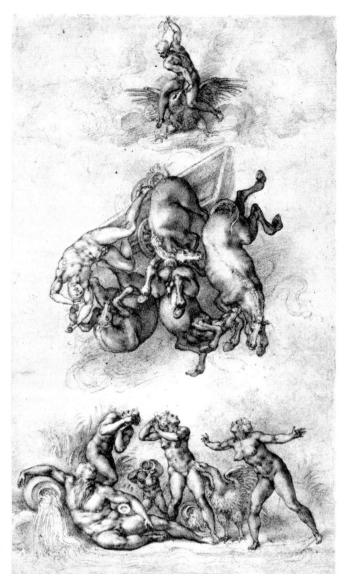

255

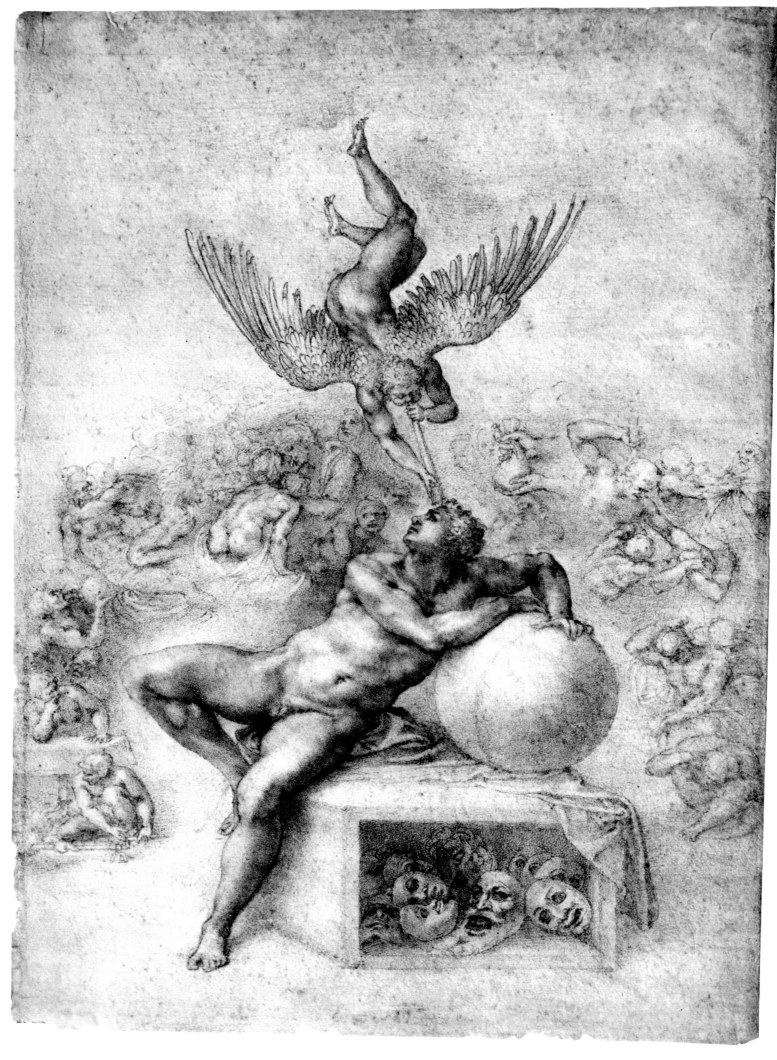

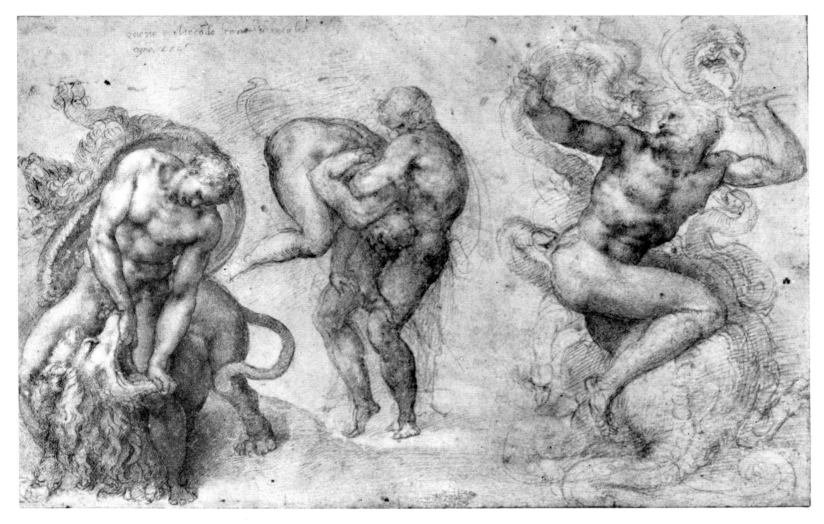

360

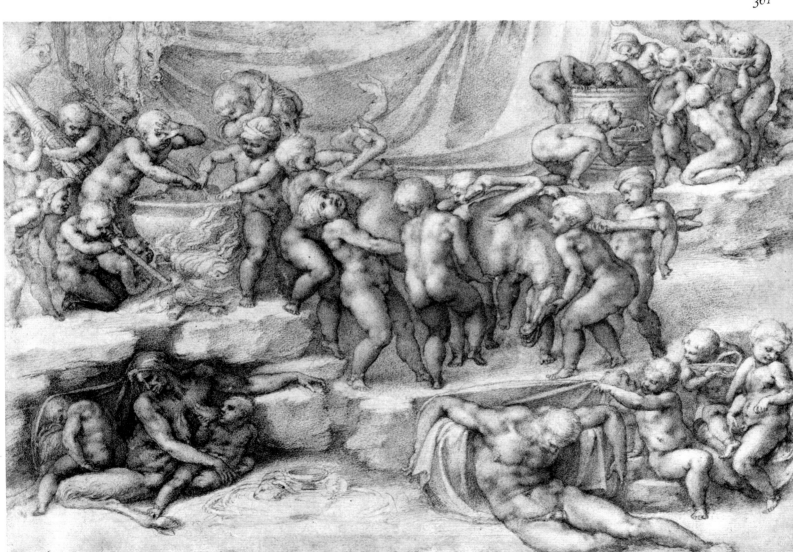

361

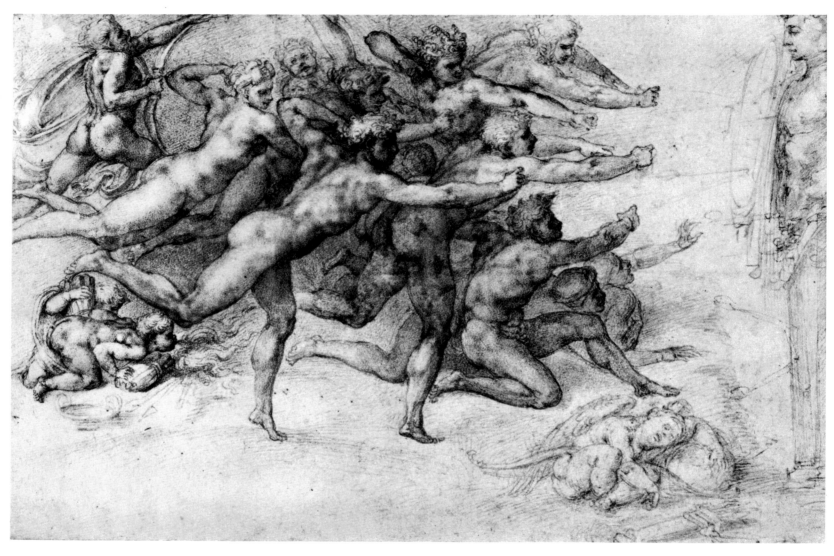

362

258

17

"Divine heads." Florence and Rome, 1528–34

Vasari tells us that Michelangelo made for his friends Gherardo Perini and Tommaso Cavalieri "many most amazing drawings, done with black and red chalk, of divine heads," especially so that the latter could learn to draw by following these examples. Imaginary heads appear early in Michelangelo's work (No. 19, for example), and turn up again and again on sheets intended as patterns for the practice of young pupils. The drawings done for Perini are known only in copies, but heads still preserved may possibly be identified with the series drawn for Cavalieri. They include at least one study from life (No. 363), of the requisite "divine beauty," and several imaginary ones in varying stages of completion. All show the emergence of new ideals of classicistic beauty, which will be reflected in the angelic heads of the *Last Judgment*.

363. *Head in profile*
1533–34(?)
Red chalk, 8×6½", folded, spotted
OXFORD, ASHMOLEAN MUSEUM, P. 315

The magic of this drawing has been so overpowering as to prevent all but two critics from considering it the work of any other hand than that of Michelangelo, and one of these has since changed his mind. The full beauty of the study can be felt only when it is seen in color. The features are clearly those of a youth, seized by some haunting and nameless melancholy. The female dress, probably added from imagination, gives the work a strange, transvestite appearance, yet the quality is high enough to transcend even that. The elusive delicacy of the surface is so closely allied to the style of the presentation drawings as to suggest a date much later than the period of the Sistine Ceiling once considered probable, or even the more recently proposed years of the first work on the Medici Chapel. None of the fierce energy of the drawings for the latter monument can be detected in this poignant and apparently personal witness. Not only are the masses and contours softly blurred—the very first lines that went on the sheet, to trace the limits of the headdress, the neck, and shoulders, waver softly even though they respond to great accuracy of vision.

364. *Head in three-quarters view*
1533–34(?)
Black chalk, 8⅜×5⅝", upper corners cut, spotted
WINDSOR, ROYAL LIBRARY, 12764 recto

This exquisitely beautiful drawing has been accepted by all but a single critic, who has detected weaknesses in the handling of the left eye. The artificiality of the drawing derives, perhaps, from the fact that it was most likely not done from life. The relationships between the shapes, even the features themselves, are schematic, approximated to an Hellenic norm rather than the Byzantine ideal of the face of *Dawn*. But the surface delicacy, the refined contour of the neck, the hatching of the throat, are all born of long experience and sensitive observation. No copy has the control of hatching over a large surface displayed by this drawing, nor shows the frequent *pentimenti* in major contours. And the drawing breathes Michelangelo's most potent magic! The wistful sketch on the verso (not illustrated) and a Madonna composition in the collection of Sir Kenneth Clark, utilizing the present mask, have been attributed to Cavalieri.

365. *Female head in profile*
1532–34(?)
Black chalk, 11¼×9¼", cut down all a round, patched at bottom
LONDON, BRITISH MUSEUM, W. 42 recto
(for verso see No. 313)

The artificiality of this highly finished study has occasioned great doubt among critics; it has, in fact, been accepted by only two. Yet the drawing cannot be dissociated from an idealizing tendency among certain of Michelangelo's works during the 1530s and 1540s, culminating in the deliberate chill of the masklike *Rachel* and *Leah* heads, finished during 1542–45 for the final version of the Tomb of Julius II but very possibly designed for the 1532 project. To these heads the present imaginary profile bears a startling resemblance, in every detail of feature as well as in contour, rhythm, and even finish. With uncanny precision, Michelangelo's stippling technique has succeeded in reproducing on paper the marmoreal consistency and the slightly matted texture of these heads, not polished like those of the Medici Chapel. The monumental grandeur of the shapes of the fantastic headdress and the implacable hardness of the contours all proclaim the master's skill. The numerous *pentimenti* in the neck and under the jaw, by the way, show that the artist expanded the forms considerably as he drew. It has been suggested that the drawing represented Venus, which the presence of a winged *putto* head makes probable. A careful copy of a companion drawing of Mars exists in the British Museum, and the difference between its neat but faltering technique and timid hatching and the noble assurance of

this study is very instructive. Oddly enough, the two were engraved in the early seventeenth century as portraits of Vittoria Colonna and and her husband.

366. *Seated woman*
1528–34(?)
Red chalk, black chalk, and pen, $12\frac{3}{4} \times 10\frac{1}{4}''$
LONDON, BRITISH MUSEUM, W. 41 recto
(for verso see No. 367)

A rapid imaginary sketch of a young woman in fantastic dress related to the armor of the Dukes in the Medici Chapel. The light chalk drawing was gone over briefly in pen, and the right hand first laid on the lap, then lifted to hold some object. The tiny male nude bending forward below the hand does not seem to have any relation to the theme of the drawing, and must have preceded it on the paper. The wide-eyed, prophetic gaze is to be found in many of the figures in the earlier portions of the *Last Judgment*. The drawing has been doubted by some scholars, and even attributed to Mini, with whose style it has no relation. It is now generally accepted.

367. *Young woman looking down*
1528–34(?)
Black chalk; for dimensions, see No. 366
LONDON, BRITISH MUSEUM, W. 41 verso
(for recto see No. 366)

This now accepted sketch was probably done at the same time as No. 366 on the recto. It is a pensive and tender drawing, of great refinement and gentleness, yet showing the power of Michelangelo's form in the shape of the standing collar, the headdress, and the bosom.

368. *Girl holding a spindle*
1528–34(?)
Black chalk, $11\frac{3}{8} \times 7\frac{1}{4}''$, cut down, lower left corner patched
LONDON, BRITISH MUSEUM, W. 40

The doubts entertained by most critics on the subject of this gentle sketch seem unjustified. It is inseparable from the preceding drawings (not the wooden profile under the left arm, of course; this must already have been on the sheet when Michelangelo started drawing). The head is almost identical with the genuine profile on No. 311. Rapid and tentative though they may seem, the contours build up a figure organized on Michelangelo's block principle. The little cherub head on the girl's bosom is a brilliant bit of invention.

369. *Young woman holding a mirror*
1532–34(?)
Red chalk, $16\frac{1}{4} \times 9\frac{1}{4}''$
WINDSOR, ROYAL LIBRARY, 12766 verso (for recto see No. 358)

This remarkable drawing, rejected by four scholars, is inseparable from the preceding female subjects in facial type, headdress, treatment of form, line, and surface. The female faces of Michelangelo's maturity are not always particularly alluring by contemporary standards, but this one is strikingly close to several to be found in the lunettes of the Sistine Ceiling, especially the mother of Jechonias. It is especially unlikely that a drawing by Mini (who left Michelangelo's service in 1531) would be on the verso of a drawing of such importance as the *Phaëthon* done for Cavalieri in 1533. The figure, contemplating a mirror, has been identified correctly as an early idea for the *Leah* for the Tomb of Julius II, very probably designed in 1532, but not finished until the final project of 1542–45.

336 ▶

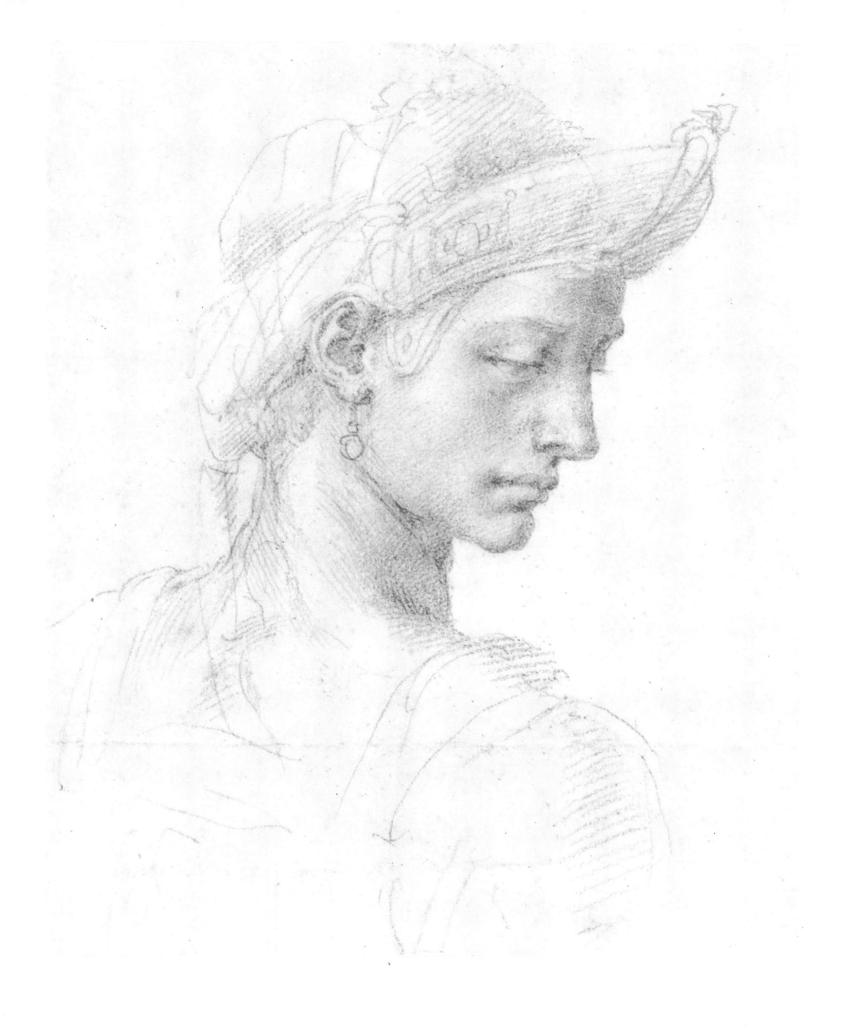

261

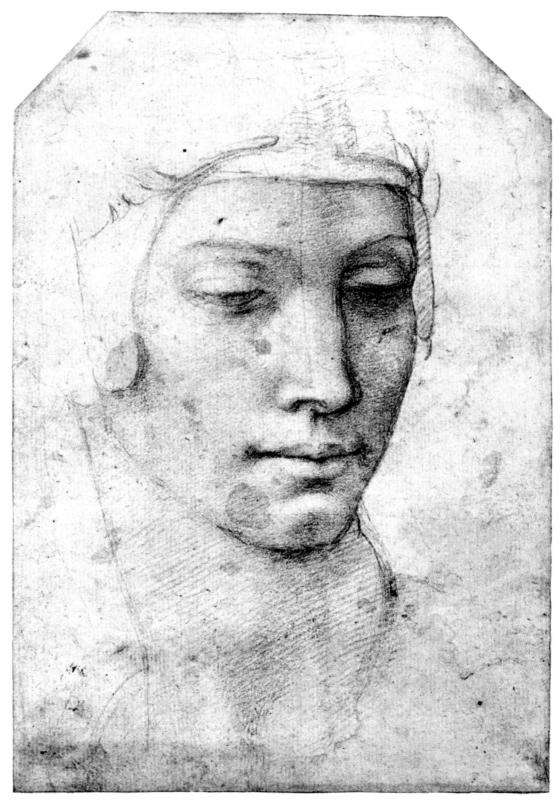

364

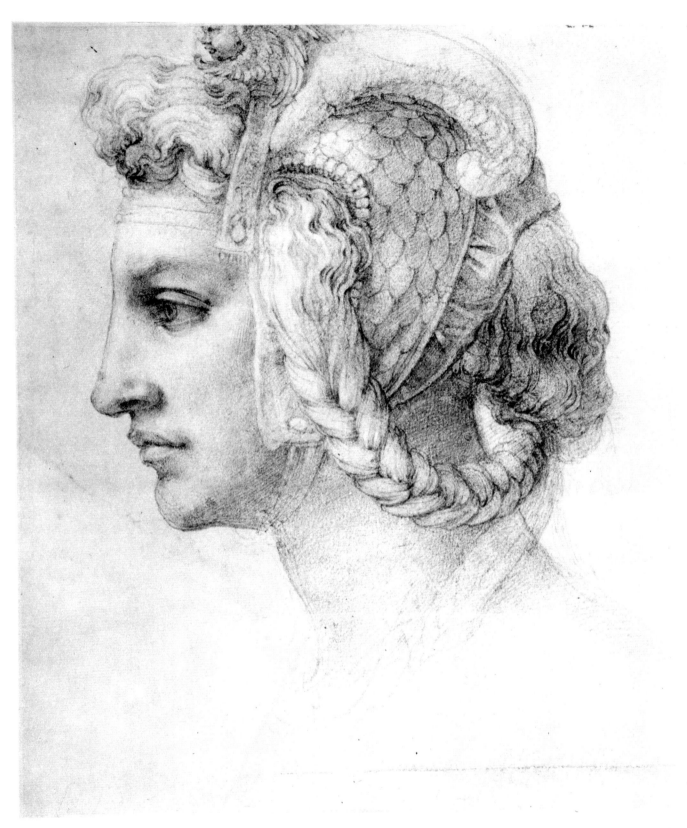

263

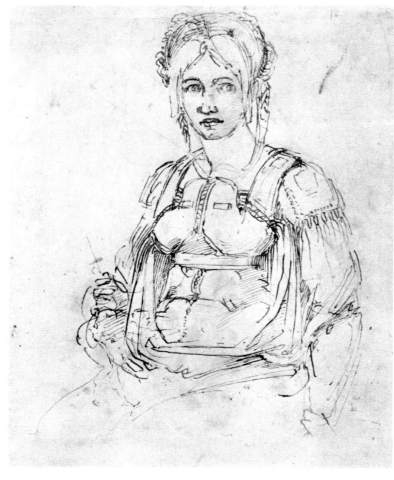

366

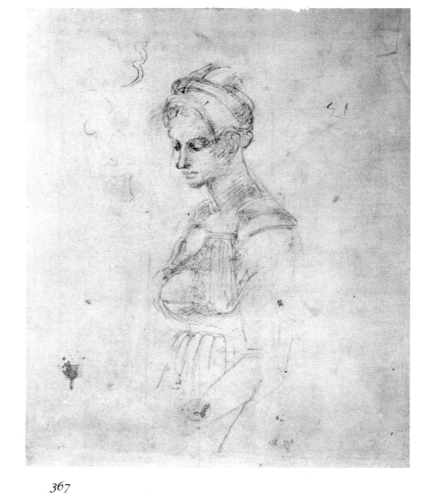

367

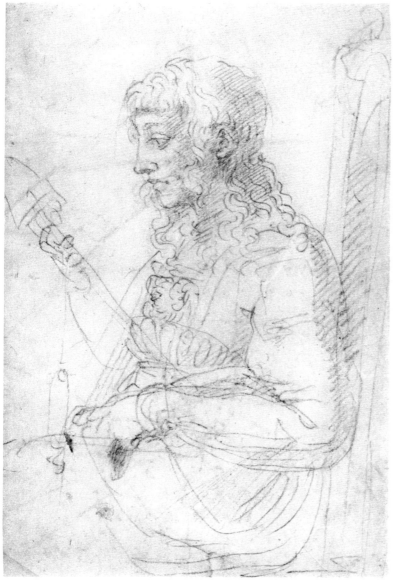

368

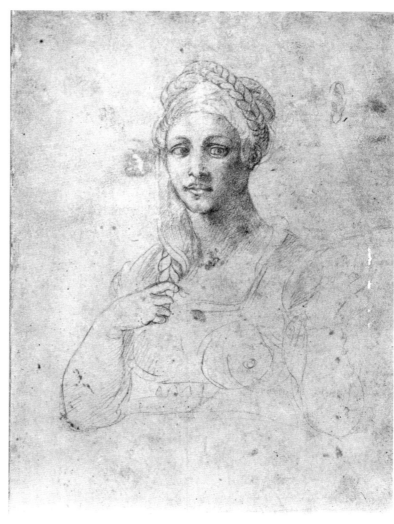

369

18

Drawings connected with the Last Judgment in the Sistine Chapel. Rome, 1534–35

The exact circumstances under which the commission for the *Last Judgment* was given to Michelangelo and the date when he began working on it are by no means clear. It has often been assumed that the meeting between Michelangelo and Pope Clement VII which took place on September 22, 1533, at San Miniato al Tedesco, in the Arno valley near Empoli, concerned the *Last Judgment*, and that this was also the major project mentioned by Sebastiano del Piombo in his letter of July 17 of the same year. But Agnello's letter of March 2, 1534, refers specifically to a *Resurrection*, for which the scaffolding had already been erected. Michelangelo's arrival in Rome on September 24, 1534, just two days before the Pope died, hardly looks as if there had been any decision for a change in the subject. The payment for the scaffolding was made on April 16, 1535, and not till April 10 of the following year was the wall completely ready for painting. It is suggested here that the order came not from Clement VII, who bore such terrible responsibility for the Sack of Rome, but from Paul III, the great Pope of the Counter Reformation, with whose ideas and program it has much more in common. The project, like so many others in Michelangelo's career, seems to have expanded in his hands. According to the earliest preserved composition drawing, No. 370, it was not originally to have covered the entire end wall, and would have left intact both Michelangelo's earlier lunettes, with the first seven generations of the Ancestry of Christ, and the altar fresco by Perugino. When the change in form and extent was made cannot be deduced from the drawings.

The great lapse of time between Michelangelo's arrival in Rome and the beginning of painting, over eighteen months, suggests that the preparatory drawings were all done before work began on the actual fresco. The entire cartoon must have been made in advance for this unified single work. Yet no space at the artist's command could easily have been large enough to draw so gigantic a cartoon. In all probability it was carried out in sections, according to a master plan or *modello*. Both the *modello* and the entire cartoon have perished. But we still possess a handful of drawings, out of the hundreds Michelangelo must have made during these eighteen months, and many of them rank among his most impressive graphic works. In keeping with the solemnity of the theme, they no longer present to us a beautiful humanity, but powerful figures transfixed with the awe of the event. They show a new kind of strength, transmitted less through direct action than through tension or even inner vibration, and in consequence the poses are often much subtler and the bodily movements more inhibited and compact than in the drawings for the Sistine Ceiling, made in a period which must in retrospect have seemed unrecapturable to Michelangelo and to his contemporaries. The contours tremble and multiply, the shapes pulsate. Generally the figures are headless; the heads were studied later, and often one suspects that Michelangelo invented them freely without preliminary study when he came to paint. Only the most general relationships of figures were probably decided at the stage of composition drawings. The elaborate construction, like those of all of Michelangelo's figural works, must have been worked out *after* the life studies had been finished and assembled.

370. *Sketch for the Last Judgment (portion of sheet)*
1534
Black chalk, 13½×11⅜″ (whole), rubbed and retouched (blank lower third not illustrated)
BAYONNE, MUSÉE BONNAT, 1217

Unanimously accepted as the earliest extant sketch for the *Last Judgment*, this drawing has nonetheless troubled several critics, possibly on account of its condition. The eyes and, here and there, the contours appear to have been reinforced by another hand. Michelangelo seems at first to have conceived the upper part of the composition as a circle in depth, around the central Christ. This would have been difficult to visualize at such a height above eye level. Moreover, it would have cut the upper section of the wall away from the rest. Possibly for these reasons Michelangelo carried it no further. Christ, pointing with His left hand to the wound in His right side, was at first drawn standing, then seated. The actual position in the fresco is a compromise, with the relation of the legs reversed. Only the raised right arm and lowered head are drawn substantially as they were later painted. The Apostles are shown in groups of six at either side, largely with their backs to the spectator. Mary, below Christ's right arm, intercedes for mankind. One figure has been faintly sketched at Christ's left, in a pose similar to that of St. Peter in the fresco. Other more or less shadowy figures of saints complete the circle. As throughout the series of studies for the *Last Judgement*, all the figures, including Christ and Mary, are nude, and Christ is in colossal scale.

371. *Sketch for the Last Judgment*
1534
Black chalk, 16½ × 11⅜″
FLORENCE, CASA BUONARROTI, 65 F recto
(for verso see No. 349)

On the recto of a sheet whose verso had already been utilized for the magnificent *Resurrection* sketch, apparently in fulfillment of an earlier project for the end wall of the Sistine Chapel, Michelangelo drew this superb and never-questioned composition sketch intended, however, for only a portion of the present extent of the fresco. The frame of Perugino's altar fresco of the *Assumption of the Virgin,* which must have been a dreadful stumbling block for Michelangelo, can be clearly seen at the bottom of the present drawing. He utilized it, nonetheless, as a perch from which angels could drive the damned pell-mell down to perdition. At the top the composition fades off in such a way as to make quite clear that he had as yet no mandate to remove his own earlier lunettes belonging to the Ceiling. While the proportions of Christ are approximately those of the figure as finally painted, the narrow shape of the composition shows that it could not have gone from wall to wall. But already Michelangelo has started to open up his scheme. The circle in depth is dissolved, in favor of an ascending motion of the dead toward Judgment (the circle will be reinstated on a vaster plan in the fresco). The Virgin still precipitates herself before Christ's throne, among Apostles and probably martyrs and prophets as well. Countless others, still unformed, surge through the background. Saints Lawrence and Bartholomew, necessary in accordance with the original dedication of the Chapel, have not as yet made their appearance; the trumpet-blowing angels appear below the Judge. The storm of figures gives a somewhat deceptive foretaste of Rubens; once Michelangelo painted them in Renaissance style they would not have looked like that. Christ appears almost exactly as in the fresco, save for His left hand, whose gentle gesture of blessing has not yet occurred to the artist (or to the patron?). Many of the figures reappear almost unchanged in the fresco; for example, the figure rising toward Heaven halfway up on the extreme left, arms above head, who occupies a similar position somewhat lower down on the wall, or the crouching figure at the lower left corner, utilized in the final composition as St. Sebastian. Here and there a very insensitive later hand has picked out and ruined Michelangelo's contours by hard strokes of the pen.

372. *Christ and the martyrs*
1534
Black chalk, 7⅝ × 11¼″, badly rubbed and spotted
FLORENCE, UFFIZI, 170 S

Questioned by three scholars, two of whom later accepted it, this sketch preserves somewhat dimly a later stage than No. 371. The Virgin approaches Christ more closely (she will eventually reverse her position and shrink into His side, to assume His function of mercy), and several of the martyrs holding crosses or other instruments of martyrdom appear in much the same positions they will later occupy. The touching embrace of those reunited in Paradise, so intense a motive in the fresco, already appears at the upper right.

373. *Sketch for martyrs*
1534
Black chalk, 6½ × 8⅞″
BAYONNE, MUSÉE BONNAT, 681 recto

More poses take shape in this uncontested sketch. The so-called Good Thief (St. Dismas) at Christ's right is clearly recognizable, with his back to us, holding a cross. He has changed places in the fresco with St. John the Baptist, who in this drawing leans forward somewhat more than in the painting, and Simon Zelotes, crouching below the Baptist here, is transferred to the other side of the fresco, below St. Peter. The contours are now firmer and the masses more solid than in the preceding relatively fluid sketches.

374. *Sketches for the Last Judgment*
1534
Black chalk, 15¼ × 10″, cut down at left
LONDON, BRITISH MUSEUM, W. 60 recto
(for verso see No. 375)

Unchallenged, save for some doubts concerning the marginal figures on the part of two scholars, this sheet is so crowded with figures that one writer has been able to discern five distinct layers of drawings. Certainly there are at least two. The first, loosely sketched, comprises the large, shadowy, seated figure toward the bottom, resembling in pose the nude at right above *Joel* on the Ceiling and (mirror image) St. Lawrence in the *Last Judgment* fresco, and (upside down) the equally vague seated-floating figure who may be a source for one of the blessed. Then come the three superimposed, densely packed, carefully drawn and hatched groups, of which the uppermost appears, with modifications, in the form of the group above Christ to the right, approaching from a distant quarter of Heaven. The next is the group of martyrs, with St. Sebastian, St. Catherine, St. Simon Zelotes, and St. Andrew (?) clearly recognizable as in the fresco, but in a different order. The lowest group comprises the angels driving the damned down to Hell, taken from No. 371 but shown much more imaginatively, the damned often from the back or even upside down, the flailing angels seen foreshortened from above to underscore their downward glances and beating arms, all much as in the fresco. The marginal sketches include single figures and groups, close to the fresco, and some large studies of heads, shoulders, and arms similar in style to No. 379.

375. *Sketches and two studies of a head for the Last Judgment*
1534
Black chalk, one figure in red chalk;
for dimensions, see No. 374
LONDON, BRITISH MUSEUM, W. 60 verso
(for recto see No. 374)

Some of the figure sketches were traced from the recto, against the light. The two sensitively studied views of the same rather middle-aged head are not followed exactly anywhere in the fresco, but the closest is that of the saint holding a cross at the extreme right of the group of martyrs. Some of the floating quality of the *chiaroscuro* in the Cavalieri drawings still pervades this head.

376. *Sketches for the dead rising*
1534
Black chalk, 11 × 16½″, patched at lower edge
WINDSOR, ROYAL LIBRARY, 12776 recto (for verso see No. 388)

Doubted only once, by a scholar who has since recanted, this magnificent drawing resounds with all the terror of the *Dies Irae*. The sheet has already become, in Michelangelo's mind, not just a piece of paper on which he can study the relationship of figures and groups of figures, but a vision of the end of all things, of the earth and sea giving up their dead. The figures and groups have already begun to compose themselves in his mind in somewhat the same order they will assume in the more compact fresco. Apparently the whole spectacle of opening graves and corpses crawling forth into the light was drawn rapidly. Most of the figures sketched here appear in the lower left-hand corner of the fresco. Then the crucial and extremely difficult groups formed by two souls, one right side up, the other upside down, the subjects of a struggle between angels and demons, are studied separately at the right, the former twice, the latter five times. The increase in the scale of the figures at the expense of the surrounding space, between composition sketch and final work, is characteristic of Michelangelo's working procedure throughout his life.

377. *Sketch for St. Lawrence (portion of sheet)*
1534
Black chalk, 11 × 8½″ (whole)
ROME, VATICAN LIBRARY, Cod. Vat. 3211, fol. 88 verso (for recto see No. 394)

This tiny sketch on a sheet partly covered by lines of verse written later, shows St. Lawrence holding his gridiron, done with a few rapid strokes of the soft black chalk, in a pose somewhat related to that adopted for St. Simon Zelotes holding his saw.

378. *Sketches for an angel*
1534–35
Black chalk, 15¾ × 10⅝″, cut down
LONDON, BRITISH MUSEUM, W. 61 verso (for recto see No. 379)

This magnificent drawing and its verso, No. 379 (and a closely related drawing, No. 380), for a neighboring angelic figure in the lunettes of the *Last Judgment,* have been unjustly rejected as copies by five of the twelve scholars who have mentioned them. No undoubted copy of such quality has ever been produced. In fact no copyist could ever draw lines of such sureness and power. The very process of copying rules that out. The *pentimenti,* the hatching, the crosshatching, the occasional bits of modeling, can all be matched innumerable times in Michelangelo's work. What is unusual is the surface quality, and that is explained by the unexampled hardness of the instrument. Substitute for any one of these smooth, hard lines the gritty ones produced by the customary soft black chalk and there is no difficulty. Experiments with circular contours and circular hatching are to be found in many of the *Last Judgment* studies. Michelangelo has here studied several different possibilities for the angel flying downward toward us in the right lunette, above the column. This angel appears also, reversed, holding the Crown of Thorns in the left lunette. Then, below, he has sketched in

mirror image the raised arm of a figure just below this cloud-borne vision. The knees, turning the sheet one quarter clockwise, belong to one of the martyrs at the upper right.

379. *Studies for an angel and for the damned*
1534–35
For medium and dimensions, see No. 378
LONDON, BRITISH MUSEUM, W. 61 recto (for verso see No. 378)

Another superb drawing, which has shared the critical fate of its verso. Quality alone should have prevented this. A muscular model of great strength has been studied in a prone position, yet not recumbent; he must have been forced to hold the pose while balanced on a very limited portion of his body, as the muscles are, for the most part, taut. The figure was used almost exactly in the right lunette, above the Column, and again from a slightly different point of view and reversed for the angel holding the Crown of Thorns. The accompanying sketches are also of the utmost brilliance. At the upper left, in a manner strikingly reminiscent of the marginal study accompanying the *Libyan Sibyl* (No. 88), Michelangelo has analyzed what appears to be the torso of the seated figure at the upper right among the martyrs, defined more exactly in No. 387 but still without the left arm. The arm at upper right is that of the same flying angel, but the forearm was used again for one of the damned piling out of Charon's bark. The strange figure clutching his arms about himself appears nowhere in the fresco, but may have suggested another of the damned being beaten by Charon's oar.

380. *Study for one of the dead rising*
1534–35
Black chalk, 8½ × 10½″
OXFORD, ASHMOLEAN MUSEUM, P. 330 recto (for verso see No. 381)

Another perplexing example of critical caprice. This drawing, displaying a command of the human figure worthy only of the very greatest master, and showing the touch and the working methods of Michelangelo in every stroke, has been even quite recently rejected by several scholars; it is impossible to understand why. All the freshness of Michelangelo's own invention runs through the free circular flow of the contours and the dazzling foreshortening of torso and thigh. The right arm and shoulder have been studied in great detail from life. One might as soon reject the painting for which Michelangelo utilized the drawing—the figure crawling from his grave at the extreme lower left of the fresco.

381. *Study for one of the damned*
1534–35
For medium and dimensions, see No. 380
OXFORD, ASHMOLEAN MUSEUM, P. 330 verso (for recto see No. 380)

The style and technique of this drawing bring it so close to the study on the recto as to make it probable that it was intended for one of the sharply foreshortened figures of the damned hurtling downward toward the lower right of the fresco. It was not utilized, however. The old hypothesis that the drawing was done after one of Michelangelo's own models for the river gods of the Medici Chapel has no basis in fact.

382. *Sketches for the right arm of Christ and the leg of a martyr*
1534–35
Black chalk, 9½ × 5¾″
OXFORD, ASHMOLEAN MUSEUM, P. 329 recto
(for verso see No. 71)

Only two critics have rejected this powerful and thoroughly characteristic sketch, exhibiting the blocky massiveness of Michelangelo's contours at their most powerful. It is surprising, therefore, that it has not till now been connected with the damning right arm of Christ, first studied half extended as in Nos. 371 and 372, then sharply contracted, with the conformation of elbow joint, biceps, and triceps very close to the mighty arm as actually painted. The thigh, but not the lower leg, was utilized for the first of the group of martyrs seated at the extreme right.

383. *Study for St. Lawrence*
1534–35
Black chalk, 9½ × 7¼″, cut down, spotted
HAARLEM, TEYLERSMUSEUM, A 23 recto
(for verso see No. 406)

Luckily this splendid study has been doubted only once. Interestingly enough, the tension and surface sheen of the musculature are inseparable from the treatment of No. 380, for one of the dead rising, which has been contested again and again. The study shows St. Lawrence in almost exactly his definitive position, only the direction and length of the lower leg having been slightly altered. The head, separately studied below, done from a balding model, was made much gentler and finer in the painting. The soft hatching of the head has remained unaltered, but the artist has both modeled and reinforced key passages of modeling and contour in the torso, left arm, and thigh.

384. *Study for St. Bartholomew*
1534–35
Black chalk, 15⅝ × 10″, cut down, wrinkled, spotted
HAARLEM, TEYLERSMUSEUM, A 19 verso
(for recto see No. 43)

Although seldom rejected, this remarkable study has never been correctly identified. The latest doubter lists it as a "youthful nude," in spite of the loose skin, knobby knees, and sagging flesh of a man of at least fifty. The drawing has also been identified with the *Victory* of the Palazzo Vecchio, with which it has only a bent knee in common. The drawing differs from the soft style of No. 383 only in the slightly higher degree of surface finish. The rich, reinforced contours and underlying hatching are identical in both. Michelangelo was faced with an extremely difficult problem—a colossal flayed figure kneeling on a cloud below the throne of Christ. From all existing evidence, this was an afterthought on the part of the patron. Neither St. Lawrence nor St. Bartholomew appears in any of the composition sketches. This delicate exploratory study of the aging saint leaning toward Christ does not seem to have satisfied the artist, who redrew the left leg in a slightly different position at the lower right. Then he studied the same leg from an inside view, at the lower left, in precisely the position adopted in the fresco. This involved automatically a change in the entire pose of the torso, which was taken up again in No. 385. While the rather flabby physical type was abandoned, perhaps as unsuitable to the monumentality of the fresco, the striking

pose of the left knee was not. It reappears twice, in mirror image, in figures of martyrs to the right of St. Bartholomew. The persistent misdating of the studies may derive from the fact that they were done on the verso of a splendid drawing made for the *Battle of Cascina* perhaps thirty years before (or, as is here suggested, early in 1506).

385. *Sketch for St. Bartholomew*
1534–35
Black chalk, 13½ × 10⅜″, rubbed
LONDON, BRITISH MUSEUM, W. 62 recto
(for verso see No. 386)

This faint sketch has been correctly identified as St. Bartholomew on account of the object, presumably a knife, he holds in his right hand. The head has now been lifted as in the fresco (judging from the position of the neck muscles) to look upward at Christ. The left knee is posed as in the final study of No. 383. Michelangelo still has not thought of the ghastly gesture in which the saint extends in his left hand his own skin, containing the artist's self-portrait. The free contours and fluid anatomy, so close to the great *Resurrection* drawings for the same wall (Nos. 347–49), suggest that this sheet, with its restudied arm and flank, was done from imagination. The drawing and its verso were until recently never assailed. We now read with astonishment that "one can have no doubt that only a workshop assistant can come in question for these works." What an assistant! One would have to assume that this helper went so far as to imagine Michelangelo's poses for him.

386. *Sketch for a martyr*
1534–35
For medium and dimensions, see No. 385
LONDON, BRITISH MUSEUM, W. 62 verso
(for recto see No. 385)

The brilliantly studied contours of a torso twisting backward were not, as has been recently stated, done for St. Bartholomew but for the martyr holding a cross (who cannot be securely identified) at the extreme right of the fresco. This figure, as we have seen, absorbed in reverse the left knee originally drawn for St. Bartholomew. It is the kind of expert analysis of figure structure one finds reappearing again and again in Michelangelo's drawings, for the Sistine Ceiling as well as for some of the sculpture. The little head, upside down, is a momentary caprice, but may have been useful in planning some of the sharply foreshortened heads in the fresco.

387. *Studies for the Last Judgment*
1534–35
Black chalk, 15⅝ × 11″, folded, cracked, patched, spotted
FLORENCE, CASA BUONARROTI, 69 F verso
(for recto see No. 453)

This drawing, formerly rejected by a number of scholars, has been reinstated by all, including one of its former detractors. The right arm at the upper left was studied from life for the figure directly to the left of St. John the Baptist, and followed almost exactly in the fresco. The torso directly beside it was done, also probably from life, for the seated figure above St. Blaise. The model's left arm was apparently moved from one side to the other so that the relation of masses

in the torso could be worked out. The upper knee cannot easily be identified, but the lower one is clearly for the figure to the left of this one. The beautiful head may be a preliminary idea for one of these saints, but apparently was not used. The figure running away has been connected with the Pauline Chapel. Much more likely, it was a preliminary sketch for one of the damned seen from the rear in the lower portion of the *Last Judgment*, at the right, perhaps the one shown sailing along on his right side.

388. *Studies and sketches for the Last Judgment*
1534–35
Black chalk, 11 × 16½", patched at lower edge
WINDSOR, ROYAL LIBRARY, 12776 verso
(for recto see No. 376)

Although this magnificent drawing never previously excited the faintest suspicion, it was attacked twenty-five years ago as "a feeble copy . . . executed after the fresco." Fortunately the author of these words has since retracted them. The principal study, a work of immense power, is a detailed analysis of the effect of great tension on the leg muscles, for the figure of one of the risen, supported by an angel under the arms and tugged downward by a demon, by means of a rope tied around his ankles. Again, one pities the model. The study was used exactly for the figure as painted, but much of the effect is lost through the addition of a bit of drapery later in the sixteenth century. His hanging hand is studied toward the right, and directly above it the hand of the demon pulling. At the lower left-hand corner the left arm of his upside-down neighbor, similarly pulled apart by a devil and an angel, is carefully studied, again from life. The lightly contoured figure on its side appears to be for the bearded monk at the extreme left corner of the fresco. The walking figure, upside down, has not been identified. The legs and arms have been strongly contoured, hatched in portions, and here and there crosshatched.

389. *Study for a kneeling figure*
1534–35
Black chalk, 10¼ × 6¼", spotted and relined
FLORENCE, CASA BUONARROTI, 54 F

This very powerful study has been doubted by three scholars, without reason as far as can be seen from its style. The drawing, in soft, broad black chalk, showing the circular hatching so frequently to be met with in studies for the *Last Judgment*, is fairly close to the kneeling demon in Hell Mouth directly above the altar—closer, let us say, than No. 385 is to St. Bartholomew.

390. *Study for one of the dead rising*
1534–35
Black chalk, 11½ × 9¼", cut down
LONDON, BRITISH MUSEUM, W. 63 recto
(for verso see No. 391)

This life study, of the utmost brilliance—hatched, crosshatched, and here and there beautifully modeled—has been rejected by several scholars including the same ones who accepted No. 383, in approximately the same style but worse condition. Again, quality alone would establish this as the work of a great master. And the free, firm contours, with many *pentimenti*, especially in the left wrist and the abdomen

and light indications of the right flank, show that it cannot be a copy. The drawing, inseparable in style from its verso and from No. 380, was made for a conspicuous figure at the lower left, pulling himself out of his grave backward. This figure sprang from Michelangelo's imagination almost exactly as it appears here and in the fresco, for it can be seen in his sketch for the whole lower left-hand group.

391. *Study for one of the dead rising*
1534–35
For medium and dimensions, see No. 390
LONDON, BRITISH MUSEUM, W. 63 verso
(for recto see No. 390)

Identical in style with the recto, this is apparently an alternative study, never utilized, for the same figure, which it would have weakened. The outstretched arm corresponds to quite a number of such elements throughout the fresco.

392. *Sketch for an arm*
1534–35
Black chalk and pen over stylus preparations, 6¼ × 5⅜"
LONDON, BRITISH MUSEUM, W. 49

Often doubted, this powerful sketch radiates the power of Michelangelo's linear style at its fiercest. One of the few scholars to accept the drawing connects it with the *Night*, neither of whose arms was ever in this position or anything like it. The blocky conception of mass is that of the *Last Judgment*, even though this is the only pen sketch preserved. It corresponds fairly closely, but in reverse, to the right arm of the figure looking up in the lowest zone, among the dead rising. The paleness of the chalk suggests that the sketch was used for counterproof, which would explain the difference in direction. The pen lines are tremendous.

393. *Study for a demon*
1534–35
Black chalk, three fragments: 6½ × 7½"; 5¼ × 4⅝"; 3 × 3¼"
HAARLEM, TEYLERSMUSEUM, A 35 recto
(for verso see No. 457)

Three scholars have questioned this powerful group of arm and shoulder studies. Curiously, they have been accepted by the same writer who rejected the group of studies for the right arm of Christ, No. 382, from whose style these are indistinguishable. They appear to be preliminary studies for the demon carrying a soul, floating above Charon's bark, considerably different in the final fresco. The blocky contours and frequent circular hatching are characteristic of Michelangelo's figure style in the *Last Judgment* series. The often noted relation to Signorelli's *Last Judgment* frescoes in Orvieto Cathedral goes little beyond the similarity of theme.

394. *Right knee*
1534–35
Black chalk, 11 × 8½"
ROME, VATICAN LIBRARY, Cod. Vat. 3211, fol. 88 recto
(for verso see No. 377)

A powerful and never contested sketch, translating into block masses the bones and tendons of the knee joint; probably, though not certainly, for St. Lawrence.

395. *Left leg*
1534–35
Black chalk, 11×8″
ROME, VATICAN LIBRARY, Cod. Vat. 3211, fol. 93 verso

Again, a very fine and unchallenged study, apparently from life, strikingly close in treatment to several of the hatched and modeled studies which have not fared so well at the hands of critics. This study corresponds very closely to the left leg of Christ, but must have been used for other figures as well.

396. *Study for the head of Christ(?)*
1534–35
Red chalk, 5×5⅝″
FLORENCE, CASA BUONARROTI, 47 F

This noble head has never been seriously questioned, but its date is far from certain. The generally accepted connection with the period of the Sistine Ceiling seems far too early for the loose and free crosshatching and the blunt and blocky contours. Although this would be the only red chalk study connected in any way with the *Last Judgment*, it seems not impossible that it was done for that work. Michelangelo often used several media during the execution of studies for a single major work. The great, though reserved, depth of feeling in the head, as well as its posture and lighting, immediately suggests the head of Christ, although this cannot

be proven in the present state of the fresco, severely altered at this point. What can be stated is that the strongly Hellenized proportions and shapes of the features in this and the following drawing, with their broad, low foreheads, heavy eyelids, straight noses, firm mouths, and square chins, do not appear in any head in the entire Sistine Ceiling. Neither does the expression, a haunting blend of gravity and compassion, which can be found again and again in the unrepainted heads of the angelic executants of Divine Judgment. Also, the tendency to detach the contour as a free shape in itself, irrelevant to the forms described within it, can be seen throughout these wonderful heads, painted with broad, rhythmic strokes of the brush.

397. *Study for a head*
1534–35
Black chalk, 9⅜×8″
OXFORD, ASHMOLEAN MUSEUM, P. 337 recto
(for verso see No. 289)

Only once questioned, this Olympian head is drawn in the same soft, pale, rather gritty chalk as the sketch for St. Bartholomew, No. 385. It shows proportions and expression very similar to those of No. 396, with a similar knitting of the brows and axial center line. Possibly this was a preliminary sketch from a model as a type for the angel heads, which were eventually painted very freely, without any further reference to reality.

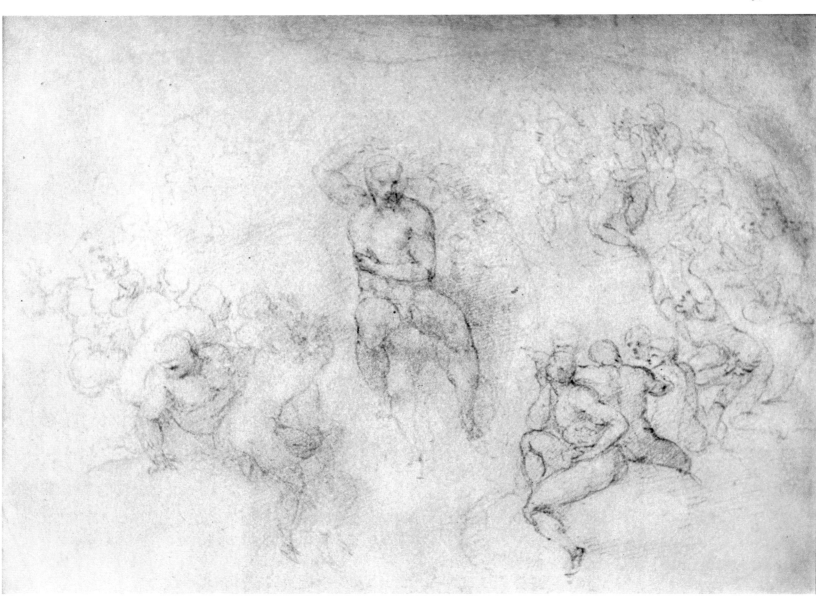

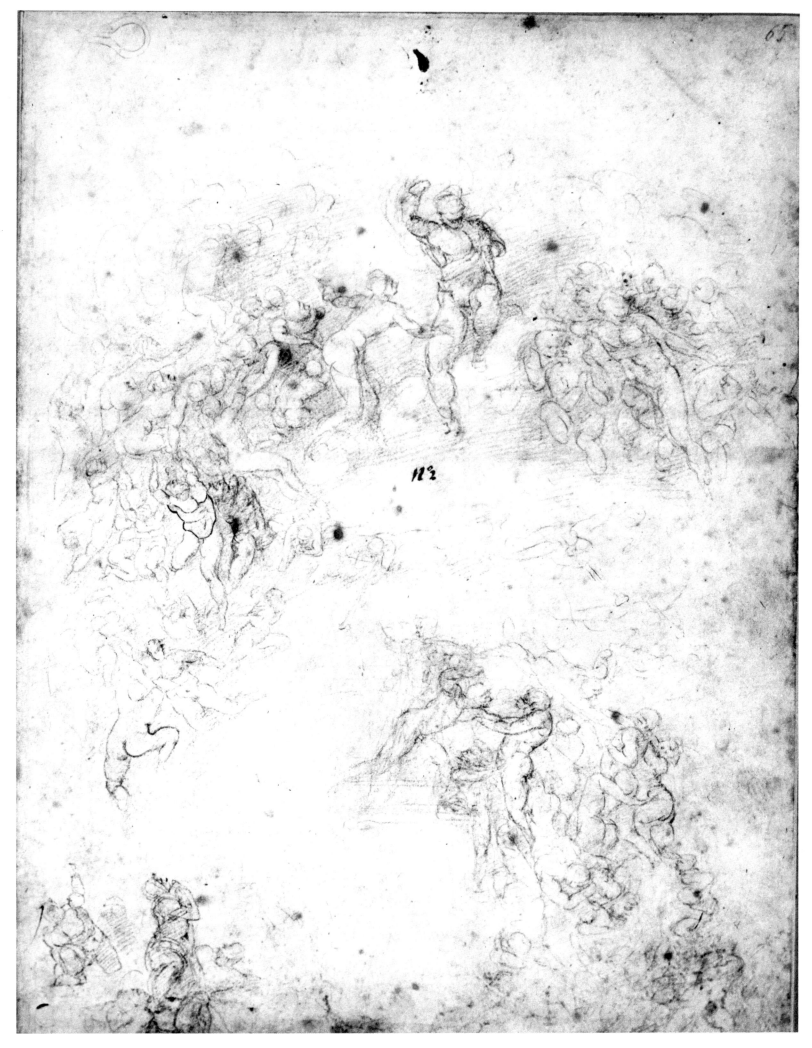

371

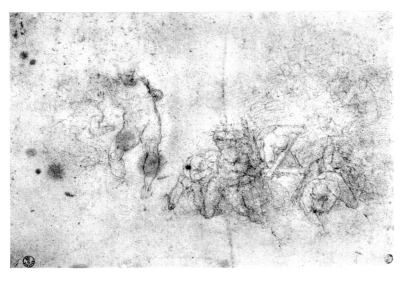

372

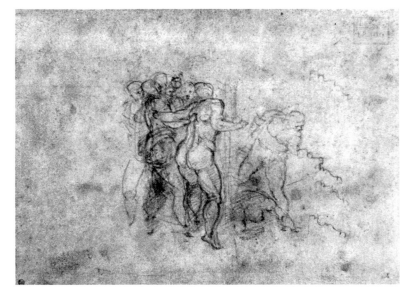

373

374

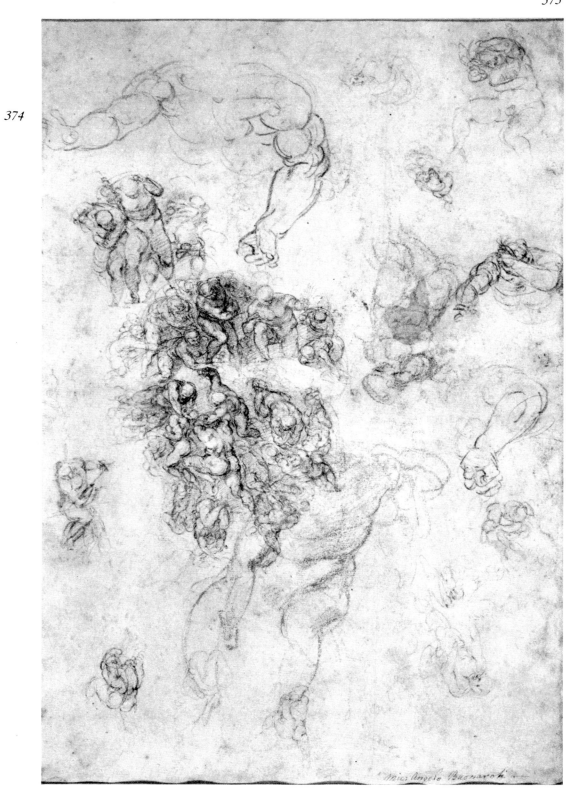

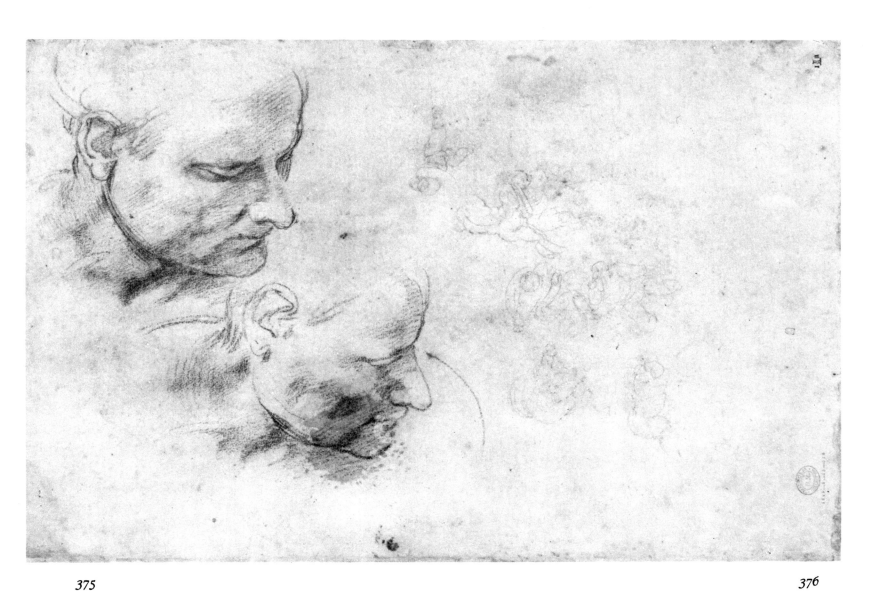

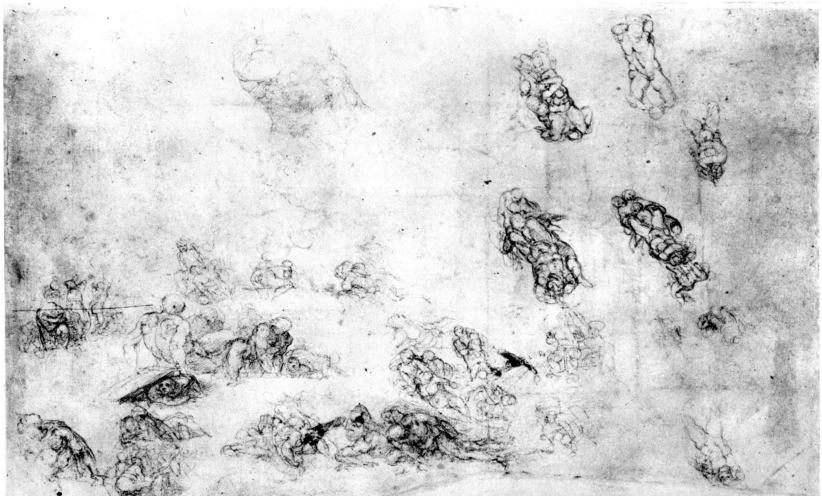

375

376

377

378 380▶

379

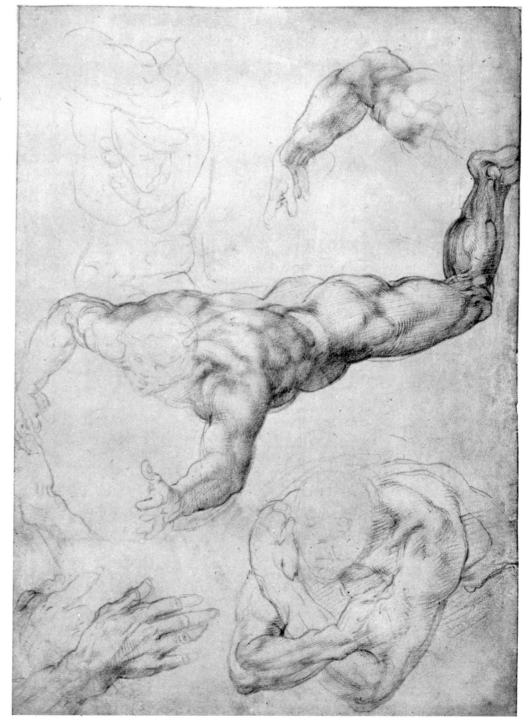

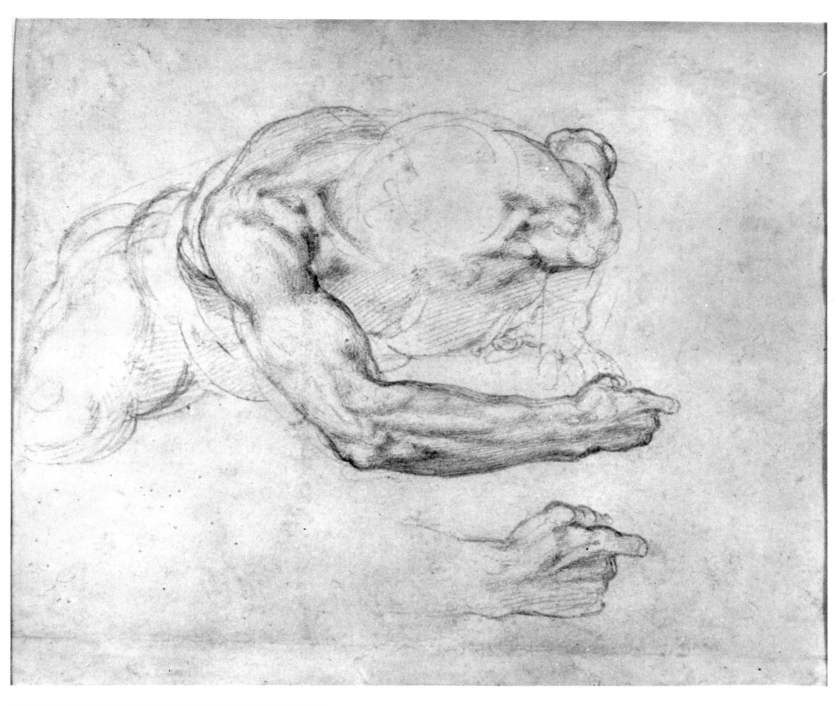

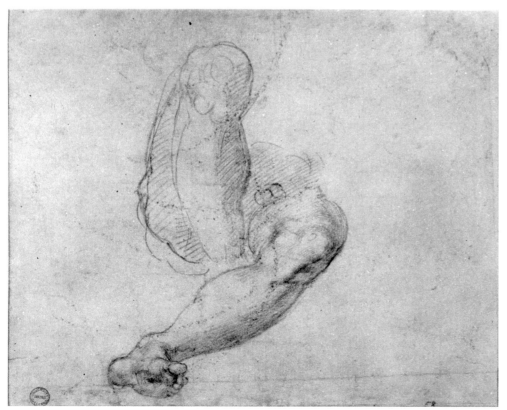

381

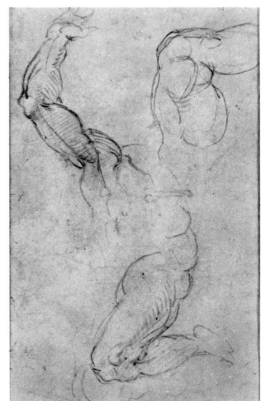

382

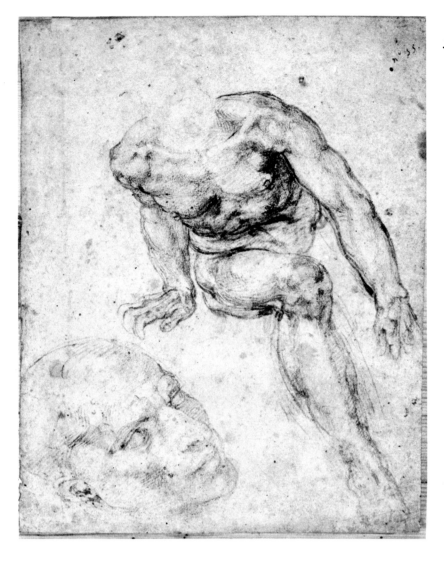

383

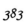

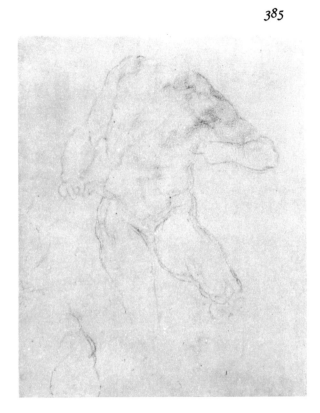

385

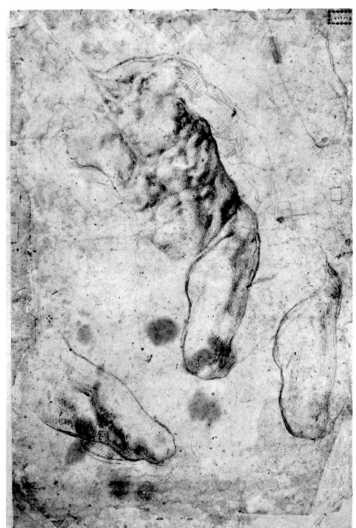

384

386

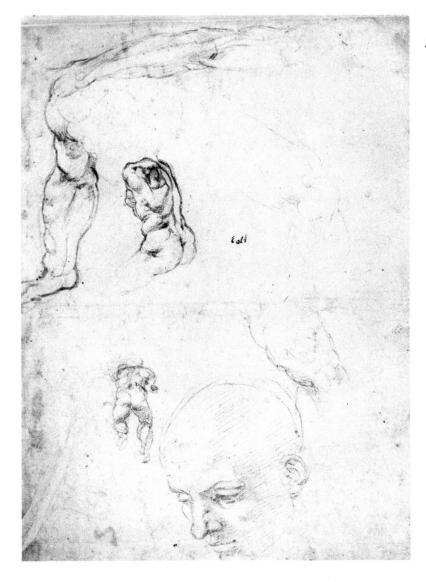

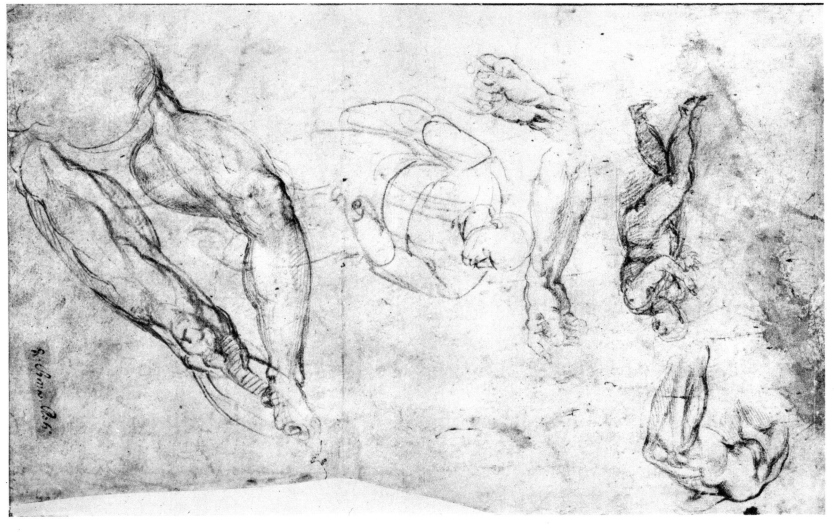

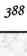

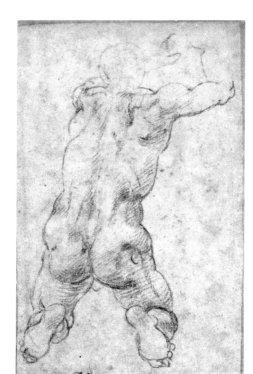

389

391 ▶

390

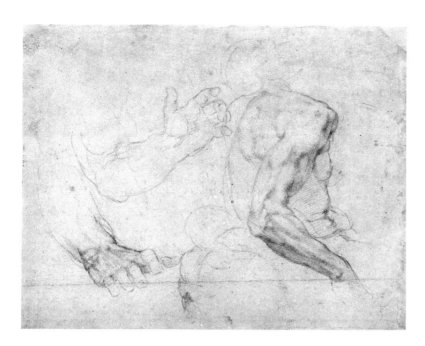

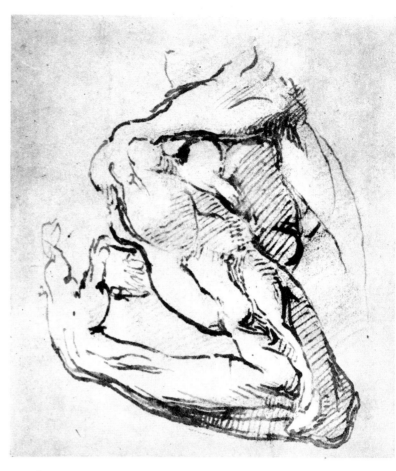

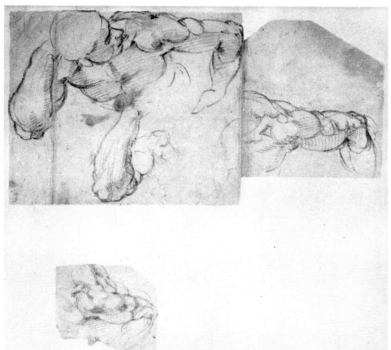

392

395

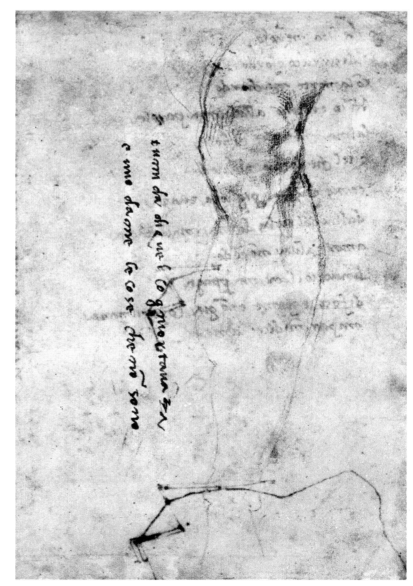

393

394

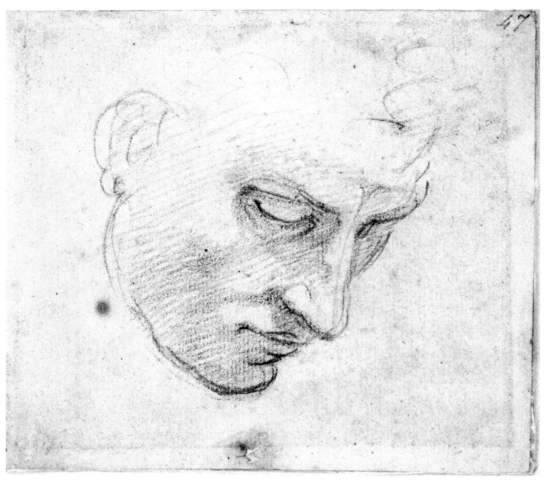

396

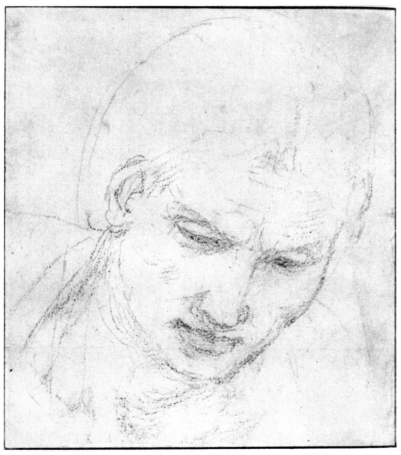

397

19

Drawings connected with the Pauline Chapel. Rome, 1541–50

So few studies of any sort for the frescoes of the Pauline Chapel remain that one can only assume Michelangelo destroyed the others himself. One precious cartoon fragment is preserved, however, the only cartoon left to us for any work actually painted by Michelangelo. There is a great deal to learn about his late style from the technique of this extensive section. Unfortunately not one of the other studies can be connected indisputably with the Pauline frescoes, but there seems to be no other explanation for them, especially since, at his advanced age and with his many infirmities, Michelangelo did not entertain many other possible commissions. Two life studies appear to have been made for the *Last Judgment* and reutilized ten years or so later in the Pauline Chapel. Although this cannot be exactly proved, it is probable that Michelangelo painted the *Conversion of St. Paul* first, and designed the *Crucifixion of St. Peter* only after 1545.

398. *Sketch for the Conversion of St. Paul; fortifications*
1541–42
Black chalk, red chalk, pen, 11⅛×10¾″,
irregularly cut down and remounted
FLORENCE, UFFIZI, 14412 F verso (for recto see No. 399)

This brilliant sketch, doubted by only two critics, has been dated at various points in Michelangelo's career, beginning with the *Battle of Cascina*. The combination of extreme fluidity and decisive power suggests a late period in Michelangelo's career, and the view of the horse from the rear can be connected in his known works only with the *Conversion of St. Paul*. Two possibilities arise: Michelangelo could have planned several horsemen for the background, or he might originally have thought of showing St. Paul at the moment when he was struck from his horse. The latter solution seems preferable. Such a formulation would then have been abandoned when Michelangelo decided (or was asked) to paint Paul, patron saint of his patron, falling in the foreground and aged, though he was young at the time of the incident. But this is pure speculation. The character of the drawing is not. It shows three figures in a moment of great dramatic violence, involving a probable fall from a horse, and the horse is drawn in the same view as the wild creature careening into space in the center of the fresco. The free, bold contours already multiply to such an extent as to compete with the hatching. In Michelangelo's latest drawings the multiple contours and

the hatching will fuse. The sketches for fortifications have been connected with those on whose construction Michelangelo was asked to advise the Pope in 1545.

399. *Sketches for the Crucifixion of St. Peter; fortifications*
1545
For medium and dimensions, see No. 398
FLORENCE, UFFIZI, 14412 F recto (for verso see No. 398)

A probable connection with the *Crucifixion of St. Peter* is provided by the halberds sketched here, the only such weapons in the whole graphic production of Michelangelo. There seems little reason for the artist to have drawn these things beyond their appearance in this fresco, and in fact the halberd silhouetted against the sky just left of center bears a considerable resemblance to the weapon shown here. The fearful shape of the two-pronged halberd appears to have fascinated Michelangelo temporarily, but he resisted the temptation to paint it. The tragic, terrible head so splendidly drawn at the extreme left is quite close to, though not identical with, that of the helmeted soldier at the right, lifting the arm of St. Peter's cross into position. The immense power of the broad, heavy contours and block masses, so close to the style of the heads in the actual fresco, and the profound inner anguish of the personality render incomprehensible the recent characterization of this face as "too soft and detailed . . . sentimental and prettified" for Michelangelo. The fragments of writing have been identified as belonging to a draft of one of the master's late sonnets.

400. *Sketches of soldiers for the Crucifixion of St. Peter*
1545
Black chalk, 6×4⅛″, torn and patched at lower edge
OXFORD, ASHMOLEAN MUSEUM, P. 331

This vivid drawing, always considered as variant preliminary figure sketches for the two soldiers at the left ascending the rock-cut steps in the *Crucifixion of St. Peter*, has been attacked only in the usual quarters—twice rejected, once ignored. The style, with broad, flowing contours and inner lines that tend to fuse with the hatching, is in many places very close to the figure on horseback in No. 398, in others identical to passages in the arms and shoulders of No. 401. There can be no reason to doubt the traditional explanation for these sketches, and in fact no reasonable counterproposal has been put forward.

401. *Sketches for the Crucifixion of St. Peter*
1545
Black chalk, 10×6⅜″
OXFORD, ASHMOLEAN MUSEUM, P. 341 recto
(for verso see No. 411)

Although once irresponsibly given to Antonio Mini, who left Michelangelo's employ in 1531, this drawing has been recognized by all other critics as a splendid work by the master, and dated in the later phase of Michelangelo's career by all recent scholars, including the writer who rejected No. 400 from which this study is inseparable. The tremulous strokes of the aging hand give a similar surface to the arms in both. At one time the drawing was thought early, on account of a suggestion of the left arm of the early *David*. In all probability it should be considered a preliminary model study for the soldier bearing the spectacular halberd, just left of center, made more compact in the fresco. The left knee and suggestion of a right thigh correspond almost exactly to the legs of the figure at the right, directly under the lower portion of the cross. The knee was used again for the giant in the Phrygian cap at the lower right. His right knee was drawn exactly among the anatomical studies for a Crucifixion on the verso.

402. *Sketch of right arm and shoulder*
1545
Black chalk, 8¼×6¼″, rubbed and faded
FLORENCE, UFFIZI, 18734 F recto (for verso see No. 403)

Only once has this characteristic late drawing been doubted. Its condition may be due to use as a counterproof. The drawing corresponds, in reverse, to the gesture of the left arm of the inquisitive spear bearer toward the upper left of the *Crucifixion of St. Peter*. The position may have been altered to its present lines on the new sheet. The arm as actually painted is startlingly close to the left arm of the *Moses*, and in 1545, when Michelangelo probably began work on this fresco, he had just set in place on the Tomb of Julius II the great statue, which had required some finishing.

403. *Sketch of left forearm*
1545
For medium and dimensions, see No. 402
FLORENCE, UFFIZI, 18734 F verso (for recto see No. 402)

Not possible to pin down to a specific use; this arm study might have been a preparation for several of the arms in the *Crucifixion of St. Peter*.

404. *Sketch of hips and thigh*
1545
Black chalk, 12⅞×7¾″, badly spotted
FLORENCE, UFFIZI, 18735 F

This rough, uncontested sketch has been connected with a figure in the *Deluge*, which it certainly resembles, but the style is much later. Possibly this was a tentative idea for one of the soldiers seen from the rear in the *Crucifixion of St. Peter*.

405. *Figure digging a hole*
1534 and 1545
Black chalk, 5½×7⅛″
LONDON, BRITISH MUSEUM, W. 70 recto
(for verso see No. 537)

Since the drawing was long ago shown to have been made for the angel drawing souls up into Paradise at the extreme left of the *Last Judgment*, next to the cornice, and more recently to have been redrawn so that it could be used again for the soldier digging a hole for St. Peter's cross, one would imagine that the problem was settled. Old doubts have been raised again, on the grounds that the folds of cloth across the shoulders demonstrate that the author of the drawing had prior knowledge of the Pauline fresco. This objection is untenable, on three counts. The folds in the drawing might more properly be considered preparations for the fresco. Second, the folds in the fresco differ considerably, so the drawing cannot be a copy. Third, the objection leaves unexplained the approximate correspondence of the original image with the angel in the *Last Judgment*, the redrawing to fit the new purpose of the figure, and its reversal, again doubtless by means of a counterproof, in the fresco.

406. *Nude seen from the rear*
1534 and 1545(?)
Black chalk, 9½×7¼″, cut down, spotted
HAARLEM, TEYLERSMUSEUM, A 23 verso
(for recto see No. 383)

This handsome study, doubted only once, forty years ago, in a sweeping and ill-fated condemnation of most of the Haarlem drawings, shows the rugged figure style of the *Last Judgment*, for which it may originally have been done. The figure could have been used for almost any number of floating, soaring, crouching, rear-view nudes in the enormous composition. But it was clearly used again for the executioner to the left of St. Peter, although that hardly makes the drawing, as its only detractor contended, a copy after Michelangelo's fresco. Else how could we account for the beautiful drawing of the right leg, completely hidden in the painting?

407. *Cartoon fragment for the Crucifixion of St. Peter*
1545
Black chalk, heightened with white, on 19 sheets, mounted to measure 8′ 7½″×5′ 1⅜″, damaged by dampness in center, large section missing near upper right, pounced
NAPLES, MUSEO NAZIONALE DI CAPODIMONTE, 398

The uniqueness of this fragment renders it infinitely precious. It is the only surviving example of a cartoon by Michelangelo for a painting he actually carried out. One is fascinated to note that the artist, who was seventy when he drew the cartoon and seventy-five when he finished painting the fresco, in spite of persistent ill health and failing vision, held with such accuracy to the cartoon as drawn. The only changes are minor—a fold here and there, the helmet of the right-hand soldier removed, that of his companion altered—largely to enrich the surface contrasts. The cartoon shows the enormous importance Michelangelo still attached to contour, notwithstanding the tendency of the vast shapes to formlessness. The shoulder, torso, and flank of the soldier on the left form a rippling counterpoint against the broader

melody of hip and thigh of his companion, played with the utmost skill, sometimes an inch apart, sometimes overlapping. The heads are very fine—that of the soldier at the upper left still reflects the beauty of the Sistine Ceiling figures, as from another planet.

Close inspection shows that the characteristic multiple contours of the late style are firmly rooted in the practice of full-scale drawing at this moment. Michelangelo built up the basic darks with the *side* of the stick of black chalk, then rubbed vigorously for the modeling. Some of the hatching was done rapidly, then rubbed off, possibly with a cloth. After this the intricate network of surface modeling was built up by means of crosshatching, frequently curved to follow and coalesce with the contours, and enriched here and there with passages of very fine white hatching and crosshatching.

398

399

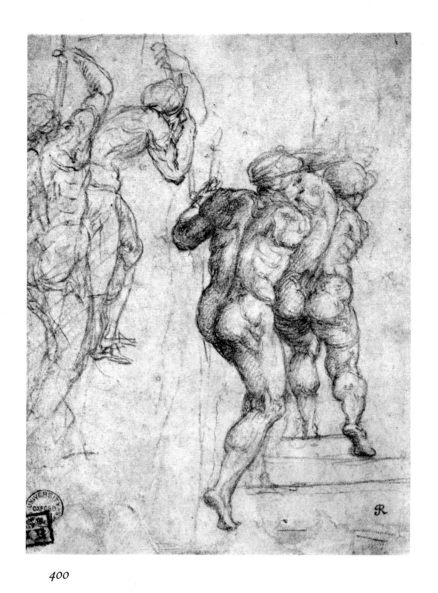

400

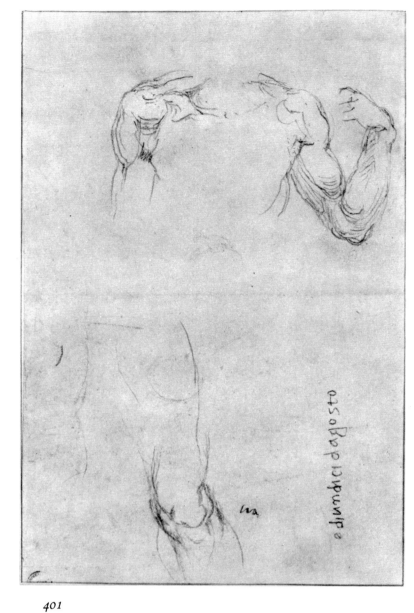

401

402

403

404

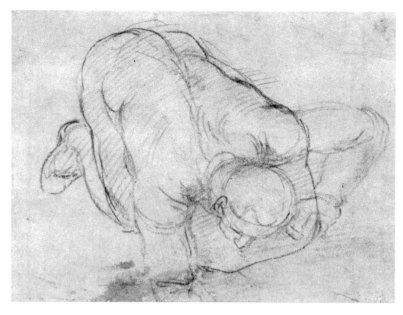

405

406

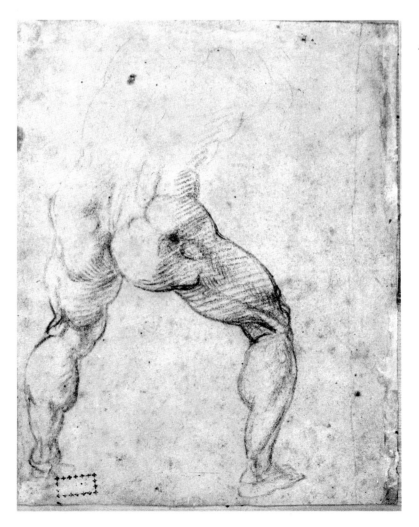

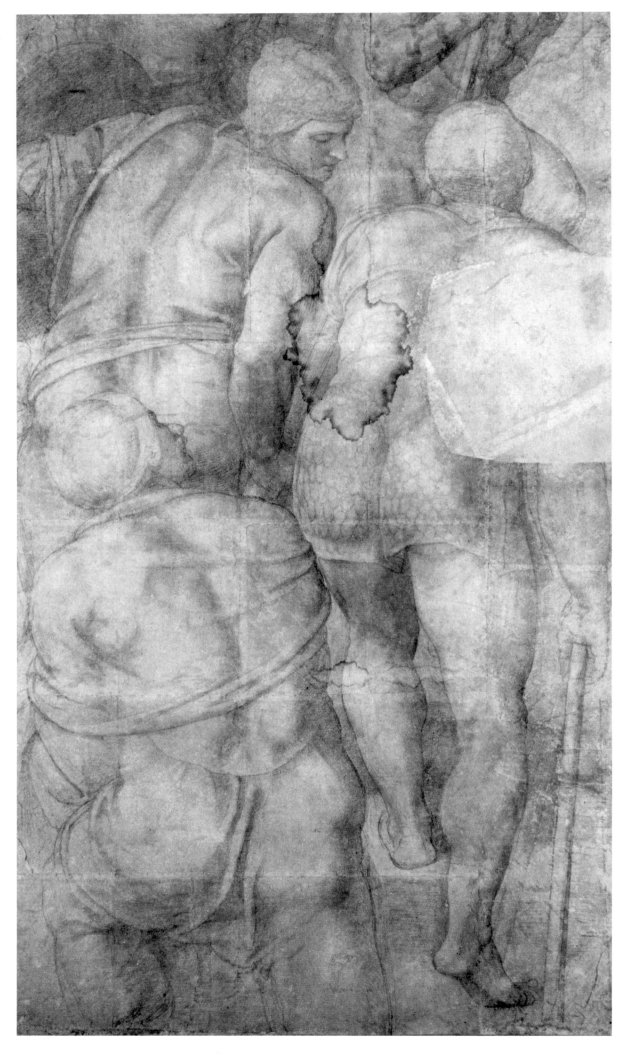

detail of 407▶

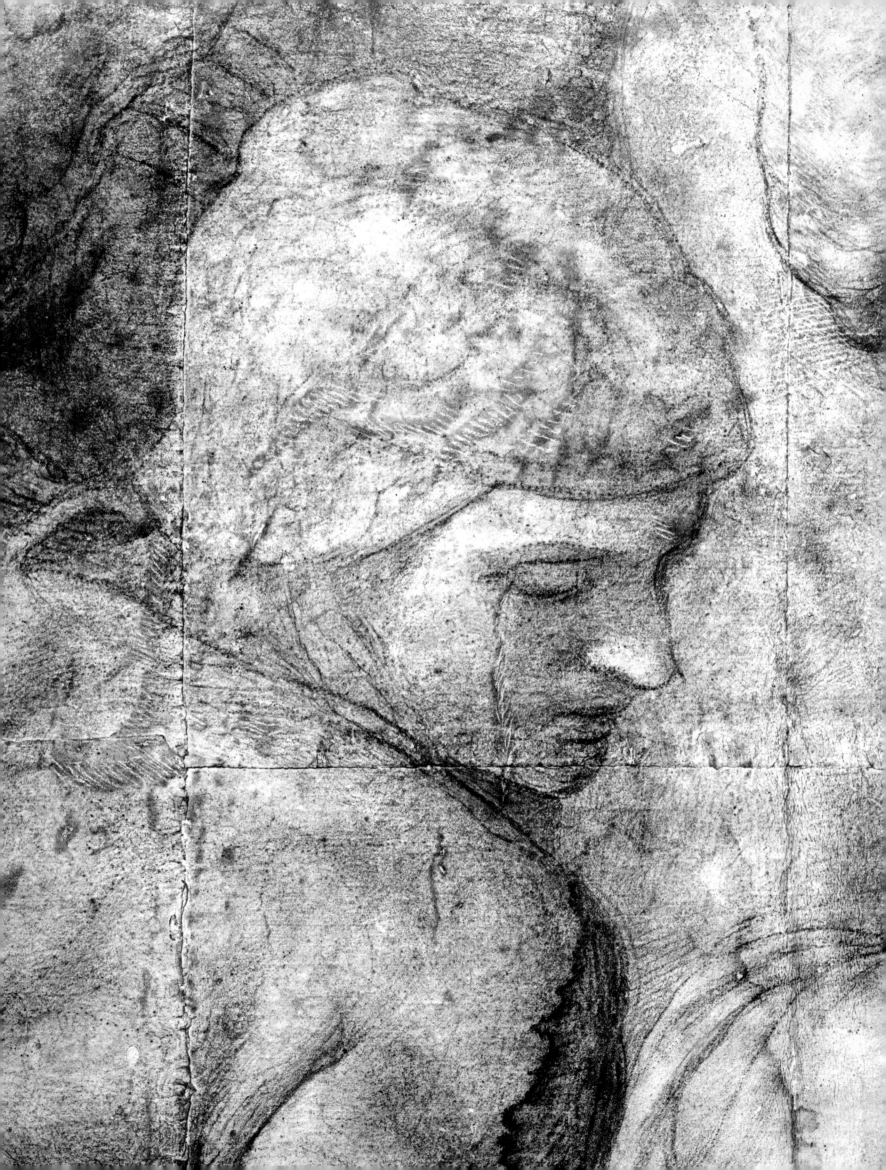

20

Drawings of the Crucifixion. Rome, 1538–64

During Michelangelo's later life he was profoundly stirred by the mysticism of the Counter Reformation, or, as it should be more properly termed, the Catholic Reformation. For the movement was well under way during the High Renaissance, when Martin Luther had yet to begin his protest. Although the great artist had always been a sincere Catholic—his glorious visions of the Creator and of a sublime human destiny under divine guidance on the Sistine Ceiling are proof enough of the strength of his Christianity—his religiosity took a new turn in later life, expressed in poems and in drawings which emphasized the passion of Christ, His sacrifice for man, the widening gap between man and God, which could be closed only by

> That Love divine which
> opened to embrace us
> His arms upon the Cross.

Michelangelo's later mysticism has been mistakenly characterized as a conversion. (How can someone who is already a true Christian be converted?) But it is certainly a change, a renunciation of much of the physical beauty Michelangelo had found in humanity in favor of a deeper, spiritual reality, a tremendous intensification of all of his energies in the direction of the salvation of his soul, a turning of the heart of his existence in the direction of the dread Figure on the Cross.

The following drawings help us move through various stages of this Pilgrim's Progress, from brilliant outward drama at the start to the deepest regions of inner experience. The drawings are for the most part so indelible a record of personal feeling that very few have ever been challenged. It will therefore seldom be necessary to record a doubt of their authenticity. Some were certainly intended for presentation, others probably for a sculptural project. Most, however, have received no credible explanation beyond that of Michelangelo's inmost witness to the process of human salvation as it affected his own soul. Contemplating these private meditations of the aged artist the observer has an almost overpowering feeling of actual presence at Christ's death.

408· *Crucifixion*
1538–40(?)
Black chalk, 14⅝ × 10⅝″, somewhat rubbed at bottom, cut down at top
LONDON, BRITISH MUSEUM, W. 67

Long considered a copy, this unique drawing is now universally accepted, although one scholar still retains doubts about the execution of the "angels" and the hill of Golgotha. The drawing is certainly the one described by Vasari and by Condivi, who calls it "a drawing of Jesus Christ on the cross, not in the semblance of one dead, as is ordinarily the custom, but in a pose of life, with his face lifted to the father it appears that he is saying: 'Eli, Eli'; where one sees the body not abandoned to fall like one dead, but as if living, through bitter suffering arousing itself and writhing." The drawing is one of several made for Vittoria Colonna, the widowed Marchioness of Pescara, Michelangelo's pious, devoted, and intimate friend until her death in 1547. In her correspondence the sheet is mentioned several times. It appears that it was submitted to her first unfinished, and returned later to Michelangelo for more work. In one letter Vittoria says that this "crucifix has crucified in my memory any other pictures that I ever saw. One can see no better made, more living or more finished image, and certainly I could never express how subtly and admirably it is done . . . I have looked at it well in the light, both with a glass and with a mirror, and I never saw a more finished thing." It has been justly pointed out that this drawing is the last work we know by Michelangelo in which the jewel-like precision of the presentation drawings for Cavalieri is still maintained. This is all the more remarkable since, if the traditionally accepted dating is correct, the work was done at a time when Michelangelo was completing the *Last Judgment*, the largest painting known in recorded history until that moment, requiring him to think and work on a colossal scale. This precious miniature seems the diametrical opposite, yet the two ideas are in reality closely interrelated. The living Christ, still suffering on the Cross, had not been painted in Italy since the Italo-Byzantine style of the thirteenth century. Giotto's introduction of the quietly hanging Christ, already dead, had been universally followed in Italy until, if the dating here proposed is correct, Michelangelo's *Three Crosses* of 1520–21 (No. 298). The present drawing, like that great work, shows a single moment in the narrative of the Crucifixion, one of the Seven Last Words: "My God, my God, why hast Thou forsaken me?" (Matthew 27: 46; Mark 15: 34). The torment of the damned in the *Last Judgment*, the ultimate pain of alienation from God, is here shown as experienced by Christ Himself. The figure retains the compactness of the *Last Judgment* poses, with inhibited forward and reverse movements, and the same subtle pulsations of contour responding to delicate changes of motion within the figure, that one finds throughout the fresco. All these are substituted for the much bolder, broader

directions of motion in the earlier works, quite possible of imitation even in a *Crucifixion,* as witness the sharp S-curves of the Italo-Byzantine pose or the jagged angles so common in the Gothic period. The modeling has the same infinite precision and delicacy of surface and the same profound understanding of the human body as an expressive instrument that we find in the Cavalieri drawings.

Some persistent misconceptions should be corrected. The small, symbolic figures on either side can in no way be considered angels. True, Michelangelo's angels are almost always wingless, but these might have been expected to grow wings in some one of the almost innumerable drawn and painted replicas and variants, and they do not. The little figures are covered by the same delicate veil of horizontal hatching, laid down with infinite care, that masks almost the entire sky. They are simply the sun and moon, darkened by the Crucifixion, and always depicted on either side of the Crucified in the art of the Middle Ages and even, now and then, in the Renaissance. The painted copies invariably show the two figures against the darkness that came over the land from the sixth to the ninth hour. It has recently been maintained that the "finishing" Vittoria Colonna was waiting for consisted of the addition of the figures of Mary and John under the Cross, which are indeed supplied, from Nos. 418 and 420, in copies. This seems to be a mistake, on three counts. First, although the edges of the original sheet are intact at left and right, there is no room for Mary and John. Second, it is hard to believe that everything else could have been so carefully finished when two essential figures were never even faintly indicated. Finally, at least one of the replicas combines these figures with a Christ taken from another Michelangelo drawing. Nor is there any indication that the block drawing, No. 417, was made with such a pose in mind. Michelangelo has left no room in the block for the sharp swing of the hips to the right and the movement of the left leg forward. Another painting in a Roman private collection, after this drawing, has recently been published as a work of Michelangelo himself. This is impossible to accept on a number of grounds, chiefly quality and the alteration, even bowdlerization, of physical details.

Beautiful as this drawing is, and highly appreciated by Michelangelo's contemporaries, modern eyes trained in expressionist movements generally find the later *Crucifixions* more easily accessible.

409. *Sketch for a Crucifixion*
1520–38(?)
Pen, 4⅛ × 2¾″
FLORENCE, CASA BUONARROTI, 30 F recto

This problematic sketch, seldom mentioned but never questioned, has been considered a Good Thief and also a crucified Christ. The writing connects the drawing with No. 416; it has been shown that the two originally formed part of the same sheet. Also the pen technique is rare in the 1530s. Yet the pose is so close to that of Vittoria Colonna's drawing (No. 408) that there would seem to be some connection. Perhaps the sketch was made on paper that had been lying around many years. Or perhaps Michelangelo simply revived an old idea. No solution is suggested here.

410. *Fragment of a Crucifixion*
1555–60(?)
Black chalk, 10 × 5⅜″, cut down
PARIS, LOUVRE, 842 recto (for verso see No. 513)

This very strange and harrowing unfinished drawing still shows the living Christ, but in a moment of deep inner pain rather than outward drama. Instead of turning to address the Father, or even looking down toward Mary and John, He half-closes His eyes and gazes inward; a shudder seems to run through his frame. The figure stands erect on the footrest so that the arms are straight and parallel with the crossbar. This is one of the two Michelangelo *Crucifixion* drawings with such a pose. The abdominal muscles are contracted, the brows knitted. In the absence of surrounding figures and of any clear external reference it is impossible to state which moment Michelangelo has intended to represent. "Father, forgive them; for they know not what they do" (Luke 23:34) and "I thirst" (John 19:28) come immediately to mind as possibilities. The artist's trembling hand, the multiple contours fusing with the hatching, and the hazy stippling suggest a very late date. The architectural drawing on the verso has been dated 1557 in a recent lecture by Charles de Tolnay. This may not be far from the date of the present *Crucifixion,* although the idea seems to have been in Michelangelo's mind a number of years earlier.

411. *Two studies for a Crucifixion; right knee*
1545
Black chalk, 10 × 6⅜″
OXFORD, ASHMOLEAN MUSEUM, P. 341 verso
(for recto see No. 401)

Among all of Michelangelo's surviving *Crucifixion* drawings, No. 410 is the only one with which the larger of the two shoulder studies may be associated, owing to the straightness of the arms and the forward thrust of the head in both, requiring a standing position on the footrest, or worse, the nail. Yet, despite the dangers in identifying too positively Michelangelo's anatomical fragments, especially in his later work, the drawing on the recto, in precisely the same harsh, bold style, and the knee study on the verso seem to have been done for the *Crucifixion of St. Peter,* begun in 1545. They certainly differ strongly in style from the vaporous edges and surfaces of No. 410. Possibly the two powerful *Crucifixion* studies (one of which is for a hanging rather than a standing Christ) once formed part of a larger series of careful drawings from the model to which Michelangelo referred when developing the more visionary No. 410. The following three studies may have belonged to such a series. The shoulder and knee drawings are separated by a beautiful freehand arc, drawn with remarkable control in five separate short strokes, two of which were immediately redrawn. Does the arc have some relation to the dome of St. Peter's (commissioned only in 1546)? Or was it Michelangelo's means of separating the *Crucifixion* studies from the knee done for another purpose? These questions cannot yet be answered.

412. *Study of a neck and shoulders*
1545(?)
Black chalk, 13¾ × 9⅝″
OXFORD, ASHMOLEAN MUSEUM, P. 318 verso
(for recto see No. 257)

This very powerful study, uncovered only in 1953, appears to have escaped publication. The firm, harsh style of the

contours and hatching bring the drawing very close to No. 411, an indication that the *Brazen Serpent* on the recto went with Michelangelo to Rome. The upward tilt of the head, turned toward the subject's right, the fact that the arms must have been brought over the crossbar, and the indication that the figure was to have been shown in action, suggest a study for the impenitent thief.

413. *Study for a Crucifixion; figure sketches (portion of sheet)*
1545(?)
Red chalk, ink, 11¼×8¼″ (whole)
HAARLEM, TEYLERSMUSEUM, A 28 verso
(for recto see No. 51)

This drawing is full of problems. The nude, fighting figures in pen and the kneeling, draped figures in red chalk are of considerable quality, but not by Michelangelo. No attribution is offered here. But the powerful life study of a nude male torso, seen from the front, shows all the traits of Michelangelo's drawing style around 1545, closely related to the preceding *Crucifixion* studies. What makes the situation especially noteworthy is that the recto contains dissection studies probably done at Santo Spirito fifty years earlier, and drawings for the *Dying Slave* forty years earlier. Although the full array of anatomical details of the front of a male torso from neck to groin are meticulously analyzed by Michelangelo, the only scholar ever to publish the drawing (he of course rejected it) has described it as a view from the *back!*

414. *Anatomical sketches for a Crucifixion(?)*
1545(?)
Black chalk, 4⅛×6½″, cut down
OXFORD, CHRIST CHURCH, C 13 verso
(for recto see No. 416)

This difficult sketch should be viewed with the writing upside down. It will then be apparent that, although the strokes at the left still elude identification, the fragmentary sketch at the right, not previously deciphered, is for a male torso. The lower part of the abdomen and the beginning of the groin are clearly visible in contour, and enough of the right thigh is indicated to make clear that the leg was raised. Possibly this was a writhing, impenitent thief. The writing, which has been misread, should be deciphered as "Andrea."

415. *Study of a window tabernacle; sketch for the Penitent Thief*
1546(?)
Black chalk, pen, 10×10⅛″, cut down
LILLE, MUSÉE WICAR, 93–94 verso
(for recto see No. 500)

The window tabernacle has been associated unsuccessfully with several different architectural projects by Michelangelo. It is probably an early idea for the courtyard windows of the Palazzo Farnese, for which Michelangelo received the commission in 1546, the same year and for the same reason as his appointment as chief architect of St. Peter's, an early project for whose dome is on the recto. The very fine line sketch of a crucified man contains memories of Michelangelo's early *Crucifix* for Santo Spirito. Some authors have connected it also with the Rondanini *Pietà*, now in Milan, a masterpiece done nearly seventy years later. The drawing cannot represent Christ. The arms are lifted and the right arm bent behind the head, indicating that the hands were tied

back over the crossbar, not nailed. Moreover, the legs are visibly broken, and the man is dead. These features pertain only to the penitent thief. The side view suggests that a work of sculpture was intended. The small sketch at the left is generally associated with the staircase for the Laurentian Library, but it is questionable whether a staircase is meant. This may only be a study of an architectural form. The note to Michelangelo's muledriver Pasquino refers to cheeses and pears, and must date from after 1557.

416. *Sketch for a Crucifixion*
1545–60
Wash over black chalk, 6½×4⅛″
OXFORD, CHRIST CHURCH, C 13 recto
(for verso see No. 414)

One of Michelangelo's rare brush drawings, this fine sketch is for that very reason difficult to place. It has been considered to be fairly early, but the lines at the top, among the few that Michelangelo himself has not completely crossed out, are in keeping with his correspondence with his friend Luigi del Riccio in Rome. The standing position with straight arms is shared only with No. 410 among Michelangelo's *Crucifixion* drawings, but the head looks upward, as if toward the Father. The contracted diaphragm appears in all the *Crucifixions*. In all probability the sketch was done from imagination.

417. *Block diagram for a Crucifixion between the Virgin and St. John*
1547(?)
Pen, 11⅜×8¼″
FLORENCE, ARCHIVIO BUONARROTI, I, 154, fol. 274

This important sketch, intended as a set of detailed instructions, complete with exact measurements, for the cutting of marble blocks for a Crucifixion between Mary and John, has been known for less than forty years. The scholar who discovered it has recently proposed a convincing solution for the problem posed by the drawing. The detailed dimensions indicated by Michelangelo are slightly more than lifesize— three and three-quarters cubits, or about seven feet for the side blocks. Allowing for the bases and for waste at the top this would bring the figures down to a little over six feet. The outlines make clear that the Christ must have been shown hanging vertically from a cross of ordinary shape, with His head turned slightly to His right, that John's arms were conceived as drawn very close to his body, and above all, that Mary's right arm could not have protruded much beyond the contour of her body, while her left arm must have been extended, supported by a strong vertical line from her descending mantle. None of the extant *Crucifixion* drawings can be fitted to this scheme, which appears in a single place, the engraving by A. Lafréry, dated 1568, the outlines of whose figures can be fitted precisely within those of the three blocks designed here. The lost Christ from which Lafréry made his engraving was copied in the Missal of the Cardinal d'Armagnac, dated 1549. The sculptural group must, therefore, have been designed before that date. Vittoria Colonna died in 1547, to Michelangelo's immense sorrow. He may very well have intended to carve a sculptural group for her tomb, or in some way as a memorial to her. To this excellent hypothesis should be added the fact that the Lafréry engraving includes the representations of the grieving Sun

and Moon, borrowed from No. 408, actually drawn for Vittoria Colonna.

The Virgin and St. John in Lafréry's engraving are clearly based on Nos. 418 and 420, which were also copied by Marcello Venusti in a painting now in the Galleria Doria, in which Venusti substituted the Christ made for Vittoria Colonna (No. 408). It had already been shown that the original Golgotha composition, for which the block diagram was drawn and from which Lafréry made his engraving, was not entirely lost, but at some time cut in three pieces. The central Christ on the Cross has indeed vanished, since Lafréry's pose does not appear in any of the surviving single-figure *Crucifixions*. But the Virgin and St. John *are* Nos. 418–20, all in the Louvre, all from Coypel's collection, and all cut down almost to the outlines of the figures. The figure types and drawing style, so closely related to the painting style of the *Crucifixion of St. Peter*, reinforce this hypothesis and that of a dating around the time of Vittoria Colonna's death. These three drawings, then, may reasonably be taken as authentic elements for the reconstruction of a great sculptural group, intended but never executed, by Michelangelo in 1547. The special role of the Virgin, as representative of womanhood, may very well derive from the purpose of the group as a memorial to Vittoria Colonna.

418. *Mary, for a Crucifixion*
1547(?)
Black chalk, 9 × 4″, cut down irregularly
PARIS, LOUVRE, 720 recto (for verso see No. 419)

The only scholar ever to consider this wonderful drawing as "of doubtful authenticity" is the same one to whom we owe the reconstruction and dating of the *Crucifixion* group for Vittoria Colonna's death (see No. 417), of the large drawing for which this and No. 420 are the only surviving fragments. Although the outlines of the present figure with the right hand pointing down and the left hand extended correspond exactly to the contours of the block in No. 417, and although the figure was reproduced almost line for line in Lafréry's engraving on which the whole reconstruction of the 1547 group is based, the drawing is still listed as "intended for the elaborate versions of the Crucifixion for Vittoria Colonna with two figures below the Cross, ca. 1538–41." The fragment is not only authentic, but of the highest importance since, with the exception of the cartoon (No. 407), it is the only surviving finished drawing by Michelangelo from the period of the Pauline Chapel. The study represents the exact graphic equivalent of Michelangelo's pictorial style in the *Crucifixion of St. Peter*, especially close to the facial types, gestures, figural proportions, and drapery surfaces of the female figures at the lower right. The surface has been softly stippled all over, in a manner suggesting the finished style of the cartoon. Many *pentimenti* are still visible along the contours.

419. *Sketch for Mary, for a Crucifixion*
1547(?)
For medium and dimensions, see No. 418
PARIS, LOUVRE, 720 verso (for recto see No. 418)

This simple sketch, blocking out the major masses of the figure of Mary, seems to have been done from a scantily clad male model. It has been doubted only once, and without reason. Faint marks at the lower left may be the legs of another figure.

420. *St. John, for a Crucifixion*
1547(?)
Black chalk, 10 × 3⅜″, relined
PARIS, LOUVRE, 698

Another fragment of the larger composition from which No. 418 was cut, this tragic figure was rejected by the same scholar who doubted the "companion piece," with the erroneous remark that it is on gray paper. The paper in both fragments is identical. The drawing is rubbed, and never so highly finished as No. 418. One can watch the numerous *pentimenti*, fusing with each other to form the characteristic multiple contours of the artist's late style. The position of the feet changes four or five times. Some of the rubbing was done by Michelangelo, preparatory to the stippling, which has already begun. The surface has a beautiful silvery quality, which reappears in many of the later religious drawings. Doubtless if the sheet were freed from its later mount, a continuation of the sketch in No. 419 would be visible on the verso.

421. *Crucifixion with the Virgin and St. John*
1550–55(?)
Black chalk, reinforced with wash and white, 17 × 11½″, damaged by water
PARIS, LOUVRE, 700

This awesome drawing is widely accepted as the earliest of the great series of seven late *Crucifixion* compositions. In the absence of external evidence it is impossible to date any of these compositions even approximately, or to assign any order to them. All attempts are bound to be arbitrary, and no new suggestions are made here. Christ appears to have just expired. His body hangs limply upon the Cross, His head is bowed in death in accordance with all the texts. The also bowed heads of Mary and John and their wide-flung arms have been reasonably interpreted as signs of humble acceptance of the Divine Sacrifice. They step forward along the nonexistent ground as if returning to the world in which, henceforward, they will be mother and son. Although ruled, the Cross has neither beginning nor end; it seems to move with them. As in many of the late *Crucifixions*, Michelangelo has reruled the Cross and redrawn figures several times, eventually having recourse to wash and to white pigment, applied with a brush, over the black chalk *pentimenti*. Among the almost innumerable changes, it may be noted that the arms of Christ were moved closer toward each other, perhaps to avoid the excessive spread of the crossbars previously inevitable in depictions of the Crucifixion. The drawn and brushed *pentimenti* combine with multiple contours radiating out into the surrounding dimness, producing a kinetic impression. As one watches, the arms appear to shrink together, the head to sink farther forward.

422. *Sketch of a left leg*
1550–55(?)
Black chalk, 8½ × 16″, cut down all around
WINDSOR, ROYAL LIBRARY, 12761 verso
(for recto see No. 425)

The beautiful left leg has been very convincingly connected with that of St. John in the preceding drawing. Against recent objections that St. John's leg is shown standing, one can only ask for a more careful examination; the positions

are identical in both. The vague line drawn around the crucified Christ which shows through from the recto has been adduced as evidence that not only this but the entire series of late *Crucifixion* compositions were intended for use as a second sculptural group like that planned for the memory of Vittoria Colonna. A single line seems inadequate to support so sweeping a conclusion.

423. *Crucifixion with the Virgin and St. John*
1550–55(?)
Black chalk, retouched with white pigment, 15 × 12¼″, cut at left, right, and top
WINDSOR, ROYAL LIBRARY, 12775

This may be the earliest of the series. The ruled Cross has a bottom, and the ground is indicated, with Mary and John placed definitely in front of the Cross. It is far from clear that Christ is dead. His body has been moved about several times before arriving at the beautiful present position, with the hips slightly tilted and the right knee advanced. His arms originally hung somewhat lower, and His head was bowed forward and to His right, in the manner of *Crucifixions* by Giotto and his followers. In the final version, however, the head is almost erect, but inclined toward John, who turns and gives a gesture of surprise, as if he did not realize the Victim could still speak. According to one author, "John's hands and facial expression seem that of a deaf man who, however, senses the roar of the storm about him." One might more reasonably suppose that Michelangelo intended to represent one of the Seven Last Words, "Behold thy mother" (John 19: 27). Mary's arms are clasped about her bosom and one hand holds her face. She looks outward as if she, too, had just heard the unexpected words. John and Mary are very nearly finished, in the most delicately stippled style, developed from, but softer than, No. 418.

424. *Crucifixion with the Virgin and St. John*
1550–55(?)
Black chalk, retouched in white pigment and gray wash, 16⅜ × 11¼″, white has partially oxidized
LONDON, BRITISH MUSEUM, W. 81

The ruled Cross revived the **Y**-shape found here and there in Italian art of the thirteenth century and often in the cross embroidered on chasubles. The crossbar creating a triangle suggests the doctrine of the Trinity. The titulus (I.N.R.I., for Jesus of Nazareth, King of the Jews) is carefully lettered, but at first Michelangelo made the N go the wrong way. Whatever its possible significance, the **Y**-cross was a superb solution to the formal dilemma, since Michelangelo never liked excessive projections. He drew the arms, head, and torso with the greatest delicacy and with a high degree of finish, stippling the surface. The original head was shown in absolute profile, turned toward Christ's right with the eyes wide open. The aquiline nose and low forehead are surprising. In the second version, the head is softly drawn, partly in brush, sunk forward in death, with the eyes apparently closed. Mary has been completely painted out with white, so that her original pose cannot be determined, and then redrawn with the brush, her arms clasped on her bosom as in No. 423, but not touching her face. John leans and gazes forward, crying out in terror. What we see of his figure appears to belong to the first version. The head and shoulders have been roughly indicated in brush above, and the legs

redrawn. There may have been a considerable passage of time between the first and second versions. Probably during the first version the surrounding air was elaborately hatched and crosshatched, to resemble the marks of Michelangelo's toothed chisel, then the groundline picked out.

425. *Crucifixion with the Virgin and St. John*
1550–55(?)
Black chalk, 16 × 8½″, cut down all a round
WINDSOR, ROYAL LIBRARY, 12761 recto
(for verso see No. 422)

This unfinished drawing was at one time badly cut down, but Michelangelo himself seems to have changed his mind at least once about the way the Cross should be ruled, and in consequence it seems to stagger. Mary and John have been very lightly sketched, and around the base of the Cross faint lines can be made out, which have been identified as the beginnings of a kneeling figure embracing the Cross, perhaps Mary Magdalen. This is impossible to verify. Christ's head hangs over on its left side, apparently in death. His body twists in a beautiful spiral pose, made purer by the restriction of the right leg, which once projected considerably. The body, left arm, and left leg are very nearly finished. In its grace and delicacy this figure probably gives a good idea of the original appearance of the Rondanini *Pietà*, now in Milan. The background has been almost filled with floating hatching fusing with radiating multiple contours as if the shadow of the Cross were moving through the air.

426. *Crucifixion with the Virgin and St. John*
1550–55(?)
Black chalk, with oxidized corrections in white pigment, 11 × 9¼″, folded and mended
OXFORD, ASHMOLEAN MUSEUM, P. 343 recto
(for verso see No. 427)

The unorthodox arrangement, with Mary on the right and John on the left, has given rise to the strangest series of interpretations, ranging from Mary in male form (!) through Peter denying Christ (which he did not do under the Cross) to the latest, the Roman soldiers Stephaton and Longinus—although the figure on the right is clearly female, with prominent breasts and the wide sash or girdle with which Michelangelo so often provides his female figures, especially Mary. The drawing is unfinished, and John's nudity would doubtless have been masked by the usual filmy draperies. Christ's head hangs forward with the deepest pathos. Mary clutches her head to shut out the terrible sight. John, one arm about the Cross, darts forward as if to accuse mankind of the guilt.

427. *Crucified Christ*
1550–55
9¼ × 11″; for medium and condition, see No. 426
OXFORD, ASHMOLEAN MUSEUM, P. 343 verso
(for recto see No. 426)

This figure, broken and alone, was discovered only in 1953 when the drawing was removed from its mount. It is a second version of the figure on the recto, redrawn with the most intense sympathy and understanding.

428. *Crucified Christ (portion of sheet)*
1557(?)
Black chalk, 11 × 7½″ (whole)
ROME, VATICAN LIBRARY, Cod. Vat. 3211, fol. 100 recto

Sketched on the recto of a sheet whose verso was used for a draft of a letter dated 1557, this little drawing may have been done before or after the writing which now makes it so difficult to see. The ink could very well have shown through in this manner only in the course of time. The idea seems most closely connected with the two foregoing drawings.

429. *Crucifixion with the Virgin and St. John*
1550–60(?)
Black chalk, corrected in white, now partly oxidized, 16⅜ × 11″
LONDON, BRITISH MUSEUM, W. 82

Perhaps the most deeply moving of all the three-figure *Crucifixions*. In an unprecedented manner, the three have now drawn close to each other, obliterating personal identities in ultimate union. John embraces the Cross with his right arm while he touches his breast gently to both Cross and Crucified, and gazes upward into the dim, quiet face. Mary, shuddering, clasps the Cross with her left arm, and presses her right arm and her cheek into Christ's thigh. The vibrating contours reach out around the three figures, uniting them as by an aura. Christ's hair hangs down, blending with the contours.

430. *Crucified Christ*
1560(?)
Black chalk, 10⅞ × 9¼″
LONDON, COUNT ANTOINE SEILERN

The Figure hangs in utter loneliness. Before emerging masses of such purity, breadth, and grandeur it is hardly meaningful any more to speak of *pentimenti*. The aged hand shakes, the contours shift and change, form and atmosphere can scarcely be distinguished from one another, substance is shadowy and melts, yet in these broken chords the ultimate shape and the ultimate meaning come through with overpowering clarity. Never in Christian art has Christ's sacrifice received a more exalted expression. We are very near the end of Michelangelo's earthly pilgrimage. This drawing should be compared with the equally mystical late *Madonna and Child*, No. 441, of which it is the counterpart. Both deal with final human and divine realities, in complete nudity.

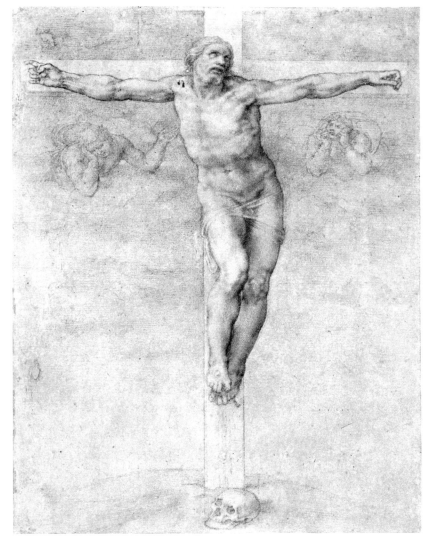

408

409

293

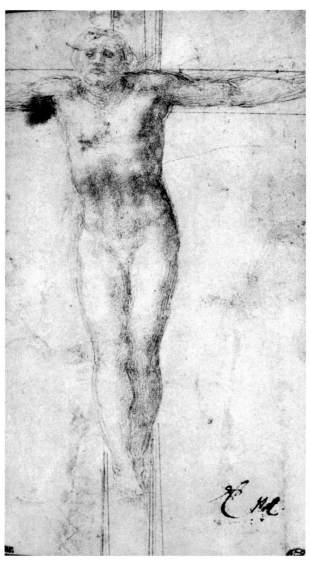

410

411

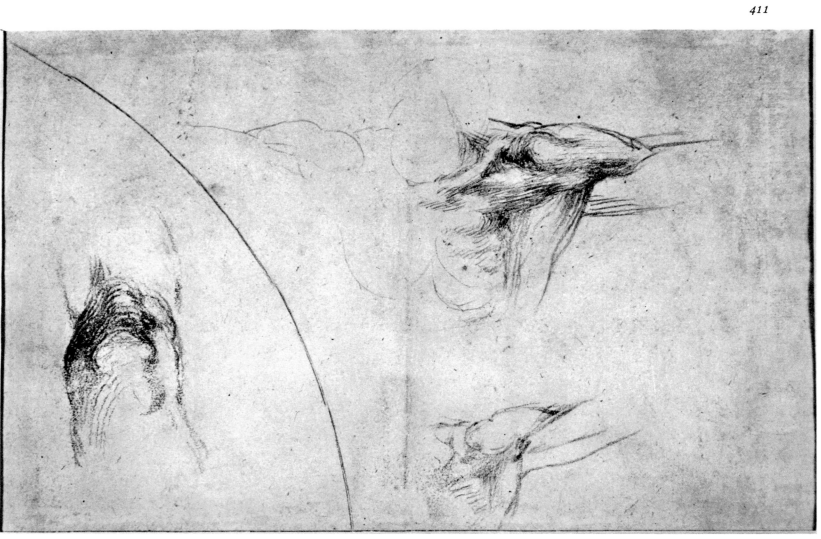

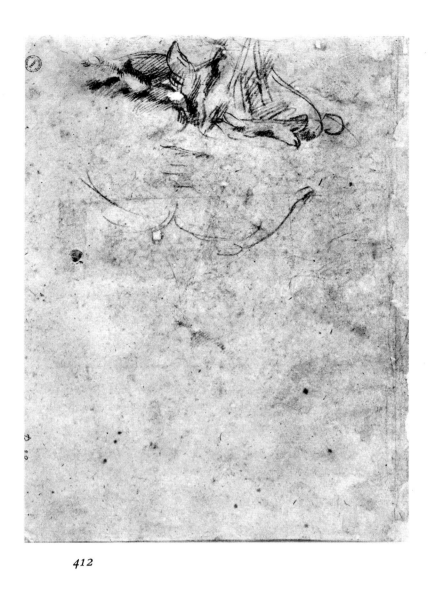

412

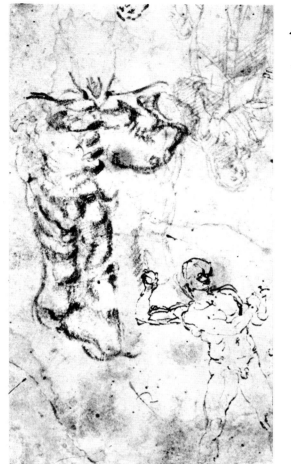

413

414

415

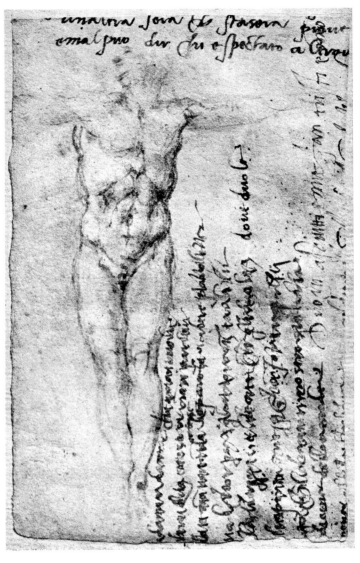

416

417

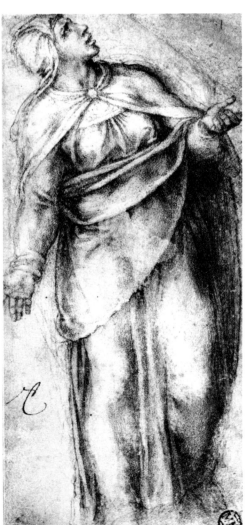

418

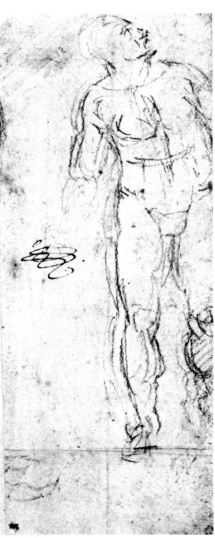

419

420

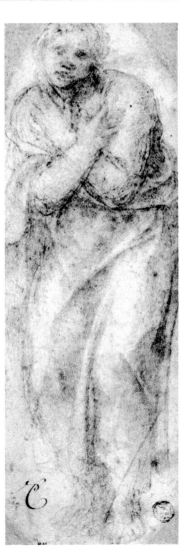

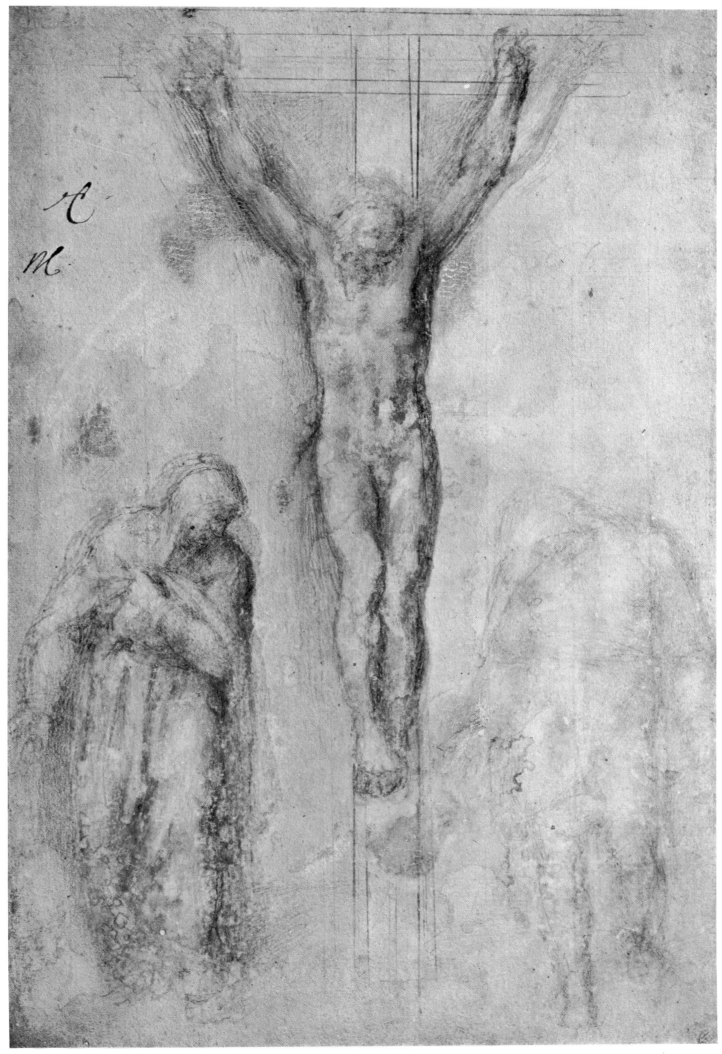

421

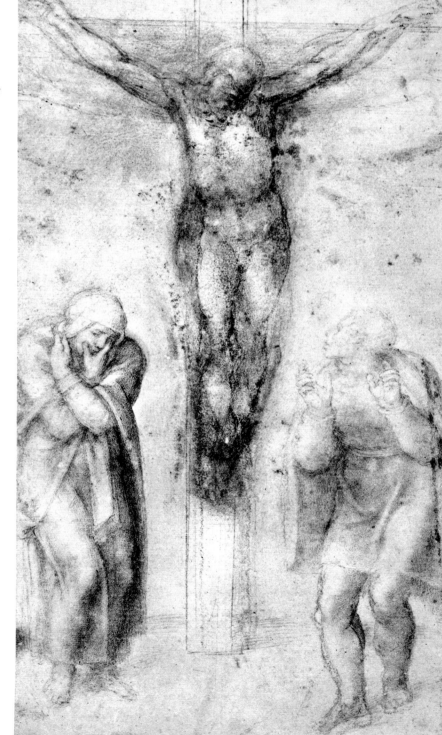

423

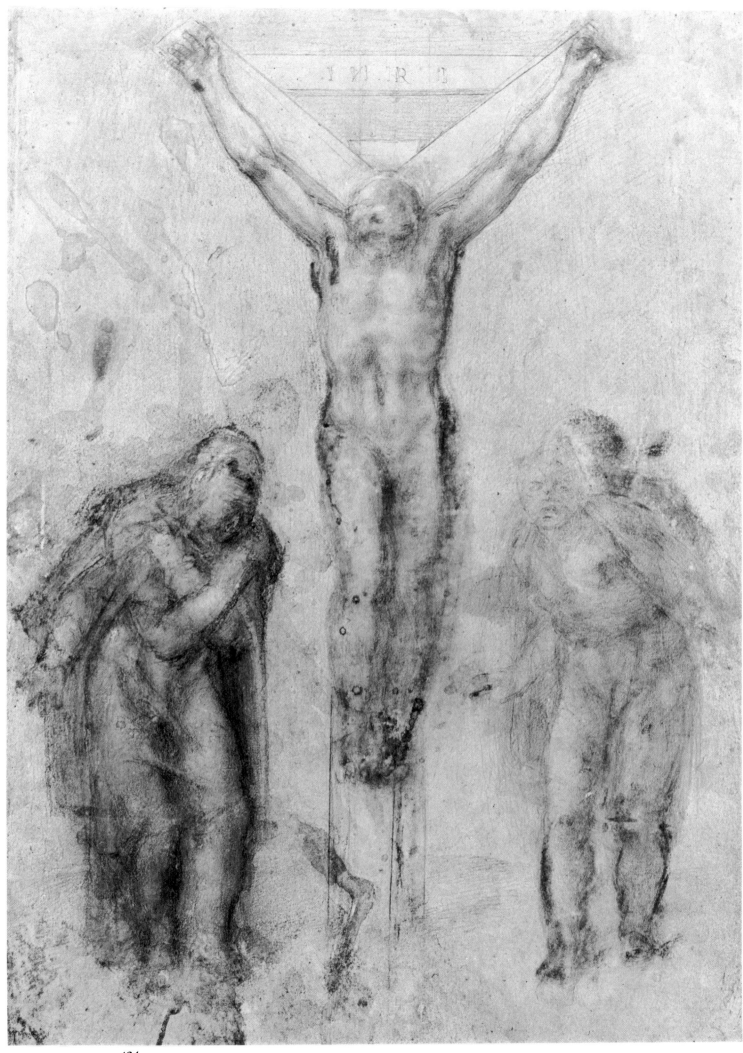

424

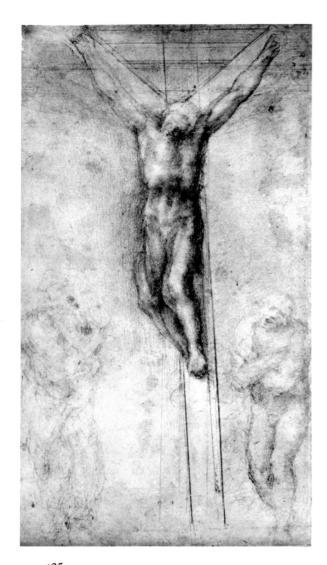

425

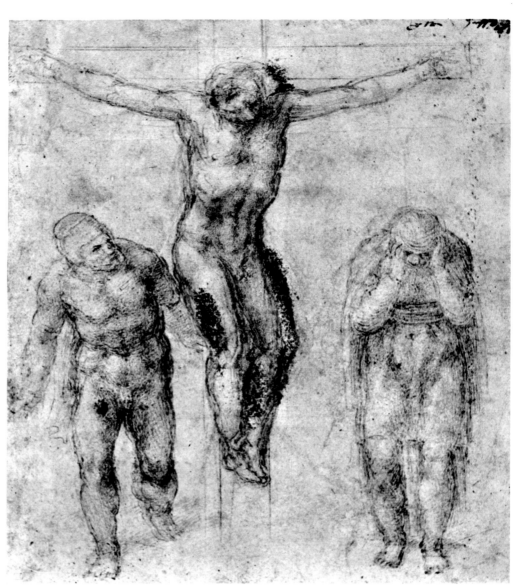

426

427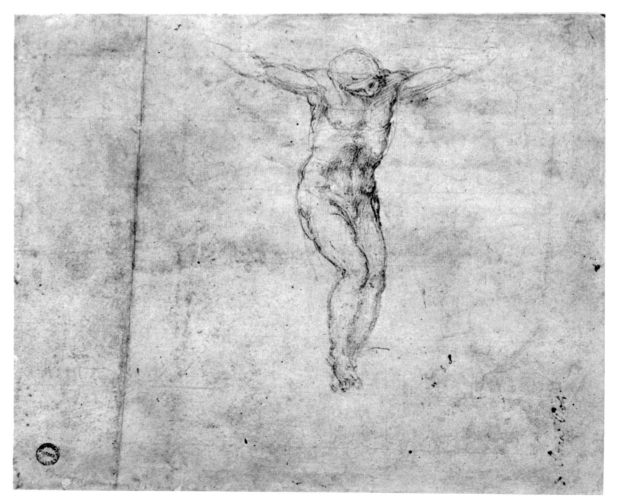

429

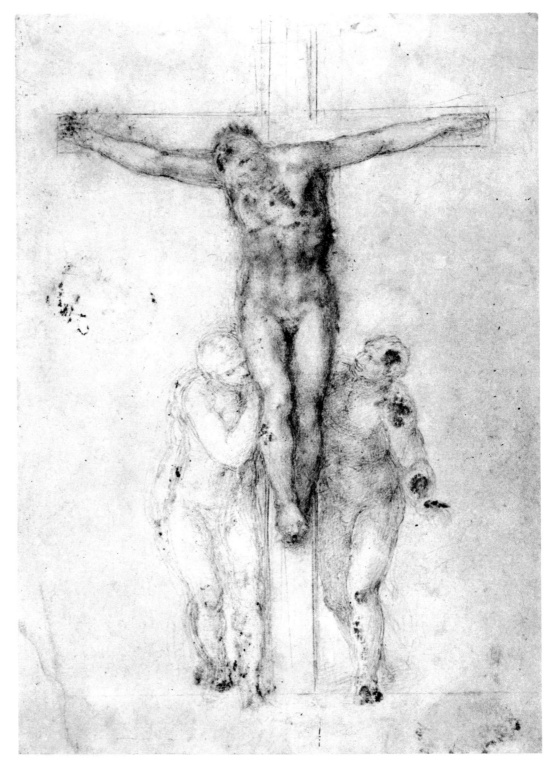

301

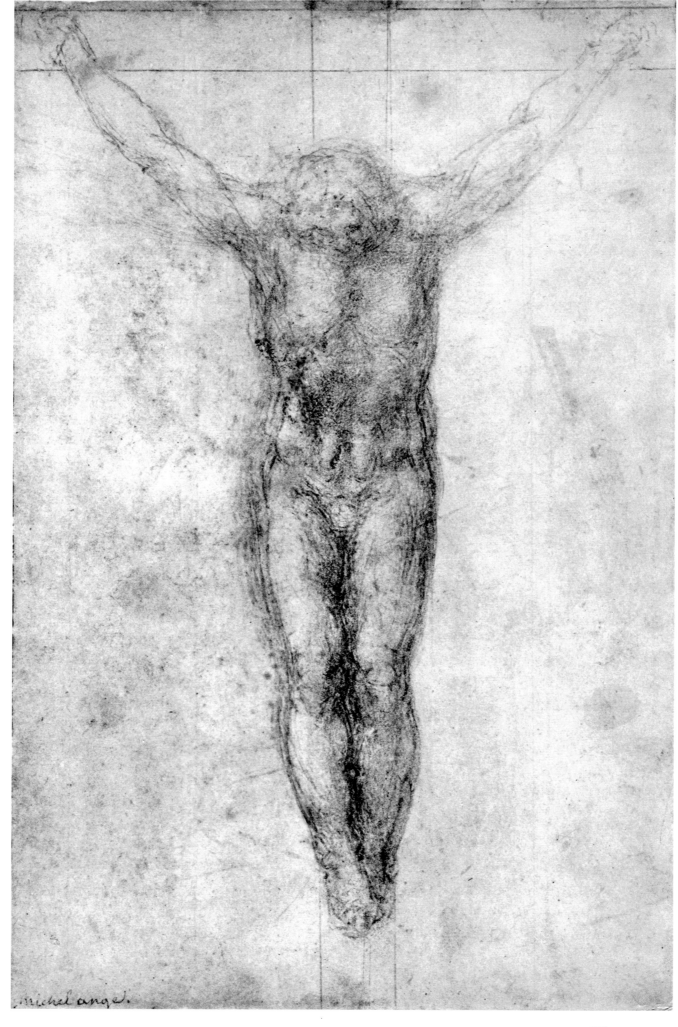

michelange.

430

21

Drawings of the Life of the Virgin. Rome, 1540–64

The Annunciation, 1550–60

In addition to the mystery of the sacrifice of Christ, Michelangelo mused on that of the Incarnation, the Word made flesh to dwell among us, which occurred at the moment of the Annuciation when the angel Gabriel brought the divine message to Mary's ear. The drawings, so different in style from Michelangelo's earlier work, were at first hard for critics to accept and were attributed to pupils and followers, but all doubt as to their authenticity has long since vanished. Only one fragmentary drawing can be clearly connected with a definite project, No. 433, for the *Annunciation* painted by Michelangelo's professional imitator Marcello Venusti, from the great master's designs, for the Cesi Chapel in Santa Maria della Pace in Rome, and datable around 1547. The other *Annunciation* drawings seem later, sometimes much later. All suggest works and ideas dating from the end of the Middle Ages. At long last, Michelangelo's angels regain their wings. Like the drawings of the Crucifixion, those of the Annunciation appear to be Michelangelo's own meditations, always deeper and more disembodied, on the central truths of Christianity. At first warm and dramatic, then astonishingly intimate and close, there takes place as in the *Crucifixion* drawings the phenomenon characteristic of Michelangelo's figures in his last works—the dissolution of the boundaries between one personality and another. Finally the theme becomes a vision, and the misty forms with their deep inner luminosity seem to contain the secret of all form and all life.

431. *Virgin of the Annunciation*
1550–60(?)
Black chalk, 13¾×8¾″, folded, cut down
LONDON, BRITISH MUSEUM, W. 71 recto

432. *Angel of the Annunciation*
1550–55(?)
Black chalk, 7¾×11⅛″, cut down, badly rubbed
LONDON, BRITISH MUSEUM, W. 72 verso
(fragment of No. 431; for recto see No. 436)

It has been shown that these two drawings originally formed part of the same large sheet. The angel's right arm is cut off by the right edge of No. 432, but the hand can be seen on No. 431. The original composition has been connected with the *Annunciation* designed by Michelangelo for the Cesi Chapel in Santa Maria della Pace in Rome, and another in

San Giovanni in Laterano, both of which were painted by Venusti. The painting in the Cesi Chapel has disappeared, but copies by Venusti are known, and it has been recently shown that the picture looked quite different. The Virgin leaned back in astonishment at the sudden appearance of the angel, who hovered above her on outstretched wings. Mary's right hand was holding a book. Number 433, as has been demonstrated, was Michelangelo's sketch for this hand, and can be dated around 1547. The altarpiece in San Giovanni in Laterano still exists, and shows a standing Virgin lifting her hands, while the angel runs toward her. Neither can be connected with the present drawing. Here Mary, seated before a desk, turns gently from her book, with her gaze cast downward. Gabriel had first been shown soaring, but then a running figure was substituted. The Virgin's bed, symbol of the Incarnation throughout the art of the late Middle Ages and the Renaissance, appears in the background at the right, very lightly drawn. Interestingly enough, Mary's zone, or girdle, age-old symbol of virginity (see *Dawn* in the Medici Chapel) is not shown, as if (in accordance with medieval belief), Mary conceived the Child within her at the moment of Gabriel's words. Her face, of the greatest transparency and Hellenic beauty, differs sharply from the heavy-featured type shown in the Cesi altarpiece and, indeed, in No. 418, which probably relates to a project also done in 1547. The silvery tonality of the drawing, as well as the innumerable floating contours, which should not be called *pentimenti* any longer, relate this cloudy drawing to the *Crucifixion* studies, and even to the latest of them. The hatching survives untouched only here and there. Elsewhere it has been softly rubbed by Michelangelo, then the floating contours cross it a hundred times, as if the tight stippling of the presentation drawings for Cavalieri had exploded throughout the surrounding space. One would imagine the date of the drawing to be well into the 1550s.

433. *Right hand of the Virgin for the Cesi Annunciation*
(*portion of sheet*)
1547(?)
Pen, 5⅝×8⅜″ (whole)
ROME, VATICAN LIBRARY, Cod. Vat. 3211, fol. 74 recto

On the verso is the draft of a letter written between April and July, 1547. The poems by Michelangelo and the beautiful

little sketch of the Virgin's right hand holding a book would seem both, therefore, to date very close to that year, although it is seldom possible to be exact in these matters. The hand has been securely identified with that in the lost Cesi altarpiece (see No. 432). It is a precious example of Michelangelo's late pen style. The wrist curves gently; the thumb and forefinger are enough to support, ever so lightly, the weightless book.

434. *Figure with arms raised*
1550–60(?)
Black chalk, 4×2⅜", cut down, badly rubbed, colored by red chalk, offset from another sheet, cut down all a round
LONDON, BRITISH MUSEUM, W. 73

This little figure, drawn in much the same style as No. 432, may originally have been just such an announcing Gabriel, but the arms have been changed, to rise upward. Could this be a fragment of still another visionary *Annunciation,* in which the angel lifts his arms ("Rejoice greatly, O daughter of Zion")?

435. *The Annunciation*
1560(?)
Black chalk, 8¾×7⅞"
OXFORD, ASHMOLEAN MUSEUM, P. 345

The inscription, for all its appearance of a religious revelation, concerns Cornelia, the widow of Michelangelo's assistant, Urbino, and the muleteer Pasquino, who carried correspondence from Michelangelo to Cornelia's home in Casteldurante. The correspondence runs from 1555 to 1561, and the drawing would seem to date from the end rather than the beginning of that period. Michelangelo first drew the angel walking, then rubbed out the legs. He drew Mary with her head starting back in surprise, and her right leg sharply bent. In the second version, her head moves forward, her right leg is folded gently underneath her, and the angel floats as in Florentine late Gothic art of the early fifteenth century, but also as in the later *Annunciations* of Signorelli. Fear has become acceptance. The miracle is neither physical nor psychological, but transcendental. Gabriel approaches, as soft and transparent as a morning mist, filled with the first sunlight.

436. *The Annunciation*
1550–60(?)
Black chalk, 11⅛×7¾", cut down, badly rubbed
LONDON, BRITISH MUSEUM, W. 72 recto
(for verso see No. 432)

This wonderful drawing seems later than Nos. 431 and 432, on the other side of which original sheet it was drawn, but there is no telling how much later. It has been shown that Michelangelo here went back to an old motive, which had fascinated him in his youth, the appearance of an angel to inspire a sibyl in the pulpit by Giovanni Pisano in Sant' Andrea in Pistoia, at the very beginning of the fourteenth century, which had already been used for the poses of some of the prophets and sibyls on the Sistine Ceiling, notably *Isaiah* and *Delphica.* But the idea has become less dramatic and more personal. The angel comes very close to Mary now, to whisper in her ear, as he points with his right hand. At first Mary lifted her left hand in the customary gesture of surprise. Then Michelangelo redrew the left hand and arm

and gathered them closer to her shoulder. Her right gently touches the zone of her virginity. Mary is supposedly seated, but the seat is not visible. Her feet, crossed like those of *Isaiah,* are pointed downward, and she seems poised on the toes. A single fold of diaphanous drapery crosses her hip and falls between her knees. The tender yet visionary intimacy of the supernatural colloquy is surprising, but typical of the personal quality of Michelangelo's religious feeling in his later works. The forms are more vaporous than ever; the floating multiple contours tangle and release; the great shapes vibrate before us.

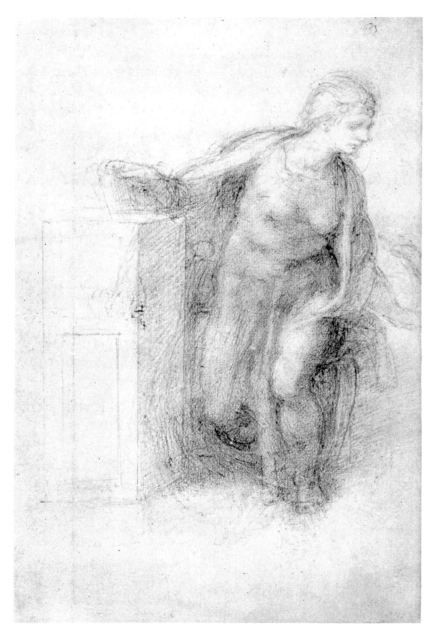

431

432

434

433

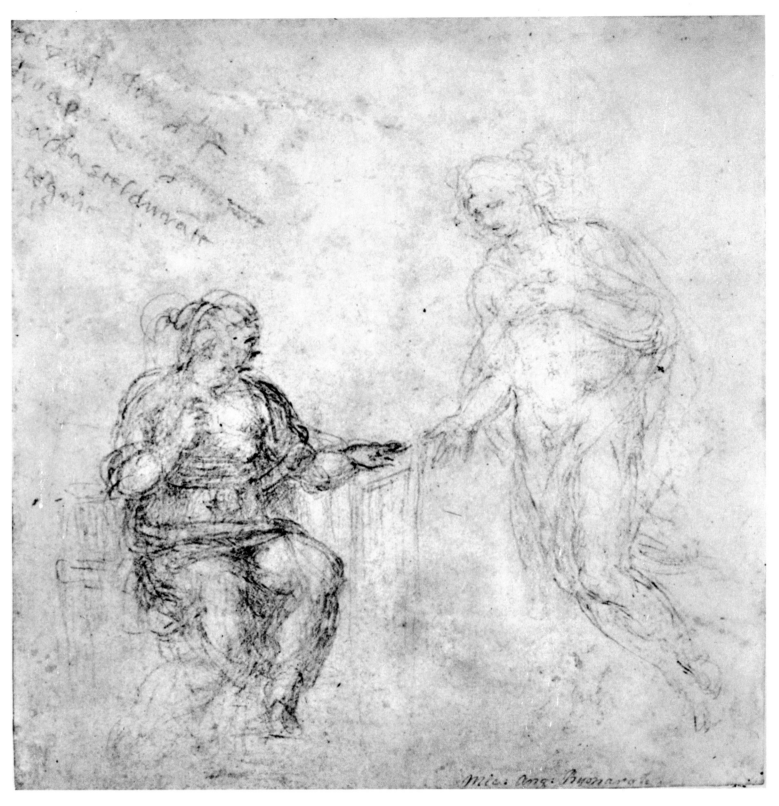

435

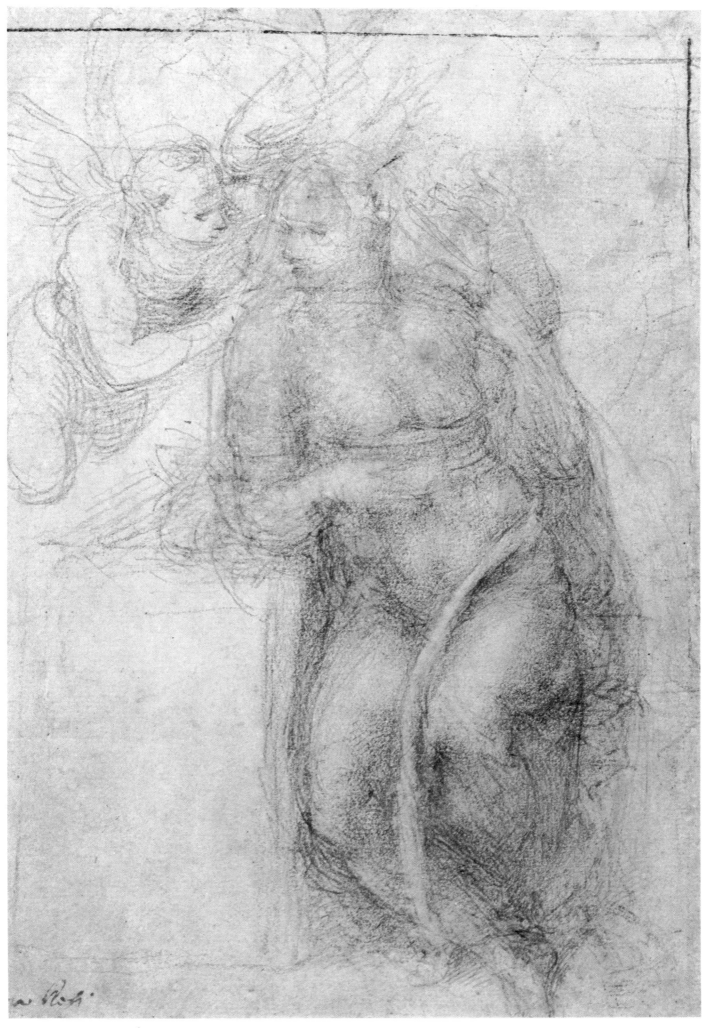

436

The Madonna and Child, 1540–64

In the last decades of Michelangelo's life he returned to one of his most poignant early themes, that of the mother and child, so responsive to his own inner psychological necessities. The drawings again take us from the most meticulous finish to the mistiest apparitions, of always increasing spiritual depth as the artist, nearing death, identified himself with the sacred personages in whose existence he soon expected to merge his own. One of these Madonnas, exactly dated, is a gigantic cartoon, a treasure house of expression and form. It enables us to fix with some accuracy in the 1550s the dating of the late *Crucifixion* and *Annunciation* drawings previously treated. The last, a drawing of profound emotional intensity and formal richness, is very close in style and feeling to what has been so beautifully described as the "blessedness and peace" of the Rondanini *Pietà* in Milan.

437. *The Madonna of Silence*
1540(?)
Red chalk, 15 × 11¼″
LONDON, DUKE OF PORTLAND

Once doubted, this remarkable drawing has been universally accepted since first being placed on public view in London in 1953. Although there is no evidence to connect the work with Vittoria Colonna, the strong resemblance in style between this and Nos. 408 and 455 has suggested to all that it was made as a presentation drawing for that great lady. As was traditional in Italian Madonna representations, death and life are both interpreted here. The sleeping Christ Child in Italian art has been shown invariably to foreshadow the death of the adult Christ, and here the pose with the hanging arm is strikingly Pietà-like. Mary, her head crowned with a diadem of love, like that of the Magdalen in the Florence Cathedral *Pietà*, meditates and looks downward, as she holds out a book. Joseph props his chin on his hand. The sands in the hourglass below have more than half run out. The reference seems to be to Michelangelo's own meditations on the approaching end of life, numerous in his poems and letters, and doubtless the subject of many a conversation with Vittoria Colonna. St. John the Baptist, patron saint of Florence, enjoins silence, so as not to waken the sleeping Child. Angels, lightly sketched in the background, were apparently rejected by Michelangelo, but could not be entirely rubbed out. The technique is on a level with that of the most finished presentation drawings, both for Cavalieri and for Vittoria Colonna. The refinement of surface and contour can be appreciated only with a magnifying glass. It is perhaps typical of the confusion still attending Michelangelo criticism that some scholars who accept this drawing should reject the *Children's Bacchanal*, No. 361, with whose style and technique this is identical down to the last form and the last touch of the chalk.

438. *Madonna and Child*
1535–40(?)
Black chalk, red chalk, and white pigment, cartoon on prepared paper, 21⅜ × 15⅝″, folded, patched, cut down, relined
FLORENCE, CASA BUONARROTI, 71 F

This beautiful cartoon, once considered a kind of archetype for Michelangelo's drawings, was rejected about sixty years ago as a work of Bugiardini, a minor master with whose style it would seem to have little to do. Scholarly opinion is still divided on the subject, although of late the balance has tipped in favor of authenticity. Interestingly enough, the one writer who still rejects the work as a Michelangelo witnesses to its high quality, and scorns the Bugiardini attribution but can produce no other. The difficulty in accepting this great cartoon may be somewhat diminished if another dating is contemplated than the usual one around the period of the Medici Chapel. The soft, loose contours, the broad, open hatching, the free shapes, and sometimes wild turns of glance, are typical of many of the drawings for the *Last Judgment*, particularly the composition and figure sketches. So, unexpectedly, is the high polish of the one finished portion, the masterly body and arm of the Child. In fact, Michelangelo's ability to produce in painting a perfect surface of this marmoreal smoothness and finish continued at least through the paintings in the Pauline Chapel. The *Crucifixion of St. Peter*, not completed until 1550, contains several passages of comparable anatomical refinement. But the Virgin's head, with its rather flattened features and haunted glance, recalls especially some of the heads in the upper portions of the *Last Judgment*. If the above approximate dating is correct, then this unfinished cartoon is the last appearance in Michelangelo's art of one of his favorite motives, the Virgin nursing the Child.

439. *Madonna and Child*
1545(?)
Black chalk over red chalk, 9⅞ × 7⅝″, background covered with spurious gold paint, now washed off
WINDSOR, ROYAL LIBRARY, 12772 recto

This fine small drawing was once attributed to Sebastiano del Piombo, but all modern scholars, including authorities on Sebastiano, have revindicated it as a work by Michelangelo. It is obviously close to the *Madonna of Silence*, No. 437, in all save surface finish, since it remains a little sketchier. The passionate directness of the maternal embrace, however, will reappear only in Michelangelo's very latest work.

440. *Holy Family with Saints*
1553
Black chalk, 7′ 7¾″ × 5′ 5⅜″, cartoon composed of 25 folio sheets, each 24 × 18⅞″ with slight overlap, mounted on panel in the sixteenth century
LONDON, BRITISH MUSEUM, W. 75

This is one of the three surviving cartoons by Michelangelo. It has been shown that the cartoon was still in Michelangelo's house at his death, for it is listed in the official inventory and mentioned in a letter from Daniele da Volterra to Vasari as the cartoon "which Ascanio was painting, if you remember." The miserable picture by Ascanio Condivi, Michelangelo's friend and biographer, is still in the Casa Buonarroti. It has been ascertained that the only years when Vasari could have witnessed Condivi's attempts to paint this picture from the present cartoon were between 1550 and 1553, when Vasari was in Rome. A recent suggestion that Vasari just *might* have seen the work during an earlier stay in Rome from 1542 to 1546 can hardly be maintained. If Condivi had received such an honor as this from Michelangelo, it would certainly have been mentioned in his life

of the artist, published in 1553. The cartoon must, therefore, have been made available to Condivi after the book had gone to press, possibly only a matter of months before Vasari's departure from Rome. There is no evidence that anyone save Michelangelo did any of the drawing. The recent contention that because the heads dimly seen at the top are not noted in the inventory they must have been added by Condivi does that individual too much honor. The tragic intensity of these heads is completely misunderstood in Condivi's inept painting.

The subject of the cartoon has never been clearly established. The Virgin listens to a young man, variously identified as St. Julian and the prophet Isaiah, while she touches or pushes St. Joseph with her left hand. The Christ Child plays between her feet. The little St. John the Baptist appears at the right. Five saints, or shepherds, can be made out in the background. Whatever the cartoon represents, it certainly cannot be the Epiphany, as the old documents say. In Condivi's painting he mistook Michelangelo's first head of the Virgin, considerably to the left of the present head, for a female saint, and added one, complete with mantle. The second head was in profile, and a very Greek profile at that. Finally Michelangelo brought it round in three-quarters view again, leaving the profile untouched, with oddly Picassoid results. For all the immense bulk and nebulous extent of the figures, they move and speak with an uncanny grace. The High Renaissance, long vanished in fact, returns in a spectral way through the measured harmony of these forms and faces. "Isaiah" and the Virgin are strikingly beautiful; so are the miraculous hands, and so are the heads and bodies of the children. From the technical standpoint, the cartoon should be studied with care, since the date can be so nearly pinpointed. The floating contours appear throughout all the figures, in a highly developed stage, save only in the roughly drawn background heads. These floating contours persistently merge with the surrounding atmosphere, to produce the dissolution of form we have noted in the late *Crucifixion* and *Annunciation* drawings—a kind of common substance in which form and space have merged. The background heads are merely struck down, with great blows of a blunt stick of black chalk, and left undefined. They may be compared in roughness and in expressive intensity to certain passages in the Rondanini *Pietà* in Milan, and indeed in other unfinished works of Michelangelo's sculpture.

441. *Madonna and Child*
1560–64(?)
Black chalk, 10½×4⅝", patched at right-hand corners
LONDON, BRITISH MUSEUM, W. 83

Perhaps the last drawing we possess from Michelangelo's shaking hand. Again in total nudity (though filmy drapery was doubtless intended) the essential forms of Mother and Child unite in a blinding embrace,

> Extinguish sight and speech,
> Each on each.

Through all the tempest of floating contours the majesty of Michelangelo's vision of form is undimmed, perhaps more beautiful than ever.

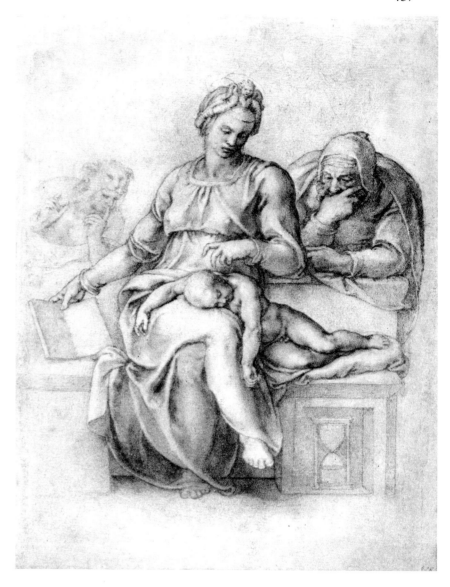

437

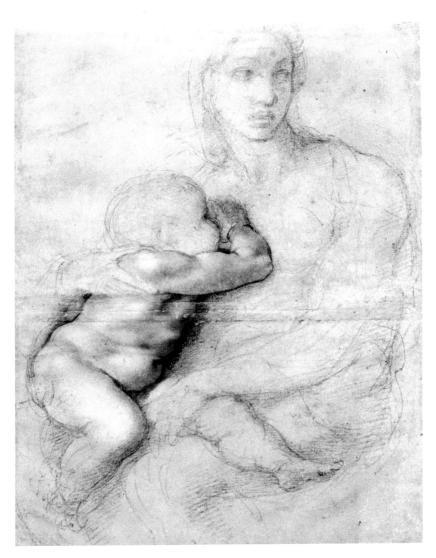

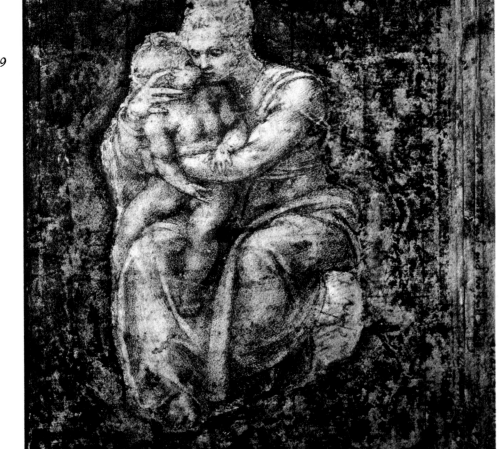

439

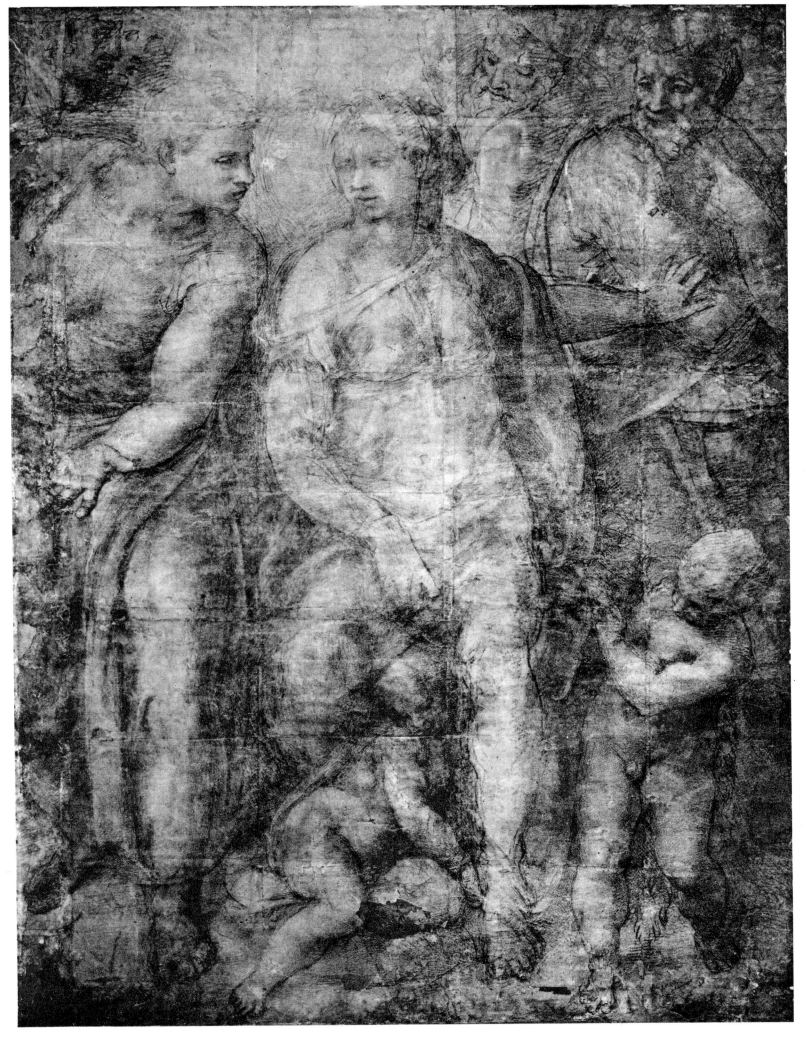

440

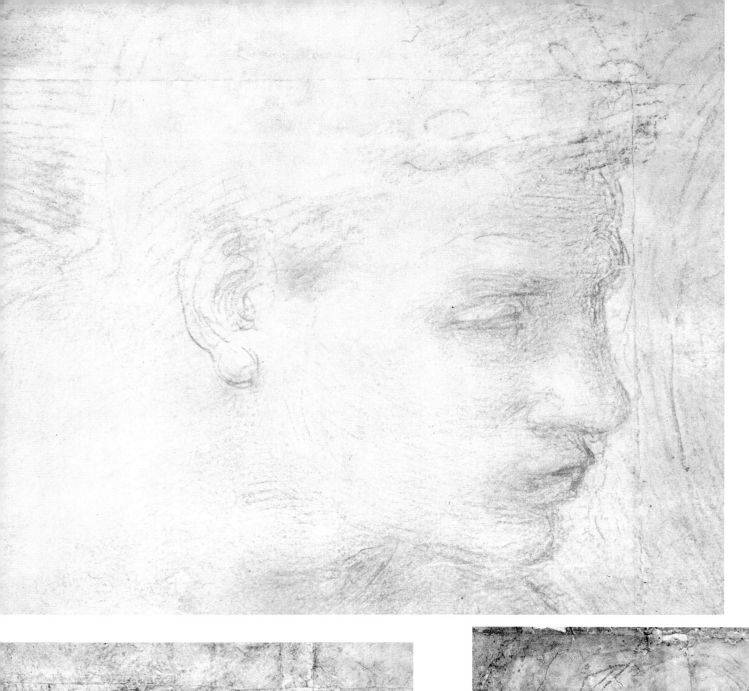

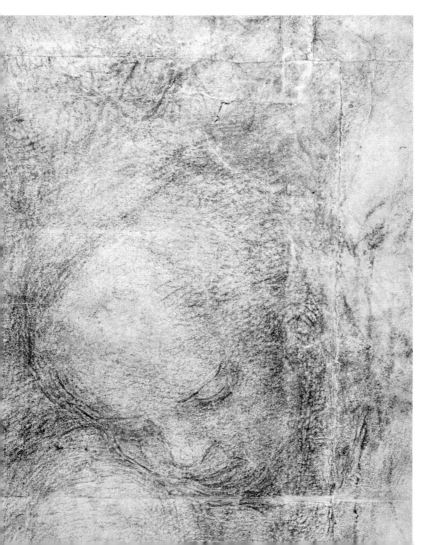

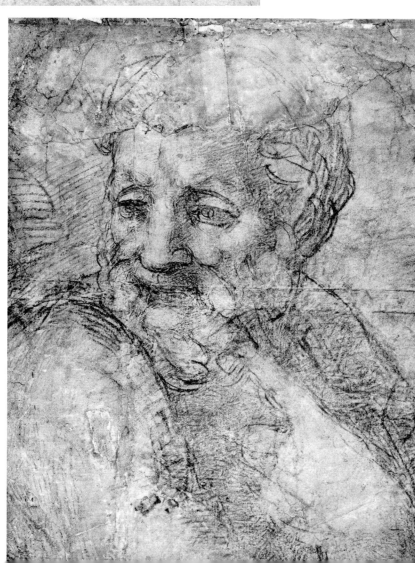

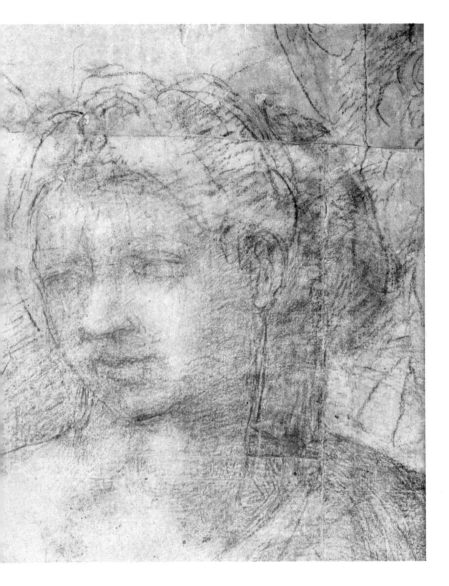

details of 440

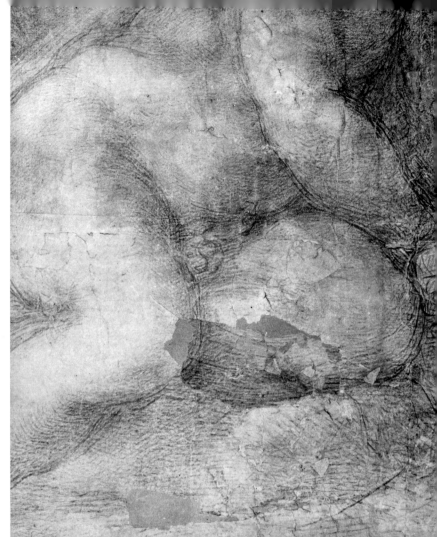

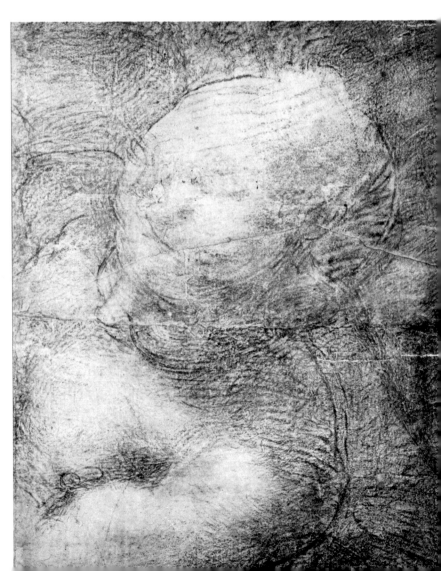

details of 440

314

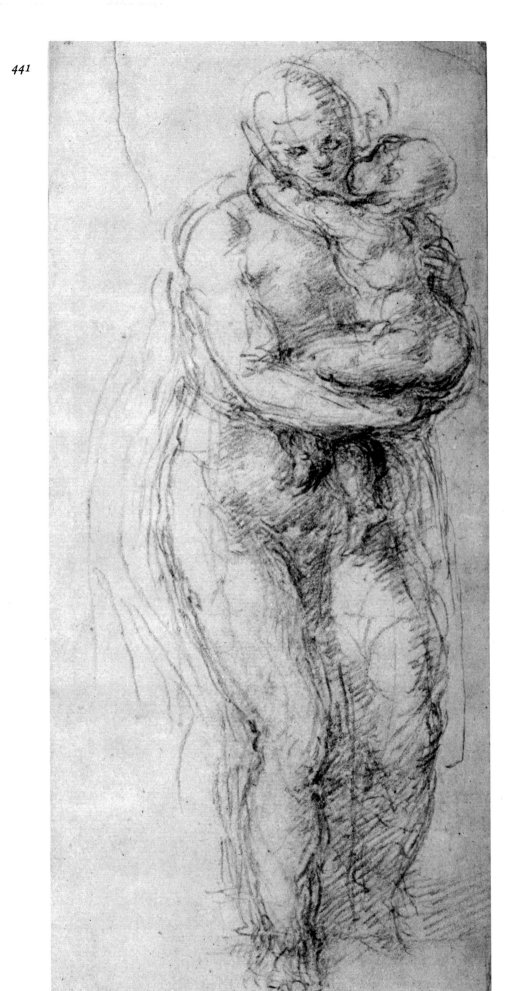

22

Drawings of New Testament subjects. Rome, 1540–55

The Expulsion of the Money-changers from the Temple, 1550–55

Seven drawings, comprising a much larger number of separate sketches, record various stages in the evolution of a painting illustrating the incident recorded in the Gospels (Matthew 21: 12–13; Mark 11: 15; John 2: 14–16) in which, immediately after His entry into Jerusalem, Christ drove from the Temple the money-changers and sellers of doves. It has been proposed that this series of drawings was intended for a small painting by Marcello Venusti, now in the National Gallery in London. This is unlikely. It is more probable that Michelangelo had a monumental composition in mind, perhaps in connection with the Pauline Chapel, whose frescoes were completed in 1550. Although there is no evidence, the most reasonable candidate for the honor is the lunette over the entrance. The Purification of the Temple was a typical Counter-Reformation subject. Soft as the figures are, the style still has much of the grandeur of the Pauline frescoes about it, and the final version is closely related to the *Holy Family with Saints* cartoon, No. 440, dated in 1553. It is very difficult to determine the exact order in which the drawings were done; they are given here in a sequence which follows the most recent one with some changes.

442.
Black chalk, 10⅞×5⅞″, cut down at left, right, and top; part of piece removed from right pasted onto No. 443
LONDON, BRITISH MUSEUM, W. 76 verso
(for recto see No. 446)

443.
Black chalk, 7×14⅝″, cut down at top, made up of six separate pieces, including part of one from No. 442
LONDON, BRITISH MUSEUM, W. 78 verso
(for recto see No. 447)

444.
Black chalk, 6⅝×5½″, cut down
LONDON, BRITISH MUSEUM, W. 77 verso
(for recto see No. 445)

445.
For medium and dimensions, see No. 444
LONDON, BRITISH MUSEUM, W. 77 recto
(for verso see No. 444)

446.
Black chalk, 5⅞×10⅞″, cut down at left, right, and top
LONDON, BRITISH MUSEUM, W. 76 recto
(for verso see No. 442)

447.
Black chalk, 7×14⅝″, cut down at top
LONDON, BRITISH MUSEUM, W. 78 recto
(for verso see No. 443)

In No. 442 Michelangelo drew Christ from the back, with His right arm raised, against a background of arches. Over the arches he tried out a front view of Christ. Turning the sheet on its side, and supplying the missing portion from No. 443, we find a running Christ seen from the front, the right arm hiding the face. Below Him the figure is studied lightly, the face no longer concealed. The woman with a pot makes her first appearance on No. 443, the missing piece, but this is composed of so many fragments that it is impossible to tell where the other figures came from or what relation they have to the scheme. On No. 444 Christ is sketched in five slightly different poses, always from the front. The next stage is apparently a more elaborate analysis of the positions of the elements of the torso, pasted onto a drawing for *Hercules slaying Cacus*, No. 473, to which the raised right arm is not unrelated. Next comes No. 445, a dense and compact arrangement of figures massed about Christ, very close to the block grouping in the *Crucifixion of St. Peter*, but relatively inert even though the spiral motion of Christ has already occurred to Michelangelo. Number 446 develops a more organic, richly articulated composition, with many foreshortenings and *contrapposti*. For the first time the whip is visible in Christ's hand. His figure has been studied again at the right, in a more carefully considered relationship to

the diagonal of the table He is overturning. The final stage, No. 447, which was actually followed by Marcello Venusti, would fit perfectly into a lunette composition. It is unexpectedly explosive. The figures erupt in waves on either side of the beautiful, destroying Christ, Whose face and forward movement, and the twist of Whose body, are very close to the Isaiah of the *Holy Family* in No. 440, while His raised right arm is remembered from Christ the Judge of the Sistine Chapel. The magnificent composition, in which the baskets of fruit and doves are now carefully drawn, shows the full dynamism of Michelangelo at his grandest. (He must have been over seventy-five at the time, and in ill health.) The tremulous, floating contours are almost identical to what we find on a grander scale in the surface of No. 440, which therefore provides it with a believable date.

442

443

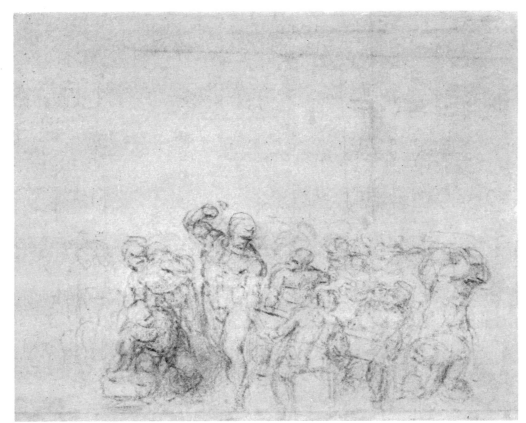

445

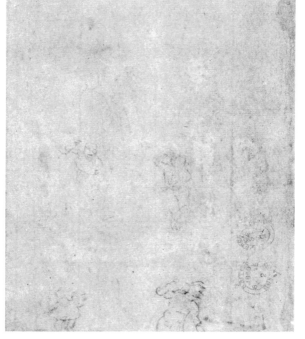

444

446

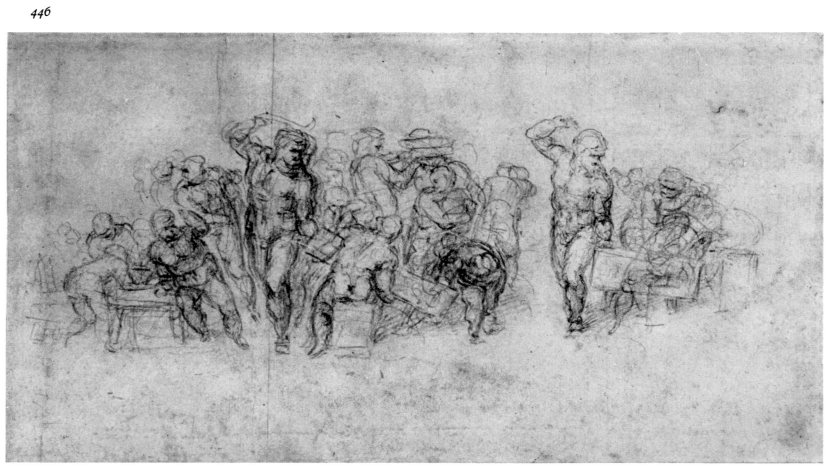

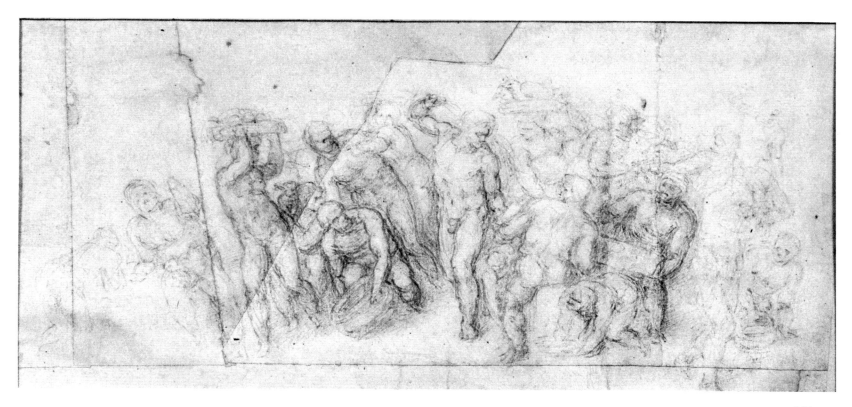

447

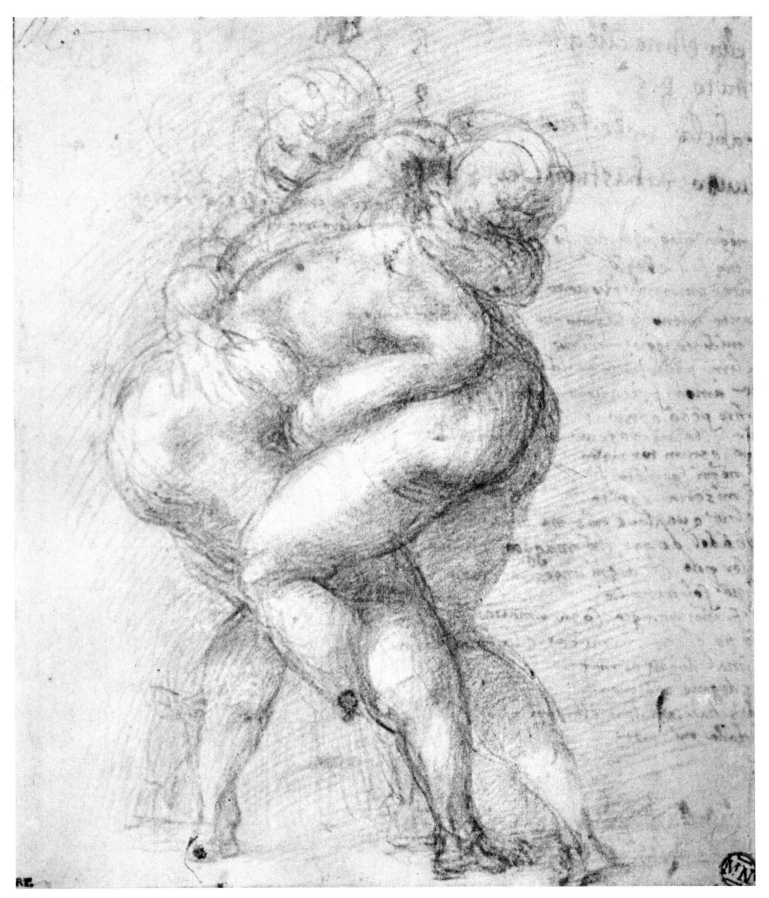

465

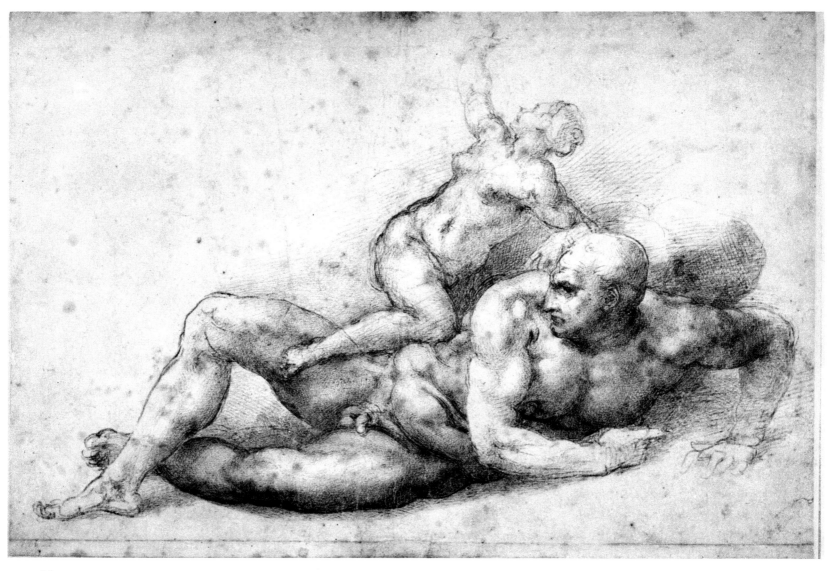

466

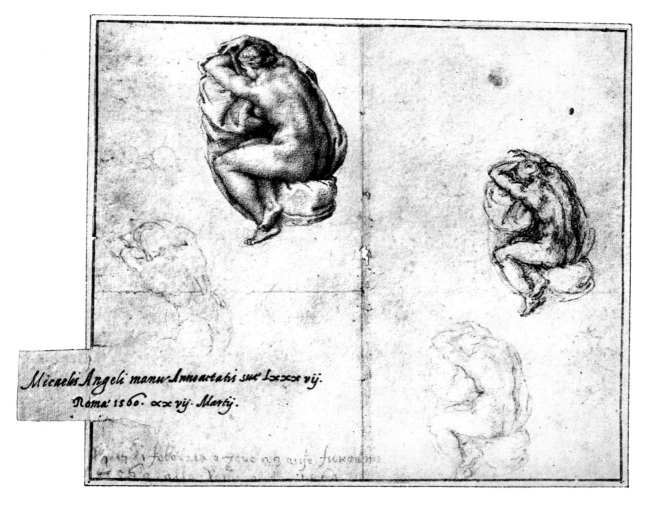

Micaelis Angeli manu Immortalis sue Lxxx vij.
Roma 1560. xx vij. Martij.

467

Saints in the Wilderness, 1556

Studies of individual saints are rare in Michelangelo's work unless connected with specific commissions. Drawings for a *Penitent St. Jerome* and a *St. John the Baptist in the Wilderness* make a sudden appearance in the artist's later years. It is noteworthy that in 1556 he stayed for a while with some hermit monks in the mountains above Spoleto, and on his return wrote to Vasari, "One cannot find peace except in the woods." Possibly both the *St. Jerome* and the *St. John the Baptist* studies reflect this sojourn. They are both shown in solitude and in meditation.

468. *Kneeling St. Jerome in the wilderness*
1504–6; 1556
Pen, 11¼×8¼″, cut down, folded, heavily corroded
PARIS, LOUVRE, 705

Connections have been observed between this remarkable drawing and Michelangelo's early work, and the words "Saint Jerome" at upper right are in a youthful handwriting. Yet, as has been clearly shown, the drawing was heavily reworked in a darker ink, probably by Michelangelo himself. The type of the Kneeling St. Jerome beating his breast with a stone in the wilderness arises about the middle of the fifteenth century in Florence, and is rare after the early sixteenth century. Michelangelo seems to have picked up in his old age an earlier drawing full of the characteristic pen hatching of his early style, and converted it to the same vein of intense, individual meditation we have found in the Old Testament series. The head of St. Jerome bears a superficial resemblance to that of St. Bartholomew in the *Last Judgment*, but this does not extend beyond the fact that they are both bearded, both bald, and both in profile. The aquiline nose and arching eyebrow are to be found in one of the late *Crucifixion* drawings in London, No. 424, so strikingly similar as to suggest that Michelangelo embodied in both representations the features of a revered monk.

469. *Two sketches for a St. John the Baptist*
1556
Black chalk, 4½×4⅜″, cut down
OXFORD, ASHMOLEAN MUSEUM, P. 338 recto
(for verso see No. 470)

These two beautiful little sketches, showing St. John the Baptist nude in the wilderness, dipping a cup into a stream, were used by Daniele da Volterra for a painting of this same subject, which survives in two versions. The heavy, soft, blotchy outlines are typical of Michelangelo's graphic work datable in the mid 1550s, such as the *Agony in the Garden* and *Pietà* sketches, Nos. 448 and 459.

470. *Sketches for a St. John the Baptist*
1556
For medium and dimensions, see No. 469
OXFORD, ASHMOLEAN MUSEUM, P. 338 verso
(for recto see No. 469)

Recently rediscovered sketches for the legs of the same figure twice studied in No. 469.

471. *Sketches for a St. John the Baptist, for the tomb of Cecchino Bracci, and for a double staircase*
1544; 1556
Black chalk, 7½×7¾″
FLORENCE, CASA BUONARROTI, 19 F recto
(for verso see No. 472)

The youth Cecchino Bracci, nephew of Michelangelo's close friend Luigi del Riccio, died in 1544, and Michelangelo was asked to provide both a series of poetic epitaphs for him and a tomb design. The monument was actually erected in Santa Maria in Araceli, and is no credit to Michelangelo. But the sketches are very interesting, containing motives remembered from the Medici tombs in San Lorenzo a quarter of a century before, especially consoles in various permutations and combinations running through both recto and verso. It is impossible to tell what the staircase design was meant for, but it might be an idea for the staircase of the Capitoline. The figure is obviously identical with the St. John the Baptist sketched in Nos. 469 and 470, although there has been an attempt to connect it with the angel pulling souls into Heaven by means of a rosary in the *Last Judgment*. The figure may have arisen in Michelangelo's mind from that pose, but is very different in its final version and was certainly drawn later.

472. *Sketches for the tomb of Cecchino Bracci, and for a St. John the Baptist*
1544; 1556
For medium and dimensions, see No. 471
FLORENCE, CASA BUONARROTI, 19 F verso
(for recto see No. 471)

Again Michelangelo used a corner of his earlier drawing of Cecchino Bracci's tomb for a *St. John* sketch. Could there have been some connection in his mind between the dead boy and the idyllic figure of the youthful anchorite? The lightly sketched male figure, faintly visible underneath the tomb sketches, is not identifiable.

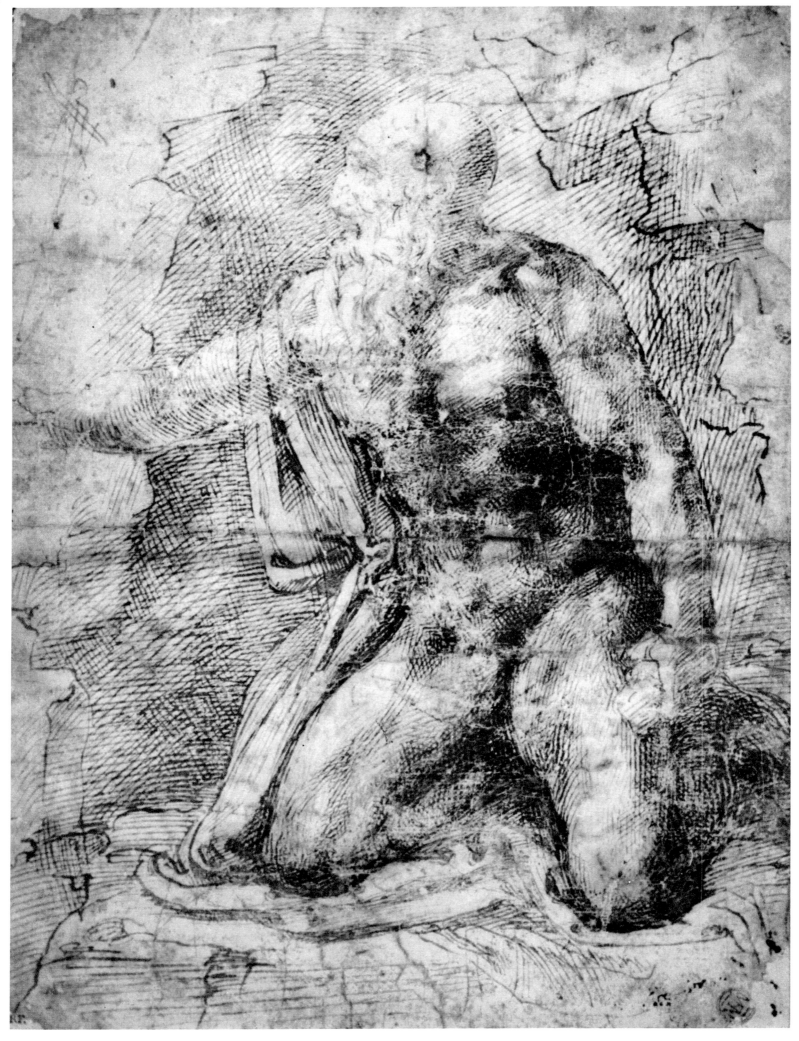

469

470

471

472

Classical subjects, 1550–60

Despite Michelangelo's own vehement disclaimer of interest in any subjects not directly related to salvation, in a famous sonnet written during his later years in Rome, he was scarcely in a position to forget his classical heritage. Living in the Macello dei Corvi, he was surrounded by the antiquities of the Forum of Trajan, and was also associated for years with the reconstruction of the adjacent Capitoline Hill as a center in which every Roman would be constantly reminded of the ancient splendor of the city. In addition to the great *Brutus* with its strong component of Florentine republicanism, there are also a few drawings which can be connected with classical subjects.

473. *Sketches for Hercules Slaying Cacus, and for Christ Expelling the Money-changers from the Temple*
1550–55(?)
Black chalk, 8¼×9⅝″
OXFORD, ASHMOLEAN MUSEUM, P. 328 recto

The two sketches for an *Expulsion of the Money-changers from the Temple* (discussed on page 00) were inserted into this drawing at a much later date and have nothing to do with the subject of the other sketches beyond the raised arm. These have been placed at all sorts of periods in Michelangelo's career, but the late dating suggested here corresponds to the present and very reasonable majority opinion. The drawings are clearly in the same style as the entire group of late sketches previously analyzed. They are especially close to the studies for *David and Goliath*, No. 463. It is a bit difficult to understand why there has been so much confusion about the subject matter of these sketches. Admittedly the upper ones show only faint indications of a weapon in the hand of the dominant figure. But in the final and richly modeled sketch toward the lower right, the outlines of an enormous club can be clearly traced running behind the head of this figure, which has been drawn three times, and some of the *pentimenti* can almost be confused with the weapon.

474. *Aeneas leaving the couch of Dido*
1550–55
Black chalk, 5⅜×7⅛″, cut down
HAARLEM, TEYLERSMUSEUM, A 32 verso
(for recto see No. 504)

This is another example of a late composition by Michelangelo utilized by his pupil Daniele da Volterra, in this case for a painting now in a private collection in Sweden. Whether these sketches were really made for Daniele, of course, remains, as in the similar instance of compositions used by Marcello Venusti, an open question. The beautiful little drawing, with its broad, smooth movements of bodily masses and its soft but strong contours, is typical of Michelangelo's drawing style of the 1550s. All attempts to attribute this sketch itself to Daniele have long since been abandoned. Aeneas is shown obeying the gods' command and going off to found Rome, a wonderful figure, full of divine inspiration. Poor Dido reclines in the background in a pose recalling the river gods of the Medici Chapel. The purpose of the architectural sketches is not clear.

475. *Aeneas leaving the couch of Dido*
1550–55
Black chalk, 4×2⅞″
LONDON, COUNT ANTOINE SEILERN

This only recently known but very powerful sketch is apparently a later stage of the composition of the two foreground figures in No. 474, with the position of Aeneas' right arm more clearly defined, and the little Astyanax now shown tugging his father forward in a typical childish way.

476. *Rape of the Sabines*
Black chalk, 4½×3⅞″
HAARLEM, TEYLERSMUSEUM, A 24 recto

Considering the close relation of this beautiful little sketch with the other composition sketches datable in the 1550s, it is difficult to understand the reluctance of a number of scholars to concede its authenticity. It is extremely close in surface handling and in contour to the preceding sketches of classical subjects, and may have had some connection with Michelangelo's work for the Capitoline projects. After all, as has been recently demonstrated, the Rape of the Sabines laid the foundation of Roman family life, and was as necessary to the existence of Rome as Aeneas' earlier decision to leave Dido. This is a very fresh and free little composition whose relation to a long series of later Mannerist and Baroque representations of the subject remains to be explored.

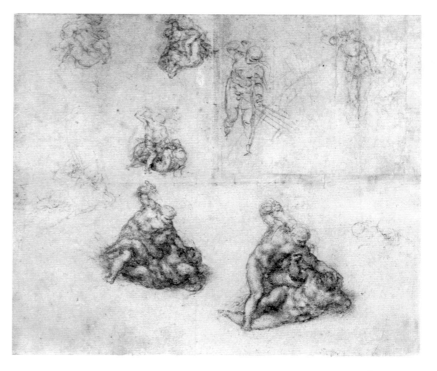

473

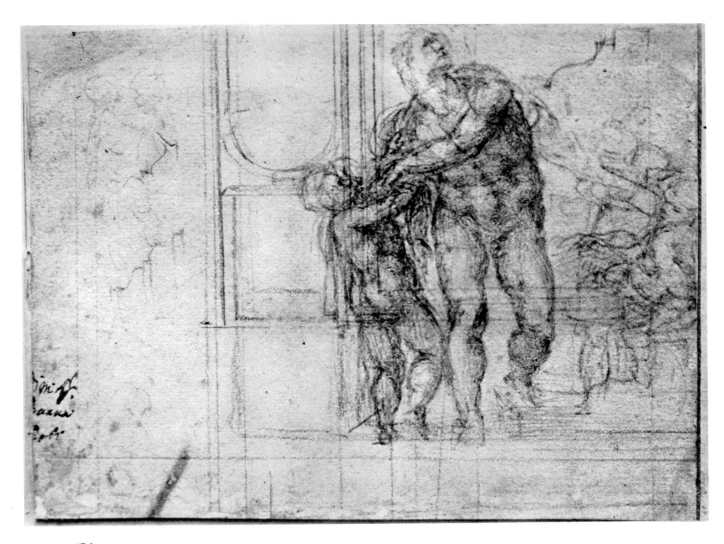

474

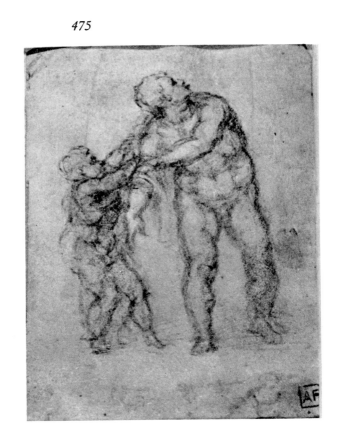

475

476

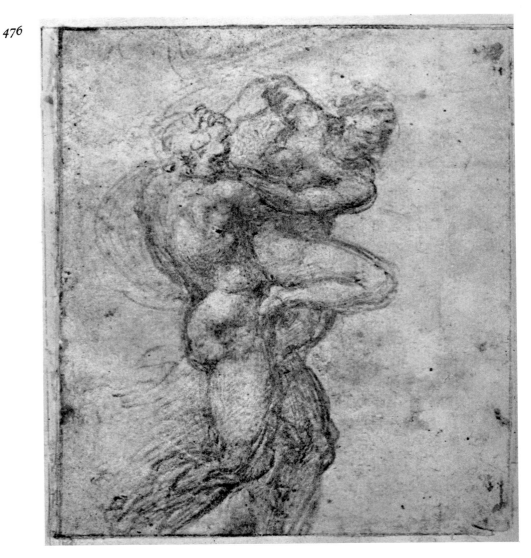

Miscellaneous figure studies, 1550–60

477. *Male torso*
1550–55(?)
Black chalk, 9½×7″
NEWBURY, DONNINGTON PRIORY,
G. E. GATHORNE-HARDY, recto

This magnificent late study may, like No. 478, possibly be a preparation for one of the late *Pietàs,* but there is nothing to indicate this clearly. What is indubitable, and fascinating, is the effect of the multiple contours fused with the hatching in producing a richly unified surface. The left shoulder is restudied once, the right twice.

478. *Study for head and shoulders*
1550–55
Black chalk, 3¾×5¾″
FLORENCE, CASA BUONARROTI, 46 F recto
(for verso see No. 458)

Clearly inseparable from No. 477 and done at the same time. There is only a slight change in the direction of the head and shoulders.

479. *Study of a right arm*
1550–55
Black chalk, 4½×6¼″
LONDON, BRITISH MUSEUM, W. 80

Often connected with the *Last Judgment,* this sketch is undoubtedly much later, and closely related to the preceding two, if a bit softer in contour.

480. *Sketch of a left leg*
1550–55
Black chalk, 11⅜×8¼″
SAN MARINO, CALIFORNIA, HUNTINGTON LIBRARY

The powerful anatomical study of a left thigh has been connected with the *Last Judgment,* but the treatment seems much more summary than the style of that period. It is preferable to connect it with the late series after the Pauline Chapel. The delicately indicated arch is so far a mystery. The poetical lines have been securely identified as a draft of a well-known sonnet by Michelangelo.

481. *Crow (portion of sheet)*
1544
Pen, 8½×9⅛″ (whole)
FLORENCE, ARCHIVIO BUONARROTI, XIII, fol. 33

This wonderful little sketch, doubtless the work of a few seconds, simply indicates Michelangelo's address in the Macello dei Corvi (Crow Market). A few touches, a bit of whimsy, and yet what power!

477

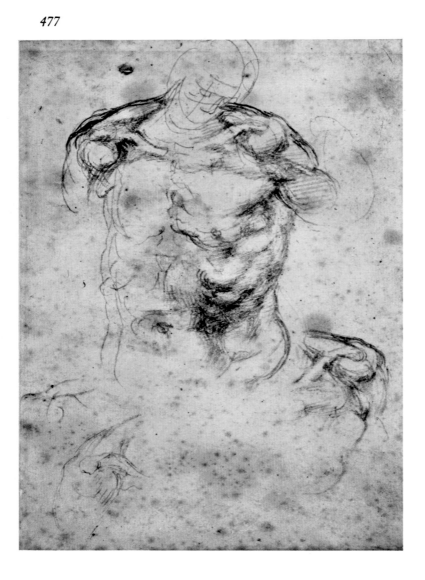

478

479

480

481

24

Drawings for the Capitoline Hill. Rome, 1538–50

The exact date of the great project for the transformation of the old and partly ruined buildings on the Capitoline Hill into a civic center worthy of Counter-Reformation Rome is still a matter of controversy. At the time of Michelangelo's death, remarkably little beyond the double-ramp stairway leading to the Palazzo del Senatore (see No. 471 for a possible sketch) had been built. The engravings by Dupérac (differing among each other in details) show the palaces substantially as at present, but they date only after Michelangelo's death. It has been credibly maintained, however, that the style of the buildings indicates that Michelangelo designed them before he worked on St. Peter's, even though the projects may have been modified in detail later on. They cannot be reconciled with the style of his late architectural works. Accordingly, the drawings generally connected with the Capitoline palaces, and a considerable group of designs for capitals brought forward for the first time in this connection, ought to fit somewhere in the late 1530s and early 1540s. Nothing more accurate can yet be proposed.

482. *Sketches for the Palazzo dei Conservatori(?)*
1538–50(?)
Black chalk, 16¼ × 10¼″
OXFORD, ASHMOLEAN MUSEUM, P. 332 verso
(for recto see No. 494)

This recently discovered set of sketches may possibly contain, among other things, an elevation for a portion of the façade of the Palazzo dei Conservatori, with alternating gabled and arched pediments. This seems to have been drawn over at least two sketched plans for a colonnade with coupled columns. The section at the top of the sheet has been considered an indication of the interior of a dome, but the convergence of the lines may only show that Michelangelo did not always rule well in his old age (see, for example, the tilting Crosses in the *Crucifixion* drawings).

483. *Sketches for the Palazzo dei Conservatori(?)*
1538–50(?)
Black chalk, 16½ × 11″
OXFORD, ASHMOLEAN MUSEUM, P. 333 verso
(for recto see No. 495)

Turned vertically, the drawing shows, very faintly, a giant order of pilasters embracing a second story of pedimented windows over a first story of arches. This seems to be related to the Palazzo dei Conservatori, the reconstruction of which was started only in 1563. The remaining architectural sketch-es are even harder to identify and date. The staircase designs may be connected with Michelangelo's sheet upside down, where one bay of an attic story with hanging festoons appears. This is so far unidentifiable. Also, the apses of chapels are still an open question. The splendid life study of a hanging right arm is so close in style to the drawings for the Pauline Chapel as to suggest that the whole sheet dates from the 1540s.

484. *Ionic capital*
1538–50(?)
Red chalk, 5¼ × 8⅜″, cut down, patched at upper right
LONDON, BRITISH MUSEUM, W. 21

A remarkably consistent series of studies of Ionic capitals has generally been dated toward the outset of Michelangelo's architectural career, in the second and third decades of the sixteenth century. There are many reasons to doubt this traditional view. There are no Ionic capitals in Michelangelo's early work, and the few studies of ancient Ionic models that do appear in the early group do not look like this. The style of the present series, roughly contoured, broadly hatched, looks very late. They have a power, a freedom, and in general a majestic disregard of classical sources nowhere to be found in the early work. Finally, No. 490, probably the last of the series, can scarcely be connected with anything other than the Ionic capitals of the lower story of the Palazzo dei Conservatori. These posed a very special problem. In this revolutionary structure Michelangelo was building what has been accurately described as a stone scaffolding. Ionic capitals were essential at this point, to distinguish the smaller columns from the embracing Corinthian order. But the conventional Ionic capital had severe disadvantages. Its volutes provided flat front and rear faces, and scroll-shaped sides. Michelangelo needed a more richly articulated form which would lead the eye inward, from the compound piers of the façade to the paneled ceiling of the portico. This drawing shows his difficulty, in a rapid perspective study of a capital on traditional lines, with a fluted necking band, to try and lead the eye more easily round the corner.

485. *Ionic capital*
1538–50(?)
Black chalk, 2½ × 3⅜″, cut down and spotted
FLORENCE, CASA BUONARROTI, 82 A

This very grand sketch eliminates the square abacus of No. 484, with its egg-and-dart decoration, and moves the fluted necking band up so as to be embraced by the volutes.

486. *Ionic capital*
1538–50(?)
Black chalk, 2×4¾″, relined
FLORENCE, CASA BUONARROTI, 86 A

A tentative sketch, quickly abandoned, but very significant.
Michelangelo has tried here to combine the Doric capital,
which really does lead the eye inward, with Ionic corner
volutes, but has not figured out how these should sprout
and from where.

487. *Ionic capital*
1538–50(?)
Black chalk, 2½×3⅛″, cut down and spotted
FLORENCE, CASA BUONARROTI, 87 A

What is essentially a lofty and very rich Roman Doric
capital is now provided with volutes which issue organically
from a band of ornament.

488. *Ionic capital*
1538–50(?)
Black chalk, 3⅜×6½″, cut down, relined, spotted
FLORENCE, CASA BUONARROTI, 56 A

This may be the next stage. A more monumental issuance
of the volutes from just above the echinus is defined, and
for the first time they are united with the necking band by
a double festoon, ancestor of the single festoon found in the
capitals as actually carved. Michelangelo has also studied
means of connecting the molded abacus with the architrave
by means of little brackets. The powerful contours of the
Doric core are particularly suggestive of Michelangelo's
drawing style in the 1540s.

489. *Ionic capital*
1538–50(?)
Black chalk, 2⅝×3⅞″, cut down and relined
FLORENCE, CASA BUONARROTI, 83 A

Apparently the next stage, the corner volutes growing more
naturally and less stiffly from the echinus, with its egg-and-
dart molding, and a single festoon, much like the festoons
of the actual capitals. The idea of the corner volutes, and
perhaps the entire Ionic-Doric combination, derives from
the Temple of Saturn, which stands in the Roman Forum
directly behind the Capitoline Hill. Michelangelo did not
have to go far for his inspiration. Nonetheless, he has designed
a capital more refined and more unified than the Roman
original.

490. *Ionic capital*
1538–50(?)
Black chalk, 3⅜×6½″
FLORENCE, CASA BUONARROTI, 55 A

This is almost the final stage. On the right Michelangelo is
already experimenting with the ideal of drooping, canted
volutes, closely related to the capitals as executed including
the profile of the abacus. But only the capital on the right
shows the all-important festoon, which in the actual build-
ing ties the canted volutes to each other and leads the eye so
gracefully from the compound pier to the portico ceiling.
Substantially the same capital was used again for the Ionic
order of the wall tabernacles on the exterior of St. Peter's.

482

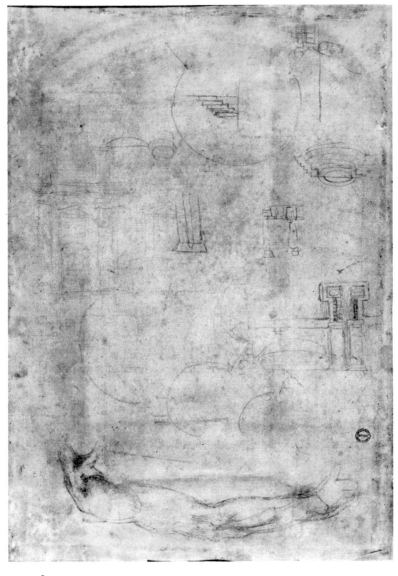

483

484

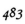

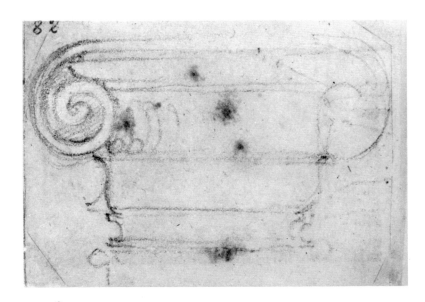

485

486

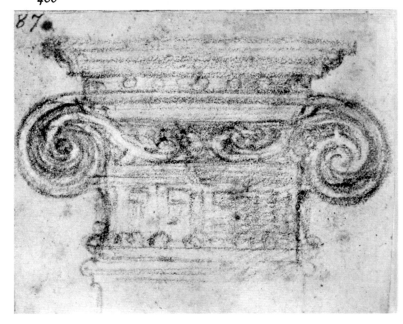

487

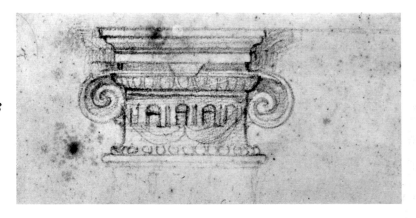

488

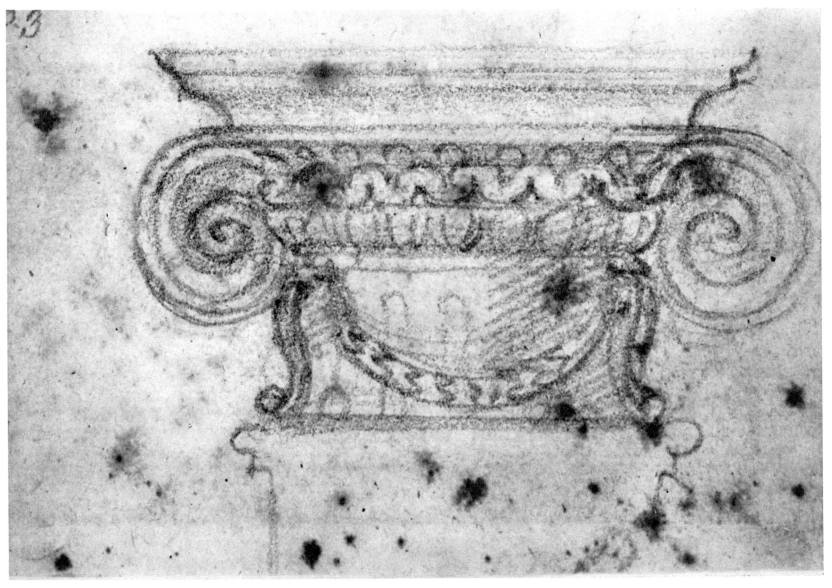

489

490

25

Drawings connected with the Farnese Palace. Rome, 1546–50

Michelangelo's designs for the continuation of the Farnese Palace, interrupted by the death of Antonio da Sangallo the Younger in 1546, transformed a relatively conservative monument in the Bramante-Raphael tradition into a brilliantly original work, of immense importance for the dynamic architecture of the following Baroque period. Unfortunately only a few architectural drawings can be securely connected with the Farnese Palace. The window designs are close to the windows actually built. One of the grotesque masks was certainly used for the frieze of the third story in the courtyard, and the others seem to have been preparations.

491. *Sketches for windows in the Farnese Palace*(?)
1546(?)
Pen, 8 × 5⅝″
ROME, VATICAN LIBRARY, Cod. Vat. 3211, fol. 58 verso

The verses in Michelangelo's writing have been dated in the 1540s, which makes probable a similar date for the architectural sketches around which they were written. The type of tabernacle window, with projecting ears, is closely related to those of the Laurentian Library, and this may have been Michelangelo's initial reaction to the problem posed by the courtyard windows of the Farnese Palace.

492. *Design for a window; house plan*
1546–49
Black chalk, pen, 15¾ × 10¾″, cut down and spotted
FLORENCE, CASA BUONARROTI, 117 A recto

The word "l'Altopascio" in Michelangelo's writing has given rise to the identification of the house plan, probably inked in by a pupil, with the palace on the Piazza Santissima Annunziata in Florence, built by Ugolino Grifoni, administrator of the hospital of Altopascio. It has been recently shown that Grifoni did not buy the land until 1549. The house was built by Ammanati, and Michelangelo's plan, with all the rooms nicely labeled, was not followed. The window design is so close to the rest of the present series, and certainly developed from the preceding sketches, as to make it very probable that it was intended for the Farnese Palace.

493. *Study for a window in the Farnese Palace*(?)
1546(?)
Black chalk, pen and wash, 14⅝ × 16⅜″, cut in half
FLORENCE, CASA BUONARROTI, 124 A verso
(for recto see No. 517)

This upper part of a drawing for a window tabernacle is on the upper part of a sheet whose recto was later used for a plan of San Giovanni dei Fiorentini. The distinction between inner and outer frame and the projecting ears are developed from the sketches in No. 491, but an arched pediment has been substituted, as in the Farnese Palace. The drawing may have been finished by a pupil for presentation.

494. *Study for a window in the Farnese Palace*(?)
1546(?)
Black chalk, pen and wash, white, 16¼ × 10¼″
OXFORD, ASHMOLEAN MUSEUM, P. 332 recto
(for verso see No. 482)

This is perhaps a little farther from the windows as executed, but the drawing is in exactly the same style as No. 495, and may have been an alternative presented to the patron. A gabled pediment seems to be issuing from an arched one, set further back. Consoles, in elevation and in profile, achieve a rich, plastic co-ordination between frame and wall. Again possibly finished by an assistant.

495. *Study for a window in the Farnese Palace*
1546(?)
Black chalk, pen and wash, white, 16½ × 11″
OXFORD, ASHMOLEAN MUSEUM, P. 333 recto
(for verso see No. 483)

This approximates the windows as they were later carried out, with the arched pediments, ram's skull in the pediment upholding a festoon, lions' heads in the corners, triglyphs instead of ears, and many other points of resemblance. However, the windows which were not built until after Michelangelo's death show a number of departures from this rich design, notably the omission of the lower lions' heads and the profile consoles, and the simplification of the moldings.

496. *Grotesque masks; sketch for Hercules and Antaeus*
1527–29; 1546(?)
Red chalk, black chalk, 10 × 13¾″
LONDON, BRITISH MUSEUM, W. 33 recto
(for verso see No. 186)

The sketch of Hercules and Antaeus was certainly done for the monument to be erected in front of Palazzo Vecchio

(see No. 302), and sketched in lightly in black chalk before being finished in red. But the heads have nothing to do with any known Florentine commission, in spite of the numerous ill-fated attempts to connect them with the ornamental masks in the Medici Chapel, which they do not resemble in any respect, least of all in content. They are whimsical to the point of caricature. Grinning, leering satyrs like these, prototypes for Goya, would have seemed a bit odd in a funerary chapel. They are drawn in a style very similar to No. 497, which was certainly used, in a highly ornamentalized form, for the frieze of masks in the Corinthian entablature of the third story of the courtyard in the Farnese Palace. They also recall the demons of the *Last Judgment*, as if Michelangelo were poking fun at these creatures in retrospect—much as he caricatured some of his own grandest inventions for the Sistine Ceiling in the brilliant series of drawings here connected with the façade of San Lorenzo. The style, with its soft, rather heavy contours and free hatching, is easier to understand in the 1540s than two decades earlier.

497. *Grotesque mask*
1546(?)
Red chalk and black chalk, 9¾×4¾″
WINDSOR, ROYAL LIBRARY, 12762 recto

This magnificent and universally accepted study must be quite late. The structure of features and facial muscles, the rhythms of all the curves, are closer to the heads in the foreground of the *Crucifixion of St. Peter* than to anything in Michelangelo's other pictorial works. Also, something of the grandeur of the *Moses*, not finished and set in place until 1542–45, is recalled here as in the Pauline Chapel frescoes. The wildness of the expression—eyes rolling, mouth open, tongue pointed—contrasts magically with the fixity of the head itself. A reduced version of this head, crown and all, was used for the frieze of the third story in the courtyard of the Farnese Palace. Was the head drawn for that or another purpose? There is no way of telling, but Michelangelo must have liked it for it was turned over to pupils for execution, with some changes, as the great keystone mask in the Porta Pia in 1561.

492

491

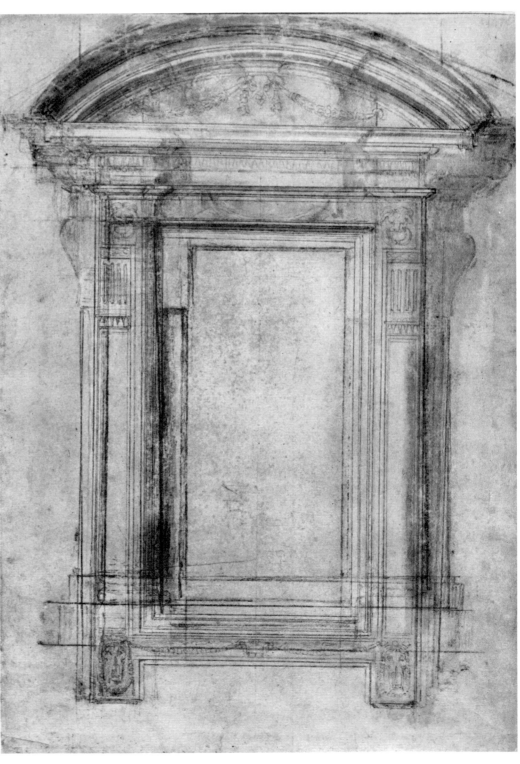

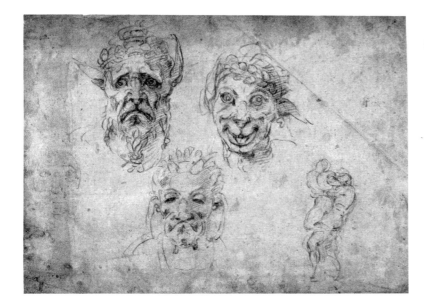

496

497

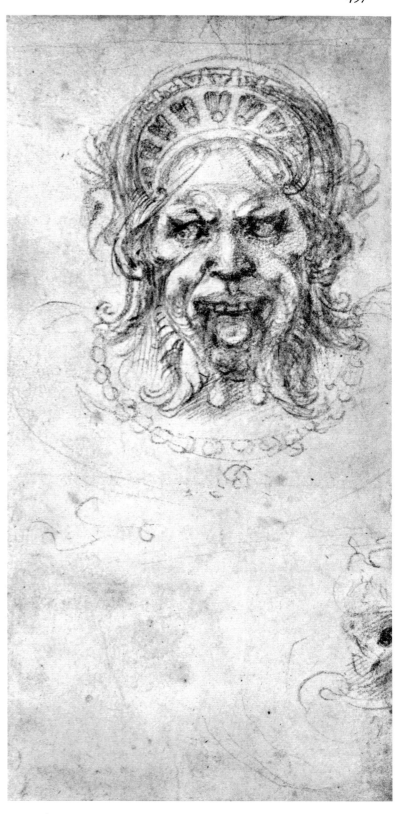

26

Drawings for St. Peter's. Rome, 1546–57

Although St. Peter's was Michelangelo's most ambitious architectural work and has given joy to millions, it brought the aged artist and his later historians and biographers little but misery. Michelangelo was tied to Rome on account of this immense undertaking, when he longed to spend what was left of his existence in Florence. The project went wrong again and again, and the struggles with the Vatican officialdom and with the heirs of Antonio da Sangallo the Younger, most of whose ideas Michelangelo had jettisoned, embittered the artist's last years. He would have been sadder yet if he could have foreseen that his beautiful profile for the dome, so painfully arrived at, would be elevated and weakened after his death by Giacomo della Porta, or that the exigencies of Counter-Reformation liturgy would eventually add a huge nave to destroy his centralized plan. Very few of the drawings remain and many of those are susceptible of the most contradictory interpretations. The sketches include a number of magnificent figures, which it is suggested here were intended for the sixteen colossal statues to form an essential part of the grand design. Their simplicity and majesty entitle these figures to a position dominating the *Urbem et Orbem*. In this swan song Michelangelo would have realized at last his ambition to turn a mountain into a colossus.

498. *Studies for the dome of St. Peter's*
1546
Black chalk, 15¾×9¼″, cut down, folded, patched
HAARLEM, TEYLERSMUSEUM, A 29 recto
(for verso see No. 503)

This important drawing shows an early stage of Michelangelo's ideas for the profile of the dome of St. Peter's, in which neither the exact curve of the dome nor the number of buttresses had been clearly decided. It has been shown that the uniform thickness adopted for the outer shell was not structurally sound and could not have been executed. Also it should be noted that, while the lantern on the dome as shown, and the detailed analysis of the lantern at the upper left, are designed to have eight columns, the lantern sketch at the side shows six and the partial elevation at the bottom (on its side) has twelve. The final solution was sixteen coupled columns corresponding to the sixteen buttresses of the dome below. In July, 1547, Michelangelo wrote to his nephew Lionardo in Florence asking him to obtain the measurements of the height of the dome of the Cathedral of Florence from the lantern to the ground and also the height of the lantern, apparently to compare these with the proportions of his proposed dome. The lantern at the upper left, with its shell-headed windows and its pilasters, shows many points of resemblance to Brunelleschi's great work, but can scarcely be dated after the beginning of the model started in December, 1546, which had paired pilasters in the lower portions of the church. These would have been incompatible with any such solution at the top. This same lantern shows an ingenious scheme for lighting the interior of the dome not through windows in the lantern, but from small openings just below its base, which would then admit a diffused illumination through small hidden windows in the rim of the central oculus. The faint sketch of a figure bending forward and to the left, underneath the lower sketch and almost concealed by it, has been connected with one of the figures at the upper right in the *Crucifixion of St. Peter*. This is by no means certain.

499. *Sketches for windows, profiles of moldings, and the lantern of St. Peter's*
1546
Black chalk, 13⅞×10″
FLORENCE, CASA BUONARROTI, 118 A verso

The window sketches are related to those for the Palazzo Farnese (Nos. 491–95). They seem to have been drawn over the drawings for the lantern, and to be later than No. 498, since the proportions have become more compact in both the upper and the lower study. The volutes have been now more carefully integrated into the entire design.

500. *Study for the dome of St. Peter's*
1546
Black chalk, pen, 10×10⅛″, cut down
LILLE, MUSÉE WICAR, 93–94 recto (for verso see No. 415)

This imposing sheet is the only preserved original drawing which shows the entire appearance of Michelangelo's dome, but it is still in a very tentative phase. The profile has been drawn several times, and the lantern seems extremely hazy as yet. Quite possibly the preceding drawings, Nos. 498 and 499, are actually a day or so later. It is not even clear at this point whether or not there were to be ribs; probably not, since sixteen buttresses are provided for, and only eight divisions of the lantern. The buttresses are given paired columns on high socles, but these are Tuscan; in the final design they are Corinthian, as throughout the basilica, and have no socles. The buttress at the extreme left is shown with the projection

from the drum somewhat exaggerated by the "informative" perspective. The buttresses continue into the attic story and terminate in colossal statues. At this stage Michelangelo wishes to import the circular, or oculus, windows from Brunelleschi's dome in Florence. In fact, the whole design is a compromise between Bramante and Brunelleschi.

501. *Sketch for the lantern of St. Peter's*
1557
Black chalk, 9⅞ × 15⅞"
OXFORD, ASHMOLEAN MUSEUM, P. 344 recto
(for verso see No. 519)

Michelangelo wrote on this drawing, to his friend Francesco Bandini, "Messer Francesco, my dear sir, about the model that has to be made it seems to me that with the Cardinal a figure has been made without a head." These tantalizing words seem to refer to the new scale model of the dome which was made in 1558–61, but their precise significance eludes us. Even at this late date, with the masonry of the drum well under way and the columns and capitals already carved, the exact profile of the dome had still not been determined. Apparently, however, Michelangelo had capitulated to pressure from the officials of the basilica, who objected to his lighting system, and adopted the usual method of illuminating the interior of the dome through the lantern.

502. *Plan for the drum of the dome of St. Peter's*
1546
Pen and wash, black chalk, 21⅞ × 15¼", cut down, patched and restored at lower right, spotted
FLORENCE, CASA BUONARROTI, 31 A

It is hard to understand why a drawing as grand as this must be (as has been recently claimed) the work of an assistant, merely because it was done with ruler and compass. Could Michelangelo not have used these simple instruments? The drawing is so close to the presentation plans for the rare book room of the Laurentian Library and the fortifications of Florence as to make it very unlikely that it was done by another hand. In fact, the slight changes here and there suggest fluctuating ideas in the artist's mind rather than the mechanical execution of a pupil. Michelangelo has planned one of the buttresses in cross section, as an explanation of No. 500, including "the palm" at the left to give Roman measurements, the words "the door of the walkway," and, at the top, "this part which remains white is the wall where the oculi are to be."

503. *Sketches for the lantern of St. Peter's, and for colossal statues*
1546
Black chalk, 15¾ × 9¼", cut down, folded, patched
HAARLEM, TEYLERSMUSEUM, A 29 verso
(for recto see No. 498)

The beautiful volute at the top, seen in elevation, has always been recognized as belonging to the summit of the lantern, and is not far from the volutes actually built after Michelangelo's death by his pupil Giacomo della Porta. It has long seemed to scholars that there must be a connection between the grandiose figures on the rest of the sheet and the dome of St. Peter's. The frames so clearly drawn around four of these figures have been interpreted very reasonably as niches, and connected with projects for the decoration of the interior of

the dome. While it is true that the shapes of these frames do not correspond to those of the interior fields as designed by Michelangelo, and in fact show none of the diminution necessary for fields so placed, the connection with St. Peter's cannot be dismissed, as has recently been attempted, with the contention that the frames "show no objective relation" to the figures and "arose independently from them." On the contrary, the relation between figure and frame is close to that found throughout Michelangelo's work: the figures are in active conflict with their surroundings and project from the shallow niches, as the statues for the second story of the Tomb of Julius II were intended to do and as the two Dukes in the Medici Chapel still do. All four frames went down on the paper along with the figures.

What was Michelangelo's intention, then? It is here suggested that these and the following drawings, several of which also contain architectural forms, were intended for the statues to be placed above the sixteen buttresses. In No. 500 the indications are so slight that sometimes they look like urns rather than statues, but almost all the engravings and paintings of the proposed appearance of the dome show colossal statues in place. Perhaps Michelangelo at first intended them to issue from niches in the attic sections of the buttresses designed in No. 500, and later, after eliminating these excrescences, used the statues as they appear in the engravings, to unify the profile of the whole structure by carrying the eye easily from buttress to dome. Certainly the figures make more sense as statues than as paintings for the interior, where they would succeed only in breaking up the beautiful shapes Michelangelo designed. Stylistically the figures date very close to the time when the dome was being designed, and none of them can really be connected with the Pauline Chapel, as has been tried. Out of the whole series only one, the central figure in the present drawing, is shown seated. All the others are standing, and usually in positions which suggest movement and agitation. Behind the figure at the center left can be seen a gigantic saw, which identifies him as the Apostle St. Simon Zelotes, martyred with this disagreeable instrument. The man at the lower right holds a staff; perhaps he is another Apostle, St. James, patron saint of pilgrims. Some figures in the following drawings hold books and must be understood as Evangelists. One seems to be female. The twelve Apostles (one of whom, St. Matthew, is also an Evangelist), plus the three Evangelists who are not Apostles, plus one female saint, would make up the required sixteen statues. Almost all of the figures lean forward, which would be essential for statues placed so far above eye level.

504. *Sketch of an Evangelist for the dome of St. Peter's*
1546
Black chalk, 7⅛ × 5⅜", cut down
HAARLEM, TEYLERSMUSEUM, A 32 recto
(for verso see No. 474)

This figure, studied a second time at the left, has long been considered an Evangelist and is clearly designated as such by his book. St. John would seem out of the question; the unintelligible lines below the right foot do not assist us in narrowing the identification further. Michelangelo seems to have abandoned the idea of niches in favor of freestanding figures in this and the following drawings. The breadth and simplicity of the masses are in keeping with the notion of a colossal scale. A closer identification of the architectural motives is also impossible, but the doubled columns again suggest St. Peter's. The profiles of cornices, with their slight projections suitable for execution in soft travertine, are very

close to those of the lantern. The fullness and softness of the technique has indicated a late date to all critics.

505. *Sketch of a female saint for the dome of St. Peter's*
1546
Black chalk, $7\frac{7}{8} \times 4\frac{3}{4}''$
OXFORD, ASHMOLEAN MUSEUM, P. 334 verso
(for recto see No. 506)

From the same series. The sheet has also been used for a sketch of two columns flanking an arched aperture, with a trace of a rectangular field above it. These might have been intended for the lantern. The figure itself, with its soft, bold contours and hazy hatching, has always been recognized as late. It has been connected with a possible *Entombment* composition, and is indeed very close to the fragment of a *Descent from the Cross*, No. 451. Given its prominence, the figure could represent St. Mary Magdalen, constantly associated with the Apostles. The plan of a cubic construction at the upper left cannot be identified with any of Michelangelo's known buildings.

506. *Sketch of an Apostle for the dome of St. Peter's*
1546
For medium and dimensions, see No. 505
OXFORD, ASHMOLEAN MUSEUM, P. 334 recto
(for verso see No. 505)

The figure has been changed once or twice, and here and there Michelangelo has used white to assist him in making corrections. This has oxidized, producing a spotty appearance. Like the other figures of the series, this one gains its effect by suggested motion.

507. *Sketches of Apostles for the dome of St. Peter's*
1546
Black chalk, $8 \times 4\frac{3}{4}''$
OXFORD, ASHMOLEAN MUSEUM, P. 336 recto

More sketches of socles and columns are faintly visible at the top and others show through from the verso, now concealed by the mount. Plans show relations of columns to projections, presumably buttresses for the dome. These two figures may represent the same young Apostle, in mirror image. The style is identical to that of the other drawings in the series.

508. *Sketch of an Apostle for the dome of St. Peter's*
1546
Black chalk, $7\frac{1}{8} \times 3\frac{1}{2}''$
OXFORD, ASHMOLEAN MUSEUM, P. 335

A free little sketch, closely related to the preceding drawing.

509. *Sketch of an Apostle for the dome of St. Peter's*
1546
Black chalk, $9 \times 4''$
NEWBURY, DONNINGTON PRIORY,
G. E. GATHORNE-HARDY

Another brief sketch of the same figure as No. 508, with doubled contours clearly visible.

510. *Sketch of an Apostle for the dome of St. Peter's*
1546
Black chalk, $6\frac{3}{4} \times 2\frac{1}{8}''$
LONDON, BRITISH MUSEUM, W. 74

A very airy and delicate little drawing, but as grand as any in the series; possibly for St. Thomas, who is often shown looking up, since he received the Virgin's golden girdle when she was assumed into Heaven.

511. *Diagrams of the vault of the Chapel of the King of France*
1557
Black chalk, red chalk, and pen, $11\frac{1}{4} \times 8\frac{1}{4}''$
AREZZO, ARCHIVIO VASARIANO, Cod. 12, cap. 22

This and the following drawing record the sad history of the vault of the Chapel of the King of France, the right transept of St. Peter's. Michelangelo had already provided an exact model by this time, but because he was prevented by various physical disabilities from supervising the construction in person, the building superintendent, appropriately named Malenotti, made a crucial error, building the wooden centering for the three compartments of the ribbed vault as if they were all the same curve. Apparently the Roman artisans did not understand Michelangelo's elaborate and beautiful design, which can quite accurately be described as a revival of Gothic vaulting principles. On July 1 Michelangelo wrote a letter to Vasari in Florence, describing the catastrophe, which necessitated taking down the vault and ruining many of the blocks which were of travertine—no brickwork.

512. *Plan of the vault of the Chapel of the King of France*
1557
Black chalk, $11\frac{1}{4} \times 8\frac{1}{4}''$
AREZZO, ARCHIVIO VASARIANO, Cod. 12, cap. 24

Apparently Vasari did not understand the diagrams illustrating the preceding letter, so Michelangelo sent this plan on August 17, explaining how the pilasters must rise in the form of ribs to join at the apex of the vault, and how the curve of the vault changes constantly in rising, involving also changes in the coffering and the medallions imbedded in the vault as it rises, and how a single curve for the centering of the whole vault would destroy all this. Michelangelo's concern, of course, is motivated by the involvement of the basic principle of his design for St. Peter's, that inside and out the structure was to be completely unified from ground to summit by a system of vertical pilasters and ribs, determining all the other forms.

513. *Diagram of the vault of the Chapel of the King of France*
1557
Black chalk, $5\frac{3}{8} \times 10''$, cut down
PARIS, LOUVRE, 842 verso (for recto see No. 410)

In an unpublished lecture delivered in Philadelphia in 1964, Charles de Tolnay explained the purpose of this only recently rediscovered and hitherto misunderstood drawing as Michelangelo's analysis of the exact changes that the surface of one vault compartment of the Chapel of the King of France would undergo on its way up.

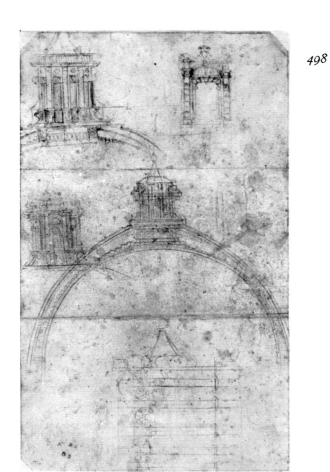

498

499

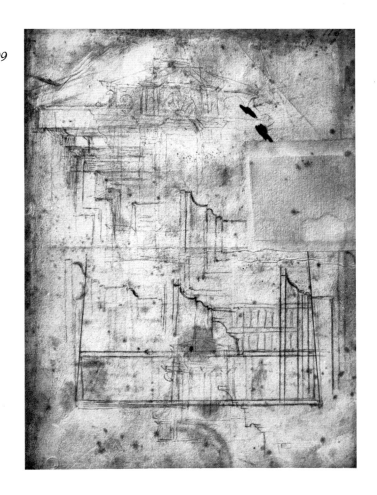

500

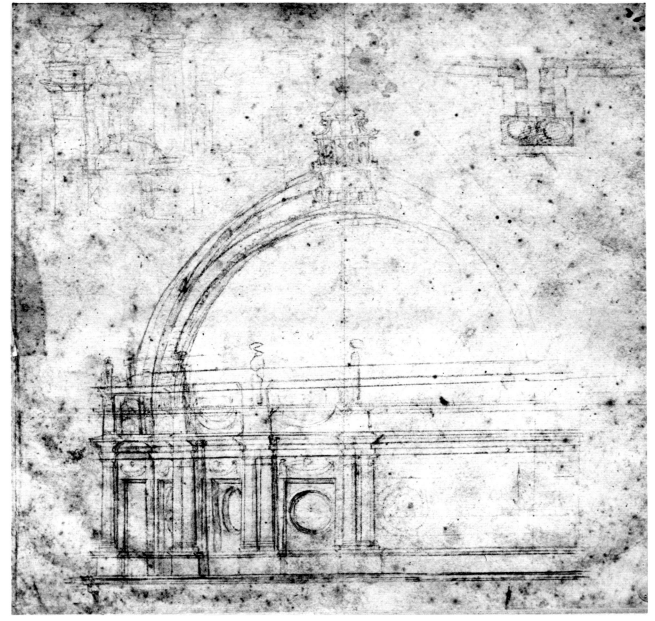

501

502

354

504

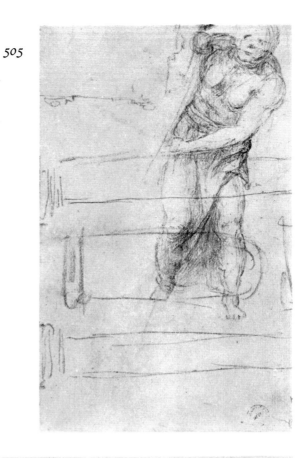

505

506

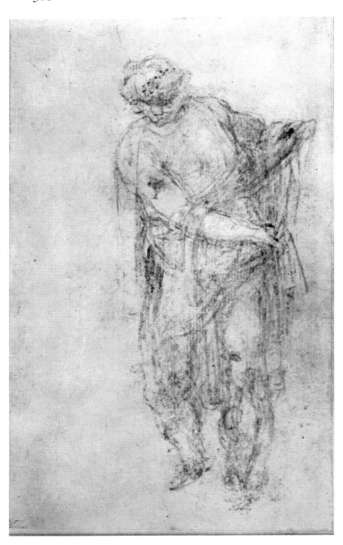

507

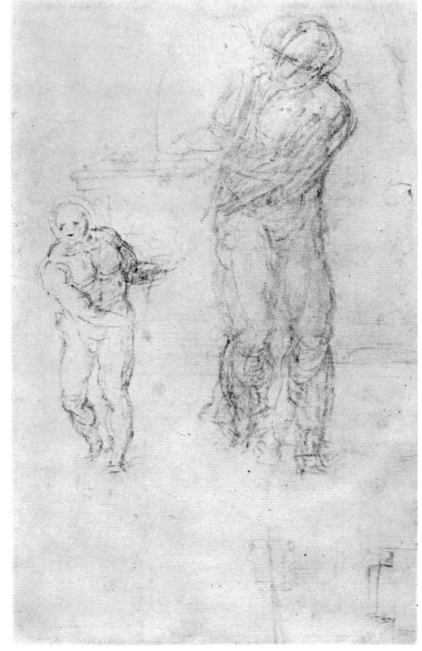

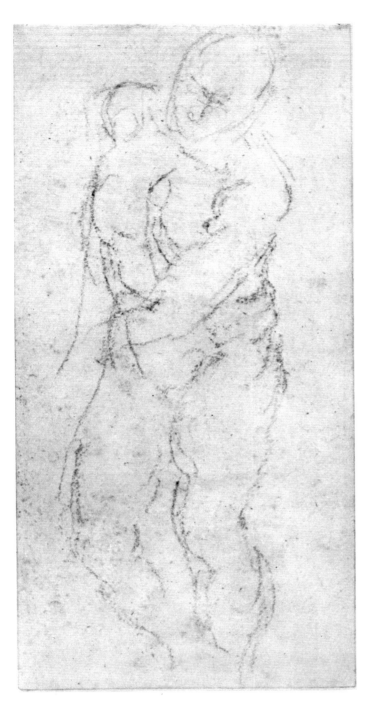

508

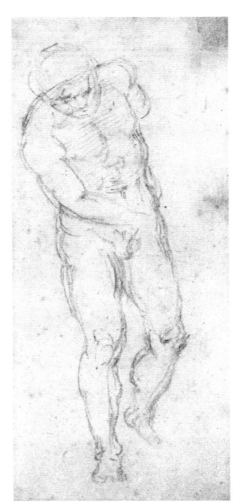

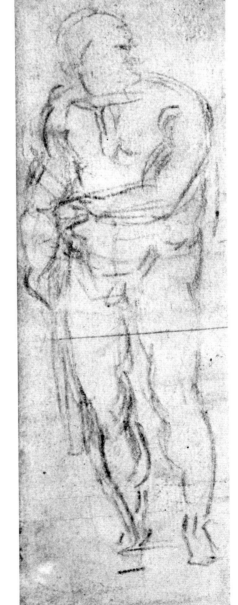

510

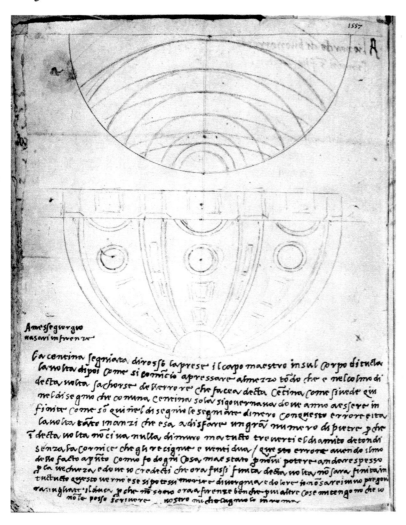

A messe georgio
uasari in firenze

La centina segnata, di rosso la prese il corpo maestro in sul corpo di tucla
la uolta dipoi come si comincio apressare almezo todo che e nel colmo di
detta uolta sa chorse de lerrore che faceu detta cetina come si uede e in
nel di segno che comincia centina sola sigouernaua doue anno a essere in
fionir come so qui nel di segnil le segnare di nero con questo errore e ita
la uolta tutte inanzi che esa a disfare un gra numero di pietre pche
i detta uolta no ci ua nulla di muro ma tucto tre uerti e chiamito de tondi
senza fa cornice che ghi re cigna e uenti dua que sta errore auendo i smo
detto facto agnto como so do gni cosa ma e stato g noni potere andare spesso
p la uechuza e doue io credeti che ora fussi fimta detta uolta no sara fimta in
tucto to questo uerno e se si potessi muoir e di uirgoma e do lore io no sarei no p gou
rara inghirir i lanci p che no sono ora firenze ben che piu altre cose intengo mo che uo
no le posso scriuere nostro mi cho lagno lo in roma

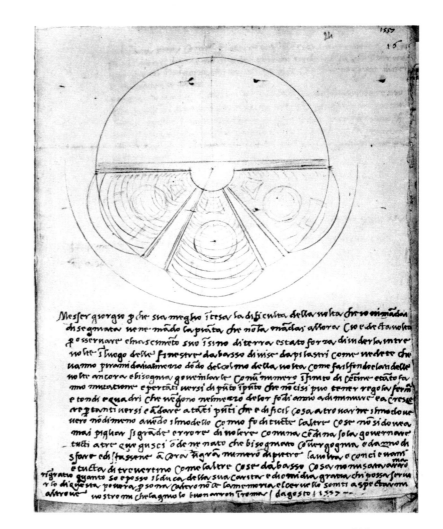

Messer georgio p che sia meglio i tesa la dificulta della uolta che io ui mandai
di segnata ue ne mado la pinta che nota mada alloua cio e de sta uolta
p osseruare e l nascimeto suo i simo di terra e stato forza di uder la intre
no stil luogo delle fenestre da basso di uise da pilastri come uedere che
uanno piramidaiamente do do de colmo della uosta come fasi indo de lati delle
uolte ancora e bisogna gouernloule con un numero i sinito di cetim estato fa
mo imtemtiom e pertanti uersi di puto i puto che no ci si puo tener regola ferm
e tondi e quadri che uegono ne mezo de lor fo di armo a di minuire e a cres
re p ra enti uersi e a loue a tuti puti che e dificil cosa altro no ni si modo ue
uero nodimeno auedo i modello como fu chi tutti lastre cose no si do uea
mai pighar si grade errore di uolere con una con centina sola gouernare
tucti altre cuy guci o de ne nato che bisogna me co tur gognin e danno di
sfare e chi tassene a cora taguer numero di pietre la uolta e conci e uoni
e tucta di tre uertino come le altre cose da basso cose no m sanu auro ma
si grato g gunto so e posso il duca della sua carita e dio mi dia grana chi possa seria
r lo di questa pouera p so m cal ro no a la memoria e lo ceruelo soni ti aspetar um
altrove nostro mi cho lagno lo buonarroti i roma d agosto i 1557

27

Drawings for various architectural purposes. Rome, 1559–64

San Giovanni dei Fiorentini, 1559

One of Michelangelo's last architectural problems (he was eighty-four) was the design for the national church of the Florentines in Rome, in a bend in the Tiber, on the site of a small oratory. He accepted only on condition that the final designs, models, and supervision of the work would be entrusted to his pupil, Tiberio Calcagni, but he himself made some wonderful drawings, ranging from Gothic solutions to Roman ones, and all profoundly influential for the Baroque period. The church was never built from his designs, but they remain among the grandest and the most arbitrary of Renaissance architectural plans.

514. *Plan for San Giovanni dei Fiorentini*
1559
Pen and wash, black chalk, $11\frac{1}{8} \times 8\frac{1}{4}''$, cut down and relined, spotted
FLORENCE, CASA BUONARROTI, 121 A

A magnificent but fantastic and confusing plan, which could not possibly have been built without substantial modifications. As has recently been pointed out, this is a radial plan which refuses to radiate. Worse, the fundamental Renaissance principle of a numerical ratio between the parts has been blithely ignored. In the center is a huge octagonal structure, not just an altar but, apparently, an enclosure. This octagon is related to the basic cross plan superimposed on and enclosing the circle, in that it presents a separate side to each of the four entrances in the four flat façades of the church. But the short sides bear no relation to the quadrants they face. Each quadrant is a separate ambulatory cut off from the others by a huge projecting vestibule leading to one of the doorways. One discovers with astonishment that only at the upper left do the intercolumniations of the arcade (or colonnade) correspond numerically to the bays divided off on the wall side by some sort of buttresses—six against six. In two of the remaining cases it is five against six and in one, at lower right, five against seven! This is by no means the end of the anomalies of Michelangelo's plan. Only at the lower right would a sacristy door have been placed in the middle of one of the walls; elsewhere they would be always just clockwise beyond the center, and in one unbelievable instance, at upper right, the buttress is placed almost, but not quite, in the middle of one of the sacristy doors. The irregular relation between columns and buttresses derives from one of Michelangelo's most fascinating old-age

medievalisms—a return to the Gothic method of vaulting ambulatories in terms of an endless succession of triangles, rather than the closed Renaissance system of ribs radiating from the center of the structure. Heaven knows what would have supported the dome, or how the huge, confronting vestibules would have looked. They would certainly have cut the interior into four separate segments.

515. *Plan for San Giovanni dei Fiorentini*
1559
Pen and wash, red chalk, and black chalk, $16\frac{5}{8} \times 11\frac{1}{2}''$
FLORENCE, CASA BUONARROTI, 120 A recto
(for verso see No. 516)

Another astoundingly un-Renaissance drawing in appearance, this was actually founded on a principle established by Leonardo da Vinci, in a drawing now in the Institut de France, including not only the plan based on an **X** crossing an octagon, but even the entrance across a long narthex. It is possible—indeed probable, considering the lapse of time and the unlikely chance that Michelangelo toward the end of his life had access to or interest in Leonardo's drawings—that the two great artists arrived at similar solutions independently, but the resemblance is striking, nonetheless. Michelangelo has carefully labeled the arches, sacristies, portico, and even the river that flows by outside. Eight arches would have upheld the dome, four of which would have had to spring from their supporting piers at an angle. The altar would have been in one of the square chapels or segments of the ambulatory, opposite to the narthex. No round columns appear. The piers would have been compound, made up of pilasters.

516. *Plan for San Giovanni dei Fiorentini*
1559
Black chalk; for dimensions, see No. 515
FLORENCE, CASA BUONARROTI, 120 A verso
(for recto see No. 515)

Here Michelangelo takes two stabs at rationalizing the weird plan on the recto, fitting the octagon into a circle with oval, rather than semicircular, chapels and no portico. He also drew very lightly a simple window tabernacle crowned with an arched pediment.

517. *Plan for San Giovanni dei Fiorentini*
1559
Black chalk, pen and wash, 16⅜ × 14⅝″
FLORENCE, CASA BUONARROTI, 124 A recto
(for verso see No. 493)

This is the last plan we have from Michelangelo's own hand, and is very close to the final design. The **X** and the cross principles of the two preceding plans are now combined in such a way that the **X** terminates in four beautiful oval chapels, strikingly prophetic of Baroque oval churches, and the cross in four narthexes. As a result the perimeter alternates between square and round forms. How the dome was ever to have been supported over an ambulatory made up of coupled columns is not indicated. The surviving copies of the working plans, by other hands, show that Michelangelo eventually suppressed the ambulatory altogether and supported the dome directly on the eight arches.

518. *Sketch for San Giovanni dei Fiorentini*
1549
Black chalk, 5⅝ × 6¾″, cut down and folded
FLORENCE, CASA BUONARROTI, 36 A recto

All critics now agree in assigning this drawing to San Giovanni dei Fiorentini. It shows, at the right, two superimposed attempts to study the ambulatory vault and then, at the left, a light sketch of the simple arch which was to be the ultimate, profoundly classical solution for what had started as a medieval atavism. The ambulatory was abandoned. Rome had won.

514

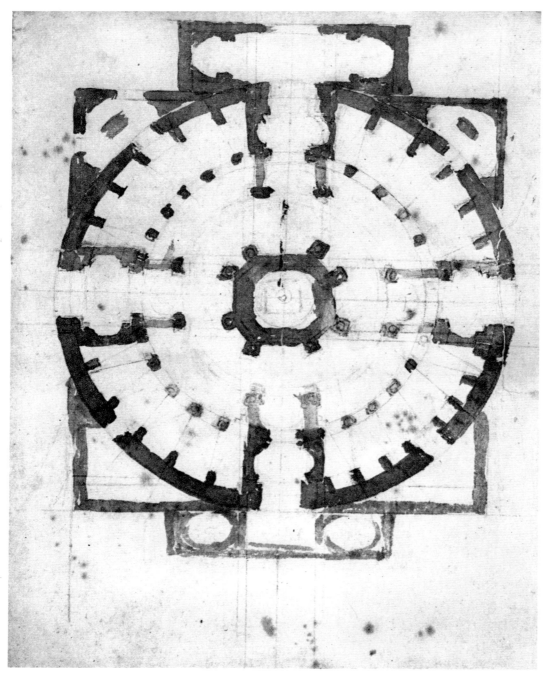

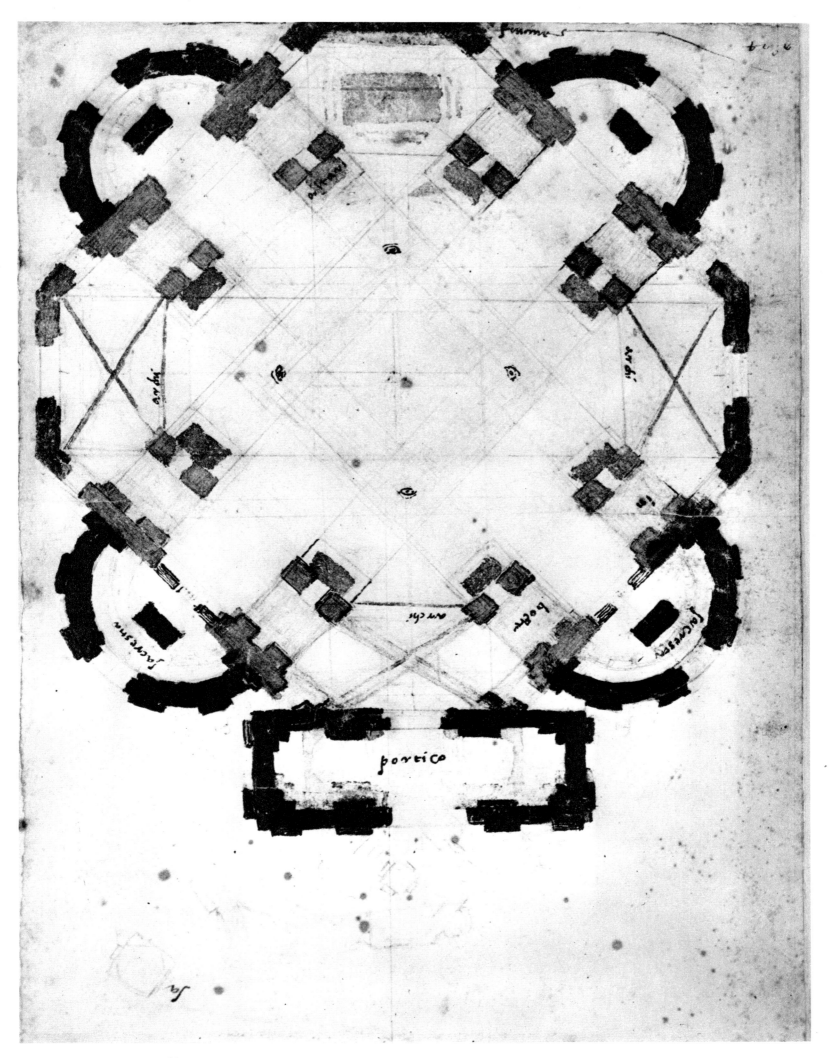

361

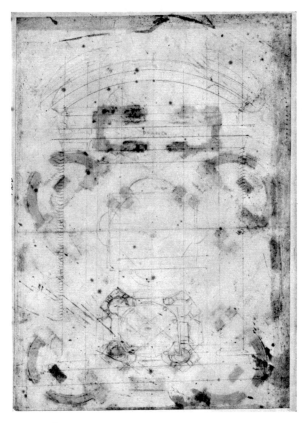

516

517

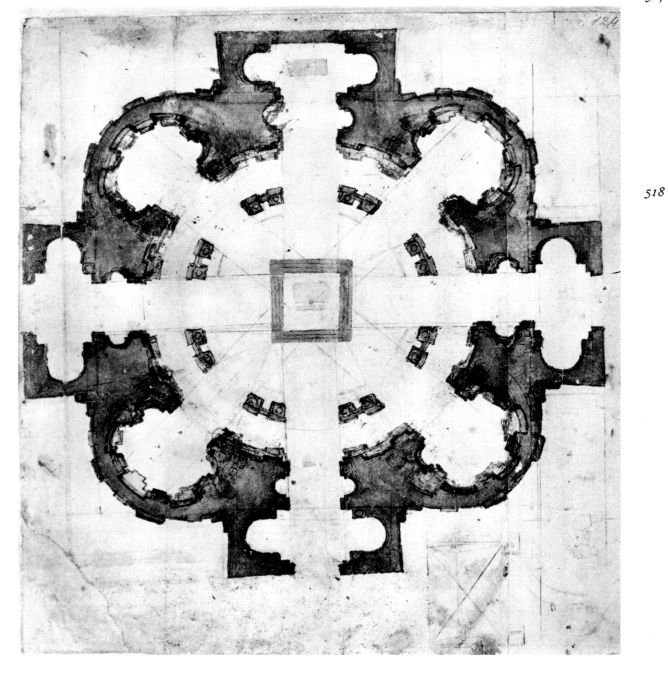

518

The Sforza Chapel, Santa Maria Maggiore, c. 1560

Although relatively small (sixty feet in diameter) and attached to a large and impressive building in which few visitors notice its existence, the Sforza Chapel was enormously important for future Italian architecture. It must have been studied reverently by such Baroque masters as Borromini. Only one of the following drawings, No. 523, can be associated with the actual structure with any degree of certainty, but the others are so closely related, dealing with the problem of a centralized building of modest proportions on a Greek-cross plan, that they may well be preparations for it. Perhaps the patron, Guido Ascanio Cardinal Sforza, originally intended Michelangelo to build the chapel freestanding, and decided only later to attach it to Santa Maria Maggiore. This hypothesis would account for the persistence of elements among the first three drawings, Nos. 519–21.

519. *Sketches for a central plan church*
1560(?)
Black chalk, $15\frac{7}{8} \times 9\frac{7}{8}''$
OXFORD, ASHMOLEAN MUSEUM, P. 344 verso
(for recto see No. 501)

At the upper right a circular plan is sketched out, with eight circular chapels radiating from an octagon. A larger plan with two concentric circles can be seen intersecting with it, and was presumably drawn first. At upper left, an elevation with pilasters flanking four arched windows; and just below this, two doodles arranging four circles around a square and around a cross. At lower left one chapel has been sketched, with ribs rising to form a lobed dome. Turning the sheet upside down, the same chapel is sketched again, with a shell vault and three windows, flanked by paired pilasters. Just to the right of this sketch is a cross section of an aisle with buttresses.

520· *Half plan of a central plan church*
Black chalk, pen and wash, $6\frac{3}{4} \times 10\frac{7}{8}''$
FLORENCE, CASA BUONARROTI, 123 A

This rather carefully drawn plan has been connected with San Giovanni dei Fiorentini, but it is clearly intended for a building on a much smaller scale, and it also appears to be attached at the left, where the wall is flat rather than apsidal. An earlier circular design has been erased, but portions have been utilized as fulcra for the new, superimposed Greek-cross plan. The squares in the re-entrant angles contain paired columns, diagonally related to the crossing piers. Basically this is the plan of the Sforza Chapel, or would be if geometrically regular forms had not been abandoned in the latter for free ones.

521. *Sketches for central plan churches*
Black chalk, $7 \times 9''$, patched at top
FLORENCE, CASA BUONARROTI, 109 A

The plans include a quatrefoil, an octagon with square chapels, an octagon with round chapels, and a lozenge with two large and two small rounded chapels. What is common to all of them is that they are flattened into ovoid shapes, like that of the Sforza Chapel. Two elevations appear, dif-

ficult to decipher, although that on the lower left seems like a façade. The building must have been intended to have a dome, as half of a cross section of a two-shell dome appears at upper right.

522. *Sketches for the Sforza Chapel*
Black chalk, $7\frac{1}{8} \times 10\frac{3}{4}''$
FLORENCE, CASA BUONARROTI, 104 A

This set of plans, generally accepted as intended for the Sforza Chapel, derives directly from the preceding series, save that there are now clear distinctions between the entrance from the church, the broad main apse opposite the entrance, and the two narrow lateral apses. The forward-set columns are already on the way to the powerful formulation of the Sforza Chapel, as is the elevation at upper left, with its richly articulated and very fluid entablature. The plans of columns and niches may be experiments with varying relationships of elements in the Chapel.

519

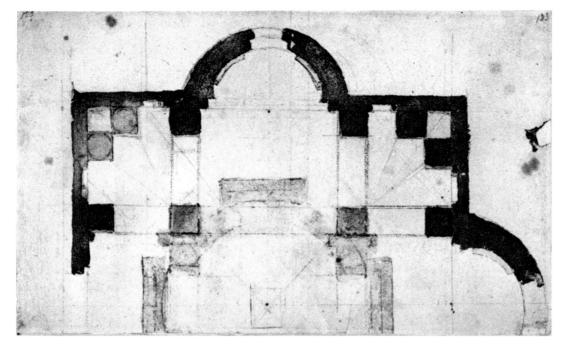

520

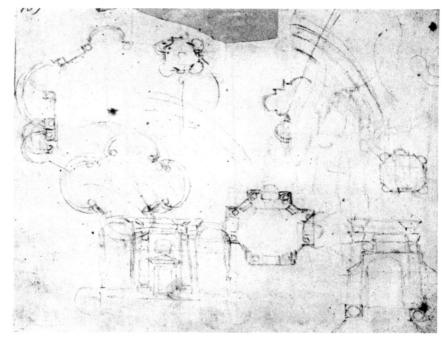

521

522

The Porta Pia, 1561

Pope Pius IV commissioned Michelangelo in 1561 to build a new gate in the ancient Roman wall, less as an entrance to the city than as an exit for a grand new street the Pope was building, or rather cutting, through villas and country estates; it was destined to be lined with imposing gateways to which the Porta Pia would form a fitting climax. There was no purpose of defense in this gate, but Michelangelo still managed to suggest in its bristling array of forms and forces some of the aesthetic, if not military, principles embodied in the never-executed designs for the fortifications of Florence. Vasari tells us that "Michelangelo, urged by the Pope at this time to provide a design for the Porta Pia, made three, all extravagant and beautiful, from which the Pope chose the least costly to execute, which may be seen today and is much praised: and since the Pope had in mind to restore the other gates of Rome as well, he made other drawings for him." Previous analyses of the drawings have not taken into account Vasari's story, which was written when the mortar of the new gate was scarcely dry, and is likely to be correct. Three separate projects can, in fact, be distinguished, and as is customary in all of Michelangelo's architectural designs from the work for San Lorenzo on down, the finished drawing for the final project has not been preserved.

Project A: Drawings for Porta Pia with Tuscan Columns

523.
Black chalk, 4⅜×3⅛", cut down, spotted
FLORENCE, CASA BUONARROTI, 84 A recto

Michelangelo here designs a pedimented gate, upheld by Tuscan columns. He started with a fairly small one with a gabled pediment enclosing an arch, then partially rubbed it out, and began again on a grander scale. The space between the arch and the entablature was filled with a smaller pediment supported on consoles, utilizing a section of the former general pediment. A flat-arched panel appears in the middle of the gabled pediment, breaking into the lower cornice.

524.
Black chalk, wash, 15¾×10½", cut down, spotted
FLORENCE, CASA BUONARROTI, 73 A bis

This massive design, of a simplicity and grandeur characteristic of Michelangelo's formal solutions at San Giovanni dei Fiorentini, preserves all the principal elements of No. 523, united and refined. The gabled shape is transferred from inner to outer pediment, and the inner pediment is suppressed along with the flat-arched tablet. But the lower cornice of the pediment is still broken, and below it, between the impost blocks of the entablature, an oblong panel is inserted, of a simplicity in keeping with the unmolded socles on which the columns stand. The smooth power of these broad, rather primitive elements, with their moldings reduced to almost nil, and the shaking hand with which the wash is applied, are so completely in keeping with the spirit and technique of the late religious drawings as to cause one to wonder at the hypothesis of a pupil's intervention at this point.

Project B: Drawings for Porta Pia with Rusticated Columns

525.
Black chalk, 6½×4⅞"
FLORENCE, CASA BUONARROTI, 99 A

A simple sketch made with a ruler over vague and confusing underlying elements. The Tuscan columns have vanished, but no substitution is yet proposed. The famous "flat arch," really an octagonal arch, has made its first appearance.

526.
Black chalk, 11⅛×10"
FLORENCE, CASA BUONARROTI, 97 A verso

The window drawings on this sheet, so rubbed as to be hardly decipherable in places, seem earlier in style, and may relate to projects of the 1540s. But the gateway design is surely for the Porta Pia. An elaboration of No. 525, it is now provided with columns of some sort (the ruler slips in the old man's hand, as so often happens), and a beautiful attic story in which great volutes above an arch(?) flank an unidentifiable object, possibly a cartouche. The octagonal arch is elevated somewhat, so that both lateral archivolts support a ferocious, projecting keystone.

527.
Black chalk, pen and wash, 18½×11", spotted
FLORENCE, CASA BUONARROTI, 102 A

A veritable palimpsest of overlays, like the late religious drawings or the Milan *Pietà*. The flanking columns are now rusticated, and the octagonal arch considerably tamed, very close, in fact, to the shape of the one actually built. The impost blocks enclose an arched lunette, similar to the one built, but this is supplanted again with a tablet. A small pediment that can be seen above is replaced by a huge arched pediment, which is in turn enclosed in a gabled one, on the principle of one of the designs for the entrance to the reading room of the Laurentian Library. The soft, visionary shapes of the attic, in their fantastic freedom and unconventionality as well as in the tremulous delicacy of their execution, protest against the attribution to any pupil. Who but the eighty-six-year-old Michelangelo could have thought of anything like the yoke over a cartouche, held up by volutes as by willing sea monsters? Or those tiny staring windows, barren, simple, and perfect?

Project C: Drawings for Porta Pia with Pilasters

528.
Black chalk, 10⅛×8¾"
WINDSOR, ROYAL LIBRARY, 12769 verso

This project, even in the stage of a sketch, absorbs from Project B only the octagonal arch, now flanked by fluted pilasters surmounted by fantastic structures masquerading as capitals and impost blocks. Above the pendent keystone appears a strange object, which begins life as a scroll and culminates as a tablet. Indecipherable caprices fill the pediment, and project even beyond it. At the right the motive has been separately studied twice, once as a broken pediment, once with a square portal under an arched pediment composed of volutes, like those of the ducal sarcophagi in the Medici Chapel forty years before, here united, however, by a garland.

The remaining architectural studies, plans of a niche flanked by columns and of a columned portico, have not been successfully identified, but they may be related to San Giovanni dei Fiorentini.

529.
Black chalk, pen, wash, and white, 17⅛ × 11⅛″, corroded, broken, cut down
FLORENCE, CASA BUONARROTI, 106 A recto
(for verso No. 530)

Closer than ever to the gateway as finally built, this fantastic design combines and elaborates both major sketches in No. 528, reinstating the octagonal arch with its dependent keystone and crowning it with the volutes, upholding a shell below which appears the tablet-scroll. Capitals and impost blocks were drawn, but they have been washed out, in favor of brutal blocks. All the emphasis runs to the volutes, which have been given the weird flutings Michelangelo had developed for the crown of his grotesque mask, No. 497, but single now instead of double. Having resurrected this wonderful mask, Michelangelo must simply have turned it over to his pupils for carving, with few changes. Just as Vasari had said, this was the cheapest project, considerably less expensive than the columns of Project A and the rustication of Project B. The changes between this and the actual gate are considerable but not essential, and involve the incorporation of elements from Project B. For instance, the enclosing pediment of Project B now keeps the great volutes in order, and the lunette turns up above the octagonal arch. Also, the rustication applied to the columns in Project B now is used for the jambs. Best of all, however, the shell has disappeared and the simplified tablet, a great block, is upheld by the equilibrium of the two mighty opposing consoles. The dimly visible sketch of a floating leg in the lower portion of the doorway suggests that when Nardo de' Rossi carved the angels flanking the escutcheon after Michelangelo's death, he was guided by designs left by the master.

530. *Sketches for tabernacles for Porta Pia*
Black chalk, for dimensions and condition, see No. 529
FLORENCE, CASA BUONARROTI, 106 A verso
(for recto see No. 529)

The brilliant little window designs relate to the tabernacles flanking the main doorway on the second story. Neither corresponds exactly to the tabernacles as executed, but the main principles are there—the dynamic and broken frame composed of volutes, broken arches, ears, and other shapes remembered from Michelangelo's past. The beautiful horse's head is a mystery. It seems to have been done from life, yet it looks as rigid as stone. The only known commission with which this head can possibly be connected is the monument to King Henry II of France, for which plans began in 1559 (see No. 534).

531. *Sketch for a window for Porta Pia*
Black chalk, 5 × 2¾″
FLORENCE, CASA BUONARROTI, 85 A recto

This little window has generally been dated forty years or so too early. It has all the rude simplicity and stumpy proportions of the barred windows of the ground floor of the Porta Pia. In the final windows, Michelangelo enlarged the brutal blocks between window and pediment still further, and simply transferred the volutes and uniting garland from above the window to below it, making a strange and neo-primitive version of his own early invention of the kneeling window for the Medici Palace in 1516. He also inserted in the pediment the discarded shell from the gateway in Project C.

523

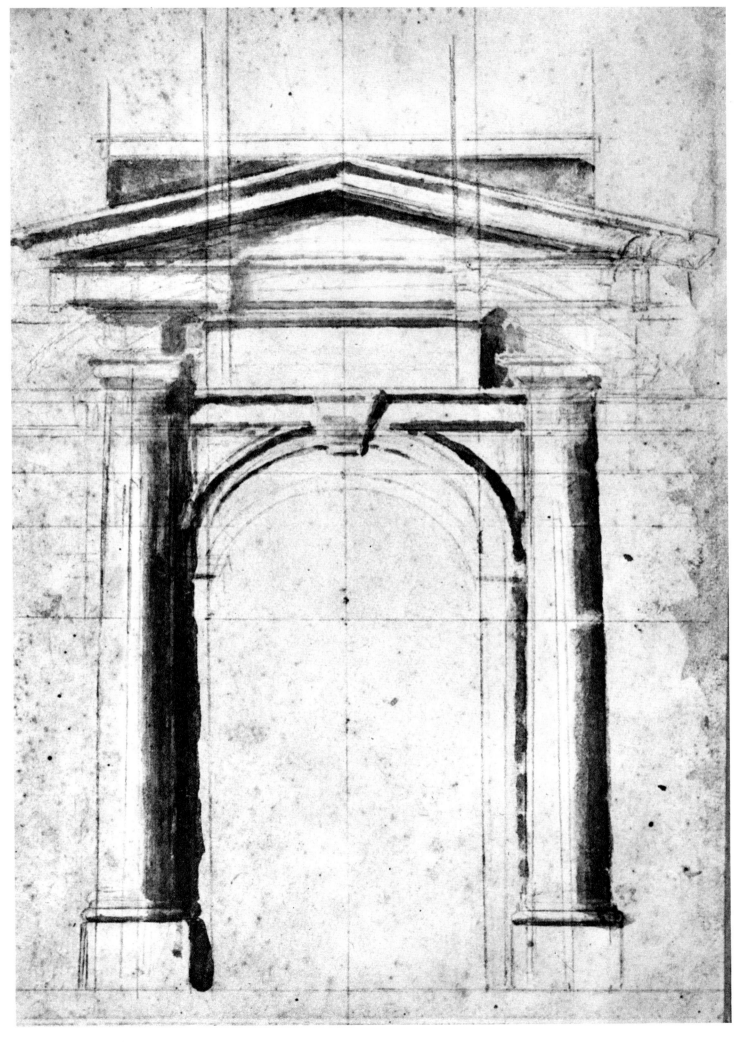

524

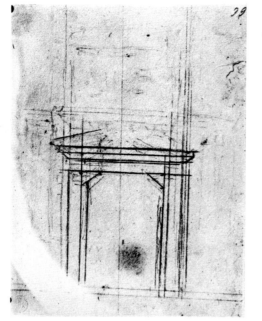

525

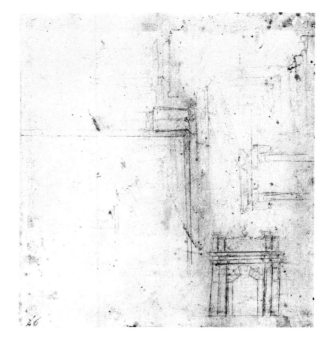

526

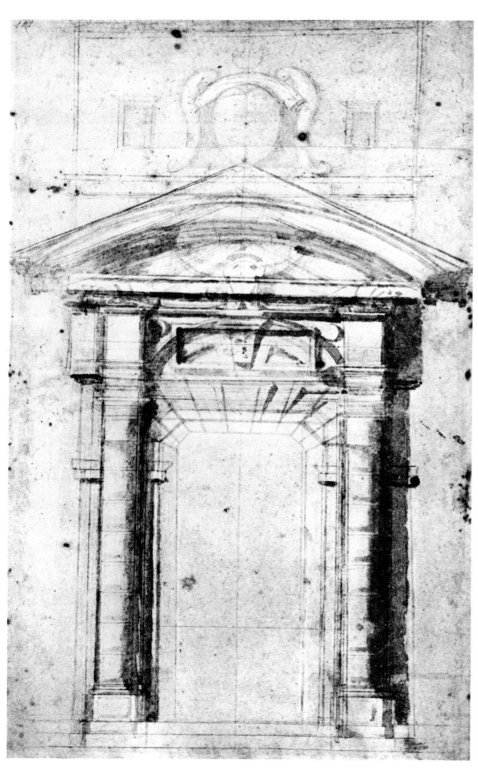

527

528

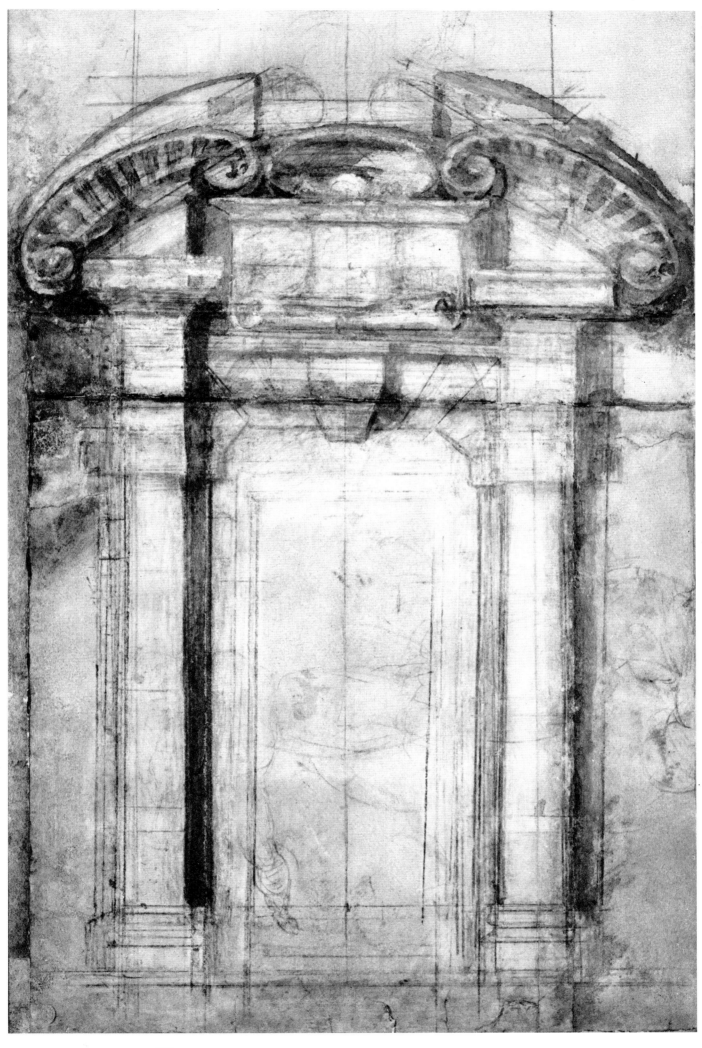

529

530

531

28

Miscellaneous ornamental and architectural drawings. Rome, 1537–64

532. *Design for a salt cellar for the Duke of Urbino*
1537
Black chalk, 8½×6⅛″, folded
LONDON, BRITISH MUSEUM, W. 66

This is the kind of commission often given to Renaissance artists and seldom accepted by Michelangelo. In fact, he would doubtless not have undertaken this one if he had not felt obligated to the Duke of Urbino on account of the slow progress on the Tomb of Julius II, for which the Duke was executor. The drawing corresponds to the descriptive letter in all respects save that on the lid it has birds' heads rather than leaves. The ornamentation is strikingly similar in feeling to that in the Medici Chapel, and the general flavor of the fantasy recalls the *Children's Bacchanal,* No. 361. This is a beautifully finished and thoroughly characteristic drawing by Michelangelo, rare only in its purpose.

533. *Sketch for a portal*
1561–62(?)
Red chalk, 3×1⅞″, cut down
HAARLEM, TEYLERSMUSEUM, A 29 bis

This beautiful little sketch, once pasted onto No. 498, has been connected with the Porta Pia by most critics, on account of the rustication and the octagonal arch. It has been recently and very credibly pointed out, however, that the drawing is much better suited to a private villa, and that it has steps leading into the doorway; furthermore, that the two immense dolphins on either side would render the scheme appropriate to Zaccaria Delfino, Nuncio for Pope Pius IV to the Imperial Court. Dolphins, of course, were the arms of the Delfino family.

534. *Sketch for a monument to King Henry II of France*
1559
Black chalk with touches of white, 5⅛×4¾″, cut down
AMSTERDAM, RIJKSMUSEUM, 53:140

This recently discovered drawing has been accurately identified as Michelangelo's sketch for an equestrian monument requested by the widowed Catherine de' Medici, Queen of France, to her late husband Henry II, who, by all accounts, did not deserve it. The monument, executed by

Daniele da Volterra on account of Michelangelo's immense age (eighty-six at the time), did not actually reach France until 1643, and was destroyed in 1793 during the Revolution. The prancing position of the horse recalls Michelangelo's great forebears in the field of equestrian portraiture: Uccello, Donatello, Castagno, and Verrocchio, not to speak of Leonardo da Vinci. But the base, with its herms flanking figures in niches and its second story divided into receding steps, is so close to the descriptions of the first project for the Tomb of Julius II in 1505 as to present not only strong evidence for the appearance of that never-executed scheme but grounds for belief that Michelangelo still had the model with him in Rome more than half a century later, and that both Condivi and Vasari saw it.

534A. *Horse studies*
1559(?)
Black chalk, some touches of red chalk, 15⅞×10⅛″, cut down, spotted
FLORENCE, CASA BUONARROTI, 22 F

This almost universally rejected drawing has been revindicated by two recent scholars, but always dated too early. It shows a horse's head seen from the front, two studies of left hindquarters in repose, one of a left hindquarter with a bent hoof, and a study of a neck and forelegs from the right. The handling of the horse's head, with its blank eyes and peculiar formation of the nostril, is identical to that of No. 530, and it must have been drawn at the same moment. Like No. 530, this drawing appears to be a set of studies for an equestrian statue, and again can be connected only with the monument to King Henry II of France sketched in No. 534. The red chalk lines may be a suggestion for an armature.

535. *Sketch for a Doric entablature*
1550–60(?)
Red chalk, 3⅝×4¾″, cut down
FLORENCE, CASA BUONARROTI, 90 A

An unidentifiable sketch–very late, to judge by its technique —for just the kind of entablature Michelangelo never built. The heavy guttae below the triglyph might have served him as a starting point for his bit of fantasy in the Porta Pia.

536. *Sketch for a window*
Red chalk, 5⅜×4¾″
FLORENCE, CASA BUONARROTI, 58 A

There has been no successful attempt to identify this vivid
and beautifully proportioned little window sketch, in which
Michelangelo seems to revert in his old age to forms of the
early Renaissance.

537. *Sketch for a window tabernacle*
1561–62(?)
Black chalk, 5½×7⅛″
LONDON, BRITISH MUSEUM, W. 70 verso
(for recto see No. 405)

A very soft and free little sketch containing many elements
which appear in the Porta Pia. The fragments of writing read:
"certain obligation to recompose the whole palace as . . .
and I don't have the courage because I am not an architect . . .
in such a way that I can know the comforts of . . . and about
living there . . ."

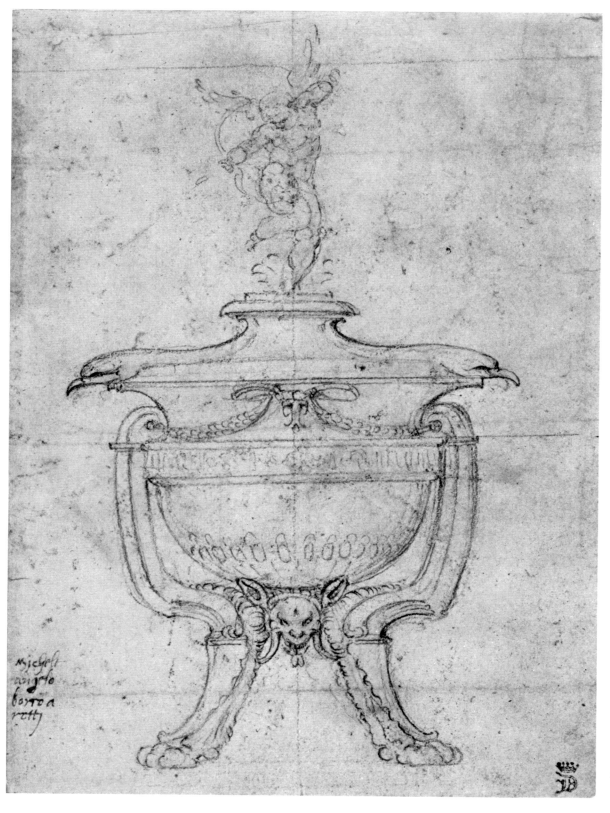

533

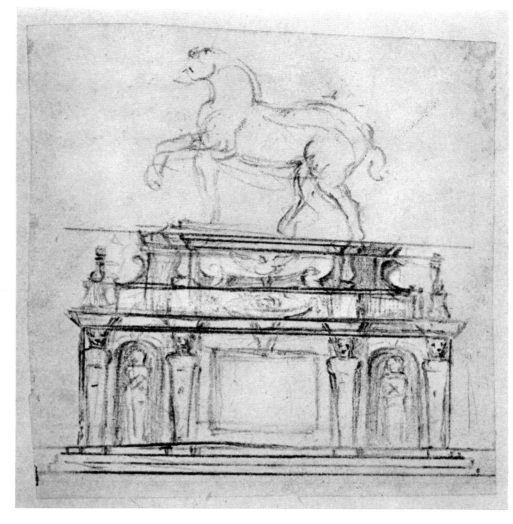

534

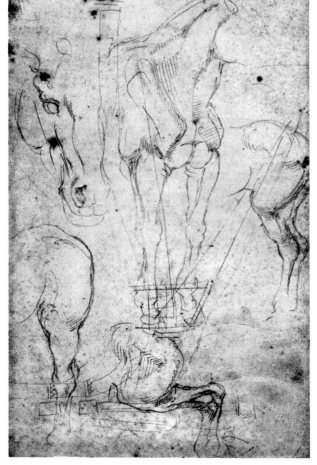

534A

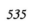
535

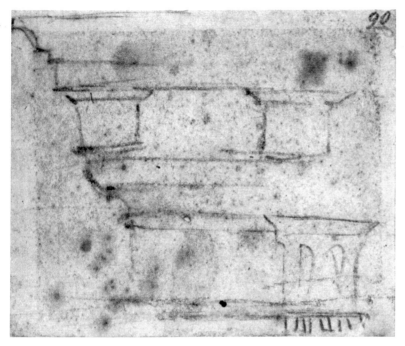

536
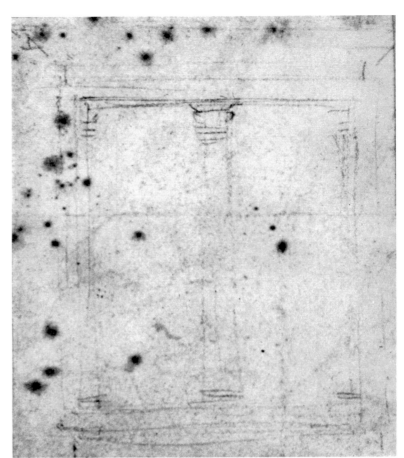

537

Concordance

The following concordance includes all the drawings treated by Luitpold Dussler in *Die Zeichnungen des Michelangelo*. The tables are alphabetically arranged by location; when more than one collection is preserved in one location, these are also alphabetically listed. Within each collection, the drawings are in the order of the latest numbers given to them in the collection. The concordance presents the opinions expressed in the nine principal catalogues of Michelangelo's drawings (by date of publication) and the present work. The complete titles of these catalogues will be found in the Bibliography; the full statements of scholarly opinion may thus be located rapidly, including all those mentioned anonymously in the entries in the catalogue of the present volume. The plus-and-minus symbols, borrowed from Dussler, will show acceptances and rejections at a glance. No attempt is made to embark on the complex question of the correct attributions of the drawings rejected here. Many architectural working drawings, rejected as autograph, must have been made under Michelangelo's direct supervision and thus, in a larger sense, are his.

In those few instances, usually concerning obscure or even vanished drawings, in which the author was unable to consult either the original work or an intelligible photograph, the space is left blank.

Certain of the abbreviations in the concordance should be explained: under the Wilde entries, which normally refer to his catalogue of drawings in the British Museum, P.-W. refers to the Popham-Wilde catalogue in *Italian Drawings at Windsor Castle*; L. E. means the London exhibition catalogue of Michelangelo drawings from numerous English collections, held at the British Museum in 1953; Victory refers to Wilde's *Michelangelo's "Victory"*. The drawings in the Ashmolean Museum, Oxford, are listed according to K. T. Parker's catalogue, *Italian Schools,* and his opinions concerning authenticity are given in symbols after each collection number; the numbers, now obsolete, assigned to these drawings by Sir Charles Robinson have been used in all previous catalogues and are here given in parentheses following Parker's ymbols.

Symbols: + Acceptance
 — Rejection
 ? Undecided
 ip In part by Michelangelo
 d Diagrammatic, therefore not reproduced
 f Too faint to reproduce well

COLLECTION NUMBER	Frey	Thode	Brinck-mann	Berenson	Goldscheider	Tolnay	Wilde	Dussler	Barocchi	Hartt
(formerly) AMSTERDAM, E. Wauters										
122	250 (−)	513c (+)		1622A (−)				367 (−)		
AMSTERDAM, Rijksmuseum										
53: 140						V 265 (+)		244 (+)		534
AREZZO, Archivio Vasariano										
Cod. 12, cap. 22								1 (+)		511
Cod. 12, cap. 24								1 (+)		512
BAYONNE, Musée Bonnat										
123		1 (+)		2474A (−)				370 (−)		(−)
650 r		512d (+)		2474B (−)				370a (−)		(−)
650 v		512d (+)		2474B (−)				370a (−)		(−)
681 r		512b (+)		1395A (+)	98 (+)	V 174 (+)		245 (+)		373
681 v						V p. 185 (+)				
682		512c (+)		2474C (−)	39 (+)		p. 30 (+)	371 (−)	p. 275 (+)	(−)
1216						IV p. 155 (+)		2 (+)		(d+)
1217		512a (+)		1395B (+)	99 (+)	V 170 (?)	p. 100 (+)	246 (+)	p. 176 (+)	370
BERLIN-DAHLEM, Staatliche Museen, Kupferstichkabinett										
1363	12 (+)	4 (+)	19 (+)	1396 (+)	176 (−)			372 (−)	p. 34 (+)	10
5132		6 (+)		1623A (−)				373 (−)		
15305 r		5 (+)		1623 (−)	p. 33 (+)	IV 123 (?)	p. 28 (+)	374 (−)	p. 294 (−)	45
15305 v		5 (+)		1623 (−)		IV 135 (?)	p. 16 (+)	374 (−)		53
BOSTON, Isabella Stewart Gardner Museum										
				1623C (−)		V 197 (+)		378 (−)		455
CAMBRIDGE, ENGLAND, Fitzwilliam Museum										
Cl. 23 r	77 (+)	367 (+)		1396A (+)	119 (+)	V 224 (+)		3 (+)		462
Cl. 23 v	78 (+)	367 (+)		1396A (+)	119 (+)	V 225 (+)		3 (+)		461
CAMBRIDGE, MASSACHUSETTS, Fogg Art Museum, Harvard University										
152				1623D (−)	64 (+)		p. 105 (+)	381 (−)		(−)
CHANTILLY, Musée Condé										
28 r		p. 7 (?)		1624 (−)			p. 125 (−)	386 (−)	p. 249 (−)	
28 v		p. 7 (?)					p. 125 (−)	386 (−)		
29 r	2 (+)	7 (+)		1397 (+)	13 (+)	I 17 (+)	p. 13 (+)	4 (+)	p. 91 (+)	6
29 v	2 (−)	7 (+)		1397 (ip)		I 18 (ip)		4 (ip)		56

COLLECTION NUMBER	Frey	Thode	Brinck-mann	Berenson	Goldscheider	Tolnay	Wilde	Dussler	Barocchi	Hartt
(*formerly*) CHESTERFIELD, ENGLAND, Mr. Locker-Lampson										
		516 (?)		1397B (+)				246a (?)		
CLEVELAND, OHIO, Cleveland Museum of Art										
40.465 r				1599A (+)		II 19A (−)		387 (−)	p. 24 (+)	104
40.465 v				1599A (+)		II 20A (−)		387 (−)		79
DETROIT, MICHIGAN, Detroit Institute of Arts										
27.2 r	247 (+)	513a (+)	22 (+)	1624B (−)		II 37 (+)	p. 18 (+)	5 (+)	p. 282 (+)	63
27.2 v	248 (ip)	513a (+)		1624B (−)		II 12A (−)	p. 19 (+)	388 (−)		81
(*formerly*) DRESDEN, Kupferstichkabinett										
						III 64 (−)	p. 50 (+)	389 (−)	p. 84 (−)	
FLORENCE, Archivio Buonarroti										
I, 29, fol. 72 v								6 (+)	330 (+)	(d+)
I, 38, fol. 93 r									315 (+)	(d+)
I, 57, fol. 144 r						IV fig. 187 (+)		7 (+)	334 (+)	(d+)
I, 57, fol. 144 v						IV fig, 188 (+)		7 (+)	334 (+)	(d+)
I, 59, fol. 151									335 (+)	(d+)
I, 74, fol. 203 v						III 103 (+)	p. 87 (+)	9 (+)	345 (+)	351
I, 77, fol. 210 v						III 48 (+)	p. 50 (+)	10 (+)	313 (+)	204
I, 77, fol. 211 r						III 101 (ip)		11 (ip)	312 (+)	315
I, 77, fol. 211 v						III 49 (+)		12 (+)	312 (+)	(d+)
I, 78, fol. 213 v						IV fig. 189 (+)		8 (+)	352 (+)	(d+)
I, 80, fol. 218						IV fig. 190 (+)		14 (+)	337 (+)	(d+)
I, 80, fol. 219						IV fig. 191 (+)		15 (+)	333 (+)	(d+)
I, 82, fols. 223–31, 233						IV figs. 124–42 (+)		16 (+)	317–26 (+)	(d+)
I, 127, fols. 240–41						IV figs. 143–44 (+)		17 (+)	327–28 (+)	(d+)
I, 128–30, 134–39, 144–50, 152, 155; fols. 243–45, 250–55, 260–67, 271, 276, 278						IV figs. 145–73 (+)		18–20, 22, 23 (+)	292–309 (+)	(d+)
I, 151, fol. 269									332 (+)	(d+)
I, 153, fol. 272						IV fig. 170 (+)		20 (+)	329 (+)	(d+)
I, 154, fol. 274						V p. 60 (+)	p. 107 (+)	21 (+)	355 (+)	417
I, 157, fol. 280						IV fig. 192 (+)		24 (+)	289 (+)	(d+)
I, 158, fol. 282								25 (+)	290 (+)	(d+)
I, 159, fol. 284						IV fig. 193 (+)		13 (+)	291 (+)	(d+)
I, 160, fol. 286						IV fig. 194 (+)		26 (+)	331 (+)	(d+)
II–III, 3 r						I 8 (+)		27 (+)	287 (+)	(d+)
II–III, 3 v						I 7 (+)		27 (+)	287 (+)	5
II–III, 30 v								247 (?)	348 (+)	(f+)
IV, 100, fol. 106								248 (?)	357 (+)	(d+)
V, 29, fol. 204 v								28 (+)	351 (+)	321

COLLECTION NUMBER	Frey	Thode	Brinck-mann	Berenson	Goldscheider	Tolnay	Wilde	Dussler	Barocchi	Hartt
FLORENCE, Archivio Buonarroti (*continued*)										
V, 38, fol. 213						III 65a (+)		29 (+)	349 (+)	(d+)
V, 66, fol. 239 v						III 74 (+)		30 (+)	353 (+)	(d+)
V, 67, fol. 240 v						IV fig. 110 (+)		31 (+)	354 (+)	(d+)
VI, fol. 24 v		203 (+)				III 113 (+)	p. 89 (+)	32 (+)	346 (+)	348
IX, fol. 524 v						III 77 (+)		33 (+)	314 (+)	(d+)
IX, fol. 539 v						III 68 (ip)	p. 38 (ip)	34 (ip)	342 (ip)	202
IX, fol. 543 v								249 (?)	389 (−)	(?)
X, fol. 578 v						I p. 48 (+)		35 (+)	341 (+)	317
X, fol. 627 v						IV fig. 184 (+)	p. 70 (+)	401 (−)	316 (+)	(d+)
XI, fol. 722 v								36 (+)	347 (+)	(d+)
XIII, fol. 33						III 105 (+)		37 (+)	356 (+)	481
XIII, fol. 79 v								38 (+)	338 (+)	(d+)
XIII, fol. 104 v								250 (?)	372 (−)	(d?)
XIII, fol. 111		197 (+)				II 39 (+)		39 (+)	288 (+)	109
XIII, fol. 127		198 (+)						40 (+)	339 (+)	(d+)
XIII, fol. 134 v								41 (+)	340 (+)	(d+)
XIII, fol. 141 v						IV p. 155		42 (+)	311 (+)	(d+)
XIII, fol. 145 v						II 40 (ip)		251 (+)	368 (−)	310
XIII, fol. 148 v		199 (+)		1460 (+)	p. 177 (−)	III 111 (−)		406 (−)	367 (−)	185
XIII, fol. 149 v		200 (+)		1461 (ip)				407 (−)	373 (−)	(−)
XIII, fol. 150 v		201 (+)				III 94 (+)	p. 83 (+)	43 (+)	344 (+)	(d+)
XIII, fol. 157 r								44 (+)	336 (+)	(d+)
XIII, fol. 157 v									336 (+)	(d+)
XIII, fol. 160						III p. 80 (+)	p. 75 (+)	45 (+)	350 (+)	(d+)
XIII, fol. 169 v						III 89 (+)	p. 3 (+)	46 (+)	343 (+)	250
XIII, fol. 175 v				1462 (+)				47 (+)	379 (−)	(?)
FLORENCE, Casa Buonarroti "A"										
1 A r	81, 82 (−)	89 (−)					p. 32 (+)	450 (−)	23 (+)	133
1 A v		89 (−)					p. 32 (+)	450 (−)	23 (+)	134
2 A r	83, 84 (−)	90 (−)					p. 32 (+)	451 (−)	24 (+)	135
2 A v		90 (−)					p. 32 (+)	451 (−)	24 (+)	136
3 A r	112, 113 (+)	92 (−)					p. 32 (+)	453 (−)	25 (+)	137
3 A v		92 (−)					p. 32 (+)	453 (−)	25 (+)	138
4 A r	101 (+)	91 (−)					p. 32 (+)	452 (−)	26 (+)	139
4 A v	102 (+)	91 (−)					p. 32 (+)	452 (−)	26 (+)	140
5 A r	111 (+)	93 (−)					p. 36 (+)	277 (+)	28 (+)	153
5 A v							p. 36 (+)	277 (+)	28 (+)	(d+)
6 A r		94 (+)		1422 (−)				454 (−)	208 (−)	(−)
6 A v		94 (+)						454 (−)	208 (−)	40A
7 A		95 (+)						455 (−)	262 (−)	(−)
8 A	161 (+)	175 (−)		1457 (?)			p. 32 (+)	278 (+)	27 (+)	141
9 A r	163 (+)	176 (+)		1458 (+)		III 73 (+)	p. 56 (+)	57 (+)	62 (+)	208
9 A v								57 (+)	62 (+)	(d+)
10 A r	162 (+)	177 (+)		1459 (+)		III 72 (+)	p. 56 (+)	58 (+)	61 (+)	209
10 A v								58 (+)	61 (+)	(d+)
11 A		195 (+)						59 (+)	102 (+)	336
13 A r		178 (+)						60 (+)	114 (+)	331
13 A v		178 (+)						60 (+)	114 (+)	330

COLLECTION NUMBER	Frey	Thode	Brinck-mann	Berenson	Goldscheider	Tolnay	Wilde	Dussler	Barocchi	Hartt
FLORENCE, Casa Buonarroti "A" (continued)										
14 A r		188 (+)		1657A (−)				61 (+)	117 (+)	334
14 A v				1657A (−)				456 (−)	117 (−)	309
15 A		193 (+)						62 (+)	111 (+)	327
16 A r		194 (+)						63 (+)	112 (+)	328
16 A v		194 (+)						63 (+)	112 (+)	(d+)
17 A r								64 (+)	113 (+)	325
17 A v		179 (+)						64 (+)	113 (+)	326
18 A		180 (+)						65 (+)	107 (+)	344
19 A		181 (+)						66 (+)	110 (+)	335
20 A r		182 (+)						67 (+)	118 (+)	332
20 A v		182 (+)						67 (+)	118 (+)	333
21 A		183 (+)						68 (+)	103 (+)	340
22 A r		184 (+)						69 (+)	105 (+)	338
22 A v		184 (+)						69 (+)	105 (+)	337
23 A		191 (+)						70 (+)	104 (+)	341
24 A		192 (+)						71 (+)	106 (+)	339
25 A		189 (+)						72 (+)	108 (+)	342
26 A		190 (+)						73 (+)	109 (+)	343
27 A r		67 (?)				IV 42A (ip)		74 (ip)	182 (−)	(−)
27 A v		67 (?)						74 (ip)	182 (−)	(−)
28 A r		185 (+)						75 (+)	116 (+)	345
28 A v		185 (+)						75 (+)	116 (+)	346
29 A		186 (+)						76 (+)	183 (−)	(−)
30 A		187 (+)						77 (+)	115 (+)	329
31 A	208 (+)	165 (+)						457 (−)	152 (?)	502
32 A r	108 (+)	100 (+)						78 (+)	40 (+)	(d+)
33 A	293b (+)	100a (+)						79 (+)	41 (+)	(d+)
34 A	267a (+)	101 (+)						459 (−)	49 (+)	(d+)
35 A r		102 (+)						460 (−)	151 (+)	(d+)
35 A v								460 (−)	151 (+)	(d+)
36 A r	223a (+)	103 (+)		1427 (+)				80 (+)	161 (+)	518
36 A v								80 (+)	161 (+)	(d+)
37 A r		104 (+)		1428 (+)		III 99 (+)	p. 93 (+)	81 (+)	83 (+)	267
37 A v						III 99 (+)	p. 93 (+)	81 (+)	83 (+)	270
38 A		105 (+)						461 (−)	184 (−)	(−)
39 A r	209 (+)	106 (+)		1429 (+)				82 (+)	82 (+)	268
39 A v	210 (+)	106 (+)		1429 (+)				82 (+)	82 (+)	269
40 A r	285 (+)	107 (+)		1430 (+)		III 60 (+)	p. 42 (+)	83 (+)	98 (+)	324
42 A r	199 (+)	173 (+)						84 (ip)	78 (ip)	258
43 A r	211a (+)	174 (+)		1456 (+)			p. 40 (+)	85 (+)	45 (+)	149
43 A v	211b (?)	174 (?)		1456 (+)		IV 136 (−)		279 (?)	45 (+)	290
44 A	29 (+)	98 (+)		1425 (+)		IV 125 (+)		86 (+)	43 (+)	147
46 A	125b (+)	96 (+)		1424 (+)		III 65 (+)	p. 75 (+)	88 (+)	94 (+)	319
47 A	96b (+)	99 (+)		1426 (+)			p. 40 (+)	89 (+)	44 (+)	148
48 A r	234 (+)	97 (+)		1423 (+)				90 (+)	81 (+)	263
48 A v								90 (+)	81 (+)	264
49 A r	125a (+)	77 (+)		1419 (+)		III 54 (+)	p. 49 (+)	91 (+)	59 (+)	211
49 A v									59 (+)	(d+)
50 A r	173 (+)	78 (+)		1420 (+)		III 83 (+)		92 (+)	38 (+)	192
50 A v	174 (+)	78 (+)		1420 (+)		III 83 (+)		92 (+)	38 (+)	193
51 A r	264 (−)	79 (+)		1421 (−)				464 (−)	246 (−)	(−)
51 A v								93 (+)	246 (−)	(−)

COLLECTION NUMBER	Frey	Thode	Brinck-mann	Berenson	Goldscheider	Tolnay	Wilde	Dussler	Barocchi	Hartt
FLORENCE, Casa Buonarroti "A" *(continued)*										
52 A		80 (+)		1663B (−)				465 (−)	258 (−)	(−)
53 A r	49 (−)	108 (+)					p. 74 (+)	94 (+)	93 (+)	277
53 A v	50 (−)	108 (+)					p. 74 (+)	94 (+)	93 (+)	278
54 A		109 (+)						466 (−)	247 (−)	(−)
55 A	107e (+)	110 (+)		1431 (+)				280 (+)	30 (+)	490
56 A	107d (+)	111 (+)		1432 (+)				281 (+)	33 (+)	488
57 A r	282a (+)	112 (+)				III 78 (+)		95 (+)	56 (+)	205
58 A	282c (+)	113 (+)		1433 (+)				96 (+)	153 (+)	536
59 A	175 (+)	82 (+)				III 76 (+)	p. 58 (+)	97 (+)	64 (+)	225
60 A		83 (+)						98 (+)	92 (+)	279
61 A		84 (+)					p. 58 (+)	99 (+)	65 (+)	226
62 A r		127 (+)						100 (+)	84 (+)	271
62 A v								100 (+)	84 (+)	272
63 A	283 (+)	114 (+)						101 (+)	85 (+)	273
64 A	53 (−)	115 (−)						468 (−)	46 (−)	150
65 A		116 (+)						469 (−)	257 (−)	(−)
66 A r	124 (+)	117 (+)		1434 (+)		III 82 (+)		102 (+)	39 (+)	194
66 A v	123 (+)	117 (+)		1434 (+)		III 82 (+)		102 (+)	39 (+)	195
67 A r		118 (+)				IV p. 155 (+)		103 (+)	53 (+)	(d+)
67 A v						IV p. 155 (+)		103 (+)	53 (+)	(d+)
68 A r		119 (+)				IV p. 155 (+)		104 (+)	54 (+)	(d+)
68 A v		119 (+)				IV p. 155 (+)		104 (+)	54 (+)	(d+)
69 A	198 (+)	120 (+)				IV 126 (+)		105 (+)	51 (+)	288
70 A	267c (+)	121 (+)				III 50 (+)		106 (+)	68 (+)	206
71 A r	267b (+)	122 (+)		1435 (+)		III 55 (+)	p. 50 (+)	107 (+)	58 (+)	213
71 A v								107 (+)	58 (+)	(d+)
72 A	266a (+)	123 (+)		1436 (+)		III 81 (+)	p. 56 (+)	108 (+)	63 (+)	221
73 A	137b (+)	124 (+)		1437 (+)		III 85 (+)		109 (+)	97 (+)	323
73 A bis		68 (+)						470 (−)	164 (+)	524
74 A r		125 (+)				IV p. 155 (+)		110 (+)	55 (+)	(d+)
74 A v		125 (+)						110 (+)	55 (+)	(d+)
75 A r		126 (+)				IV p. 155 (+)		111 (+)	50 (+)	(d+)
75 A v		126 (+)				IV p. 155 (+)		111 (+)	50 (+)	(d+)
76 A r	68 (+)	131 (+)						112 (+)	96 (+)	(d+)
76 A v	69 (+)	131 (+)						112 (+)	96 (+)	322
77 A r		132 (+)						113 (+)	48 (+)	151
77 A v	268 (+)	132 (+)						113 (+)	48 (+)	(d+)
78 A		133 (+)						114 (+)	86 (+)	274
79 A	166 (+)	141 (+)						115 (+)	87 (+)	281
80 A	167 (+)	142 (+)						116 (+)	88 (+)	282
81 A	235 (+)	143 (+)					p. 74 (+)	117 (+)	77 (+)	(d+)
82 A	107a (+)	144 (+)		1447 (+)				282 (+)	32 (+)	485
83 A	107b (+)	145 (+)		1448 (+)				283 (+)	31 (+)	489
84 A r	211c (+)	146 (+)		1449 (+)				118 (+)	166 (+)	523
85 A r	211d (+)	147 (+)		1450 (+)				119 (+)	101 (+)	531
85 A v								119 (+)	101 (+)	(f+)
86 A	107f (+)	148 (+)		1451 (+)				284 (+)	34 (+)	486
87 A	107c (+)	149 (+)		1452 (+)				285 (+)	35 (+)	487
88 A	70 (+)	134 (+)		1440 (+)		III 53 (+)	p. 50 (+)	120 (+)	57 (+)	210
89 A r	71 (+)	135 (+)		1441 (+)		III p. 170 (+)		121 (+)	80 (+)	260
89 A v	72 (+)	135 (+)						121 (+)	80 (+)	261
90 A	282b (+)	136 (+)		1442 (+)				122 (+)	154 (+)	535

COLLECTION NUMBER	Frey	Thode	Brinck-mann	Berenson	Goldscheider	Tolnay	Wilde	Dussler	Barocchi	Hartt
FLORENCE, Casa Buonarroti "A" (*continued*)										
91 A r	96a (+)	137 (+)		1443 (+)				123 (+)	42 (+)	146
92 A r	164 (ip)	138 (ip)		1444 (ip)			p. 72 (ip)	124 (ip)	89 (ip)	284
92 A v	165 (ip)	138 (ip)		1444 (ip)			p. 72 (ip)	124 (ip)	89 (ip)	283
93 A r	125c (+)	139 (+)		1445 (+)		III 63 (+)	p. 50 (+)	125 (+)	60 (+)	214
93 A v							p. 50 (+)	125 (+)	60 (+)	215
94 A	269 (+)	140 (+)		1446 (+)				126 (+)	90 (+)	285
95 A		150 (+)						472 (−)	254 (−)	(−)
96 A r		151 (+)						127 (+)	79 (−)	(−)
96 A v		151 (+)						127 (+)	79 (+)	259
97 A r		152 (+)						473 (−)	167 (−)	(−)
97 A v		152 (+)						128 (+)	167 (+)	526
99 A		154 (+)						129 (+)	165 (+)	525
100 A		155 (+)						475 (−)	253 (−)	(−)
101 A	286 (+)	156 (+)		1453 (+)				130 (+)	29 (+)	198
102 A	237 (−)	157 (+)						476 (−)	168 (+)	527
103 A r	233 (?)	158 (+)						131 (+)	264 (−)	(−)
103 A v								131 (+)	264 (−)	(−)
104 A	95 (+)	69 (+)					p. 121 (+)	132 (+)	162 (+)	522
105 A	177b (+)	129 (+)		1439 (+)		III 80 (+)		133 (+)	67 (+)	207
106 A r		70 (+)						134 (+)	169 (+)	529
106 A v								134 (+)	169 (+)	530
107 A	214b (+)	128 (+)		1438 (+)		III p. 130 (−)		286 (+)	66 (+)	216
108 A		130 (+)						477 (−)	252 (−)	(−)
109 A	284 (+)	159 (+)						135 (+)	163 (+)	521
110 A	73 (+)	160 (+)		1454 (+)		III 61 (+)		136 (+)	36 (+)	199
111 A		161 (+)					p. 74 (−)	478 (−)	256 (−)	(−)
112 A	117a (?)	162 (+)		1455 (+)		III 79 (+)		137 (+)	100 (+)	154
113 A r		163 (+)						479 (−)	47 (ip)	(d+ip)
113 A v		163 (+)						479 (−)	47 (+)	(?)
114 A r		164 (+)						138 (−)	37 (−)	(−)
114 A v		164 (+)				III 62 (+)		138 (+)	37 (+)	200
115 A		71 (+)						480 (−)	249 (−)	(−)
117 A r		166 (+)						139 (+)	155 (+)	492
117 A v								139 (+)	155 (+)	(d+)
118 A r		167 (+)						140 (+)	156 (+)	(d+)
118 A v		167 (+)						140 (+)	156 (+)	499
119 A r		168 (+)						141 (+)	99 (+)	(d+)
119 A v		168 (+)						287 (?)	99 (?)	354
120 A r	295 (?)	169 (+)				IV p. 86 (+)	p. 112 (+)	142 (+)	159 (+)	515
120 A v						IV p. 86 (+)	p. 112 (+)	142 (ip)	159 (ip)	516
121 A	296 (?)	170 (+)				IV p. 86 (+)	p. 112 (+)	143 (+)	158 (+)	514
123 A	293a (+)	72 (+)						144 (+)	157 (+)	520
124 A r	294 (?)	73 (+)				IV p. 86 (+)	p. 112 (+)	145 (+)	160 (+)	517
124 A v								145 (+)	160 (ip)	493
125 A		85 (+)						483 (−)	263 (−)	(−)
126 A	266b, c (+)	86 (+)		1455A (+)				146 (+)	91 (+)	287
127 A		87 (+)				III 84 (−)		484 (−)	259 (−)	(−)
128 A	14 (+)	88 (+)				III 66 (+)	p. 75 (+)	87 (+)	95 (+)	320
128 A bis		74 (+)						485 (−)	260 (−)	(−)

COLLECTION NUMBER	Frey	Thode	Brinck-mann	Berenson	Goldscheider	Tolnay	Wilde	Dussler	Barocchi	Hartt

FLORENCE, Casa Buonarroti "F"

COLLECTION NUMBER	Frey	Thode	Brinck-mann	Berenson	Goldscheider	Tolnay	Wilde	Dussler	Barocchi	Hartt
1 F r	52 (+)	11 (+)		1400 (+)	29 (+)	II 45 (+)		48 (+)	8 (+)	12
2 F		12 (−)		1655 (−)		V 151 (+)	p. 125 (+)	409 (−)	133 (+)	(−)
3 F		13 (?)		1655A (−)				410 (−)	190 (−)	(−)
4 F	155b (+)	14 (+)		1401A (+)		V 159 (+)	p. 93 (+)	252 (+)	139 (+)	356
5 F		15 (ip)					p. 79 (ip)	411 (−)	180 (−)	(−)
7 F	16 (+)	16 (+)	31 (+)	1401 (+)	66 (+)	II 44 (+)	p. 83 (+)	49 (+)	122 (+)	305
8 F	232c (+)	17 (+)				II 23A (−)	p. 16 (+)	413 (−)	20 (+)	67
9 F		18 (+)		1656 (−)	18 (+)	I 26 (+)		253 (+)	5 (+)	36
10 F		18a (+)					p. 81 (+)	254 (+)	71 (+)	249
11 F	263a (+)	19 (+)		1401B (+)			p. 81 (+)	255 (+)	73 (+)	236
12 F		20 (+)		1657 (−)				414 (−)	176 (−)	(−)
13 F		21 (+)				V 195 (+)		415 (−)	75 (+)	237
14 F		24 (?)						416 (−)	178 (−)	(−)
15 F		25 (+)					p. 62 (+)	417 (−)	179 (−)	(−)
16 F		26 (+)					p. 80 (+)	418 (−)	69 (+)	243
17 F	126b (+)	27 (+)		1402 (+)			p. 86 (+)	256 (+)	125 (+)	172
18 F	126a (+)	28 (+)		1403 (+)			p. 86 (+)	257 (+)	127 (+)	173
19 F r	236 (+)	75 (+)		1403A (+)		III 69 (+)	p. 109 (+)	50 (+)	150 (+)	471
19 F v				1403A (+)		III 70 (+)	p. 109 (+)	50 (+)	150 (+)	472
21 F		p. 81 (−)		1658 (−)		IV 137 (+)		258 (+)	124 (+)	159
22 F		22 (?)		1659 (−)		III 97 (+)		259 (+)	206 (−)	534A
23 F		p. 81 (−)						260 (+)	9 (+)	13
24 F r		23 (+)						420 (−)	242 (−)	(−)
27 F		28a (+)		1660A (−)		V 190 (−)		423 (−)	283 (−)	(−)
29 F	231 (+)	29 (+)		1404 (+)		IV 130 (+)		51 (+)	240 (−)	(−)
30 F r	244c (+)	30 (+)		1405 (+)		V 156 (+)		52 (+)	119 (+)	409
31 F		31 (+)		1661A (−)				425 (−)	181 (−)	(−)
32 F	179 (+)	32 (+)		1406 (+)	72 (+)		p. 89 (+)	261 (+)	138 (+)	255
33 F		33 (+)		1661C (−)			p. 21 (+)	262 (+)	17 (+)	94
35 F		35 (+)		1407 (+)	80 (+)			427 (−)	135 (+)	460
36 F r				1663 (−)		I p. 179 (−)	p. 82 (+)	428 (−)	173 (−)	(−)
37 F		36 (+)		1408 (+)				429 (−)	170 (−)	(−)
38 F	291b (+)	37 (+)		1409 (+)			p. 86 (+)	263 (+)	126 (+)	171
39 F		38 (+)					p. 22 (+)	430 (−)	234 (−)	(−)
41 F		p. 81 (−)					p. 80 (+)	432 (−)	70 (+)	244
42 F r		p. 81 (−)				IV 133 (+)		264 (+)	241 (−)	(−)
42 F v								264 (+)	241 (−)	(−)
44 F	114 (+)	40 (+)	40 (+)	1409A (+)	58 (+)	III 98 (+)	p. 81 (+)	53 (+)	74 (+)	238
45 F	115 (+)	41 (+)	24 (+)	1409B (+)	70 (+)	II 5A (−)		434 (−)	18 (+)	70
46 F r	280c (+)	42 (+)		1409C (+)			p. 119 (+)	265 (+)	149 (+)	478
46 F v								265 (+)	149 (+)	458
47 F	172a (+)	43 (+)		1409D (+)			p. 97 (+)	266 (+)	22 (+)	396
48 F	263b (+)	44 (+)		1409E (+)			p. 81 (+)	267 (+)	72 (+)	251
49 F	232b (+)	45 (+)		1409F (+)		II 23A (−)		268 (+)	16 (+)	97
51 F r		46 (+)				IV 45A (−)	p. 88 (−)	436 (−)	200 (−)	(−)
52 F r	171 (+)	47 (+)		1663A (−)		II 22A (−)	p. 21 (+)	437 (−)	227 (−)	(−)
52 F v							p. 19 (+)	437 (−)	227 (−)	(−)
53 F r	176 (−)	48 (+)		1664 (−)		III p. 184 (−)	p. 80 (+)	438 (−)	174 (−)	(−)
54 F	276 (?)	49 (+)		1409G (+)				439 (−)	146 (+)	389
56 F		50a (+)						441 (−)	229 (−)	(−)
57 F	244a (+)	51 (+)		1410 (+)				54 (+)	120 (+)	308

FLORENCE, Casa Buonarroti "F" (continued)

COLLECTION NUMBER	Frey	Thode	Brinck-mann	Berenson	Goldscheider	Tolnay	Wilde	Dussler	Barocchi	Hartt
58 F	244b (+)	52 (+)		1411 (+)				269 (+)	130 (+)	176
59 F		52a (+)		1411A (+)				442 (−)	2 (+)	(−)
60 F	232a (?)	52b (+)		1411B (+)		II 23A (−)	p. 83 (+)	270 (+)	123 (+)	306
61 F r		53 (+)	61 (+)	1665A (−)	75 (+)	V 163 (?)	p. 89 (−)	443 (−)	137 (+)	181
61 F v				1665A (−)		V 163 (?)	p. 89 (+)	443 (−)	137 (+)	182
62 F	155c (+)	54 (+)		1666 (−)	71 (+)	III p. 217 (−)	p. 87 (+)	444 (−)	134 (+)	352
63 F	244d (+)	55 (+)		1412 (+)			p. 67 (+)	271 (?)	10 (+)	61
64 F	105 (+)	56 (+)	25 (+)	1666A (−)		II 4A (−)		445 (−)	238 (−)	(−)
65 F r	20 (+)	57 (+)	60 (+)	1413 (+)	100 (+)	V 171 (+)	p. 65 (+)	55 (+)	142 (+)	371
65 F v				1413 (+)	76 (+)	V 172 (+)	p. 89 (+)	55 (+)	142 (+)	349
66 F		58 (+)	62 (+)	1667 (−)		V p. 179 (?)	p. 89 (+)	446 (−)	136 (+)	180
67 F	126c (+)	59 (+)		1414 (+)			p. 86 (+)	272 (+)	128 (+)	174
68 F	126d (+)	60 (+)		1415 (+)			p. 86 (+)	273 (+)	129 (+)	175
69 F r	15 (+)	61 (+)		1416 (+)	61 (+)	V p. 181 (?)		274 (+)	143 (+)	453
69 F v				1416 (+)	61 (−)	V 182 (ip)		274 (+)	143 (+)	387
70 F	292 (+)	62 (+)		1417 (+)	85 (+)			275 (+)	140 (+)	464
71 F		63 (+)	20 (+)	607 (−)	178 (−)	V 142 (?)	p. 64 (+)	447 (−)	121 (+)	438
72 F r		64 (?)						448 (−)	203 (−)	(−)
73 F	26 (+)	65 (+)		1418 (+)		I 22 (+)		56 (+)	6 (+)	3
75 F	116 (+)	66 (+)		1668A (−)		II 16A (−)	p. 60 (+)	276 (+)	15 (+)	98

FLORENCE, Uffizi

COLLECTION NUMBER	Frey	Thode	Brinck-mann	Berenson	Goldscheider	Tolnay	Wilde	Dussler	Barocchi	Hartt
170 S	100 (+)	235 (+)	63 (+)	1399K (+)		V 173 (+)	p. 100 (+)	294 (+)	141 (+)	372
233 F r		215 (−)	8 (+)	1645A (−)		I p. 255 (−)	p. 5 (+)	488 (−)	1 (+)	24
233 F v				1645A (−)			p. 5 (+)	488 (−)	1 (+)	(−)
598 E r		206 (+)	87 (−)	1626 (−)	50 (+)	V 149 (−)		491 (−)	185 (−)	(−)
598 E v		206 (+)		1626 (−)	50 (−)	V 149 (−)		491 (−)	185 (−)	(−)
599 E r		204 (−)		1627 (−)	51 (+)			492 (−)	186 (−)	(−)
599 E v		204 (−)		1627 (−)	47 (+)			492 (−)	186 (−)	(−)
601 E		p. 98 (−)		1628 (−)	49 (+)	V 150 (−)		493 (−)	187 (−)	(−)
603 E		207 (?)		1630 (−)				494 (−)	189 (−)	(−)
608 E r		209 (−)		1632 (−)		IV 124 (−)		497 (−)	244 (−)	45A
608 E v		209 (−)		1632 (−)		IV 51A (−)	p. 3 (+)	497 (−)	244 (−)	52
611 E r		216 (+)		1634 (−)				498 (−)	277 (−)	(−)
611 E v		216 (+)		1634 (−)			p. 83 (+)	498 (−)	277 (−)	(−)
613 E r		208 (+)	12 (+)	1397C (+)	p. 29 (−)	I p. 214 (−)	p. 24 (+)	499 (−)	4 (+)	25
613 E v				1397C (+)			p. 24 (+)	499 (−)	4 (+)	26
618 E		213 (+)		1398 (+)				503 (−)	145 (+)	187
620 E		214 (+)		1399 (+)				288 (?)	7 (+)	(−)
621 E r	54 (ip)	205 (+)		1398A (+)		III 102 (+)		289 (+)	131 (+)	314
622 E			41 (+)	1642 (−)					205 (−)	(−)
14412 F r	98 (+)	217 (+)		1399A (+)		V 202 (+)		290 (+)	147 (+)	399
14412 F v	99 (+)	217 (+)	6 (+)	1399A (+)	p. 29 (−)	V 202 (+)		290 (+)	147 (+)	398
17379 F	67a (+)	227 (+)		1399A-1 (+)		II 14A (−)		505 (−)	13 (+)	64
17380 F	67b (+)	228 (+)		1399A-1 (−)		II 14A (−)		506 (−)	14 (+)	65
17381 F	249b (+)	229 (+)		1399A-2 (+)		II 1A (−)		507 (−)	12 (+)	69
18718 F r		218 (+)		1399B (+)	28 (+)	II 42 (+)		147 (+)	21 (+)	85
18718 F v		218 (+)		1399B (+)	28 (−)	II 21A (−)		147 (+)	21 (+)	108
18719 F r		219 (+)	39 (+)	1399C (+)			p. 85 (+)	291 (+)	76 (+)	239
18719 F v		219 (+)	39 (+)	1399C (+)			p. 85 (+)	291 (+)	76 (+)	240

COLLECTION NUMBER	Frey	Thode	Brinck-mann	Berenson	Goldscheider	Tolnay	Wilde	Dussler	Barocchi	Hartt
FLORENCE, Uffizi (*continued*)										
18720 F r		220 (+)		1399D (+)		V 160 (?)		292 (+)	19 (+)	101
18720 F v		220 (+)		1399D (+)				292 (+)	19 (+)	102
18721 F r	65 (+)	230 (+)		1654A (−)	192 (−)	II 27A (−)		508 (−)	175 (−)	(−)
18721 F v	66 (+)	230 (+)		1654A (−)				508 (−)	175 (−)	(−)
18722 F r		221 (+)		1399E (+)		II 9A (−)	p. 27 (+)	509 (−)	11 (+)	73
18722 F v		221 (+)		1399E (+)				509 (−)	11 (+)	99
18723 F		222 (+)		1399F (+)				510 (−)	225 (−)	(−)
18724 F r		231 (+)		1653A (−)				511 (−)	237 (−)	(−)
18724 F v		231 (+)		1653A (−)				511 (−)	237 (−)	(−)
18729 F		223 (+)		1399G (+)				512 (−)	52 (+)	(−)
18730 F	97 (+)	232 (+)		1399G-1 (?)				513 (−)	236 (−)	(−)
18733 F		233 (+)		1399G-2 (+)				514 (−)	226 (−)	(−)
18734 F r		234 (+)		1399G-3 (+)				515 (−)	148 (+)	402
18734 F v		234 (+)		1399G-3 (+)				515 (−)	148 (+)	403
18735 F		224 (+)		1399H (+)				293 (+)	144 (+)	404
18736 F	74 (+)	225 (+)		1399I (+)				516 (−)	132 (+)	95
18737 F		226 (+)		1399J (+)		III p. 192 (−)	p. 8 (+)	517 (−)	3 (+)	29
FRANKFURT, Städelsches Kunstinstitut										
392 v		247 (+)		1669 (−)			p. 66 (−)	520 (−)		
393		248 (+)		1669A (−)				521 (−)		(−)
HAARLEM, Teylersmuseum										
A 16 r	312 (ip)	257 (+)	95 (−)	1670 (−)		II 26A (−)	p. 26 (+)	522 (−)		92
A 16 v	313 (ip)			1670 (−)				522 (−)		80
A 17 r	307 (+)	270 (?)	92 (−)	1473 (?)				523 (−)		168A
A 18 r	305 (+)	253 (+)	85 (−)	1463 (+)		I p. 219 (−)		524 (−)		42
A 18 v	306 (+)	253 (+)	86 (−)	1463 (+)		II p. 181 (−)		524 (−)		66
A 19 r	303 (+)	254 (+)	84 (−)	1464 (+)		I p. 219 (−)		525 (−)		43
A 19 v	304 (+)	254 (+)		1464 (+)			p. 82 (+)	525 (−)	p. 226 (+)	384
A 20 r	310 (+)	256 (+)		1466 (+)		II 18A (−)	p. 23 (+)	526 (−)		75
A 20 v	311 (+)	256 (+)		1466 (+)	190 (−)	II 18A (−)	p. 27 (+)	526 (−)		76
A 22 r	301 (+)	271 (+)		1474 (+)				527 (−)		163
A 22 v	302 (+)			1474 (+)	202 (−)			527 (−)		164
A 23 r	322 (+)	261 (+)	83 (?)	1468 (+)	102 (+)	V 183 (+)		295 (+)	p. 180 (+)	383
A 23 v	323 (+)	261 (+)		1468 (+)		V 184 (+)	p. 87 (+)	295 (+)		406
A 24 r	320 (+)	268 (+)		1472 (+)	62 (+)	III p. 184 (−)		528 (−)		476
A 24 v	321 (+)	268 (+)		1472 (−)		III p. 184 (−)		528 (−)		
A 25 r	330 (−)	266 (+)	89 (−)	2480 (−)	89 (+)	V 241 (+)	p. 65 (+)	529 (−)		452
A 25 v	331 (−)	266 (−)		2480 (−)	89 (−)	V 241 (−)	p. 81 (ip)	529 (−)	p. 57 (−)	
A 27 r	308 (+)	255 (+)	94 (−)	1465 (+)	183 (−)	II 17A (−)	p. 16 (+)	530 (−)	p. 150 (+)	103
A 27 v	309 (+)	255 (+)		1465 (+)		II 17A (−)	p. 27 (+)	530 (−)	p. 224 (−)	74
A 28 r								531 (−)		51
A 28 v							p. 3 (+)	531 (−)		413
A 29 r	326 (+)	264 (+)		1469 (+)		V 212 (+)		148 (+)	p. 197 (+)	498
A 29 v	327	264 (+)		1469 (+)		V 213 (+)		148 (+)		503
A 29 bis	326 (+)	264 (+)		1469 (+)				296 (+)		533
A 30 r	316 (+)	258 (+)		1671 (−)			p. 85 (+)	532 (−)	p. 98 (+)	232

COLLECTION NUMBER	Frey	Thode	Brinck-mann	Berenson	Goldscheider	Tolnay	Wilde	Dussler	Barocchi	Hartt
LONDON, British Museum (continued)										
1859–5–14–818	251 (ip)	314 (ip)		1502 (ip)	53 (+)	III 88 (ip)	31 (ip)	149 (ip)	p. 254 (ip)	177
1859–5–14–819		315 (−)		1685 (−)			49 (+)	549 (−)	p. 94 (+)	392
1859–5–14–820		316 (+)		1476A (+)			14 (+)	304 (+)	p. 20 (+)	246
1859–5–14–821 r	192 (+)	317 (+)		1477 (+)			45 (+)	305 (+)	p. 94 (+)	248
1859–5–14–821 v	191 (+)	317 (+)		1477 (+)			45 (+)	305 (+)		128
1859–5–14–822 r	47 (+)	318 (+)	35 (+)	1495 (+)		III 52 (+)	26 (+)	150 (+)	p. 79 (+)	217
1859–5–14–822 v	48 (+)	318 (+)		1495 (+)		III 51 (+)	26 (+)	150 (+)	p. 79 (+)	218
1859–5–14–823 r	55 (+)	319 (+)		1497 (+)		III 57 (+)	27 (+)	151 (+)	p. 87 (+)	220
1859–5–14–823 v	56 (+)	319 (+)		1497 (+)		III 100 (−)	27 (+)	151 (+)	p. 87 (+)	291
1859–5–14–824 r	10a (+)	320 (+)		1501 (+)		IV 127 (+)	23 (+)	152 (+)		126
1859–5–14–824 v	10b (+)	320 (+)		1501 (+)		IV 128 (+)	23 (+)	152 (+)		127
1859–6–25–543 r	9a (+)	285 (+)		1496 (+)		III 58 (+)	28 (+)	153 (+)	p. 45 (+)	224
1859–6–25–543 v	9b (+)	285 (+)		1496 (+)		III 59 (+)	28 (+)	153 (+)	p. 45 (+)	223
1859–6–25–544 r	60 (+)	286 (+)	42 (+)	1491 (+)	57 (+)	III 95 (+)	35 (+)	154 (+)	p. 94 (+)	252
1859–6–25–545 r	39 (+)	287 (+)		1494 (+)		III 56 (+)	25 (+)	155 (+)	p. 79 (+)	212
1859–6–25–545 v	38 (+)	287 (+)		1494 (+)		II 8A (−)	25 (+)	306 (+)		78
1859–6–25–546	186 (+)	288 (+)		1503 (+)			24 (+)	156 (+)		197
1859–6–25–547 r	184 (+)	289 (+)	29 (+)	1482 (?)		III 90 (?)	41 (+)	307 (+)		366
1859–6–25–547 v	185 (+)	289 (+)		1482 (?)		V p. 167 (+)	41 (+)	307 (+)		367
1859–6–25–548	241 (+)	290 (+)				III 75 (−)	20 (+)	308 (+)	p. 44 (+)	152
1859–6–25–549	131 (+)	291 (+)		1492 (+)			21 (+)	309 (+)	p. 47 (+)	484
1859–6–25–550 r	117a (+)	292 (+)		1500 (+)			37 (+)	157 (+)	p. 302 (+)	275
1859–6–25–550 v	117b (+)	292 (+)		1500 (+)			37 (+)	157 (+)	p. 302 (+)	276
1859–6–25–551	212b (+)	293 (+)		1509 (+)			51 (+)	310 (+)	p. 156 (+)	167
1859–6–25–552 r	280a (+)	294 (+)				V 155 (+)	68 (+)	311 (+)		253
1859–6–25–553	212c (+)	295 (+)		1504 (+)		III 122 (+)	56 (+)	158 (+)	p. 173 (+)	307
1859–6–25–554 r	137a (+)	296 (+)		1488 (+)		III 79A (ip)	30 (+)	312 (+)	p. 226 (+)	301
1859–6–25–555	281 (+)	297 (+)	28 (+)	1487 (+)	56 (+)	II 24A (−)	12 (+)	313 (+)	p. 254 (+)	165
1859–6–25–556 r	229 (+)	298 (+)		1513 (+)		V 161 (+)	62 (+)	551 (−)	p. 30 (+)	385
1859–6–25–556 v	230 (?)	298 (+)		1513 (+)		V 162 (−)	62 (+)	551 (−)	p. 30 (+)	386
1859–6–25–557 r	31 (+)	299 (+)	43 (+)	1490 (+)		III 91 (+)	33 (+)	159 (+)	p. 229 (+)	496
1859–6–25–557 v	32 (+)	299 (+)		1490 (+)		III 91 (−)	33 (+)	159 (+)		186
1859–6–25–558	221 (+)	300 (+)		1480 (+)			9 (+)	314 (+)	p. 26 (+)	93
1859–6–25–559 r	106 (+)	301 (+)		1499 (+)		III 67 (+)	22 (+)	160 (+)		201
1859–6–25–559 v	106 (−)	301 (−)		1499 (+)		III 67 (−)	22 (−)	552 (−)	p. 218 (−)	(−)
1859–6–25–560/1 r	85 (+)	302 (−)		1506 (+)			18 (+)	315 (ip)	p. 37 (+)	142
1859–6–25 560/1 v	86 (+)	302 (−)		1506 (+)			18 (+)	315 (ip)	p. 37 (+)	143
1859–6–25–560/2 r	181 (+)	303 (−)		1505 (+)			19 (+)	316 (+)	p. 37 (+)	144
1859–6–25–560/2 v	182 (+)	303 (+)		1505 (+)			19 (+)	316 (+)	p. 37 (+)	145
1859–6–25–561		304 (?)		1680 (−)	52 (+)		40 (ip)	553 (−)		368
1859–6–25–562	257 (+)	305 (+)	81 (+)	1518 (+)	130 (+)	V 266 (+)	83 (+)	161 (+)		441
1859–6–25–563	183 (+)	306 (+)		1478 (+)		II 3A (−)	47 (+)	317 (+)	p. 171 (+)	292
1859–6–25–564 r	45 (+)	307 (+)	9 (+)	1479 (+)	20 (+)	I 24 (+)	5 (+)	162 (+)	p. 3 (+)	27
1859–6–25–564 v	46 (+)	307 (+)		1479 (+)	19 (+)	I 25 (+)	5 (+)	162 (+)	p. 3 (+)	28
1859–6–25–565 r	227 (−)	308 (−)		1508 (+)	193 (−)		p. 142 (−)	553a (−)		(−)
1859–6–25–565 v	228 (−)	308 (−)		1508 (+)			p. 142 (−)	553a (−)		(−)
1859–6–25–566 v		309 (+)		1680A (−)			46 (+)	554 (−)	p. 284 (−)	230
1859–6–25–567 r	43 (+)	310 (+)	21 (+)	1483 (+)	25 (+)	II 36 (+)	7 (+)	163 (+)	p. 15 (+)	62
1859–6–25–567 v	44 (+)	310 (+)		1483 (+)	25 (−)	II 11A (−)	7 (+)	318 (+)		82
1859–6–25–568 r	122 (+)	311 (+)		1484 (+)	38 (+)		8 (+)	319 (+)	p. 10 (+)	100
1859–6–25–568 v	121 (+)	311 (+)	34 (+)	1484 (+)	26 (ip)	II 41 (ip)	8 (+)	164 (+)	p. 22 (+)	96

COLLECTION NUMBER	Frey	Thode	Brinck-mann	Berenson	Goldscheider	Tolnay	Wilde	Dussler	Barocchi	Hartt

LONDON, British Museum (*continued*)

COLLECTION NUMBER	Frey	Thode	Brinck-mann	Berenson	Goldscheider	Tolnay	Wilde	Dussler	Barocchi	Hartt
1859–6–25–569 r	147 (−)	312 (+)		1498 (+)	60 (+)		48 (−)	555 (−)		(−)
1859–6–25–569 v	146 (?)	312 (+)		1498 (+)	60 (+)	III p. 150 (−)	48 (+)	555 (−)	p. 180 (+)	235
1859–6–25–570		313 (?)		1686 (−)			43 (+)	556 (−)	p. 91 (+)	241
1859–6–25–571		313 (?)		1686A (−)			44 (+)	557 (−)	p. 91 (+)	242
1860–6–16–1		321 (+)		2482 (−)	p. 46 (+)	V p. 165 (−)	58 (+)	558 (−)		(−)
1860–6–16–2/1 r	252a (+)	324 (+)		1516 (+)	108 (+)	V 233 (+)	77 (+)	165 (+)	p. 181 (+)	445
1860–6–16–2/1 v	252b (+)	324 (+)		1516 (+)	108 (+)	V 232 (+)	77 (+)	165 (+)	p. 181 (+)	444
1860–6–16–2/2 r	253 (+)	323 (+)		1515 (+)	109 (+)	V 231 (+)	76 (+)	166 (+)	p. 181 (+)	446
1860–6–16–2/2 v	254 (+)	323 (+)		1515 (+)	109 (+)	V 230 (+)	76 (+)	166 (+)	p. 181 (+)	442
1860–6–16–2/3 r	255 (+)	322 (+)	69 (+)	1517 (+)	110 (+)	V 235 (+)	78 (+)	167 (+)	p. 181 (+)	447
1860–6–16–2/3 v	256 (+)	322 (+)		1517 (+)		V 234 (+)	78 (+)	167 (+)	p. 181 (+)	443
1860–6–16–3		325 (+)		2485 (−)	90 (+)		32 (+)	559 (−)	p. 171 (+)	298
1860–6–16–4	258 (?)	326 (+)	71 (+)	1514 (+)			69 (+)	320 (+)	p. 175 (+)	451
1860–6–16–5 r	278 (−)	327 (+)	68 (+)	1684 (−)		V 191 (−)	61 (+)	560 (−)	p. 182 (+)	379
1860–6–16–5 v	277 (−)	327 (+)		1684 (−)		V 192 (−)	61 (+)	560 (−)	p. 182 (+)	378
1860–6–16–133	59 (+)	328 (+)	46 (+)	1507 (+)	79 (+)	III 110 (+)	52 (+)	168 (+)	p. 163 (+)	350
1860–7–14–1		329 (−)		2484 (−)		III p. 20 (−)	17 (+)	561 (−)	p. 73 (+)	(−)
1860–7–14–2		330 (+)	93 (−)	2483 (−)	40 (ip)	III p. 20 (−)	16 (+)	562 (−)	p. 73 (+)	(−)
1885–5–9–1893	279b (+)	331 (+)		1510 (+)		V 223 (+)	73 (+)	321 (+)		434
1885–5–9–1894	279a (+)	332 (+)		1511 (+)		V 228 (+)	79 (+)	322 (+)	p. 247 (+)	449
1886–5–13–5 r	299 (−)	333 (+)		1683 (−)		V 185 (+)	63 (+)	563 (−)	p. 324 (+)	390
1886–5–13–5 v	300 (−)	333 (+)		1683 (−)		V 186 (+)	63 (+)	563 (−)	p. 324 (+)	391
1887–5–2–115 r	242 (+)	334 (+)		1486 (+)	33 (+)		29 (+)	323 (?)		55
1887–5–2–116 r	103 (+)	335 (+)	11 (+)	1476 (+)		I 31 (−)	6 (+)	324 (+)	p. 12 (+)	41
1887–5–2–116 v	104 (+)	335 (+)		1476 (?)			6 (+)	565 (−)		(−)
1887–5–2–117 r	91 (+)	336 (+)	10 (+)	1481 (+)	16 (+)	I 23 (+)	4 (+)	169 (+)	p. 12 (+)	4
1887–5–2–117 v	92 (+)	336 (+)	18 (+)	1481 (+)	21 (+)	I 21 (ip)	4 (+)	169 (+)	p. 4 (+)	11
1887–5–2–118 r	94 (ip)	337 (ip)		1485 (ip)	172 (−)	II 38 (−)	10 (+)	566 (−)	p. 277 (+)	84
1887–5–2–118 v	93 (+)	337 (+)		1485 (+)		II 38 (ip)	10 (+)	325 (+)	p. 27 (+)	83
1887–5–2–119	110 (+)	338 (+)	51 (+)	1507A (+)	159 (+)	V 165 (ip)	53 (+)	326 (+)	p. 251 (+)	132
1895–9–15–492		343 (?)		1688 (−)		V 147 (−)	87 (−)	567 (−)		(−)
1895–9–15–493 r	289 (−)	344 (+)		1689 (−)		V 148 (−)	42 (+)	568 (−)	p. 165 (+)	365
1895–9–15–493 v	290 (−)	344 (ip)		1689 (−)		V 148 (−)	42 (ip)	568 (−)	p. 228 (−)	313
1895–9–15–495		345 (+)		1520 (+)	15 (+)		2 (+)	327 (+)	p. 283 (+)	157
1895–9–15–496 r	13a (+)	346 (+)	5 (+)	1521 (+)	22 (+)	I 19 (+)	3 (+)	170 (+)	p. 19 (+)	22
1895–9–15–496 v	13b (+)	346 (+)		1521 (ip)	23 (+)	I 20 (+)	3 (+)	170 (+)	p. 38 (+)	23
1895–9–15–497 r	261 (+)	347 (+)		1690 (−)		II 25A (−)	13 (+)	569 (−)	p. 30 (+)	90
1895–9–15–497 v	262 (+)	347 (+)		1690 (−)		II 25A (−)	13 (+)	569 (−)		91
1895–9–15–498 r	41 (+)	348 (+)		1522 (+)	14 (+)	I 6 (+)	1 (+)	171 (+)	p. 282 (+)	21
1895–9–15–498 v	42 (+)	348 (+)	26 (+)	1522 (+)	41 (+)	II 43 (+)	1 (+)	171 (+)	p. 282 (+)	245
1895–9–15–500		349 (−)		2487 (−)			15 (+)	570 (−)	p. 73 (+)	(−)
1895–9–15–501 r	288 (+)	350 (+)	50 (+)	1523 (+)	81 (+)	V 166 (+)	54 (+)	328 (+)		183
1895–9–15–501 v	288 (−)	365 (+)		1523 (+)	81 (−)	V 166 (ip)	54 (+)	571 (−)	p. 220 (+)	190
1895–9–15–502 r	159b (+)	351 (+)		1525 (+)		V 189 (?)	70 (+)	572 (−)	p. 186 (+)	405
1895–9–15–502 v	159a (+)	351 (+)		1525 (+)		V 189 (+)	70 (+)	172 (+)		537
1895–9–15–503	297b (+)	352 (+)		1526 (+)		III p. 184 (−)	34 (−)	573 (−)	p. 226 (−)	(−)
1895–9–15–504	287 (−)	353 (+)		II p. 239 (−)	113 (+)	V 198 (ip)	67 (+)	329 (?)		408
1895–9–15–507 r	120a (+)	354 (+)		1527 (+)			39 (+)	330 (+)	p. 119 (+)	318
1895–9–15–507 v	120b (−)	354 (+)		1527 (?)			39 (−)	574 (−)		(−)
1895–9–15–508 r	118 (+)	355 (+)		1528 (+)			36 (+)	173 (+)		265
1895–9–15–508 v	119 (ip)	355 (ip)		1528 (ip)			36 (ip)	173 (ip)	p. 227 (ip)	266

COLLECTION NUMBER	Frey	Thode	Brinck-mann	Berenson	Goldscheider	Tolnay	Wilde	Dussler	Barocchi	Hartt
LONDON, British Museum (*continued*)										
1895-9-15-509	127 (+)	356 (+)		1529 (+)	131 (+)	V 251 (+)	81 (+)	174 (+)	p. 188 (+)	424
1895-9-15-510	128 (+)	357 (+)	75 (+)	1530 (+)	129 (+)	V 256 (+)	82 (+)	175 (+)	p. 188 (+)	429
1895-9-15-511 r	274 (−)	358 (+)	66 (+)	1692 (−)			57 (+)	575 (−)		(−)
1895-9-15-511 v	275 (−)	358 (+)		1692 (−)			57 (ip)	575 (−)		(−)
1895-9-15-512	280d (+)	359 (+)		1531 (+)			p. 142 (−)	576 (−)		
1895-9-15-513	291a (−)	360 (+)		1532 (+)		V 214 (+)	74 (+)	331 (+)		510
1895-9-15-514	297a (+)	361 (+)		1533 (+)			50 (+)	332 (+)	p. 171 (+)	189
1895-9-15-516 r	259 (?)	362 (+)	77 (+)	1534 (+)	126 (+)	V 221 (?)	72 (+)	176 (+)	p. 246 (+)	436
1895-9-15-516 v	260 (?)	362 (+)		1534 (+)	124 (+)	V p. 207 (−)	72 (+)	176 (+)	p. 246 (+)	432
1895-9-15-517	57 (+)	363 (+)	55 (+)	1535 (+)	94 (+)	III 117 (+)	55 (+)	117 (+)	p. 163 (+)	355
1895-9-15-518 r	79 (+)	364 (+)	64 (+)	1536 (+)	101 (+)	V 178 (ip)	60 (+)	333 (+)	p. 182 (+)	374
1895-9-15-518 v	80 (+)	364 (+)		1536 (+)	103 (+)	V 179 (?)	60 (+)	333 (+)	p. 182 (+)	375
1895-9-15-518★		552 (+)		1537 (+)	118 (+)	V 236 (ip)	75 (+)	178 (+)		440
1895-9-15-519							59 (+)	577 (−)	p. 150 (+)	(−)
1895-9-15-813				2488 (−)			15a (+)			129

For Wilde 15a, see Philip Pouncey and J. A. Geere, *Italian Drawings in the Department of Prints and Drawings in the British Museum: Raphael and his Circle*, London, 1962, no. 276 and Appendix I.

COLLECTION NUMBER	Frey	Thode	Brinck-mann	Berenson	Goldscheider	Tolnay	Wilde	Dussler	Barocchi	Hartt
1896-7-10-1 r		339 (+)		2486 (−)	114 (+)		64 (+)	578 (−)		(−)
1896-7-10-1 v		339 (+)		2486 (−)	114 (−)		64 (−)	578 (−)		(−)
1900-6-11-1 r	190 (?)	340 (+)	78 (+)	1519 (+)	122 (+)	V 220 (+)	71 (+)	179 (+)	p. 246 (+)	431
1926-10-9-1 r		517 (+)		1519A (+)		II 6A (−)	11 (+)	580 (−)	p. 30 (+)	77
1926-10-9-1 v		517 (−)		1519A (−)		II 6A (−)	11 (+)	580 (−)		107
1946-7-13-33 r				1397A (+)			38 (+)	180 (+)		280
1946-7-13-33 v				1397A (+)			38 (+)	180 (+)		(d+)
1946-7-13-33a							84 (+)	181 (+)	p. 204 (+)	(d+)
1947-4-12-161						IV 52A (−)	66 (+)	582 (−)		532

COLLECTION NUMBER	Frey	Thode	Brinck-mann	Berenson	Goldscheider	Tolnay	Wilde	Dussler	Barocchi	Hartt
LONDON, Sir Kenneth Clark										
		373 (ip)		1694 (−)		V p. 171 (−)		585 (−)		(−)

COLLECTION NUMBER	Frey	Thode	Brinck-mann	Berenson	Goldscheider	Tolnay	Wilde	Dussler	Barocchi	Hartt
LONDON, Mr. Brinsley Ford										
recto	36 (+)	372 (+)		1543 (+)		III 86 (ip)		182 (+)		296
verso	37 (+)	372 (+)		1543 (+)		III 86 (−)	p. 94 (+)	335 (?)		297

COLLECTION NUMBER	Frey	Thode	Brinck-mann	Berenson	Goldscheider	Tolnay	Wilde	Dussler	Barocchi	Hartt
(*formerly*) **LONDON**, J. P. Heseltine										
		371 (+)								

COLLECTION NUMBER	Frey	Thode	Brinck-mann	Berenson	Goldscheider	Tolnay	Wilde	Dussler	Barocchi	Hartt
LONDON, Duke of Portland										
					141 (?)	V 196 (+)		336 (+)		437

COLLECTION NUMBER	Frey	Thode	Brinck-mann	Berenson	Goldscheider	Tolnay	Wilde	Dussler	Barocchi	Hartt
(*formerly*) **LONDON**, Sir Charles Robinson										
		376 (+)		1542 (+)						

COLLECTION NUMBER	Frey	Thode	Brinck-mann	Berenson	Goldscheider	Tolnay	Wilde	Dussler	Barocchi	Hartt
LONDON, Dr. A. Scharf										
						IV p. 155 (+)		183 (+) 184 (+)		
LONDON, Count Antoine Seilern										
Aeneas and Dido (*formerly* Coll. Dr. V. Bloch)						V 210 (+)		334 (+)		475
Crucified Christ						V 257 (+)	p. 120 (+)	185 (+)		430
Dream of Life		520 (+)	59 (?)	1748B (−)	93 (+)	V 169 (+)	p. 95 (+)	589 (−)		359
Sketches for a Bound Captive (*formerly* Coll. F. Springell)										
recto				1696A (−)		III 104 (ip)		216 (ip)		131
verso				1543A (+)		III 104 (ip)		216 (ip)		130
MUNICH, Graphische Sammlung										
2191	11 (+)	380 (+)		1544 (+)	1 (+)	I 3 (+)	p. 2 (+)	186 (+)	p. 218 (+)	2
NAPLES, Museo Nazionale di Capodimonte										
398		554 (+)		1544A (+)	117 (+)	V 203 (+)	p. 116 (+)	187 (+)		407
399							p. 93 (?)			
NEWBURY, Donnington Priory, G. E. Gathorne-Hardy										
recto		369 (?)		1544C (+)			p. 119 (+)	337 (+)	p.187 (+)	477
verso				1544C (+)				337 (?)		(d+)
recto		368 (?)		1544B (+)		V 219 (+)	p. 116 (+)	338 (+)		509
verso							L.E. 118 (+)	592 (−)		(?)
NEW YORK, Metropolitan Museum										
24.197.2 r	4 (+)	378 (+)	32 (+)	1544D (+)	30 (ip)	II 46 (ip)	p. 26 (+)	339 (+)	p. 17 (+)	87
24.197.2 v	5 (+)	378 (+)		1544D (+)	30 (−)	II 13A (−)		339 (+)		88
NEW YORK, Pierpont Morgan Library										
I, 32 a–d	76 (+)	367a (+)		1544E (+)	106–107 (+)	V 207 (+)		188 (+)		463
OXFORD, Ashmolean Museum (*Parker catalogue numbers precede*)										
291 r (+) (22 r)		406 (+)		1561 (+)	8 (+)	I 9 (+)	p. 3 (+)	193 (+)	p. 4 (+)	9
291 v (+) (22 v)		406 (+)		1561 (+)	7 (+)	I 10 (+)	p. 77 (+)	193 (+)	p. 4 (+)	16
292 r (+) (21 r)		405 (+)		1560 (+)	12 (+)	I 12 (+)	p. 3 (+)	192 (+)	p. 6 (+)	17
292 v (+) (21 v)		405 (+)		1560 (+)	11 (+)	I 11 (+)	p. 3 (+)	192 (+)	p. 6 (+)	18
293 r (+) (18)	141 (+)	402 (+)		1558 (+)	44–45 (+)	III 96 (+)	p. 8 (+)	191 (+)	p. 257 (+)	30
294 (+) (16)	132 (+)	400 (+)		1556 (+)	46 (+)	III 106 (+)	p. 8 (+)	190 (+)	p. 18 (+)	31

OXFORD, Ashmolean Museum (*continued; Parker catalogue numbers precede*)

COLLECTION NUMBER	Frey	Thode	Brinck-mann	Berenson	Goldscheider	Tolnay	Wilde	Dussler	Barocchi	Hartt
295 (ip) (17)	142 (ip)	401 (+)		1557 (ip)			p. 8 (+)	603 (−)	p. 316 (+)	34
296 r (+) (19 r)	202 (+)	403 (+)		1559 (+)		I 28 (−)	p. 8 (+)	344 (?)		35
296 v (+) (19 v)	201a (+)	403 (+)	7 (+)	1559 (+)	p. 29 (−)	I 27 (−)		344 (?)	p. 11 (+)	32
297 r (+) (23 r)	3 (+)	407 (+)	33 (+)	1562 (+)	32 (+)	II 47 (+)	p. 7 (+)	194 (+)	p. 23 (+)	89
297 v (+) (23 v)	156 (+)	407 (+)		1562 (+)				194 (+)		54
298 (?) (27)		416 (+)		1563 (+)			p. 30 (+)	612 (−)		(−)
299 r (+) (24.1)	152 (−)	408 (+)		1702 (−)		II 28A (−)		604 (−)	p. 292 (−)	121
299 v (+) (24.1A)	151 (−)	408 (+)		1702 (−)		II 28A (−)		604 (−)	p. 292 (−)	117
300 r (+) (24.2)	152 (−)	409 (+)		1702 (−)		II 28A (−)		605 (−)	p. 292 (−)	119
300 v (+) (24.2A)	151 (−)	409 (+)		1702 (−)		II 28A (ip)		605 (−)	p. 292 (−)	122
301 r (+) (24.3)	152 (−)	410 (+)		1702 (−)		II 28A (−)		606 (−)	p. 292 (−)	
301 v (+) (24.3A)	151 (−)	410 (+)		1702 (−)		II 28A (−)		606 (−)	p. 292 (−)	114
302 r (+) (24.4)	152 (−)	411 (+)		1702 (−)		II 28A (−)		607 (−)	p. 292 (−)	123
302 v (+) (24.4A)	151 (−)	411 (+)		1702 (−)		II 28A (−)		607 (−)	p. 292 (−)	110
303 r (+) (25.1)	153 (−)	412 (+)		1703 (−)		II 28A (−)		608 (−)	p. 292 (−)	120
303 v (+) (25.1A)	154 (−)	412 (+)		1703 (−)		II 28A (−)		608 (−)	p. 292 (−)	113
304 r (+) (25.2)	153 (−)	413 (+)		1703 (−)		II 28A (−)		609 (−)	p. 292 (−)	(−)
304 v (+) (25.2A)	154 (−)	413 (+)		1703 (−)		II 28A (−)		609 (−)	p. 292 (−)	118
305 r (+) (25.3)	153 (−)	414 (+)		1703 (−)		II 28A (−)		610 (−)	p. 292 (−)	115
305 v (+) (25.3A)	154 (−)	414 (+)		1703 (−)		II 28A (−)		610 (−)	p. 292 (−)	116
306 r (+) (25.4)	153 (−)	415 (+)		1703 (−)		II 28A (−)		611 (−)	p. 292 (−)	112
306 v (+) (25.4A)	154 (−)	415 (+)		1703 (−)		II 28A (−)		611 (−)	p. 292 (−)	111
307 r (+) (42 r)	214a (+)	425 (+)		1709 (−)		III p. 130 (−)	p. 75 (+)	621 (−)	p. 306 (−)	219
307 v (+) (42 v)	213a (+)	425 (+)	38 (+)	1709 (−)				621 (−)		158
308 r (+) (40)	143 (+)	423 (+)		1566 (+)			p. 75 (+)	345 (+)	p. 119 (+)	222
308 v (+)								345 (+)		286
309 r (+) (6 r)	216 (?)	390 (+)		1548 (+)		III p. 150 (−)	p. 85 (+)	598 (−)	p. 97 (+)	228
309 v (+) (6 v)	217 (?)	390 (+)		1548 (+)			p. 83 (+)	598 (−)		293
310 (+) (7)	218 (?)	391 (+)		1549 (+)	59 (?)	III p. 150 (−)	p. 85 (+)	599 (−)	p. 97 (+)	227
311 r (+) (49 r)	135 (+)	432 (+)		1713 (−)			p. 90 (+)	199 (+)		(+)
311 v (+) (49 v)	136 (+)	432 (+)		1713 (−)		III 112 (?)	p. 89 (+)	199 (+)		347
312 r (+) (48.2)	138c (+)	430 (+)		1567 (+)			p. 46 (+)	197 (+)		196
313 (+) (48.3)	138b (+)	431 (+)		1567 (+)			p. 65 (+)	198 (+)		166
314 r (+) (8 r)	193 (+)	392 (+)		1550 (+)				340 (+)		294
314 v (+) (8 v)	194 (+)	392 (+)		1550 (+)				340 (+)		295
315 (+) (10)	172b (+)	394 (+)	30 (+)	1552 (+)	65 (+)	V 152 (+)		342 (+)	p. 278 (+)	363
316 r (+) (9 r)		393 (+)		1551 (+)		V 153 (+)		341 (+)		161
316 v (+) (9 v)				1551 (+)		V 153 (+)		341 (+)		303
317 r (+) (45 r)	145 (ip)	428 (+)		1712 (−)		III 92 (ip)	p. 65 (+)	196 (+)	p. 293 (−)	302
317 v (ip) (45 v)	144 (ip)	428 (ip)		1712 (−)			p. 67 (+)	622 (−)		312
318 r (+) (29)	51 (+)	417 (+)	45 (+)	1564 (+)	91 (+)	III 107 (+)	p. 11 (+)	195 (+)	p. 215 (+)	257
318 v (+)								195 (+)		412
319 (+) (55)		434 (?)		1718 (−)	67 (+)		p. 125 (+)	624 (−)		466
320 (+) (53a)	178 (+)	433 (+)		1568 (+)			p. 86 (+)	346 (+)		188
321 (+) (71)	279c (+)	445 (+)		1573 (+)			p. 86 (+)	350 (+)	p. 155 (+)	170
322 (+) (11)		395 (+)		1553 (+)	201 (−)		p. 79 (+)	600 (−)		156
323 r (+) (13 r)	133 (+)	398 (+)		1555 (+)			p. 60 (+)	343 (+)		191
323 v (ip) (13 v)	134 (ip)	398 (ip)		1555 (−)			p. 77 (ip)	343 (ip)		311
324 (+) (31)		p. 210 (−)		1705 (−)				614 (−)		155
325 (+) (30)		418 (−)		1704 (−)			p. 60 (+)	613 (−)		160

COLLECTION NUMBER	Frey	Thode	Brinck-mann	Berenson	Goldscheider	Tolnay	Wilde	Dussler	Barocchi	Hartt
OXFORD, Ashmolean Museum *(continued; Parker catalogue numbers precede)*										
326 (?) (1)	197 (−)	387 (+)		1545 (−)	203 (−)			596 (−)		(−)
327 r (?) (2 r)		388 (+)		1546 (+)	200 (−)			597 (−)		(−)
327 v (?) (2 v)		388 (−)		1546 (+)				597 (−)		(−)
328 r (+) (69 r)	157 (+)	441 (+)	44 (+)	1571 (+)	105 (+)	V 211 (+)	p. 117 (+)	200 (+)	p. 173 (+)	473
328 v (−) (69 v)	158 (−)	441 (−)		1571 (−)	105 (−)	V 211 (−)	p. 117 (+)	630 (−)		(−)
329 r (+) (67 r)	195 (+)	440 (+)	27 (+)	1570 (+)		V 204 (?)		629 (−)		382
329 v (+) (67 v)	196 (+)	440 (+)		1724 (−)				629 (−)		71
330 r (+) (58 r)	148 (?)	435 (+)		1568A (+)		V 187 (+)	p. 103 (+)	625 (−)		380
330 v (+) (58 v)	149 (?)	435 (+)		1568A (+)		V 188 (?)		625 (−)		381
331 (+) (77)	200a (+)	450 (+)		1577 (+)	187 (−)			631 (−)		400
332 r (+) (80)	271 (−)	452 (−)						633 (−)		494
332 v (+)								206 (+)		482
333 r (+) (81 r)	272 (−)	453 (+)						634 (−)		495
333 v (+) (81 v)	273 (+)	453 (+)						352 (+)		483
334 r (+) (60.1 r)		436 (+)		1569 (+)	121 (+)	V 217 (+)	p. 114 (+)	347 (+)		506
334 v (+) (60.1 v)		436 (+)		1569 (+)	121 (+)		p. 114 (+)	347 (+)		505
335 (+) (60.2)		437 (+)		1569 (+)		V 218 (?)	p. 114 (+)	348 (+)		508
336 r (+) (60.3)		438 (+)		1569 (+)		V 216 (+)	p. 114 (+)	349 (+)		507
336 v (+)								349 (+)		(?)
337 r (+) (75 r)	225 (−)	449 (+)		1576 (+)				351 (+)		397
337 v (+) (75 v)	226 (+)	449 (+)		1576 (+)				351 (+)		289
338 r (+) (70.3)	280b (+)	444 (+)		1572B (+)		V 208 (+)		203 (+)		469
338 v (+)						V 208 (+)		203 (+)		470
339 (+) (70.1)	239 (+)	442 (+)	80 (+)	1572 (+)	111 (+)	V 246 (+)		201 (+)		459
340 (+) (70.2)	240 (+)	443 (+)		1572A (+)		V 227 (+)	p. 118 (+)	202 (+)	p. 247 (+)	448
341 r (+) (5 r)	203 (+)	389 (+)		1547 (+)		V 261 (+)		189 (+)		401
341 v (+) (5 v)	201b (+)	389 (+)		1547 (+)		V 262 (+)		189 (+)	p. 11 (+)	411
342 (+) (37)	150 (?)	420 (+)	76 (+)	2491 (−)	88 (+)	V 242 (?)		616 (−)		456
343 r (+) (72)	180 (+)	446 (+)		1574 (+)	125 (+)	V 254 (+)	p. 120 (+)	204 (+)		426
343 v (+)						V 255 (+)		204 (+)		427
344 r (+) (82 r)	168 (+)	454 (+)						207 (+)		501
344 v (+) (82 v)	169 (+)	454 (+)						207 (+)		519
345 (+) (74)	140 (+)	448 (+)	79 (+)	1575 (+)	127 (+)	V 264 (+)	p. 113 (+)	205 (+)	p. 175 (+)	435
368 (−) (60.4)		p. 210 (−)		1569A (+)				627 (−)		
370 (−) (12.1)	155a (+)	396 (+)		1554 (+)				601 (−)	p. 23 (+)	(−)
372 (−) (42.1)	p. 104 (−)	426 (+)		II p. 236 (−)				620 (−)		
374 (−) (12.2)		397 (−)		1554 (+)				602 (−)		(−)
375 (−) (39 r)	222 (−)	422 (+)		1565 (+)				618 (−)	p. 266 (−)	(−)
378* (−) (48.1)	138a (+)	429 (+)		1567 (+)			p. 68 (−)	623 (−)		(−)
761 (−) (59)		556 (?)		1568B (?)	169 (−)			626 (−)		(−)

OXFORD, Christ Church										
B 21 r		458 (−)		2493 (−)			p. 123 (+)	636 (−)		(−)
B 21 v		458 (−)		1578A (+)			p. 123 (+)	636 (−)		44A
C 13 r	139a (+)	456 (+)		1578 (+)	37 (+)		p. 62 (+)	353 (+)		416
C 13 v	139b (+)	456 (+)		1578 (+)				353 (+)		414
DD 24 r						IV p. 168 (−)	p. 39 (+)	638 (−)		(−)
DD 24 v						III 71 (−)	p. 39 (+)	638 (−)		203

COLLECTION NUMBER	Frey	Thode	Brinck-mann	Berenson	Goldscheider	Tolnay	Wilde	Dussler	Barocchi	Hartt
PARIS, Ecole des Beaux-Arts										
34556 r		513 (+)		1746 (−)		IV 36A (−)		641 (−)		(−)
		512 (+)				IV 50A (−)		642 (−)		(−)
PARIS, Louvre										
684 r		460 (+)	2 (+)	1728 (−)	199 (−)			644 (−)		304
685 r	27 (+)	461 (+)	3 (+)	1579 (+)	35 (+)	I 33 (+)	p. 13 (+)	208 (+)		57
685 v	28 (+)	461 (+)		1579 (+)	31 (+)	I 32 (+)		208 (+)		60
686 r	89 (−)	462 (+)		1729 (−)		IV 46A (−)		645 (−)		(−)
686 v	90 (−)	462 (+)		1729 (−)			p. 57 (+)	645 (−)		(−)
688 r	87 (+)	477 (+)		1588 (+)	10 (+)	I 14 (+)	p. 25 (+)	209 (+)		46
688 v	63 (+)	477 (+)		1588 (ip)	24 (ip)	I 34 (ip)		209 (ip)		47
689 r		478 (+)	15 (+)	1589 (+)	55 (+)	V 140 (ip)	p. 14 (+)	354 (?)	p. 157 (+)	58
689 v		478 (+)		1589 (+)	55 (−)	IV 41A (−)	p. 4 (+)	646 (−)		49
690		479 (+)						647 (−)		
691		463 (+)	36 (+)	2494 (−)			p. 9 (+)	648 (−)		(−)
691b	40 (+)	464 (+)	48 (+)	1580 (+)	77 (+)	III 108 (+)	p. 89 (+)	210 (+)	p. 168 (+)	254
692 r		465 (+)		2495 (−)	86 (+)			649 (−)		(−)
692 v		465 (+)		2495 (−)				649 (−)		(−)
694 r		466 (+)	1 (+)	1730 (−)		IV 48A (−)		650 (−)		(−)
694 v		466 (+)		1730 (−)		IV 49A (−)		650 (−)		(−)
697		468 (+)	82 (?)	1581 (+)				652 (−)		(−)
698		469 (+)		1582 (+)	116 (+)	V 201 (−)	p. 120 (+)	355 (+)		420
699		470 (+)		1732 (−)		IV 33A (−)		653 (−)		(−)
700		471 (+)	74 (+)	1583 (+)		V 249 (+)	p. 120 (+)	211 (+)		421
702		480 (?)		1737 (−)				654 (−)		(−)
703		472 (+)	37 (+)	2496 (−)			p. 63 (+)	655 (−)		(−)
704 r		473 (+)	65 (+)	1584 (+)		V 240 (−)		656 (−)		(−)
704 v		473 (+)	65 (+)	1584 (?)				656 (−)		(−)
705				1590A (ip)		V 144 (+)		657 (−)		468
706 r	1 (+)	481 (+)		1587 (+)	1 (+)	I 2 (+)	p. 2 (+)	212 (+)		1
706 v				1587 (+)		I 2 (+)	p. 12 (+)	212 (+)		14
707		482 (+)		1591 (+)	69 (+)			658 (−)		(−)
708		483 (+)		1592 (+)				659 (−)		(−)
709 r	33 (+)	484 (+)		1593 (+)		III p. 184 (−)		356 (?)		465
709 v	35a (−)	484 (+)		1593 (+)				356 (−)		
710 r		485 (+)		1733A (−)				660 (−)		(−)
710 v		485 (+)		1733A (−)				660 (−)		(−)
712 r		486 (+)		1594 (+)	180 (−)	IV 39A (−)		661 (−)		39
712 v		486 (+)						661 (−)		(?)
714 r	24 (+)	474 (+)	4 (+)	1585 (+)	9 (+)	I 16 (+)	p. 30 (+)	213 (+)		20
714 v	25 (+)	474 (+)		1585 (+)	6 (+)	I 13 (+)	p. 3 (+)	213 (+)		15
716	21 (+)	475 (+)	23 (+)	1586 (+)	43 (+)	V 168 (ip)	p. 104 (+)	664 (−)	p. 150 (+)	454
718 r		487 (+)		1598 (+)		I fig. 283 (−)	p. 11 (−)	665 (−)		(−)
718 v				1598 (+)		I fig. 284 (−)	p. 11 (+)	665 (−)	p. 8 (+)	37 A
720 r		488 (+)		1595 (+)	115 (+)	V 199 (?)	p. 120 (+)	357 (+)		418
720 v		488 (+)		1595 (+)	120 (+)	V 200 (?)		357 (+)		419
722		489 (+)		1596 (+)	181 (−)			666 (−)		(−)
723		490 (+)								
725 r		491 (+)							p. 266 (−)	
725 v		491 (+)							p. 266 (−)	

COLLECTION NUMBER	Frey	Thode	Brinck-mann	Berenson	Goldscheider	Tolnay	Wilde	Dussler	Barocchi	Hartt
PARIS, Louvre (*continued*)										
726 r		492 (+)		1742 (−)	179 (−)		p. 16 (+)	667 (−)		(−)
727 r		493 (+)		1597 (+)		V p. 167 (−)	p. 3 (+)	668 (−)	p. 6 (+)	(−)
727 v				1597 (+)		V p. 167 (−)	p. 3 (+)	668 (−)		(−)
739		495 (+)				V p. 173 (−)		670 (−)	p. 323 (−)	
748		496 (+)								
775		497 (+)				III p. 192 (−)		672 (−)		
815		500 (+)				III p. 192 (−)		674 (−)		
836		501 (+)						p. 246 (−)		
841		502 (+)				V p. 226 (−)		676 (−)		
842 r		503 (+)		1598A (+)		V 248 (+)	p. 120 (+)	358 (+)		410
842 v				1598A (+)		V 248 (+)		358 (−)		513
844 r		505 (+)		1743A (−)		IV 37A (−)		678 (−)		(−)
844 v		505 (+)		1743A (−)		IV 35A (−)		678 (−)		(−)
846		506 (+)						679 (−)		
860 r		507 (+)		1598B (+)	27 (+)		p. 16 (+)	680 (−)	p. 152 (+)	106
860 v		507 (+)		1598B (+)	27 (?)			680 (−)		(−)
2491				1598C (+)				681 (−)		(−)
2715				1598D (+)	p. 11 (−)			682 (−)		(−)
11725		510 (+)						684 (−)		
R. F. 70–1068 r	64 (+)	498 (+)		1590 (+)	5 (+)	I 15 (+)	p. 24 (+)	214 (+)		48
R. F. 70–1068 v	88 (+)	498 (+)		1590 (+)	17 (+)	I 35 (+)		214 (+)	p. 31 (+)	50
R. F. 4112 r		511d (+)		1599 (ip)	48 (+)	V 138 (+)		359 (?)		178
R. F. 4112 v		511d (+)		1599 (+)	34 (+)	V 139 (+)		359 (+)		179
PARIS, Frits Lugt										
						IV p. 155 (+)		215 (+)		
ROME, Galleria Corsini										
125514		514 (+)		1600 (+)	191 (−)		p. 87 (−)	689 (−)		(−)
ROME, Vatican Library, Codex Vaticanus 3211										
fol. 25 v						IV 129 (+)		217 (+)		(f+)
fol. 53 v								218 (+)		(f+)
fol. 58 v								219 (+)		491
fol. 74 r				1600B (+)		V 222 (+)	p. 111 (+)	220 (+)		433
fol. 79								221 (+)		(f+)
fol. 81 v						V 226 (+)	p. 118 (+)	222 (ip)		450
fol. 82 v						V 226 (+)	p. 118 (+)	223 (+)		(f+)
fol. 84 r								224 (+)		(+)
fol. 84 v								224 (+)		(f+)
fol. 87 r								225 (+)		(d+)
fol. 87 v		515b (+)						225 (+)		(d+)
fol. 88 r						V 194 (+)		226 (+)		394
fol. 88 v						V 175, 177 (+)	p. 99 (+)	226 (+)		377
fol. 89 v		515a (+)						688 (−)		
fol. 90 r		515a (+)						688 (−)		
fol. 91 r								227 (+)		(f+)
fol. 91 v								227 (+)		(f+)

COLLECTION NUMBER	Frey	Thode	Brinck-mann	Berenson	Goldscheider	Tolnay	Wilde	Dussler	Barocchi	Hartt
ROME, Vatican Library, Codex Vaticanus 3211 (*continued*)										
fol. 92 v								228 (+)		(d+)
fol. 93 r						V 176 (+)		229 (+)		(f+)
fol. 93 v						V 193 (+)		229 (+)		395
fol. 95 v						V 260 (+)		230 (+)		(f+)
fol. 96 v						V 259 (+)		231 (+)		(f+)
fol. 100 r						V 258 (+)		232 (+)		428
ROTTERDAM, Boymans-Van Beuningen Museum										
I. 185				1676B (−)		V 146 (+)		691 (−)		(−)
I. 513 r				1676C (−)				692 (−)		33
I. 513 v				1676C (−)			p. 124 (+)	692 (−)	p. 31 (?)	68
SAN MARINO, CALIFORNIA, Huntington Library										
						V 205 (+)		233 (+)		480
SETTIGNANO, Villa Michelangelo										
				1462A (+)	42 (+)	I 1 (+)		359a (+)		(−)
TURIN, Biblioteca Ex-Reale										
15627 r				1746B (−)			p. 24 (+)	693 (−)		86
15627 v				1746B (−)			p. 30 (+)	693 (−)	p. 27 (−)	(−)
VENICE, Accademia										
177	75 (+)	518 (+)	57 (+)	1601 (+)	95 (+)	III 118 (+)	p. 92 (+)	234 (+)	p. 173 (+)	357
199 r		519 (+)		2501 (−)			p. 85 (+)	694 (−)		(−)
199 v		519 (+)		2501 (−)				694 (−)		(−)
VIENNA, Albertina										
S. R. 136 r		521 (+)		2502 (−)		V 239 (?)		696 (−)		(−)
S. R. 137		522 (+)	70 (+)	2503 (−)	87 (+)	V 243 (−)	p. 104 (+)	697 (−)		(−)
S. R. 138		523 (+)			174 (−)			697a (−)		(−)
S. R. 150 r	23 (+)	525 (+)		1602 (+)	2 (+)	I 4 (+)	p. 2 (+)	235 (+)	p. 218 (+)	7
S. R. 150 v	22 (+)	525 (+)		1602 (+)	3 (+)	I 5 (+)	p. 2 (+)	235 (+)	p. 218 (+)	8
S. R. 152 r		526 (+)	16 (+)	1603 (+)	54 (+)	V 141 (−)	p. 14 (+)	360 (+)	p. 3 (+)	38
S. R. 152 v		526 (+)		1603 (+)	54 (−)	I fig. 285 (−)	P.-W. p. 262 (+)	700 (−)		59
S. R. 155 r		527 (+)		1748A (−)			p. 19 (+)	701 (−)		105
S. R. 155 v		527 (+)		1748A (−)			p. 19 (+)	701 (−)		72
S. R. 157 r	61 (+)	528 (+)	14 (+)	1604 (+)		I 29 (?)		361 (?)	p. 12 (+)	37
S. R. 157 v	62 (+)	528 (+)	13 (+)	1604 (+)		I 30 (−)	p. 16 (+)	361 (?)		44
S. R. 167		530 (+)		1605 (+)		I p. 181 (−)		703 (−)		40
S. R. 169		531 (+)	67 (+)	1606 (ip)	83 (+)	V 229 (ip)	p. 118 (ip)	361a (?)		467

WINDSOR CASTLE, Royal Library

COLLECTION NUMBER	Frey	Thode	Brinckmann	Berenson	Goldscheider	Tolnay	Wilde	Dussler	Barocchi	Hartt
0624							439 (−) L.E. 116 (+)	710 (−)		(ip)
0802							440 (−) L.E. 119 (+)	711 (−)		(ip)
0803							441 (−) L.E. 117 (+)	712 (−)		132E
01365 r		544 (+)		1619 (+)		V p. 169 (−)	453 (−)	713 (−)	p. 187 (−)	(−)
01365 v		544 (+)		1619 (+)			453 (−)	713 (−)		(−)
12761 r	129 (+)	547 (+)	72 (+)	1621 (+)	128 (+)	V 252 (+)	437 (+)	236 (+)		425
12761 v	220 (+)	547 (+)		1621 (+)		V 253 (+)	437 (+)	236 (+)		422
12762 r	212a (+)	535 (+)		1610 (+)	63 (+)	III 93 (+)	425 (+)	237 (+)		497
12762 v	213b (−)	535 (+)		1610 (−)		III 93 (−)	425 (−)	237 (−)		(−)
12763 r	204 (ip)	534 (+)		1750A (−)			422 (+)	714 (−)	p. 220 (+)	162
12763 v	205 (ip)	534 (+)		1750A (−)			422 (+)	714 (−)		168
12764 r		533 (+)		1608 (+)	84 (+)	V 154 (+)	434 (+)	715 (−)	p. 153 (+)	364
12765 r		532 (+)		1607 (+)		IV 131 (?)	421 (+)	716 (−)		(−)
12765 v		532 (+)		1607 (+)		IV 132 (?)	421 (+)	716 (−)		(−)
12766 r	58 (+)	542 (+)	56 (+)	1617 (+)	96 (+)	III 119 (+)	430 (+)	238 (+)	p. 165 (+)	358
12766 v		542 (+)	58 (+)	1617 (−)		V p. 167 (−)	430 (+)	717 (−)		369
12767 r	19 (+)	537 (+)	47 (+)	1612 (+)	78 (+)	III 109 (+)	427 (+)	239 (+)	p. 168 (+)	256
12767 v	224 (+)	537 (+)		1612 (+)		III 109 (−)	427 (+)	362 (?)		124
12768	8 (+)	541 (+)	49 (+)	1616 (+)		V 167 (ip)	428 (+)	363 (+)	p. 169 (+)	125
12769 r	206 (−)	551 (+)		2506 (−)			433 (+)	718 (−)		(−)
12769 v	207 (+)	551 (+)		2506 (+)			433 (+)	240 (+)	p. 205 (+)	528
12770	7 (+)	536 (+)	53 (+)	1611 (+)	68 (+)	III p. 185 (−)	423 (+)	363a (+)	p. 163 (+)	360
12771 r	6 (+)	540 (+)	54 (+)	1615 (+)	74 (+)	III 115 (+)	429 (+)	241 (+)	p. 163 (+)	353
12771 v	219 (+)	540 (+)		1615 (+)		V p. 175 (+)	429 (+)	241 (+)	p. 172 (+)	184
12772 r	34 (+)	550 (+)		2505 (−)		V 237 (+)	435 (+)	242 (+)		439
12773 r		549 (+)		2504 (−)			426 (+)	719 (−)		(−)
12775	130 (+)	548 (+)	73 (+)	1622 (+)	p. 58 (+)	V 250 (+)	436 (+)	243 (+)		423
12776 r	188 (+)	545 (+)		1620 (+)		V 180 (+)	432 (+)	364 (+)		376
12776 v	189 (+)	545 (+)		1620 (+)		V 181 (+)	432 (+)	364 (+)		388
12777	187 (+)	543 (+)		1618 (+)	92 (+)	III 120 (−)	431 (+)	365 (+)	p. 165 (+)	361
12778	298 (+)	538 (+)	52 (+)	1613 (+)	73 (+)	III 121 (−)	424 (+)	721 (−)	p. 163 (+)	362
13036	18 (+)	539 (+)	88 (−)	1614 (+)	p. 45 (−)	III 116 (−)	457 (−)	722 (−)	p. 321 (−)	(−)

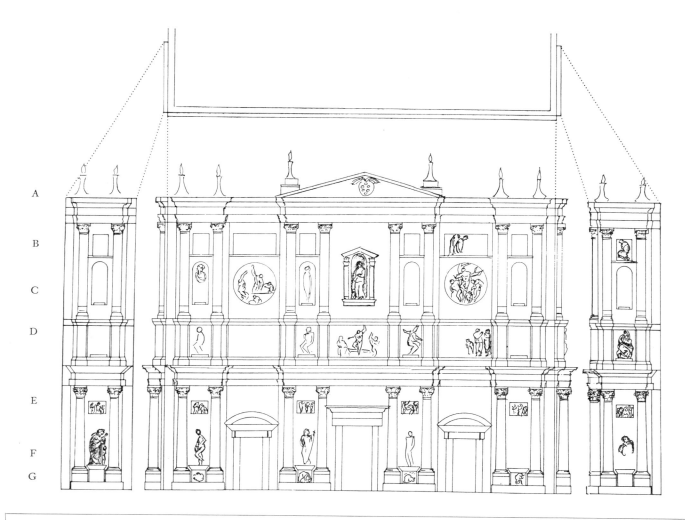

		SOUTH RETURN		CENTRAL FAÇADE					NORTH RETURN	
A		Torches No. 149	Torches No. 149			Medici Arms No. 186			Torches No. 149	Torches No. 149
B	TOP LEVEL	Seated Saint	St. Julian?	*Relief* Life of St. Lawrence?	St. Leo?		St. Mary Magdalen?	*Relief* Life of Sts. Cosmas & Damian? No. 164	St. Minias?	St. Giovanni Gualberto? No. 162
C	2nd STORY	St. Dominic?	St. Luke[1] No. 161	*Tondo* Martyrdom of St. Lawrence? Nos. 186–87	St. Matthew[1]	Madonna & Child? Nos. 177–79	St. John Evangelist[1]	*Tondo* Martyrdom of Sts. Cosmas & Damian? Nos. 165–68	St. Mark[1]	St. Francis?
D	MEZZANINE	St. Zenobius?	St. Jerome?	*Relief* Life of St. Lawrence?	St. Ambrose?[4]	*Relief* Resurrection? Nos. 180–85	St. Augustine?[3] No. 159	*Relief* Martyrdom of Sts. Cosmas & Damian?	St. Gregory?	St. Reparata? No. 160
E	SMALL RELIEFS	Six reliefs of Fires of St. Lawrence, Nos. 169–74								
F	GROUND STORY	St. Cosmas[2] No. 155	St. Lawrence[1] No. 158		St. John Baptist[1] No. 157		St. Peter[1,3]		St. Paul[1]	St. Damian[2] No. 156
G	PEDESTALS	Four reliefs of Salamanders, Nos. 188–91								

Note: Superior numbers refer to footnotes below. Numbers following the subjects refer to drawings in this volume.

1 Position stipulated in letter from Domenico Buoninsegni to Michelangelo, February 2, 1517.

2 Mentioned in Buoninsegni letter but for another position, no longer possible in final version of façade.

3 Pose appears in copy in Louvre, attributed to Bandinelli: see Tolnay, "Michel-Ange et la façade de San Lorenzo," *Gazette des beaux-arts*, 6ᵉ série, 11, 1934, fig. 13.

4 Pose appears in copy in Uffizi, Arch. 790 recto: see Ackerman, *The Architecture of Michelangelo*, I, fig. 4c.

Biographical Outline

1475 MARCH 6: Michelangelo di Lodovico di Lionardo Buonarroti Simoni born at Caprese, a tiny village in the Apennines (now in Arezzo province), the second son of Lodovico (1444–1531), then 169th Podestà (Florentine Commissioner) of Caprese, and Francesca di Neri di Miniato del Sera.

 MARCH 31 (?): Lodovico's term as Podestà concluded, the ancient but impoverished family returns to Florence, where for centuries they had lived in the Quarter of Santa Croce. Michelangelo given to a wet nurse, the wife of a stonecutter, at Settignano near Florence, where the family owned a farm.

1481 Lodovico Buonarroti, with his brother Francesco (1434–1508), a money-changer, rents brother-in-law's house in the Via dei Bentaccordi (believed to be No. 7, still standing) in the Quarter of Santa Croce. Michelangelo and brothers Lionardo (1473–1510), Buonarroto (1477–1528), Giovansimone (1479–1548), and Sigismondo (1481–1555) move to this house at an unknown date. Michelangelo goes to grammar school taught by one Francesco da Urbino.

1485 Lodovico Buonarroti marries a second time, to Lucrezia di Antonio di Sandro Ubaldini da Gagliano (died 1497). Lodovico and Francesco oppose Michelangelo's desire to become an artist, as unworthy of family's position.

1488 APRIL 1: Lodovico Buonarroti places Michelangelo in the shop of Domenico and David del Ghirlandaio to learn painting; he is to receive salary of 24 florins for 3 years but stays only a year.

1489 Michelangelo introduced by his friend the painter Francesco Granacci to Lorenzo de' Medici, the Magnificent; received into Lorenzo's art school in the Medici Gardens, opposite the monastery of San Marco. Taught by Bertoldo di Giovanni, pupil of Donatello. Opportunity to study from classical sculpture; contact with members of Lorenzo's Neoplatonic Academy; lives in Medici Palace; treated "as Lorenzo's son." Carves *Madonna of the Stairs* and *Battle of Lapiths and Centaurs*. Draws from Masaccio's frescoes in the Brancacci Chapel, Church of the Carmine, receives a disfiguring blow from young sculptor, Pietro Torrigiani.

1492 APRIL 8: Death of Lorenzo de' Medici. Michelangelo returns to father's house, but later invited back to Medici Palace.

 MONTH UNKNOWN: Buys marble block for a larger-than-lifesize statue of Hercules, completed before 1494; sold by the Strozzi family to King Francis I of France in 1529; lost since 1731. Reported to have dissected corpses at the monastery of Santo Spirito. Carves a smaller-than-lifesize wooden crucifix for the prior of Santo Spirito; lost since the early 19th century, this crucifix rediscovered in 1963.

1494 JANUARY 20 (?): Receives only commission from Piero de' Medici, the Unfortunate, son and successor of Lorenzo the Magnificent: a statue in snow.

 Before OCTOBER 14: Flees to Venice for fear of the invading French, then to Bologna. Carves small marble figures of *St. Petronius*, *St. Proculus*, and candle-bearing *Angel* for the tomb of St. Dominic at San Domenico in Bologna, started by Nicola Pisano in the 13th century and remodeled by Niccolò dell'Arca. Lives in the house of Gianfrancesco Aldrovandi; studies Dante, Petrarch, and Boccaccio.

 NOVEMBER 9: Piero de' Medici is banished from Florence; the Ferrarese monk Girolamo Savonarola, prior of San Marco, takes over the government.

1495 LATE IN YEAR: Returns to Florence; possibly lives with Lorenzo di Pierfrancesco de' Medici and brother Giovanni, members of the younger branch of the Medici family, next to the Medici Gardens. Carves two small statues, *St. John the Baptist* and *Sleeping Cupid*

(both lost.) *Cupid* sold to a dealer, Baldassare del Milanese in Rome, who offers it as a work of ancient sculpture; Michelangelo tries in vain to buy it back.

1496 JUNE 25: Arrives in Rome, where he lives in great poverty.

 JULY 5: Begins work on a marble block bought for him by Cardinal Riario, nephew of the late Pope Sixtus IV and cousin of Michelangelo's future patron Cardinal Giuliano della Rovere, later Pope Julius II. This block is probably that of the *Bacchus*. Lives with a nobleman near the palace of Cardinal Riario; works in the house of Jacopo Galli, a rich banker who had a collection of ancient sculpture.

1497 JULY 1: Refuses to leave Rome for Florence until Cardinal Riario has paid him for recent work, *Bacchus*, eventually bought by Galli.

 AUGUST 19: Writes to his father that he is "at times in a great passion for many reasons that happen to him who is away from home."

1498 MONTH UNKNOWN: Makes a cartoon for a painting of the *Stigmatization of St. Francis*, for Cardinal Riario, to be painted by his barber; cartoon and painting are both lost.

 MONTH UNKNOWN: Carves a statue of Cupid or Apollo for Galli; now lost.

 MONTH UNKNOWN: Lodovico Buonarroti moves to an apartment in the Via San Proculo in Florence.

 MARCH (?): Arrives in Carrara to oversee quarrying of marble block for the *Pietà*, for which the French Cardinal Jean Bilhères de Lagraulas had negotiated since November, 1497.

 AUGUST 27: Signs contract arranged by Galli with Cardinal Bilhères de Lagraulas to carve *Pietà* in one year for 450 ducats; to be "the most beautiful work in marble which exists today in Rome . . . no master would do it better today." First in church of Santa Petronilla attached to south side of Old St. Peter's, the group has occupied three other sites in St. Peter's.

1499–1500 Probably at work on *Pietà*.

1501 SPRING: Returns to Florence.

 JUNE 19: Signs contract for the Piccolomini altar, signed June 5 by Cardinal Francesco Todeschini-Piccolomini, later Pope Pius III. Agrees to complete 15 statuettes in 3 years, for 500 gold ducats. Work eventually done by pupils. Michelangelo threatened with lawsuit as late as 1561; after his death, nephew Lionardo repays 100 ducats to Piccolomini heirs.

 AUGUST 16: Commissioned to execute the marble *David* in 2 years, from block cut in 1464 by Agostino di Duccio for one of the buttresses of the Duomo of Florence, at monthly salary of 6 gold florins. Begins work September 13.

1501–5 Paints *Madonna* for Angelo Doni (Uffizi). Carves *Bruges Madonna*, and Madonna *tondo* for Taddeo Taddei (London, Royal Academy).

1502 FEBRUARY 28: Price of marble *David* now 400 gold florins.

 AUGUST 12: Signs contract for bronze *David*, 2½ braccia high (53 ins.), for Pierre de Rohan, Maréchal de Gié, for 50 gold florins.

 NOVEMBER 1: Piero Soderini installed for life as Gonfaloniere of the Republic of Florence.

1503 APRIL 24: Signs contract with the Consuls of the Arte della Lana to carve 12 over-lifesize Apostles for the Duomo in 12 years for 2 gold florins a month.

 APRIL 29 and OCTOBER 10: Receives 2 payments of 20 gold florins each for bronze *David*, which was probably poured by that date.

 JUNE 12: Opera del Duomo (Cathedral Board of Works) decides to build a dwelling and studio for Michelangelo at the corner of Borgo Pinti and Via della Colonna, from a model by Simone del Pollaiuolo, called Il Cronaca.

1504 JANUARY 25: Commission of 30, including Andrea della Robbia, David del Ghirlandaio, Filippino Lippi, Botticelli, Giuliano and Antonio da Sangallo, Leonardo da Vinci, Perugino, Andrea Sansovino, and other artists, is appointed to decide on a place for the marble *David*.

APRIL: Marble *David* finished.

JUNE 8: Marble *David* placed on the terrace in front of Palazzo Vecchio.

AUGUST–DECEMBER: Payments to stonecutters in Carrara for block for *St. Matthew*, one of 12 Apostles for the Duomo.

OCTOBER 31: Payment for paper for cartoon of the great fresco, *Battle of Cascina*, for Sala del Cinquecento in the Palazzo Vecchio, facing Leonardo's *Battle of Anghiari*.

DECEMBER 31: Payment for mounting the pieces of paper; Michelangelo is already at work on the cartoon.

1505 FEBRUARY 28: The Signoria of Florence pays Michelangelo 280 lire advance on the painting of the *Battle of Cascina*.

MARCH: Called to Rome for the first contract for the Tomb of Julius II; planned to be freestanding with approximately 40 over-lifesize marble statues and several reliefs, all to be executed in 5 years for 10,000 ducats.

APRIL–DECEMBER: In Carrara supervising quarrying of the marble for the Tomb. Wants to carve a mountain overlooking the sea into a Colossus.

NOVEMBER 12: Engages shipowners to bring 34 wagonloads of marble to Rome.

DECEMBER 10: Contracts for delivery of 60 wagonloads of marble; blocks to be cut to Michelangelo's specifications sent from Florence.

DECEMBER 18: In Florence, voids the contract for the 12 Apostles for the Duomo.

1506 JANUARY: Returns to Rome; takes house near St. Peter's for work on Tomb.

JANUARY 14: The Laocoön group discovered in Rome.

JANUARY 27: From Rome, buys a property with vineyards, woods, orchards, and house at Pozzolatico near Florence.

JANUARY 31: Marble from Carrara held up by bad weather; whole boatload of blocks flooded by overflowing Tiber.

APRIL 11–17: Tries unsuccessfully to obtain money from the Pope: according to his own later account he was "chased away" from the papal court. Leaves in anger for Florence.

APRIL 18: Cornerstone of Bramante's St. Peter's laid.

MAY: At work again in Florence, possibly on *St. Matthew* and Madonna *tondo* for Bartolommeo Pitti (Bargello).

MAY 2: Replies to a letter from Giuliano da Sangallo containing Pope Julius II's offer to hold to the original agreement if Michelangelo is willing; proposes to continue work in Florence on the Tomb, sending finished statues to Rome.

MAY 9: Giovanni Balducci writes recommending that Michelangelo return to Rome.

MAY 10: Pietro Roselli writes Michelangelo of the Pope's plan to have him paint ceiling of Sistine Chapel; says Bramante declared Michelangelo would not accept the job.

JULY 8: Papal *breve* summons Michelangelo to Rome.

JULY–AUGUST: Negotiations for Michelangelo's return involve Piero Soderini, head of the Florentine Republic, his brother, the Cardinal of Volterra, and Cardinal Alidosi. Michelangelo meanwhile is apparently at work on the *Battle of Cascina*.

NOVEMBER 21: Pope Julius II, who has by now outflanked the Florentine Republic to the east and entered Bologna in triumph, summons Michelangelo to Bologna, by a letter from Cardinal Alidosi to the Signoria of Florence.

NOVEMBER 27: Piero Soderini writes, "Michelangelo has commenced a painting for the palace (*Battle of Cascina*) which will be an admirable thing." Date of destruction of the fresco is unknown. Cartoon was eventually cut up, fragments dispersed, all are now lost. Michelangelo leaves for Bologna, probably meeting Pope Julius II there on November 29 "with a rope around his neck." Pope pardons Michelangelo; commissions larger-than-life bronze statue of himself.

1507 JANUARY 29: Pope visits Michelangelo in his studio behind San Petronio. Trouble with assistants; Michelangelo dismisses one, who takes the other with him.

MAY 26: Maestro Bernardino, armorer of the Republic of Florence, arrives in Bologna to superintend casting of the statue. Michelangelo writes that he lives "with great discomfort and extreme labor"; shares bed with three assistants; finds the heat intolerable and the wine bad.

JULY 6: Statue of Julius II is cast; pouring successful only up to the waist. Kiln has to be destroyed and remade.

JULY 9: Second, successful pouring.

1507 JULY–MARCH 1508: At work finishing statue of Julius II.

1508 MARCH: Returns to Florence; believes himself "free of Rome."

MARCH 8: Buys from Benedetto di Andrea Bonsi three houses on Via Ghibellina in Florence, nucleus of the present Casa Buonarroti, for 1050 florins.

MARCH 18: Rents for a year the house constructed by the Opera del Duomo in the Borgo Pinti. Statue of Julius II unveiled in Bologna.

Late MARCH or early APRIL: Julius II calls him to Rome to work on the Sistine Ceiling. First contract calls for 12 Apostles in 12 spandrels, and ornament covering central section, for 3,000 ducats. Rents workshop near St. Peter's. Uncomfortable and always in difficulties with servants.

MAY 10: Receives 500 ducats on account; begins preliminary work.

MAY 11–JULY 27: Makes payments through Francesco Granacci to Jacopo di Piero Roselli to apply rough preliminary coat of plaster (*arricciato*) to the ceiling.

MAY 13: Writes to Fra Jacopo Gesuato in Florence to send a specially fine blue.

JUNE (?): Second contract, for the ceiling as executed. Prepares drawings and cartoons. Complains to Lodovico that he is discontented, unwell, and penniless.

JUNE 10: Cardinals unable to conduct services of the Vigil of Pentecost in the Sistine Chapel on account of the noise, and the dust from the scaffolding.

JUNE: Michelangelo's brother Giovansimone visits Rome.

JULY 22: Giovanni Michi writes from Florence offering the services of Raffaellino del Garbo as assistant.

JULY 29: Writes Lodovico Buonarroti to send Giovanni Michi from Florence to help with the work.

JULY or AUGUST: Records deposit of 20 ducats each for 5 assistants to come from Florence.

AUGUST 7 (?): Francesco Granacci writes from Florence concerning other possible assistants.

SEPTEMBER 2: Buonarroto Buonarroti sends his brother Michelangelo a 2½ pound bag of colors from Florence.

DECEMBER 26: Bronze *David*, poured by Michelangelo but left unfinished (completed by Benedetto da Rovezzano in Florence), is finally shipped to France. Benedetto is paid the remaining 10 florins.

1509 JANUARY 27: Writes to Lodovico that "it is now a year that I haven't had a *grosso* from this Pope, and I don't ask anything because my work is not proceeding in such a way that it seems to me would merit it. And this is the difficulty of the work, and it is still not my profession. And thus I waste my time without result. God help me."

Before JUNE 3: Albertini in his book on Rome mentions painting well under way in the Sistine Chapel.

JUNE: Writes Lodovico Buonarroti he is not dead as had been reported in Florence, but still alive, although "it doesn't matter much. . . . Don't speak about me to anyone, because there are bad men." Letters throughout the period of the Sistine Ceiling deal with his family's financial necessities, transfer of funds, advice in buying land and choosing wives, and attempts to set two brothers up in business by the purchase of a shop. "Life matters more than belongings."

JUNE: Sends devastating reprimand to Giovansimone for apparent acts of arson and for threats to Lodovico: ". . . for the last twelve years I have trudged all over Italy; supported every shame; suffered every want; lacerated my body with every labor; placed my own life in a thousand dangers, only to help my family; . . . you alone want to overturn and ruin in one hour what I have done in so many years and with such labor; by the body of Christ it will not be true."

SEPTEMBER: Lodovico, now Podestà of San Casciano near Florence, embezzles 100 florins belonging to Michelangelo.

SEPTEMBER 15: Sends Lodovico 350 ducats, apparently from payment for first portion of the Sistine Ceiling.

SEPTEMBER 22–25: Goes to Bologna to appeal for money from Pope Julius II, who had left Rome about September 1 to conduct his campaign against the French in the Po Valley; stops in Florence to visit with his family.

OCTOBER 17: Writes from Rome to his brother Buonarroto in Florence to dissuade his brother Sigismondo from visiting him in Rome: "I am here in great distress and the greatest physical labor, and I have no friends of any kind and I don't want any; I don't have the time that I can eat what I need: therefore let me have no more trouble for I cannot stand another ounce." Probably the second section of the Sistine Ceiling had reached a crucial stage.

NOVEMBER–DECEMBER: Sigismondo comes to Rome anyway.

1510 DECEMBER–JANUARY 7, 1511: Second trip to Bologna for money, which is paid to him on his return to Rome. Apparently he then paints third section of the Sistine Ceiling.

1511 FEBRUARY 23: Contemplates third trip to Bologna for money.
AUGUST 14: Unveiling of the Sistine Ceiling; lunettes remain to be executed. Mass of the Vigil of the Assumption is celebrated by Pope Julius II in the Sistine Chapel.
DECEMBER 30: The statue of Julius II is destroyed in Bologna by the Bentivoglio family, who had captured the city in May. The bronze fragments are sent to Alfonso d'Este, Duke of Ferrara, to be melted down for cannon.

1512 MAY and JUNE: Acquires property in parish of Santo Stefano, outside Florence.
JULY 4–19: Alfonso d'Este, in Rome to ask the Pope's pardon, visits the scaffolding of the Sistine Chapel.
SEPTEMBER 5: Advises his family to flee Florence for safety, after the Sack of Prato.
SEPTEMBER 18: After the triumphal entry of Cardinal Giovanni de' Medici into Florence, advises his brother Buonarroto:" . . . don't make friends or familiars of anyone except God; and don't speak of anyone either well or ill. . . ."
OCTOBER: Writes to Lodovico: "Attend to living; and if you cannot have the honors of the Territory like other citizens, suffice it that you have bread and live well with Christ and poorly as I do here; for I live meanly and I care neither for life nor honor, that is of the world, and I live with the greatest labors and with a thousand suspicions. And already it is about fifteen years that I have never had an hour of well-being, and all this I have done to help you, nor have you ever known it or believed it."
OCTOBER 31: The Sistine Chapel is reopened.

1513 FEBRUARY: Entreats Lodovico to have the father of a pestiferous pupil send for his son to come home to Florence.
FEBRUARY 21: Pope Julius II dies at the age of 69.
MARCH 11: Michelangelo's childhood friend, Cardinal Giovanni de' Medici, son of Lorenzo the Magnificent, is elected Pope Leo X. Has no work for Michelangelo.
MAY 6: Second contract for the Tomb of Julius II signed with the dead Pope's executors, Lorenzo Pucci, Cardinal Santiquattro, and Leonardo Grosso della Rovere, Cardinal Aginensis. To be completed in seven years and reduced somewhat in scope, projecting on three sides only, but to culminate in a statue of the Virgin and Child.

1513–16 Works in Rome, in house in the Macello dei Corvi (a section now completely destroyed for the Victor Emmanuel Monument). Carves the *Moses* and two *Slaves,* later given to Roberto Strozzi who presented them to King Francis I of France. Designs a small chapel façade for Pope Leo X at Castel Sant' Angelo.

1513 JULY 30: Writes bitter letter to his brother Buonarroto accusing him of ingratitude: ". . . but you have never known me and you do not know me."

1514 JUNE 14: Signs contract for *Resurrected Christ* of Santa Maria sopra Minerva, with Canon Bernardo Cencio, Maria Scapucci, and Metello Vari Porcari; to be executed in 4 years for 200 gold ducats. First version left incomplete, because of a bad vein in marble; now lost.

1515 OCTOBER 20: Mentions a painting he agreed to do for Pierfrancesco Borgherini; eventually refers the commission to Andrea del Sarto.
LATE IN YEAR: Probable first interest of Michelangelo in Leo X's projected façade for San Lorenzo in Florence.
DECEMBER: Pope Leo X confers the title of Counts Palatine on Michelangelo's family.

1516 JULY 8: Signs third, greatly reduced contract for the Tomb of Julius II to be executed wherever he liked, in 9 years. Workshop is put at his disposal, in the Regione Trevi, near Santa Maria di Loreto, apparently connected with house in the Macello dei Corvi.
SEPTEMBER: In Carrara for marble for Tomb of Julius II.
OCTOBER: Pope Leo X agrees to give the commission for the façade of San Lorenzo to Michelangelo and Baccio d'Agnolo.
NOVEMBER 23: Writes to Buonarroto directing that all care be taken of their father Lodovico in his serious illness; no money to be spared from Michelangelo's account in Florence; in case of danger, the sacraments of the Church to be assured.

1516–20 Makes sketches for a *ballatoio* (outer gallery) for the drum of the dome of the Cathedral of Florence. Sends figure drawings to Sebastiano del Piombo for use in his paintings.
DECEMBER 1 or 5: Leaves Carrara for Rome to confer with Pope Leo X about the façade of San Lorenzo.
Before DECEMBER 22: Returns to Florence to superintend the clay model for the façade. Existing foundations inspected and considered too weak.
DECEMBER 31: Leaves for Carrara.

1517 (?) Designs windows for the lower story of the Medici (now Riccardi) Palace, Florence.

1517 MARCH 20: After visits to Florence in January and February, rejects façade model as "childish"; begins own clay model.
APRIL 17: Buys a house in Via Mozza (now Via San Zanobi) as workshop for San Lorenzo façade and Tomb of Julius II; buys additional land in July.
MAY 2: Clay model is misshapen "like pastry," and Pope Leo X asks for a wooden one. Cost is raised from 25,000 to 35,000 ducats. The new design is to be "the mirror of all architecture and sculpture of Italy."
AUGUST 31–DECEMBER 22: Supervises in Florence the wooden model for the San Lorenzo façade, with 24 wax figures by Pietro Urbano. New foundations finished in December.
SEPTEMBER: Vari reminds Michelangelo of his obligation to finish statue of *Resurrected Christ* for Santa Maria sopra Minerva, Rome; Michelangelo demands his first payment of 150 scudi; received December 17.

1518 Piero Soderini asks Michelangelo's advice for an altar and reliquary for the head of St. John the Baptist and two tombs, for the church of San Silvestro in Capite.
JANUARY 19: Contract signed with Pope Leo X obligates Michelangelo to complete façade of San Lorenzo in 8 years for 40,000 ducats including all costs, project inevitably conflicting with Tomb of Julius II. Two-story design was to frame 8 standing statues in marble and 4 seated ones in bronze, all over-lifesize, and 11 large and 4 small reliefs.
FEBRUARY (?): Pope Leo X insists on transferring the excavations to Pietrasanta and Seravezza in Florentine territory, requiring Michelangelo to build a new road in unworked territory and train new crews.

1518–19 Almost overwhelmed by troubles in the quarries: the ignorance of the new stonecutters, the strike of the bargemen egged on by the stonecutters from Carrara, a workman's death in a stoneslide, the serious illness of an assistant, a completed column shattered by a fall to the bottom of a ravine, the complaints from Cardinal Aginensis about the Tomb of Julius II. Writes to his brother Buonarroto: "I have undertaken to raise the dead in trying to domesticate these mountains and bring art to this village." Quarries new block of marble for Vari's *Resurrected Christ.*

1519 JUNE: Cardinal Giulio de' Medici takes G. B. Figiovanni, canon of San Lorenzo, from lunch, giving him charge of spending 50,000 scudi for additions to San Lorenzo—library, and tomb chapel for Magnifici Lorenzo and Giuliano and Dukes Lorenzo and Giuliano.
NOVEMBER 4: Medici Chapel begun; some walls of San Lorenzo destroyed, and two houses of Nelli family. Chief architect Michelangelo Simoni, "for whom Job having had patience would not have had it with that man one day."

1520 MARCH 10: Contract for the façade of San Lorenzo suddenly and inexplicably annulled and marbles abandoned. Confused and bitter artist writes of "great humiliation." Has lost three years in mechanical struggles.
APRIL: Reports that *Resurrected Christ* is finished, and requests balance due him.
JUNE: Intervening with Cardinal Bibbiena to obtain the commission of the frescoes in the Sala di Costantino in the Vatican for his friend and follower Sebastiano del Piombo, refers to himself as a "man poor, vile, and mad."
DECEMBER: Model for the Medici Chapel completed.

1521 MARCH 21: Vari's *Resurrected Christ* finally sent from Florence; arrives in Rome in June; much retouching required.
APRIL 10: Goes to Carrara to measure the blocks for the tombs, the architecture, and the figures: quarrying and roughcutting continues until January, 1526.
APRIL 21: Medici Chapel completed to level of cornice.
SEPTEMBER (?): In Florence briefly; writes to Lodovico in Settignano protesting he cannot understand why Lodovico should have thought Michelangelo "chased him away." "You have made trial of me thirty years already, you and your sons, and you know that I have always, when I could, thought and done good for you."
DECEMBER 6: Death of Pope Leo X; new Dutch Pope, Hadrian VI, has no work for Michelangelo.

1522 MARCH 17: Frizzi asks Michelangelo to make drawings for a tomb in Bologna.
MAY: Cardinal Fiesco asks for a statue of the Virgin.
SEPTEMBER: Executors of Julius II complain to Pope Hadrian VI, who orders Michelangelo to fulfill his obligations with regard to the Tomb.
MONTH UNKNOWN: Michelangelo's friend Leonardo Sellaio asks for a drawing for a painting to be executed by his servant Gobbo (the Hunchback).

1523 MONTH UNKNOWN: Senate of Genoa asks for a statue of Andrea Doria.

JUNE: Cardinal Grimani, Patriarch of Aquileia, asks for a work, either in painting or in sculpture.

JUNE: Angry letter to Lodovico, who had accused him of diverting income from his mother's dowry: ". . . If I annoy you by living, you have found the way to remedy it . . . say whatever you will about me, but don't write me any more, because you don't let me work. . . . You die only once, and you don't come back to repair things badly done."

JULY: Writes to Bartolommeo Angelini, "I am old and in bad shape; if I work one day I have to rest four."

NOVEMBER 19: Cardinal Giulio de' Medici elected Pope; assumes name of Clement VII.

DECEMBER: Michelangelo goes to Rome for an audience with the new Pope, who renews proposal of new library for San Lorenzo. Negotiations with the executors of Julius II under threat of lawsuit; first proposal for a simple wall tomb made and rejected. Negotiations continue in succeeding years.

1524 JANUARY 12–MAY 12: Wooden models for the architectural portions of the Medici tombs executed in Florence.

JANUARY: Writes Pope Clement VII that lantern of cupola of the Medici Chapel is finished; calls himself "crazy and bad."

MARCH 29: Finer execution of rough-hewn blocks for the tombs begun in Florence under the stonecutter Andrea Ferrucci da Fiesole. Before APRIL 21: Commences carving the figures; four blocks still missing.

MAY: Pope Clement VII proposes tombs for Leo X and for himself; no room for them in the Medici Chapel, as one of the ducal tombs was too far along to be changed. Michelangelo's proposal to put them in the anteroom rejected.

1525 MAY: Writes to Sebastiano about a dinner party which gave him "the greatest pleasure, because I got out of my melancholy a little, or my madness. . . ."

DECEMBER: Writes to Giovanni Fattucci in Rome ridiculing Pope Clement VII's proposal for a colossus 40 braccia high (approximately 70 feet) for the Piazza San Lorenzo, suggesting that it be placed on the opposite corner from the Medici Palace, enclosing the barbershop so as not to lose the rent; smoke would come out of a horn of plenty in the statue's hand, and Michelangelo's costermonger friend suggested (very secretly) that the head would make a nice dovecote. Or, since San Lorenzo needed a campanile, bells could go in the head and the sound would come out of the open mouth, so that on feast days when the biggest bells were rung the statue would seem to be crying "Mercy, mercy!"

1525 Pope Clement VII wants a ciborium for the high altar of San Lorenzo; the Duke of Suessa wants a tomb for himself and his wife; Bartolommeo Barbazza, canon of San Petronio in Bologna, wants a tomb for his father.

1526 MARCH 10: The *Medici Madonna, Twilight, Dawn,* and *Lorenzo* apparently nearing completion for Medici Chapel.

JUNE: Architecture of one Medici tomb completed. Clement VII in financial difficulties due to war with Charles V.

OCTOBER: Construction reduced in the Laurentian Library.

1527 APRIL 29: Michelangelo gives the key to the Medici Chapel to his friend Piero Gondi as a hiding-place for his belongings; all work at a standstill.

MAY 7: Rome sacked by imperial troops.

MAY 21: Republic proclaimed in Florence.

JUNE 7: Pope Clement VII captured and imprisoned in Castel Sant' Angelo.

DECEMBER 6: Pope Clement VII escapes to Orvieto.

1528 EARLY: Pope Clement VII offers Michelangelo 500 ducats to continue working for him.

APRIL 22: Receives commission from Florentine Republic for colossal statue of *Hercules* to flank marble *David;* the block was originally quarried for Michelangelo in 1508, but assigned by Leo X to Baccio Bandinelli in 1515.

1529 Prior of San Martino in Bologna wants a painting or a cartoon of the Virgin and Child with four saints, for Matteo Malvezzi, 8 braccia high and 5 wide (14½ by 9 ft.).

JANUARY 10: Appointed member of the Nove della Milizia, for the defense of Florence.

APRIL 6: Made Governor and Procurator General of the Florentine fortifications.

JUNE: Inspects citadels of Pisa and Livorno.

JULY (?): Painting of *Leda* commissioned by Alfonso I d'Este, Duke of Ferrara.

SEPTEMBER 21: Flees Florence with his money to save it from requisition by Republic for prosecution of the war. Arrives Ferrara the 23rd, Venice the 25th. Wants to go to France with Battista della Palla; Francis I's offer of a house and a pension arrives after Michelangelo had left Venice.

OCTOBER: Republic of Florence sends repeated requests for Michelangelo's return.

NOVEMBER 9: Goes to Ferrara, arriving in Florence about the 20th. Renews activity on fortifications.

1530 AUGUST 2: Baglioni betrays Florence to the Medici forces.

AUGUST 12: Florence capitulates; the papal commissioner Baccio Valori begins political persecutions, issuing order for Michelangelo's assassination. G. B. Figiovanni, canon of San Lorenzo, hides artist to protect his life.

OCTOBER: Completes *Leda* for Alfonso d'Este; offended by the tactlessness of the Duke's envoy, Michelangelo refuses to give up the painting.

NOVEMBER: Pope Clement VII orders friendly treatment of Michelangelo, who resumes work on the Medici Chapel.

1531 Federigo Gonzaga, Duke of Mantua, requests work of any sort for the Palazzo del Te; Baccio Valori wants a design for his house; Cardinal Cybò wants a design for his tomb.

EARLY IN YEAR: Lodovico Buonarroti dies in Florence at the age of eighty-seven.

APRIL: Francesco Maria della Rovere, Duke of Urbino and heir of Julius II, reported angry because of the noncompletion of the Tomb.

JUNE: Michelangelo offers to return the house in Rome, repay 2,000 ducats to the executors, and finish the monument in 3 years.

JUNE 16: One figure for the Medici Chapel, presumably the *Dawn,* finished.

JUNE 26: Renews offer to return 2,000 ducats to the Rovere executors, give drawings, models, finished statues and marble friezes, and blocks to younger artists to complete the Tomb.

AUGUST 19: Second figure for the Medici Chapel completed, probably the *Night.*

SEPTEMBER 28: Giovanni Battista Mini notes that Michelangelo had lost weight sharply through excessive work; fears for his life. Work on *Twilight* probably finished next day.

NOVEMBER: Gives the *Leda* to his pupil Antonio Mini, to furnish dowries for his sisters and to provide him funds; Mini goes to France where he was flooded with orders for copies but never succeeded in selling the original, which cannot be traced after the 18th century.

NOVEMBER 21: Pope Clement VII issues a *breve* forbidding Michelangelo on pain of excommunication to undertake any work other than the commissions for him and the completion of the Tomb of Julius II.

1531–32 Working ·on unfinished *David-Apollo* for Baccio Valori.

1531 NOVEMBER–APRIL 1532: Negotiations for a reduced version of the Tomb of Julius II; goes to Rome in early April for 4th contract, for wall tomb in S. Pietro in Vincoli; agrees to pay 3,000 ducats in 3 years and bear working expenses, to work 2 months each year in Rome; ratified June 13.

1532 JUNE 13: Leaves for Florence. Still working on Medici Chapel, and possibly on *Victory* for the Tomb of Julius II.

AUGUST: Returns to Rome. Probable time of meeting with Tommaso Cavalieri.

1533 JANUARY 1: Writes to Tommaso Cavalieri a letter which exists in three separate drafts, comparing their relationship to a little river at the start, which one could cross with dry feet, but now to an ocean in which he is submerged; calls Cavalieri "light of our century, unique in the world." Writes in drafts that Cavalieri seems to have been "many other times in the world," and that he, Michelangelo, would be born dead "and in disgrace with heaven and earth" if Cavalieri did not accept some of his works.

JUNE: Returns to Florence; at work on the Medici Chapel, the Laurentian Library, and probably the *Victory* (now in the Palazzo Vecchio) and the four *Slaves* (now in the Accademia) for the Tomb of Julius II.

JULY 25: Montorsoli commissioned to finish the *Giuliano de' Medici* for the Medici Chapel.

JULY 28: Writes to Cavalieri of his great, "even measureless love"; ". . . I can no sooner forget your name than the food on which I live; in fact sooner . . . food . . . which nourishes only the body unhappily than your name, which nourishes body and soul . . . so that while my memory lasts I can feel neither pain nor fear of death."

OCTOBER 11: Writes to Bartolommeo Angelini that his heart is in Rome with Tommaso Cavalieri. "Therefore if I desire without intermission night and day to be there, it is for nothing else than to return to life, which cannot be without the soul"; his is in the hands of Cavalieri.

OCTOBER: Returns to Rome. Possible discussion with Pope Clement VII of a *Resurrection* for the Sistine Chapel.

1534 FEBRUARY: Pope Clement VII persuades Michelangelo to paint a *Resurrection*; scaffolding erected.

MAY or JUNE: In Florence; continues on the same projects.

SEPTEMBER 23: Arrives in Rome two days before the death of Pope Clement VII, leaving statues strewn about the Medici Chapel; never returns to Florence.

1535 Before APRIL 16: End wall of Sistine Chapel prepared for *Last Judgment* ordered by new Pope, Paul III; preparations for painting in oil directed by Sebastiano del Piombo.

SEPTEMBER 1: Appointed by Pope Paul III "supreme architect, sculptor, and painter of the Apostolic Palace."

1536 JANUARY 25: Preparation for oil painting removed.

APRIL: Brick wall and new plaster completed for painting the *Last Judgment* in fresco.

APRIL 10–MAY 18: Commences painting.

NOVEMBER 17: Pope Paul III frees Michelangelo from all obligations to the Rovere executors and heirs until the *Last Judgment* is completed.

1537 JANUARY: Pope Paul III urges finishing of the *Last Judgment*.

JANUARY 6: Lorenzino de' Medici assassinates the tyrant Alessandro de' Medici, his cousin, first Duke of Florence. At the request of Donato Giannotti, chief of the Florentine exiles in Rome, Michelangelo carves at some time during the next few years a commemorative bust of *Brutus* as tyrant-slayer, for Cardinal Ridolfi.

FEBRUARY 2: Begins bronze horse for the Duke of Urbino.

FEBRUARY 4: Pope Paul III visits the Sistine Chapel.

JULY 4: Mention of a salt cellar for the Duke of Urbino.

SEPTEMBER 15: Pietro Aretino offers his advice about the subject and composition of the *Last Judgment*. Michelangelo gently turns it down, saying the work is largely completed.

OCTOBER 12: Bronze horse for the Duke of Urbino finished unsuccessfully; the duke asks for the wax model, but Michelangelo will not relinquish it.

NOVEMBER 26: G. M. della Porta writes that Michelangelo is continuously busy with the painting in the Sistine Chapel.

DECEMBER: Sandro Fancelli, called Scherano, paid for work on the *Madonna and Child* for the Tomb of Julius II.

1538 NOVEMBER: Interruption in the *Last Judgment*.

1538–39 Projects for remodeling and new constructions for civic center on Capitoline Hill; except between 1555–59, the work continues until long after Michelangelo's death.

1538 (?) Meets Vittoria Colonna, marchioness of Pescara.

1540 JULY: Writes ill-tempered letter to his nephew Lionardo Buonarroti in Florence complaining of the poor quality of the shirts Lionardo sent him, and warning Lionardo he will leave him nothing unless he leads a respectable life.

DECEMBER 15: Upper part of the *Last Judgment* complete; carpenter Lodovico paid for lowering the scaffolding, probably to the lower cornice level of the side walls.

1541 MONTH UNKNOWN: Falls from the scaffolding in the Sistine Chapel, "from no little height"; slightly injured.

AUGUST 20: In a letter to Lionardo Buonarroti mentions the intensity of his work and asks him not to come to Rome.

OCTOBER 12: Letter from Alessandro Farnese, nephew of Pope Paul III, indicates the Pope's wish to have his new chapel painted by Michelangelo.

OCTOBER 31: All Saints Eve; *Last Judgment* unveiled; Pope Paul III says High Mass in Sistine Chapel.

1542 FEBRUARY 27: Signs contract with Raffaello da Montelupo to finish 3 figures by Michelangelo for Tomb of Julius II.

MAY: Sends Luigi del Riccio a madrigal, probably on youth Cecchino Bracci: ". . . so that if you like you can give it to the fire, that is, to that which burns me. . . . last night, greeting our idol in a dream, it seemed that while smiling he threatened me; and not knowing which of the two things I should believe, I ask you to find out from him. . . ."

MAY 16: Signs contract with stonecutters for the architecture of the upper story of the Tomb; a new contract had to be drawn up and signed June 1.

JULY 20: Petitions Pope Paul III for release from the 1532 contract, and declares the two *Bound Slaves* (Louvre, Paris) no longer suitable for the work.

AUGUST 20: Fifth and final contract for the Tomb of Julius II signed; statues of *Active Life* and *Contemplative Life* to be finished by Raffaello da Montelupo.

AUGUST 23: Arranges that Raffaello da Montelupo will complete the *Active Life* and *Contemplative Life*.

OCTOBER: Writes his friend Luigi del Riccio: "I have been much entreated by Messer Pier Giovanni to begin painting [in the Pauline Chapel]: as one can see, for four to six days I do not think I can, because the plaster is not dry enough so that one can begin. But there is another thing that gives me more trouble than the plaster, and that, much less paint, does not let me live, and that is the ratification [of the contract] which does not come . . . so that I am in great despair." ". . . sculpture, painting, work, and good faith have ruined me. . . . Better would it have been in the early years if I had been put to making sulphur matches, I would not now be in such a passion." Writes to Cardinal Alessandro Farnese: "I have lost all my youth tied to this tomb. . . . All the discords which arose between Pope Julius and me were due to the envy of Bramante and Raphael of Urbino and this was the reason why he did not follow through with the tomb in his lifetime: to ruin me: and Raphael was right, because everything he had in art he got from me." (Note that in 1506, when the Tomb was halted, Raphael had not yet arrived in Rome.)

NOVEMBER: Mentions that he is finishing the *Active Life* and *Contemplative Life* (the present *Rachel* and *Leah*). Duke of Urbino finally ratifies the contract.

NOVEMBER: One fresco begun in the Pauline Chapel, probably the *Conversion of St. Paul*.

NOVEMBER 16: Michelangelo's servant Urbino receives payment for preparation of colors.

1543 APRIL 14: Writes to Lionardo Buonarroti: ". . . when you write me, don't put: *Michelangelo Simoni*, nor *sculptor*; just say Michelangelo Buonarroti, for thus I am known here."

1544 MARCH 29: Turns down commission for bust of Duke Cosimo de' Medici on account of "the trouble I have, but more because of old age, because I do not see light."

JUNE: Exhausted, and seriously ill. Taken by Luigi del Riccio to the house of Roberto Strozzi, nursed with care and saved from death.

JUNE 21: Offers through Roberto Strozzi to erect a statue of King Francis I of France in the Piazza della Signoria at his own expense if he will liberate Florence from the Medici.

JULY 11: Writes to Lionardo Buonarroti: "I have been sick: and you have come to bring death to me . . . and to see if I will leave you something. Isn't there enough of mine in Florence to satisfy you? You cannot deny that you resemble your father (Buonarroto), who in Florence chased me from my house. Know that I have made my will in such a way that you won't have to worry about what I have in Rome. Therefore go with God and don't arrive in front of me and don't write me again."

1545 Niccolò Tribolo and Raffaello da Montelupo finish Medici Chapel, several statues left incomplete; now open to public.

JANUARY 25: Statues finished by Raffaello da Montelupo put in place on the upper story of the Tomb of Julius II.

FEBRUARY: Three statues by Michelangelo, *Moses*, *Rachel*, and *Leah*, placed on the Tomb of Julius II.

JULY 12: Pope Paul III visits the Pauline Chapel; the *Conversion of St. Paul* probably finished.

AUGUST 10: Assistant Urbino reimbursed for expenses in plastering second wall of Pauline Chapel.

1546 JANUARY: Again ill in house of Roberto Strozzi; again nursed by Luigi del Riccio.

FEBRUARY 6: Writes another bitter letter to Lionardo Buonarroti berating him for rushing to Rome, throwing his money away, and being too anxious for his inheritance. ". . . the love you bear me: the love of the graveworm! . . . You have all lived off me for forty years now, and never have I had from you as much as a good word."

MARCH: Payments for scaffolding and colors.

APRIL 26: Promises King Francis I to do a work for him in marble, another in bronze, another in painting. "And if death interrupts this desire of mine, and one can still carve and paint in the other life, I will not fail from there, where one no longer grows old."

JUNE 5: Writes to Lionardo Buonarroti: ". . . don't write me any more; every time I get one of your letters I have a fever, such hard work to read it."

AUTUMN: Appointed architect of Farnese Palace; finishes top story and cornice; work continues into 17th century.

NOVEMBER: Accepts the commission for the building of St. Peter's, only under direct orders from Pope Paul III; works for the love of God, without fee.

DECEMBER: First clay model for St. Peter's.

DECEMBER 4: Insists Lionardo Buonarroti buy a house in the family quarter, offering him from 1,500 to 2,000 scudi for the purpose. ". . . an honorable house in the city brings much honor . . . we are citizens descended from a noble line. I have always tried to resuscitate my house, but I did not have brothers for that. . . . Gismondo must come back and live in Florence, so that they will not say any more to my

shame here that I have a brother who in Settignano goes behind the oxen."

1547 MARCH: Involved in Vatican fortifications for about a year.

MONTH UNKNOWN: Begins work on the *Pietà,* now in the Cathedral of Florence, intended for his own tomb, with his self-portrait as Joseph of Arimathea.

AUGUST: Receives at his own request a Florentine *braccio* (cubit) from Lionardo Buonarroti; complains because it is made of brass like one that a mason or carpenter might use; "I was ashamed to have it in the house and gave it away."

AUTUMN: Completes wooden scale model for St. Peter's. Construction continues with interruptions and delays until his death, and into the 17th century. Due to age and infirmities, work largely directed from studio in the Macello dei Corvi by messenger and letter; results sometimes catastrophic.

1547 Probable date for the writing of the first life of Michelangelo by Giorgio Vasari, in *Lives of the Painters, Sculptors, and Architects,* published 1550.

1548 JANUARY 16: Saddened by the death of his brother Giovansimone in Florence. Wants particularly to know whether his brother confessed and received the sacraments.

MARCH: Thanks Lionardo for informing him of Duke Cosimo de' Medici's severe proscriptions against Florentine exiles and their families. ". . . I am always alone, I go about little and I speak to no one and especially not to Florentines. . . ."

APRIL 7: Writes to Lionardo Buonarroti his advice to make a pilgrimage to Loreto for the repose of his father's soul, rather than Masses, ". . . because giving the money to priests God knows what they do with it."

MAY 2: Complains to Lionardo of urinary blockage. Repeats that he must not be addressed as sculptor; ". . . I was never a painter or a sculptor like those who keep shops. I always kept the honor of my father and my brothers, although I have served three Popes [actually four] it was through force." Later frequently complains of kidney stone.

1549–50 Designs ceiling, floor, and desks for the Laurentian Library in Florence.

1549 OCTOBER 13: Pope Paul III visits the Pauline Chapel.

NOVEMBER 10: Pope dies; Chapel still unfinished on the 29th.

1550 MARCH: *Crucifixion of St. Peter* now finished. No further evidence of Michelangelo's participation in the Palazzo Farnese.

SEPTEMBER: Commences stairway in the upper garden of the Vatican Belvedere.

DECEMBER 20: Writes to Lionardo Buonarroti to pick a wife for her family, character, and health of body and soul, not dowry, for if he chooses a poor girl he will not be obligated to all the "show and foolishness of women . . . as for beauty, since you are not the best looking boy in Florence, you shouldn't care too much as long as she is not deformed or repulsive." This advice starts in 1547; in 1553 Lionardo marries Cassandra Ridolfi, to his uncle's great satisfaction.

1555 (?) Begins first version of the Rondanini *Pietà,* now in Castello Sforzesco in Milan. Late, mystical drawings (*Annunciation, Crucifixion, Agony in the Garden,* etc.) date from this time.

MAY 11: Refuses to go to Florence to work for Duke Cosimo because it would be a sin to abandon St. Peter's.

JUNE 22: Writes to Giorgio Vasari, "No thought is born in me in which death is not sculptured."

SEPTEMBER 28: Designs stairway for Laurentian Library.

Before DECEMBER: Mutilates the *Pietà* (now in Florence Cathedral); stopped by his pupils, he gives it to Tiberio Calcagni who tries to finish it.

DECEMBER 3: Death of Urbino, Michelangelo's faithful servant and assistant.

1556 FEBRUARY 23: Writes of Urbino to Vasari: ". . . in life he kept me alive, dying he taught me how to die, not with displeasure but with desire for death . . . he was sorry to leave me alive in this traitorous world, with so much distress . . . nothing remains for me but infinite misery." Requests Lionardo Buonarroti to come to see him in Rome.

DECEMBER 18: Writes to Vasari about his sojourn with the hermit monks in the mountains above Spoleto; ". . . one cannot find peace except in the woods. . . ."

1557 MAY: Writes Duke Cosimo I of his wish to "repose with death, with whom I seek day and night to familiarize myself, so that she will treat me no worse than other old men."

JUNE 16: Writes to Lionardo Buonarroti that he could not come to Florence because of ill-health; ". . . if I left the comforts I have here I would not live three days."

1558 DECEMBER 16–JANUARY 29, 1559: New design for the Laurentian Library staircase comes to him in a dream; model built and sent to Vasari in Florence for execution.

1559 Florentine colony in Rome persuades Michelangelo to submit designs for their national church, San Giovanni dei Fiorentini. After elaborate design, approved by Duke Cosimo, work stops in 1562. Church completed only in the 17th century by other architects with other designs.

c. 1560 Designs chapel for Cardinal Guido Ascanio Sforza in Santa Maria Maggiore.

1560–61 Leone Leoni's medal depicts a blind old man with a dog, groping his way; subject suggested by Michelangelo, from Psalm 51: 15, "Thou shalt lead the sinner."

1561 Designs partial remodeling of great hall of the Baths of Diocletian, Rome, for church of Santa Maria degli Angeli.

Before MARCH 24: Preliminary designs for the Porta Pia, Rome. Construction continues after Michelangelo's death, until 1565.

1563 DECEMBER 28: Last letter to Lionardo Buonarroti, thanking him for his customary gift of sheep cheese; his hand no longer obeys him.

1564 FEBRUARY 12: Still at work recarving the Milan (Rondanini) *Pietà.*

FEBRUARY 14: Ill, refuses to go to bed; goes out of doors.

FEBRUARY 15: Weakened, sits by the fire with a high fever.

FEBRUARY 16: Finally goes to bed; desires his body to be sent to Florence. Dictates a will in three clauses: his soul to God, his body to the earth, his belongings to his nearest relatives. In the moment of his death his friends are to remember the death of Christ.

FEBRUARY 18: Dies in presence of Tommaso Cavalieri, his pupil Daniele da Volterra, Diomede Leoni, his servant Antonio del Franzese, and his two doctors.

FEBRUARY 19: Inventory of his belongings by the governor of Rome shows few possessions. Most drawings apparently burned by his own hand; only three statues were left, the Rondanini *Pietà,* a *St. Peter,* and a small *Christ Carrying the Cross,* latter two now lost; also ten cartoons. Michelangelo's body conveyed to church of the Santi Apostoli.

FEBRUARY 21: Lionardo Buonarroti arrives in Rome. He makes arrangements to transport the body to Florence concealed as a bale of merchandise.

MARCH 10: Body arrives in Florence; when coffin was opened in sacristy of Santa Croce, in presence of Vincenzo Borghini, director of the Academy, the body was intact; burial in Santa Croce in tomb designed by Vasari, finished 1572.

JULY 14: Memorial services in San Lorenzo with a splendid catafalque decorated with sculpture and paintings by city's leading artists, in presence of principal citizens and 80 artists.

Selected Bibliography

The literature on Michelangelo is so enormous that it is possible to give only a few of the most important titles. The following list includes those most readily available, as well as some, notably the collections of letters and other documents, to be found only in well-equipped art libraries. Michelangelo's leading position in the art of the High and Late Renaissance means that all general works on the period discuss his art in greater or less detail. The literature on special problems has largely been selected with a view to its relevance to the artist's paintings and drawings. Through the bibliography of Steinmann and Wittkower, and the bibliographies in the other starred items below, it should be possible for the interested reader to pursue on his own any major problem connected with Michelangelo's life and work.

GENERAL WORKS

★FREEDBERG, SYDNEY J., *Painting of the High Renaissance in Rome and Florence,* 2 vols., Cambridge, Mass., 1961. The only thorough, systematic, and successful attempt to place Michelangelo's stylistic development through the Sistine Ceiling into the general context of the evolution of the High Renaissance.

★POPE-HENNESSY, JOHN, *Italian Renaissance and Baroque Sculpture,* 3 vols., New York and London, 1963. Despite its critical dullness, capricious judgments, and unaccountable omissions, and plates poorly reproduced from bad photographs, this book remains a convenient guide to documentary material and early literature on Michelangelo.

VENTURI, ADOLFO, *Storia dell'arte italiana,* vol. IX, pt. 1, and vol. X, pt. 2, Milan, 1901–38.

WÖLFFLIN, HEINRICH, *Classic Art,* translated by Peter and Linda Murray, London and New York, 1952 (from the 8th German edition; subsequent English editions 1953 and 1959).

BIBLIOGRAPHY

STEINMANN, ERNST, and WITTKOWER, RUDOLF, *Michelangelo Bibliographie* Leipzig, 1927.

DOCUMENTS

BOTTARI, GIOVANNI, *Raccolta di lettere sulla pittura, scultura ed architettura,* 2nd edition, Milan, 1822–25.

DAELLI, GIOVANNI, *Carte Michelangiolesche inedite,* Milan, 1865.

DOREZ, LEON, *La Cour du Pape Paul III, d'après les registres de la trésorerie secrète,* Paris, 1932.

FREY, KARL, *Sammlung ausgewählter Briefe an Michelagniolo Buonarroti,* Berlin, 1899. The most important collection of letters written by others to Michelangelo.

GAYE, GIOVANNI, *Carteggio inedito d'artisti dei secoli XIV–XVI.,* 3 vols., Florence, 1839–40.

MILANESI, GAETANO, *Les correspondants de Michel-Ange, I: Sebastiano del Piombo,* Paris, 1890.

————, *Le lettere di Michelangelo Buonarroti,* Florence, 1875. The complete edition of Michelangelo's letters in the original Italian. Authoritative save for a number of instances in which dates have had to be changed, and two spurious letters.

★RAMSDEN, E. K., *The Letters of Michelangelo,* 2 vols., Stanford, 1963. The only reliable English translation, with dates corrected and voluminous notes and appendices on many related aspects of Renaissance history and economic life.

SOURCES

ALBERTINI, FRANCESCO, *Memoriale di molte statue et picture nella città di Firenze,* 1510 (edition Milanesi, Florence, 1863).

————, *Opusculum de mirabilibus novae urbis Romae,* Rome, 1510. These two little guidebooks by Albertini are the first printed notices of Michelangelo and his works.

BORGHINI, RAFAELLO, *Il Riposo,* 5th edition, Reggio, 1826–27.

CELLINI, BENVENUTO, *La vita* Rome, 1911; *An Autobiography,* English translation by George Bull, paperback, Harmondsworth, 1956.

CONDIVI, ASCANIO, *Le vite di Michelangelo Buonarroti scritte da Giorgio Vasari e da Ascanio Condivi,* edition Karl Frey, Berlin, 1887. Condivi, artist and friend of Michelangelo's during his old age, published his life in 1553. The edition cited here contains also the first version of Vasari's life of Michelangelo, published in 1550, and the second, which appeared in 1568, altered in many respects according to Condivi.

HOLLANDA, FRANCISCO DE, *I dialoghi michelangioleschi di Francisco d'Olanda,* edition Antonietta Maria Bessone Aureli, Rome, 1953. An account by a Portuguese painter of conversations he claims to have had with Michelangelo on the subject of painting. Their authenticity is still controversial, and they contain, at the very least, many personal interpolations by Francisco de Hollanda, out of keeping with Michelangelo's known style and ideas.

LANDUCCI, LUCA, *Diario fiorentino dal 1450 al 1516,* edition Florence, 1883.

VASARI, GIORGIO, *Vita di Michelangelo Buonarroti.* In addition to the edition of both the 1550 and 1568 lives, cited above under Condivi, there is the standard edition of Vasari's *Vite de' più eccellenti Architetti, Pittori et Scultori,* with notes by Gaetano Milanesi, Florence, 1885, vol. VII., pp. 135–404. A standard English translation is by Gaston du C. De Vere, London, 1912–14.

BIOGRAPHIES

GOTTI, AURELIO, *Vita di Michelangelo Buonarroti,* 2 vols., Florence, 1875.

GRIMM, HERMAN, *Leben Michelangelos,* 19th edition, Stuttgart, 1922.

HOLROYD, CHARLES, *Michael Angelo Buonarroti,* 2nd edition, London, 1911.

SYMONDS, JOHN ADDINGTON, *Life and Works of Michelangelo Buonarroti,* 2 vols., London, 1893, and many subsequent editions.

MONOGRAPHS

★BAROCCHI, PAOLA (ed.), *Giorgio Vasari, La Vita di Michelangelo nelle redazioni del 1550 e del 1568,* 5 vols., Milan–Naples, 1962. By means of notes to Vasari's *Lives,* the editor has succeeded in assembling an astonishingly complete array of passages illustrating the history of every major problem and idea in Michelangelo scholarship and criticism.

HARTT, FREDERICK, *Michelangelo,* London 1965.

————, *Michelangelo, the Complete Sculpture,* The Paintings of London, 1970.

JUSTI, CARL, *Michelangelo. Beiträge zur Erklärung der Werke und des Menschen,* Leipzig, 1900; also *Neue Beiträge,* Vienna and Leipzig, 1908.

KNAPP, FRITZ, *Michelangelo* (Klassiker der Kunst), 4th edition, Stuttgart and Leipzig, 1912.

MACKOWSKY, HANS, *Michelangelo,* 4th edition, Berlin, 1925.

SPRINGER, ANTON, *Raffael und Michelangelo,* 3rd edition, Leipzig, 1895.

THODE, HENRY, *Michelangelo. Kritische Untersuchungen über seine Werke,* 3 vols., Berlin, 1908–13.

————, *Michelangelo und das Ende der Renaissance,* 3 vols., Berlin, 1908–13.

★TOLNAY, CHARLES DE, *Michelangelo,* 6 vols., Princeton, 1943–. This immense work is the most thorough study of Michelangelo's art ever attempted, and the only good complete monograph on the artist in English. The sixth volume, on Michelangelo's architecture, will be published shortly.

DRAWINGS

BAROCCHI, PAOLA, *Michelangelo e la sua scuola*, vols. 1–2, *I disegni della Casa Buonarroti e degli Uffizi*, Florence, 1962; vol. 3, *I disegni dell'Archivio Buonarroti*, Florence, 1964. Well-nigh exhaustive study of the drawings in the Casa Buonarroti, the Uffizi, and the Archivio Buonarroti in Florence, constituting the largest body of Michelangelo's drawings preserved anywhere, amounting to nearly half of his surviving graphic work. All drawings including those rejected are illustrated, some with several details. The work contains the most recent and complete bibliography for each drawing. The drawings are analyzed chronologically. The treatment of the innumerable problems is exemplary, and the analysis of the work by pupils and imitators reliable and informative.

BERENSON, BERNARD, *The Drawings of the Florentine Painters*, esp. 2nd edition, Chicago, 1938, and 3rd edition, Milan, 1963 (not available for consultation when the present work was being prepared). Berenson's great work when it was first published in its 1903 edition represented a pioneer attempt to bring order into the mass of drawings attributed to Michelangelo. Some of his conclusions he has himself reversed in later editions, and others have been contested, but the book remains a study of first importance. Although the drawings are listed in the catalogue volume in order of collections, the text volume contains one of the rare attempts to summarize Michelangelo's style as a draftsman and to outline its development.

BRINCKMANN, A. E., *Michelangelo-Zeichnungen*, Munich, 1925. A selection.

DUSSLER, LUITPOLD, *Die Zeichnungen des Michelangelo*, Berlin, 1959. The most recent general study, treating in detail 722 sheets (comprising about 1200 drawings, counting rectos and versos) by Michelangelo and his school, with the latest bibliography on all drawings except those in Florence; for these Dussler is superseded by Barocchi. Despite thorough and conscientious treatment of a multitude of problems, the book is exceedingly difficult to use. Representing almost the extreme of the revisionist school, Dussler's opinions are frequently in sharp contrast with those of Wilde, Parker, and Barocchi, not to speak of traditional scholarship. There are only 275 illustrations, and many of these are devoted to inferior school works. The book is divided into three sections: certainly authentic (243 sheets), attributed (122 sheets), and apocryphal (357 sheets). The first two sections might as well have been consolidated, since Dussler accepts all drawings included in the second, save for an occasional doubt or query. The "apocryphal" section includes a surprising number of great and famous Michelangelo drawings, accepted by most other scholars. Less than a quarter of the drawings included are illustrated. In each section the drawings are listed according to collections, but since there is no general index, the reader unaware of Dussler's attribution in advance must look up an individual drawing in all three sections. This process is hampered by the absence of running heads on the pages, and of any consistent order among the illustrations. There are no paragraph divisions in the catalogue, even when an entry runs to two columns. The description of a verso is not separated in any way from that of a recto.

FREY, KARL, *Die Handzeichnungen Michelagniolos Buonarroti*, 3 vols., Berlin, 1909–11. The classic, if by now largely obsolete, catalogue of Michelangelo's drawings. Contains illustrations and discussions of 300 drawings.

FREY-KNAPP: KNAPP, FRITZ, *Die Handzeichnungen Michelagniolos Buonarroti. Nachtrag*, Berlin, 1925; supplement to Frey's catalogue, discussing the drawings in Haarlem and illustrating most of them.

GOLDSCHEIDER, LUDWIG, *Michelangelo Selected Drawings*, London, 1951. A selection of 208 drawings from various collections, all illustrated; intended for the general public.

PARKER, K. T., *Catalogue of the Collection of Drawings in the Ashmolean Museum*, vol. II, *Italian Schools*, Oxford, 1956. Thorough but sparsely illustrated catalogue of the Ashmolean Museum drawings.

POPHAM, A. E., and WILDE, JOHANNES, *Italian Drawings at Windsor Castle*, London, 1949. The Michelangelo section was written by Johannes Wilde, and constitutes the opening battle in the anti-revisionist campaign, with many important observations on Michelangelo drawings in other collections; fully illustrated.

———, *Summary Catalogue of an Exhibition of Drawings by Michelangelo*, British Museum, London, 1953.

THODE: See above under Monographs. The drawing catalogue, not illustrated, is in vol. III of his *Kritische Untersuchungen*.

TOLNAY: See above under Monographs. Michelangelo's drawings are catalogued through all five of the volumes already published. At first the author followed the extreme revisionist tendency, and throughout he has rejected a great number of generally accepted drawings with slight explanation, often with none at all. Many more generally accepted drawings, even

some illustrated by Berenson in full-page plates, are omitted entirely from the catalogue. Many early opinions have now been changed, and certain important drawings, previously rejected or ignored, have found their way back into vol. V as "Drawings Anticipating the *Last Judgment*"! The index of drawings is of little use, because the only numbers given are the author's own. The museum numbers, even in such vast collections as the Louvre or the Uffizi, are seldom listed in the catalogue entries or anywhere else. There are no concordances of other catalogues. Often the only way to find a given drawing is to hunt visually for the illustration.

WILDE, JOHANNES, *Italian Drawings in the Department of Prints and Drawings in the British Museum, Michelangelo and His Studio*, London, 1953. The second battle in the campaign to reverse the revisionist trend which had been rejecting important original drawings along with schoolwork. Most of Wilde's reattributions have been accepted by Parker and Barocchi, some by Tolnay, few by Dussler.

———, *Michelangelo's "Victory"*, Oxford, 1954.

ARCHITECTURE

*ACKERMAN, JAMES S., *The Architecture of Michelangelo*, 2 vols., London, 1961. An unusually well-written and convincing survey of Michelangelo's architectural style and the development of his architectural works, followed by a catalogue of all the supporting evidence; of first importance. Sparsely illustrated.

*PORTOGHESI, PAOLO, and ZEVI, BRUNO (eds.), *Michelangelo Architetto*, Turin, 1964. This collection of essays and a catalogue by ten Italian scholars has something of the flavor of an anti-Ackerman committee. The essays, though contentious, are often revealing, and the array of largely new photographs of Michelangelo's architecture, measured drawings of his buildings, and color facsimiles of his architectural drawings is astonishing in quality and completeness.

REPRODUCTIONS

GOLDSCHEIDER, LUDWIG, *The Paintings of Michelangelo*, London, 1939.
———, *The Sculptures of Michelangelo*, London, 1940.
SALVINI, ROBERTO, and CAMESASCA, ETTORE, *The Sistine Chapel*, 2 vols., New York, 1971

SPECIAL STUDIES

BAUMGART, F., and BIAGETTI, B., *Gli affreschi di Michelangelo ... nella Cappella Paolina in Vaticano*, Vatican City, 1934. The first full publication of the frescoes of the Pauline Chapel.

BIAGETTI, B., "La volta della Cappella Sistina," *Rendiconti della Pontificia Accademia Romana di Archeologia*, IX, 1936, pp. 199ff. and 366ff. Technical report on the consolidation of the Sistine Ceiling in 1935–36, with important observations on Michelangelo's pictorial methods.

BROCKHAUS, H., *Michelangelo und die Medici-Kapelle*, Leipzig, 1911.

CAMPOS, D. REDIG DE, and BIAGETTI, B., *Il Giudizio universale di Michelangelo, Vatican City*, 1944. The standard work on Michelangelo's Last Judgment.

CAMPOS, D. REDIG DE, *Michelangelo. Affreschi della Cappella Paolina in Vaticano*, Milan, 1950. Edition of the Pauline Chapel in color.

HARTT, FREDERICK, "Lignum Vitae in Medio Paradisi: the Stanza d'Eliodoro and the Sistine Ceiling," *The Art Bulletin*, XXXII, 1950, pp. 115–45 and 181–218; defended and amplified in *The Art Bulletin*, XXXIII, 1951, pp. 262–73. The complete exposition with supporting texts of the interpretation of the Sistine Ceiling summarized in this book.

———, "The Meaning of Michelangelo's Medici Chapel," *Festschrift für Georg Swarzenski*, Berlin and Chicago, 1951, pp. 145–55.

PANOFSKY, ERWIN, "The First Two Projects of Michelangelo's Tomb of Julius II," *The Art Bulletin*, XIX, 1937, pp. 561 ff.

———, "The Neoplatonic Movement and Michelangelo," *Studies in Iconology* (Chapter VI), New York, 1939. Crucial and enormously influential interpretation of the content of Michelangelo's art, especially important for its analysis of the Tomb of Julius II, the Medici Chapel, and the allegorical drawings. Unsurpassed statement of the principles of Michelangelo's style.

POPP, ANNY E., *Die Medici-Kapelle Michelangelos*, Munich, 1922. Important and controversial attempt to reconstruct the history and final appearance of the unfinished Medici Chapel.

STEINMANN, ERNST, *Die Sixtinische Kapelle*, vol. II, Munich, 1905. Basic and exhaustive monograph on the entire Sistine Chapel; the second volume deals with the Ceiling.

Index

Entries include page references to persons, places, and titles of works of art. Entries in *italic type* refer to Michelangelo's executed works or projects, unless otherwise identified. Not indexed are Michelangelo's drawings and information available in the Table of Contents and Concordance.